GUIDE
TO CANADIAN
PHOTOGRAPHIC
ARCHIVES –
Provisional Edition

ARCHIVES
PHOTOGRAPHIQUES
CANADIENNES –
Édition provisoire

ALAIN CLAVET
Coordinator – Coordonnateur

OTTAWA

1979

Public Archives
Canada

Archives publiques
Canada

Cover: Group of vacationers at the Tadoussac Hotel.

Tadoussac, Quebec. ca. 1880-1900. Collection and photograph:
Jules Ernest Livernois. Negative No.: PA 23940.

Couverture: Groupe de vacanciers à l'hôtel Tadoussac.

Tadoussac (Québec), vers 1880-1900. Fonds et photo:
Jules Ernest Livernois. Nº de négatif: PA 23940

© Minister of Supply and Services Canada 1979/
Ministre des Approvisionnements et Services Canada 1979
Cat. No./Nº de cat.: SA2-108/1979
ISBN/ISBN: 0-662-50346-5

TABLE OF CONTENTS – TABLE DES MATIÈRES

Introduction	v	Introduction	vii
Explanation of entries	ix	Explications des notices	xi
List of Abbreviations	xiii	Liste des abréviations	xiii
List of participating repositories	xiv	Liste des dépôts participants	xiv
Description of entries	1	Description des notices	1
Catalogue-by-repositories	154	Catalogue par dépôt	154
Index	170	Index	170
Caption list	225	Liste des légendes	225
Errata	231	Errata	231
Key to location of photographs		Liste numérique des dépôts	

Introduction

The *Guide to Canadian Photographic Archives* is a catalogue describing the holdings and collections of photographic archives in over 110 Canadian institutions. These institutions include repositories of federal, provincial and municipal governments, universities, historical societies, libraries, museums, research centres, private companies and photography studios.

With the aid of the *Guide to Canadian Photographic Archives* the researcher, confronted with an enormous mass of photographic records, can rapidly ascertain the photographic resources available in Canada. He can then identify and choose the group of photographic documents that will increase his knowledge in a given field of research.

With the ever-growing use of photographic records by publishers, teaching establishments, the media and the general public, such finding aids are necessary. Two prominent researchers have stated that:

> No knowledgeable person doubts that there are many significant and touching images buried in our depositories everywhere - unknown, uncatalogued, unavailable for use. They should be catalogued, for local, statewide and regional listings of our collections are badly required. A National Union List of Photographs must ultimately take its rightful place in research libraries as a valuable and much needed bibliographical tool.*

Convinced of the merits of this view, the Public Archives of Canada, in collaboration with the provincial archives, have encouraged and supported the preparation of this *Guide*.

The first volume of the preliminary inventory includes approximately 2,800 entries arranged alphabetically by titles of holdings. Of these entries, 1,800 are part of the National Photography Collection of the Public Archives of Canada; 1000 are from other participating repositories. Each of these holdings or collections may contain from one to several hundred thousand photographs. Since equal space is provided for all the entries, the smaller units of photographic records are described in greater detail than the very large ones.

The location of each of the holdings is indicated by all alpha-numerical code, for which there is a key in the appendix. That code is followed by a number which designates one holding in particular. For example, the code 7P-83 stands for the holdings of the photographer William James Topley in the Public Archives of Canada.

Each entry is made up of a title, based on the name of the individual or organization responsible for producing or bringing together the photographs; some biographical and historical information concerning this individual or body; the period covered by these records and the number of black and white or colour photographs; and a description of the main subjects, names of individuals and places photographed, and of the known photographers. Titles of finding aids for individual holdings are also listed to help the researcher. Once the entries have been selected, the researcher may contact the institution concerned to obtain additional information.

In this first volume the descriptions are in French or English, according to the language in which the description was submitted. Two further volumes will be published, depending on how much information is received from institutions, with entries in French or in English. These volumes will constitute a provisional inventory. They will then be expanded, revised and translated to form a permanent inventory.

The *Guide to Canadian Photographic Archives* is the result of a collective effort.

Elizabeth Jong and Brian Carey compiled the subject index; Sharon Kelly-Uno and Christopher Seifried assisted in editing. Joy Williams, Peter Robertson, Joan Schwartz, Lilly Koltun and Andrew Rodger wrote the descriptions of the Public Archives of Canada holdings and collections; and E. Grace Hyam and Victorin Chabot, the editor and assistant editor respectively of the *Union List of Manuscripts in Canadian Repositories,* provided guidance and the benefit of their advice and experience. Public Archives Information Services collaborated in the publishing of this volume.

I would like to thank the Provincial archivists, librarians, curators, historians, photographers, support staff and directors of institutions for their valuable participation.

*Weinstein, Robert A. and Larry Booth. *Collection, Use and Care of Historical Photographs.* American Association for State and Local History, Nashville, 1977, p. 17.

I wish in particular to acknowledge the contribution of the provincial archivists who agreed, despite their own heavy workloads, to collaborate in the production of this inventory.

This first edition of the preliminary inventory is bound to contain omissions and errors. I would be grateful to receive any comments from researchers that may help to improve subsequent editions.

Alain Clavet,
Coordinator

Introduction

Le *Guide des archives photographiques canadiennes* répertorie et décrit les fonds et collections d'archives photographiques conservés dans plus de cent dix institutions canadiennes. Ces institutions sont des dépôts d'archives fédérales, provinciales, municipales et universitaires, des sociétés historiques, des bibliothèques, des musées, des centres de recherche, des compagnies privées et enfin des studios de photographes.

Le *Guide des archives photographiques canadiennes* vise à aider le chercheur, confronté à une quantité énorme de documents photographiques, à connaître rapidement l'ensemble des sources photographiques canadiennes disponibles, et à repérer et choisir le groupe de documents photographiques qui saura lui être utile pour approfondir un sujet de recherche donné.

L'utilisation sans cesse croissante de la documentation photographique par les maisons d'édition et les établissements d'enseignement, par les media et le public en général, est à l'origine de cet instrument de recherche. D'ailleurs, deux éminents chercheurs n'ont-ils pas affirmé :

> Toute personne avisée sait qu'il existe quantité de photographies, importantes et pertinentes, enfouies quelque part dans nos dépôts, inconnues, non cataloguées et donc inutilisables. Il y aurait avantage à les cataloguer puisque des répertoires s'imposent aux niveaux local, provincial et régional. Chaque bibliothèque de recherche devra un jour être dotée d'un catalogue collectif de photographies, outil bibliographique précieux et indispensable*.

Persuadées du bien-fondé de cette opinion, les Archives publiques du Canada, en collaboration avec les archives provinciales, ont encouragé et soutenu la préparation de ce *Guide*.

Ce premier volume de l'inventaire préliminaire comprend approximativement 2,800 notices classées selon l'ordre alphabétique des titres de fonds. 1 800 proviennent de la Collection nationale de photographies des Archives publiques du Canada et 1000 des autres dépôts participants. Chacun de ces fonds ou collections peut compter d'une à plusieurs centaines de milliers de photographies. Comme un espace identique est prévu pour les notices, les petits groupes de documents photographiques sont décrits de façon plus complète que les groupes quantitativement très importants.

Les dépôts, où ces fonds sont conservés, sont identifiés par des symboles alpha-numériques. Ces symboles, dont une liste se trouve en appendice, sont suivis d'un nombre qui identifie un fonds en particulier. Par exemple, la cote 7P-83 correspond au fonds photographe William James Topley conservé aux Archives publiques du Canada.

La notice comprend un titre correspondant au nom de l'individu ou de l'organisme qui est responsable de la création ou du regroupement des documents photographiques; des renseignements d'ordre biographique et historique; une évaluation de la période couverte par ces documents photographiques ainsi que la quantité en noir et blanc ou couleur; et une description mentionnant les principaux thèmes, les noms des individus et des lieux photographiés, ainsi que les noms des photographes s'ils sont connus. Afin de faciliter la recherche, les titres des instruments de recherche se rapportant à chacun de ces fonds sont également mentionnés. Une fois le fonds repéré, le chercheur n'a plus qu'à communiquer avec l'institution concernée pour obtenir de plus amples renseignements.

Dans ce premier volume, les descriptions ont été publiées en français ou en anglais selon la langue utilisée pour la description. Un ou deux autres volumes paraîtront, selon l'importance de la participation des institutions, avec des notices en français ou en anglais. Ces volumes constitueront un inventaire provisoire. Ils seront ensuite augmentés, révisés et traduits pour constituer un inventaire permanent et à grand tirage.

La réalisation du *Guide des archives photographiques canadiennes* résulte d'un travail d'équipe.

Elizabeth Jong et Brian Carey ont travaillé à la compilation de l'index des sujets; Sharon Kelly-Uno et Christopher Seifried ont standardisé les notices. Joy Williams, Peter Robertson, Joan Schwartz, Lilly Koltun et Andrew Rodger ont décrit les fonds et les collections conservés aux Archives publiques du Canada. E. Grace Hyam et Victorin Chabot, respectivement rédacteur et rédacteur adjoint du *Catalogue collectif des manuscrits conservés dans les dépôts d'archives canadiens,* ont su nous guider par leurs conseils et leur expérience. Le concours des Services d'information des Archives publiques a facilité la publication de ce volume.

* Weinstein, Robert A. et Larry Booth, *Collection, Use and Care of Historical Photographs,* American Association for State and Local History, Nashville, 1977, p. 17.

Nous tenons à remercier tous les archivistes provinciaux, les bibliothécaires, les conservateurs, les historiens, les photographes et les responsables des institutions qui ont participé à cet effort collectif.

Cette première édition de l'inventaire préliminaire ne peut se faire sans omissions et sans erreurs. Nous serions reconnaissants aux chercheurs de nous communiquer tout commentaire susceptible d'améliorer la prochaine édition.

Alain Clavet
Coordonnateur

EXPLANATION OF ENTRIES

Researchers are asked to read the following explanations before using this guide.

Language

The holdings and collections of photographic archives in this provisional edition are described in French or in English. A revised and corrected bilingual edition will be published at a later date.

Location of Holdings and Collections

The repositories which participated in the production of this guide were assigned alpha-numerical codes corresponding to numbers used in the *Union List of Manuscripts* (ULM) (7P for Public Archives of Canada, 32P for Mount Allison University Archives). New codes were assigned to repositories not listed in the ULM (327P for Notman Photographic Archives and 339P for Saskatoon Public Library). The code appears after the title of the unit. The number preceding the hyphen corresponds to one of the archival repositories listed in the "Key to Location of Photographs" on the last page of the volume. All entries received from the same institution are numbered consecutively following the hyphen.

Titles of Units

Units are listed under the names of the persons, corporate bodies and government agencies which received, produced and assembled the photographic records.

Dates of Birth and Death

Whenever possible the dates of birth and death of the individual whose photographs are described in this guide are given.

Order of Entries

The entries are arranged in alphabetical order, word by word.

 e.g. Baker, D.H.
 Baker, Raymond F.
 Baker, Russell
 Bourchier (famille)
 Bourdon, Louis-Honoré

Names beginning with the letters "Mac" and "Mc" are arranged in strict alphabetical order.

 e.g. MacDonald, James Edward Hervey
 MacPherson, Robert G.
 Manitoba, Museum of Man
 McDonald, Percy

Titles of holdings beginning with a numeral appear after those in alphabetic characters.

 e.g. Vanier Institute of the Family
 Van Zeggeren, Frederic
 153 Mile House Store

Residence and Principal Occupation

Whenever possible the place of residence and the principal occupation of individuals have also been given. They are listed next to the dates of birth and death, following the title.

Type, Quantity and Inclusive Dates of Records

This section indicates whether the holding or collection is made up of original photographic material exclusively or of copies exclusively. Nothing is indicated for units containing both types of records. The number of black and white and of colour photographs is given, if this information is known. The dates listed refer to the production of the photographic records, and not to the subjects of the photographs.

Description of Photographic Records

This paragraph contains a concise description of the main divisions and contents of the unit. Whenever possible the principal subjects, prominent events and well-known persons appearing in the photographs are named.

Restricted Access

Some holdings and collections may not be consulted and/or reproduced without the permission of the owner. Researchers are therefore advised to inquire about terms of access to archives in which they are interested before visiting a repository.

Catalogue-by-repositories

An alphabetic listing of all holdings and collections is given for each participating repository at the end of the *Guide to Canadian Photographic Archives*. These listings, arranged by repository code, help the researcher to identify rapidly the records described for a given repository.

Key to Location of Photographs

The last page of this volume contains a key to the alpha-numerical codes used for the repositories. The name and full address of each repository are given in the "List of Participating Repositories".

EXPLICATION DES NOTICES

Les chercheurs sont priés de lire les explications suivantes avant de se servir de ce guide.

La langue

Les fonds et les collections d'archives photographiques de cette édition provisoire sont décrits en français ou en anglais. Une édition bilingue revue et corrigée sera publiée ultérieurement.

Localisation des fonds et collections

Les dépôts d'archives participant à l'élaboration de ce guide ont reçu un symbole alpha-numérique correspondant à celui du *Catalogue collectif des manuscrits* (C.C.M.) (7P pour les Archives publiques du Canada, 32P pour le Mount Allison University Archives). Si le dépôt n'a pas été répertorié dans le C.C.M. un nouveau numéro lui a été assigné. (327P pour les Archives photographiques Notman et 339P pour le Saskatoon Public Library). Ce symbole numérique paraît après le titre du fonds. Le chiffre qui précède le tiret, correspond à l'un des dépôts d'archives énumérés dans la liste numérique des dépôts qui se trouve à la dernière page du volume. Tous les fonds d'une même institution sont numérotés consécutivement et ce numéro suit le tiret.

Titres des fonds et collections

Les titres des fonds et collections sont désignés par le nom des personnes, physiques ou morales, et des organismes gouvernementaux qui ont reçu, créé et accumulé les documents photographiques.

Dates de naissance et de décès

Dans la mesure du possible, on mentionne les dates de naissance et de décès des personnes dont les photos sont décrites dans ce guide.

Classement des notices

Les titres des notices sont classés en ordre alphabétique, mot par mot.

Exemples :

> Baker, D.H.
> Baker, Raymond F.
> Baker, Russell
> Bourchier (famille)
> Bourdon, Louis-Honoré

Les noms commençant par les lettres « Mac » et « Mc » sont classés en ordre alphabétique strict.

Exemples :

> MacDonald, James Edward Hervey
> MacPherson, Robert G.
> Manitoba, Museum of Man
> McDonald, Percy

Les titres de fonds commençant par des chiffres arabes apparaissent à la fin de l'ordre alphabétique.

Exemples :

> Vanier Institute of the Family
> Van Zeggeren, Frederic
> 153 Mile House Store

Domicile et occupation principale.

Le lieu de résidence et l'occupation principale des personnes sont également mentionnés lorsqu'ils sont connus. Ces renseignements apparaissent à la suite des dates de naissance et de décès, après le titre.

Catégories, quantité et dates extrêmes des documents.

Cette section indique si le fonds ou la collection est composé uniquement de documents photographiques originaux ou de copies. S'il y a des originaux et des copies dans le même fonds ou la même collection, rien n'est indiqué. La quantité de documents photographiques en noir et blanc ou en couleur est mentionnée si elle est connue, et les dates sont celles de la création des documents photographiques et non celles des sujets qu'ils représentent.

Description des documents photographiques

Ce paragraphe décrit brièvement les principales divisions ainsi que le contenu du fonds ou de la collection. Dans la mesure du possible, les sujets principaux, les événements marquants et les personnes éminentes apparaissant sur les photos sont mentionnées.

Restriction

Certains fonds et collections ne peuvent être consultés et/ou reproduits sans la permission de leur propriétaire. Avant de se rendre à un dépôt d'archives, les chercheurs ont donc avantage à s'enquérir des conditions de consultation des fonds et collections qui les intéressent.

Catalogue par dépôt

Afin de connaître rapidement les fonds décrits provenant d'un dépôt en particulier, on trouvera à la fin du *Guide des archives photographiques canadiennes,* selon l'ordre numérique des dépôts participants, la liste alphabétique des titres de tous leurs fonds et collections.

Liste numérique des dépôts

Les chercheurs trouveront à la dernière page de ce volume une liste des symboles alpha-numériques des dépôts et des noms correspondants. Le nom et l'adresse exacte de chaque dépôt sont indiqués dans la liste des dépôts participants.

List of Abbreviations - Liste des abréviations

b.	born
b&w	black and white
ca.	circa
col.	coloured
coul.	couleur
d.	died/décès
Dept.	Department
est.	established
f.	fondé/founded
fl.	flourished
n.	né
n.&b.	noir et blanc
n.d.	no date/sans date
no.	number
photo	photograph/photographie
photo.	photographer/photographe (index only/index seulement)

LIST OF PARTICIPATING REPOSITORIES/LISTE DES DÉPÔTS PARTICIPANTS

Federal Government/Gouvernement fédéral

Canadian Broadcasting Corporation Archives
Archives de la Société Radio-Canada
Historical Section/Section historique
1500, rue Bronson St.
OTTAWA (Ontario)
K1G 3J5 311P

National Library of Canada
Bibliothèque nationale du Canada
395, rue Wellington St.
OTTAWA (Ontario)
K1A 0N4 149P

National Gallery of Canada
Galerie nationale du Canada
OTTAWA (Ontario)
K1A 0N4 123P

National Research Council of Canada
Conseil national de recherches du Canada
OTTAWA (Ontario)
K1A 0R6 332P

Public Archives of Canada
Archives publiques du Canada
395, rue Wellington St.
OTTAWA (Ontario)
K1A 0N3 7P

Alberta

Archives of the Canadian Rockies
Box 160
BANFF, Alberta
T0L 0C0 166P

Glenbow-Alberta Institute
9th Avenue and 1st Street East
CALGARY, Alberta
T2G 0P3 11P

Provincial Archives of Alberta
12845-102nd Avenue
EDMONTON, Alberta
T5W 0M6 13P

University of Alberta Archives
EDMONTON, Alberta
T6J 2J4 92P

British Columbia/Colombie-Britannique

Cariboo-Chilcotin Archives
2002 R.R. 1
WILLIAMS LAKE, British Columbia
V2G 2P1 228P

Fort Steele Historic Park
FORT STEELE, British Columbia
V0B 1N0 333P

Kamloops Museum
207 Seymour St.
KAMLOOPS, British Columbia
V2C 2E7 91P

New Westminster Public Library
716 - 6th Avenue
NEW WESTMINSTER, British Columbia
V3M 2B3 334P

Provincial Archives of British Columbia
VICTORIA, B.C.
V8V 1X5 12P

Rossland Historical Museum
P.O. Box 26
ROSSLAND, British Columbia
V0G 1Y0 110P

Vancouver Public Library
Historical Photograph Section
750 Burrard St.
VANCOUVER, B.C.
V6V 1X5 300P

Manitoba

Archives de la Société historique de
 Saint-Boniface
C.P. 125
SAINT-BONIFACE (Manitoba)
R2H 3B4 222P

Jewish Historical Society of Western
 Canada Inc.
403 - 322 Donald St.
WINNIPEG, Manitoba
R3B 2H5 305P

Provincial Archives of Manitoba
200 Vaughan St.
WINNIPEG, Manitoba
R3C 0P8 9P

New Brunswick/Nouveau-Brunswick

Centre d'études acadiennes
Université de Moncton
Cité universitaire
MONCTON (Nouveau-Brunswick)
E1A 3E9 15P

Centre de documentation de la Société historique
 Nicolas-Denys
Site 19, C.P. 6
BERTRAND (Nouveau-Brunswick)
E0B 1J0 341P

Moncton Museum Inc.
20 Mountain Road
MONCTON, New Brunswick
E1C 2J8 337P

Mount Allison University Archives
SACKVILLE, New Brunswick
E0A 3C0 32P

New Brunswick Museum
Canadian History Department
SAINT JOHN, New Brunswick
E2K 1E5 2P

Provincial Archives of New Brunswick
Archives provinciales du Nouveau-Brunswick
Centennial Building
Edifice du Centenaire
Box 6000/B.P. 6000
FREDERICTON, (Nouveau-Brunswick)
E3B 5H1 46P

Newfoundland/Terre-Neuve

Memorial University of Newfoundland
 Folklore and Language Archives (MUNFLA)
ST. JOHN'S, Newfoundland
A1C 5S7 39P

Provincial Archives of Newfoundland
Colonial Building
ST. JOHN'S, Newfoundland
A1C 2C9 4P

Provincial Reference Library
Arts and Culture Centre
Allandale Road
ST. JOHN'S, Newfoundland
A1B 3A3 38P

Nova Scotia/Nouvelle-Écosse

Army Museum
P.O. Box 3666
HALIFAX South P.O., Nova Scotia
B3J 3K6 304P

Beaton Institute of Cape Breton Studies
College of Cape Breton
Box 760
SYDNEY, Nova Scotia
B1P 6J1 104P

Dalhousie University Archives
HALIFAX, Nova Scotia
B3H 3S5 31P

Mount St. Vincent University Archives
Mount St. Vincent University
HALIFAX, Nova Scotia
B3M 2J6 340P

Public Archives of Nova Scotia
HALIFAX, Nova Scotia
B3H 1Z9 1P

United Church of Canada
Maritime Conference Archives
Pine Hill Divinity Hall
HALIFAX, Nova Scotia
B3H 3B5 24P

University of King's College Library
Coburg Road
HALIFAX, Nova Scotia
B3H 2A1 302P

Ontario

Archives Deschâtelets
Oblats de Marie-Immaculée
175, rue Main
OTTAWA (Ontario)
K1S 1C3 193P

Archives de l'Archidiocèse d'Ottawa
256, avenue King Edward
OTTAWA (Ontario)
K1N 7M1 306P

Archives of the Brothers of the Christian
 Schools of Ontario
5 Avonwick Gate
DON MILLS, Ontario
M3A 2M5 310P

Archives of Ontario
77 Grenville St., Queen's Park
TORONTO, Ontario
M7A 2R9 8P

Archives of the Presbyterian Church
 in Canada
59 St. George Street
TORONTO, Ontario
M5S 2E6 317P

Archives of the Toronto Board of Education
155 College St.
TORONTO, Ontario
M5T 1P6 143P

Art Gallery of Ontario
Grange Park
TORONTO, Ontario
M5T 1G4 308P

Bank of Nova Scotia Archives
44 King St. West
TORONTO, Ontario
M5H 1E2 309P

Centre de recherche en civilisation
 canadienne-française
Université d'Ottawa
65, rue Hastey
OTTAWA, Ontario
K1N 6N5 185P

City of Toronto Archives
City Hall
TORONTO, Ontario
M5H 2N2 140P

Globe and Mail Library
140 King St. West
TORONTO, Ontario
M5H 1K1 312P

Hamilton Public Library
55 Main St. West
HAMILTON, Ontario
L8P 1H5 45P

Hartill Art Associates
181 St. James Street
LONDON, Ontario
N6A 1W7 313P

Lakehead University Library
Oliver Road
THUNDER BAY, Ontario
P7B 5E1 146P

Lennox and Addington Historical Museum
P.O. Box 160
NAPANEE, Ontario
K7R 3M3 22P

Metropolitan Toronto Library
789 Yonge St.
TORONTO, Ontario
M4W 2G8 18P

Oakville Museum
Box 395
OAKVILLE, Ontario
L6J 5A8 47P

Ontario Hydro Photo Library
700 University
TORONTO, Ontario
H5G 1Z5 316P

Ottawa Diocesan Archives
Christ Church Cathedral
71 Bronson Avenue
OTTAWA, Ontario
K1R 6G6 301P

Peterborough Centennial Museum and
 Archives
P.O. Box 143
PETERBOROUGH, Ontario
K9J 6Y5 158P

Queen's Own Rifles
Regimental Museum
Casa Loma
1 Austin Terrace
TORONTO, Ontario
M5R 1X8 82P

Queen's University Archives
KINGSTON, Ont.
K7L 5C4 75P

Ryerson Institute Archives
50 Gould Street
TORONTO, Ontario
M5B 1E8 307P

St. Michael's Hospital Archives
30 Bond St.
TORONTO, Ontario
M5B 1W8 318P

Sault Ste. Marie and 49th Field Regiment
R.C.A. Historical Society
Box 309
SAULT STE. MARIE, Ontario 121P

Sisters of St. Joseph Archives
St. Joseph's Motherhouse
3377 Bayview Avenue
WILLOWDALE, Ontario
M2M 3S4 319P

Sisters Servants of Mary Immaculate
 Community Archives
5 Austin Terrace
TORONTO, Ontario
M5R 1Y1 338P

Stephen Leacock Memorial Home
ORILLIA, Ontario
L3V 6K5 95P

Thomas Fisher Rare Book Library
University of Toronto
120 St. George Street
TORONTO, Ontario 16P

Toronto Dominion Bank Archives
Head Office
P.O. Box 1, Toronto Dominion Centre
TORONTO, Ontario
M5K 1A2 320P

Toronto Harbour Commissioners
60 Harbour St.
TORONTO, Ontario
M5J 1B7 322P

University College Archives
c/o German Department
University of Toronto
TORONTO, Ontario 321P

University of St. Michael's College
 Library
81 St. Mary Street
TORONTO, Ontario
M5S 1J4 200P

University of Toronto Archives
120 St. George Street
TORONTO, Ontario
M5S 1A5 196P

Women's Canadian Historical Society
153 Spadina Road
TORONTO, Ontario
M5R 2T9 314P

York University Archives
105 Scott Library
4700 Keele St.
DOWNSVIEW, Ontario
M3J 1P3 160P

Prince Edward Island/Île-du-Prince-Édouard

Public Archives of Prince Edward Island
Box 1000
CHARLOTTETOWN, Prince Edward Island
C1A 7M4 5P

Quebec/Québec

Archives des Clercs de Saint-Viateur
 de Montréal
450, avenue Querbes
MONTRÉAL (Québec)
H2V 3W5 208P

Archives des Franciscains
5750, boulevard Rosemont
MONTRÉAL (Québec)
H1T 2H2 328P

Archives du monastère de l'Hôtel-Dieu
 de Québec
75, rue des Remparts
QUÉBEC (Québec)
G1R 3R9 171P

Archives du séminaire de Nicolet
Grand séminaire de Nicolet
rue Brossard
C.P. 610
NICOLET (Québec)
J0G 1E0 324P

Archives du séminaire de Québec
2, rue de la Fabrique
QUÉBEC (Québec)
G1R 4R7 131P

Archives générales des Oblates
 missionnaires de Marie-Immaculée
7535, boulevard Parent
TROIS-RIVIÈRES (Québec)
G9A 5E1 331P

Archives nationales du Québec
Centre régional de la Mauricie Bois-Francs
140, rue Saint-Antoine
Suite 408
TROIS-RIVIÈRES (Québec)
G9A 5N6 315P

Archives nationales du Québec
Centre régional du Saguenay-Lac
 Saint-Jean
555, rue Bégin
CHICOUTIMI (Québec)
G7H 4N7 335P

Archives provinciales des Clercs de
Saint-Viateur de Joliette
132, rue Saint-Charles nord
JOLIETTE (Québec)
J6E 3Z2 221P

Bell Canada (Collection historique)
1050 Côte-du-Beaver Hall
Pièce 1436
MONTRÉAL (Québec)
H3C 3G4 330P

Bibliothèque de la ville de Montréal
1210, rue Sherbrooke est
MONTRÉAL (Québec)
H2L 1L9 113P

Bishop's College School
LENNOXVILLE (Québec) 346P

Centre de documentation de La Presse
7, rue Saint-Jacques
MONTRÉAL (Québec)
H2Y 1K9 303P

Centre Emilie Gamelin
5655, rue Salaberry
MONTRÉAL (Québec) 326P

C.E.G.E.P. de Shawinigan
SHAWINIGAN (Québec) 352P

Conseil Intermunicipal des Loisirs du
Témiscouata
NOTRE-DAME-DU-LAC (Québec) 343P

Jean Fontaine
1312, rue Saint-Louis
PLESSISVILLE (Québec) 353P

Roland Lemire
511, rue Saint-Georges
TROIS-RIVIÈRES (Québec) 354P

Ministère des Communications du Québec
Division de la Documentation
photographique
1601 ouest, boulevard Hamel
QUÉBEC (Québec) 342P

Musée du Royal 22e Régiment
La Citadelle
QUÉBEC (Québec) 134P

Notman Photographic Archives
McCord Museum
McGill University
690 Sherbrooke Street West
MONTREAL, Que.
H3A 1E9 327P

Photos Duplain Enr.
216 rue Saint-Michel
SAINT-RAYMOND, Cté de Portneuf (Québec) 345P

Banque Royale (archives historiques)
C.P. 6001
MONTRÉAL (Québec)
H3C 3A9 323P

Maurice Saint-Pierre
187, rue Saint-Jean-Baptiste
BROMPTONVILLE (Québec) 347P

Alain Sauvageau
256, rue Saint-Georges
CAP-DE-LA-MADELEINE (Québec) 351P

Service central des archives de la
congrégation des Soeurs des Saints
Noms de Jésus
1420, boulevard Mont-Royal
OUTREMONT (Québec) 325P

Service des archives
Maison provinciale des Filles de la
Charité du Sacré-Coeur de Jésus
575, rue Allen
SHERBROOKE (Québec)
J1G 1Z1 329P

La Société historique du comté de Shefford
66 Dufferin
GRANBY (Québec)
J2G 4W7 344P

Studio Boutet
1312, 4ième Avenue
LA POCATIÈRE, Cté de Kamouraska (Québec) 349P

Studio Gendreau
733, 4ème Avenue
LA POCATIÈRE, Cté de Kamouraska (Québec) 348P

Studio Jean-Paul
520, 12ème Rue
SAINT-PASCAL, Cté de Kamouraska (Québec) 350P

Saskatchewan

Moose Jaw Public Library
Archives Department
461 Langdon Crescent
MOOSE JAW, Saskatchewan
S6H 0H6 163P

Royal Canadian Mounted Police Museum
Box 6500
REGINA, Saskatchewan
S4P 3J7 81P

Saskatchewan Archives Board
University of Regina
REGINA, Saskatchewan
S4S 0A2 10P

Saskatoon Public Library
Local History Department/Archives
311–23rd Street East
SASKATOON, Saskatchewan
S7P 0J6 339P

Yukon

Yukon Territorial Archives
Box 2703
WHITEHORSE, Yukon
Y1A 2C6 161P

DESCRIPTION OF ENTRIES

DESCRIPTION DES NOTICES

Abel, G.C., Yorkton (Sask.), militaire.

 7P-1 Originaux, n.&b. 1. [].
 Portrait de l'officier-pilote G.C. Abel qui fut décoré de la médaille
 de George lorsqu'il faisait parti du Corps d'aviation royal canadien
 (R.C.A.F.).

Aberdeen and Temair, John Campbell Hamilton Gordon, Marquess of,
(1847-1934), Governor General of Canada.

 18P-16 b&w 2. ca. 1897.
 Portraits of Lord and Lady Aberdeen.

Abrey, Mabel, Toronto, Ont.

 200P-17 b&w 70. 1948.
 Sixth biennial convention of the Canadian Federation of Catholic
 Convent Alumni, Vancouver 24-28 August 1948.

Acadia Gas Engine Co., (est. 1908), Bridgewater, N.S., engine
manufacturers.

 31P-75 b&w 140. ca. 1930-1960.
 Catalogue, photos and views of plant.

Adams, Frank, Mrs., Regina, Sask.

 81P-1 Original, b&w 22. ca. 1909-1975.
 Self portraits by G.W. Brinkworth of himself and his family; war
 memorial, Regina, Sask.; R.N.W.M.P. on parade passing officers
 houses and the guard room.

Adams, Frank Dawson, (1899-1940), Montreal, Que., geologist.

 31P-3 Original, b&w 350. ca. 1900.
 Tour of coal mining operations in B.C. and Nova Scotia; geological
 field trips in Quebec, Manitoba and Mexico.

Adams, John, curator of the Heritage Village, B.C.

 81P-2 Original, b&w 1. 1913.
 Portrait of Thomas Sherwood Belcher, Yorkton, Sask.

Adams family.

 334P-34 Copies, b&w 6. 1878-ca. 1912.
 New Westminster scenes: house, school, store; events: Hyack
 Festival, May Day; B.C. Electric Railway car-building shops.

Adamson, Agar Stewart Allan Masterton, (1865-1929), Toronto, Ont.,
military officer.

 7P-2 b&w 27. ca. 1890-1914.
 Activities of Mr. Agar Adamson and friends during canoe trip in
 Algonquin Park, Ont., ca. 1890-1914.

Adamson, Anthony, (1906-), Toronto, Ont., Architect.

 18P-56 b&w 67. ca. 1893-ca. 1928.
 Swansea area of Toronto.

Adaskin, Murray, (1906-), Victoria, B.C., composer and teacher.

 149P-1 b&w [25]. 1931-1970.
 Adaskin with family and friends as well as at the Banff School of
 Fine Arts.

Affleck, Minnie, Middleville, Ont., nurse.

 7P-3 b&w 3. ca. 1900.
 Cutting wood with horse-powered saw, Lanark, Ont; portraits of
 nursing sister Minnie Affleck, First Canadian Contingent, South
 African War.

Agriculture - Manitoba.

 9P-46 b&w [1,500]. 1870 to date.
 Photographs of agricultural scenes, machinery, and exhibitions.

Air Canada, Montréal (Québec), compagnie de transport aérien.

 7P-4 Originaux, n.&b. 169. 1937-1970.
 Personnel et flotte de la Trans-Canada Air Lines; avions de la
 compagnie Air Canada; opérations de maintenance; portraits de
 Gordon R. McGregor par les photographes Karsh et Gaby; vol de
 Montréal à Vancouver le 30 juillet 1937.

Akins, Thomas B., (1809-1891), Halifax, N.S., record commissioner for
Nova Scotia.

 1P-3 Original, b&w (200). ca. 1860-ca. 1870.
 Canadian politicians, government officials and clergy; British
 politicians, royalty, nobility and officials concerned with the
 government of Canada; photos of public buildings in Halifax, N.S.,
 Fredericton, N.B., Montreal, and Quebec City, Que., and Toronto,
 Ont., by Notman, Parish & Co.

Albani, Marie Louise Cécile Emma (Lajeunesse), Dame, (1847-1930),
Londres, Angleterre, cantatrice d'opéra et d'oratorio.

 149P-2 n.&b. [5]. ca. 1870-1911.
 Photographies de Mme Albani.

Alberta, Department of Culture, Provincial Archives, Edmonton, Alta.

 13P-7 b&w 5,222, col. 110, total 5,332. ca. 1966.
 Views of Alberta towns, cities, families, homesteads, buildings,
 farms, modes of transportation, activities, special events, ethnic
 groups, individuals.

Alberta, Government Services, Bureau of Public Affairs, Edmonton, Alta.

 13P-6 b&w [150,000], col. 50,000, total [200,000]. 1936-67.
 Street scenes in Alberta towns and cities, agriculture, exhibitions,
 businesses, provincial parks, government officials, buildings, sports,
 ceremonies, royal visits, lakes, points of interest, mountains, special
 events, industries, M.L.A.'s etc.

Alberta Legislature Library, Edmonton, Alta.

 13P-10 b&w [398]. [n.d.].
 N.W.M.P., Indians, fur trade, river boats, individuals, groups,
 houses, Agriculture, Churches, Alberta Communities, W.W. I,
 Businesses, Royal visits, visits by dignitaries, special events and
 celebrations, ceremonies, M.L.A.'s, sports, Fort Edmonton, C.N.R.
 construction, etc.

Alberta Medical Association, Edmonton, Alta., professional organization.

 92P-2 b&w 95. [n.d.].
 Doctors, nurses, and hospitals in Alberta.

Albertype Company, Brooklyn, and New York, N.Y.

7P-5 b&w [1,300]. 1900-1925.
Views of cities and towns across Canada, 1900-1925.

18P-58 Copies, b&w [1637]. ca. 1890-ca. 1920.
Canadian views.

Alessio, Orio J., Deep River, Ont.

7P-6 b&w 24. ca. 1910.
Portraits of unidentified individuals and groups.

Alexander, W.M., Regina, Sask.

81P-3 Original, b&w 1. 1911.
Coronation of King George V and Queen Mary.

Alexander, William John, (1855-1944), Halifax and Toronto, professor of English.

16P-1 b&w 34. ca. 1860-1930.
Family photos of W.J. Alexander, his wife, née Laura Morrow of Halifax, of their immediate forebears and of their children; includes a few Notman photos.

Alexander of Tunis, Harold, Viscount, (1891-1969), Ottawa, Ont., Governor-General of Canada.

7P-7 Original, b&w 56. 1949.
Martyrs' Shrine, Fort Ste. Marie, Midland, Ont.; chute du Diable, Peribonka, Qué.; Shipshaw Power Development on the Saguenay River at Arvida, Qué.; Port Alfred, Qué.; Iles Malignes, Grande Décharge, Lac Saint-Jean, Qué.; aluminum Plant, Arvida, Qué.

Alexandra Studio, Weston, Ont., photographers.

7P-8 b&w 7087. 1870-1950.
Opening of the Welland Canal, Ont.; V-E and V-J Day celebrations, Toronto, Ont.; political events in Toronto, Ont.; aspects of the Canadian National Exhibition, Toronto, Ont.; activities of the Toronto Maple Leafs Team in the International Baseball League; views of Toronto, Timmins, Paris, Weston, Ont.

Allan, Andrew Edward Fairbairn, (1907-1974), Toronto, Ont., producer, writer and director.

7P-9 b&w 418, col. 174, total 592. 1940-1967.
Andrew Allan's second marriage; activities of Andrew Allan as a producer for the Canadian Broadcasting Corporation and an artistic director of the Shaw Festival, 1963-1965; Lucio Agostini, Andrew Allan and Sandra Scott Salverson at the fifth birthday party of the series "Stages", 23 Jan., 1949; S S *Empress* and S S *Duchess of Richmond;* Malahat Drive, Vancouver Island, B.C. Lake Wah-Wash-Kesh, Ont.

Allard, Alexandrine, Lachine, Que.

7P-10 Original, b&w 26. 1910-1920.
Parks, walks, and piers in Lachine, Que.; portrait of Henri Groulx.

Allard, D.M., Ottawa, Ont.

7P-11 Copies, b&w 40. 1911-1928.
Officers of the Royal Canadian Regiment, Halifax, N.S., ca. 1911; presentation of Colours to the 128th Battalion, C.E.F., Moose Jaw, Sask., 1 May, 1919; visit of H.R.H. the Prince of Wales to Regina, Sask., 4 Oct., 1919; various activities of Inspector A.B. Allard,

R.C.M.P., 1928-30; portraits of Viscount Byng of Vimy and Lady Byng.

Allard, Dorothy M., Ottawa, Ont.

81P-4 b&w 2. [n.d.].
Barracks, Regina, Sask.

Allard, Joseph Arthur, Lachine (Québec).

7P-12 Copies, n.&b. 2. ca. 1925.
Livraison de charbon de bois et d'eau de javelle La Parisienne par l'agence Joseph Arthur Allard, à Lachine (Québec), ca. 1925; photos prises par C.A. Barbier.

Allen, Orval W., Toronto, Ont., photographer.

18P-96 Original, b&w 66. ca. 1933; ca. 1955.
North Toronto houses, ca. 1933; Toronto scenes.

Allen, Phillip E., North Battleford, Sask.

7P-13 b&w 36. ca. 1948.
Dawson, Klondike, Whitehorse, Old Crow, Yukon; Jefferson Randalph Smith's parlor, Skagway, Alaska; Presbyterian Church, Lake Bennett, B.C.; Chilkoot Pass., B.C; Indian fish racks, Fort Rae, N.W.T.; overland stages of the White Pass and Yukon Transportation Co. and the overland Stage Co.; old engines of the Klondike Municipal Railway; sternwheel steamboats: *Casca, Klondike, Yukoner, Alaska, Bonanza King, Julia B., Tutshi;* Yellowknife, N.W.T.

Alleya, W.J., Mrs., Sault Ste. Marie, Ont.

81P-5 b&w 9. ca. 1900.
Photos of Dawson and Yukon area.

Allison, Gordon H., Hamilton, Ont.

7P-14 Original, b&w 19. ca. 1860-1920.
Workers at the stone quarry, Kelso, Ont., ca. 1891; sunday school class at the parsonage, Hamilton, Ont., ca. 1899; portraits of: Sir John Alexander Macdonald; the Duke and Duchess of Cornwall and York; photos. by Elridge Stanton, F.H. Sharky, Morgan and Mann, J.C. Walker, H.E. Hammond, Butler, Thompson and Son, D.M. Reid, Cockburn, R.G. Harkness, S. King, and Royal Studios.

Allison, R.S., Abby-De-La-Zouch, Leicestershire, England, educator.

7P-15 Copies, b&w 1. ca. 1917.
Lieutenant-Colonel P.E. Bent, V.C., D.S.O.

Almon, Albert.

7P-16 b&w 2. ca. 1878-1888.
Portrait of Mr. Hupman, Allendale, N.S., dwarf; portrait of Mr. and Mrs. Martin Van Buren Bates, ca. 1878-1888, giants.

Alpine Club of Canada - Dr. Winthrop Ellsworth Stone Collection, (1862-1921), Lafayette, Ind., chemist, university president.

166P-18 Original, b&w 488. 1912-1920.
Original prints collected by Dr. Winthrop Ellsworth Stone; mountaineering expeditions and scenery in the Rocky Mountains and Selkirk Range, B.C.; annual camps of the Alpine Club of Canada 1912, 1914, 1915, 1920.

Alpine Club of Canada - Edward Feuz Jr., (b. 1884), Golden, B.C., Alpine climbing guide.

166P-43 Original, b&w 40. 1890.
Original prints by Swiss mountaineer Emil Huber entitled *The Selkirks from Hector Pass to Beaver Glacier;* scenic views of the Selkirk Range, B.C., 1890.

Alpine Club of Canada - Elizabeth Parker Collection, (1856-1944), Winnipeg, Man., journalist.

166P-22 Original, b&w 312. 1906, 1907.
Original prints collected by Elizabeth Parker; annual camps of the Alpine Club of Canada, 1906-1907.

Alpine Club of Canada - Frank W. Freeborn Collection, (d. 1919), Brooklyn, N.Y., teacher.

166P-4 Original, b&w [4,700]. 1905-1914.
Original prints collected by Frank W. Freeborn; annual camps of the Alpine Club of Canada 1906-1914; mountaineering and scenery of the Rocky Mountains and Selkirk Range, 1905-1914.

Amateur Athletic Union of Canada, (1884-1971).

7P-17 b&w 14. 1960-1970.
Portraits of provincial officials of the Amateur Athletic Union of Canada.

Ambrotypes, Québec (Québec).

131P-7 Originaux, n.&b. 4. [n.d.].
Portrait de J.W. Vandry, père de Mgr Ferdinand Vandry, à l'âge de 3 ans. Trois portraits anonymes.

Ames, A.J.

7P-18 Originaux, n.&b. 1350, coul. 61, total 1411. ca. 1900-1920.
Portraits de A.J. Ames et de sa famille; portraits de William Lyon MacKenzie King; sports d'hiver dans la région d'Ottawa, ca. 1900-1920; manufacture d'altimètres pendant la guerre à Ottawa; instruments optiques et de la compagnie Instruments Canada 1 ferrotype; diapositives de projection prises par A.J. Ames.

Amherst Internment Camp, (ca. 1914-1919), Amherst, N.S.

31P-42 Copies, b&w 16. 1914-1919.
Prisoners engaged in various work and recreational activities.

Amundsen, Roald, (1872-1928), Oslo, Norway, explorer.

7P-19 b&w 5. 1902-1957.
Cairn at Gojoa Haven, King William Island, N.-W.T., 1957, erected in memory of George Von Newmayer, instructor to Roald Amundsen; copy portrait of George Von Newmayer, ca. 1902.

Anderson, A.H., Maj., army officer.

7P-20 Original, b&w 1. 1908.
Members of the first ordnance course held at the Royal School of Artillery, Quebec, Que., Feb., 1908; included are: Maj. J.F. Macdonald, Lt. Col. D.C.F. Bliss, Maj. L. du Plessis, Maj. A.H. Anderson, Maj. A.H. Panet, Lt. Col. C.E. English, Capt. J.E. Mills, Lt. Col. J.A. Morin, Maj. A. de L. Panet; photos by M.A. Montminy.

Anderson, Charles, Mrs., Maple Creek, Sask.

81P-6 b&w 1. [n.d.].
Photo of old North West Mounted Police barracks.

Anderson, Douglas E., Inglewood, Ont., airline pilot.

7P-21 Copies, b&w 14. 1939-1941.
Blackburn "Shark" II and III aircraft of Nos. 4 and 6 Squadrons, R.C.A.F., B.C., 1939-1941.

Anderson, E.A., Mrs., Victoria, B.C.

81P-7 b&w 33. 1912-1919.
Portraits of Cpl. and Mrs. Torpey; photo by Crawford, Drumheller, Alta.

Anderson, Ethel Cameron, ([b. 1892]), Edmonton, Alta., teacher.

92P-3 b&w 41. 1908-1912.
Students in first graduating class of University of Alberta, 1908-1912; activities, sports; many pictures of the first women in the University: seven co-eds.

Anderson, Frederick, (1868-1957), Ottawa, Ont., hydrographic surveyor.

7P-22 b&w 205. ca. 1900.
Photos by Frederick Anderson including views of Ottawa, Ont., ships on the Great Lakes, Rondeau Harbour, Ont., Charlottetown, P.E.I., various recreational activities, and office scenes.

Anderson, Rudolph Martin, (1876-1961), Ottawa, Ont., scientist and public servant.

7P-23 b&w [1681]. 1908-1945.
Scientific field trips of Dr. Anderson to Quebec, Alberta, British Columbia, Nova Scotia, New Brunswick, Ontario, 1921-1939; all aspects of the Canadian Arctic Expedition, 1913-1918; photos by R.M. Anderson, H.M. Laing, Fred Maurer, G.H. Wilkins, William McKinlay, K.G. Chipman, J.R. Cox, Diamond Jenness, Fritz Johansen, J.J. O'Neill.

Andreassen, John, Montreal, Que., archivist.

7P-24 Original, b&w 3. [n.d.].
Presbyterian College, Montreal, Que.; portrait of Dr. Wilder Penfield; cottage owned by Dr. Wilder Penfield.

Anglican Church of Canada, Diocese of Athabasca, Peace River, Alta.

13P-12 b&w 334, col. 86, total 420. 1900-1956.
Fort Simpson, Yellowknife, Fort Norman, Hay River, Fort Chipewyan, Waterways, Athabasca (Landing), Berwyn, Grande Prairie, Peace River Country in general, travellers and their modes of transportation, buildings, rural scenes, and missionaries.

Anglican Church of Canada, Diocese of Edmonton, Edmonton, Alta.

13P-11 b&w [71]. 1913-54.
Trip to Canada by an Anglican Missionary from England, Edmonton Mission House, Rossington ferry on Pembina River, La Roche Miette, Pocahontas; Diocese of Rupert's Land, early clergy, early Manitoba Churches, and the Most Reverend and Right Honorable Geoffrey Francis Fisher, Archbishop of Canterbury.

Anglican Church of Canada, Diocese of Ottawa, Archives, (est. 1896), Ottawa, Ont., church records.

> 301P-1 b&w [1,011], col. [100], total [1111]. 1880-.
> Portraits of persons connected with the Diocese; groups of people; buildings, special events, scenery and places.

Anglin, Frank, Ottawa, Ont.

> 7P-25 Copies, b&w 12. [n.d.].
> Portraits of Hon. T.W. Anglin and Margaret Anglin.

Annetts, Helen, Ottawa, Ont.

> 7P-26 Original, b&w 10. 1920.
> Reunion of Canadian Victoria Cross winners and relatives, Toronto, Ont., 1920.

Anonymes, Montréal (Québec).

> 113P-09 n.&b. [8,500], coul. [500], total [9,000]. ca. 1900-1940.
> Négatifs sur verre et sur nitrate de personnages, de monuments et de maisons historiques; une partie de la collection se rapporte à l'Egypte, à New-York et à Paris.

Anticosti Island, Quebec.

> 7P-28 Original, b&w 30. 1905.
> *Bacchante* (yacht); Quebec, Que., Anticosti Island, Que.; portrait of Henri Menier.

Appelbe Teskey, Louise, (ca. 1900-1972), Oakville, Ont.

> 47P-2 Original, b&w 15, col. 1, total 16. 1908-1959.
> Louise Appelbe from childhood on; 127th Bn. Canadians aboard ship (series); radial station; "The Firs" Oakville Residence; fancy dress party; Appelbe Family; Wilson Family.

Appleby, Arthur W., Braeside, Ont., military officer.

> 7P-29 b&w 3. 1932-1970.
> Group photos of the Brooker Cup Teams, Arnprior Golf Club, Arnprior, Ont., 1932, 1942, 1970.

Appleton, W.S., Boston, Mass.

> 7P-30 b&w 28. 1900.
> Views of Quebec, Que., Whycocomagh, Ingonish, N.S., Bay of Islands, Nfld.; Steamships *Bonavista* and *Harlaw*.

Archer, Anthony S., Vancouver, B.C., photographer.

> 7P-31 b&w 46400. 1950-1959.
> Portraits of various residents of Vancouver, B.C., 1950-1959; photos by Tony Archer.

Archer, Violet, (b. 1913), Edmonton, Alta., composer.

> 7P-32 b&w 1. 1952.
> Miss Violet Archer with Mayor Camilien Houde, Montreal, Que., 1952.

Archibald, Raymond Clare, (1875-1955), Providence, R.I., and Sackville N.B., teacher.

> 32P-1 b&w [220]. 1885-1950.
> Portraits of family, and friends; photographs of various homes and places visited; some lantern slides and glass negatives.

Archibald, Sanford, New York, N.Y., Granville Ferry, N.S., printer.

> 31P-33 Original, b&w 9. ca. 1942-1946.
> Kenneth Leslie and *The Protestant*.

Archibald, William Munroe, (1876-1949), Creston, B.C., aviator, engineer.

> 7P-33 b&w 21. ca. 1929-1938.
> Activities of Mr. W.M. Archibald as general manager of mines of Cominco Ltd., Trail, B.C.; various types of aircraft used by Cominco Ltd. for flying training and for mining exploration.

Archives du Musée du Royal 22ième Régiment, Québec (Québec).

> 134P-1 n.&b. 43. 1887-1893.
> Feu de la citadelle de Québec de 1887; étable de la cavalerie, le Bastion Dalhousie et Richmond; camp de la batterie d'artillerie, ca. 1891 à l'Ile d'Orléans; entrainement d'hiver des artilleurs; les chutes Montmorency; le lac St-Charles; monument à Sainte-Foy (Parc des Braves); Québec, vu de la citadelle; le major C.J. Short, R.C.A., Sergent Wallack, R.C.A.; Hôtel de Tempérance de E. Lachance-Mercier à Sainte-Anne (Québec); Eglise de Sainte-Anne de Beaupré (Québec); village de Château-Richer (Québec); éboulements, Basse-ville, Québec (Québec); R.S. Hall, R.C.A. L'Ile-du-Pont (Port) à Kingston, (Ont.); photos attribuées à Jules-Ernest Livernois.

Archives du Séminaire de Québec, (f. 1663), Québec (Québec).

> 131P-9 Originaux, total [30,000]. 1851 à nos jours.
> Mosaïques des finissants, dont trois daguerréotypes et portraits des prêtres du séminaire de Québec, 1850 à nos jours; photos par Jules-Ernest Livernois, Louis Prudent Vallée, Marc Alfred Montminy, Beaudry, Audet, Michel, W.E. Edwards, Roger Bédard, Ernest Rainville, Légaré et Ked, Alarie, Pierre Itey, Marie LaTerrière, tous de Québec (Québec); vues de la ville de Québec et environs, 1865 à nos jours; activités du Séminaire de Québec, 1879 à nos jours; grands événements religieux aux Canada et à l'étranger, 1875; stéréogrammes du 300ième anniversaire de la fondation de Québec, 1968, photos par Keystone View Co.

Archives du séminaire de Rimouski, Rimouski (Québec).

> 7P-34 n.&b. 35. 1930-1964.
> Cérémonies à l'occasion du centenaire de Rimouski, Rimouski, (Québec), 1964, portraits de personnalités originaires de Rimouski: avocats, juges, hommes politiques, écrivains, évêques; Rimouski, (Québec).

Archives of Ontario Collection, (est. 1903), Toronto, Ont.

> 8P-16 b&w [50,000]. ca. 1850-ca. 1960.
> Daguerreotypes, stereographs, tintypes; Ontario's history, particularly political and social; portraits, Indians, buildings, transportation, mining, fur trade, railways, aerial photos; also the collections of early photographers in the Toronto area such as: Robert W. Anderson, William Armstrong, Humphrey L. Hime, Robert Astley, George R. James, James Jameson, C. Lemaitre, Daniel Beere.

Archives Provinciales des Clercs de Saint Viateur, (ca. 1860 à nos jours), Joliette (Québec).

> 221P-1 n.&b. [10,000]. ca. 1860.
> Photos individuelles, photos de groupes, photos d'établissements, d'églises et de presbytères, photos relatives à certains événements et cartes mortuaires.

Arless, Richard, (b. 1919), Montreal, Que., photographer.

7P-35 b&w 12. 1946.
Slums in Point St. Charles district, Montreal, Que., 25 April 1946; photos by Richard Arless.

Armbrister, Frederick, Nassau, Bahamas, professional photographer.

166P-30 Original, b&w 222.
Original negatives by Fred Armbrister; views of Banff townsite, Banff events; scenic views of Banff National Park, particularly Lake Louise area.

Armitage, Mona, Ottawa, Ont.

7P-36 b&w 1. [n.d.].
Portrait of Sir Henry Gray.·

Armstrong, Agnes, Toronto, Ont.

7P-37 b&w 79. 1870-1906.
Portraits of Hon. Edward Blake, members of the Blake Family, and various political contemporaries of Blake; photos by H.E. Simpson, R.D. Ewing, William James Topley, Elliott and Fry.

Armstrong, Alan, Ottawa, Ont.

7P-38 b&w 51. ca. 1898-1920.
Aftermath of the fire of April 1904, Toronto, Ont.; photos by H.F. Sharpe and A.A. Martin; portraits of Mr. and Mrs. H.F. Sharpe. Ref./Réf.: List of Captions.

Armstrong, Ernest Howard, (1864-1946), Yarmouth, N.S., Premier of Nova Scotia.

1P-27 Original, b&w 48. ca. 1895-1926.
Sanatorium, Kentville, N.S.; various views of Weymouth Bridge, N.S.; portraits of E.H. Armstrong; E.H. Armstrong with friends and at official functions; various views of N.S. including Yarmouth Academy, Yarmouth, Princes Lodge, Bedford, construction of an unidentified bridge; photographers: L.G. Swain, Harry J. Moss, Commercial Photo Service, Macaskill.

Armstrong, Frederick Henry, (b. 1926), London, Ont., Historian, author.

7P-39 b&w 1.
Portrait of John and Alice Birrell.

Armstrong, Harry William Dudley, (1842-1937), Ottawa, Ont., civil engineer.

7P-40 b&w 2. 1897.
View of Mr. Elmsley's survey camp, Little Sand Creek, B.C., 1897.

Armstrong, Neil J., (b. 1920), Calgary, Alta., aviator and geologist.

7P-41 b&w 19. ca. 1940-1960.
Activities of Neil Armstrong as pilot and geologist with Eldorado Mining and Refining, International Nickel Company, Hudson's Bay Oil and Gas Company, Polymer Corporation, Spartan Air Services and Aerophysics Ltd. in the Northwest Territories, 1949-1969.

Armstrong, Omar, Ottawa, Ont., businessman.

7P-42 b&w 4. 1924-1939.
Group photos of the Ottawa Rugby Football Club and Ottawa Rough Rider teams, Ottawa, Ont., 1924, 1925, 1926, 1939.

Arnison, Lance.

334P-23 Copies, b&w 3. ca. 1940-ca. 1920.
Munitions factory; Home guard (World War I); Soccer club group portrait.

Art Gallery of Ontario, (est. 1900), Toronto, Ont.

7P-43 b&w 1. ca. 1851-1914.
Group photo of Mr. and Mrs. William Armstrong, and family; Toronto, Ont.

140P-16 b&w 260. 1933-1940.
Art classes, etc. at the Gallery, and shots of the J.E.H. Macdonald Memorial Exhibition, 1933.

308P-1 Original, b&w [6,900], col. ([1,320]), total [8,220]. ca. 1900 to present.
Works of art (Canadian, American, European), exhibitions, Canadian works of art not in the collection, European and American works of art not in the collection, artists, activities and events.

308P-2 b&w [8,500], col. [45,000], total [53,500]. 1860-1977.
Boulton family ca. 1860-1911; selective staff, Board of Trustees, and visitors, ca. 1950-1977 activities and events, exhibition openings and installation/views, tours, painting classes, balls, annual meetings, etc. ca. 1919-1977; building (offices, galleries and exterior) ca. 1919-1977; works of art in Art Gallery of Ontario Collection and in other collections.

Arthur, Eric Ross, Toronto, Ont., architect, professor.

7P-44 Original, b&w 294. 1962.
Photos by James Acland of Canadian architecture in Quebec and the Maritimes Provinces.

18P-53 b&w [500]. ca. 1860-ca. 1960.
Photographs used in Arthur's *Toronto no mean city,* and related photographs not used; tombstones, chiefly in Toronto.

Arthur, Richard M., Ottawa, Ont., public servant.

7P-45 b&w 18. 1950-1955.
Railway engines and rolling stock, Canadian National Railway yards, Union Station, Ottawa, Ont.

Ashton, F.G., (1888-1967), Ottawa, Ont., photographer.

123P-2 b&w 70. 1930-1960.
Bromoil, carbon, gum bichromate and chloro-bromide gelatin silver prints; harbour scenes, fishing scenes, grain harvesting, log cabin, stone mill, Sun Life building, Montreal; Ottawa, Rockport; general landscapes, street scenes and portraits.

Association of American Editorial Cartoonists.

7P-46 Copies, b&w 24. ca. 1973.
Portraits of Canadian cartoonists Victor Roschov, Roy Peterson, Ted Martin, Graham Pilsworth, Robert Daigneault, Rusins Kaufmanis, Andrew Danato, Edward Franklin, George B. Scott, Yardley Jones, Ben Wicks, Edward D. Wuschak, Merle R. Tingley, Robert LaPalme, Thomas W. Innes, Raoul Hunter, Anthony Hendrick, Jean-Pierre Girard, John Collins, Roy Carless, Terrance

Association of American Editorial Cartoonists.
(Cont'd/Suite)

Mosher (Aislin) Blaine, Douglas Sneyd, Peter Pickersgill, Leonard M. Norris, and Robert W. Chambers.

Atkin, Gilbert M., Dr., (1878-1969), Banff, Alta., physician.

166P-31 Original, b&w 192. ca. 1912-1940.
Original prints collected by Dr. Gilbert M. Atkin; Banff people and events; views of Banff townsite and surrounding area.

Attanyi, Anthony, Calgary, Alta., photographer.

7P-47 b&w 5, col. 20, total 25. 1958-1973.
Landscape, industrial, advertising and portrait photography in and around Calgary, Alta., 1958-1973; photos by Anthony Attanyi.
Ref./Réf.: List of captions.

Attree, E.H.L., Fort Steele, B.C.

333P-23 Copies, b&w 2. 1911-1917.
Ella Fenwick, 1917; Fort Steele, B.C., 1911.

Audet, Francis Joseph, (1867-1943), Ottawa, Ont., public servant.

7P-48 b&w 13. ca. 1860-1929.
Portraits of various Roman Catholic clergy, Quebec, C.E.; photos by Jules-Ernest Livernois, J. Dynes, Fraser's Photographic Gallery, Fraser and Webb; portrait of Mgr. O.E. Mathieu, Regina, Sask.

Audette, Louis de la Chesnaye, (n. 1907), Ottawa (Ont.), fonctionnaire.

7P-49 n.&b. 79. ca. 1860-1910.
Les familles Audette et Stuart; le séminaire de Québec après l'incendie ca. 1860-1870; portraits de F.X. Garneau et de Etienne Parent; [cartes de visite].

August, E.M., Miss, Ottawa (Ont.).

7P-50 n.&b. 20. ca. 1920-ca. 1950.
Amis et commerce de A.J. Ames propriétaire de Instruments Ltd.; portraits de A.J. Ames.

Augustines du Monastère de l'Hôtel-Dieu de Québec, (f.1639), Québec (Québec), soins hospitaliers.

171P-2 Originaux, n.&b. [2,000], coul. [1,000], total [3,000]. 1877 à nos jours.
Stéréogrammes, 1877: administration de l'Onction des malades, communion, services du dîner, église de l'Hôtel-Dieu, photos par Louis Prudent Vallée; vues intérieures et extérieures du monastère des Augustines, ca. 1910 à nos jours; portraits des Augustines-hospitalières, ca. 1905 à nos jours; maisons de la Fédération des Augustines de France, d'Angleterre, d'Afrique du Sud et du Canada; ferme des Augustines à l'Ile-aux-Oies, 1909-1945.

Austin, Bradley Sherwood, Etobicoke, Ont.

7P-51 b&w 1.
Mr. W.A. Austin's home "Beaver Lodge", Ottawa, Ont.

Austin, Jacob (Jack), Ottawa, Ont., public servant.

7P-52 col. 48. 1965.
Visit of Hon. Arthur Laing and John Turner to Russia, 1965.

Aylan-Parker, Ronald, Ottawa, Ont., public servant.

7P-53 b&w 19. 1912-1946.
Portraits of Major-General R.O. Alexander, C.B., D.S.O.; activities of the Alexander Family.

Ayre, Charles P., St. John's, Nfld.

7P-54 b&w 53. ca. 1910-1925.
Shipping activity in and around St. John's, Nfld.; sealing operations off the coast of Newfoundland.
Ref./Réf.: List of Captions.

B.C. Department of Lands and Works, Water Rights Branch, Victoria, B.C.

12P-18 b&w 22. 1927.
Illustrations to report on Black Mountain irrigation district showing orchards, fields, buildings, and tobacco farming.

Babbage, Richard Henry.

7P-55 Originaux, n.&b. 1. ca. 1969.
Photo.-passeport de Richard Henry Babbage, à l'âge de 81 ans.

Baber, John, Lemberg (Sask.).

7P-56 n.&b. 1. ca. 1908.
Cinquantième anniversaire de mariage de John et Anna Maria Baber à Neudorf, Sask.

Bach, Bertram, Toronto (Ont.).

7P-57 Copies, n.&b. 4, total 4. 1927.
Bertram Bach et d'autres membres du personnel de l'Ontario Motion Picture Bureau installant et utilisant un équipement spécial pour filmer une éclipse totale du soleil à Long's Corners près d'Hamilton (Ont.).

Badanai, Hubert (Umberto), (n. 1895), Thunder Bay (Ont.), député fédéral.

7P-58 n.&b. 2. ca. 1949-1958.
Deux portraits d'Hubert (Umberto) Badanai lorsqu'il était maire de la ville de Fort William (Ont.).

Badgley, C.W., Ottawa (Ont.).

7P-59 Originaux, n.&b. 14. 1895.
Quelques activités de la division C de la Gendarmerie Royale des Territoires du Nord-Ouest à Battleford (T.N.-O.); danses amérindiennes traditionnelles: la danse du soleil (T.N.-O); photos prises par G. Moodie de Battleford (T.N.-O.).

Bahlawan, W., Mississauga (Ont.).

7P-60 Originaux, n.&b. 35. ca. 1880-1890.
Diverses vues de la ville de Montréal (Québec); photos prises par J.G. Parks et William Notman Cie, photo.

Baker, D.H., Ottawa (Ont.).

7P-61 Originaux, n.&b. 784. 1935-1944.
Visite officielle du roi George VI et de la reine Elizabeth à Ottawa (Ont.) en 1939; le gouverneur-général John Buchan Tweedsmuir, le Baron à Camp Fortune, Hull (Québec); plusieurs vues des régions d'Ottawa (Ont.) de Victoria (C.-B.) et de Patricia Bay (C.-B.); parties de football à Ottawa (Ont.); le pavillon canadien à l'Exposition universelle de New York (N.Y.) de 1939; mouvements

Baker, D.H., Ottawa (Ont.).
(Cont'd/Suite)

 aériens dans plusieurs postes des forces de l'air de l'armée
canadienne en Colombie-Britannique, 1940-1944.

Baker, Edgar C., British naval officer.

 <u>1P-5</u> b&w 50. 1865-1867.
Albums of portraits assembled by Edgar C. Baker of *H.M.S.
Duncan,* stationed at Halifax, N.S., 1865-1867; mostly individuals
from Halifax.

Baker, Frederick Clements, Russell, Man.

 <u>9P-1</u> b&w [40]. ca. 1882-1911.
Photographs of Binscarth and Russell Districts, Manitoba.

Baker, Mrs. Frances (Stubbs), Edmonton, Alta.

 <u>92P-4</u> b&w 42. 1916-1920.
Student life and activities, University of Alberta Campus,
1916-1920.

Baker, Raymond F., Ottawa (Ont.).

 <u>7P-62</u> Copies, n.&b. 2.
Portraits du capitaine B.H. Liddell Hart et du major-général J.F.C.
Fuller.

Baker, Russell, Edmonton (Alta.), président de la «Pacific Western Airlines
Ltd».

 <u>7P-63</u> n.&b. 101. 1913-1947.
Portraits de Russell Baker, de Pierre Berton et Art Jones; Russell
Baker et C.D. Howe, Winnipeg (Man.) 1928; avions et personnel
de la «Central B.C. Airways», de la «Western Canada Airways» et
du «Pacific Western Airlines»; divers aspects de la carrière de
Russell Baker avec la «Canadian Airways» et le «Canadian Pacific
Air Lines»; portraits d'amis et de collègues comme celui de Walter
E. Gilbert.

Balchen, Bernt, (1899-1973), pilote et explorateur.

 <u>7P-64</u> n.&b. 6. ca. 1974.
Portraits de Bernt Balchen lorsqu'il reçut la médaille de l'ordre
d'Icare du Brigadier Général R.S. Christie, 1974.

Balcom, Samuel, (b. 1888), Halifax, N.S., pharmacist.

 <u>31P-12</u> b&w 69, col. 1, total 70. 1876, 1899.
Career of S. Balcom including First World War service with the
Dalhousie No. 7 Stationary Hospital, France; Red Cap Snowshoe
Club, 1876, 1899.

Baldwin, Charles O., Toronto, Ont.

 <u>92P-5</u> b&w 11. 1926.
University of Alberta campus, Edmonton; views of river valley,
1926.

Baldwin, William Willcocks, (1830-1893), Toronto, Ont., clerk.

 <u>18P-30</u> Original, b&w 39. ca. 1860-ca. 1880.
Portraits of Baldwin and his family.

Ballantyne, Charles Colquhoun, (1867-1950), ministre et sénateur.

 <u>7P-65</u> n.&b. 24. ca. 1900-1950.
Portraits de Charles Colquhoun Ballantyne.

Ballon, Ellen, (1898-1969), Montreal, Que. and New York, N.Y., pianist.

 <u>31P-99</u> Original, b&w 90. ca. 1929-1969.
The career of Ellen Ballon, and photos of Sir Thomas Beecham,
Leonard Bernstein, Aaron Copland, Edna Ferber, Sir Wilfred
Laurier, W. Somerset Maugham, Eleanor Roosevelt, Franklin D.
Roosevelt, Arthur Rubinstein, Virgil Thomson, and Hector
Villa-Lobos.

Balsdon, Allan, Burford (Ont.).

 <u>7P-66</u> Copies, n.&b. 6. 1925-27.
Portraits d'officiers du Tenth Brant Dragoons.

Bamber, W. Harry, (1885-1971), Leduc, Alta., photographer.

 <u>13P-5</u> b&w [3,000]. ca. 1910-1970.
Buildings and street scenes in Leduc and neighbouring communities
such as Calmar, Breton, Lamont, Bashaw, etc.; assorted businesses,
residences, schools, churches, etc.; special events, parades and
leisure activities, harvesting and agricultural machinery, sports,
aviation, sawmills and family pictures.

Band family, Penetang, Ont.

 <u>18P-82</u> Original, b&w 45. 1862-1932.
Family portraits and scenes.

Banfield, A.W., Rev., Toronto, Ont., clergyman.

 <u>1P-28</u> Original, b&w 40. 1936.
Album of a trip from Toronto, Ont., via the Gaspe peninsula to
Daniel M. Owen's camp on an island in St. Margaret's Bay, N.S.;
scenes on the Gaspe and St. Margaret's Bay and at Peggy's Cove;
fishing industry at Lunenburg, N.S.

Bank of Nova Scotia, (f.1832), Toronto (Ont.).

 <u>7P-67</u> Copies, n.&b. 2. 1912.
Tableau de distribution téléphonique de la Banque de
Nouvelle-Ecosse; John Kennedy, comptable à son bureau; Prince
Albert (Sask.) 1912.

 <u>309P-1</u> b&w [10,900], col. [100], total [11,000]. ca. 1860 to present.
Staff, premises and related activities of The Bank of Nova Scotia;
includes portraits and group shots of employees, office interiors,
bank buildings; related activities include advertising, celebrations,
meetings, etc.; also photographic records relating to amalgamated
banks, subsidiaries and affiliates.

Banting, Frederick Grant, (1891-1941), Toronto, Ont., doctor, medical
researcher, discoverer of insulin.

 <u>16P-2</u> b&w [530]. ca. 1921-1943.
Photos documenting Banting's personal life (vacations, family, etc.),
and his professional life (colleagues, friends and associates,
patients, occasions held in his honour); includes photos of
Henrietta Banting at memorial occasions after his death (launching
the SS *Banting* in 1943, etc.) ca. 1921-1943; photos taken on trip
to Carribean, 1924; photos of landscape, Inuit, and Banting's
companions (including A.Y. Jackson) on a painting trip to the
Arctic 1927.

Barber, George Thomas, (1884-1965), Winnipeg, Man., surveyor.

> 9P-2 b&w 288. 1906-1910.
> Railway Construction, Manitoba/Ontario border.

Barclay, R.G., Toronto (Ont.), militaire.

> 7P-68 Copies, n.&b. 1. [n.d.].
> Portrait de Timothy O'Hea.

Bardy, Pierre-Martial, Dr, (1797-1869), Québec (Québec), médecin.

> 171P-3 Originaux, n.&b. 4. 1861-1880.
> Portraits du dr Pierre-Martial Bardy, 1861, Madame Pierre-Marcial Bardy, 1861. Portrait en studio de Marie Virginie Célina Bardy à l'âge de 30 ans, Québec (Québec) octobre 1875; groupe d'élèves de l'Académie commerciale portant des costumes historiques, le 24 juin 1880.

Barker, William, Toronto (Ont.), pilote.

> 7P-69 Copies, n.&b. 41. ca. 1915-1919.
> William Barker pilote d'un vol où prit place le Prince de Galles, 1919; différents types d'avions de la première guerre mondiale; portraits de William Barker et de Billy Bishop.

Barkham, B., Limbourg (Québec).

> 7P-70 Copies, n.&b. 3. ca. 1856-1900.
> Portraits de la famille de Sir Henri Gustave Joly de Lotbinière, homme politique, 1829-1908.

Barnard (famille), Québec (Québec).

> 185P-20 n.&b. 32. 1860-1967.
> Photographies de la famille d'Edouard-Andrew Barnard (1835-1898) agronome; de la famille de Sir Thomas Chapais (1858-1946) et de son frère Jean-Charles Chapais (1850-1926); aussi de leurs amis.

Barnes, A., Ottawa (Ont.).

> 7P-76 n.&b. 53. ca. 1860-1900.
> George W. Steacy et J. Hale Ramsay et leurs familles; visite du Prince de Galles, c. 1860; Maisons de George W. Steacy à Buckingham (Québec); puis à Ottawa (Ont.) ca. 1885.

Barnes, Elliott, Kootenay Plains, Banff, and Jumping Pound, Alta., rancher, outfitter and trail guide, professional photographer.

> 166P-15 b&w 530. 1905-1919.
> Pack trips; Banff area scenes, events and activities; logging, mining, ranching and animals.

Barnett, Mary G., Toronto (Ont.).

> 7P-73 n.&b. 13. c. 1880-1904.
> L'Honorable James Cox Aikins et sa famille; maison des Aikins à Burnhamthrope (Ont.).

Barnett, Sydney.

> 7P-74 n.&b. 2. ca. 1875-1885.
> Un régiment à Niagara Falls (Ont.).

Barnhart (famille), (1884-1957).

> 7P-75 n.&b. 52.
> W.S. Barnhart et sa famille incluant le docteur John Barnhart; Samuel et Alice Short et leur famille.
> Ref./Réf.: Liste de légendes.

Barr, George, (1898-), North Star Mine and Fort Steele, B.C., rancher.

> 333P-17 Copies, b&w 5. 1895-1910.
> North Star Mine, B.C.; Fort Steele, B.C. people.

Barthe (famille), Hull (Québec).

> 185P-18 n.&b. 34. 1903-1963.
> Portraits des membres de la famille, en particulier de Marcelle Barthe, speakerine de Radio-Canada à Montréal, 1937-1965.

Bartle Brothers, travelling photographers.

> *Archi Ont* 8P-11 Original, b&w [3,000]. ca. 1890-ca. 1905.
> The collection consists of 3 x 4 (inches) glass negatives depicting mainly fashions in [Williamstown], [Martintown], Lancaster and St. Andrews, Ont.; photos by Bartle Brothers.

Bartlett, Hazel L., Long Beach (Calif.).

> 7P-71 n.&b. 1. [n.d.].
> Monsieur Glidden au volant d'une automobile circulant sur des voies ferrées.

Bartlett, Robert, capitaine de navire.

> 7P-72 Copies, n.&b. 30. [n.d.].
> Chasse aux phoques (T.-N.).

Bass, W.R., Ottawa (Ont.).

> 7P-77 Copies, n.&b. 20. ca. 1890-1896.
> Chantier de bois, camps de bûcherons en Ontario.

Bataillon Mackenzie - Papineau.

> 7P-79 n.&b. 306 total 306. 1936-1938.
> La participation canadienne à la guerre civile espagnole; départ et retour du bataillon à la gare, sur les quais et à bord de navires; blessés en Espagne; bannière du Parti Communiste Canadien; portraits de membres de ce bataillon.

Bateson, W.J., Ottawa (Ont.).

> 7P-78 n.&b. 19. 1938-1940.
> Avions et équipages des esquadrons numéros 2(AC) et 110(AC) du C.A.R.C., Petawawa (Ont.), Halifax (N.-E.); Odiham, Angleterre; personnel du camp d'entraînement technique du C.A.R.C., Borden (Ont.) 1938.

Battleford, Sask. - Settlement.

> 7P-832 b&w 1. ca. 1900-1910.
> Group of settlers at Battleford, Sask.

Baudry, C., Ottawa (Ont.).

> 7P-80 n.&b. 24. ca. 1917-1919.
> Différents types d'avions de l'armée de l'air française; vues aériennes de Paris, France.

Baxter, H., (ca. 1920-), Charlottetown, P.E.I., photographer.

5P-8 b&w [100,000]. 1945-1975.
Portraits, group and individual.

Bayer, J.A.S., (fl. 1900-1935), Charlottetown, P.E.I., photographer.

5P-9 b&w 37. ca. 1910-1935.
Group portraits, theatrical, sports teams.

Beach, D.M.

7P-82 b&w 124. 1872-1875.
North American Boundary Commission 1872-1875; views from Fort Garry west to Rocky Mountains; Saskatchewan, Peace River, Rocky Mountains and Northern B.C., views, 1872-1873 by C. P. Exploration Party; photos by Charles Horetsky.

Beale, A.M., Ottawa (Ont.).

7P-84 n.&b. 177. 1906-1916.
Arpentage au nord de Saskatchewan.

Beals, C.S., Dominion Astronomer.

7P-85 b&w 11. ca. 1920-1960.
Construction of radio telescope, Penticton, B.C.; astronomical devices at the Dominion Observatory, Ottawa, and at the Dominion Astrophysical observatory, Victoria, B.C.; various meetings and receptions; graphs and plates of spectra and astronomical phenomena possibly used by Beals; C.S. Beals, Dominion Astronomer.

Beament, Harold, Montreal, Que., artist.

7P-86 b&w 1. 1946.
Harold Beament and Field Marshall Viscount Alexander of Tunis taken during the opening of the first exhibition of Canadian War Art at the National Gallery in Ottawa.

Beamont, E., Edmonton, Alta.

92P-6 b&w 501. 1954-1962.
Photographs of Studio Theatre productions, University of Alberta, Edmonton, Alta.

Beaton, Cecil, photographe.

7P-88 n.&b. 1. 1939.
Sa majesté la reine Elizabeth, 1939; photo prise par Cecil Beaton.

Beaton, Neil S., Toronto (Ont.).

7P-87 n.&b. 12. 1922.
Drave de la compagnie E.B. Eddy dans le nord-ouest québécois aux Rapides des Quinze (Québec); photos prises par Neil S. Beaton.

Beaton Institute of Cape Breton Studies, College of Cape Breton, (est. 1957), Sydney, N.S., archives.

104P-1 b&w [2,000]. ca. 1855 to present.
General views of the economic, social, educational and cultural life of Cape Breton Island; architecture, buildings, churches and monuments; sceneries, towns and villages, transportation, steel and coal industry, portraits of local and national personalities; ethnic groups (Micmac Indians, Scotts).

Beattie, Stewart, Vancouver (C.-B.).

7P-89 Copies, n.&b. 1. ca. 1872-1890.
Pensionnat de Cache-Creek (C.-B.).

Beauchesne, Arthur, Ottawa (Ont.).

7P-90 n.&b. 1. [n. d.].
A. Patrick, employé à la Chambre des communes, Ottawa (Ont.).

Beaudet, Jean-Marie, (1908-1971), musicien.

7P-91 n.&b. 21. 1945-1966.
Apparitions de Jean-Marie Beaudet dans différents groupes musicaux: Brott, H. Weelan, Wilfrid Pelletier, Igor Stravinsky; portraits de Roger Baulu, de Camilien Houde et de Jean Drapeau.

Beaudoin, Louis-René, (1912-1970), Ottawa (Ont.), orateur de la Chambre des Communes.

7P-92 n.&b. 700. 1934-1964.
Photos de famille, d'amis, de voyage; portraits du juge Edouard Archambault.

Beaulieu, Jean-Paul, (n.1902), St-Jean (Québec), député et ministre.

7P-93 n.&b. 2. ca. 1966.
Portraits de Jean-Paul Beaulieu.

Beaumont, Charles.

7P-94 Copies, n.&b. 24. [n. d.].
Bateaux à vapeur et navires, au Yukon: Le SS *Keno,* le SS *Whitehorse,* le SS *Aksala,* le SS *Casca* et le SS *Klondike.*

Beauregard, S.S.T., Toronto, Ont.

196P-49 b&w 5. n.d., 1927.
Victoria College Mulock Cup Semi-finalists, n.d.; Victoria College Junior Basketball team, 1927; University of Toronto Junior Basketball team, 1927; University of Toronto O.R.F.U. Team, 1927; Varsity Senior O.R.F.U. Team, 1927.

Beck, Geoffrey Ronald, (1896-1975), Montreal, Que., pilot and aviation insurance agent.

7P-95 b&w 89. 1915-1952.
Aerial views of southern England, 1921; German airship LZ-127 *Graf Zeppelin;* short "C" - class flying boats *Caledonia* and *Cambria* " of Imperial Airways, Canada, 1937; activities of Mr. Geoffrey Ronald Beck as general manager of No. 8 A.O.S., R.C.A.F., Ancienne Lorette, Que., 1941-1944; visit of Marshall of the R.A.F.; Lord Trenchard, Ottawa, Ont., 1952; activities and associates of Captain Geoffrey Ronald Beck, Royal Flying Corps and R.A.F., 1915-1918; wreckage of H.M. Airship R-101, France, 1931; personnel and activities of No. 8 Air observers school R.C.A.F., Ancienne Lorette, Quebec City, Que., 1943; portraits of Sir Winston Leonard Spencer Churchill, President Franklin Delano Roosevelt and Lt. Geoffrey Ronald Beck, R.F.C., London, England, 1916.

Becker, Lavy M.

7P-96 n.&b. []. ca. 1930-1973.
Congrès international et canadien des juifs.

Beckett Photography, (1925-1972), Hamilton, Ont., photography studio.

45P-2 Original, b&w [26,000]. 1925-1972.
Portraits and wedding photography.

Beckstead, Ira W., Iroquois (Ont.), photographe.

7P-97 n.&b. 3,516. ca. 1890-1910.
Photos des régions d'Iroquois et de Morrisburg (Ont.).

Beeching, Charles, Victoria (C.-B.).

7P-98 Copies, n.&b. 8. 1919-1929.
Vues de la ville de Calgary Alberta.

Beet, Harry Churchill, Vancouver (C.-B.).

7P-100 Copies, n.&b. 1. [n. d.].
Portraits du lieutenant Harry Churchill Beet, C.V.

Begley, Michael, Cochrane (Ont.), éducateur.

185P-6 Copies, n.&b. 38. 1908-1968.
Photographies réunies par Michael Begley et publiées dans
Cochrane d'hier à demain.

Béique, Frédéric Liguori, (1845-1933), Montréal (Québec), sénateur.

7P-101 n.&b. 1. 1920-1930.
Portrait de l'honorable George-Casimir Dessaulles avec sa famille.

Belfie, William G.

7P-102 n.&b. 202. 1870-1910.
Scènes de chasse et de pêche en Ontario; pique-nique, voile, pêche
et chasse dans la région de Gananoque (Ont.); visite du duc et de
la duchesse de Cornwall et de York à Gananoque (Ont.), 1900;
portraits de résidents de Gananoque et les environs; photos prises
par A.B. Munto, W.W. Black, H.E. Paigne, Finley, tous résidents de
Gananoque.

Bell, Frederick Charles, (ca. 1890-1971), Vancouver, B.C., medical doctor.

9P-3 b&w 13. 1906.
Surveying in Saskatchewan.

Bell, James McKintosh.

7P-103 n.&b. 12. ca. 1910-1920.
International Nickel Co. à Copper Cliff (Ont.) et à Creighton
Mines, (Ont.).

Bell, Ken, Toronto (Ont.), photographe.

7P-104 n.&b. 12,431, cou. 169, total 12,500. 1940-1965.
Vues de la ville de Toronto (Ont.); l'université de Toronto, le port,
le Fort York et plusieurs industries et édifices; l'université Western
Ontario, London (Ont.); le barrage des Joachimes, Rivière des
Outaouais, 1949; vues de Val d'Or (Québec), 1949; opérations de
l'armée canadienne au nord-ouest de l'Europe, 1944-1945; la
troupe nationale de ballet du Canada.

Bell, Richard Albert, (n. 1913), Ottawa (Ont.), homme politique.

7P-105 n.&b. [124]. 1940-1966.
Portraits de Richard Albert Bell; activités du Parti
progressiste-conservateur du Canada.

Bell Canada, (est. 1880), Montreal, Que., telecommunications.

7P-99 Copies, b&w 15. 1936-1964.
Mine disaster, Moose River, N.S.; transmission towers of
trans-Canada microwave and telephone systems; troposheric scatter
antennae, Emeric, Que.; various aspects of the use of the telephone
in Canada; Dr. Alexander Graham Bell and associates.

330P-1 b&w [50,000], col. [5,000], total [55,000]. 1870 to date.
Telephone instruments from 1870's, switching equipment, telephone
plant; construction crews, operators at work; highlights in
telecommunications; Alexander Graham Bell; Bell Homestead.

Bell family, (1850-1960), Halifax, N.S.

32P-2 b&w 1,186. [n.d.].
Family photographs.

Bellemare, Raphael, (1821-1906), Montréal (Québec), inspecteur du
revenu.

7P-106 n.&b. 2. ca. 1890.
Portraits de Raphael Bellemare exécutés par le studio Archambault
de Montréal (Québec).

Belmont (Barque), (built, 1891), Port Glasgow, Scotland.

31P-103 Copies, b&w 5. ca. 1895.
Views of *Belmont* including Captain's cabin.
Provenance: Yarmouth County Historical Society, Yarmouth N.S.

Belson, W.R., Hamilton (Ont.).

7P-107 n.&b. 29. [n. d.].
Portraits de W.R. Belson, M.R.C.; photos de H.M.C.S. *Dockyard,*
Halifax, (N.-E.); du H.M.C.S. *Stadacona,* Halifax (N.-E.); et du
H.M.C.S. *Cornwallis,* Deep Brock, (N.-E.).

Benamou, Jean-Pierre, Lille, France.

7P-108 n.&b. 5. 1944.
Troupes canadiennes près de Falaise, France, 18 août 1944.

Bengough, Percy, (1883-1971), syndicaliste et ingénieur.

7P-109 n.&b. 248. 1934-1954.
Rencontres annuelles du *Trades and Labour Congress* de 1934 à
1954 dans différentes villes au Canada; Congrès de l'American
Federation of Labour, 1939 et de l' *International Labour Congress;*
Genève, 1938; portraits de Percy Bengough et de Bill Green.

Benjamin, Walter R., New York (N.Y.).

7P-110 n.&b. 4. [n.d.].
Portraits de Charles G.D. Roberts, et de Pauline Johnson.

Bennett, Percy, Ottawa, (Ont.).

7P-112 n.&b. 1. 1917.
Carte de visite de W.R. Lounsbury, Simcoe (Ont.), représentant un
orchestre militaire jouant au concert de la Victoire à Ottawa (Ont.).

Bennett, Richard Bedford, (1870-1947), premier ministre du Canada.

7P-111 n.&b. (50). [n. d.].
La maison, le bureau et quelques portraits du Très Hon. Richard Bedford Bennett.

Bennie, H.T., Ottawa (Ont.).

7P-113 n.&b. 1. 1860-1870.
Les édifices du Parlement canadien, aile ouest, Ottawa (Ont.).

Benoit, Rosario, abbé, (1892-1966), Québec (Québec), professeur.

131P-2 Originaux, n.&b. [2,000]. 1911-1966.
Mosaïques des finissants du Petit Séminaire de Québec de 1911-1965; vues intérieures et extérieures du Séminaire de Québec, 1911-1965; vues du camp d'été du Séminaire: le Petit-Cap, Saint-Joachim (Québec), ca. 1914, Maizerets, Saint-Pascal, ca. 1915; excursions des étudiants aux chutes Sainte-Anne-de-Beaupré, à Sainte-Pétronille sur l'Ile d'Orléans, à l'Ange Gardien, comté de Montmorency, à la chute «Larose» Saint-Féréol, aux Sept-Chutes, et à la Baie des Chaleurs; visite du Duc de Connaught au Petit-Cap, Saint-Joachim; Mgr Gosselin au Petit-Cap, Saint-Joachim (Québec) 1914; les activités scolaires et para-scolaires du Petit Séminaire de Québec, ca. 1911-1965.

Benson, George Frederick, (fl. 1910), Montreal, Que., manufacturer.

75P-1 b&w [275]. ca. 1900.
Benson family and friends and many pictures of the Thousand Islands.

Bergevin, A.F., Iberville (Québec).

7P-114 Originaux, n.&b. 206, cou. 31, total 237. 1892.
Voyage autour du monde de A.F. Bergevin avec Olivier Faucher, son épouse Virginie; Honoré Beaugrand, son épouse et leur fille adoptive Flora Frappier; photos prises aux Indes, en Egypte, au Port Said et en Palestine, à Rome, à Venise, à Milan, à Florence et au Japon.

Bergh, Philip, Mme, Little Neck (N.Y.).

7P-115 n.&b. 1. 1915.
Le 35 ième bataillon du Corps expéditionnaire canadien, Toronto (Ont.); photo du studio Rembrandt.

Bernay, M. L., Londres, Angleterre, militaire.

7P-116 Copies, n.&b. 1. [n.d.].
Portraits de M.L. Bernay, G.M., R.C.N.

Bernhardt, P., Uxbridge (Ont.), directeur d'école secondaire.

7P-117 Copies, n.&b. 1. [n. d.].
L'école secondaire Uxbridge, Uxbridge (Ont.).

Bernier, Joseph-Elzéar, (1852-1934), explorateur.

7P-118 n.&b. 267. 1869-1923.
Expédition canadienne à La Baie d'Hudson en 1904-1905 à bord du vapeur du gouvernement canadien *Arctic*; portraits du commandant le Maj. J.D. Moodie, du capitaine Joseph-Elzéar Bernier, et d'esquimaux; photos prises par F. McKean; expéditions subséquentes de Joseph-Elzéar Bernier dans l'Archipel arctique, 1906-1911; le *Elena* et le *Neptune*.

Berry, A. Matt, Calgary (Alberta).

7P-119 Copies, n.&b. 148. ca. 1930.
Vues aériennes de Coppermine (T.N.-O.), McMurray (Alberta) et Bathurst Inlet (T.N.-O.).

Bertcly, Leo W., Pierrefonds (Québec).

7P-121 n.&b. 1. 1975.
Salle d'exposition de photographies illustrant plusieurs personnalités de race noire au Canada, Montréal (Québec).

Bessborough, Vere Brabazon Ponsonby, Comte de, (1880-1956), gouverneur général du Canada.

7P-123 n.&b. 3. ca. 1935.
Portraits de Vere Brabazon Ponsonby, Comte de Bessborough,.

Bessborough, Vere Brabazon Ponsonby, Mme.

7P-122 n.&b. 1. [n. d.].
Portrait de Madame Vere Brabazon Ponsonby Bessborough; photo prise par Yousuf Karsh.

Best, J. Linden, (1950-1974), Cambridge Station, N.S.

31P-62 Copies, b&w 43. 1972.
Halifax theatre history.

Bethel, V.M., Ottawa (Ont.).

7P-120 n.&b. 37. 1920-1952.
Vues intérieures et extérieures des deux limousines McLaughlin-Buick construites pour la visite royale de 1939; gâteau offert à l'occasion de la visite royale de sa Majesté le Roi George VI le 20 mai 1939.

Bethune, A.M.

18P-46 Original, b&w 48. ca. 1860.
Portraits of Bethune family and acquaintances.

Beurling, George F., Ladysmith (C.-B.).

7P-124 Copies, n.&b. 1. ca. 1945.
Portrait de George F. Beurling.

Bibaud, François Marie Uncas Maximilien, (1824-1887), Montréal (Québec), avocat.

7P-125 n.&b. 302. [n. d.].
Portraits de religieux, d'hommes politiques canadiens et de diplômés des classes de droit qu'avaient connu Maximilien Bibaud.

Biberovich, Ladislaus, (ca. 1897-1971), Toronto, Ont., public servant and editor.

7P-126 b&w 1. 1936.
Portrait of Mr. E. Holmes, Provost, Alta.

Bibliothèque Municipale de Montréal, Montréal (Québec).

7P-127 n.&b. [8,500]. 1943-1953.
Terrains de Jeux: patinoires, pistes de toboggan, pistes de ski; grands parcs publics; Mont-Royal, Lafontaine, Ile Sainte-Hélène, Jardin botanique; maisons d'éducation: Université de Montréal, école des Beaux-Arts; représentations théâtrales et radiophoniques,

Bibliothèque Municipale de Montréal, Montréal (Québec).
(Cont'd/Suite)

scènes d'hiver à Péribonca et travaux publics à Montréal (Québec); photos prises par Henri Paul.

Biehler, J.A.

7P-128 Copies, n.&b. 15. ca. 1930-1940.
Avions des escadrons numéros 4 et 6 du C.A.R.C. (C.-B.).
Ref./Réf.: Liste de légendes.

Biesenthal, Clarence, Oshawa (Ont.).

7P-129 n.&b. 50. 1934-1937.
Différents modèles d'avions civiles et militaires, Port Arthur (Ont.).

Big Bear; Poundmaker.

7P-130 n.&b. 1. 1885.
Groupe de participants aux événements du nord-ouest de 1885; Horse Child, Big Bear, A.D. Stewart, Poundmaker, Constable Black, Rev. Louis Cochin, Capitaine Burton Deane, Rév. Alexis André et Beverly Robertson.

Big Bend Highway, British Columbia.

7P-1142 b&w 79. 1931-1936.
Construction of the "Big Bend" highway, B.C.

Bigelow, E.A., New York (N.Y.).

7P-131 n.&b. 2. [n.d.].
Les pistolets et l'écharpe du général James Wolfe.

Bigelow, John, Halifax, N.S., civil servant.

31P-104 Copies, b&w 6. 1903, 1918.
Tern Schooners *Coral Leaf, Cape Blomidon;* ship building in Mahone Bay.

Biggar, Henry P.

7P-132 n.&b. 1. 1892.
Portrait de l'honorable Alexander Mackenzie; photo prise par William James Topley.

Biggs, Hugh Beynon, (1876-1941), Beynon, Alta., rancher.

11P-12 Original, b&w 68. ca. 1893-1925.
Ranch buildings and life; Canadian National Railway construction; Blackfoot Indians.

Billinsky, S., Winnipeg (Man.).

7P-133 n.&b. 2. 1906 et 1937.
Portrait des premiers finissants de la *Ruthenian Training School,* Brandon (Man.), 1906; photo prise par Steele & Co.; portrait de Paulo Macenko, chef d'orchestre du *Ukrainian National Home Choir,* Winnipeg (Man.).

Birch, Arthur Nonus, (ca. 1837-1915), Londres, Angleterre, administrateur.

7P-134 n.&b. 116. 1864-1875.
Vues de New Westminster, Yale, Kamloops, Lytton en Colombie-Britannique; photo prises par Charles Gentile; portraits d'amérindiens, B.C.; Frederic Seymour et son équipe; édifices du parlement canadien et la région de La Chaudière, Ottawa (Ont.), ca. 1866; les rapides, Montmorency (Québec); équipages du H.M.S. *Sutlej* et du H.M.S. *Sparrowhawk;* vues de Californie (E.-U.) et du Ceylan.

Birch, J. Edgar, (1866-1931), Montreal, Que., musician.

7P-135 b&w 2. ca. 1890-1898.
Ottawa Choral Society souvenir photo taken at the *Elijah* concert; J. Edgar Birch, Conductor, April 18, 1898; photo by J.J. Jarvis; unidentified group of men with J. Edgar Birch.

Bird, Florence Bayard, (n. 1908), Ottawa, Ont., journaliste de l'enquête sur le statut de la femme et présidente de la commission royale.

7P-136 n.&b. [200]. ca. 1930-1975.
Les activités marquant la carrière de Florence Bird (Anne Francis, pseudonyme) de 1948 à 1975; Florence Bird animatrice à la radio, écrivain et présidente de la commission royale d'enquête sur le statut de la femme; Florence et John Bird avec des amis; photos de Florence Bird adolescente.

Bird, R.A., Calgary, Alta., professional photographer.

11P-4 b&w 752. ca. 1910-1930.
Negatives, mainly of buildings, personalities and events in Calgary and area, and of petroleum industry, Turner Valley, Alta.

Birks, Henry et Fils Ltée.

7P-137 n.&b. 125. 1850-1949.
La famille Birks; les établissements commerciaux; les orfèvres et les travaux d'orfèvrerie.

Birmingham, W.H., Vancouver (C.-B.).

7P-138 n.&b. 4. 1970.
Totems près de la rivière Skeena (C.B.).

Birney, Earle, (1904-), Toronto and Vancouver, professor of English and author.

16P-3 b&w 36 cms. 1890-1967.
Earle Birney's family, career and travels.

Bishop, Billy.

7P-139 n.&b. 58. ca. 1916-1955.
Paysages des campagnes anglaises vers 1950; différents types d'avions de combat des alliés de la 1e guerre mondiale; portraits de Billy Bishop.

Bishop, W.A. et W.G. Barker.

7P-140 n.&b. 3. 1919.
Les lieutenants-colonels W.A. Bishop et W.G. Barker avec un avion Fokker DV11, Leaside, (Ont.), septembre 1919; photos prises par Pringle et Booth de Toronto (Ont.).

Bishop's College School, Lennoxville (Québec).

346P-1 n.&b. 1,000. 1863-1958.
Photos de groupes dans des activités théâtrales, sportives et diverses cérémonies durant les années scolaires de 1863-1932; albums de photos couvrant les années 1885-1958.

Bethel, V.W., Ottawa, (Ont.), militaire.

7P-141 Copies, n.&b. 1. [n.d.].
Portrait de Percioal H. Shelton.

Black, Harry, Lakeland (Flor.), militaire.

7P-142 n.&b. 15. ca. 1898-1921.
James Brewer devant un magasin, Ottawa (Ont.); Arthur, duc de
Connaught, 1913; un groupe de mineurs américains et de
prospecteurs, Yukon, 1898; le vieux pont de la rue Sussex et le
moulin Edward, Ottawa (Ont.), 1919; première visite du Prince de
Galles, Ottawa (Ont.), 1921.

Blackett, Arthur E., Dr., (d. 1957), New Glasgow, N.S., medical doctor.

31P-39 Original, b&w 14. 1916-1917, ca. 1953.
Canadian Medical Corps, 1916-1917; portrait of Dr. A.E. Blackett.

Blackman, D.A., Ottawa (Ont.).

7P-143 n.&b. 43. 1865-1953.
Niagara Falls (Ont.) et (N.Y.), 1865-1875; l'exposition canadienne
à Londres, Angleterre, ca. 1900; le Rocher Percé (Québec); vues des
montagnes rocheuses de William James Topley; bal du Department
of Soldiers Civil Re-establishment dans la salle rose du Château
Laurier, Ottawa (Ont.), 1922; portrait de Ross MacDonald, orateur
de la Chambre des communes, Ottawa (Ont.), 1949-1953.

Blair, Sidney Martin, (b. 1900), Bolton, Ont., engineer and researcher.

92P-7 b&w 103. ca. 1923.
Tar Sands research on Athabaska River.

Blakey, Joseph Adamson, (1870-), Toronto, Ont., clerk and amateur
photographer.

18P-10 Original, b&w 1602. 1901-1910.
Scenes in and around Toronto; scenes in England, especially
Scarborough; portraits of family and friends.

Blanchet, Guy, (1884-1966), Victoria, B.C., surveyor and explorer.

12P-22 b&w 1,625, col. 28, total 1,653. 1920-1950.
Northern Canada: survey parties, Eskimos, transportation, wildlife,
and views; family vacations and activities.

Bland, John Otway Percy, (1863-1945), historian.

16P-4 b&w [80-100]. 1883-1954 (particularly 1890-1914).
Photographs of Bland, the Bland family (including early family
photos in England) and photographs of China and Chinese life,
particularly of Peking and Shanghai.

Blatz, William E, (1895-1966), Toronto, Ont., child psychologist.

196P-5 b&w [700]. 1927-1957.
Institute of Child Study classes in action; building, staff, and
playground; students receiving training at the School; 1927-1957;
Windy Ridge elementary school in operation, classes, staff
1929-1951; classes at Garrison Lane Nursery school, Birmingham,
Eng., 1942; photos of Dionne quintuplets taken during shooting of
a feature movie, *Reunion,* produced by 20th Century Fox, 1936.
Provenance: Dionne photos copyright held by 20th Century Fox.

Blenkinsop, Edward Weyman, (1920-1945), Victoria, B.C., squadron leader,
R.C.A.F.

12P-16 b&w 195. 1925-1943.
Blenkinsop family activities, R.C.A.F. groups, planes and buildings,
views of Victoria.

Blois, Evelyn, Halifax, N.S., school teacher.

1P-58 Original, b&w 3. 1898, 1903.
Senior class in Arts and Science, Dalhousie University, Halifax,
N.S., 1903; graduating class, Halifax Academy, Halifax, N.S., 1898;
football team, Halifax Academy, 1898.

Bloom, Lloyd, Hamilton (Ont.), photographe.

7P-144 n.&b. (42,000). 1951-1971.
Vues intérieures et extérieures des bâtiments d'une industrie: la
"Steel Company of Canada; les travailleurs, l'administration, la
production et le transport des produits de la Steel Company of
Canada, Hamilton (Ont.).

Blouin, Jules, Saint-Lambert (Québec), photographe.

7P-145 n.&b. 21,000, cou. 2,310, total 23,310. 1965-1969.
Le développement du Manoir Richelieu; site de l'Exposition
Universelle à Montréal en 1967 avant les constructions; projets de
construction de bâtiments par la compagnie Donollo, Montréal
(Québec); activités politiques de Daniel Johnson.

Blount, Austin Ernest, (1870-1954), Ottawa, Ont., Clerk of Senate, Clerk of
Parliament.

7P-146 b&w 6. ca. 1911-1930.
Hon. Robert Borden and Mr. A.E. Blount during the federal
election campaign in Northern Ontario, 1911; portraits of Senator
Raoul Dandurand and Mr. A.E. Blount; session of the Senate at
the Victoria Memorial Museum, Ottawa, Ont., ca. 1916-1919; view
of the Parliament Buildings, Ottawa, Ont., ca. 1930.

Bluenose (Schooner), (built 1921), Lunenburg, N.S.

31P-105 Copies, b&w 5. 1931.
International Schooner Races, 1931.

Blyth, Alfred, (b. 1901), Edmonton, Alta., photographer.

13P-3 b&w 14,300. 1916-70.
Photographs mostly of Edmonton and area including: buildings,
street scenes, exhibitions, sky lines, sports, commercial photography,
individual portraits, royal visits, activities, aviation, farm and
harvest scenes, Indians; Banff, Jasper, Calgary and cities in the
United States.

Blyth, M., Ottawa (Ont.).

7P-147 n.&b. 34. ca. 1910.
Edifices du Parlement fédéral, Ottawa (Ont.); statue de Sir John
Alexander Macdonald, Ottawa (Ont.).

Bobcaygeon Historical Museum.

7P-149 n.&b. 32. ca. 1880-1900.
Camps de bûcherons et travail du bois en forêt à Fenelon Falls,
Haliburton, et Kawartha (Ont.).

Bodrug, John, ministre ukrainien.

> 7P-150 n.&b. 10. 1910-1924, 1946.
> Portraits du Révérend John Bodrug avec sa famille et des amis, 1911-1946; pique-nique à l'église ukrainienne de la rue Soulanges, Montréal, (Québec), 1914; congrégation à l'église ukrainienne de la rue Soulanges, Montréal, (Québec), 1915-1919.

Boeing Company, Seattle (Wash.).

> 7P-151 n.&b. 38. 1918-1944.
> Différents modèles d'avion fabriqués par la compagnie Boeing.

Boggis, Michael A., Guelph (Ont.).

> 7P-152 n.&b. 1. ca. 1916.
> Portrait du lieutenant Gordon T. Scott.

Boissevain Community Archives Collection.

> 9P-82 b&w 290. 1912.
> Businesses and homes in south-western Manitoba (photographer unknown).

Boivin, (famille), Québec (Québec).

> 7P-153 n.&b. 30. 1875-1910.
> Membres de la famille Boivin.

Bollinger, E.A., Halifax, N.S., owner of photographic studio "The Camera Shop".

> 1P-29 Original, b&w [4,500]. 1941-1959.
> Photographs advertising various business firms and products; individual portraits, group and wedding photographs; Halifax buildings, streets and scenes; various Nova Scotia communities; rural scenes in Nova Scotia.

Bompas, J.G.G., Victoria (C.-B.).

> 7P-154 n.&b. 1. [n.d.].
> Portrait de l'évêque William C. Bompas.

Bonar, James Charles, (n. 1906), Montréal (Québec), archiviste de la compagnie de chemin de fer du canadien pacifique.

> 7P-163 n.&b. 52. ca. 1900-1970.
> Portraits des sénateurs libéraux du gouvernement Mackenzie King, 1930; portraits de James Charles Bonar, de Raoul Dandurand, Gabriel Marchand, de Gaspé Beaubien et du sénateur John Fitzgerald Kennedy accompagné de son épouse Jacqueline Kennedy; portrait de Notman et Fils, Montréal (Québec), et de Frederick Lyonde et Fils, Toronto (Ont.).

Bond, Courtney Claude Joseph, (n. 1914), Ottawa (Ont.), historien.

> 7P-164 n.&b. 570, coul. 785, total 1,355. 1886-1915, 1950-1969.
> Vues de paysages ruraux des Maritimes et de villes canadiennes: Charlottetown (I.-P.-E.), Toronto (Ont.), ca. 1960, Québec (Québec), Saskatoon (Sask.), 1959, Victoria (C.-B.); constructions de chemins de fer en 1886, 1914-1915; arpentage des frontières du Manitoba, de la Saskatchewan, de la Ontario, de l'Alaska, de l'Alberta, des Territories du Nord-Ouest et de la Colombie-Britannique.

Bonneau, J.C., Halifax, N.S., officer, Canadian Armed Forces.

> 1P-59 Original, b&w 8. 1967.
> Steel trawler *Cape Bonnie* lying on a reef off Woody Island, Lower Prospect, N.S., Feb. 21, 1967.

Bonneau G.E., Gatineau (Québec).

> 7P-161 n.&b. 38. ca. 1916.
> Vues de St-Jovite (Québec), Du Lac Guindon (Québec), de la rivière à Gagnon (Québec); photos d'activités sportives: le hockey, la promenade en raquette à neige.

Boorne & May, photographes.

> 7P-156 n.&b. 5. 1890.
> Initiation d'un brave pendant une danse du soleil amérindienne; portraits de Setuk-Muccom, Sikunnakis, Mutsenamakan et Stumetsekini, indiens de la tribu des Sarsi, Apistoan et Akanoo.

Borbridge, H.B., Ottawa (Ont.).

> 7P-157 n.&b. 1. 1903.
> Les officiers et les hommes de la Princess Louise's Dragoon Guards Ottawa (Ont.) 1903; photos par A.G. Pittaway.

Borden, Lorris Elijah. (1877-1963), Nelson et Victoria (C.-B.), physicien et explorateur de l'Arctique.

> 7P-159 n.&b. 38. 1903-1904, 1923.
> Voyage du C.G.S. *Neptune* pour l'expédition de Albert Peter Low, 1903-1904; vue de la Baie Erebus, Iles Beechey (T.N.-O.), 1904; dixième congrès annuel des clubs rotary, Tacoma (Wash.) Mars 1923.

Borden, Robert Laird, Sir, (1854-1937), premier ministre du Canada.

> 7P-160 n.&b. 187. ca. 1896-1918.
> Troupes canadiennes participant à la bataille de la Somme, France, 1916; visites de Hon. Robert Laird Borden et de son épouse en France et en Angleterre, 1912; le Imperial War Cabinet, Londres, Angleterre, 1917; vues de Bristol, Londres, Bisley, Elswick et Liverpool, Angleterre; Glasgow, Ecosse et Paris, France; portraits de Robert Laird Borden, de Lady Borden, de Lord Strathcona, de John Alexander Macdonald et de William Lyon Mackenzie King; photos prises par Pittaway, Topley, Huber et Lafayette.

Borden-Clarke, Morrisburg (Ont.).

> 7P-158 n.&b. 382. ca. 1850-1900.
> La guerre des Boers, Afrique du Sud, 1900; trois albums de familles canadiennes dont un appartenant à Isabel Joséphine Vickers, 1880-1890; vues du Nouveau-Brunswick; Hitler et ses collègues durant les années précédant la seconde guerre mondiale; dix ambrotypes non-identifiés, ca. 1850.

Borrett, R.G., Rexdale (Ont.).

> 7P-162 n.&b. 18. ca. 1870-1875, 1900, 1932.
> Construction d'une écurie, Bolton-Brampton (Ont.), avion de la compagnie Havilland du Canada, Mount Dennis (Ont.); eglise Anglicane Seaforth (Ont.).

Borrowman, R.E.

> 7P-171 n.&b. 375. 1895-1920 et ca. 1940.
> Communautés du comté de Lanark (Ont.); Perth, Lanark, Hopetown, Middleville, Rosetta, Watsons Corners, McDonalds Corners; agriculture et fabrication du sirop d'érable, comté de

Borrowman, R.E.
(Cont'd/Suite)

Lanark, (Ont.); génératrice d'électricité aux rapides Sly, Smiths Falls (Ont.); résidents du comté de Lanark (Ont.).

Boss, G., Crowsnest area, B.C.

333P-40 Original, b&w 19. ca. 1900-1910.
Baker B.C., ca. 1907; Crowsnest B.C./Alta. border; C.P.R. Bridges, Crowsnest area.

Bossy, Walter J.,

7P-165 n.&b. 22. 1880-1955.
Le bureau du service des néo-canadiens, Montréal (Québec), ca. 1949; portraits de Walter J. Bossy et de sa famille; portrait de Louis Rosenberg.

Bostock, H.S., Ottawa (Ont.).

7P-173 n.&b. 4. 1913-1914.
Officiers du 34e régiment, Camp Sewell (Man.), ca. juin 1913; chambre du Sénat pendant une session, Ottawa (Ont.), mai 1914; la masse du Sénat canadien, Ottawa (Ont.).

Bothwell, Marjorie, Buckingham (Québec).

7P-166 Copies, n.&b. 24. [n.d.].
Construction d'un barrage sur la Rivière du Lièvre (Québec); SS *George Bothwell* sur la Rivière du Lière (Québec).

Boucher de LaBruère, Joseph L.O. Montarville, Sorel (Québec).

7P-170 n.&b. 3. [n.d.].
Ambrotypes de René Boucher de LaBruère ; daguerréotype du docteur Claude Boucher de LaBruère: avec son fils Pierre.

Bourassa, Anne, Montréal (Québec).

7P-167 n.&b. 1. ca. 1860.
Ambrotype portrait de Napoléon Bourassa.

Bourchier (famille), Ottawa (Ont.).

7P-168 n.&b. 75. 1860-1890.
Membres de la famille Bourchier; photos prises par William James Topley, Stiff, Jarvis, Notman et Fraser, Ewing, Cooper, Griffiths.

Bourdeau, Robert, (b. 1931), Ottawa, Ont., photographer.

123P-9 b&w 47. 1965-1977.
Landscapes: Gatineau Park; Algonquin Park; Nahant, Mass.; Ontario; Quoddy Head, Maine; White Mountains, New Hampshire; Isle of Skye, Scotland; near Keswick, Cumbria, England; Utah; close-up views of rocks, leaves and other natural forms.

Bourdon, Louis-Honoré, (1890-1974), Montréal (Québec), impressario.

7P-169 n.&b. 139. 1890-1974.
Portraits d'artistes venus au Canada grâce à L.H. Bourdon.

Bourgeau, G.R., Ottawa (Ont.).

7P-172 n.&b. 7. 1900-1929.
Exploitation forestière; déraillement d'un train du Canadien National, Britannia? (Ont.); agents de contrôle du transport des marchandises à la New York Central Railway, Détroit (Mich.), le 24 septembre 1929.

Bourinot, A.S.

7P-176 n.&b. 3. 1890-1898.
Portraits: Sir John Alexander Macdonald, Sir Charles Tupper & James A. Macdonald.

Bourke, Rosalind T., Esquimault (C.-B.).

7P-175 Copies, n.&b. 2. [n.d.].
Portrait du lieutenant R. Bourke.

Bourque, F.L.

7P-174 n.&b. 1. [n.d.].
Portrait de Georges-Casimir Dessaulles.

Bovey, Wilfrid, Montréal (Québec), militaire.

7P-177 n.&b. 1. 1935.
Vue de Paspébiac (Québec); photo prise par la compagnie de chemin de fer du Canadien National.

Bowell, Mackenzie, Sir, (1823-1917), premier ministre du Canada.

7P-178 n.&b. 13. 1895.
Le voyage de Sir Mackenzie Bowell dans les Territoires du Nord-Ouest et la Colombie-Britannique.

Bowen, R.C., Winnipeg (Man.).

7P-179 n.&b. 15. 1919.
Activités du Corps expéditionnaire canadien pour la Sibérie, Vladivostok, U.R.S.S.

Bowles, Ottawa (Ont.), fonctionnaire fédéral.

7P-180 n.&b. 1. ca. 1930-1934.
Portrait de l'Honorable Henry Herbert Stevens.

Bowles, R.S., Winnipeg (Man.).

7P-181 n.&b. 1. [n.d.].
Portrait de l'Honorable R.S. Bowles.

Boyd, E.D.H., Ottawa (Ont.).

7P-182 n.&b. 17. 1936.
Pèlerinage canadien à Ypres, Belgique.

Boyd, John, (1865-1941), Toronto (Ont.), photographe.

7P-186 n.&b. 28,959. 1888-1920.
Vues des édifices du parlement canadien pendant le feu du 3 janvier 1916, Ottawa (Ont.); vues de villes au sud-ouest de l'Ontario et de Sarnia (Ont.); Toronto (Ont.) et Muskoka (Ont.); activités économiques et sociales de ces villes entre 1888 et 1920.

Boyd, John, (1865-1941), Toronto (Ont.), photographe.
(Cont'd/Suite)

8P-6 b&w 1,087. ca. 1880-ca. 1930.
Rural scenes, scenery, fishing, canoeing, camping in Haliburton,
Parry Sound District, Muskoka and Toronto regions, Ont.; portraits
of Oka Indians and Chinese; views of Quebec Bridge, Que., and
Welland Canal, Ont.; photos by John Boyd.

Boyd, John H., Smiths Falls (Ont.).

7P-187 n.&b. 8. ca. 1890-1910.
Vues de Smiths Falls (Ont.) et de Merrickville (Ont.).

Boyd, Mossom, (1815-1833), Bobcaygeon (Ont.), industrie du bois.

7P-183 n.&b. 607. ca. 1870-1880, ca. 1900-1916.
Vues des Chutes Niagara (Ont.), de la ville de Québec (Québec),
des chutes Chaudières, Ottawa (Ont.); différentes photos prises en
Grande-Bretagne, aux Etats-Unis et au Canada; inspection du Roi
George V de la Canadian Field Artillery, le 1 er juillet, 1916;
portrait du lieutenant colonel Charles Leslie; Le SS *Calumet* à
l'écluse Fenelon (Ont.).

Boyd, Mossom & Co., Bobcaygeon (Ont.).

7P-184 Copies, n.&b. 89. ca. 1839-1949.
Activités de la compagnie Mossom Boyd dans l'industrie du bois de
la région de Bobcaygeon (Ont.); la navigation à vapeur dans la
vallée Trent (Ont.).

Boyd, Sheila A., Bobcaygeon (Ont.).

7P-185 n.&b. 1. [n.d.].
Moulin appartenant probablement à la famille Boyd, Geneva Bay,
île de Vancouver (C.-B.).

Bracher family.

334P-35 Copies, b&w 3. 1916-1930.
Musicians; symphony orchestra; quartet.

Bracken, John, (1883-1969), Winnipeg (Man.), Manotick (Ont.), premier
ministre du Manitoba, député du parlement fédéral.

7P-188 n.&b. 122. ca. 1885-1910, ca. 1928-1939.
Enfoncement du dernier clou de la ligne transcontinentale du
Canadien Pacifique, 7 novembre 1885; ferme des Bracken,
1928-1935; Hillcrest Lumber Co., Mesachie Lake (C.-B.); photos de
famille des Brackens, leurs activités et leurs résidences; la grève de
Flin Flon (Man.) 1939; portraits de D. Fulton et D. Fleming.

Bradell, David L.

9P-5 b&w 27. 1912-1919.
Unidentified people, harvesting scenes, mostly from Saskatchewan.

Bradford, William, Ottawa (Ont.), photographe et explorateur.

7P-190 n.&b. 140. 1872-1873.
Activités du peuple esquimau au Groenland; ours polaires sur des
glaciers, Groenland; vues de Julianeshaab et de la Baie de Melville,
Groenland; portraits de Peter Motzfeldy et de Syartehuk.

Bradley, H. Mme, Ottawa (Ont.).

7P-189 n.&b. 52,021. ca. 1900-1956.
Photos de famille de H. Bradley; ponts couverts; vues de la ville de
Québec (Québec), du Lac Mégantic (Québec), de la région
Gaspésienne (Québec), de Shelburne (N.E.) et d'Ottawa (Ont.).

Bradley, William Inglis, Ottawa (Ont.).

7P-191 n.&b. 1. ca. 1880.
Etudiants à l'école de médecine de l'université McGill dont William
Inglis Bradley, Montréal (Québec).

Braidwood, Florence Gwendolyn (Lazier), ([1905]-), Belleville, Ont.

75P-2 b&w [200]. ca. 1920-1930.
Photographs concerned with Miss Lazier's horseback ride from
Belleville, Ont. to Washington, D.C., to present an invitation to
President Calvin Coolidge from the Canadian people on the 140th
anniversary of the settlement of Upper Canada held in June, 1924;
many family vacation pictures.

Brander, Maude, (1895-1975), Fort Steele and Cranbrook, B.C.

333P-32 Copies, b&w 5. 1925-1930.
Brander family; Fort Steele School, 1926.

Branley, Bill, Victoria (C.-B.).

7P-192 Copies, n.&b. 12. [n.d.].
Vapeurs du Yukon: les SS *Klondike,* SS *Veno* et le SS *Casca.*

Brant, Joseph, Brantford, Ont.

7P-196 b&w 9. 1850-1872.
Group photo of various six nations Chiefs examining Wampum
record near Brantford, Ont., September 1871; photo by J.N. Edy &
Co.

Brant County Museum, Brantford (Ont.).

7P-197 n.&b. 3. 1917.
Dévoilement du monument commémoratif de la compagnie Bell
Téléphone, Brantford (Ont.), le 24 octobre 1917.

Brant (famille), Halton (Ont.).

7P-195 n.&b. 20. ca. 1916.
Photos de la famille de Joseph Brant; camp Borden (Ont.), 1916.

Brant I.O.D.E., Brantford (Ont.).

7P-193 n.&b. 1. ca. 1934.
Chapelle de la tribu des Mohawks, Brantford (Ont.); photo prise
par le studio Walker.

Bratt, Marion, Mrs., (b. ca. 1911), Pine Pass, B.C., fishing camp operator.

12P-25 b&w 184. 1952-1968.
Illustrations to manuscript: "History at Silver Sands, 1952-1968:
Reminiscences of Life in the Peace River District, B.C.";
construction of Silver Sands Fishing Lodge, activities at lodge, oil
drilling, P.G.E. construction, highway construction, and winter
scenes.

Brault, Lucien, Ottawa (Ont.), historien.

7P-194 n.&b. 23. ca. 1886-1967.
Vue du couvent de la rue Rideau, Ottawa (Ont.), 1886; portraits d'historiens et d'écrivains canadiens-français: Lucien Brault, Marcel Trudel, Séraphin Marion, Fernand Ouellette, Carmen Roy; portraits du major Huguet-Latour par William Notman et de Placide Gaudet.

Breen (famille).

7P-198 n.&b. 34. ca. 1905-1930.
Photos de famille et des enfants de John A. Breen.

Brennan, R.L., Ottawa (Ont.).

7P-202 n.&b. 1. 1896.
Champions juniors du club de crosse Hollyhock, Ottawa (Ont.), 1896; photo prise par S.J. Jarvis.

Brereton, C.R., Ottawa (Ont.).

7P-200 Copies, n.&b. 88. 1937-1956.
Vues du Casummit Lake (Ont.), de Goldpines (Ont.), Sioux Lookout (Ont.), Lansdown House (Ont.), Pickle Lake (Ont.), Osnaburg House (Ont.), Churchill (Man.), Goldfulls (Sask.), Fort Nelson (C.-B.), Whitehorse (Yukon), Yellowknife (T.N.-O.); avions de la Canadian Airways Limited; forts de la compagnie de la Baie d'Hudson.

Breton, William E., chirurgien.

7P-201 Copies, n.&b. 11. ca. 1870.
Vues D'Esquimalt (C.-B.), de Gorge (C.-B.), de Victoria (C.-B.), de Yale (C.-B.), Cariboo Rd. (C.-B.), et de New Westminster (C.-B.); photos du H.M.S. *Opal;* H.M.S. *Shaw.*

Brett, R.G., Dr., and family, (1855-1935), Banff, Alta., physician, Lieutenant-Governor of Alberta.

166P-12 Original, b&w [945]. 1860-1935.
Original prints collected by R.G. Brett family; family portraits; Banff events and people; Brett-owned buildings; views of Banff townsite and surrounding area.

Brewer, George MacKenzie, (1885-1947), Montreal, Que., composer and organist.

149P-3 b&w [25]. ca. 1920-1947.
Photographs of Brewer with friends and family at home and during European travels, as well as at the organ.

Brewster, F.O. (Pat), (b. 1897), Banff, Alta., outfitter.

166P-17 Original, b&w [500]. 1887, 1899, 1910-1940.
Original prints collected by Pat Brewster; Banff people and events; views of Banff townsite and surrounding area.

Brewster Transport Company, (est. 1892), Banff, Alta.

166P-14 Original, b&w [750]. ca. 1925-1950.
Original prints and negatives collected by Brewster Transport Company; Banff people and events, views of Rocky Mountains; pack trains, horse drawn vehicles, motorized vehicles; Sunshine and Norquay ski areas, Alta.

Bridgewater Hospital Chorus and Drama Society, (1972-1975), Bridgewater, N.S.

31P-64 Original, col. 3. 1972-1975.
Chorus and Drama Society productions.

Brigden family, Toronto, Ont., printers.

18P-84 Original, b&w 231. ca. 1910-1941.
Family portraits; camping trips.

Brine, A.J.

334P-16 Copies, b&w 6. ca. 1890-1900.
Dry goods store; wagon and horse team; houses.

Brintnell, W. Leigh, pilote.

7P-204 n.&b. 165. ca. 1914.
Le Baron John Buchan Tweedsmuir visitant le Grand Lac de l'Ours (T.N.-O.); appareils de la compagnie Western Canada Airways; différents modèles d'avion utilisés pendant la première guerre mondiale; photos illustrant quelques étapes de la carrière de W. Leigh Brintwell dans l'aviation.

Brisker, M., Walmer, Ky.

7P-205 b&w 33. ca. 1870.
Views of Victoria, Esquimalt, B.C., Montreal, Que., Toronto, Niagara Falls, Ottawa, Barrie, Bothwell, Ont.; portraits of various members of the Brisker family and friends.

Bristol, Helen Marcelle (Harrison), (n. 1909), Point Roberts, Wash., pilote.

7P-206 Copies, n.&b. 30. 1896-1968.
Avions et vols des pionniers de l'aviation; Helen Marcelle Bristol avec divers clubs d'aviation; portraits de Helen Marcelle Bristol.

Briston, J.F., Merritt (C.-B.).

7P-207 n.&b. 6. 1914-1941.
Sir John Dill et des officiers de l'armée canadienne, Vernon (C.-B.).

British Columbia Security Commission.

7P-208 n.&b. 160. 1942-1946.
Activités des canadiens d'origine japonaise relogés dans des camps en Colombie-Britannique, 1942-1946.

British Empire Exhibition, Wembley, England.

7P-209 b&w 1. 1924-1925.
The Prince of Wales modelled in Butter in the costume of a Red Indian, showing in the Canadian Pavillon, Wembley, England, 1924-1925.

British Photo Co., (ca. 1918), Vancouver, B.C., photographers.

334P-6 Copies, b&w 1. 1918.
New Westminster Fire Dept. drawn up outside the City Market.

British Railways.

7P-210 n.&b. 57. 1903-1904.
Différents modèles de locomotives anglaises.

Brodie, Fred, (1930-1977), Halifax, N.S., printer, trade unionist, political activist.

 31P-114 Original, b&w 4. 1952-1972.
 Career of Fred Brodie.

Bronowski, Jacob, (1908-1974), San Diego, Calif., writer on intellectual history.

 16P-6 b&w 100. 1950-1970.
 Chiefly publicity shots from the *Ascent of Man* television series and the Salk Institute, San Diego, Ca., and scrapbook of stills from the B.B.C. television series *Insight* and scrapbook from the National Coal Board of Great Britain, International Conference, 1956.

Bronson Home, Ottawa (Ont.), orphelinat.

 7P-212 n.&b. 17. c. 1864-1930.
 Fondatrices et présidentes de l'on orphelinat Bronson Home.

Broomfield, George, Cooksville (Ont.).

 7P-211 Copies, n.&b. 6. ca. 1915-1917.
 Tirées de l'album intitulé "Forêt de St-Evroult" Dans "Retrospection and Two War Diaries" (1ère guerre mondiale).

Brothers of the Christian Schools, Toronto Province, (1851), Don Mills, Ont., teaching, summer camps.

 310P-1 Copies, b&w [242], col. [55], total [297]. 1900-1974.
 Groups of teachers and students; schools, including residential ones; photos of individuals.

Brough, J.N., Ottawa (Ont.).

 7P-215 Copies, n.&b. 415. 1906-1940.
 Construction de la ligne de chemin de fer transcontinentale; chemins de fer au nord de l'Ontario à: Muskego, Mattagami, Nagagami, Ground Hog River, Cochrane, Abitibi et Frederick House; portraits d'Andrew Meleron, de Sandy Martin, de E.F. Pullen, de R.S. Round, du capitaine Albert E. Nash et de la reine Victoria.

Brouillard, George, Pascong (R.I.).

 7P-214 n.&b. 1. [n.d.].
 Portrait d'Alexis St. Martin avec sa femme.

Brown, Adam, (1826-1926), Hamilton, Ont., politician.

 45P-6 b&w 51. 1891.
 Photographs of Jamaica, taken while Adam Brown was Honorary Trade Commissioner in 1891.

Brown, Cecil W., Ottawa (Ont.).

 7P-223 n.&b. 4. 1854-1864.
 Trois ambrotypes: portraits d'hommes et de femmes non identifiés; un ferrotype de trois hommes non identifiés.

Brown, Ernest.

 7P-217 b&w 156. ca. 1870-1910.
 Various aspects of the development of the Canadian West, such as the Canadian Pacific Railway, the Riel Rebellion, etc., ca. 1870-1910; photos by C.W. Mathers and Ernest Brown.

 333P-10 Copies, b&w 4. 1883.
 Wildhorse Post office, Wildhorse hydraulicing, Galbraith's Ferry, B.C., Kootenay, B.C.

Brown, Ernest, (1877-1951), Edmonton, Alta, photographer.

 13P-1 b&w 43,442. 1886-1957.
 Photographs relating to the history of Alberta including Indian portraits, ceremonies, scenes and activities, Eskimos, Northern Alberta, Klondike Gold Rush, N.W.M.P., railroad companies, transportation, Riel Rebellion, coal mining, natural resources, ranching, farming, homesteads, Alberta towns, Hudson's Bay fort at Edmonton, Edmonton scenes, industries, etc., inauguration of Alberta, theatricals, sports, individual portraits; photographs taken by Boorne and May Photographers who sold to C.W. Mathers in 1893 who in turn sold to Ernest Brown in 1904.

Brown, Ernest Mme, Wakefield (Québec).

 7P-251 n.&b. 21. [n.d.].
 Vues de Gracefield (Québec), Kirks Ferry (Québec), Chelsea (Québec).

Brown, Francis Roy, pilote.

 7P-216 n.&b. 156. ca. 1925-1958.
 Appareils des compagnies Wings Ltd., Canadian Pacific Airlines, et Central Northern Airways Ltd. dans le nord et l'ouest du Canada, surtout au Manitoba; portraits de Francis Roy Brown.

Brown, H. Leslie, (b. 1903), Ottawa, Ont., public servant.

 7P-221 b&w 18. 1898-1910.
 Views of the C.P.R. bridge over the St. Mary River, 1898, and of Hosmer, B.C., ca. 1910; portrait of Mr. F.D. Alderson.

Brown, Helen, Ottawa (Ont.).

 7P-220 Copies, coul. 1. [n.d.].
 Portrait de William Lyon Mackenzie King.

Brown, Howard M., Ottawa, Ont., historian.

 7P-222 b&w 19. ca. 1860-1925.
 Views of Carleton Place, Ont.; various aspects of business, educational and sporting activity, Carleton Place, Ont.

Brown, J.T. Mme, Brantford (Ont.).

 7P-218 n.&b. 2. [n.d.].
 Newhouse, chef de la tribu des Mohawks.

Brown, Robert, Mme.

 7P-224 n.&b. 1. 1870-1892.
 Portrait de James Mather; photo prise par W. Rodgers.

Brown, Roy R., Saskatoon, Sask.

 7P-225 Copies, b&w 1. 1942.
 Members of 9th Intelligence Course, Royal Military College, Kingston, Ont., July to September 1942; photo by Studio Marrison.

Brown, Sibella.

31P-43 Original, b&w 88. ca. 1860-1880.
Brown family portraits.

Brown, Winifred (Killoran), Toronto, Ont.

200P-1 Original, b&w 53. 1902-1923.
Family photographs with special reference to her son, Edward
Killoran Brown; Brown home on 213 acres at Bedford
Park, Toronto, photographs taken during a trip to England in 1911;
photographs of the family cottage and neighborhood in Muskoka,
1910-1923.

Bruce, Charles Tory, (1906-1971), Toronto, Ont., journalist and writer.

31P-36 b&w [60], col. 1, total [61]. 1900-1960.
Career of C.T. Bruce.

Bruce, Herbert Alexander, (1868-1963), Toronto, Ont., surgeon and
politician.

75P-3 b&w [65]. ca. 1932-1937.
Photographs taken during Bruce's term as Lieutenant Governor of
Ontario.

Bruce, Robert Randolph, (1863-1942), Brandon, Man., Calgary, Alta. and
Eastern B.C., mining engineer, Lieut. Gov. of B.C., 1926-1931.

11P-11 b&w 83. ca. 1890.
C.P.R. survey; mining in eastern B.C.; dwellings; winter sports and
scenes Calgary, Alta., and Brandon area, Man.

Bruce Mines (Ont.).

7P-226 n.&b. 9. ca. 1960.
Rues et quelques maisons, Bruce Mines (Ont.).

Bruckhof, W. & Comp.

7P-227 n.&b. 5. ca. 1870-1880.
Stéréogrammes de Saint John (N.-B.).

Bruer, Léonard, Guelph (Ont.).

7P-81 n.&b. 1. 1880-1890.
Groupe d'hommes et de femmes avec de l'équipement pour le
battage du blé près de Brandon (Man.).

Bruun, Chris, Edmonton (Alberta).

7P-228 n.&b. 59, coul. 177, total 236. ca. 1910, 1955-1975.
Vues D'Edmonton (Alberta); Northlands Park, Mayfair Park et le
centre ville; vues de Spruce Grove (Alberta); vues de Port Radium
(T.N.-O.); photos prises par Chris Bruun.

Buchanan, Isaac, (1810-1883), Hamilton (Ont.), politicien et marchand.

7P-230 n.&b. 89. [n.d.].
Portraits d'Isaac Buchanan et de sa famille.

Buchanan, K.M., Harrow (Ont.).

7P-229 Copies, n.&b. 1. 1926.
Train de C.A. Arther, Rosetown (Sask.) où apparaît K.M.
Buchanan; photo prise par Gibson, Saskatoon (Sask.).

Bucke, Richard M., (1837-1902), London (Ont.), psychiatre.

7P-231 n.&b. 3. ca. 1900.
Le docteur Richard M. Bucke avec sa famille et dans son bureau.

Buller, F.J. Mme, Vancouver (C.-B.).

7P-232 Copies, n.&b. 5. ca. 1900.
Portraits du Major Arthur L. Howard.

Bullman, Allan, Toronto (Ont.).

7P-233 Copies, n.&b. 24. 1913.
Vues intérieures et extérieures d'un train de fabrication canadienne.

Buntin, Gillies & Co., (1848-1967), Hamilton (Ont.), manufacturier et
marchand de papier.

7P-234 n.&b. 3. 1937.
Fabrication de papier à la compagnie Buntin, Gillies & Co.,
Hamilton (Ont.).

Burbidge, Maurice, Victoria (C.-B.).

7P-235 Copies, n.&b. 8. [n.d.].
Portraits de Maurice Burbidge.

Burdock-Love, F.J., Sydney, Australie.

7P-236 n.&b. 14. ca. 1900.
Quais de Québec (Québec); vues de Montréal (Québec) et de
l'université McGill, Montréal (Québec).

Burian, Yvonne, Stewart River (Yukon).

7P-237 Copies, n.&b. 7. [n.d.].
Vues de Stewart River (Yukon).

Burke, Richard Thomas, (1859-1941), Owen Sound, Ont., priest.

200P-2 Original, b&w 3. 1906-1919.
Couvent des Soeurs de l'Assomption, Haileybury, Ontario showing
front of Ste. Croix Cathedral, about 1913; unidentified church and
large brick house with upper veranda; unidentified house in
residential district.

200P-11 Original, b&w 27. 1860-1930.
Priest friends taken about 1890; photographers represented are:
P.E. Park, Brantford, Ont., S.Y. Richards, Pittson, Pa., Frank
Paltridge, Galt, Ont., J.E. Livernois, Quebec City, Notman and
Fraser, Toronto, J.H. Lemaitre, Toronto, J.E. Watson, Detroit,
Farmer Bros., Hamilton, A.D. Harding, Susquehanna, Pa.; family
photographs including, 3 tintypes, 9 portraits ca. 1890-1910, and 3
snapshots of the 1930's; photographers represented are: United
Photo Studios, Scranton, Pa., Lyonde, Hamilton and Dundas, Thos.
H. Tincall, Mount Forest, Ont., Cochran, Hamilton, Ont., E.H.
Price, Hamilton, Ont., Frank Paltridge, Galt, Ont.

Burkholder, Ted.

7P-238 n.&b. 8. ca. 1880-1920.
Equipe féminine de hockey; groupe de cadets.

Burn, George.

> 7P-239 n.&b. 496. [n.d.].
> Daguerréotype, ambrotypes et ferrotypes; portraits de George Burn et de sa famille; camps militaires de la première guerre mondiale; photos prises par J.F. Cooke.

Burns, Thomas.

> 9P-6 b&w 613. ca. 1870-1930.
> Photographs of Winnipeg, Man., and of sporting events.

Burpee, E.L.H., Ottawa (Ont.).

> 7P-240 Copies, n.&b. 1. [n.d.].
> Portrait du chanoine Hanington.

Burpee, Lawrence Johnston, (1873-1946), Ottawa (Ont.), historien et fonctionnaire.

> 7P-241 b&w 201. 1879-1943.
> Vues de Montréal (Québec); Ellice (Man.) 1879; photo prises par G.M. Dawson; la rivière Athabasca à Prairie Creek (Alberta), Frances Lake (Ont.), 1939; Lewes Creek (Yukon) 1939; portraits de Sir Robert Borden, de Sir Charles Tupper, ca. 1896; photos prises par William James Topley; portraits de membres de la Société royale du Canada et de plusieurs auteurs canadiens.

> 31P-15 b&w [50]. ca. 1930.
> Life and work of James De Mille.

Burritt, B., Ottawa (Ont.).

> 7P-242 n.&b. 1. [n.d.].
> Hôtel Russel, Ottawa (Ont.).

Burt, Alfred Leroy, (1888-1971), professeur d'histoire.

> 7P-243 n.&b. 2. 1950.
> Portraits de Alfred Leroy Burt et de James Kearney.

Burton, Holmes, Hollywood (Calif.).

> 7P-244 n.&b. 11. 1926.
> Vues de Vancouver (C.-B.).

Bush, Hazel, Toronto (Ont.).

> 7P-245 n.&b. 1. 1914.
> Portrait de Hiram Leake accompagné de son épouse, 1er janvier 1914.

Bushnell, Ernest L., (n. 1900), radiodiffuseur, homme d'affaire et fonctionnaire.

> 7P-246 n.&b. 133. ca. 1934-1975.
> Employés de la société Radio Canada, 1934; Conférence du Commonwealth sur la radiodiffusion, 1945; la carrière de Ernest L. Bushnell à la société Radio Canada.

Butterfield, Daniel.

> 7P-247 n.&b. 1. 1860-1865.
> Portrait du major général Daniel Butterfield de l'armée américaine.

Button, M.O., Ottawa (Ont.), photographe.

> 7P-248 n.&b. 3. 1922-1924, 1944, ca. 1960.
> S.J. Jarvis et Associés, Ottawa (Ont.), 15 février 1944; la maison Stanley, New-Richmond (Québec).

Byers, J.W., Halifax, N.S., surveyor.

> 1P-60 Original, b&w 12. 1924, ca. 1930.
> Lumbering on the St. Mary's River at Caledonia, Guysborough Co., N.S.

Byng De Vimy, Julian Hedworth George Byng, vicomte, (1862-1935), gouverneur général du Canada.

> 7P-249 n.&b. 1. 1924.
> Portrait de Julian Hedworth George Byng, Vicomte Byng De Vimy.

Bytown Glass, Ottawa (Ont.).

> 7P-250 n.&b. [4]. ca. 1870-1880.
> Sports d'hiver: patinage à la patinoire Victoria; photo composite par William James Topley; glissade en toboggan; photo de William James Topley.

C.T.V. Television Network, Toronto, Ont.

> 7P-301 b&w 35. 1970.
> Scenes from C.T.V. programs such as *Canada AM, Window on the World, The Human Journey*; portraits of various C.T.V. staff.

Caines, John, Longpond, Manuels, Conception Bay, Newfoundland, farmer.

> 38P-1 b&w 20. 1900-1930.
> Various Newfoundland scenes; Sir William Ford Coaker at various functions of the Fishermen's Protective Union (FPU).

Calbick, Garth, New Westminster, B.C.

> 334P-20 Copies, b&w 2. 1975.
> New Westminster, B.C.; houses.

Caldwell, Ewan R., Ottawa, Ont., forest engineer.

> 7P-252 b&w 4,159. 1840-1936.
> Views of Carleton Place, Ont.; Long Sault, Ont.; Baie des Pères, Que.; Temiscaming, Que.; lumbering operations in the Ottawa Valley; activities of the Gillies and Caldwell families.

Caldwell, John F., (b. 1892), Belfast, Northern Ireland, lawyer.

> 7P-253 b&w 137. 1890-1915.
> Views along the northeast coast of Hudson Bay and in the Ungava District of Quebec; personnel and trading posts of the Hudson's Bay Company for Trading Activity in the Ungava District; native peoples of the Ungava District.

Callaghan-Bagshaw Inc., Montreal, Que., commercial photographers.

> 7P-254 b&w 3. 1967.
> Site of Expo '67, Montreal, Que.; aerial photograph by Gordon F. Callaghan.

Calvin, Delano Dexter, (1881-1948), Toronto, Ont., author and architect.

 7P-255 b&w 1. 1890-1923.
 Timber raft of Calvin Company Ltd. on route from Kingston, Ont.,
 to Quebec, Que.

Cameron, Alan Emerson, (1890-1977), Wolfville, N.S., Edmonton, Alta.,
professor.

 92P-8 b&w 1,324, col. 7, total 1,331. 1911-ca. 1966.
 Professional activities, family photographs on University of Alberta
 campus, teaching slides, field trips in the Lake Athabasca and
 Great Bear Lake regions.

Cameron, Benjamin Serby, Lacombe, Alta., professional photographer.

 11P-9 b&w 405. 1902-1948.
 Dwellings, commerce, education, amusements and personalities in
 Lacombe and area.

Cameron, Donald A., Sherbrooke, N.S. and Sackville, N.B., school teacher,
registrar at Mt. Allison University.

 1P-61 Original, b&w 21. ca. 1860.
 Construction of St. Peter's Canal, Richmond Co., N.S.

Cameron, Duncan, (b. 1928), Ottawa, Ont., photojournalist.

 7P-256 Original, total 175,000. 1948-1976.
 Documentation by Capital Press Ltd.; aspects of national public
 affairs in Ottawa; activities of the federal government; activities of
 national political parties; federal election campaigns across Canada;
 visits of foreign heads of state to Canada; activities of Canadians
 prominent in various occupations; visits to China and Cuba of Rt.
 Hon. Pierre E. Trudeau; activities in Africa and Asia of the
 Canadian International Development Agency; portraits of Claude
 Wagner, Joe Clark, Brian Mulroney, Flora MacDonald and Paul
 Hellyer.

Cameron, Evan Guthrie, Ottawa, Ont., physician.

 7P-257 b&w 87. 1919-1923.
 Construction of the Saint John dry dock, Saint John, N.B.; photos
 by Isaac Erb and Son.

Cameron, Stanley, Toronto, Ont., television researcher.

 7P-258 b&w 8. ca. 1893-1935.
 Activities of Mr. John Pearson, architect who took part in the
 reconstruction of St. John's, Nfld., after the fire of 1892, and in the
 reconstruction of the centre block of the Parliament Buildings in
 Ottawa, Ont., after the fire of 1916.

Campbell, Archibald M., (1860-1948), Perth, Ont., mining geologist.

 7P-259 Original, b&w 700. ca. 1890-1930.
 Various aspects of mining and forestry operations in Ontario.

Campbell, Donald J., Ottawa, Ont.

 7P-260 b&w 12. 1944-1945.
 Lockheed-Vega Ventura aircraft of the Royal Canadian Air Force
 taking part in exercise "Polar Bear", British Columbia.

Campbell, G.A., Cranbrook and Crowsnest, B.C.

 333P-42 Original, b&w 8. 1910-1920.
 Cranbrook, B.C.; Bull River, B.C.

Campbell, G.D., and Sons, (ca. 1865-1955), Weymouth, N.S., shipbuilding,
lumber merchants, general store.

 31P-66 Original, b&w 43. ca. 1895-1925.
 G.D. Campbell family and business history.

Campbell, John A., (1872-1963), Man., politician, lawyer.

 9P-7 b&w 884. 1920-1945.
 Photographs of northern Manitoba.

Campbell, Nina, Renfrew, Ont.

 7P-261 Copies, b&w 2. ca. 1917.
 Views of bridge and dam, Renfrew, Ont.

Camsell, Charles, (1876-1958), Ottawa, Ont., geologist, public Servant.

 7P-262 b&w 186. 1874-1955.
 Fur-trading activities of the Hudson's Bay Company in the
 Northwest Territories; aspects of the Klondike Gold Rush, Yukon;
 shipping operations on the Mackenzie River, N.W.T.; views of
 various communities in the Northwest Territories, Yukon, Alberta,
 British Columbia; career of Dr. Charles Camsell with the
 Geological Survey of Canada and as Deputy Minister of Mines.

Canada, Archives publiques du Canada, Ottawa (Ont.).

 7P-1910 n.&b. [1,416]. 1852-1974.
 Vues de l'édifice des Archives du Canada, Ottawa (Ont.), 1932; de
 l'édifice de la bibliothèque nationale et des Archives publiques,
 Ottawa (Ont.), 1973-1974; de l'Hôtel de ville de Montréal,
 Montréal (Québec); de villes et de villages canadiens, 1860-1920;
 du Fort Prince of Wales, Churchill Falls (T.N.-O.), 1879, par
 Robert Bell; activités du Corps expéditionnaire canadien, Camp
 Hughes (Man.); l'incendie de la bibliothèque du Parlement,
 Ottawa (Ont.), 1952; portraits de J. Bower Lewis, ca. 1855; du duc
 et de la duchesse de Devonshire, du Dr. A.G. Doughty, Vancouver
 (C.-B.), 1917; de Mme Tiberius Wright; daguerréotypes, ferrotypes
 et ambrotypes.

Canada, Archives territoriales du Yukon.

 7P-1973 Originaux, n.&b. 27. 1943-1944.
 Maisons délabrées à Dawson (Yukon); première canadienne du
 film «This is the Army», Whitehorse (Yukon).

Canada, Atlantic Tidal Power Programming Board, (1966-1970).

 7P-1921 Original, b&w 4,150, col. 200, total 4,350. 1955-1968.
 Aerial views of the Canadian Atlantic Coastline, the Bay of Fundy,
 Nova Scotia and New Brunswick.

Canada, Bureau du Conseil Privé, (f. 1867), Ottawa (Ont.).

 7P-1922 Originaux, []. 1943-ca. 1967.
 Membres du Comité de Guerre, 1943, et du Secrétariat du Bureau
 du Conseil Privé, Ottawa (Ont.), 1945; centres de distribution de
 brochures d'information du gouvernement fédéral.

Canada, Bureau du Premier Ministre, Ottawa (Ont.).

 7P-1960 n.&b. 4. 1967, 1971.
 Portraits du Très Hon. Lester B. Pearson, 1967; et du Très Hon.
 Pierre Elliott Trudeau, Ottawa (Ont.), 1971, par Duncan Cameron.

Canada, Centennial Commission, Ottawa, Ont.

 7P-1898 total 24,614. 1961-1967.
 Dominion-Provincial Conference, Charlottetown, P.E.I., 1961;
 ceremonies and special events throughout Canada celebrating the
 Centennial of Confederation, 1966-67; photos by Malak,
 Dominion-Wide Photos, Frank Grant, Ted Grant, Harold Whyte,
 Walter Petrigo, Henry Kalen, Gordon Heenan, Bob Brooks, Jim
 Ryan, David Proulx.

Canada, Central Mortgage and Housing Corporation, (f. 1946), Ottawa,
Ont.

 7P-1899 total 19,407. 1939-1970.
 Housing construction, housing developments, and slum conditions
 in cities and towns throughout Canada.

Canada, Chambre du Sénat, Ottawa (Ont.).

 7P-1896 n.&b. 3. ca. 1895.
 Bal à la Chambre du Sénat, Ottawa (Ont.) ca. 1895; photo prise
 par S.J. Jarvis; portraits de l'Hon. Philippe Roy et de Sir Richard
 Scott.

Canada, Chambre du Sénat, Comité Sénatorial sur la Pauvreté.

 7P-1897 n.&b. 24. 1970.
 Vues de diverses régions de Terre-Neuve; le Comité sénatorial sur
 la pauvreté siègeant à Terre-Neuve.

Canada, Commission de la capitale nationale, (f. 1959), Ottawa (Ont.),
aménagement de la région de la capitale nationale.

 7P-1951 n.&b. 379. 1950-1967.
 Portraits d'individus ayant occupé des postes officiels à la C.C.N.;
 vues de la ville d'Oka, (Québec); vues de la ville d'Ottawa (Ont.).

Canada, Commission royale d'enquête sur le statut de la femme,
(1967-1971), Ottawa (Ont.).

 7P-1968 n.&b. 2. 1971.
 Portraits de groupe de la Commission royale d'enquête sur le statut
 de la femme au Canada; photos par Dominion-Wide Photos,
 Ottawa (Ont.).

Canada, Conseil national de recherches du Canada, (f. 1916), Ottawa
(Ont.).

 7P-1957 n.&b. 24. 1942-1948.
 La division de génie mécanique du Conseil national de recherches;
 Engineering Institute of Canada, North Bay (Ont.), 1948; portraits
 des membres du personnel du Bureau d'information publique,
 1942.

Canada, Défense Nationale, Officier de liaison avec l'Université d'Ottawa,
Ottawa (Ont.).

 303P-9 n.&b. [100], coul. 8, total [108]. 1940-1968.
 Canadian Officers' Training Corps (C.O.T.C.); bals et réceptions de
 militaires; parades; séances d'entraînement; camp d'été de
 Brockville; photographies individuelles et de groupes.

Canada, Department of Agriculture.

 7P-1901 b&w [5,271]. ca. 1900-1962.
 Agricultural views across Canada: several taken by William James
 Topley; federal agricultural farms; Department of Agriculture
 offices; portraits of: William Saunders and W.H. Fairfield; Frank
 Thomas Shutt, 1920; Clifford Hanks Robinson, 1933; J.C.
 Woodward, 1949; A.R.G. Emslie, 1955; representatives to the
 Dominion Conference, Agriculture Service, Toronto, Ont., Aug. 29,
 1932 taken by the Panoramic Camera Co.; processing of dairy
 products; sheep shearing and grading, Southern Ontario, 1953;
 sheep exhibits, 1961-1962, Royal Agricultural Winter Fair, Toronto,
 Ont.; Haida Indians and totem poles; the school, Masset, B.C.; the
 school children, Masset, B.C.; Sangan River, Masset, B.C.

Canada, Department of Energy, Mines and Resources, Ottawa, Ont.

 7P-1903 b&w [57,523]. ca. 1865-1965.
 Views of National Parks; Canadian Pacific Railway Surveys of
 1872 and 1875 by Charles Horetzky; agriculture and lumbering
 across Canada by H.N. Topley, Davidson Bros., John Woodruff,
 Endre J. Cleven, Reuben R. Sallows, J.H. Clarke; immigration,
 hunting and fishing scenes by J.E. Livernois; highway and railway
 construction in the Prairies, British Columbia and Alaska; views
 along boundaries between British Columbia and Yukon, Ontario
 and Manitoba, Saskatchewan and Northwest Territories; views of
 Canadian waterways; various observatories across Canada, Europe
 and the United States; portraits of various Canadian politicians:
 John A. Macdonald; John S.D. Thompson; J.J.C. Abbott; R.C.
 Borden; Charles Tupper; Mackenzie Bowell; Charles Stewart;
 Arthur Meighen; James Lougheed; Robert Rogers.

Canada, Department of Finance, Ottawa, Ont.

 7P-1905 b&w 8. ca. 1944, 1945.
 Unidentified portraits by Karsh; various other portrait including
 R.B. Bennett and William Lyon Mackenzie King, ca. 1944;
 Dominion-Provincial Conference on Reconstruction, Ottawa, Ont.,
 Aug. 6, 1945.

Canada, Department of Immigration and Colonization, Ottawa, Ont.

 7P-1906 b&w 193. ca. 1865-1935.
 Buildings and offices of the Department of Immigration and
 Colonization in Canada and Britain; exhibits in the United States
 and Europe promoting immigration to Canada; activities of
 immigrants from countries such as Russia, Finland, Germany,
 Rumania, Britain; various aspects of farming in Western Canada;
 activities of Dr. Barnardo's Farm for Boys, Russell, Man., and of
 the Canadian Jewish Farm School, Georgetown, Ont.

Canada, Department of Indian Affairs and Northern Development, Ottawa,
Ont.

 7P-1904 b&w [81,900]. 1880-1966.
 Views of historic sites, monuments, forts and national parks across
 Canada; Indian and Eskimo life; Treaty 9 Commission: visits and
 payments, 1929-1935; views of the Northwest Territories and
 Arctic Archipelago; the Alaska Highway project; the
 Unemployment Relief Camp projects.

Canada, Department of Justice, (est. 1868), Ottawa, Ont.

 7P-1927 b&w 52. ca. 1920-1925.
 Photographs used in the case of the shooting of Amédée Bilodeau,
 May 1925; portraits from Canadian penitentiaries; views of Eskimo
 River, Coxsippi River, "Pitstau Nipi" and "Webistan Nipi" along
 Labrador Boundary, Labrador, 1920.

Canada, Department of Labour, Ottawa, Ont.

7P-1928 b&w 12,643. ca. 1910-1968.
Relocation of Japanese evacuees in Manitoba; International Labour Organization Building, Montreal, Que.; officials of the Trades and Labour Congress of Canada; Canadian delegations to conferences and participation in activities of the International Labour Organization; Department of National Defence relief projects across Canada; Dominion-Provincial Youth Training Plan at University of British Columbia, Vancouver, B.C., Reserve Labour Pool, Halifax, N.S.

Canada, Department of Militia and Defense.

7P-1933 b&w 10. 1916-1937.
Aerial photographs of the area around Amiens, August 1918; composite portrait of the officers of the 5th Regiment, Canadian Expeditionary Force (Royal Highlanders of Canada), 1916; armoured car of the Royal Canadian Dragoons, truck hauling heavy artillery piece, 1937.

Canada, Department of Munitions and Supply, Ottawa, Ont.

7P-1934 b&w 336. 1940-1945.
Production, verification and testing of war material; staff of the Metals Control Board, Department of Munitions and Supply, at work in their offices in Ottawa during World War II.

Canada, Department of National Defence, (est. 1923), Ottawa, Ont.

7P-1976 b&w [615,000]. 1900-1971.
Canadian military participation in the South African War, World Wars One and Two, and the Korean Conflict, 1900-1954; operational activities, personnel, bases and equipment of the Canadian Army, Royal Canadian Navy, and Royal Canadian Air Force, both in Canada and in various foreign countries, 1900-1971; Unemployment Relief Projects administered by the Department of National Defence throughout Canada, 1932-1936.

Canada, Department of Naval Service, Ottawa, Ont.

7P-1974 b&w [3,000]. 1913-1914.
Members and activities of the Canadian Arctic Expedition; H.M.C.S. *Karluk,* schooners *Alaska* and *Duxburry.*

Canada, Department of the Environment, (est. 1971), Ottawa, Ont.

7P-1917 b&w 6,196. ca. 1880-1967.
St. John's Harbour, Nfld., ca. 1896 by C. Chisholm; sixth British Commonwealth Forestry Conference, August - September, 1952: delegates, speakers, events, visits and tours; trees across Canada, 1915-1967; forestry operations and forest conditions across Canada, 1902-1928; photographic album: *Canadian Trees,* Department of Interior, by Horace H. Topley, ca. 1880; aftermath of explosion in Halifax, N.S., 1917; G.G.S. *Cartier, Parry, Henry, Hudson;* Newfoundland coastline taken from a boat, 1952; views of the Canadian Court at the International Fisheries Exhibition, 1883, by London Stereoscopic & Photographic company.

Canada, Department of the Interior, Ottawa, Ont.

7P-1926 b&w 60,449. 1870-1931.
Agriculture, forestry, fisheries, scenery, transportation, sports and cities through Canada, ca. 1905-1931; Doukhobor land rush at Yorkton, Sask., June 14, 1907; mining and industrial activity in Canada, 1920-1930; the firing of land, March 1920-May 1922; aerial views of French cities by the "Compagnie Aerienne Française" Suresnes, France, ca. 1929; views of Winnipeg, Man., ca. 1880; immigration sheds, Montreal, Que., 1911; surveying activities and views of Ottawa, Ont., by J. Woodruff, 1900-1920; views of: Yellowstone National Park, Wyo., 1915; Mount Edith, Sawback Range, Rundle Mountain, Crowfoot Glacier, Bow Lake

and Glacier, Cascade Mountain and Peyto Glacier, Alta., 1918.

Canada, Department of the Solicitor-General, Royal Canadian Mounted Police, Ottawa, Ont.

7P-1938 b&w 147. 1872-1910.
Activities of Jefferson "Soapy" Smith, Skagway, Alaska, 1898; Northwest Mounted Police detachments at Fort McPherson and Fullerton, N.W.T. 1903-1905; Peace River and Fort MacLeod, Alta., 1910; views of A.P. Low Expedition, Fullerton, N.W.T. 1903-1904; views by J.D. Moodie and his wife during expeditions to Hudson Bay, 1903-1905; portrait of D.A.E. Strickland; Eskimos; North American Boundary Commission photographs from north west angle of Lake of the Woods to the eastern side of the Rocky Mountains; composite of individual members of the Dominion Police Force, Ottawa, Ont., 1909.

Canada, Department of the Solicitor-General Penitentiary Branch, Ottawa, Ont.

7P-1937 b&w 357. 1932-1961.
Views of the Canadian penitentiaries of Dorchester, N.B.; Saint-Vincent-de-Paul, Que.; of British Columbia and Saskatchewan; including scenes of daily life, facilities, security, services; Warden's Conference, Kingston, Ont., 1961 by George Lilley Photography, Kingston, Ont.

Canada, Department of Transport, Ottawa, Ont.

7P-1911 b&w [42,720], col 329, total [43,049]. 1886-1966.
Hudson Strait Expedition, 1927-1928; Hudson Bay Railway Terminus, Fort Churchill, N.W.T., 1927-1929; Arctic Resupply Bases, 1948-1956; views of Quebec and Ontario canals; of the new Quebec bridge; of airfields and airports across Canada; of lighthouses in Canada; damaged merchant ships and wreckage of Canadian aircraft investigated by the Department of Transport; federal telecommunication facilities and equipment throughout Canada, 1909-1950's.

Canada, Department of Transport, Coast Guard, Aids and Waterways, Ottawa, Ont.

1P-30 Original, b&w [500]. 1900-1906.
Department of Transport wharf and depot, Dartmouth, N.S.; various Nova Scotia light houses; lifesaving station, other views of Sable Island; Department of Transport and other ships; Marine Hospital, Sydney, N.S.

Canada, Dominion-Provincial Conference on Reconstruction, (1946), Ottawa, Ont.

7P-1941 b&w 2. 1946.
Dominion-Provincial Conference on Reconstruction, Ottawa, Ont., 1946.

Canada, Eastern Rockies Forest Conservation Board, (1947-1955), Ottawa, Ont., conservation of forest resources,.

7P-1942 Original, []. [n.d.].
Photos illustrating a geological report.

Canada, Economic Council of Canada, National Productivity Council, Ottawa, Ont.

7P-1956 b&w 62. ca. 1969.
Group photographs of European national labour councils; portraits of National Productivity Council members.

Canada, Energie Mines et Ressources, Commission géologique du Canada, Ottawa (Ont.).

7P-1916 n.&b. 32,570. 1858-1947.
Opérations minières dans les régions de la Gatineau au Québec, de Sudbury et de Kingston en Ontario; l'incendie de Ottawa-Hull en 1900; l'époque de la ruée vers l'or dans la région du Klondike au Yukon, 1862-1910; vues de villages et de la topographie des Maritimes, du Québec, de l'Ontario, des Provinces de l'ouest, des Territoires du Nord-ouest et de régions de l'Arctique, 1858-1921; vues de Oldham et Liverpool, (N.-E.) Helen Mine, Michipicoten (Ont.); Steep Rock Mine, Steep Rock Lake (Ont.); Quemont Mine, Noranda (Québec); Waite-Amulet-Dufault Mine, Noranda (Québec); 8 albums de «*Atlas of Topographic Forms*» 1901-1939; étude topographique; du Québec en 1873 et de la Nouvelle-Ecosse et de Terre-Neuve de 1873 à 1879 par T.C. Weston; et de la Terre de Rupert 1884-1885 par A.P. Low; portrait de Robert Clarence Borden; composite du personnel de la Commission géologique du Canada dont A.R.C. Selwyn.

Canada, Energy Mines and Resources, International Boundary Commission, Ottawa, Ont.

7P-1913 b&w 9,230. 1893-1919.
Preliminary survey of 1893-1896 and the final establishment of the Alaska-British Columbia boundary; the marking of the line from St. Elias, Yukon, to the Artic Ocean; re-survey along 49th parallel from Cascade Mountains, B.C., to the Pacific Ocean; survey on Quebec-New York boundary in Passamoquoddy Bay, N.B., and at Lake of the Woods, Ont.

Canada, Food Prices Review Board, Ottawa, Ont.

7P-1943 b&w 10. ca. 1974-.
Portraits of Beryl Plumptre, Chairman, Food Prices Review Board, and officials of the Board; photos by Andrews-Newton, Ottawa.

Canada, House of Commons, Ottawa, Ont.

7P-1945 b&w 1. 1952.
Composite photo of Members of Parliament, Ottawa, Ont.

Canada, Legislative Assembly.

18P-31 Original, b&w 15. ca. 1858.
Portraits of various members of Legislative Assembly.

Canada, Les Musées nationaux.

7P-1909 n.&b. 326. 1898-1937.
Ruée vers l'or du Klondike, Yukon; photos prises par Hegg, Larss et Duclos 1898-1910; expositions des Musées nationaux du Canada, 1937.

Canada, Library of Parliament, (est. 1871), Ottawa, Ont.

7P-1947 b&w 431. ca. 1855-ca. 1960.
Parliament Buildings, Ottawa, Ont.; various Canadian and British personalities of the nineteenth century; royalty, politicians, clergymen, Indian chiefs; Pan-American Exposition; views of Ottawa and Toronto, Ont.; Montreal and Percé, Que.; group of Indians, Victoria Museum, Ottawa, Ont., ca. 1940; Queen Victoria's Diamond Jubilee Procession, London, England, 1897; Rt. Hon. Lester B. Pearson, 1960; members of the Canadian Artillery Team visiting Britain, 1896.

Canada, Ministère de la Marine et des Pêcheries, Ottawa (Ont.).

7P-1930 Originaux, n.&b. 92. 1917-1930.
Cale sèche en construction pour la Canadian Vickers Ltée., Barrow-in-Furness, Angleterre, 29 septembre, 1911; divers remorqueurs commerciaux, Vancouver (C.-B.), ca. 1927; schooner, *Glooscap,* Saint John (N.-B.), ca. 1927; vaisseau patrouille *St. Roch* de la Gendarmerie Royale du Canada (G.R.C.), (C.-B.) et (T.N.-O.) ca. 1928; navires de la marine marchande endommagés dans les eaux canadiennes; dynamitage du SS *Shamrock,* Montréal; (Québec); échouage du SS *Novadoc;* dommages causés au SS *Rosecastle* lors d'une collision; vues de Anderson's Hollow (N.-B.); le dragueur *Churchill N I;* le C.G.S. *Grenville;* le chantier naval du gouvernement canadien à Sorel (Québec).

Canada, Ministère de la Santé nationale et du Bien-être social.

7P-1931 Originaux, n.&b. 50,078. 1946-1970.
Activités et personnel de la Direction de la santé et du sport amateur; activités sportives et défilé des athlètes au festival de la santé nationale, 1962.

Canada, Ministère de l'Emploi et de l'Immigration, Ottawa (Ont.).

7P-1929 n.&b. 12,929. 1907-1961.
Vues de régions rurales et urbaines dans plusieurs provinces canadiennes; activités et travaux d'immigrants au Canada; situation des camps de constructions pour la voie de chemin de fer du Grand Tronc dans l'ouest canadien; le navire C.P.S. *Empress of Canada.*

Canada, Ministère de l'Industrie et du Commerce, Ottawa (Ont.).

7P-1907 n.&b. 100,732, coul. 62,200; total 162,932. 1865-1973.
Participation canadienne à diverses foires commerciales en Angleterre et à Singapour, 1926-1939; Expo '67: planification et activités pendant l'Exposition universelle de Montréal (Québec), 1967; les activités de la Commission des expositions du gouvernement canadien, 1971-1973; vues de parcs nationaux, provinciaux et municipaux; de villes et de villages; portraits de Sir John J.C. Abbott; de Dr O.D. Skelton; de George VI et de la reine Elizabeth, Ottawa (Ont.), 1939.

Canada, Ministère des Affaires des anciens combattants, Ottawa (Ont.).

7P-1940 Originaux, n.&b. 546. 1878-ca. 1965.
Camp du 58 bataillon du corps expéditionnaire canadien, Niagara, (Ont.), 1915; construction du monument commémoratif à Vimy, France; personnel du ministère des Affaires des anciens combattants, administration des terres, région de l'ouest de l'Ontario, ca. 1960; maisons construites sous l'égide du «*Veterans' Land Act*», dans les régions de Windsor, London et Guelph (Ont.); volontaires de la région d'Ottawa qui ont participé à la Guerre des Boers, Afrique du Sud, 1900; opérations du «*Canadian Corps of Firefighters*» en Grande-Bretagne, 1942-1944; vues de Winnipeg (Man.); Saskatoon (Sask.); Calgary et Edmonton (Alberta); portrait de Po-ti-nak, guerrier «*Blood*».

Canada, Ministère des Affaires extérieures, (f. 1909), Ottawa (Ont.).

7P-1918 n.&b. 11,450, coul. 424, total 11,874. 1879-1970.
Commémoration du 240e anniversaire de la mort de Pierre Lemoyne d'Iberville, La Havane, Cuba, le 9 juillet 1946; vues de Rideau Hall, Ottawa (Ont.), de Québec (Québec) et de Victoria (C.-B.) 1882; scènes de chasse par W. Notman; la Bibliothèque du Parlement, Ottawa (Ont.); couronnement de la reine Mary, 1911; Sir Robert L. Borden en France le jour du Dominion, le 1.er juillet 1918; la Conférence impérial: Sir E. Kemp et Sir George Perley; Sir Robert L. Borden et Sir T. Mackenzie; la présentation de la Verge noire à Sir Robert L. Borden, Londres, Angleterre 1918; l'Hon. Paul-J.-J. Martin, 1967; diverses villes et régions en Autriche, ca. 1920-1939; visites de leurs Altesses Royales le Prince de Galles et le prince George pour l'ouverture du pont de la Paix

Canada, Ministère des Affaires extérieures, (f. 1909), Ottawa (Ont.). (Cont'd/Suite)

sur la rivière Niagara le 7 août 1927; inspection des troupes canadiennes en Angleterre, ca. 1942; tirages des archives de l'Office national du film et photos publicitaires sur le Canada, ca. 1960; ministres canadiens en voyage, ca. 1940; le personnel et des cérémonies officielles, ambassade canadienne à Washington, D.C. 1927; la tournée royale et l'exposition universelle, 1939; la participation canadienne au plan de Colombo; des dignitaires et des représentants de pays étrangers à des cérémonies officielles au Canada et des représentants canadiens à des cérémonies officielles à l'étranger.

Canada, Ministère des Postes, (f. 1867), Ottawa (Ont.).

7P-1961 Originaux, n.&b. 7,122. 1870-1950.
Différentes fonctions des services postaux canadiens; portraits de fonctionnaires affectés aux Postes; service postal aérien le long du fleuve Mackenzie (T.N.-O.) 1929-1932.

Canada, Ministère des Travaux publics, (f. 1867), Ottawa (Ont.).

7P-1935 n.&b. 13,756, coul. 204, total 13,960. ca. 1860-1969.
Autoroutes ponts, ports, hôpitaux, bureaux de poste et divers édifices construits par le Ministère des Travaux publics du Canada dans plusieurs villes canadiennes; construction des nouveaux édifices du Parlement, Ottawa (Ont.), 1916-1921; construction, édifices et équipement du canal Lachine (Québec) et du canal Desjardins (Ont.); vues des canaux du Québec; Chambly, Carillon, Grenville et ses environs, Soulanges, Lachine et Beauharnois, ca. 1900-1959; vues de Peace River (Alberta), 1920; de barraques militaires à Halifax (N.-É.); de Trail, Aiyansh, Pender Harbour, Sechelt, Quesnel, Huntington, Lytton et Fort George (C.-B.); Beauceville, Saint-Lambert, Rawdon, Berthierville et Saint-Laurent (Québec); Sackville (N.-B.); construction de l'édifice de l'Est du Parlement, Ottawa (Ont.), 1860.

Canada, Ministère du Revenu national (Douanes et Accise), (f. 1927).

7P-1932 n.&b. 215. ca. 1900-1921.
Personnel du Bureau des Douanes et Accise, Edmonton (Alberta); troisième congrès annuel des officiers des Douanes et Accise, Ottawa (Ont.), 1921; anciennes maisons des Douanes à Halifax (N.-É.) ca. 1910 et à Hamilton (Ont.); portraits de F.E. Osborne, J.W. Shera, P.D. Fowler, P.E. Dennison, de A.H. Elliott et de l'officier T.F. Fitzgerald.

Canada, Musée canadien de la guerre, Ottawa (Ont.).

7P-1908 n.&b. [478]. 1897-1945.
Les troupes canadiennes dans le nord de la Russie, 1918-1919, l'entrée des troupes canadiennes à Mons, Belgique, le 11 Nov. 1918; les troupes canadiennes à Dieppe, France, le 19 août 1942; les camps de prisonniers en Allemagne, 1942-1945; portraits de militaires.

Canada, Mutual Aid Board, (est. 1943), Ottawa, Ont.

7P-1949 Original, b&w 11. 1944.
40 mm. Bofors Bantam Anti-aircraft gun.

Canada, National Battlefields Commission, (1908), Quebec, Que., preservation of historic battlefields.

7P-1950 b&w 1. ca. 1932.
View by W.B. Edwards of tablet erected by National Battlefields Commission to commemorate l'Hôtel-Dieu, Quebec City, Que.

Canada, National Harbours Board, (est. 1936), Ottawa, Ont.

7P-1953 b&w 1,153. 1886-1958.
Various aspects of the Port of Vancouver, B.C., 1886-1958: activities, views, facilities; portraits of members of the Vancouver Harbour Commission.

Canada, National Library of Canada, (est. 1953), Ottawa, Ont.

7P-1952 b&w 500, col. 2, total 502. 1859-1959.
Construction of Parliament Buildings, Ottawa, Ont., 1859-1866; photos by Samuel McLaughlin; views in and around Tadoussac, Que., by W.J. Topley; views of Quarantine Station, Grosse Isle, Que., 1900-1910; visit of Mr. Rupert Brooke to Mr. D.C. Scott, Ottawa, Ont., 1913; views of Newfoundland and Labrador, 1933; Commonwealth Parliamentary Association Conference, Wellington, N.Z., 1950; portraits of Members of the Ontario Legislature, 1873; photos by Notman & Fraser; portrait of H.M. Queen Elizabeth II and Prince Philip, 1959, by Donald McKague.

Canada, National Museums, National Gallery of Canada Collection, Ottawa, Ont.

123P-1 Original, b&w [7,000], col. [50], total [7,050]. ca. 1840-ca. 1970.
History of photography as an image-making process from approximately 1835 to the present; the scope of the collection is international with some fifteen countries represented; it includes the work of such well-known masters as David Octavius Hill (1802-1870), Charles Nègre (1820-1880), Auguste Salzmann (1824-1872), Julia Margaret Cameron (1815-1879), Alexander Gardner (1821-1882), T.H. O'Sullivan (1840-1882), H.P. Robinson (1830-1901), William Notman (1826-1891), Alexander Henderson (1831-1914), P.H. Emerson (1856-1936), Frederick Evans (1853-1943), Eugène Atget (1857-1927), Alfred Steiglitz (1864-1946), Lewis Hine (1874-1940), Edward Steichen (1879-1973), Edward Weston (1886-1958), Walker Evans (1903-1975), Aaron Siskind (b.1903), Harry Callahan (b.1912).

Canada, National Museums, National Museum of Science and Technology, Ottawa, Ont.

7P-1948 b&w 63. [n.d.].
Aerial views of the Montreal area; aircraft; bush-pilot craft; flying boats; locomotive 'Samson' used by General Mining Assn. Ltd., between East River and New Glasgow, N.S.; portrait of Reginald A. Fessenden.

Canada, National Museums Corporation, National Gallery of Canada, (est. 1882), Ottawa, Ont.

7P-1954 b&w 21. 1850-1964.
"Old Guard Dinner" of prominent members of The Conservative Party, Toronto, Ont., 1882; visit of H.M. King George VI and Queen Elizabeth to Ottawa, Ont., 1939; portraits of Messrs. Théophile Hamel, Antoine Plamondon, J.E.H. Macdonald, Tom Thomson, Allan Fleming and other winners of the Typography '64 competition.

Canada, Northern Ontario Pipe Line Crown Corporation, (1956-1967).

7P-1958 b&w 245. 1957-1960.
Construction of the Trans-Canada Pipeline through Manitoba and Ontario, 1957-1960.

Canada, Office of the Secretary to the Governor General, Ottawa, Ont.

7P-1970 b&w 16. 1931-1967.
Portrait by John Powis of Viscount and Lady Willingdon; portraits by Cavouk of H.E. D. Roland Michener; portrait of Lord Bessborough, various aspects of incident involving SS *Komagata Maru*, Vancouver, B.C., 1914.

Canada, Resources for Tomorrow Conference, (1961), Montreal, Que.

7P-1902 b&w 627. 1949-1961.
Forest and water resources in Canada; aspects of the Resources for Tomorrow Conference, Montreal, Que., October 1961.

Canada, Royal Commission into the Non-Medical Use of Drugs (Le Dain Commission).

7P-1966 b&w 3, col. 1,354, total 1,357. 1969-1972.
Colour transparencies of a drug-user's eye during a two-month period; portraits of street people either working for or interviewed by the Commission; Royal Commission into the non-medical use of drugs in session, December 1969.

Canada, Royal Commission Investigating Halifax Disorders.

7P-1964 b&w 80. 1945.
Riots in Halifax, N.S., 7-8 May 1945.

Canada, Royal Commission on Bilingualism and Biculturalism, (1963-1971).

7P-1962 b&w 86. 1964-1970.
Presentation of freedom of city of Soest, West Germany, to the 1st Battalion, Royal Canadian Regiment (R.C.R.), 1964; portraits of members of the Royal Commission on Bilingualism and Biculturalism, 1970.

Canada, Royal Commission on Farm Machinery, (1966-1971).

7P-1963 b&w 7. 1967.
Views of London, Ont., and of the service school of International Harvester Company.

Canada, Royal Commission on Newfoundland Finances, (est. 1957).

7P-1965 b&w 42. 1957.
Road conditions in Newfoundland, 1957.

Canada, Royal Commission on Pilotage, (1962-1971).

7P-1967 b&w 6. 1961.
View of St. John's, Nfld.; grounding of SS *Hermion,* Prince Rupert, B.C., 1961.

Canada, St. Lawrence River Joint Board of Engineers, (est. 1952).

7P-1969 b&w 2,772. 1954-1959.
Construction of the St. Lawrence Seaway, 1954-1959.

Canada, Secrétariat d'Etat, Ottawa (Ont.).

7P-1971 n.&b. 1,066, coul. 3, total 1,069. 1864-1973
Le voyage du président Franklin Delano Roosevelt au Canada, 1936; la visite royale de la princesse Elizabeth et du prince Philip au Canada, 1951; «THE GREAT RING», cadeau des Etats-Unis au Canada; la masse du Sénat, ca. 1930; les funérailles de Sir Wilfrid Laurier, Ottawa (Ont.), 1919; la mort d'Edward VII, 1910; le vicomte Willingdon, Lord Tweedsmuir, le vicomte Byng de Vimy; la conférence de Québec (Québec), 1864, par J.E. Livernois; portfolio de la carrière, de la famille et des funérailles de Lester B. Pearson; portrait de l'Hon. Walter E. Foster, 1925; portraits officiels de sa majesté la reine Elizabeth II et de son altesse royale le prince Philip par Cavouk, Toronto (Ont.), août 1973.

Canada, Treasury Board, Ottawa, Ont.

7P-1285 b&w 32. ca. 1867-ca. 1963.
Portraits of ministers and deputy ministers of Finance; composite portrait of members of the House of Commons, 1930; statue in butter of King Edward VII.

Canada, Wartime Prices and Trade Board, Ottawa, Ont.

7P-1972 Original, b&w 450. ca. 1940.
Wartime prices and trade activities and program.

Canada Air Board.

7P-1919 Copies, b&w 5. 1920.
The first aerial survey of Ottawa, Ont., 8 Oct. 1920.
Provenance: PAC National Map Collection item S/44D.

Canada Airport Inquiry Commission, (est. 1973).

7P-1920 Original, b&w 27. 1973.
Views of the arable land near Claremont, Ont.

Canada Atlantic Railway Old Boys' Association, Ottawa, Ont.

7P-263 Original, b&w 500. ca. 1886-1953.
Personnel, buildings, rolling stock, train wrecks of the Canada Atlantic Railway System between Coteau Junction and Parry Sound, Ont.; annual meetings of the Canada Atlantic Railway Old Boys's Association, Ottawa, Ont.

Canada Foundation, (b. 1942), Ottawa, Ont.

7P-264 Copies, b&w 155. 1943-1954.
Supplying of information on Canada to allied Military Personnel during World War II; dignitaries attending benefit performance of film *The Red Shoes* at the Odeon Theatre, Ottawa, Ont.; handicrafts such as woodcarving in Quebec and the Maritime Provinces; portraits of Mr. Justice J.T. Thorson and Mr. W.B. Herbert of the Canada Foundation; photos by Karsh, T.V. Little, Bill & Jean Newton, Capital Press, Henri Paul, B.B. Salmon, National Film Board.

Canada House, London, England.

7P-265 b&w 61. 1914-1919.
Buildings, staff and patients of the Queens Canadian Military Hospital, Shorncliffe, Kent, Eng.; photos by J. Lambert Weston & Son.

Canada National Museums of Canada, National Museum of Natural Science, Ottawa, Ont.

7P-1955 col. 3,770. [n.d.].
Canadian birds and Canadian bird sanctuaries.

Canada Steamship Lines, Montreal, Que.

7P-266 b&w 1. ca. 1926-1939.
SS *Lemoyne;* photo by Associated Screen News.

Canada's Aviation Hall of Fame, Edmonton, Alta.

7P-269 b&w 23. 1920-1957.
Airfield at Bowness, Alta.; operations in Ontario of Austin Airways Ltd.; R.C.A.F. officers and civilian pilots at Camp Borden, Ont.; retirement dinner for G/C Z.L. Leigh, R.C.A.F.; portraits of Messrs Casey Bladwin, J.A.D. McCurdy, J.A. Richardson, Sr., Jack Austin.

Canadian Army Photo Collection.

9P-8 b&w 355. 1939-1945.
Military Activities in Manitoba; Hon. John Bracken visiting troops in Europe.

Canadian Association of Amateur Oarsmen, Ottawa, Ont.

7P-267 b&w 1. 1942.
Fred Weatherhead, Boatmaster, at the Lachine Rowing Club, Lachine, Que.

Canadian Authors' Association, Ottawa, Ont.

7P-268 b&w 1. 1868.
Funeral of Hon. Thomas d'Arcy McGee, Montreal, Que.; photo by James Inglis.

Canadian Baptist Archives, Hamilton, Ont.

7P-270 b&w 133. ca. 1890-1945.
Interior and exterior views of schools in Canada; various aspects of agriculture in Canada; mining operations at Val d'Or, Que., Copper Cliff, Ont.; lumbering operations in British Columbia, Alberta, Manitoba; various aspects of marine, air, land transportation in Canada.

Canadian Christian Council for the Resettlement of Refugees, Winnipeg, Man.

7P-271 b&w 51. 1950.
Views of refugee camp operated by the Canadian Christian Council for the Resettlement of Refugees, Bremen, West Germany.

Canadian Citizenship Council, (1941-), Ottawa, Ont.

7P-272 b&w 125. 1955-1966.
Annual meetings of the Canadian Citizenship Council; portraits of Hon. Judy Lamarsh, Dr. J.E. Robbins and Allan Clarke.

Canadian Commission for UNESCO, Ottawa, Ont.

7P-273 b&w 25. 1961-1964.
National Conference of 1961 of the Canadian Commission for UNESCO; portraits of members of the Commission; World School Children's Art Exhibition of 1964.

Canadian Conference of the Arts, (est. 1945), Toronto, Ont.

7P-274 b&w 64. ca. 1958-1968.
Participants in the "Seminar 66" conference; architectural model of the National Arts Centre, Ottawa, Ont.; portraits of Rt. Hon. Vincent Massey and H.E. Roland Michener, Messrs. Alan Jarvis, Peter Dwyer, David Silcox, and various officers of the Canadian Conference of the Arts.

Canadian Dental Association, (f. 1902), Ottawa, Ont.

7P-275 b&w 11. 1894-1947.
First meeting of the Canadian Dental Association, Montreal, Que., 1902; various annual conventions of the Canadian Dental Association; group portraits of various graduating classes of the Royal College of Dental Surgeons.

Canadian Eclipse Expedition, Arctic expedition to observe Solar eclipse.

45P-4 b&w 86. 1905.
Photographs showing various aspects and activities of the Eclipse expedition including the outward journey, scenery, the camp, equipment, camp activities and individuals.

Canadian Federation of Agriculture, (1935), Ottawa, Ont.

7P-276 b&w 4. [n.d.].
Activities of H.H. Hannam, President of the Canadian Federation of Agriculture, 1939-1965.

Canadian Federation of Business & Professional Women's Clubs.

7P-288 b&w 1. 1937.
Participants in the annual convention of the Canadian Federation of Business and Professional Women's Clubs, Niagara Falls, Ont.; photo by James, Niagara Falls.

Canadian Federation of Catholic Convent Alumni, (1931-1975), Toronto, Ont., education.

200P-16 Original, b&w 100. 1931-1977.
The Canadian Federation of Catholic Convent Alumni.

Canadian Federation of Music Teachers' Associations, (f. 1935).

7P-277 b&w 9, col. 1, total 10. 1936-1959.
Annual conventions of the Canadian Federation of Music Teachers' Associations.

Canadian Federation of University Women.

7P-278 b&w 179, col. 16, total 195. 1919-1969.
Delegates to annual conventions of the Canadian Federation of University Women and of the International Federation of University Women; winners of Annual Fellowships and Grants awarded by the Canadian Federation of University Women.

Canadian Figure Skating Association, (f. 1913), Ottawa, Ont.

7P-279 b&w 82, col. 46, total 128. 1963-1967.
Various competitions sponsored by the Canadian Figure Skating Association.

Canadian Film Institute, Ottawa, Ont.

7P-280 b&w 1. 1929.
Visit of Lord and Lady Willingdon to Kakabeka Falls, Ont.

Canadian Forestry Association, (f. 1900), Ottawa, Ont.

7P-281 b&w 1,000. ca. 1920-1965.
Aspects of forestry in Canada such as tree farming, entomology, forest fire, recreation, wood industries; activities of the Canadian Forestry Association such as fire prevention and youth work.

Canadian Government Exhibition Commission, Ottawa, Ont.

7P-1944 b&w 2,008. 1900-1973.
Canadian pavillions and displays at various national and international trade fairs and exhibitions.

Canadian Hadassah-Wizo, (f. 1917), Montreal, Que.

7P-282 b&w 276. 1929-1970.
Activities and personalities of the Canadian Hadassah-Wizo
(Womens' International Zionist Organization); activities of the
Israel-Wizo in Israel.

Canadian Institute on Public Affairs, (est. 1932), Toronto, Ont.

7P-283 b&w 151. 1944-1958.
Group photos of participants in the Couchiching Conferences,
Geneva Park, Ont., 1944-1958.

Canadian Intercollegiate Athletic Union, (f. 1961), Vanier, Ont.

7P-284 col. 10. 1970.
Canadian teams competing in the World University Games, Turin,
Italy.

Canadian Interfaith Conference.

7P-285 b&w 171. 1966-1967.
Religious celebrations marking Centennial of Confederation,
Parliament Hill, Ottawa, Ont.; group photos of members of the
Canadian Interfaith Conference.

Canadian Labour Congress, (f. 1956), Ottawa, Ont.

7P-289 b&w 51, col. 1, total 52. ca. 1873-1965.
Portraits of the presidents and secretary-treasurers of the Canadian
Labour Union, the Trades and Labour Congress of Canada, the All
Canadian Congress of Labour, and the Canadian Labour Congress;
group photos of members of the T.L.C. and C.L.C.

Canadian Ladies' Golf Association, (f. 1913), Vanier, Ont.

7P-286 b&w 8. 1923-1954.
First annual banquet of Canadian Women's Senior Golf
Association, Montreal, Que.; members of Canadian Ladies' Golf
Union, Winnipeg, Man.; portrait of Ella W. Murray.

Canadian Marconi Company, Montreal, Que.

7P-287 b&w 46. 1907-1969.
Marconi Wireless Stations, Cape Race, Nfld.; Glace Bay, N.S.;
sealing ships in icefield off coast of Newfoundland; Boy Scouts
learning telegraphy at Marconi Wireless Co. School, Montreal,
Que.; various aspects of radio and television broadcasting in
Canada.

Canadian Mothercraft Society.

7P-290 b&w 2. 1963-1965.
Graduating classes of the Canadian Mothercraft Society, Toronto,
Ont.; photos by Bev Best.

Canadian National Exhibition, (f. 1878), Toronto, Ont.

7P-291 b&w 400. 1875-1960.
Buildings, grounds, exhibits and shows of the Canadian National
Exhibition, Toronto, Ont.

Canadian National Railways, (f. 1919), Montreal, Que.

7P-292 total [5,210]. 1860-1964.
Various aspects of operations of Canadian National Railway and
other railways such as the Grand Trunk Railway, the Grand Trunk
Pacific Railway, the Canadian Northern Railway, and the London

and Port Stanley Railway: engines, rolling stock, construction,
accidents, terminals, offices, hotels, personnel; events such as the
Royal Tour of 1939; activities of immigrants brought to Western
Canada by the C.N.R.; individual and group portraits of C.N.R.
officials; view of Wesport, Ont.; grounding of SS *Prince David;*
collision or torpedo damage to various Canadian and American
ships; Sudbury Junction, Ont., 1910; grain elevator, Port Arthur,
Ont., 1912.

Canadian Overseas Telecommunications Corporation, (f. 1949), Montreal,
Que.

7P-293 b&w 3. 1955.
Landing of Trans-Atlantic Telephone Cable from H.M. Telegraph
Ship *Monarch;* submersible vessel *Pisces V.*

Canadian Pacific Airlines, (f. 1942), Vancouver, B.C.

7P-294 b&w 271. 1925-1970.
Various types of aircraft used by Canadian Pacific Airlines and its
predecessors; Mr. G.W.G. McConachie and various senior
executives of Canadian Pacific Airlines.

Canadian Pacific Railway, (f. 1880), Montreal, Que.

7P-295 b&w [3,372]. 1880-1969.
Various aspects of agriculture, lumbering, mining, hydroelectric
power generation, and sports in Canada; events such as the Royal
Tour of 1939; industrial and military activities in Canada during
World War II; portraits of Presidents and Chairmen of Canadian
Pacific Railway.

Canadian Photographers.

327P-4 total 150,000. 1845-1975.
A vast range of subjects throughout Canada - boats, cities, villages,
street scenes, buildings, construction, Eskimos, fishing, Indians,
Klondyke, landscapes, lumbering, railways. Some portraits,
ambrotypes, daguerreotypes, tintypes, paper prints, stereographs.

Canadian Press, (f. 1917), Toronto, Ont.

7P-296 Original, b&w [12,200]. 1970-1973.
National and international events as illustrated in the various
Canadian newspapers using Canadian Press Picture Service.

Canadian Ski Museum, Ottawa, Ont.

7P-297 b&w 145. 1897-1970.
Views of ski resorts across Canada; skiing at Quebec City,
Kingsmere, Camp Fortune, Que.; Ottawa, Ont.; Camrose, Alta.;
Miss Lucile Wheeler winning gold medal in World Cup, Bad
Gastein, Austria, 1958; photos of prominent Canadian skiers such
as Herman "Jack Rabbit" Johanneson, Eddie Condon, Rhoda and
Rhona Wurtele, Lucile Wheeler, Malcolm Hunter, Viscount
Alexander of Tunis, Percy Douglas.

Canadian Soccer Association, Vanier, Ont.

7P-298 b&w 1. 1912.
Delegates attending inaugural meeting of the Dominion of Canada
Football Association, Winnipeg, Man., 9-13 July 1912.

Canadian Society of Microbiologists, (f. 1951).

7P-299 b&w 54. 1952-1963.
Annual meetings of the Canadian Society of Microbiologists;
portraits of various officials and members of the Society.

Canadian Teachers' Federation, (f. 1920).

 7P-300 b&w 544, col. 24, total 568. 1950-1967.
 Annual General Meetings of the Canadian Teachers' Federation, 1958-1961 and 1963-1967.

Canadian Theatre Centre, (1958-1973), Toronto, Ont.

 7P-302 b&w 1,008. 1960-1970.
 'Colloquium '67' theatre conference held during Expo '67, Montreal, Que.; portraits of Canadian actors, actresses, directors and producers.

Canadian Tribune, Toronto, Ont.

 7P-303 b&w 516. 1945-1970.
 Activities of the Labour-Progressive Party of Canada and the Canadian Labour Congress; various demonstrations and strikes; activities of the staff of the Canadian Tribune; portraits of officials and personalities of the Labour-Progressive Party of Canada and the Canadian Labour Congress.

Canadian Vickers Limited, (f. 1911), Montreal, Que.

 7P-304 b&w 795. 1912-1967.
 Interior and exterior views of the plant of Canadian Vickers Limited; industrial activities of Canadian Vickers Limited; construction and repair of warships, merchant ships, and aircraft, and fabrication of various types of heavy machinery and equipment; photos by Hayward Studio and Associated Screens News.

Canadian Water Ski Association, (f. 1950), Vanier, Ont.

 7P-305 b&w 70. 1960-1967.
 Waterskiing competitions sponsored by the Canadian Water Ski Association.

Canadian Women's Press Club, (est. 1907), Winnipeg, Man.

 9P-9 b&w 51. 1906-1960.
 Photographs of Club's activities.

Canadian Writers Foundation Inc., Ottawa, Ont.

 7P-306 b&w 5. 1925-1930.
 Portraits of Sir Charles G.D. Roberts and Mr. Duncan Campbell Scott; photos by Arthur S. Goss and Dupras & Colas.

Cannon, T., Toronto, Ont.

 7P-307 b&w 730. 1895-1920.
 Visits of the aviators Count Jacques de Lesseps and Mr. C.F. Willard to Toronto, Ont.; views of Toronto, Milton, Erindale, Meadowvale, Kingston, Sudbury, Ont.; activites of the SS *Grenfell* in Labrador; sports such as tobogganing, baseball, cricket, lawn bowling, motorcycle racing.

Cantin, Louise, Quebec, Que.

 7P-308 b&w 2. 1904-1923.
 View of church at St. Cyriac, Que.; members of the Emond family at blacksmith shop, St. Cyriac, Que.

Caouette, David-Réal,(1917-1977), Rouyn, Que, politician.

 7P-309 b&w 10. 1950-1965.
 Social Credit party rally in Quebec, 12 May 1956; portraits of M. Réal Caouette and Mr. Robert Thompson.

Card, R.C., Ottawa, Ont., public servant.

 7P-310 b&w 5. 1939.
 Views of Montreal, Que.; St. Jean Baptiste Day Parade, Montreal, Que.

Cariboo Stopping Houses, Wagon Road, (1860-1920), Ashcroft, B.C., Quesnel, B.C., stopping houses.

 228P-4 b&w 10. 1860-1920.
 Cornwalls' Ashcroft Manor, Hat Creek House, Clinton Court House, 51 Mile - Pollards, 108 Mile House, 117 Mile House, 134 Mile Bull Barn, 137 Mile - McCartney's, 141 Mile - Murphy's and First Automobile, 150 Mile Hotel and general view.

Carling, J. Innes, London, Ont.

 7P-311 b&w 3. 1887-1955.
 Sir John Alexander Macdonald with members of the Carling family, Dalhousie, N.B., 1887; photo by J.D. Wallis; unveiling of plaque commemorating Sir John Carling, London, Ont.; taken 1948-1955.

Carroll, E. Gary, Charlottetown, P.E.I., and Vancouver, B.C.

 7P-312 b&w 74. 1860-1941.
 Views of Charlottetown, P.E.I.; Fredericton, N.B.; Fort Garry and Norway House, Man.; Macoun and Outlook, Sask.; Hope, B.C.; ice boats in the straits of Northumberland off Prince Edward Island; portraits of Hon. David Laird and family, and of Rt. Rev. John Medley.

Carson, Percy A., (d. 1945), Ottawa, Ont., public servant, surveyor, lawyer.

 7P-313 b&w 108. 1907-1925.
 Aspects of surveying operations in the Rocky Mountains; portrait of Miss Gertrude Bennett.

Carter, John, (1832-ca. 1917), Toronto, Ont., teacher and organist.

 149P-4 b&w [5]. ca. 1880-1900.
 Photographs of Carter with his family.

Carter, Joseph C., Prof., (ca. 1911), professor (emeritus) of Journalism, Temple University, Philadelphia, Pa.

 337P-2 Original, b&w 4. ca. 1850-1865.
 Photos of: Anne Bell Elliott Truro ca. 1850; Adelaide Elliot, ca. 1860; John and Harriet Elliott, ca. 1853; Harriet Elliott, ca. 1864, probably taken in Saint John, New Brunswick.

Cartier, George-Etienne, Hon. Sir, (1814-1873), Montreal, Que., politician.

 7P-314 b&w 43. 1913-1920.
 Unveiling of monuments commemorating Hon. Sir George-Etienne Cartier, Montreal; St. Antoine-sur-Le Richelieu; Quebec, Que.; photos by Edwards, and British & Colonial Press.

Cartier, Joseph-Louis, Saint-Antoine-sur-Richelieu (Québec).

7P-315 Originaux, n.&b. 198. 1900-1920.
Vues de villes et de villages près de la rivière Richelieu dans la province de Québec: Saint-Ours, Saint-Hyacinthe, Saint-Denis, Saint-Charles-sur-Richelieu, Saint-Marc, Verchères, Saint-Antoine-sur-Richelieu; activités de M. Joseph-Louis Cartier, sa famille et ses amis à Saint-Antoine-sur-Richelieu (Québec).

Cartwright, John Robert, (b. 1895), Ottawa, Ont., judge.

7P-316 b&w 6. 1966-1970.
Mr. Justice J.R. Cartwright and Rt. Hon. L.B. Pearson at Armistice Day ceremony, Ottawa, Ont., 1966; swearing-in of H.E. Daniel Roland Michener as Governor General of Canada, Ottawa, Ont., 1967; photos by The Globe and Mail, Dominion-Wide photos, Murray Mosher/Photo Features.

Carty, Olive E., London, Ont.

7P-317 b&w 13. 1927.
Attempted flight of the Stinson Detroiter aircraft *Sir John Carling* from London, Ont., to London, England, September 1927; portraits of Captain T.B. Tully, Lieutenant J.V. Medcalf, and Mr. A.C. Carty.

Case and Draper, commercial photographers.

7P-319 Original, b&w 1. ca. 1898-1902.
Skagway, Alaska; photo by Case and Draper.

Casgrain, Marie Thérèse (Forget), (b. 1896), Montreal, Que., politician.

7P-318 b&w 425, col. 72, total 497. ca. 1890-1975.
Various activities and portraits of Madame Casgrain, and of the families of Sir Rodolphe Forget and Pierre and Thérèse Casgrain.

Cashman, Caroline, Mrs., (b. 1875), Stellarton, N.S.

31P-37 Original, b&w 16. 1936.
Vimy Ridge, France; battlefields; pilgrimage, Canadian Legion, July, 1936.

Cass, John, Nanaimo, B.C., historian.

12P-11 b&w 157, col. 45, total 202. 1960-1975.
Views of Vancouver Island, Nanaimo and area, Genoa Bay, Newcastle Island, B.C.

Cass, Samuel, (1908-1975), Toronto, Ont., rabbi.

7P-320 b&w 2,931, col. 12, total 2,943. ca. 1930-1969.
Activities of Rabbi Samuel Cass; service in the Canadian Army during World War II; various visits to the Middle East; travels in Canada.

Castonguay, Jules Alexander, (1877-1972), Ottawa, Ont., portrait photographer.

7P-321 Original, b&w 46,291. ca. 1902-1960.
Portraits by J.A. Castonguay of Members of Parliament, Public Officials, businessmen, and private citizens of the National Capital Region.

Catherwood, Frederick J., Ottawa, Ont.

7P-322 Original, []. 1958.
Avro Arrow aircraft 25201 over Niagara Falls, Ont.

Cauchon, Noulan, Ottawa, Ont., town planner.

7P-323 b&w 31. 1927.
Views of Ottawa; North Bay, Ont.; Chicoutimi, Que.

Cavoukian (Cavouk), Artin, Toronto, Ont., portrait photographer.

7P-324 total 23. [n.d.].
Portraits by Cavouk of various heads of state, cabinet ministers, and performing artists: Rt. Hon. Vincent Massey, Rt. Hon. Roland and Mrs. Michener, H.E. Major-General and Mme Georges Vanier, Rt. Hon. Lester B. Pearson, Hon. Mitchell Sharp, Mr. David Ben-Gurion, Mr. Leonid Brezhnev, Mr. Ludwig Erhard, Miss Maureen Forrester, Miss Lois Smith, Dr. Hsieh-Yen Shih, Mr. Harry Somers.

Central Canada Veterinary Association, (f. 1903).

7P-325 Original, . ca. 1895-1900.
Portrait of Dr. A.W. Harris, D.V.S.

Centre Emilie Gamelin, Montréal (Québec).

326P-1 Originaux, []. [n.d.].
Mère Emilie Tavernier-Gamelin (Soeur de la Providence, Montréal (Quebec), fondatrice, les reproductions ont été réalisees, pour un bon nombre, par le photographe Armour Landry, de Montréal.

Century Village Museum, Lang, Ont.

7P-326 b&w 23. ca. 1860-1914.
Views of Keene, Ont.

Challies, John Bow, (b. 1881), Montreal, Que., hydraulic engineer.

7P-327 Original, []. 1921.
Meeting of the Council of the Engineering Institute of Canada, King Edward Hotel, Toronto, Ont., 3 February 1921.

Champagne, Claude, (1891-1965), Paris, France et Montréal (Québec), compositeur et professeur.

149P-5 n.&b. [200]. 1896-1965.
Photographies de Claude Champagne en famille dès son enfance, comme étudiant à Paris et comme professeur et père de famille, surtout au Conservatoire à Montréal et à l'école Vincent d'Indy.

Champagne, Harvey Joseph Moise, Ottawa, Ont.

7P-328 b&w 315, col. 32, total 347. 1860-1940.
Seal hunting off the coasts of British Columbia and Alaska; lumbering operations in British Columbia; flax crushing in Quebec; Haida Indians in British Columbia; Calgary, Alta.; Transcona, Man.; activities of the Beaugrand *dit* Champagne family in Western Canada.

Champlain Studio, New York, N.Y.

7P-329 Original, []. ca. 1922.
Portrait of Hon. W.L. Mackenzie King, New York, N.Y.; photo by Champlain Studio.

Chandler, Albert, (b. 1893), Melfort, Sask.

7P-330 b&w 1. ca. 1914.
Troops of the 53rd Regiment, Sherbrooke, Que.

Chapman, George Arthur Emerson, Maj., (1881-1968), Ottawa, Ont.,
military officer.

7P-331 b&w 4,814. 1900-1936.
Activities and personnel of the 3rd Battalion, East Kent Regiment,
in the South African War; views taken during Major Chapman's
travels in Britain, Europe, North America, and the Middle East;
activities of the Chapman family and friends in and around
Ottawa, Ont.

Chapman, M., Mrs., Ottawa, Ont.

7P-332 b&w 26. 1905.
Inspection of port facilities by Sir MacKenzie Bowell and party,
Montreal, Que.; views of Montreal, Que.; various women's
fashions; portraits of Sir MacKenzie Bowell and Sir George Foster.

Chapman, William, (1850-1917), Québec (Québec) et Ottawa (Ont.),
poète, journaliste et traducteur.

185P-17 n.&b. 53. 1876-1916.
Album de cartes de visite des membres de la famille Angers,
parents de William Chapman du côté de sa mère.

Chapple, F.G., Mrs., Pasadena, Calif.

7P-333 b&w 3. 1916-1919.
Operations of the Canadian Forestry Corps in Britain.

Charbonneau, Blondine, Vankleek Hill (Ont.), institutrice.

185P-8 n.&b. 152. 1940-1950.
Album de photos du personnel et des élèves de l'école
Saint-Gérard à Vankleek Hill (Ont.).

Chard, C.S., (b. ca. 1866), Stirling, Ont., employee of Temiskaming and
Northern Ontario Railway.

7P-334 b&w 6. ca. 1848-1910.
Horse-drawn water tank used to maintain ice surface of log road,
Crooked River, Sask., 1910; portraits of various members of the
Chard family, ca. 1848.

Charlottetown Camera Club, (1964-), Charlottetown, P.E.I.

5P-5 b&w 91. 1967.
Historic buildings of P.E.I.

5P-6 b&w [1,200]. [1930]-1960.
Photos of all aspects of P.E.I. history.

Charlottetown Conference.

7P-335 b&w 1. 1864.
Delegates to Charlottetown Conference outside Province House,
Charlottetown, P.E.I., 1864.

Charlton, John Andrew.

7P-336 b&w 3. 1895.
Lumber camps at Aylen Lake, Ont.

Chergwin, W.L., Sydney Mines, N.S.

1P-62 b&w 7. 1860.
Locomotives built in Sydney Mines, N.S.; shops of the General
Mining Association; portrait of Richard Brown, General Manager,
General Mining Association, 1827-1864; officers and men of
Sydney Mines Volunteer Rifles, 2nd Co., 4th Regiment of Nova
Scotia Militia; monument commemorating the visit of Edward,
Prince of Wales to Sydney Mines, N.S., 1860; artifacts from
fortifications at Sydney and Sydney Mines, N.S.

Chesterfield, A.A., (fl. 1900-1930), Montreal, Que., photographer.

75P-5 b&w [300]. ca. 1900-1935.
Photographs of Hudson Bay and the Ile d'Orléans.

Chesterton, Lillian, Ottawa, Ont.

7P-337 b&w 1. n.d.
Portrait of Miss Lillian Chesterton.

Chevrier, Lionel, (b. 1903), Cornwall, Ont., politician and lawyer.

7P-338 b&w 41. 1948-1958.
Aspects of the political career of Hon. Lionel Chevrier, M.P.,
Minister of Transport, 1945-54; president, St. Lawrence Seaway
Authority, 1954-1957; photos by Ashley and Crippen, Capital
Press, J.N. Goudreault, Hamilton Spectator, P.A. Reuter.

Chiel, Arthur A., (b. 1920), Winnipeg, Man., and New Haven, Conn.,
rabbi.

7P-339 b&w 10. ca. 1890-1930.
Portraits of Jewish residents of Hoffer, Sask.

Chien D'or, le.

7P-340 b&w 1. ca. 1860.
"Le Chien D'Or" plaque above entrance to the Post Office,
Quebec, C.E.

Chipman, Kenneth Gordon, (1884-1974), Ottawa, Ont., geologist.

7P-341 b&w [584]. 1913-1918.
Activities and personnel of the Canadian Arctic Expedition.

Chisamore, Lloyd, Ottawa, Ont., public servant.

7P-342 b&w 1. [n.d.].
Sod house in Saskatchewan.

Chisholm, George Brock, (1896-1971), Victoria, B.C., psychiatrist.

7P-343 b&w 1. 1948-1953.
Portrait of Dr. Brock Chisholm during his term of office as
Director-General of the World Health Organization, Geneva,
Switzerland; photo by Urs G. Arni.

Christensen, J., Ottawa, Ont.

7P-344 b&w 1. 1869,.
Portrait of H.R.H. Prince Arthur.

Christian, J.H. Mrs., Halifax, N.S.

1P-31 Original, b&w 16. 1914-1939.
Sealing disaster, Apr. 1, 1914 in which the SS *Newfoundland* lost 77 men on the ice in a snowstorm; Moose River, N.S., mine disaster, 1936; Queen Hotel, Halifax, after the fire which destroyed it, Mar. 2, 1939.

Christie, Duncan H.

7P-345 b&w 733. 1920-1930.
Buffalo drive from Wainwright, Alta., to Wood Buffalo National Park; oil wells in Alberta; riverboats in Alberta.

Christie, M.

334P-36 Copies, b&w 3. 1915-ca. 1923.
Family at local beach; power launch; automobile.

Chuchla, Walter F., (b. 1904), Calgary, Alta., miner and community leader.

7P-346 b&w 18. 1910-1974.
Activities of Polish immigrants in Alberta; unveiling of plaque commemorating Nicholas Copernicus, Calgary, Alta.; portraits of Mr. Walter Chuchla and the Copernicus Committee.

Church, Thomas Langton, (1870-1950), Toronto, Ont., lawyer and politician.

18P-43 Original, b&w 101. 1914-ca. 1920.
Official civic events during Church's period in office as controller, and later mayor.

Church family, Big Creek, B.C., ranchers.

12P-6 b&w 66. 1910-1930.
Church family and friends in Big Creek community; views of ranch and ranching activities.

Churchill, Gordon M., (b. 1898), Winnipeg, Man., politician.

7P-347 b&w 183. 1952-1963.
Aspects of the political career of Hon. Gordon Churchill, M.P., Minister of Trade and Commerce, 1957-1960; Minister of Veterans' Affairs, 1960-1963; Minister of National Defence, 1963; photos by Abbass Studio, Capital Press, Department of National Defence, Fednews, Shedden.

City of Toronto Architect's Department, Toronto, Ont.

140P-1 b&w [1225]. 1912-1942.
Developments in the construction of public buildings in the City of Toronto as well as their renovation and repair; these photographs include firehalls, police stations, Civic Abattoir, theatres, Canadian National Exhibition, re-roofing of the Old City Hall (1920-1921), park shelters, hospitals, Colborne Lodge, North Toronto Town Hall, demolition of St. Andrew's Market, the Sir Adam Beck monument, the St. Lawrence Market, etc.; after-effects of fires in various buildings.

City of Toronto Assessment Department, Toronto, Ont.

140P-2 b&w [1,125]. 1911-1946.
The work of the department and includes frontal views of various residences and commercial buildings in the City.

City of Toronto Assessment Department, Real Estate Branch, Toronto, Ont.

140P-7 b&w [50]. 1919.
Frontal views of office buildings, banks, theatres, hotels, apartment buildings, etc. throughout the City.

City of Toronto Buildings Department, Housing Section, Toronto, Ont.

140P-3 b&w 1,030. 1935-1946.
Houses slated for demolition, interiors showing plumbing problems, houses in generally poor condition and photographs of houses before and after renovation.

City of Toronto City Engineer's Department, Toronto, Ont.

140P-9 b&w 555. 1893-1906.
Various projects undertaken by the Department including: paving roads, laying streetcar tracks, construction and repair of bridges, subways, sewers, etc.; also includes general views of Ashbridge's Bay, Toronto Islands, St. Lawrence Market and Old City Hall; photos by Bruce and Micklethwaite.
Provenance: Public Archives of Canada houses copy negatives.

City of Toronto Department of Public Health, Toronto, Ont.

140P-4 b&w [880]. 1911-1946.
Various activities of the Health Department including interiors and exteriors of slum housing, infant and baby clinics, dispensaries, infants available for adoption, school milk programmes.

City of Toronto Department of Public Works, Toronto, Ont.

140P-11 b&w [12,500]. 1909-1949.
Works Department projects such as street gradings, bridge and subway construction, street widenings, civic car line construction, road maintenance, sewer construction, etc.; includes construction of Bloor Street Viaduct (1912), photographs of the Eastern Beaches (1929-1935), Toronto Islands (1913-1932) and garbage disposal (1909-1915); this collection also includes the J.V. Salmon Collection; most of the 2,250 negatives in the Salmon Collection were extracted by him from the Engineer's Department photographs and catalogued by subject; photos by Arthur S. Goss.

City of Toronto Department of Public Works, Miscellaneous Photographs, Toronto, Ont.

140P-12 b&w 436. 1900-1944.
Records of Civic Receptions, welcomes, etc., including returning troops, receptions for Royalty, Orange Day parades and City Hall decorations; photos Arthur S. Goss.

City of Toronto Department of Public Works, Portraits, Toronto, Ont.

140P-13 b&w [400]. 1911-1920.
Portraits of Civic Officials and distinguished visitors to the City; photos Arthur S. Goss.

City of Toronto Mayors, Toronto, Ont.

140P-10 b&w 56. 1934-1977.
Photographic images of each of the City's 56 Mayors; some are original photographs, others reproductions from lithographs, paintings or drawings.

City of Toronto Parks Department, Toronto, Ont.

140P-5 b&w [1,600]. 1913-1945.
Activities of the Parks Department including photographs of general views of City parks, close-ups of park comfort stations,

City of Toronto Parks Department, Toronto, Ont.
(Cont'd/Suite)

playground activities, sports teams and supervisors; also includes photographs of Fort York restoration (1932-1934), Toronto Island, Grange Park and Colborne Lodge; photos by Arthur S. Goss.

City of Toronto Planning Board, Toronto, Ont.

140P-18 b&w 185. 1958-1964.
Sites within the City involved in possible applications for changes in land use.

City of Toronto Property Department, Toronto, Ont.

140P-6 b&w [250]. 1911-1945.
Buildings maintained by the Department including firehalls, police stations, stables, public baths, Civic Abattoir, St. Lawrence Market, Sunnyside Beach and wartime housing units; photos by Arthur S. Goss.

City of Toronto Street Cleaning Department, Toronto, Ont.

140P-8 b&w [500]. 1913-1949.
Departmental activities such as incinerators, street cleaning and garbage collection vehicles, City dumps, etc.; also includes interiors of the Department offices.

City of Toronto Water Works, Toronto, Ont.

140P-14 b&w [3,000]. 1875-1946.
Photographs documenting activities of the Department including the High Level Pumping Station, Main Pumping Station, Island Filtration Plant, St. Clair Reservoir, Woodbine Avenue Sewage Plant and the Water Works Tunnel; some photos by Arthur S. Goss.

Clare, F.A., (ca. 1880-1966), presbyterian minister.

9P-10 b&w 8. 1897-1906.
Student organizations and sport teams, University of Manitoba, Winnipeg, Man.

Clark, Cecil, Victoria, B.C., journalist.

12P-9 b&w [300]. 1870-1970.
B.C. history; city of Victoria, including buildings, citizens, streets and views; photographs used to accompany historical articles in local newspapers.

Clark, Charles, Morden, N.S.

1P-8 b&w 17. ca. 1900.
Views of Morden, King's Co., N.S.; photos by Charles Clark.

Clark, Lily, Ottawa, Ont.

7P-348 b&w 1. ca. 1840-1955.
Portrait of Hon. Thomas McKay, Ottawa, C.W.

Clarke, Borden, Morrisburg, Ont., antiquarian bookseller.

7P-349 b&w 21. 1898.
Activities of Blackfoot and Cree Indians along the line of the Canadian Pacific Railway in Western Canada; views of the Klondike Gold Rush.

Clarke, Katharine, Toronto, Ont.

7P-350 b&w 1. ca. 1894.
Mrs. Archibald Lampman with her children Natalie and Archibald.

Clarke, Roger F., Vineland Station, Ont., land surveyor.

7P-351 b&w 48. 1912-1913.
Views of Northern Manitoba taken by the party of Mr. O. Rolfson, D.L.S., Topographical Surveys Branch, Department of the Interior.

Claxton, Brooke, (1898-1960), Ottawa, Ont., politician and lawyer.

7P-352 b&w [6,600]. 1898-1958.
Childhood, schooling, military service, and political career of Hon. Brooke Claxton, M.P., Minister of National Health and Welfare, 1944-1946; Minister of National Defence, 1946-1954.

Clay, Charles, (b. 1906), Bewdley, Ont., author.

7P-353 Original, []. 1940-1967.
Window display for Canada Book Week, 1940; reception by Canadian Authors Association for H.E. Earl Alexander of Tunis, Toronto, Ont., 29 June 1946; various aspects of firefighting in Canada, 1949-1963; views of Fredericton, N.B., Grand Manan Island, N.B., Upper Canada Village, Ont., Tobermory, Ont.; Executive Committee, League of Nations Society of Canada, Ottawa, Ont.; portraits of Messrs. W.D. Jones, Roderick Kennedy; photos by T.C. Hodgson, Joe Stone and Son.

Clay, Rush, Unity, Sask.

7P-354 b&w 1. 1910.
Mr. Rush Clay and his father-in-law scraping buffalo horns, Unity, Sask.

Clearihue, J.B., Victoria, B.C., judge.

12P-27 b&w 32. 1891-1916.
Clearihue family portraits; Victoria Boys Central School, ca. 1898; Victoria, 1916 snow storm; Players Club, Victoria College, 1904.

Clearihue, Joyce, Victoria, B.C.

7P-355 b&w 4. 1898.
Pack Train of Mr. J. Clearihue at Glenora, B.C., en route to Dawson, Yukon; views of Glenora, B.C.

Clementt, Amelia, Brentwood Bay, B.C.

7P-356 b&w 2. ca. 1915-1917.
Portraits of Lieutenant Robert G. Combe, V.C., 27th Canadian Infantry Battalion.

Clercs de Saint-Viateur, Province de Montréal - Archives, (f. 1847), Montréal (Québec).

208P-1 n.&b. [plus de 5,000]. 1850 à nos jours.
Clercs de Saint-Viateur, et autres personnes; aussi, collection de cartes mortuaires comportant photos; religieux, élèves, paroissiens; écoles, institutions dirigées par les clercs de Saint-Viateur; albums classés, relatifs aux endroits, et albums «historiques»; un daguerréotype (portrait d'un religieux, vers 1852, Chambly); quelques ferrotypes et ambrotypes.
Ref./Réf.: Fiches des noms des individus.

Clercs de Saint-Viateur de Montréal, Montréal (Québec).

7P-357 n.&b. 172. ca. 1890-1920.
Portraits, sur papier et sur zinc, de personnes inconnues.

Clerihue.

334P-37 Copies, b&w 3. 1908.
Masonic funeral procession for J.T. Scott.

Cléroux, Alexina, Casselman (Ont.).

185P-12 Copies, n.&b. 5. 1905-1941.
Photographies des cultivateurs à Casselman (Ont.); de la salle à manger d'un camp forestier à Sturgeon Falls (Ont.) et des prospecteurs devant leur camp à Porcupine (Ont.).

Cleverdon, Catherine L., Bronxville, N.Y., author.

7P-358 b&w 4. [n.d.].
Portraits of Marie-Thérèse Forget-Casgrain, Carrie M. Derick, Frank Hatheway, Idola Saint Jean used in Dr. Cleverdon's book *The Woman Suffrage Movement in Canada*.

Clifford, Theodore A., Mrs., Bethel, Vt.

31P-21 Copies, b&w 1. ca. 1885.
Nova Scotia militiamen.
Provenance: Mrs. T. Clifford, Bethel, Vt.

Clougher, Nugent M.

7P-359 b&w [3,000]. 1900-1946.
Various aspects of agriculture, lumbering, industrial activity, rail transportation, winter sports in Canada; views of various places in British Columbia, Alberta, Saskatchewan, Manitoba, Ontario, Quebec, Northwest Territories; portraits of the Clougher family.

Coates, David Mervin, Waterloo, Ont.

7P-360 b&w 2. ca. 1941-1945.
Portraits of Flight-Sergeant D.M. Coates, G.M., R.C.A.F.

Coates, E.E., Nappan Station, N.S., farmer,.

1P-64 Original, b&w 3. ca. 1910, 1966.
Coal mines at Chignecto, N.S.; gravestones of Amos Seaman and his family at Minudie, N.S.

Coatsworth, Emerson, (1854-1943), Toronto, Ont., lawyer, politician and judge.

18P-59 Original, b&w 4. 1906-1907.
Official appearances as mayor of Toronto.

Coburn, C.C., Mrs., Ottawa, Ont.

7P-361 b&w 8. 1923-1934.
Photographs of Lionel Hitchman; group photograph of the Boston Bruins Hockey Club of 1933-1934.

Cockburn, W.H., Winnipeg, Man.

9P-77 b&w 13. 1919-1932.
Hockey, baseball and rugby teams in Winnipeg, Man.

Coderre, Joan E., Ottawa, Ont.

7P-362 b&w 58. ca. 1880-1910.
Personnel and equipment of the Bell Telephone Company; views of Coteau-du-Lac, Coteau-Landing, Laprairie, Berthierville, Rivière-Rouge, Saint-Zotique, Que., Palmerston, Penetanguishene, Ont.; photographs of the Fowler and Coderre families.

Cody, H.J., Mrs., Toronto, Ont.

7P-363 b&w 13. 1918.
Photographs of the Maple Leaf Club financed by the Province of Ontario, London, England, 1918; photos by W. and D. Donney.

Cody, Henry J., Toronto, Ont.

196P-8 b&w 23. 1889-1945.
Portraits of H.J. Cody; University of Toronto, Class of 1889 Arts; Wycliffe College, Graduating Class 1893; University College Alumni Association 1948; Ontario Agricultural College, 1st Graduating Class, 1945; miscellaneous.

Cogswell, A.R., Halifax, N.S., photographer.

7P-364 b&w 1. ca. 1890-1930.
View of Herring Cove, N.S.; photo by A.R. Cogswell.

Cohen, Horace and Lyon, Montreal, Que.

7P-365 b&w 23. 1915-1967.
Activities of Messrs. Horace and Lyon Cohen, leaders in the Jewish Community in Montreal, Que.

Colchester Historical Society, Truro, N.S.

31P-106 Copies, b&w 11. ca. 1880-1900.
N.S. vessels.

Coldwell, Major James William, (1888-1974), teacher and politician.

7P-366 b&w 25. 1928-1944.
Group photographs of City Council, Regina, Sask., 1928-1932; Rt. Hon. Winston Churchill addressing joint session of Parliament, Ottawa, Ont., December 1941; portraits of Messrs. M.J.W. Coldwell and Angus McInnis.

Cole, Jean, Peterborough, Ont.

7P-367 b&w 8. ca. 1850-1959.
Views of Glencoe Cottage, St. Andrews East, Que., and Spokane House, Wash.; photographs of various members of the family of Chief Factor Archibald McDonald of the Hudson's Bay Company.

Colebrook, F.H., Mrs., Victoria, B.C.

7P-368 b&w 2. ca. 1915-1917.
Graves of officers of the Kootenay Battalion, Villers-Au-Bois, France.

Collier, F.C., Ottawa, Ont.

7P-369 b&w 1. ca. 1888.
Portrait of the Hon. Sir Charles Tupper, C.B., K.C.M.G., G.C.M.G.

Colombie-Britannique, Archives provinciales, (f. 1893), Victoria (C.-B.).

7P-371 n.&b. 75. 1850-1880, 1966.
Première; assemblée législative en Colombie-Britannique après la Confédération; garde d'honneur lors de l'ouverture du Conseil législatif, 1870; vues de Victoria, Vancouver, San Juan Islands, Nanaimo, New Westminster, Yale, Lytton, Clinton, Barkerville, Quesnel; photo de groupe de l'Assemblée législative de la Colombie-Britannique, 1875.

Colombie-Britannique, Yukon, Alaska - Autoroute.

7P-370 n.&b. 25. ca. 1898-1943.
Le Nugget Express à son arrivée à Dawson (Yukon); vues de Nahlin (C.-B.); Telegraph Creek (C.-B.); Finlay River (C.-B.); Fox River (C.-B.); Whitehorse (Yukon); Five Finger Rapid (Yukon).

Columbia River Valley.

7P-372 b&w 120. 1937.
Aerial views of the upper Columbia River valley taken by the 91st Observation Squadron, U.S.A.A.C., August 1937.

Columbian (newspaper), (1861-), Coquitlam, B.C.

334P-28 Copies, b&w 185. 1960-1974.
New Westminster scenes: historic houses, schools, churches, theatres, parks, etc.; events: fires, sports, May Day, demolitions, etc.; industrial buildings: breweries, sawmills, canneries.

Colwell, Wayne, Ottawa, Ont.

7P-373 b&w 6. 1908.
Tercentenary celebrations at Quebec, Que.

Comer, George.

7P-374 b&w 18. ca. 1900-1905.
Crew of the whaling schooner *Era,* New Bedford, Mass.; portrait of Mr. Charles T. Luce.

Cominco Ltd., Vancouver, B.C.

7P-375 b&w 165. ca. 1928-1939.
Mineral exploration and mine sites at various locations in Ontario, Quebec, New Brunswick, Newfoundland and Labrador.

Comité de la Grande Fête de Hull, (1975), Hull, Que.

7P-376 b&w 49. ca. 1900-1945.
Views and activities in and around Hull, Que.; photos gathered by Le Comité de la Grande Fête de Hull to mark the 175th anniversary of the founding of the city.

Commercial and Press Photographers Association of Canada, Toronto, Ont.

7P-377 b&w 710, col. 2, total 712. 1954-1956.
Photographs used in the Association's publication *Cappac News* during the editorship of Mr. Eric Trussler.

Commission Canadienne du Transport, Ottawa (Ont.).

7P-1894 n.&b. [210]. 1934-1935.
Vues de diverses communautés sur les côtes de la Colombie-Britannique, du Québec et des Provinces Maritimes desservies par des navires à vapeur et des vaisseaux subventionnés par le gouvernement fédéral; portraits individuels des membres de la Commission.

Commission des Chemins de Fer.

7P-148 n.&b. 31. 1936.
Vues de Rexford (Mont.); ligne de chemin de fer, Fernie (C.-B.).

Commissioner of National Parks for Canada, Ottawa, Ont.

1P-6 b&w 97. 1934.
Album of photographs compiled by R.W. Cautley illustrating a report to the Commissioner of National Parks on an examination of sites for a proposed National Park in Nova Scotia, 1934; views of Blomidon, Cape Split, Lunenburg, Yarmouth Co., Cape Breton Island, N.S., and New Brunswick.

Commonwealth War Graves Commission, Ottawa, Ont.

7P-378 b&w 27. ca. 1920-1930.
Views of various military cemeteries and memorials in France and Belgium.

Compagnie d'assurance-vie Métropolitaine, Ottawa (Ont.).

7P-379 n.&b. 15. ca. 1897-1944.
Aciérie, Hamilton (Ont.), 1897; compagnie de la Dominion Iron & Steel Co., Sydney (N.-E.), ca. 1900; activités de la Croix-Rouge canadienne, 1942-1944.

Company of Young Canadians, Ottawa, Ont.

7P-1900 b&w 134. ca. 1960-1970.
Activities, staff and offices of the Company of Young Canadians, Vancouver, B.C., Calgary, Alta., Toronto, Ont., Cape Breton Island, N.S.; some photos by Pamela Harris-McLeod.

Conférence de Bruxelles de 1920, Bruxelles, Belgique.

7P-380 n.&b. 26. 1920.
Délégués à la Conférence de Bruxelles de 1920, Belgique.

Congrégation des Filles de la Charité du Sacré-Coeur de Jésus, (1905), Sherbrooke (Québec), communauté religieuse.

329P-1 n.&b. 4,278, coul. 806, total 5,084. 1823-1977.
Photos d'individus, de groupes communautaires, scolaires, hospitaliers, familiaux, de visiteurs, d'édifices: intérieur et extérieur, et de sites divers, provenant du Canada, des Etats-Unis, de France, de l'Afrique du Sud, du Brésil, de Tahiti.

Congrégation des Soeurs des Saints Noms de Jésus et de Marie, (f. 1843), Outremont (Québec), éducation.

325P-1 total [5,000]. 1843 à nos jours.
Religieuses, couvents de l'Institut, maisons d'enseignement, élèves, professeurs, missions lointaines: Afrique, Japon, Etats-Unis, Brésil; événements divers.

Conklin, Maurice, Ottawa, Ont.

7P-381 b&w 6. 1902-1911.
Group photograph of girls' basketball team of Orangeville High School, Orangeville, Ont., 1902; Girls' Hockey team of Victoria College, Toronto, Ont., ca. 1908; snowshoeing in Toronto, Ont., 1909; university students aboard SS *Keewatin,* ca. 1911.

Connolly, Earl, Mrs., Halifax, N.S.

> 1P-65　Original, b&w 4. ca. 1880-1888.
> Exhibition grounds, Halifax, N.S.; Mayflower No. 5 Division,
> Halifax Volunteer Fire Department; fire engine "Perserverance" of
> the Halifax Fire Department; unidentified Victorian drawing room.

Connor, Harry, (b. 1904), Ottawa, Ont., hockey player.

> 7P-382　b&w 1. 1929.
> Group photograph of members of the New York American Hockey
> Club of 1928-1929.

Connor, W.M., Manotick, Ont.

> 7P-383　b&w 31. ca. 1870-1900.
> Views of the factory of Connor Washing Machine Company;
> portraits of James Henry Connor and family.

Connors, Thomas, Halifax, N.S.

> 1P-32　Original, b&w [700]. 1871 - ca. 1946.
> Sports in Nova Scotia, including basketball, baseball, boxing,
> hockey, rowing, track and field and tug of war mainly team
> photographs; various views of Halifax including buildings, street
> scenes and parades.

Conseil intermunicipal des loisirs du Témiscouata, Notre-Dame-du-Lac
(Québec).

> 343P-1　total []. [n.d.].
> La région du Grand-Portage avec une préséance sur les 14
> municipalités du Conseil; section 1: vues d'ensemble et
> panoramiques; section 2: institutions et services publics; section 3:
> restauration et hébergement; section 4: socio-économie (agriculture,
> industrie, commerce, transport); section 5: équipements récréatifs;
> section 6: activités récréatives et manifestations; section 7:
> éducation; section 8: patrimoine.

Conseil national de recherches, Direction de l'information publique (DIP),
divisions du CNRC, (1916-), Ottawa (Ont.), recherche scientifique.

> 332P-1　total [50,000]. 1916-.
> Photographies diverses de 1916 jusqu'à présent; photographies sur
> la recherche en général dans les domaines de la chimie, de la
> physique, du génie électrique, du génie mécanique, de
> l'aéronautique, des sciences biologiques, de l'astrophysique;
> portraits d'anciens membres de la direction du CNRC, de
> chercheurs, de scientifiques invités, photographies de différentes
> étapes de construction de diverses installations du CNRC.
> Provenance: Direction de l'information publique et divisions du
> CNRC.

Constantine, Charles Francis, (1883-1953), Toronto, Ont., military officer.

> 7P-384　b&w 1. 1885.
> Group at the N.W.M.P. Barracks, Regina, N.W.T., 1885; Riel
> Rebellion, 1885; Horse Child, son of Big Bear; Big Bear, Cree
> Chief; Mr. A.D. Stewart; Poundmaker, Cree Chief; Constable
> Black; Rev. Louis Cochin; Capt. Burton Deane; Rev. Alexis André;
> Beverley Robertson; photo by Prof. O.B. Buell.

Constantine, Henrietta.

> 7P-385　b&w 6. 1906-1907.
> Views of the Peace River and Lesser Slave Lake districts of
> Alberta, 1906-1907; photos by Henrietta Constantine.

Contant, Alexis, (1858-1918), Montréal (Québec), compositeur.

> 149P-6　n.&b. [10]. ca. 1890-1918.
> Photographies surtout de Contant dirigeant ces propres oeuvres.

Cook, George Douglas, Fort Lauderdale, Fla.

> 7P-386　b&w 1. 1941-1945.
> Portrait of Lieutenant-Commander G.D. Cook, G.M. and Bar,
> R.C.N.V.R.

Cook, Sidney Jabez, (b. 1889), Ottawa, Ont., economic chemist.

> 7P-387　b&w 4. 1933-1946.
> Delegates to the Fifth Pacific Science Congress, Victoria-Vancouver,
> B.C., 1933; members of the Associate Committee on Army Medical
> Research 1942-1946; portrait of Dr. H.M. Tory.

Cook, Terry, Ottawa, Ont., archivist.

> 7P-388　b&w 5. ca. 1900.
> Views of Goring-on-Thames, Oxfordshire, England.

Cooksley, William T., New Westminster, B.C., journalist and photographer.

> 334P-7　b&w 1. 1905.
> Knights of Pythias: group photo.

Coombs, Douglas, Toronto, Ont.

> 7P-389　b&w 12. ca. 1920.
> Aspects of the life of the late David E. Hornell, V.C., R.C.A.F.

Cooper, Richard J.G., Ottawa, Ont.

> 7P-390　b&w 14. ca. 1900.
> Views of Ottawa, Ont., and Diamond City, Alta.

Cooperative Commonwealth Federation, (1932-1960), political party.

> 7P-391　Original, []. ca. 1932-1958.
> Aspects of the Depression in Canada; members of the C.C.F.
> Parliamentary Group, Ottawa, Ont., 1942; members of the C.C.F.
> delegation to the Commonwealth Labour Parties Conference of
> 1944; Mr. David Lewis addressing meeting in Winnipeg, Man.,
> 1945; aspects of the C.C.F. Convention, Montreal, Que., 1958;
> portraits of C.C.F.; members of the Legislative Assembly of
> Saskatchewan, 1934-1938; portraits of Mr. M.J.W. Coldwell;
> photos by Karsh, Majorie Davison, National Film Board, Photo
> Illustrations of Canada.

Copland, A.D., Ottawa, Ont.

> 7P-392　b&w 5. [n.d.].
> Personnel of the R.N.W.M.P. detachment, Cape Fullerton, N.W.T.;
> skulls of members of the Franklin Expedition, King William Island,
> N.W.T.

Corless, C.V., Tillsonburg, Ont., mining and metallurgical engineer.

> 7P-393　b&w 1. [n.d.].
> Portrait of Dr. C.V. Corless.

Cornell, Margaret, Toronto, Ont.

196P-43 b&w 1. 1913.
University of Toronto graduating class in Arts (University College) 1913.

Cornell University Archives, Ithaca, N.Y.

7P-394 b&w 1. 1922.
Salmon caught on the Cascapedia River, Que., 27 June 1922.

Corston, James, Dr., (1879-1963), Halifax, N.S., medical doctor.

31P-23 Original, b&w 2. [n.d.].
Portraits of Dr. J. Corston.

Côté, J.G., Montreal, Que.

7P-396 b&w 5. 1864-1952.
Members of the International Boundary Commission, ca. 1894; reception for Lord Strathcona, Edmonton, Alta., 7 September 1909; photo by Ernest Brown; members of the family of Charles E. Gagnon, Louiseville, Que., ca. 1864; strikers from relief camps in British Columbia en route to Ottawa, Regina, Sask., 1935; explosions at Port Arthur, Ont., 1945 and 1952.

Côté, Mme Ernest A., Ottawa, Ont.

7P-395 b&w 5. 1879-1905.
Individual and group portraits by Livernois Ltd., Quebec, Que.

Cottingham, William McOuat, Hon., (b. 1905), Lachute, Que., legislator.

7P-397 b&w 1,764, col. 129, total 1,893. 1901, 1954-1960.
Activities of Hon. W.M. Cottingham, Minister of Mines; province of Quebec, 1954-1960; views of Lachute, Que.; Sorel, Que.

Cotton, E.

334P-38 Copies, b&w 2. 1907.
General view of New Westminster; portrait of early "native son", Mr. Macdonald.

Cotton, William Henry, (1848-1914), military officer.

7P-398 b&w 2. ca. 1870-1880.
Views of Kingston, Ont.

Couchman, Arthur, Ottawa, Ont., singer.

7P-399 b&w 15. ca. 1940-1954.
Personnel of the 3rd Field Company, R.C.E., Petawawa, Ont., 1940; productions such as *Faust* staged by the Ottawa Grand Opera Company, Ottawa, Ont., 1946-1954; portraits of Mr. Arthur Couchman.

Coughlin, Mary, Ottawa, Ont., public servant.

7P-400 col. 1. ca. 1910.
View of Bank Street, Ottawa, Ont.

Coulombe, Danielle, Hearst (Ont.).

185P-11 Copies, n.&b. 11. 1930-1950.
Photographies illustrant la vie économique des canadiens-français de Hearst; conditions de vie à l'époque de la colonisation; coupe et transport du bois; agriculture.

Courtois, Joseph, Rev., Caraquet, N.B., priest.

46P-5 b&w 400. 1900-1905.
Views, activities, staff and student portraits of the Eudiste Fathers' College at Caraquet; scenic views of the area, sports and outdoor activities; commerical fishing, lumbering, carrying trade and wharfside activities.

Coutlee, Charles R., Ottawa, Ont., public servant.

7P-401 b&w 1. [n.d.].
View of Reversing Falls, Saint John, N.B.

Covert, Earl, Hay River, N.W.T.

7P-402 b&w 3. 1928.
Arrival of first airmail flight, Fort Simpson, N.W.T., 1928; view of SS *Distributor.*

Cowan, E.M., Mrs., Ottawa, Ont.

7P-403 b&w 11. ca. 1914-1918.
Activities of the 66th Battery, Canadian Field Artillery.

Cowan, George Hoyle, Toronto, Ont.

196P-4 b&w 1. 1870-1871.
Toronto School of Medicine, Graduating Class 1870-1871.

Cowan, James A., Gravenhurst, Ont.

7P-404 b&w 130. 1937.
Visit of Lord Tweedsmuir and party to the uranium mine of Eldorado Mining and Refining Ltd., Port Radium, N.W.T.; banquet honouring major figures in the Canadian uranium refining program, Ottawa, Ont.; photos by Associated Screen News and Alexandra Studio.

Coward, Elizabeth (Ruggles), (1887-1959), Bridgetown, N.S., local historian.

1P-11 Original, b&w [160]. ca. 1870-1958.
Album of Bridgetown, N.S. individual portraits, group photographs, houses, hotels, churches, schools, stores, mills, factories, shipping, other forms of transportation, street scenes; majority of photographs by Elizabeth Ruggles Coward.

Cowell, John, (ca. 1881-), Flee Island, Man., farmer.

9P-11 b&w 90. 1886-1943.
Farm scenes and activities near Portage la Prairie, Man.

Cowley, F.P.V.

9P-12 b&w 31. ca. 1869-1935.
Early churches and religious figures in Manitoba.

Cox, Dorothy Gordon, Victoria, B.C., producer.

1P-66 b&w 29. ca. 1875-1900, ca. 1930.
Portraits of various individuals.

Cox, Dudley, St. John's, Nfld., stage director.

38P-2 b&w 22. 1914-1918.
Photographs of Newfoundland soldiers in training and in action during W.W.I.

Craib, Peter, Woodbridge, Ont.

 7P-405 b&w 2. ca. 1919-1925.
 Curtiss JN4 (Can) aircraft.

Craick, W.A., Toronto, Ont.

 1P-67 b&w 10. ca. 1870-1925.
 Uniacke House, Mount Uniacke, N.S.; portraits of the Uniacke
 family; photographers: Notman, Gauvin and Gentzell.

Crain, Harold F., Ottawa, Ont., business executive.

 7P-406 col. 5. ca. 1898.
 Aspects of the Klondike Gold Rush.

Craswell, O.C., (fl. 1924-1942), Charlottetown, P.E.I., photographer.

 5P-7 b&w [15,000]. 1924-1942.
 Portraits, group and individual.

Craven Foundation, Toronto, Ont.

 7P-407 b&w 183. 1972-1975.
 Interior and exterior views of the Craven Foundation Museum and
 Restoration Centre, Toronto, Ont.; views of individual vintage
 North American and European automobiles preserved in the
 Museum.

Crawford, Isabella Valancy, (1850-1887), Toronto, Ont., poet.

 7P-408 b&w 2. ca. 1870-1887.
 Portrait of Isabella Valancy Crawford.

Crawley Film Ltd., Ottawa, Ont.

 7P-409 b&w 35. ca. 1898.
 Aspects of the Klondike Gold Rush in British Columbia, Alaska,
 and the Yukon Territory.

Creighton family, (fl. 1820-1977), Dartmouth, N.S.

 31P-11 Copies, b&w 1. ca. 1850.
 Portrait of Thomas Colton Creighton.

Crerar, Henry Duncan Graham, (1888-1965), army officer.

 7P-410 b&w 203. 1908-1960.
 Entry of the Canadian Corps into Namur, Belgium, 1918; activities
 of General Crerar as General Officer Commanding 1st Canadian
 Army in Britain and Northwest Europe during World War Two.

Creston Valley Archives, Creston, B.C.

 7P-411 b&w 1. 1909-1910.
 Composite photograph of students of the Normal School, Ottawa,
 Ont., 1909-1910; photo by the Pittaway Studio.

Crocker, Ernest, (1877-1968), Victoria, B.C., photographer.

 9P-13 b&w 309. 1900-1910.
 Photographs of Winnipeg, Man.

Cropp, Marjorie E., Beachville, Ont.

 7P-412 b&w 4. 1860-1875.
 Portraits of Mr. Henry Vansittart Jr., Rev. William Bettridge, Dr.
 Levi Hoyt Perry and R.A. Fife.

Crosby, R.T., Mrs., West Vancouver, B.C.

 7P-413 b&w 12. 1861-1919.
 View of 70 Mile House on the Cariboo Trail, B.C., 1861; first
 automobile on the Cariboo Road, Clinton, B.C., 1907; express
 stagecoaches on the Cariboo Road, B.C., 1910-1916; Curtiss JN4
 (Can) aircraft, Clinton, B.C., 1919.

Crossley, H.N., Toronto, Ont.

 7P-414 col. 9. ca. 1968.
 Various residences of Sir John A. Macdonald, Kingston, Toronto,
 and Ottawa, Ont.

Croton Studio, (ca. 1947-), Burnaby, B.C., photographers.

 334P-3 Copies, b&w 23. ca. 1950-ca. 1960.
 Queensborough Bridge - construction and completed aerial views;
 New Westminster Public Buildings, churches, waterfront, park; May
 Day celebrations.

Cruickshank, Ernest Alexander, (1853-1939), Ottawa, Ont., military officer.

 7P-415 b&w 8. 1900-1917.
 Views of Sarcee Camp, Alta., ca. 1900-1914; photos by Matt Park,
 Calgary; portrait of Brigadier-General E.A. Cruickshank, Calgary,
 Alta., ca. 1915-1917; photo by A.L. Hess.

Cruickshank, Gwen, Leicester, England.

 7P-416 b&w 1. ca. 1918.
 Portrait of Private R.E. Cruickshank, V.C.

Cryderman, Raymond L., Edmonton, Alta.

 7P-417 b&w 7. 1944-1947.
 Consolidated Liberator V, VI, and VIII aircraft of No. 5 O.T.U.,
 No. 168 (HT) Squadron, and Northwest Air Command, R.C.A.F.

Cumberland County Council, Cumberland Co., N.S.

 31P-44 Original, b&w 1. 1949.
 County councillors, 1947-1949.

Cunningham, Walter, Ottawa, Ont.

 7P-418 b&w 3. ca. 1905.
 Views of City Hall and Rideau Canal locks, Ottawa, Ont.; Nurse
 Sadie McGuire with Walter Cunningham, Major's Hill Park,
 Ottawa, Ont.

Curiosity Shop, Winnipeg, Man.

 7P-419 b&w 2. ca. 1885.
 View of Medicine Hat, Alta.; group photo of unidentified unit of
 the Northwest Field Force.

Curran, John Edward Gardiner, (1874-1873), Orillia, Ont., sportsman.

7P-420 b&w 815. ca. 1855-1937.
Mr. J.G. Gaudaur winning world rowing championship, London, England, 1896; celebration of the relief of Ladysmith, Orillia, Ont., 1900; views of Orillia, Barrie, Lake Couchiching, Ont.; Dawson City, Yukon; Mining Boom at Cobalt, Ont., 1905; group photographs of Orillia Orchestra, Hockey and Lacrosse Clubs, Orillia, Ont., 1895-1896; group photographs of the Canadian lacrosse teams of 1902 and 1907; sports such as lacrosse, yachting, canoeing, curling, hockey.

Currie, Arthur William, (1875-1933), Montreal, Que., military, officer, educator.

7P-421 b&w 56. ca. 1917.
Activities of Canadian soldiers in France; aerial photographs of battlefields in France.

Currie, Garner O., Ottawa, Ont.

7P-422 b&w 1. 1917.
Investiture of Lieutenant-General Arthur William Currie as Knight Commander of the order of St. Michael and St. George by H.M. King George V, France, June 1917.

Currie, Thomas R., Strasbourg, Sask.

7P-423 b&w 3. ca. 1944-1945.
Consolidated Liberator G.R. VI aircraft No. 11 (BR) Squadron, R.C.A.F., Dartmouth, N.S.

Currier, Cyril, Ottawa, Ont.

7P-424 b&w 9. ca. 1860-1910.
Views of Ottawa, Ont.; group photographs of students of Ashbury College and of the family of James D. Slater, Ottawa, Ont.

Curtis, Mrs. G.S., Mass., U.S.A.

7P-425 b&w 4. ca. 1911.
Building construction, Saskatoon, Sask.

Curtis, Wilfrid Austin, (b. 1893), Toronto, Ont., military officer.

7P-426 b&w 430. 1914-1969.
Aspects of the military career of Air Marshal W.A. Curtis, R.N.A.S. and R.C.A.F., 1914-1969.

Curylo, Frederick A., Kitchener, Ont.

7P-427 b&w 46. ca. 1855-1890.
Views of Elora, Fergus, and Niagara Falls, Ont.; New York City, N.Y.; types of cameras built by Mr. Thomas Connon; photos by John and Thomas Connon.

Curzon, George Nathanel, 1st Marquis, (1859-1925), politician.

7P-428 b&w 1. ca. 1887-1924.
Portrait of the Earl Curzon of Kedleston.

Cuthbertson, Eileen (Odevaine), Sackville, N.B.

1P-68 Original, b&w [275]. ca. 1860-ca. 1905.
Portraits of Uniacke family of Mount Uniacke and Halifax, N.S.; portraits of various individuals; views of Halifax, N.S., including Royal Artillery Park and York Redoubt; Petite Rivière, N.S.; departure of the 2nd Contingent from Halifax, N.S. for the Boer War, 1900; Capt. James Taylor Wood of the *Tallahassee;* photographers: Notman, Parish and Co., Joseph S. Rogers, W.Chase, W.D. O'Donnell, James McLaughlan, T.A. Salter.

Cuthbertson, George Adrian, (1900-1969), Thurso, Que., artist and marine historian.

7P-429 b&w 40. [n.d.].
Views of Port Dalhousie, Port Colborne, Ont.; sailing ships in the Welland and Sault Canals, Ont.; H.M.S. *Algerine* off the coast of British Columbia; portrait of Mr. G.A. Cuthbertson.

Cutts, Anson Bailey, Minneapolis, Minn.

7P-430 b&w 919. ca. 1930.
Aspects of architecture in Ontario and Quebec.

Cyriax, Richard Julius, (1897-1967), Warwickshire, England, physician, author.

7P-431 b&w 495. ca. 1845.
Views of various places in the Northwest Territories connected with the 1845 expedition of Sir John Franklin; portraits of Sir John Franklin, Sir Leopold McClintock, Dr. John Rae.

Cyril T (Schooner), (built 1918), River John, N.S.

31P-107 Copies, b&w 1. ca. 1918.
Cyril T under construction.

Daguerréotypes, Québec (Québec).

131P-8 Originaux, n.&b. 2. ca. 1851-1854.
Portrait d'un individu anonyme.

Dahl, E.H., Ottawa, Ont., archivist.

7P-447 b&w 10. 1924-1941, before 1971.
Hop farming, Sumas Prairie, B.C.; potato harvest, Winkler, Man.; Boy Scout Group, Parliament Hill, Ottawa, Ont.; Christ Church Cathedral, Ottawa, Ont.; portraits of Jacob Epp, John Harder and E.H. Dahl.

Dailey, H.C., East Kootenay area.

333P-6 Original, b&w 6. 1898.
Fort Steele, B.C.; Wildhorse Creek, B.C.; Wardner, B.C.; Cranbrook, B.C.

Dainty, Ernest, (1891-1947), Toronto, Ont., organist and composer.

149P-9 b&w [25]. ca. 1920-1947.
Photographs primarily with various musical groups (dance band orchestras and radio shows) in which he participated.

Dale, F.N., Montreal, Que.

7P-446 b&w 4. 1941.
Blackburn Shark III aircraft of No. 4 (BR) Squadron, R.C.A.F., Ucluelet, B.C.

Dale, Jack.

7P-445 b&w 5. ca. 1930-1940.
Portraits of Jack Dale (Samatilka), Canadian Radio singer and actor.

Dalgleish, J.B., Windsor, Ont., photographer.

7P-444 Copies, b&w 4. ca. 1941-1948.
Activities of J.B. Dalgleish as a photographer with the R.C.A.F.
and *The Windsor Star.*
Provenance: J.B. Dalgleish.

Dalglish, Alex.

7P-443 b&w 5. ca. 1880.
Store of George Dalglish, 72-74 Queen St., Ottawa, Ont.;
unidentified Western town scene; Cold Spring Land & Water Co.;
screw of SS *Pearl.*

Dalhousie University, (est. 1820), Halifax, N.S.

31P-1 [1,400]. ca. 1850 to date.
University faculty, students, graduates, societies, sports teams,
official ceremonies, buildings, campuses, etc.

Dallinger, Henry, Thunder Bay, Ont.

7P-442 Copies, b&w 3. 1942-1944.
Bristol Bolingbroke IV T aircraft 9930 and 9987 of the R.C.A.F.
Provenance: Henry Dallinger.

Dally, Frederick, Victoria, B.C., photographer.

18P-8 Original, b&w 140. ca. 1862-ca. 1870.
British Columbia scenes and buildings including Caribou District,
Lilooet District, Vancouver Island, Victoria and Esquimalt; portraits
of B.C. Indians; British naval vessels and crew on B.C. coast; State
of Washington.

Dallyn, Gordon Mealey, (1891-1973), forester, editor.

7P-441 b&w 541, col. 1,478, total 2,019. ca. 1915-1957.
Various tourist spots across Canada; forestry operations in Canada;
career of Gordon Mealey Dallyn.

D'Altroy, R., Vancouver, B.C., photographic curator.

7P-440 b&w 6. ca. 1890-1897.
Views of Edmonton, Alta. and Whitewood, Sask.; ferrying across
the Saskatchewan River, ranching stockyard portrait by N. Caple &
Co., Vancouver, B.C.; portrait of Class of '98, Applied Science,
McGill University, Montreal.

Daly, George J.

9P-14 b&w 22. ca. 1890-1915.
Family and railway photographs.

Daly, Harold M., Ottawa, Ont.

7P-439 b&w 127. 1870-ca. 1935.
Mourning ribbon with portrait of J.A. Macdonald, 1891; portraits
of various political figures, largely Canadian and Conservative,
including R.B. Bennett, Harold M. Daly, etc.; Louis Riel and
Council, 1870; C. Squadron, Lord Strathcona Horse, 1900.

Dalziel, W.J., Moncton, N.B.

7P-438 Copies, b&w 73. 1914-1919.
Aircraft and Canadian personnel in the Royal Flying Corps during
the First World War.
Provenance: W.J. Dalziel.

Dandurand and Marchand families, Quebec, politicians.

7P-437 b&w 41. ca. 1875-1925.
Portraits of Dandurand and Marchand families; Raoul Dandurand,
1861-1942, politician and diplomat; Felix Gabriel Marchand,
1832-1900 was a savant (President of the Royal Society of
Canada) and politician (Prime Minister of Quebec, 1897-1900).

D'Angelo family, Toronto, Ont.

7P-436 b&w 27. ca. 1910-1920.
Italians in Toronto.

Daniels, G., Burlington, Ont.

7P-435 b&w 58. ca. 1900-1955.
Views of Owen Sound district, Caledonia (schools & Alabartine
mines), Cayuga, Niagara Falls, Kingston, Welland Canal; also
views of Hamilton sailboats, the SS *Kingston,* Hamilton-Jarvis bus
line, 1923; threshing on Toth farm, Haldimand Co., 1923, and
clearing railway line between Hamilton and Dundas, ca. 1938.

Darling, Gordon J.

7P-434 b&w 113. ca. 1930.
Railway locomotives and views in Montreal, Bonaventure Island,
Percé, Weir, Que.; photos by Gordon J. Darling.

Darragh, Harold, Ottawa, Ont.

7P-433 Copies, b&w 5. ca. 1930.
Portraits of hockey personalities Harold Darragh, Roger Smith, Tex
White, Philadelphia Quakers, 1930-1931 and Pirates.

Dartmouth, N.S.

31P-45 Copies, b&w 1. ca. 1890.
Dartmouth Ferry terminal.

Daviault, Georges A.

7P-432 b&w 3. ca. 1885, ca. 1890, ca. 1930.
Harbour at Weymouth, N.S., ca. 1890; portrait of R.B. Bennett as
Prime Minister by Canadian Government Motion Picture Bureau,
ca. 1930; genealogical tree of the presidents and chaplains of the
St. Jean Baptiste Society of Montreal.

David Heath, (b. 1931), Toronto, Ont., photographer, photography
instructor at Ryerson.

123P-7 b&w 82. 1952-1961.
Portraits of men, women and children, some taken in Korea; all the
photographs in this collection appear in the book, *A Dialogue with
Solitude,* Community Press, 1965; the most accurate description of
these photographs is probably given by the photographer himself:
"In these photographs I have tried to touch upon this malaise
d'age for I, too, am disconcerted at the seeming impingement of
impersonal forces upon the destiny of our lives".

Davidson, George, (1858-1936), Rural Manitoba, Vancouver and
Chilliwack, B.C., photographer.

9P-15 b&w 29. ca. 1880-1940.
Family photographs.
Provenance: Mrs. R.N. Mulvin, Victoria.

Davidson, T.G.M., Halifax, N.S., manufacturers' agent.

 1P-69 b&w 4. 1918-1919.
 Return of Canadian troops to Halifax, N.S., World War I.

Davies, Blodwen, Toronto, Ont.

 7P-448 b&w 17. ca. 1916 - ca. 1943.
 Birthplace and home of Tom Thomson, in Claremont and Leith, Ont.; portrait of Mr. and Mrs. John Thomson; Tom Thomson's and Edward Gondin's camp, Grand Lake, Ont., 1916; Tom Thomson playing with children of Hon. Wesley Gordon, Annan, Ont.; Tom Thomson's gravestone and Canoe Lake totem.

Davies, Frank Thomas, Ottawa, Ont.

 7P-450 b&w 189, col. 196, total 385. ca. 1930.
 Views of the Arctic and Antarctic, and Canadian Polar Expedition, 1932-1933.
 Ref./Réf.: 1 sound tapes by F.T. Davies describing a number of the images.

Davies, Raymond Arthur, (b. 1908), journalist.

 7P-451 b&w 3. ca. 1914.
 Portraits of R.A. Davies, Dana Wilgress (Canadian Ambassador), Dana Wilgress and daughter.

Davies Book Co. Ltd., Montreal, Que.

 7P-449 b&w 1. [n.d.].
 Boys in classroom, photo by E.T. Hamly, Port Hope, Ont.

Davis, H.P.

 7P-452 b&w 229. 1909-1967.
 Mining towns in northern Ontario (eg. Cobalt, Sudbury, Porcupine, Elk City etc.), n.d.; views of prospecting and Hollinger Mines; portraits of Ben Hollinger, Jack McIntyre; track and field, C.N.E., Toronto, Ont., 1914.

Davis, J.S., Victoria, B.C., military officer (RTD).

 7P-454 b&w 1,856. 1940-1955.
 Career of Commander Davis in the Royal Canadian Navy and Royal Navy, 1940-1955, including service in H.M.C. Ships *Wolf, Naden, Quesnel, Venture, Fairmile Q-60, La Malbaie, Royalmount,* and H.M.S. *Venerable;* coverage of yachting on Lake Ontario and along the west coast.

Davis, Jake, Richmond, Calif.

 7P-453 Copies, b&w 13. 1912, 1915, 1919.
 Vancouver and Victoria, B.C., Mann Cup Lacrosse teams.
 Provenance: Jake Davis.

Davis family, Oakville, Ont., realtors.

 47P-3 Original, b&w 23. ca. 1900.
 Davis family members; Holyrood House; Lake Ontario and the Sixteen Mile Creek and ships.

Davison, A.W., Ottawa, Ont.

 7P-455 Copies, b&w 7. ca. 1858-1900.
 Views of Ottawa and Montreal including E. Spencer photos of construction of Parliament Buildings, 1858-1867; view of Canadian exhibit at Pan American Exposition.

Provenance: Davison, A.W.

Davison, Edward S., (1890-1950), La Have, N.S., photographer.

 31P-82 Original, b&w [200]. ca. 1890-1950.
 Photographs by Davison, F.D. MacKean, W.J. Boyd, O. Chisolm of Antigonish, N.S., G.F. Parker of Liverpool, N.S., L.-P. Vallée of Quebec, Que., N.D. Hammett of Liverpool, N.S., Dodge of Bridgewater, N.S.; Dept. of the Interior, Forest Service, Yukon, 1914; construction of the Chignecto Marine Railway, 1890; Labrador, 1905.

Dawe, Harold.

 334P-14 Copies, b&w 10. ca. 1918.
 Shipbuilding in New Westminster; launchings.

Dawe, Mary.

 334P-39 Copies, b&w 6. ca. 1880-ca. 1911.
 New Westminster: May Day, visit of Lord Strathcona, houses, tugboat *D.M.B.*

Dawson, George M.

 7P-456 b&w 124. 1872-1875.
 Views taken by 4 anonymous Royal Engineers during North American Boundary Commission, 1872-1875.

Dawson, Robert MacGregor, (1895-1968), scholar.

 31P-25 Original, b&w 75. ca. 1915-1920.
 Dawson house, Bridgewater, N.S.; Dalhousie graduates' portraits; Dawson family; views of Halifax and Bridgewater, N.S.

Day, Bernhard, Toronto, Ont.

 7P-457 Copies, b&w 77. 1932-1933.
 Radium ore prospecting in the Great Bear Lake, N.W.T. area by B.E.A.R. Exploration; Eldorado Mines; Aircraft and personnel in the N.W.T., mining camps and operations.
 Provenance: Bernhard Day.

Day, Frank Parker, (1882-1950), Lake Annis, N.S., author and educator.

 31P-32 b&w [430]. ca. 1900-1950.
 Careers of F.P. Day and of his wife, Mabel Killam Day.

Day, Vivian, Sydney, N.S.

 7P-458 Copies, b&w 1. [n.d.].
 Private John B. Croak, J.C.
 Provenance: Vivian Day.

De Cruz, Hugh Emil, Ottawa, Ont.

 7P-460 b&w 1. 1937.
 Group portrait: «Souvenir du Centenaire de St. Hermas, 1e août, 1937» by A. Roy, Montreal.

De Havilland Aircraft of Canada, Downsview, Ont., aircraft production.

 7P-462 b&w 7. [n.d.].
 Phil Garratt and other company employees.

De La Roche, Mazo, (1885-1961), Toronto, Ont., author.

16P-7 b&w 25. ca. 1925-1957; ca. 1964-66.
De La Roche and family, 1925-1957; gravestones of De La Roche family and houses where De La Roche lived, taken by Ronald Hambleton during research for her biography; 1964-66.

De Lorme, Louis Alfred, lawyer.

7P-465 b&w 4. ca. 1900-1915.
Views of St. Yvon Ouest, Gaspésie Residence of Edouard Fortin at Cap Saint-Grace; pulling stumps with bulls, Ste. Louise, Montmagny; portraits of M. and Mrs. Joseph Levesque and family, Lac St-Jean, Que.

De Mille, James, (1836-1880), Saint John, N.B. and Halifax, N.S., novelist.

31P-4 b&w 2. ca. 1865-1880.
Portraits of De Mille.

Dearing, W.E., Winnipeg, Man.

9P-16 b&w 54. 1955-1965.
Steam tractors and engines.
Provenance: W.E. Dearing, Winnipeg, Man.

Deckson, W.A., Whitehorse, Yukon.

7P-459 Copies, b&w 100. ca. 1900-1920.
Photos by E.J. Hammacher; first planes arriving at Whitehorse, Yukon; potlatch dance at Carcross; views of towns in B.C. and Yukon: Bennett, B.C., Whitehorse, Carcross, Conrad, Kluane Lake, Five Finger Rapid, Sheep Creek, Jarvis River, Takhini Lake, Miles Canyon, Yukon; views of Canadian Alaska boundary and life in the north.

D'Egville, Geoffrey, journalist.

7P-461 b&w 418. ca. 1920-1946.
Views of Canadian north and west, perhaps by Geoffrey D'Egville; publicity shots from C.N.R. and C.P.R., largely of western Canada; photos by J.D. Soper and A.E. Porsild, photographers for the Dept. of the Interior.

Deja, Ron.

7P-463 b&w 30. 1865-1885.
Views of St. John, N.B., Montreal, Quebec and Montmorency, Que.; C.P.R. Engine no. 31 at Big Grade Rockies, B.C.; the Halton Rifles, 20th Regiment.

Delisle, Georges, Ottawa, Ont., civil servant.

7P-464 b&w 1. 1973.
Georges Delisle and William Rider-Rider at the opening of the exhibition *Relentless Verity: Canadian Military Photographers since 1885,* Ottawa, Ont., Sept. 11, 1973.

Demers, M.C., Rockcliffe, Ont., member of armed forces.

7P-466 b&w 8. 1939-1945.
R.C.A.F. bomber attack on Germany; German battleship *Bismarck.*

Dempsey, W., (1905-), St. Eugene Mission, B.C.

333P-3 Original, b&w 28. 1905-1925.
Kootenay Indians, Shuswap encampment, Historical Pageant, 1922; Plains Indians; Tobacco Plains Indians.

Denholm Angling Club, (1891-1973), Gatineau, Que.

7P-467 b&w 21, col. 2, total 23. ca. 1897-1950.
Snapshots of activities of Denholm Angling Club at Lac St. Germain and near Poltimore, Que.

Denison, George Taylor III, (1839-1925), militia officer, magistrate.

7P-468 b&w 13. ca. 1865-1905.
Portraits of "Red George" Macdonell, ca. 1865; the poet Charles Mair and his wife, ca. 1905; White Cap, a Sioux chief, ca. 1885; views of the Northwest Rebellion, the Telegraph Station in Humboldt, Sask., bands of the Sioux chief White Cap, 10th Royal Grenadiers, Queen's Own Rifles, and the Governor General's Body Guards, all ca. 1885.

Denison, M., Cloyne, Ont.

7P-469 b&w 28. 1917.
Views of Camp Borden, 1917.

Denison family, Toronto, Ont.

18P-68 Original, b&w 7. ca. 1870-1897.
Portraits of family and house of George Taylor Denison II.

Denley, Norman.

7P-470 b&w 105. ca. 1880-1900.
Views of Western Canada, including Canadian Pacific Railway line, Victoria, B.C; some by J.R. Brock; portraits of Indians by Buell; unidentified portraits of legislators and Roman Catholic clergy.
Ref./Réf.: Caption List and Introductory page.

Denman, Harold, Ottawa, Ont.

7P-471 b&w 19. 1931-1933.
Views of Fort Churchill, Man.

Denne, T.H.G., (1863-1942), Peterborough, Ont., Mayor of Peterborough 1901-1902.

158P-1 b&w 164. ca. 1850-1925.
Buildings, people, boats, and a few district pictures of mills, Peterborough, Ont.

Denny, William.

7P-472 b&w 1. ca. 1860.
View of Citadel, Quebec, Canada East; possibly by William Denny.

Densmore, Mattie, Halifax, N.S., stenographer.

1P-70 Original, b&w 12. 1914-1918, 1939.
Celebration of Armistice Day at Halifax, N.S., Nov. 11, 1918; camouflaged SS *Aquitania* docked in Halifax, N.S., during World War I; visit of King George VI and Queen Elizabeth to Halifax, N.S., 1939.

Dent family, Toronto, Ont.

18P-61 Original, b&w 83. ca. 1870-ca. 1879.
Portraits of John Charles Dent's family and friends.

Dependants Allowance Board, (1942-1955).

<u>7P-473</u> b&w 6. [n.d.].
Model of D.V.A. Shaughnessy Hospital.

Derengoski, W. A., Halifax, N.S.

<u>1P-33</u> Original, b&w [65]. ca. 1880-ca. 1900, ca. 1930.
Portraits of various individuals, mainly Nova Scotians; Forrest
Building, Dalhousie University, Halifax; photographers: Gauvin
and Gentzell, Notman, Queen Studio, Kelley and Co., Halifax
Photographic Co., Newcombe, O'Donnell, A.R. Cogswell and Co.

Derry, Douglas M., Toronto, Ont., amateur photographer.

<u>18P-27</u> Original, b&w 132. ca. 1945-ca. 1950.
Toronto churches.

Desbiens, Raymond, Montréal (Québec).

<u>7P-474</u> n.&b. 1. [n.d.].
Commission pour la codification des lois du Bas-Canada
(Québec), photo par Jules Ernest Livernois.

Desmond, L.A., Winnipeg, Man.

<u>7P-475</u> Copies, b&w 8. ca. 1860, 1900-1950.
Portrait of John Jordan, M.L.A., N.B., ca. 1860; views of ship
yards, Loch Lomond, Black River and Gardner Creek, N.B.
Ref./Réf.: Caption List.

Désy, Jean, (1893-1960), diplomat.

<u>7P-476</u> b&w 8. [n.d.].
Photos of Jean Désy with other officials; autographed portraits of
Albert Schweitzer and André Siegfried by Karsh.

Det Kongelige Bibliotek, Kobenhavn K, Denmark, Royal Library.

<u>7P-477</u> b&w 3. 1875-1876.
Naress Expedition to Arctic Regions.

Detroit Marine Historical Society, Michigan, U.S.A.

<u>7P-478</u> col. 1. 1969.
Canadian Steamship Lines vessel *Le Moyne.*

Dettloff, Claude P., Vancouver, B.C.

<u>7P-479</u> Copies, b&w 2. 1940-1945.
Jack Bernard going to and returning from the Second World War.

Deyglun, Henri, (1903-1971), comédien.

<u>7P-480</u> Originaux, n.&b. 52. 1932-1952.
Henri Deyglun et Mimi D'estée costumés en Nénette et Rintintin;
également les portraits de plusieurs artistes: Charles Trenet, Roger
Baulu, Gisèle Schmidt, Jacques Normand, Charles Aznavour, Jean
Rafa, Luis Mariano, Paul Berval, Raymond Lévesque, Normand
Hudon, Denyse Saint-Pierre, Yvette Brind'amour, Frenchie Jarraud.

Di Giulio, Donald, (fl. 1939-1974), businessman.

<u>7P-484</u> b&w 2. 1922.
Group photo of Supreme Council, Daughters of Italy, Local Council
No. 2 on picnic at Grimsby Beach, Ontario, Aug. 16, 1922; Italian
group at the World Congress of Scientists at Toronto, Ont., 1922.

Dibdin, Hanry G., Broxton, Cheshire, England.

<u>7P-488</u> b&w 22. ca. 1912.
Views of Montreal, Que., Brockville, Toronto and Prescott, Ont.
including views of construction work at Canadian National
Exhibition; all photos printed in 1975 from negatives ca. 1912.
Ref./Réf.: Caption List.

Dibney, Dora, (b. 1894), editor, journalist.

<u>7P-487</u> b&w 9. ca. 1867.
Portraits of C. Banks, No. 6 Battery, 4th Battalion, Grand Trunk
Brigade.

Dickie, Alfred, (1860-1929), Stewiacke and Halifax, N.S., lumber merchant.

<u>31P-73</u> b&w 51.
Lumber operations; photos taken aboard the ship *Integral;* Dickie
family history.

Dickins, Clennell Haggerston, (b. 1899), pilot.

<u>7P-486</u> Copies, b&w 11. 1924-1944.
Portraits of C.H. Dickins, R.A.F.; views of events in the life of
C.H. Dickins as bush pilot in Canadian North.
Ref./Réf.: Caption List.

Dickson, J.R., Ottawa, Ont.

<u>7P-485</u> b&w 8. 1904.
Wilfrid Laurier during federal election campaign, 1904; view of
Kent House, Montmorency, Que., and Grand Trunk Railway
Engine No. 974 used by Laurier during campaign.

Diefenbaker, John George, (b. 1895), Ottawa, Ont., politician, Prime
Minister of Canada.

<u>7P-489</u> b&w 31. 1916-1973.
John G. Diefenbaker, John Einarsson and Michael A. McMillan in
France 1916-17; Lieut. J.G. Diefenbaker, Canadian Officer's
Overseas Draft, Regina, Aug. 29, 1916; 27th Parliament, Jan. 12,
1967; Rt. Hon. J.G. Diefenbaker visiting Sir Winston Churchill,
London, England, May 12, 1960; Mrs. Edna Mae Diefenbaker;
presentation of a CTV VTR cassette *The Homestead Years* to
Dominion Archivist.

Digby County, N.S.

<u>1P-19</u> Original, b&w 83. ca. 1900.
Photographs taken by an unknown individual on a group fishing
expedition to Digby Co., N.S. Woodland and fishing scenes;
various views of Bear River, Church Point, Weymouth and
Corberrie, Digby Co., including Acadian homes, families and
schools; Micmacs on the Bear River Indian Reservation.

Dillon, M., Hull, Que.

<u>7P-483</u> b&w 1. 1897.
Wilfrid Laurier at Hawarden Castle, New Chester, England, with
Louis Davies, W.E. Gladstone, R. Reid and R. Seldon on the
occasion of the knighting of Laurier and Davies.

Dimock family, Newport and Windsor, N.S.

<u>31P-27</u> Original, b&w 1. 1976.
Photo of a relief model of the Barque *Fairmont.*

Diocese of the Arctic, Toronto, Ont.

7P-482 b&w 2. before 1941.
Interior and exterior views of All Saints Protestant Cathedral, Aklavik, N.W.T.

Dixon, Frederick A., (1843-1919), tutor.

7P-481 b&w 217. ca. 1875-1950.
Dixon family portraits; rural and bathing scenes; photos by F.A. Dixon and his son, John Dixon.

Dodge, George Blanchard, (1874-1945), B.C., civil engineer and Dominion land surveyor.

12P-8 b&w 29. 1906-1908.
B.C.-Yukon-N.W.T. boundary survey, 1906-08.

Dodge family, Middlesex County, Ont.

7P-490 b&w 3. ca. 1880.
Members of the Dodge family.

Dolan, D. Leo, (1895-1966), civil servant.

7P-491 b&w 58. ca. 1934-1958.
Portraits of D. Leo Dolan, Director of the Canadian Government Travel Bureau, 1934-56, and Canadian Consul in Los Angeles, 1956-58; events and ceremonies connected with his career.

Dominion Bridge Company of Canada, (1882), Montreal, Que.

7P-492 b&w [30,000]. ca. 1882-1960.
Construction projects of the Dominion Bridge Company across Canada, both actual and proposed, showing course of construction and use of equipment.
Ref./Réf.: Report and Caption List.

Dominion Chair Co., (est. 1860), Bass River, N.S.

31P-72 Original, b&w 99. ca. 1875-1920.
Union Furniture and Merchandise Co., 1860-1903, and Dominion Chair Co., ca. 1903, factories; furniture catalogue photos; James S. Crealman; George Fulton.

Dominion Drama Festival, (est. 1936).

7P-494 b&w 1900. 1950-1970.
All aspects of the annual Dominion Drama Festivals, 1950-1970: plays, actors, officials.

Dominion Drama Festival, Nova Scotia Region, (est. 1932), Halifax, N.S.

31P-58 Original, b&w 2. 1969.
Dominion Drama Festival, N.S.; regional festival, Antigonish, N.S.

Dominion of Canada Rifle Association, (1868), Ottawa, Ont.

7P-493 b&w 1,498. ca. 1870-1974.
Activities of the Association at the Rideau, Rockcliffe and Connaught Ranges, Ottawa, Ont., and at the National Rifle Associations Empire Meet at Bisley, England; teams representing the Association at various national and international meetings; Dominion Rifle Association Meeting at Ottawa, ca. 1900.

Dominion Wabana Ore, Limited, (1966), Bell Island, Nfld., mining (iron ore).

38P-3 b&w 11. [n.d.].
Photographs showing various aspects of mining operations in the Bell Island iron mines.

Dominion-Wide Photographs Ltd., Ottawa, Ont.

7P-495 b&w [34,200]. 1966-1968.
News photos of events and people in Ottawa, Ont.

Donald, E.F., Edmonton, Alta.

7P-496 Copies, b&w 2. 1921.
Junkers F.B. aircraft G-CADP "Vic" and G-CADQ "Rene" of Imperial Oil Co. at Peace River, Alta.

Donalda, Pauline (Lightstone), (1882-1970), London, England, Paris, France and Montreal, Que., singer and teacher.

149P-7 b&w [100]. 1890-1968.
Photographs of her in various roles, as a teacher and at public appearances in Ontario and Quebec.

Donnachie, Dave, Sherbrooke, Que.

7P-497 b&w 499. ca. 1924-1928.
Eastern Arctic patrols, 1927-28, including view of cinematographer Valiquette at work; views of Lower Saint-Laurent, Cap Rouge, Port Burwell, Nottingham I (Radio Station 1927-28); views of aviation in Canadian North; sailing; Windsor, Ont. flying school; outdoor scenes with hunting and photographer apparatus; views of icebreakers *Montcalm* and *Lady Grey*.

Donnell, Robert, Ottawa, Ont., Dominion carilloneur.

7P-498 b&w 6. 1956-1966, 1971.
Portraits of Robert Donnell, 1956-66; Peace Tower of Parliament Buildings showing details of carillon installation, ca. 1971.

Donovan, Duncan, Alexandria, Ont., photographer.

8P-14 Original, b&w [5,000]. ca. 1895-ca. 1924.
Glass negatives; portraits of prominent persons from Alexandria, Glengarry Co., Ont.; buildings, street scenes, carriage factory (Munro & McIntosh), sport events, Alexandria, Glengarry Co., Ont.; photos by Duncan Donovan.

Donovan, Oscar Glennie, (1883-1977), Halifax, N.S., medical doctor.

31P-31 Original, b&w 30. ca. 1914-1939.
Medical service, World War I.

Doolittle, G.A., West Hill, Ont.

7P-499 Copies, b&w 11. 1942.
Blackburn Shark III Aircraft of No. 7 (BR) Squadron, R.C.A.F., Prince Rupert, B.C.
Ref./Réf.: Caption lists.

Doran, Harold J., architecte.

113P-6 n.&b. 18. 1946-1947.
Photos de la maison de rapport Benny Farm Gardens, Montréal (Québec).

Dore, William G., Ottawa, Ont., botanist.

7P-500 b&w 2. 1961.
Gravestones of Billings family, family plot, Billing's Bridge, Ottawa, Ont.

Dorion, Best A., Ottawa, Ont.

7P-501 Copies, b&w 1. 1927.
Charles Lindbergh and Prime Minister William Lyon Mackenzie King, Ottawa, Ont.

Dornan, Harold Alexander, (b. 1919), special assistant to Prime Minister.

7P-502 b&w 8. ca. 1964-1966.
Portraits of Lester Bowles Pearson and Lyndon Baines Johnson.

Dornbush, Trevor.

7P-503 b&w 2. 1974.
Cinegraph portraits of Ann Dornbush and Trevor Dornbush.

Doucet, H.E.T., Ottawa, Ont.

7P-504 b&w 2. 1888.
Portraits by William James Topley, one of Henri Doucet, May 1, 1888.

Doughty, Arthur George, Sir, (1860-1936), Ottawa, Ont., public servant.

7P-508 b&w 32. ca. 1867-1930.
Views of Quebec, Que., Kingston, Ont.; exterior and interior views of the Public Archives of Canada, Ottawa, Ont.; group photo of historical research scholars, Public Archives of Canada, Ottawa, Ont.; portraits of Sir Arthur Doughty, Sir Wilfrid Laurier, Sir John A. MacDonald.

Douglas, George Mellis, Lakefield, Ont.

7P-505 Copies, b&w 1. n.d.
Portrait of Surgeon G.M. Douglas, V.C.

Douglas, H.T., Ottawa, Ont.

7P-506 b&w 3. 1903.
Ottawa Harrier Club meet, April 25, 1903, by Pittaway; cartes-de-visite of Mr. Turner by Stiff, and Hammett P. Hill and Gregory, by Spencer.

Douglas, Howard, and family, (1850-1929), Banff and Edmonton, Alta., superintendent Banff National Park, chief superintendent of parks.

166P-35 Copies, b&w 103. ca. 1895-1912.
Copies of photographs collected by the Douglas family; Banff people, views of Banff and Jasper National Parks; Pablo-Allard buffalo roundup, 1907.

Douglas, Robert, Laval-Sur-Le-Lac, Que.

7P-507 b&w 243. ca. 1865-1910.
Indian and Eskimo views and portraits by Robert Bell and others on Baffin Island, N.W.T.; Aux Sables Lake, Que.; cartes-de-visite by miscellaneous English, Scottish and Canadian photographers; visit of Lord Strathcona to Canada, 1909; miscellaneous photos (6 cyanotypes of stuffed water buffalo, burnt areas on Montreal Lookout, 1910).

Dowson, William C.H., Willowdale, Ont.

7P-509 b&w [50]. ca. 1860-1946.
Views of Jesse Ketchum School and students, Toronto, Ont.; views of shops in Toronto, Ont.; the Parish Church of Bedford, Ont.; area near Matheson, Ont.; portraits of members of the Dowson family; views of aftermath of the Matheson, Ont, fire, July, 1916; group of Jewish carpenters, Toronto, Ont., ca. 1920; views of log turning, Rivermen, stonecutters, ca. 1885-1910; Col. Sam McLaughlin's Residence, 1946; extensive descriptions in letters from W.C.H. Dowson.

Doyle, Charles Hastings, (1804-1883), Colonial Governor.

7P-510 b&w 119. 1867-1873.
Views of Halifax, N.S., Fredericton, N.B., Charlottetown, P.E.I., Quebec, Que.

Dragon, George E., Saskatoon, Sask., doctor, member of legislative assembly, Sask.

7P-511 b&w [300]. 1910-1964.
Meeting and activities of various Ukrainian organizations and the Ukrainian community in Canada (mainly in the West); career and activities of Dr. G.E. Dragan, M.L.A.; portraits of G.E. Dragan and family.
Ref./Réf.: Caption List.

Drayton, W.A., Fort Steele, B.C., Rancher.

333P-31 Copies, b&w 16. 1930-1935.
Drayton residence, Fort Steele, B.C.

Drew, George Alexander, (1894-1973), Premier of Ontario, leader of the opposition.

7P-512 b&w [6,720]. [n.d.].
Career of George Alexander Drew.

Drewitt, Lillian, Sundrige, Ont.

7P-513 Copies, b&w 1. ca. 1850-1856.
Portrait of Charlotte Sadler-Leake, 1837-1925.

Dryden, J.W., Edmonton, Alta.

7P-514 Copies, b&w 5. 1943-1945.
Consolidated Liberator G.R. Mk. VI Aircraft 3717 and 3731 of No. 11 (BR) Squadron, R.C.A.F., Dartmouth, N.S.; Consolidated Canso A Aircraft of No. 161 (BR) Squadron, R.C.A.F., Batwood, N.S.
Ref./Réf.: Caption List.

Dubé, Raymond, Québec (Québec).

7P-515 n.&b. 1. 1885-1987.
Le manoir de Philippe Aubert de Gaspé à St-Jean, Port-Joli, Québec.

Duberger.

7P-516 b&w 3. before 1932.
Duberger model of Quebec, Que.

Ducharme.

> 7P-517 b&w 2. [n.d.].
> Portraits of Sir George Campbell, and Mme Emma Albani-Gye, 1847-1930.

Dudeney, Gertrude, Frinton-On-Sea, Essex, England.

> 7P-518 b&w 88. ca. 1860-1970.
> Stereograph views in and around Quebec and Montreal; also scenes in Bermuda, U.S.A., and North Wales.
> Ref./Réf.: Caption List.

Duff, Lyman Poore, Sir, (1865-1955), chief justice.

> 7P-519 b&w 199. ca. 1902.
> Views of Whitehorse, Yukon, 1902; portraits of Sir Lyman P. Duff, relatives and friends.

Dufferin, Harriet Georgiana, Lady, (1843-1936), Ottawa, Ont.

> 7P-528 b&w 231. 1872-1878.
> Visits of the Earl and Countess of Dufferin to the United States in 1874 and to British Columbia in 1876; social activities at Rideau Hall, Ottawa, Ont.; views of Quebec, Montreal, Sherbrooke, Que.; Ottawa, Niagara Falls, Fort William, Ont., Winnipeg, Man., Victoria, B.C.; portraits of members of the Dufferin family.

Dufferin and Sappers' Bridges, Ottawa, Ont.

> 7P-529 b&w 1. n.d.
> Dufferin and Sappers' Bridges, Ottawa.

Dumaresq, J. Philip, Halifax, N.S., architect.

> 1P-34 Original, b&w 23. ca. 1948, ca. 1965.
> Interior, exterior and aerial views of the (old) Bluenose Wharf, Halifax, N.S.; Dominion Coal Co. offices, [Sydney], N.S.; chapel, Yarmouth cemetery, Yarmouth, N.S.; aerial view of construction of homes, Westmount subdivision, Halifax, N.S.

Dumouchel, Jean, LeMoyne (Québec).

> 7P-520 b&w 24. 1970.
> Organisation du parti libéral à Chambly incluant le ministre du Travail l'Hon. Jean Cournoyer.

Dumoulin, J.L., Ottawa (Ont.), juge.

> 185P-3 n.&b. 9. [ca. 1890].
> Série de photographies présentant Québec à la fin du XIXe siècle; vues des portes de la ville et de quelques rues.

Dunbrack, Charlotte S.

> 31P-46 Original, b&w 23. ca. 1870-1895.
> Dunbrack family portraits and tintypes.

Dunlap, Clarence Rupert, (b. 1908), Ottawa, Ont., military officer.

> 7P-527 b&w [2,940], col. [300], total [3,240]. 1928-1968.
> All aspects of the R.C.A.F. career of Air Marshal C.R. Dunlap, C.B.E., Silver Star, Crois de guerre, D.C.L., D.Eng., B. Sc., 1928-68; view of R.C.A.F. Station, Dartmouth, N.S., 1941-45.

Dunlop, Edward Arunah, Toronto, Ont., military officer.

> 7P-530 Copies, b&w 1. ca. 1946.
> Major Edward A. Dunlop, G.M.

Dunlop, R.G., Ottawa, Ont.

> 7P-531 b&w 8. Before 1930.
> Views of Indo-China and Tibet by an unknown Canadian photographer.

Dunn, G., Hull, Que.

> 7P-532 b&w 2. 1910.
> Views of Fort-Coulonge, Que.

Dunn, Oscar.

> 7P-521 b&w 1. ca. 1880.
> Portrait of Oscar Dunn.

Duplessis, Edgar, Ottawa, Ont.

> 7P-522 b&w 1. [n.d.].
> Portrait of Mgr. Joseph Thomas Duhamel, 1841-1909, by Desmarais.

Dupuis, Frank J., Birmingham, Ala., collector.

> 7P-523 b&w 20. 1900-1905.
> Exterior and interior views of the Ross Rifle Factory, Quebec, Que.

Durand, Paul, Ottawa, Ont.

> 7P-524 b&w 5. ca. 1958-1960.
> Views of Montreal around St. Vincent de Paul, East Montreal Refineries, and Dorval Airport.

Durnford, Hugh, Montreal, Que., journalist.

> 7P-525 b&w 2. [n.d.].
> Portraits of Pauline Johnson, 1862-1913.

Durocher, Lyman, Waltham, Que.

> 7P-526 b&w 12. n.d.
> Views of Pontiac County and construction of Waltham Power Station on Black River.

Dyonnet, Edmond, (1859-1951), Montréal (Québec), peintre.

> 113P-2 total 77. 1930-1950.
> Négatifs sur verre et épreuves des membres du *Pen and Pencil Club of Montreal* (Québec).

E. & H.T. Anthony & Co., New York, N.Y., publishing company.

> 7P-27 Original, b&w 2. ca. 1870-1880.
> Stereographs, views of Quebec, Que., ca. 1870-1880.

Easson, A., Keene, Ont.

> 7P-533 Copies, b&w 8. ca. 1800-1900.
> Views of Keene Lumber Mill, Easson Farm and Hope House at Lang, Otonabee Township, Peterborough County, Ontario.

Easson, J.G., Ottawa, Ont.

7P-534 Copies, b&w 25. ca. 1943.
Views of Queen Charlotte City, Docks, Skidegate Inlet General
Hospital, R.C.A.F. Stations (Alliford Bay), Japanese Fishermen's
House; portraits of Charley Valley, Honourary West Coast Indian
Chief.

East Kootenay Area.

333P-8 b&w 610. 1890-1930.
Fort Steele, B.C., buildings and people; Cranbrook, B.C., buildings;
paddlewheelers, Fort Steele, B.C. and Jennings, Montana;
construction of Kootenay Central Railway, Wildhorse, B.C.; Fort
Walsh, Saskatchewan; Fernie, B.C.; Kootenay Indians; St. Eugene
Mission, B.C.; Tobacco Plains Indians; trains; Sam Steele;
Kootenay River; East Kootenay villages; Crowsnest Railway and
area villages; Perry Creek, B.C.

Eastcott, J.C., lieutenant surgeon, Esquimalt, B.C., naval officer.

12P-21 b&w 27. 1862-1870.
Esquimalt naval facilities and harbour; Cariboo locations, B.C.;
Indians; many photographs by F. Dally.

Eaton, Arthur Wentworth Hamilton, (1849-1937), Kentville, N.S., Boston,
Mass., and New York, N.Y., clergyman, local historian.

1P-35 Original, b&w 25. 1880-1925.
Arthur W.H. Eaton, his family and friends; photographers: Topley,
Notman, Climo.

Eckert, K., Medley, Alta.

7P-535 Copies, b&w 2. 1940.
Blackburn Shark II Aircraft and Fairchild 71B Aircraft of no. 111
(CAC) Squadron, R.C.A.F., Patricia Bay, B.C.

Eckhardt-Gramatte, Sonia Carmen, (1902-1974), Berlin, Vienna, and
Winnipeg, Man., composer.

149P-8 b&w [245]. 1910-1974.
Photographs from her youth as a child prodigy on piano and violin,
from her marriage to the painter Gramatté and her years in
Canada, including several photographs on her death-bed.

Eckman, C.M., policeman.

7P-536 b&w 186. 1918-1920.
Patrols, scenes in Northern Ontario and Saskatchewan.

Eckstein, Simon Layble, (b.1919), Ottawa, Ont., rabbi, author.

7P-537 b&w 35. 1957-1975.
Activities of Rabbi Simon Eckstein, Beth Shalom Congregation,
Ottawa, Ont.

Edelsten, E.R.F., Ottawa, Ont.

7P-538 b&w 200. 1929-1935, ca. 1955-1967.
Ottawa Buildings, scenics, streets; ocean vessels, parades, ca.
1955-67; R.C.A.F. Aircraft AW Siskin IIIa; 1929-35.

Eden, St. Eugene Mission and Fort Steele, B.C.

333P-28 Original, b&w 9. 1910-1925.
Trains; St. Eugene Mission, B.C.; Fort Steele, B.C.

Edgar, Mary Susanne, (1889-1973), Toronto, Ont., writer and social worker.

75P-6 b&w [100]. ca. 1925-1970.
Photographs taken during extensive travels abroad (including many
views of Japan) and some family photographs.

Edmonds, Mabel and Sarah, Lindsay, Ont.

7P-539 Copies, b&w 2. [n.d.].
Portraits of Frederick Conway Edmonds, Lindsay, Ont.
Ref./Réf.: Captions.

Edmonton Journal, Edmonton, Alta., daily newspaper.

13P-8 b&w [210,000]. 1965-1970.
Public works: roads, bridges, schools; private construction and
works projects: new buildings, demolition of old buildings;
celebrities, special events: Klondike Days Parade, conventions,
changes of business directorship, elections; fires, floods, other
extraordinary accidents and disasters; heritage sites and buildings;
labour strikes, boycotts, organized protests; sports events.

Edwards, Howard, Carleton Place, Ont.

7P-540 Copies, b&w 8. ca. 1874-1910.
Exterior and interior of J.H. Edwards' General Store and C.P.R.
Station, Carleton Place, Ont.

Edwards, R.G., ship captain.

7P-541 b&w 156. 1942-1943.
Views of wartime shipbuilding at Pictou shipyard, Pictou, N.S.

Edwards, Ron, Lumberton, Fort Steele, Bull River, B.C.

333P-39 Original, b&w 14. 1900-1925.
Saw Mill, Lumberton, B.C.; Commercial Hotel, Fort Steele, B.C.;
C.P.R. Camp, Bull River, B.C.

Edwards, W.S.

7P-543 b&w 797. 1909-1935.
Views of mining, Dome Mine, Porcupine, Ont.; towns of Porcupine,
Cobalt, Haileybury, Golden City, Potts, Scottsville, Aura Lee Lake;
hunting, fishing, camping; transportation by rail, water, dog, horse;
portraits of W.S. Edwards, J. Wilson, D.D. Allen, L.O. Bryant,
prospectors and miners.

Edwards, William B., Quebec, Que., photographer.

7P-542 b&w 3670. ca. 1930-1960.
Views of a wide variety of subjects including the city of Quebec, its
streets and environs.

Edy Brothers, London, Ont., photographers.

7P-544 b&w 152. ca. 1900-1920.
Views around London, Ont.; unidentified portraits.

Egerton, Frank, (Mrs.).

7P-546 b&w 1. 1870.
Fort William (presently Thunder Bay), Ont.,.

Eglise catholique du Canada, archidiocèse d'Ottawa, (f. 1847), Ottawa (Ont.), organisme religieux.

306P-1 n.&b. [500]. ca. 1847 de nos jours.
Evêques de diocèses étrangers; paroisses, églises, presbytères, événements religieux; évêques; photos et cérémonies religieuses prêtres diocésains ou autres, vivants ou décédés; congrès marial, Université d'Ottawa; séminaires diocésains, Grand Séminaire, Petit Séminaire; bénédiction; photos de groupe; activités.

Eldorado Mining & Refining Ltd., Ottawa, Ont.

7P-545 b&w 95. ca. 1930's.
Development of Radium and Uranium operations of the Eldorado Mining and Refining Ltd., Port Hope, Ont. and Port Radium, N.W.T.

Eldred, Doris E., London, England.

7P-547 b&w [80]. 1912.
Informal views and activities in Canada, including Calgary Stampede, steamers, railroads, farming, B.C. mountains, views of Quebec, Que. and Lake Superior.

Elgin, Earl of, Dunfermline, Scotland.

7P-548 Copies, b&w 12. 1848-1851.
Portrait of James Bruce, Earl of Elgin and Kincardine, 1848, by T.C. Doane; portrait of Lord and Lady Elgin, Lady Alice Lambton and Lord Mark Kerr at Montreal, 1848, by T.C. Doane; portraits of Victor Alexander Bruce, 9th Earl of Elgin, 1851.
Ref./Réf.: List of captions.
Provenance: The Earl of Elgin and Kincardine.

Eliot, Charles W.

7P-549 b&w 1. 1917.
Portrait of Charles W. Eliot by J.A. Lorenz, photographer, Boston.

Ellefsen, Marc, Chicoutimi, Que.

7P-550 b&w 110. ca. 1860-1886.
Views of Quebec cities, towns and rural areas including scenes with railways, Indians, fires, etc.; portraits of H. Mercier and M. Duplessis; a collection of 7 photographs taken by Livernois and C. Hetherington.

Elliott, J. Davis, Prescott, Ont.

7P-551 b&w 2. 1927.
View of ruins of mill at mouth of Lemon Creek and Maitland, Ont.

Elliott, W.E., Goderich, Ont.

7P-552 Copies, b&w 45. ca. 1870-1880, 1908.
Farm views of Goderich, Ont., by Reuben R. Sallows and E.L. Johnson.
Ref./Réf.: Caption List and newspaper biography of R.R. Sallows.

Ellis, W., Dartmouth, N.S.

7P-553 Copies, b&w 7. 1942.
Bristol Bolingbroke Mk. IV Aircraft of No. 8 (BR) Squadron and Curtiss Kittyhawk I Aircraft of No. 111 Squadron, R.C.A.F., Alaska.
Ref./Réf.: List of captions.
Provenance: W. Ellis.

Ells, Sidney Clarke, (1878-1971), Victoria, B.C., mining engineer, public servant.

7P-554 b&w 360, col. 235, total 595. 1914-1944.
Portraits of Dr. and Mrs. R.W. Ells, S.C. Ells and family, 1914-48; views of China, Europe, United States, 1914-48; McMurray, Alta., 1914-48; Athabaska Tar Sands, Alta., 1917-69; view of model of oilsands refinery.
Provenance: S.C. Ells.

Elmer, V., Prince Albert, Sask.

7P-555 Copies, b&w 1. 1943.
Personnel of No. 419 (Moose) Squadron, R.C.A.F., with Handley Page Halifax Aircraft VR:N of W/C M.M. Fleming.

Empringham, George, (1837-1915), Toronto, Ont., hotel keeper.

18P-55 Original, b&w 81. ca. 1900-ca. 1920.
Views of Empringham Hotel and vicinity; portraits of Empringham family.

Empry, Gino.

7P-556 b&w 1,507. 1968-1970.
Theatrical activity in Toronto, Ont., relating to "Spring Thaw" productions.

England, L. (Mrs.), Toronto, Ont.

7P-557 Copies, b&w 1. c. 1942-1944.
Group portrait of Ship's company on H.M.C.S. *Trois-Rivières*.

Eno, John C., banker, railway executive.

7P-558 b&w 1. ca. 1895.
Portraits of Messrs. T.F. Oakes and John C. Eno.

Entomological Society of Canada, (f. 1950).

7P-559 b&w 143. 1871-1963.
Views of all aspects of entomological field work and research across Canada, 1871-1963; portraits of prominent Canadian entomologists.
Ref./Réf.: Caption List.

Epstein, David, Ottawa, Ont.

7P-560 b&w 2. [n.d.].
Parliament Buildings from Major Hill Park, View of East Block, Parliament Hill, Ottawa, Ont.

Erkan, Ismet, Willowdale, Ont.

7P-561 b&w 2. 1971.
Pierre Elliott Trudeau and soccer player Pele at Varsity Stadium, Toronto, Ont.

Ernsberger, Auburn, N.Y., photographer.

31P-83 OP b&w 1. ca. 1885.
Carte-de-visite.

Esson, James, photographer.

7P-562 b&w 8. ca. 1880.
Stereograph views of Ottawa and the Thousand Islands, Ont., by James Esson.

8P-8 b&w 129. ca. 1875-1880.
Stereographs; sceneries, buildings, rural and street scenes of Sault Ste. Marie, Hamilton, Toronto, Thousand Islands, Ottawa, Ganagoque, Thunder Cape, Muskoka, Couchiching, Silver Islet, Burleigh Falls, Ont.; portrait of Chippewa Indians; SS *Nipissing,* SS *Lady of the Lake,* SS *Countess of Dufferin;* photos by James Esson.

European War, 1914-1918 - decorations.

304P-2 b&w [70]. 1914-1918.
Photos of servicemen who received the Victoria Cross during World War I.

Evening Telegram, (1879-), St. John's, Nfld., newspaper.

38P-4 b&w 52. 1976-1977.
Photographs used in issues of the newspaper.
Provenance: Evening Telegram.

Ewanchuk, Michael, Winnipeg, Man., school inspector.

9P-81 b&w 7. 1926-1970.
Ukrainian life in Manitoba.

Ewers, W.G. (Mrs.), Ottawa, Ont.

7P-563 b&w 9. ca. 1905-1923.
Views of train wreck at Pembroke, C.P.R. Engine No. 206; young girl with doll toys, 1908-1913; panoramic view of Niagara Falls, Ont.; Rowe and Corrigan families and friends vacationing at Trois Pistoles, Que., ca. 1905; children of Maurice Rowe, Ottawa, Ont. 1923.

Exposition universelle de Bruxelles, Bruxelles, Belgique.

7P-565 n.&b. 4. 1958.
Vue de l'exposition universelle de Bruxelles, Belgique, 1958.

Eykyn, D.A.D., Edinburgh Castle, Scotland, military officer.

7P-564 Copies, b&w 1. n.d.
Portrait of H.H. Robson, V.C.

Fabien, Henri Zotique, (1878-1935), Ottawa (Ont.), artiste.

185P-19 n.&b. [200], coul. [20], total [220]. ca. 1900-1973.
Négatifs sur verre, négatifs de nitrate et photographies de l'homme, de sa famille et de ses huiles fusains et statues.

Fabien, J. Henri, Ottawa, Ont.

7P-566 b&w 1. n.d.
Mr. J. Henri Fabien with Dr. R. Tait Mackenzie.

Fackenheim, Emil L., (b. 1916), philosopher and rabbi.

7P-567 b&w 10. ca. 1930-1965.
Rabbi Emil Fackenheim, at one time Professor of History, University of Toronto, Ont., with others.

Fader family, Head of St. Margaret's Bay and Halifax, N.S., fishing suppliers, fish merchants.

1P-36 Original, b&w 215. ca. 1895-ca. 1925.
Various views of Black Point and Ingramport, N.S.; unidentified actor in various costumes; unidentified individuals, Halifax and Sydney, N.S.; lumber mill and workers at Ingramport, N.S.; Fader family fish markets at Halifax and Vancouver, other fish and butcher shops; construction and opening of Memorial Tower at Halifax; Public Gardens, Halifax; apple farming, Annapolis Valley, N.S.; photographers: W.H. Edwards, W.D. O'Donnell, Platinum Photo Co., Harry J. Moss, James A. Ross, Gauvin and Gentzell, W. Chase, Kelley, Dodge, J. McLauchlin, A.R. Cogswell, O. Bertram - Stubbs, Climo, C.A. Conlon, Bayley and Murphy, R.S. Pridham.

Fahlman, M., Regina, Sask.

7P-568 b&w 1. ca. 1910.
Andreas A. and Anne Maria Fahlman family, immigrants to Canada from Katharinenthal, South Russia, in 1893, showing Russian-German style of dress.

Fainstein, Clara, Winnipeg, Man.

9P-17 b&w 81. 1908-ca. 1930.
Hoffer family, Neaman family; photographs of Hoffer, Sask., and Hodgson, Man.

Fairbanks family, Dedham, Mass. and Halifax, N.S.

1P-9 Original, b&w 50. ca. 1865-ca. 1905.
Fairbanks family house, Dedham, Mass.; Fairbanks family and friends, mainly photographed in Halifax by Notman, Gauvin and Gentzell, Bayley and Murphy and A.R. Cogswell, Mass.

Falardeau, Antoine-Sébastien, (1822-1889).

7P-569 b&w 1. ca. 1875.
Portrait of Antoine-Sébastien (Le Chevalier) Falardeau, an artist.

Falconar-Stewart, Nita, Dunblane, Perthshire, Scotland.

7P-570 b&w 2. 1907, 1943.
View of Allan Line ship *Grampian,* 1907, and of Swedish American liner *Drottningholm,* 1943.

Famee Furlane Association, (f. 1932), Toronto, Ont., mutual aid society.

7P-571 Copies, b&w 8. 1918-1960.
Toronto Manresa Pickering Italian Choir.

Fanshawe College, London, Ont.

7P-572 b&w 2, col. 16, total 18. 1974.
Views of various subjects in Utah, Colorado, New Mexico, Arizona, 1974; photos taken during the "Southern Exposure '74" Expedition by photography students of Fanshawe College: Brian Lee, Doris Neiser, Michael O'Henly, Carol Tesiorowski, Steve Matthews, Phil Martin, Martha Kuehner, Gloria Dezell-Stanley, Paulette Godin.

Farm and Country Records.

75P-7 b&w [300]. ca. 1927-1952.
Executive members of Canadian farm organizations, persons prominent in the Canadian farm movement; United Farmers' Convention, December, 1944; farmers' delegation to 1932 mass meeting in Ottawa; material relating to agricultural courses at Canadian colleges and universities.

Farman, Violet, Ottawa, Ont.

7P-573　b&w 25. ca. 1900-1903.
Views in Ottawa and area, including Hull and Ottawa fire, 1900,
Royal Visit, 1901; Parliament Buildings, Government House,
Chaudiere Falls, Rideau Falls; portraits of Lord and Lady Minto,
1903.

Farquhar, George, (1880-1975), Halifax, N.S., clergyman and lawyer.

31P-121　Original, b&w [70]. ca. 1904-1908.
Dalhousie University graduates' portraits.

Faulkner, Charles, Toronto, Ont., collector.

18P-66　b&w 51. 1908-1913.
Toronto buildings and parks.

Faulkner, Dora, (d. 1977), Halifax, N.S.

31P-30　Original, b&w 5. ca. 1910.
Theater productions.

Faulkner, Jenifer, Glasgow, Scotland.

7P-574　b&w 1. ca. 1890-1901.
Portrait of Commander Clifton-Sclater, H.M.S. *Condor,* lost off
Cape Flattery, Dec. 3, 1901.

Fauteux, Aegidius, (1876-1941), Montréal (Québec), journaliste,
bibliothécaire et historien.

103P-11　n.&b. [500]. ca. 1880-1940.
Portraits d'individus liés à l'histoire du Canada.

Fayle, L.U., Toronto, Ont.

7P-575　Copies, b&w 16. 1940-1943.
Various aircraft of the R.C.A.F., Trenton, Ont.

Feagan, Isabelle Anne, Ottawa, Ont.

7P-576　b&w 36. ca. 1870-1900.
Students, families, unidentified portraits.

Fédération des femmes libérales du Canada.

7P-1865　Originaux, n.&b. 100. 1950-1965.
Photos lors de divers congrès de la Fédération des femmes libérales
du Canada, l'exécutif national et quelques membres de cette
fédération, 1950-1965.

Federation of Canadian Archers, (f. 1927), Toronto, Ont.

7P-577　b&w 672, col. 102, total 774. 1949-1971.
Various Canadian archery championships and activities of the
Federation of Canadian Archers.

Fee, Norman, (1889-1973), Ottawa, Ont., archivist.

7P-578　b&w 2. ca. 1905.
Submarine *Unad,* St. John's, Nfld., by James Vey; Lion's Head,
Ont., by McDonald Studio, Wiarton, Ont.

Ferguson, Michael Joseph, (1839-1913), Toronto and Windsor, Catholic
priest, educator, writer.

200P-12　Original, b&w 48. 1865-1885.
Priests and other friends; photographers outside Toronto
represented include: J.E. Watson, Detroit; Ferd. Arth, Annonay,
France; Bracy Diehl, Detroit; Gubelman, Jersey City, N.J.; Chas.
Gall, Hamilton, Ont.; William Craig, Owen Sound, Ont.; Millard,
Detroit; Arthur & Philbric, Detroit; Doide & Co., Plymouth,
England; Andrew Price, Canton, Ohio; Toronto photographs
include: S.J. Dixon, J.H. Lemaitre & Co. (heavily represented),
Fraser and Sons, Notman and Fraser, E. Wing, P. Hynes.

Ferland, A., Saint-Antoine de Storthoaks, Sask., priest.

7P-579　b&w 26. ca. 1915.
Priests travelling through Moose Mountain area, Sask., ca. 1915;
views of fishing, Kenosee Lake, Sask., Storthoaks, Wilcox,
Bellegarde, Lac de Saint-Maurice, Sask; view of cemetary; croquet
game; portraits of Fr. Ferland and Fr. Poirier, Mr. Garrand, Mgr.
Prud'homme, Dr. Hébert and J. Ferland.

Ferland, Albert, (1872-1943), Montréal (Québec), poète, artiste,
fonctionnaire au Ministère des postes.

185P-14　n.&b. 12. 1883-1922.
Portrait des membres de la famille d'Albert Ferland et de quelques
amis.

Fernet-Martel, Florence, (1892), Montreal, Que.

7P-580　b&w 52. ca. 1880-1966.
Convent Jésus-Marie at Woonsocket, R.I., ca. 1880; family and
activities of Mrs. Fernet-Martel.

Ferrier, R. Douglas, Edmonton, Alta., fur trader.

92P-10　b&w 22. ca. 1920-1940.
Fur trade and transportation on Athabasca River, Fort McMurrary,
Fort Fitzgerald, Fort Wrigley, Fort Vermillion, Little Red River.

Fesenko, Michael, (b. 1900), Toronto, Ont., clergyman.

7P-581　b&w 15. 1917-1966.
Views of Ukrainian Presbyterian Church, Toronto, Ont. and various
members of the Church.

Feuz, Edward Jr., (b. 1884), Golden, B.C., Alpine climbing guide.

166P-11　Original, b&w [700], col. [275], total [975]. 1904-1976.
Original prints collected by Edward Feuz pertaining to early
mountaineering expeditions, including many first ascents, in the
Rockies and the Selkirks 1910-1945; mountaineers, packers and
guides; staff and guests of Chateau Lake Lousie; original color
slides by Edward Feuz; climbs and general scenics in the Rocky
Mountains ca. 1950-1976.

Fielding, P.S., Charlottetown, P.E.I., Deputy Provincial Secretary.

7P-582　b&w 1. ca. 1939.
Confederation Chamber, Provincial Building, Charlottetown, P.E.I.

Filey, Michael, Toronto, Ont.

7P-583　b&w 51. ca. 1865-1955.
Six views of Toronto, Ont., streets, ca. 1865-75; views in Toronto,
including Sunnyside Beach, ca. 1920-36; aerial views, ca. 1955;
Jesse Ketchum School, and miscellaneous.

Fillmore, Roscoe Alfred, (1887-1968), Centreville, N.S., gardener, socialist.

31P-118 Original, b&w 3. 1923, 1958.
Kemerobo, U.S.S.R., 1923, passport photos, 1923, 1958.

Fillmore, W.E., Amherst, N.S.

7P-584 b&w 4. 1919-1923.
Vickers Vimy aircraft of Alcock and Brown taking off on
trans-Atlantic flight, St. John's, Nfld., 1919; Martinsyde aircraft of
Major F.S. Cotton and Captain Benett, St. John's, Nfld., 1922-23.

Findlay, A.A.W. (Mrs.), Ottawa, Ont.

7P-585 Copies, b&w 35. 1927-1929.
Visit of Captain Charles Lindberg to Ottawa, Ont., July, 1927;
views of buildings, personnel, aircraft and vehicles, R.C.A.F. Station
Camp Borden, Ont.

Finland, George Harold, (b. 1901), pilot/geologist.

7P-586 b&w 79. 1928-1943.
Portrait of G.H. Finland; views of various aircraft flown by him
for Consolidated Mining & Smelting Ltd.; views of various friends
and personnel of same company; aircraft and personnel of Western
Canada Airways, Prince Albert and Lac La Ronge, Sask., including
those in search for G.H. Finland, 1930.

Finner, Francis, Ottawa, Ont.

7P-587 b&w 3. n.d.
View of Renfrew, Ont., and ruins at Ypres, Belgium.

Finnish Canadian Rest Home Association, Vancouver, B.C.

7P-588 b&w 20, col. 1, total 21. 1962-1975.
Residents, buildings and annual meetings of the Finnish Canadian
Rest Home.

Finnish Organization of Canada, (f. 1911), Sudbury, Ont.

7P-589 b&w 326. ca. 1900-1970.
Activities and members of the Finnish Organization of Canada.

First Slovak Radio Club in Canada, (1938-1967), St. Catharines and
Niagara Falls, Ont.

7P-590 b&w 8. ca. 1938-1955.
Various members, announcers, directors and producers in the First
Slovak Radio Club in Canada.

Firth, Edith G., Toronto, Ont., librarian.

7P-591 b&w 282. 1894-1900.
Views of Soulanges Canal, 1899-1900; Government House, Ottawa,
Ont. 1894; Lord and Lady Aberdeen;, Majoribanks family, 1894.

Fischer, Sarah, (1896-1975,), operatic singer.

7P-592 b&w 9. ca. 1919, 1925.
Photos relating to the career of Sarah Fischer, some dated 1919
and 1925.

Fisken, John, and Co., Toronto, Ont., commission, financial, and real estate
agency.

18P-75 Original, b&w 9. ca. 1895-1904.
John Fisken's House "Lawton Park" in Toronto.

Fitch, Stephen.

18P-85 Original, b&w 88. 1930-ca. 1957.
Toronto, Crowe's Beach; parades.

Fitzpatrick, Charles, (1853-1942), Quebec, Que., Lieutenant-Governor of
Quebec.

7P-593 b&w 200. ca. 1860-1940.
Views of Brig *Eliza,* unidentified ship, and Juvenists Convent
School, Rigaud, Que.; portraits, largely unidentified, of family and
acquaintances of the Fitzpatricks, many by Livernois, Topley,
Notman & Sandham, J.L. Jones, etc.; snapshots of family activities,
unidentified places.

Fitzsimmons, Ernie, Oromocto, N.B.

7P-594 Copies, b&w 750, col. 30, total 780. ca. 1909-1975.
Portraits of hockey players and various teams.

Fitzsimmons, Robert C., (1881-1971), Edmonton, Alta., McMurray Tar
Sands Developer.

13P-13 b&w 347. 1914-1965.
Construction and operation of the International Bitumen Co. river
steamboats, small power boats, air propelled boats, planes,
Northern Alberta Railroad, farm houses and buildings, portraits of
Fitzsimmons, Fort McMurray, inauguration of air mail service
between Fort McMurray and Aklavik and Fitzsimmon's family
photos.

Flahiff, Margaret, Sister, Halifax, N.S., librarian.

1P-37 Original, b&w 23. ca. 1890-1900, ca. 1928-ca. 1939.
Unidentified people and scenes in England; faculty and class, Arts,
Science and Commerce, Dalhousie University, Halifax, N.S., 1939.

Flavelle, Joseph Wesley, (1858-1939), industrialist, financier.

7P-595 b&w 13. 1918.
Views of explosion damage to British Chemical Factory, Trenton,
Ont., Oct. 14, 1918.

Fleet, Max and Neil Newton, Ontario, photographers.

7P-596 b&w 12,996. ca. 1954-1964.
Architectural views of buildings around Toronto, Ont.

Fleming, R.B., & Co. Ltd., London, England.

7P-597 b&w 11. n.d.
Views of room in which London Conference of 1866 was held.

Fleming, Robert John, (1854-1925), Toronto, Ont., politician and
businessman.

18P-71 Copies, b&w 21. ca. 1915.
Fleming's house in Toronto.

Fleming, Roy F., (1879-1958), Ottawa, Ont., teacher.

 <u>7P-598</u> b&w 2. ca. 1945.
 Photo of club used by Chief Blackbird at capture of Fort Dearborn
 in 1812; view of Treaty house, Manitowaning, Ont., ca. 1945.

Fleming, Sandford, (1827-1915), engineer and businessman.

 <u>7P-599</u> b&w (715). ca. 1860-1907.
 Views of the construction of the Intercolonial Railway, the
 Canadian Pacific Railway, and railways in the United States; views
 from Fort Garry to Jasper House; composite portrait of S. Fleming
 and family by Topley; album titled *Canadian Views and Studies* by
 Alexander Henderson, showing Quebec scenes; scenes of federal
 governments, 1906-07; Arctic Expedition, photos by Lancefield;
 view of laying of Pacific Cable from British Columbia to New
 Zealand, 1902.

Fletcher, W.A., Ottawa, Ont.

 <u>7P-600</u> Original, []. 1867.
 Members of the Ottawa Chess Club, June 13, 1867.

Fletcher family, Brockville, Ont., later Toronto, Ont.

 <u>18P-49</u> Original, b&w 17. ca. 1864-ca. 1867.
 Portraits of various members of family.

Flewin, W.R., Port Simpson, B.C.

 <u>12P-5</u> b&w 93. 1900-1912.
 Views of Port Simpson, Port Essington, Skeena River, Hazelton,
 Princess Royal Island, Kitwanga, Queen Charlotte Island, and
 Prince Rupert; C.P.R. boats in service; survey party in Skeena
 District (ca. 1903-1912).

Floral Show 1974.

 <u>7P-601</u> b&w 1. [n.d.].
 View of Bonaventure Island, Gaspé, Que., by William Douglas
 Bostock.

Flowers, J.F., Thunder Bay, Ont.

 <u>7P-602</u> b&w 36. ca. 1900-1920.
 Views of C.P.R. derailment, Rocky Mountains, family portraits,
 miscellaneous.

Fokes, Roy, Ottawa, Ont.

 <u>7P-603</u> b&w 1. 1930.
 Funerals of Captain Pratt and fireman Willette, May 22, 1930,
 Ottawa, Ont.

Fontaine, Jean, Plessisville (Québec).

 <u>354P-1</u> total 8,000. 1972 à nos jours.
 Photos de la vie régionale.

Foote, Lewis Benjamin, (1873-1957), Winnipeg, Man., photographer.

 <u>9P-19</u> b&w 2,464. 1906-1948.
 Photographs of major buildings, prominent citizens and visitors,
 and major events, mostly related to Winnipeg, Man.

Footner, Hulbert, Baltimore, Maryland, writer.

 <u>92P-11</u> b&w 126. 1911-1912.
 Photographs of Peace River district, Northern Alberta by Hulbert
 Footner and Auville Eager for the book *New Rivers of the North*.

Forbes, C. Mrs., Ottawa, Ont.

 <u>7P-604</u> b&w 1. 1898.
 Portraits of William E. Gladstone, by Payne, Aylesbury, England.

Fordyce, Patrick C., Wakefield, Que.

 <u>7P-605</u> b&w 2. 1895.
 Views in Ottawa of ice structure, by A.G. Pittaway, and of
 ornamental gate to Exhibition grounds.
 Ref./Réf.: Caption.

Forest City Coins, London, Ont.

 <u>7P-606</u> b&w 4. ca. 1860-1880.
 Three unidentified tintype portraits and one ambrotype of Miss
 Lizzie Rogers, Ireland.

Forester, Norman Gladstone, (b. 1898), Edmonton, Alta., pilot.

 <u>7P-607</u> Copies, b&w 18. ca. 1918-1948.
 Views of bush aircraft used between the World Wars, mail flights
 to the Yukon, 1932, and N.G. Forester flying in Europe.

Forsey, Eugene, Ottawa, Ont.

 <u>7P-608</u> b&w 250. ca. 1874-1916.
 Parliament buildings destroyed by fire, 1916, and view of Centre
 Block, June 1874; bean supper, Rideau Hall, 1900; views of towns
 in Newfoundland, Alberta, Ontario and British Columbia,
 1904-1909, by S.M. Parsons and others; views of sealing and
 fishing; portraits of Sir Robert Bond, Premier of Nfld., and Eugene
 Forsey.

Fort Point, California, U.S.A.

 <u>31P-47</u> b&w 1. ca. 1910.
 View across the Golden Gate.

Forward, Dorothy, Toronto, Ont.

 <u>7P-609</u> b&w 16. ca. 1900.
 Panoramas of the Ottawa River, showing the *E.M. Bronson,* and of
 Montreal.

Fosbery, K.G., Scarborough, Ont.

 <u>7P-610</u> b&w 2. ca. 1942-1950.
 Portraits of Lieutenant K.G. Fosbery with Lieutenant-Commander
 A.O. Take, R.C.N.V.R., and of K.G. Fosbery with a 4 x 5 format
 camera.

Foster, George Eulas, (1847-1931), politician.

 <u>7P-611</u> b&w 89. 1900-1918.
 Portraits of George E. Foster and his family; scenes of his political
 activities, particularly in the Borden Cabinet.
 Ref./Réf.: Biographical Sketch of G.E. Foster.

Foster, Margaret C., missionary.

> 7P-612 b&w 108. 1939-1954.
> Scenes of Royal Visit 1939; H.M. King George VI; H.M. Queen
> Elizabeth II; views of evacuation of Japanese Canadians to the
> interior of B.C. and settlements in B.C. and Ont., 1942-1954.

Foster, Ralph E., Ottawa, Ont.

> 7P-613 b&w 1. 1941.
> Winston Churchill and W.L. Mackenzie King outside the Centre
> Block, Parliament Hill, Ottawa, Ont.

Fotheringham, John Taylor, (1860-1940), military officer, surgeon.

> 7P-614 b&w 92. ca. 1890-1920.
> Views of a North West River Post, ca. 1890's; University of
> Toronto Medical Faculty, 1905-1906; and the Canadian Army,
> 1914-1917.

Fowler, Walter Warren, (b. 1906), pilot.

> 7P-615 Copies, b&w 29. ca. 1928-1965.
> Portrait of W.W. Fowler; views of various aircraft, personnel of
> Canadian Airways Ltd., Municipal airports at Moncton, N.B., and
> Charlottetown, P.E.I; scene of first winter airmail flight to the
> Magdalen Islands, Jan. 11, 1928.

Fox-Movietone, New York, N.Y.

> 7P-616 b&w 27. 1938.
> Street scene, Ottawa, Ont; originals; Trans-Canada Air Lines first
> crash, Regina, Sask; Nov. 22, 1938.
> Provenance: Fox-Movietone News Film.

Framed Portraits.

> 7P-617 b&w 17. ca. 1869-1950.
> Political, military and religious personalities and groups, including:
> last of the British Troops to leave Canada 1869-1870; first general
> assembly of the Presbyterian Church of Canada, 1875, by Inglis of
> Montreal; members of the House of Commons, 1893, 1902 and
> 1922; Princess Elizabeth, late 1940's; and various other political
> figures.
> Ref./Réf.: Caption list.

Fraser, Geoffrey, Toronto, Ont.

> 7P-621 b&w 116, col. 542, total 658. 1967.
> Centennial Year activities.

Fraser, H. Douglas, Mrs., Glace Bay, N.S.

> 7P-618 Copies, b&w 1. 1907.
> First wireless telegram across Atlantic Ocean from Cape Breton
> Island to Ireland, Oct. 17, 1907.

Fraser, Helen G., London, Ont.

> 7P-619 b&w 8. ca. 1890.
> Portraits of members of Fraser and Mills families; some by Frank
> Cooper, London, Ont.
> Ref./Réf.: Caption list.

Fraser, Ronald, Renfrew, Ont.

> 7P-620 Copies, b&w 42. 1915-1918.
> Scenes after First World War battles where Canadians participated,
> ie. Lens, Passchendale, Vimy Ridge, Valenciennes, Ypres.

Fraser River, B.C.

> 334P-31 Copies, b&w 128. ca. 1865-1900.
> Fishing fleet on Fraser River, delivery wagon, studio group portrait
> of children, bridge construction.

Fréchette, Louis-Honoré, (1839-1908), writer.

> 7P-622 b&w 5. [n.d.].
> Portraits of L.-H. Fréchette and views of his study.
> Ref./Réf.: Caption list.

Freeland, William Thomson, Toronto, Ont., photographer.

> 18P-36 Original, b&w 3. 1922.
> Sir John Craig Eaton's house "Ardwold", Toronto.

Freiman, Lawrence, (b. 1909), Ottawa, Ont., merchant.

> 7P-623 b&w 2,410, col. 340, total 2,750. ca. 1924-1970.
> Portraits of the Freiman family of Ottawa, Ont.;, views of their
> department store and their careers and activities; some of the
> photos are by Newton, T.V. Little, Van's Studio, Dominion-Wide,
> Lathe of Ottawa, Hands Studio, Malak, Jacques Potvin, Capital
> Press, Warrander, Notman, Castonguay and Karsh, all of Ottawa.
> Ref./Réf.: Inventory.

Frish, Neil A., Johannesburg, South Africa.

> 1P-38 Copies, b&w 68. ca. 1850-1976.
> Individual and group portraits of the Hallamore family.

Frolick, Stanley William, (b. 1920), Toronto, Ont., lawyer and community
leader.

> 7P-624 b&w 9. ca. 1920-1930.
> Views of Hillcrest, Alta.; coal mines, mine disaster.
> Ref./Réf.: Caption list.

Frontier College, (est. 1899), Toronto, Ont.

> 7P-625 b&w 5,000. ca. 1860-1960.
> Portraits of Dr. E.W. Bradwin, founder of Frontier College, and
> family members; also Mr. A. Fitzpatrick, Principal of the college,
> with his family; views of students, classrooms and activities at the
> college.
> Ref./Réf.: Short caption list.

Frost, Patricia, Sarnia, Ont.

> 7P-626 Copies, b&w 1. ca. 1940.
> Portrait of AC1, Ernest Ralph Clyde Frost, G.C., R.A.F.

Fry, Frederick Ernest Joseph, Toronto, Ont.

> 196P-12 b&w 1. 1934.
> Candid photograph showing Alan Freeth Coventry in a classroom.

Fryer, Enid, Toronto, Ont.

7P-627 Copies, b&w 1. [n.d.].
Portrait of Bryant W. Fryer.

Fryer-Keighley Collection, Toronto, Ont.

7P-628 Copies, b&w 13. [n.d.].
Portraits of Bryant W. Fryer and Geoffrey Keighley.
Ref./Réf.: Caption list.

Fuller, Howard, Winnipeg, Man.

7P-629 b&w 72. ca. 1890-1908.
Views in Manitoba, including lower Fort Garry, ca. 1890-1908.
Winnipeg, various towns scenes, automobiles, Indians 1886-1908;
Winnipeg general strike, 1919, and fire in business block of the
city; views of St. Catharines, Ont., Regina, Sask., Clinton and
Vancouver, B.C. and Edmonton, Alta., 1906-1907; miscellaneous
(e.g. Dionne quintuplets).

Fullerton, Elmer Garfield, (1891-1968), air officer, aviator.

7P-630 Copies, b&w 52. ca. 1920-1960.
Events in career of E.G. Fullerton, including his flights in "Vie"
and "Rene" aircraft of Imperial Oil Ltd.; portrait of E.G.
Fullerton.
Ref./Réf.: Caption list.

Fulton, E. Davie, (b. 1916), Ottawa, Ont., cabinet minister.

7P-631 b&w 327, col. 34, total 361. 1957-1962.
Portrait of E.D. Fulton, Minister of Justice; election campaigns of
Progressive Conservative Party, 1957-1958 and 1962; Fulton at an
officer's dinner, Rockcliffe, Ont., 1960.

Fushimi, Prince of Japan, Japan.

7P-632 b&w 12. 1907.
H.R.H. Prince Fushimi of Japan and entourage in B.C.

Futvoye, E.M., Mrs., Montreal, Que.

7P-633 b&w 4. [n.d.].
Portraits of Major George Futvoye, Deputy Minister of Militia and
Defence.

GAF Corporation, New York, N.Y.

7P-634 b&w 1. 1972.
Edward Anthony taking daguerreotype views of the Canada-U.S.A.
border in 1840.

Galbraith Collection, Toronto, Ont.

312P-2 b&w [500]. 1890 to date.
Photos of things and events around Toronto some as far back as
turn of century.

Gallaway, William E., Ottawa, Ont., film archivist.

7P-635 b&w 638, col. 155, total 793. 1915-1970.
Lantern slide views of Canadian cities, activities; allied activities
during W.W. II, ca. 1944-1945; C.P.R. locomotives, equipment,
stations; Stephen Leacock family residence, Lake Couchiching, Ont;
Sir Wilfred Laurier and group; pre-war and W.W. II photos of
German troops, politicians and activities; originals; abandoned
farm, Que. and Saskatchewan Indian and cart, ca. 1930-1932;

views and portraits, Val d'Or, Que., ca. 1928-1941; R.A. Hockey
Champions, 1946; C.P.R. engines 5926; Countess of Dufferin, Lucy
Dalton; Quebec Pageant Booklet; Capt. Vernon Castle, R.C.F.C;
group photo of R.C.M.P. and other unidentified portraits;
abandoned mine, Cobalt, Ont. 1969; views of mining towns in
Ontario and Quebec, (eg. Rouyn, Que., Kirkland Lake, Ont.)
including early construction and development; street scenes,
transportation, etc., 1915-1929; portrait of Louis Riel and group;
views of N.F.B. Fire, Beaconsfield, July 1963; trip through Western
Canada, Sept. 17, 1969; picking up Roffman Film Collection, Apr.
4, 1970; Canadian Amateur Golf Championship, Aug. 12-15, 1970;
opening of "Reflections on a Capital" Exhibit, Dec. 7, 1970;
portraits of Mary Pickford, Glenn Ford and Diana Durbin, c.
1930-1950; views of Mammoth Icicle and West Falls, Horseshoe
Falls (Niagara Falls), by George Barker, Lake Monora, by A.C.
Isaacs.
Ref./Réf.: Partial Caption Lists.

Galt, Alexander Tilloch, (1817-1893), cabinet minister.

7P-636 b&w 1. 1927.
Boy Scouts laying wreath on Galt Monument, Mount Royal
Cemetary, Montreal, Que., July 1, 1927.

Gamble, Alvan, Ottawa, Ont.

7P-637 Copies, b&w 38. 1941-1942.
Personnel, aircraft and operations of No. 1 Bombing and Gunnery
School, R.C.A.F., Jarvis, Ont.; No. 2 Bombing and Gunnery School,
Mossbank, Sask.; No. 6 Bombing and Gunnery School, Mountain
View, Ont.
Ref./Réf.: Caption list.

Gamble, Millie, (1887-), Westmoreland, P.E.I., school teacher.

5P-2 b&w 148. 1904-1919.
Farming, school, church activities in Tryon and Westmoreland,
P.E.I.

Gammon, Arthur, Mrs.

7P-638 b&w 5. 1885.
Regiments engaged in Riel Rebellion, by O.B. Buell.

Gano, John Henry, (d. 1947), Vermilion and Wainwright, Alta. and Unity,
Sask., professional photographer and homesteader.

11P-8 b&w 144. 1906-1939.
Ranching, homesteading and settlement; sod houses; Wainwright
national park and town; petroleum industry.

Garbutt, Dorothy, (ca. 1900-), Winnipeg, Man., writer.

9P-20 b&w 269. 1865-1950.
Scott and Colcleugh family photographs; views of Selkirk, Man.

Gariepy, Edgar, Montreal, Que.

7P-639 b&w 2. 1915.
Houses in Montreal, Que., by Edgar Gariepy.

Garrett, Roland S., Ottawa, Ont.

7P-640 b&w 46. 1908-1920.
Aftermath of fire in Fernie, B.C., 1908; Nels Nelson ski jumping.

Gaskell, I., Ottawa, Ont.

7P-641 b&w 2. [n.d.].
B. Squadron, Remounted Depot, C.E.F., Salisbury Plain, England;
first airplane in North Battleford, Sask.

Gates, H.L., Ottawa, Ont.

7P-642 b&w 10. ca. 1910-1940.
Lumber barges and tugboats of the Ottawa Transportation
Company; views of the *Rideau Queen* and *Rideau King;* portraits of
Allen Keefer by Karsh and of A.E. Hanington and R.E.
Wodehouse.

Gatineau Historical Society, Wakefield, Que.

7P-643 b&w 16. 1860-1910.
Events and views, Rupert and Wakefield, Que., 1860-1910; views
of properties and homes near Chelsea and Meach Lake, Que.
Ref./Réf.: List of captions.

Gaudard, Pierre, Montreal, Que., photographer.

7P-644 b&w 27. 1974-1975.
Prison life in the following institutions: Laval, Que; (Leclerc
Maximum Security and Correctional Development Centre);
Cowansville, Que.; Kingston, Ont. (Women's prison); St. Anne des
Plaines, Que. (Archambault).
Ref./Réf.: Caption list.

Gaudette, Alice, St. Catharines, Ont.

7P-645 b&w 22. 1923-1943.
Train wrecks; R.C.M.P. training; unidentified family photographs.

Gault, E.F., Ottawa, Ont.

7P-646 b&w 90. 1937-1945.
Avro Lancaster B X aircraft of No. 6 (R.C.A.F.) Bomber Group on
return from England, Greenwood, N.S., 1945; various R.C.A.F. and
civil aircraft, Trenton, Ont., 1937-1938, and Saskatoon, Sask.,
1940-1942; aircraft and activities of No. 6 (BR) Squadron,
R.C.A.F. B.C., 1938-1940.
Ref./Réf.: Caption list.

Gault, W. Lea, Ottawa, Ont.

7P-647 Copies, b&w 13. 1923-1939.
Portraits of Escort Company of the Governor-General's Foot
Guards during visit of H.M. King George VI and Queen Elizabeth,
Ottawa, Ont., and of members of Roamer Bicycle Club of Ottawa
and of Montreal Riders Bicycle Club; also George Roe.

Gauthier, Clarence, Windsor, Ont.

7P-648 Copies, b&w 3. 1945.
Surrendered German Submarine *U-190* alongside H.M.C.S.
Protector, Sydney, N.S., Sept. 5.

Gauthier, Juliette, concert singer, folklorist.

7P-649 b&w 5. ca. 1920 - 1940.
"Singers and dancers of the Seigneurie de la Petite Nation;"
portraits of Juliette Gauthier, actress, in various stage and motion
picture productions.

Gauvreau, Robert, Montréal (Québec), notaire.

131P-1 Originaux, n.&b. 64. ca. 1871-1907.
Portraits de Joseph Edward Plamondon et de sa femme Judith Paré
ainsi que de leurs descendants: John Alexander, Rena, Adelaide,
Eva Estelle, Adelaide C., Edward R., Ignace, Narcisse, Joseph,
Louise, Marie, photos prises par W. Notman, Montréal (Québec);
Vaillancourt, Montréal (Québec); Beauregard, Saint-Hyacinthe
(Québec); Archambault, Saint-Hyacinthe (Québec); H.W. Weber,
Cornwall (Ont.); Nat. W. Taylor, Asherville, Car. du N.; Van Loo,
Cincinnati, Ohio; A.B. Rue, Louisville, Kent.; S.W. Finley, Salem,
Ind.; J.R. Laughlin, Philadelphia, Penns.

Geggie, N.S., Wakefield, Que.

7P-650 b&w 33. 1880-1892, 1894-1914, 1900.
Gatineau River views, Que.; views of MacLaren's Mill; buildings
in and around Wakefield, Que., ca. 1894-1914; log jam on the
Gatineau River near Wakefield, Que., ca. 1900; views of
Wakefield, Que., ca. 1880-1892.
Ref./Réf.: Partial Caption List.

Geiger-Torel, Herman, (1907-1976), Toronto, Ont., opera director and
producer.

149P-10 b&w [10]. ca. 1950-1976.
Basically family photographs, especially with his mother and sister.

Gelling family, Bridgewater N.S.

1P-13 b&w [120]. 1859-1873, ca. 1920.
Photographs and tintypes of the Gelling family and friends, and of
British royalty.

Gely, Gabriel, Lucerne, Que.

7P-651 b&w 139. ca. 1962-1969.
Portraits of Eskimo artists and children; views of Baker Lake,
N.W.T.

Gemmill family, Sarnia, Ont.

7P-652 b&w 3. [n.d.].
2 tintypes of women; 1 portrait of Mrs. W.R. Gemmill.

General Assembly of the Presbyterian Church in Canada, (1875-).

317P-2 b&w 102. 1875-1975.
Group photographs of clergy involved with the General Assemblies.

General Motors of Canada Co. Ltd., Oshawa, Ont., automobile
manufacturers.

7P-653 Copies, b&w 5. 1939.
Dionne quintuplets with Chevrolet automobiles, Callendar, Ont.

Georgevich, Alex S., Toronto, Ont.

7P-654 b&w 9. 1923-1936.
Views of activities in Ridgetown, Ont., including: picnics, school
children, experimental farm, wedding anniversary, etc. by E. Fish.

Gertsman, S. Lillian, community worker.

7P-655 b&w 28. 1915-1964.
Activities in Ottawa, Ont., including; cast of play by Ottawa Ladies
College, ca. 1930-1940, photo by Pittaway & Jarvis; B'nai B'rith
Society activities for war veterans, 1944-1949; photos by Newton,

Gertsman, S. Lillian, community worker.
(Cont'd/Suite)

Thibault; Engineers' Wives Association activities; views of home of A.H. Caplan, by Pittaway; portrait of E.F. Pullen by Lyonde and Mr. and Mrs. A.H. Caplan, by Castonguay, Karsh.

Gervais, H.G., Sturgeon Falls, Ont.

7P-656 b&w 7. 1970.
Views of Field, Ont. and tornado disaster, Field, Ont., August, 1970.

Gibbon, Murray, Sainte-Anne de Bellevue, Que.

7P-657 b&w 1. [n.d.].
Portrait of Captain John Palliser.

Gibbons, Alan O., Mrs., Ottawa, Ont.

7P-658 b&w [150]. ca. 1864-1880, ca. 1910-1914.
Garden party for Duke of Connaught at Sir Edmund Boyd Osler's home in Toronto; portraits of E.B. Osler and Duke of Connaught, Toronto, ca. 1910-1914; unidentified cartes-de-visite and cabinet photos by various Canadian photographers.

Gibbs, S., Ottawa, Ont.

7P-659 b&w 3. ca. 1890-1910.
View of Dresden and Blasewits, Germany, 1898; H.M. King George V and Queen Mary.

Gibson, Mrs. Helen (Beny), Lethbridge, Alta., professional basketball player, secretary-assistant at University of Alberta.

92P-13 b&w 46. 1920-1929.
Student life and activities, University of Alberta campus.

Gibson, William Hewison, Victoria, B.C., photographer.

7P-660 b&w 155. ca. 1895-1910.
Aspects of Indian Life in and around Bella Bella, B.C.; view of Cowichan River, Cowichan Lake, Sproat Lake, B.C.

Gilbert, Albert, Toronto, Ont., photographer.

7P-661 b&w 15. 1966-1975.
Portraits by Mr. Al Gilbert, M.P.A., F.R.P.S., F.I.I.P., M. Photog. Cr., of prominent Canadians such as, Chief Justice Bora Laskin, Dr. Charles Best, and Messrs. Harold Ballard, Peter Gordon and Ken Forbes; examples of Mr. Gilbert's photographs of children and weddings in and around Toronto, Ont.

Gilbert, Walter Edwin, (b. 1899), Point Roberts, Wash., aviator.

7P-662 b&w 12. ca. 1917-1934.
Walter E. Gilbert in cockpit of SE5a aircraft of No. 56 Squadron R.A.F.; Walter Gilbert with Stan Knight and Richard Finnie during the aerial expedition to the North Magnetic Pole in 1930; various aircraft of Canadian Airways Ltd.

Gilchrist, Varge, Ottawa, Ont., agricultural economist.

7P-663 b&w 12. 1943-1945.
Aircraft of Nos. 11(BR) and 160(BR) Squadrons, R.C.A.F., Dartmouth, N.S., and Torbay, Nfld.

Gilchrist, W.A., Mrs.

7P-664 b&w 16. 1912-1961.
Views of Saskatoon and Estevan, Sask.; aspects of various subjects such as Agriculture and Indian Life.

Gillespie, A.

7P-665 b&w 8. 1927-1939.
Everett L. Wasson and various aircraft of British Yukon Navigation Co. and United Air Transport Ltd., Yukon.

Gilmour, Thomas Chalmers, (b. 1850), public servant and scholar.

7P-666 b&w 11. 1891-1898.
Views of Fort Saskatchewan, N.W.T.; portraits of Messrs. Geo. H. Cook, Charlottetown, P.E.I., and of Clark and Bowness, Summerside, P.E.I.; portraits by J.C. Prince of various unidentified residents of Trois-Rivières, Que.

Giroux, Albert, Sainte-Anne-de-la-Pérade (Québec).

7P-667 n.&b. 1. 1974.
Maquette du manoir où habitait Madeleine de Verchères et son époux de 1706 à 1747.

Giroux, Sylvio, Ottawa, Ont.

7P-668 b&w 2. 1897-1917.
Automobile used by Sir Wilfrid Laurier; portrait of Sir Wilfrid and Lady Laurier.

Gittel, Arch A., Winnipeg, Man., airline pilot.

7P-669 b&w 1. ca. 1951-1954.
North American Harvard IIa aircraft of No. 1 Pilot Weapons School, R.C.A.F., MacDonald, Man.

Gladish, William M., (b. 1886), Ottawa, Ont., journalist.

7P-670 b&w 25. 1914-1952.
Activities of the 109th (Cyclists) Battalion, C.E.F; Toronto, Ont., 1914, and of the Roamer Bicycle Club, Ottawa, Ont., 1920-1922; portrait of Mr. Robert Falconer, President of the Canadian Wheelmens' Association; group photo of officers of the Canadian Philatelic Society, 1951-1952.

Gleason, Arthur A., London, Ont., photographer.

7P-671 b&w 143. ca. 1900-1920.
Views in and around London, Ont.

Gleason, Herbert W., (1855-1937), Minneapolis, Minn., professional photographer.

166P-47 b&w 12. 1906, 1912.
Photogravures by Herbert Gleason; Windermere Valley, Columbia Valley, Purcell Mountains, B.C.

Glenbow Foundation, Glenbow-Alberta Institute, Calgary, Alta.

7P-672 b&w 35. 1872-1930.
Aspects of immigration to Western Canada; views of Guelph, Ont., Winnipeg, Man., Cardston and Bassano, Alta.; portraits of various officials of the Department of Agriculture, the Bank of Montreal, Ford Motor Co. of Canada, and International Harvester Co.; photos by Notman and Moffett Studios and Canadian Government Motion Picture Bureau.

Globe and Mail Ltd., The, (1844), Toronto, Ont., newspaper.

7P-673 b&w (245,000). 1962-1976.
News events of municipal, provincial and national significance in and around Toronto, Ont.; photos taken by various staff photographers of the Globe and Mail.

312P-1 b&w [1,200,000]. 1890 to date.
News events and people in the news pictures taken by staff photographers 1922 to date.

Gloucestershire Regiment, Gloucester, England.

7P-674 b&w 1. ca. 1857.
Portrait of Sergeant Herbert T. Reade, V.C. 61st (South Gloucestershire) Regiment, British Army.

Glover, Donald A., Seattle, Wash., bookseller.

7P-675 b&w 27. 1898.
Various aspects of the Klondike Gold Rush; photos by E.A. Hegg.

Glynn, Hugh, Ottawa, Ont.

7P-676 b&w 1. 1974.
Portrait of Mr. Hugh Glynn, Vice-President of the National Sport and Recreation Centre, Vanier, Ont.

Godard, George, Bridgewater, N.S., commission merchant and insurance.

1P-12 Original, b&w 29. ca. 1868-1892.
Government officials and residents of Haiti, Foreign visitors to Port-au-Prince, Haiti.

Godin, Aimé et Raoul, Hull, Que.

7P-677 b&w 7. 1919-1930.
Houses in Hull, Que.; ice cutting and ice storage buildings, Leamy Lake, Hull, Que.; portrait of M. Lorenzo Godin.

Goodeve, H.T., Mrs., Fort Hope, Ont.

7P-678 b&w 1. 1899.
Businessmen attending the opening of the Columbia Western Railway, B.C., December 1899.

Goodman, Gisli, (ca. 1893-).

9P-21 b&w 411. ca. 1870-ca. 1890.
Views of Western Canada.

Gordon, Jacob, (1877-1934).

7P-679 b&w 1. ca. 1904-1934.
Portrait of Rabbi Jacob Gordon of Toronto, Ont.

Gordon, Norman G., Westhill, Ont.

7P-680 b&w 1. ca. 1944.
F/L N.G. Gordon and crew of Handley Page Halifax aircraft *Friday the 13th* of No. 158 Squadron, R.A.F., which completed 128 operational flights over Europe.

Gordon, Victor (Capt.), (1884-1928), St. John's, Nfld., British High Commissioner to Newfoundland.

38P-5 b&w 30. 1924-1925.
Photographs of Newfoundland's exhibits at the British Empire Exhibition, 1924-1925; scenes from a Newfoundland historical pageant at the Exhibition; some photos by "Campbell-Gray" photographers of London.

Gorman, Joseph, Ottawa, Ont.

7P-681 b&w 7. 1908.
Activities of the Canadian Olympics Lacrosse Team in England.

Gorman, Thomas Patrick, (1886-1961), Ottawa, Ont., sportsman.

7P-682 b&w 101. 1900-1955.
Activities of Mr. T.P. Gorman as Lacrosse player, ice hockey team manager and sports promoter in Canada, the United States and Mexico; group photographs of various cricket, lacrosse, baseball and ice hockey teams in Canada and the United States; portraits of various National Hockey League officials and players, and of Miss Barbara Ann Scott.

Gosling, Laura M.E. (Nash), (ca. 1890-).

38P-6 b&w 37. ca. 1925.
Variety of views of St. John's and outlying settlements on the Avalon Peninsula.

Goulden, Robert A., (1859-1929), Ottawa, Ont., hotelkeeper.

7P-683 b&w 4. ca. 1880-1900.
Portraits of Mr. R.A. Goulden and family, Ottawa, Ont.

Goulden, W. Taylor, Ottawa, Ont.

7P-684 b&w 1. 1945.
Personnel of Princess Louise's Dragoon Guards, Hilversum, Netherlands.

Goulding, William S., Toronto, Ont.

196P-46 b&w 2. 1870, 1876.
Toronto School of Medicine, 1870-1871, 2nd year students; Taddle Creek, 1876, by Charlotte M.B. Schreiber.

Grace, W.J., Ottawa, Ont.

7P-685 b&w 4. ca. 1867-1896.
Portraits of Hons. Alexander Mackenzie and David Mills by James Ashfield, Ottawa; group photo of Lord and Lady Aberdeen, Sir Wilfrid and Lady Laurier and Sir Frederick W. Borden at the Citadel, Quebec, Que.

Graham, Dorothea, Ottawa, Ont.

7P-686 b&w 12. 1880-1915.
Studio of the photographer S.J. Jarvis, Ottawa, Ont.; portrait by J.F. Jackson of Mr. and Mrs. E.C. Drury, Barrie, Ont.; portraits by J.J. Abbott, J.D. Wallis, G.A. Snider, Dorion & Delorme, Pittaway & Jarvis, of various unidentified residents of Ottawa.

Graham, Eleanor, Ottawa, Ont.

7P-687 b&w 422. 1906-1920.
Views of Queen's University, Kingston, Ont.; group photographs of students of Queen's University; views of the Kaministiquia Power

Graham, Eleanor, Ottawa, Ont.
(Cont'd/Suite)

Co. Plant, Kakabeka Falls, Ont.; activities of Mr. W.H. Norrish with various field parties of the Geodetic Survey of Canada in Quebec, Ontario, Saskatchewan and British Columbia.

Graham, H.P., East Kootenay area, B.C.

333P-25　Copies, b&w 3. 1895-1920.
Steamships; elephants - Cranbrook, B.C.

Graham, Stuart, (1896-1977), Port Charlotte, Fla., aviator.

7P-688　b&w 35. 1951-1963.
Activities of Mr. Stuart Graham as an International Civil Aviation Organization advisor in countries in the Middle East, East Africa and Latin America.

Grand Trunk Railway Co., (1852-1923), Toronto, Ont.

7P-689　b&w 20. 1859-1912.
Various locomotives and train ferries of the Grand Trunk Railway Co.; views of various stations along the G.T.R. system through Ontario and Quebec.

Grant, Charity, Toronto, Ont.

7P-690　b&w 10. ca. 1890-1939.
Photos of Professor W.L. Grant with various members of the Grant, Parkin, Massey and MacDonnell families; of Sir George R. Parkin and grandson George Grant; and of Mrs. Pegi Nicol and daughter Jane.

Grant, M., Cranbrook, B.C.

333P-33　Original, b&w 5. 1905-1915.
Cranbrook, B.C.; first auto in Cranbrook, B.C.

Grant, Maude, (1880-1963), educator.

7P-691　b&w 396. ca. 1872-1935.
Activities of Professor W.L. Grant; portraits of various members of the Grant and Lawson families and their friends.

Grant, Thomas J., Montreal, Que., British Army officer.

7P-692　b&w 356. ca. 1860-1870.
Views of Halifax, N.S., Quebec, Montreal, Que., Ottawa, Niagara Falls, Ont.; various winter sports in Canada; portraits of officers of the British Army; photos by William Notman, Alexander Henderson.
Provenance: Central library, Folkestone, Kent, England.

Grant, William Lawson, (1872-1935), educator and historian.

7P-693　b&w 538. ca. 1860-1951.
Activities of the Grant, Parkin, Massey, MacDonnell and Wimperis families in England and Canada; views of Halifax and Sydney, N.S.; portraits of various members of the Grant, Parkin, Massey Families and friends; photos by Sheldon & Davis, Elliott & Fry, H.E. Simpson, A.L. Jarché.

Grantmyre, Barbara, (d. 1977), Elmsdale, N.S., author.

7P-694　b&w 1. ca. 1927.
Group of Mimac Indians, Elmsdale, N.S.

Graphic Antiquity, Arlington Heights, Ill.

7P-695　b&w 22. ca. 1855-1873.
Ambrotype view of Hamilton, Ont.; views of Halifax, N.S., Quebec, Montreal, Que., Ottawa, Niagara Falls, Ont.; photos by L.P. Vallée and William Notman.

Grassi, Lawrence, (b. 1890), Canmore, Alta., miner, alpine climbing guide.

166P-29　b&w 224. 1880-1962.
Original prints collected by Lawrence Grassi; cabinet portraits ca. 1880; Banff-Canmore people; views of Banff-Canmore area 1920-1962; 31 Rocky Mountain scenics by Richard Rushworth.

Graver, Nicholas M., Rochester, N.Y.

7P-696　b&w 7. ca. 1860-1880.
Stereographic view by J.G. Parks of Victoria Square, Montreal; cartes-de-visite; portraits of various unidentified individuals by the following photographers: J.G. Parks, Montreal, Que., J.H. Noverre, W. Windeat, Toronto, Ont., T. Hunter, Galt, Ont., W.H. Burgess, W.S. Denroche, W. Marshall, Guelph, Ont.

Graves, Wesley G., (d. 1977), Aylesford, N.S.

1P-39　Original, b&w 8. ca. 1880-1890.
Photographs and tintypes of individuals, Halifax, N.S., and eastern United States; photographers: Kelley & Co., Halifax, N.S. and American photographers.

Gray, Charles F., (1879-1954), Winnipeg, Man., engineer and municipal politician.

7P-698　b&w 2. 1913-1947.
View of Westinghouse Power Company plant, Point du Bois, Man.; banquet marking fiftieth anniversary of the Imperial Life Assurance Co. of Canada, Hotel Vancouver, Vancouver, B.C.

Gray, Jack, (b. 1927), Toronto, Ont., playwright and author.

7P-697　b&w 89. 1964.
Scenes from Mr. Jack Gray's play *Louisbourg,* Neptune Theatre, Halifax, N.S.

Gray, John, Mrs., Vancouver, B.C.

7P-699　b&w 11. ca. 1930-1945.
Photos of Lieutenant Robert Hampton Gray, V.C., R.C.N.V.R., and members of his family.

Great Britain, Army, Rifle Brigade.

18P-37　Original, b&w 37. ca. 1862-ca. 1869.
Portraits of members of the Brigade and their families; 1st Battalion was in Canada 1861-1870.

Great Lakes Historical Society, Cleveland Heights, Ohio.

7P-700　b&w 35. ca. 1913.
Views of Port Arthur, Ont.; photos of various steamships, such as SS *Noronic,* operating on the Great Lakes.

Greely, Adolphus Washington, Lt., (1844-1935), American Army officer and explorer.

7P-701　b&w 13. 1881-1884.
Activities and personnel of the Greely Arctic Expedition of 1881-1884; views of Fort Conger and Ellesmere Island, N.W.T.;

Greely, Adolphus Washington, Lt., (1844-1935), American Army officer and explorer.
(Cont'd/Suite)

portrait of Lieutenant A.W. Greely.
Provenance: National Archives and Library of Congress, Washington, D.C.

Green, Hubert Unsworth, (d. 1962), Banff, Alta., park warden, author.

166P-26 Original, b&w [260]. ca. 1930-1940.
Original prints by Hubert Unsworth Green; birds and animals of Banff and Riding Mountain National Parks.

Green, John.

9P-22 b&w 117. 1850-1930's.
Selkirk settler family.

Green, T.B., Mrs., New Westminster, B.C.

7P-702 b&w 1. 1915.
Group photo of personnel of No. 5 Canadian General Hospital, R.C.A.M.C.

Greenaway, Keith Rogers, Brig. Gen., (b. 1916), Ottawa, Ont., military officer.

7P-703 b&w 12. ca. 1940-1970.
Aspects of the career of Brigadier-General Greenaway in the R.C.A.F. and Canadian Forces, particularly his research activities in the field of Aerial Navigation in the Arctic.

Greenhill, Ralph Ackland, (b. 1924), Toronto, Ont., photographer and historian.

7P-704 b&w 270. 1859-1973.
Ambrotype and stereographs of Yarmouth, N.S., Saint John, N.B., Murray Bay, Cap à l'Aigle, Quebec, Montreal, Que., Ottawa, Port Hope, Toronto, Hamilton, Niagara Falls, Ont., Victoria, B.C.; portrait of Mr. W.A. Leggo; photos by William Notman, J.G. Parks, James Esson, J.P. Sproule, Charles Berstadt, J.W. Love, L.P. Vallée, W.J. Topley, James McClure, Ellisson & Co.; photos by Ralph A. Greenhill illustrating the books *Rural Ontario* and *Ontario Towns;* funeral procession of the Late Hon. Thomas D'Arcy McGee, Montreal, Que.; photo by James Inglis.

Greenlees, Stephen, Mrs., Ottawa, Ont.

7P-705 b&w 12. ca. 1860-1875.
Views of Ottawa, Ont., by W.J. Topley.

Greer, George S., Trenton, Ont., postal clerk.

7P-706 b&w 1. 1889.
Farm workers with threshing machine near Weyburn, Sask.

Gregg, Milton Fowler, (b. 1892), military officer and cabinet minister.

7P-707 b&w 6. 1941.
Group photos of classes at the Canadian Army Officer Cadet Training Unit, Bramshott, Surrey, England.

Grégoire, Félix, St. Jean Baptiste, Man., farmer.

9P-23 b&w 9. ca. 1890-ca. 1927.
Family photographs taken in St. Jean Baptiste, Man.

Greig family, Toronto, Ont.

18P-81 Original, b&w 104. 1890-1921.
Views of Grieg house, Queen's Park, Toronto, and vicinity; scenes on family's holidays, Canada and abroad.

Grice, Arthur D., North Vancouver, B.C., photographer.

7P-708 b&w 8. 1972-1973.
Views of buildings in Vancouver, B.C.

Grier, Col. Crawford G.M., Toronto, Ont.

196P-35 b&w 1. 1866.
No. 9 Company, Queen's Own Rifles, 1966.

Griffin, Peter, Ottawa, Ont.

7P-709 b&w 5. 1899-1930.
Group photo of 'F' Company, 43rd Battalion, 1899; visit of H.M. Airship *R-100,* St. Hubert, Que., 1930; aircraft of Nos. 2 and 3 General Purpose Detachments, R.C.A.F., Fort Fitzgerald, Alta., ca. 1930.

Griffis, C.H.R., Shaftesbury, Dorset, England.

7P-710 b&w 80. 1911-1928.
Aspects of agriculture and Indian life in Saskatchewan; views of Maidstone and North Battleford, Sask., and of Vancouver, Nanaimo and Barnston Island, B.C.

Griffis, Edith, (fl. 1913-1930), teacher.

9P-24 b&w 9. 1913.
Views of journey from Norway House to York Factory.

Grittani, Giuseppe, (b. 1907), Toronto, Ont., insurance broker.

7P-711 b&w 40. 1930-1965.
Activities of Canadians of Italian origin, Toronto, Ont.

Groh, Phillip, (1896-1975), Toronto, Ont., wainwright.

7P-712 b&w 2. 1937-1962.
Activities of German choral groups, Toronto, Ont.; " *Ein Garten Fest in Wien* " Deutschen Verein Harmonie.

Grohovaz, Giovanni Angelo, (b. 1926), Downsview, Ont., journalist.

7P-713 b&w 1572, col. 2, total 1574. 1956-1974.
Photos from the files of the newspaper *Il Giornale di Toronto* illustrating activities of the Italian community in Toronto, Ont.; portraits of Ballet Dancers such as Rudolf Nureyev and Veronica Tennant.

Grossman, John, Hedley, B.C., homesteader.

12P-24 b&w 35. 1929-1970.
Homesteading activities (ploughing, fencing, building); local views at Rose Prairie.

Grosvenor, Len, Kanata, Ont.

7P-714 b&w 3. 1927-1930.
Group photo of the London Green Stripes Team of the International Professional Hockey League, London, Ont.; photo by Dominion Panoramic Co., London, Ont.

Groupe des Sept.

7P-716 b&w 1. 1945.
Group photo of members of the "Groupe des Sept", Ottawa, Ont.:
Gustave Lanctôt, Pierre Daviault, Louvigny de Montigny, Marius
Barbeau, Seraphin Marion, Robert de Roquebrune, Marcel Dugas.

Groves, R. James, Ottawa, Ont.

7P-715 b&w 2. 1929.
Group photo of Canadian contingent en route to the Boy Scout
World Jamboree in England; Ottawa, Ont.

Guillet, Edwin Clarence, (1898-1975), Toronto, Ont., author and historian.

7P-719 b&w 60. 1865-1906.
Views of Gore Bay, Ont.; portrait of Sir John A. MacDonald by
Eldridge Stanton, Toronto, Ont.

18P-44 b&w 9. 1904.
Toronto fire, 1904.

Gunn, Ann.

334P-40 Copies, b&w 2. 1906-1908.
"Sons of Scotland" picnic, dedication of Simon Fraser monument.

Gunn, George H., (ca. 1864-1945), Lockport, Man., minister.

9P-25 b&w 196. ca. 1890-ca. 1930.
Personalities and events of Western Canada.

Gunn, Norman A., Willowdale, Ont., cinematographer.

7P-718 b&w 3. 1927.
Group photos of the original members of the Canadian Society of
Cinematographers, Toronto, Ont.

Gustafson, David, (b. 1941), Toronto, Ont., director and writer.

7P-717 b&w 136, col. 4, total 140. 1967- 1973.
Views of the Shaw Festival Theatre, Niagara-on-the-Lake, Ont.,
and of the Bishop's University Centennial Theatre, Lennoxville,
Que.; various aspects of the Charlottetown Festival, Charlettetown,
P.E.I.

Haines, Durwards M., Ottawa, Ont., hydro serviceman.

7P-720 b&w 13. 1917-1921.
Training operations of the Royal Flying Corps in Texas; group
photo of personnel of the R.A.F. School of Aerial Gunnery,
Beamsville, Ont.; flying operations of the Canadian Air Board,
Sioux Lookout, Ont.; group photo of personnel of the Canadian Air
Board, Dartmouth, N.S.

Halcro, W.A., Ottawa, Ont.

7P-721 b&w 49. ca. 1940-1945.
Various aspects of Life in Canada during the Second World War
as seen in still photos from the National Film Board's series of
documentaries *Canada Carries On.*

Hale, Reginald B., Ottawa, Ont.

7P-722 b&w 50. 1899-1907.
Views of Ottawa, Toronto, Hamilton, Brantford, Ont.; New York,
N.Y.; engines and equipment of the Grand Trunk Railway.

Haliburton, Thomas Chandler, (1796-1865), Windsor, N.S., humourist and
historian.

7P-723 b&w 2. ca. 1925-1935.
Interior of former home of Judge T.C. Haliburton, Windsor, N.S.

Halifax, N.S. - Places, Halifax, N.S.

1P-78 b&w [1,750]. 1856-.
Airport, buildings, businesses, cemeteries, churches, dockyard,
Explosion 1917 and 1945, fires, fire department, general views,
grand parade, harbour, hospitals, houses, McNab Island, market,
North End, North West Arm, Point Pleasant, police dept., Public
Gardens, schools, special events, street scenes, Town Clock,
waterfront.

31P-48 Copies, b&w 9. 1890-1945.
Martello Tower, North West Arm, Vessels in Harbour; Explosion,
1917; munitions explosion, 1945.

Halifax Citadel.

1P-15 Original, b&w 7. 1880.
Halifax Citadel, military quarters in Halifax, N.S.

Halifax (City).

1P-63 Original, b&w 35. 1963-1966.
Belvedere Apartments, Brunswick St., Halifax, N.S., after the fire,
1963; Nathaniel West house, Brunswick St., Halifax, N.S.

Halifax Local Council of Women, (est. 1894), Halifax, N.S.

1P-41 Original, b&w 17. ca. 1918-1974.
Group photos and conventions, Halifax Local Council of Women,
Nova Scotia Provincial Council of Women and National Council of
Women of Canada; photographers: Halifax Photo Service, Allen
Fraser, Harry Cochrane.

Halifax Photographic Co., Halifax, N.S., photographers.

31P-84 OP b&w 1. ca. 1885.
Carte-de-visite.

Halifax Relief Commission, (1917-1975), Halifax, N.S.

1P-42 Original, b&w [65]. 1917, ca. 1942.
Damage caused by the Halifax explosion of 1917; monuments to
the victims of the Halifax explosion; offices of the Halifax Relief
Commission, Halifax, N.S.; reconstruction in Halifax after the 1917
explosion; air raid precautions in Halifax during World War II.

Halifax School for the Blind, (est. 1872), Halifax, N.S.

1P-25 Original, b&w [450]. ca. 1890-1945.
Sir Charles Frederick Fraser, his family and their home "Farraline"
at Bedford, N.S.; various scenes in Nova Scotia, including Halifax
and the Annapolis Valley, Quebec, Massachusetts, England,
Scotland, France and Germany; photo by Charles Frederick Fraser,
Jr.

Halkett, Margaret, Ottawa, Ont.

 7P-724 b&w 3. ca. 1870-1917.
 Portraits by W.J. Topley, A.G. Pittaway and S.J. Jarvis of various
 members of the John Johnson family of Ottawa, Ont.

Hall, Emmett Matthew, (b. 1898), Ottawa, Ont., judge.

 7P-725 b&w 22, col. 1, total 23. ca. 1960.
 Portrait of Major-General Georges P. Vanier, and group photos of
 the judges of the Supreme Court of Canada.

Hall, Frank, Winnipeg, Man., journalist.

 9P-26 col. [600]. ca. 1950.
 Views of Western Canada businesses and industries.

Hall, Janet, Hudson, Que.

 7P-726 b&w 79. ca. 1917.
 Construction of bridge across the Nelson River at Port Nelson,
 Man.

Halle, André, Saint-Rédempteur, Que.

 7P-727 col. 83. ca. 1970.
 Views of communities along the North Shore of the Gulf of St.
 Lawrence in Quebec; shipping activity in the Gulf of St. Lawrence;
 aspects of the life of Montagnais Indians.

Halliday, D., Manotick, Ont.

 7P-728 b&w 8. ca. 1870-1880.
 Views of Quebec, Montreal, Que.; Ottawa, Toronto, Ont.

Halliday, Milton S., Ottawa, Ont.

 7P-729 b&w 1. 1926.
 Portrait of Mr. Milton S. Halliday, Ottawa, Ont.

Halliday, W.E. Durrant, Ottawa, Ont., public servant.

 7P-730 b&w 237. ca. 1860-1910.
 Views of Ottawa, Almonte, Ont.; Pointe-Gatineau, Kirks Ferry,
 Que.

Hambourg, Clement, Toronto, Ont.

 7P-731 b&w 1. ca. 1926.
 Group photo of members of the Hart House String Quartet,
 Toronto, Ont.; Messrs. Harry Adaskin, Milton Blackstone, Geza de
 Kresz, Boris Hambourg.

Hamilton, Ont., (1846-), Hamilton, Ont.

 45P-1 b&w [3,000]. 1860's to present.
 Photographs of many aspects of city life in Hamilton, including
 photos of street scenes, buildings, special events, portraits.

Hamilton, S. Ross, Pointe Claire, Que.

 7P-732 b&w 2. ca. 1944.
 Consolidated Liberator GR VI Aircraft of No.10(BR) Squadron,
 R.C.A.F.

Hamilton, W. Raymond, Brampton, Ont.

 7P-733 b&w 16. 1940-1945.
 Personnel and activities of the Cameron Highlanders of Ottawa in
 Iceland, England, and Germany during the Second World War.

Hamilton, Zachary, M.

 7P-734 b&w 1. ca. 1885-1897.
 Portrait of Mr. H.H. Smith, Dominion Lands Commissioner
 1885-1897.

Hamilton, Zachary M., (ca. 1872-1950), Regina, Sask., journalist.

 9P-27 b&w 121. 1870-1945.
 Personalities, places, events in Western Canada.

Hammond, Melvin Ormond, (1876-1934), Toronto and Ottawa, Ont.,
journalist photographer and author.

 8P-1 Original, b&w [3,000]. 1898-1933.
 Portraits of politicians, journalists and Canadian artists such as
 Alfred Laliberté, Dorothy Stephens, Arthur Lismer, Dickson
 Patterson, Joseph Saint-Charles, Gertrude Spurr Cutts, John
 Hammond, James Henderson, John W. McLaren, Paul Alfred,
 Emily Carr, Louis Jobin, John Alexander Ewan, Duncan Campbell
 Scott, Sir Wilfrid Laurier, Hon. William Templeman and Hon.
 Sydney Arthur Fisher; portraits of the M.O. Hammond family;
 rural and street scenes of Brantford, Meadowdale, Hamilton,
 Niagara Falls, Niagara-on-the-Lake, Ottawa and Toronto, Ont.;
 Quebec, ile d'Orleans, Lachine, Saint-Denis, Montreal,
 Trois-Rivières, Sherbrooke, Que.; Halifax, Yarmouth, Wolfville,
 Chester, N.S.; Saint John, Fredericton, N.B.; photos by M.O.
 Hammond.

 196P-8 b&w 77. ca. 1880-ca. 1900.
 A collection of photographs of Canadian artists, most of whom
 were founding and early members of the Royal Canadian Academy
 of the Arts (R.C.A.) which was formed in Ottawa in 1880;
 biographical information about each artist is included on the back
 of each photograph.

Hamwood family, Saskatchewan and Toronto, Ont.

 18P-86 b&w 112. 1906-1939.
 Family portraits; Saskatchewan farm; Toronto scenes.

Hand, Kenneth H., Montreal, Que., photographer.

 7P-735 b&w 7. 1941.
 Students celebrating graduation from No. 3 Wireless School,
 R.C.A.F., Winnipeg, Man.

Hand, Stella, Ottawa, Ont.

 7P-736 b&w 15. ca. 1900-1911.
 Views of Ottawa, Ont.

Handford, Arthur L., Renfrew, Ont., photographer.

 7P-737 b&w 257. ca. 1900-1915.
 Views in and around Renfrew, Ont.

Handy, Clifford.

 31P-108 Copies, b&w 10. [n.d.].
 Ships and shipbuilding.

Hanson, Richard Burpee, Hon., (1879-1948), Fredericton, N.B., politician and lawyer.

7P-738 b&w 1. ca. 1940.
Portrait of Hon. Richard Burpee Hanson, leader of the Conservative Party, 1940-1943.

Harding, Alice, Vancouver, B.C.

166P-27 Original, b&w 254. 1915-1917.
Original prints collected by Alice Harding; people, events and scenery at Glacier House, (former CPR hotel in Roger's Pass, B.C.) 1915-1917.

Hardy, Una M., New Westminster, B.C.

7P-739 b&w 2. 1876-1910.
Carte-de-visite portrait of Mr. W.R. Burrows and family, 1876; composite photo of the Y.M.C.A. Senior Basketball Team, Sherbrooke, Que. 1910.

Hare, Mary P., Oshawa, Ont.

7P-740 Copies, b&w 194. 1860-1950.
Views of Oshawa and Muskoka, Ont.; views of carriage and automobile manufacturing by the McLaughlin Carriage Works and by General Motors of Canada Company Ltd.; scenes of automobile, speedboat and aircraft racing; portraits of various members of the McLaughlin family.

Harley, Mr.

7P-741 b&w 1. 1858.
View of the Roman Catholic Cathedral, St. Boniface, Man.; photo by H.L. Hime.

Harlow, Frederica, Gallery Inc., New York, N.Y., art dealers.

7P-742 b&w 1. ca. 1860-1870.
Views of Montmorency Falls, Que.

Harman family, Toronto, Ont.

18P-65 Original, b&w [1,000]. 1860's-1940's.
Family portraits and scenes, Victoria, B.C.; Cardston and Lethbridge, Alberta.

Harmer, William Morell, (1859-1949), Ottawa, Ont., photographer.

7P-743 b&w 388. ca. 1900-1910.
Views in and around Ottawa, Ont., and Aylmer, Que.; lumbering operations in the Ottawa River Valley and in Michigan; photos by W.M. Harmer.

Harmon, Byron, (1880-1942), Banff, Alta., professional photographer.

166P-3 Original, b&w [6,500]. 1907-1942.
Original negatives by Byron Harmon; annual camps and expeditions of the Alpine Club of Canada in the Canadian Rockies and Selkirks, 1907-1913; private movie-making expeditions in the Canadian Rockies and Selkirks; mountain scenics for postcard purposes, Banff events and development; skiing; road construction; birds and animals.

Harmon, Donald, (b. 1917), Banff, Alta., professional photographer.

166P-20 b&w [350], col. [50], total [400]. 1883-1970.
Original and copy prints collected by Donald Harmon; Rocky Mountain scenics used for commercial purposes; Banff people; views of Banff townsite and surrounding area ca. 1883-1915.

Harmon, Lloyd, (b. 1914), Banff, Alta., professional photographer.

166P-7 Original, b&w [2,500]. ca. 1930-1950.
Original negatives by Lloyd Harmon; views of Banff and surrounding area; general mountain scenics of Banff and Jasper National Parks, 1940-1950; skiing - Sunshine, Norquay, Alta.; touring, racing, jumping, technique shots; personalities, 1933-1940.

Harms, William L.

7P-744 b&w 6. ca. 1910-1920.
Construction of the Grand Trunk Pacific Railway from Edmonton, Alta., and Prince Rupert, B.C.

Harries, James Leslie, London, England.

7P-745 b&w 1. ca. 1943-1945.
Portrait of Commander J.L. Harries, G.M. and Bar, R.C.N.V.R.

Harrington, Charlotte Geddie, Halifax, N.S.

31P-29 Original, b&w 25. ca. 1850.
Rev. John Geddie and his family; Geddie's mission in Aneityum (Anatom), New Hebrides; mission houses of fellow missionaires in New Hebrides; mission ship *Dayspring;* Geddie Memorial Church, Park Corner, P.E.I.

Harrington, Richard Walter, (b. 1911), Toronto, Ont., photographer and author.

7P-746 b&w 6,116. 1948-1953.
Aspects of Eskimo life and views of such places as Coppermine, Padlei, Spence Bay, Igloolik, N.W.T.; photos by Richard W. Harrington.

Harris, Gladys M., Torrington, Devon, England,.

7P-747 b&w 1. ca. 1885.
Portrait of Dr. Henry Trevan, R.N.

Harris, Lawren Stewart, (1885-1970), Toronto, Ont.; Vancouver, B.C., artist.

7P-748 b&w 66, col. 14, total 80. 1911-1969.
Artistic activities of Mr. Lawren S. Harris and of other members of the Group of Seven such as Messrs. Tom Thomson, Fred Varley, A.Y. Jackson, J.E.H. MacDonald and Arthur Lismer.

Harris, Robert E., (1860-1931), Annapolis Royal, Yarmouth and Halifax, N.S., Chief Justice of Nova Scotia.

1P-43 Original, b&w 9. 1910-ca. 1928.
Portraits of Robert E. Harris; miners at Wabana, Bell Island, Nfld.; photographers: W.R. Macaskill, Harry J. Moss.

Harrison, William Joseph, (1878-1963), Ottawa, Ont., sculler and businessman.

7P-750 b&w 20. ca. 1910.
Group photos of various teams of the Ottawa Rowing Club, Ottawa, Ont.

Harriss, Charles Albert Edwin, (1862-1929), London, England and Ottawa, Ont., composer, choir director and impressario.

149P-11 b&w [10]. ca. 1880-1925.
Various photographs of famous musicians with whom Harriss worked during his lifetime.

Hartill Art Associates, (1976-), London, Ont., architectural photographer and art historian team.

313P-1 Original, col. [18,000]. 1976 to date.
Architectural subjects; Canadian ecclesiastic, civic and domestic; European, Mexican and Brasilian subjects.

Hartling, Philip, (1952-), Dartmouth, N.S., microfilm archivist.

1P-26 Copies, b&w [230]. ca. 1890-1972.
People and scenes, including houses, churches, schools, stores and transportation, of various communities on the "Eastern Shore" of Nova Scotia, including Harrigan Cove, Moser River, Mushaboom, Port Dufferin West, Sheet Harbour Passage, Sober Island, Upper Musquodoboit and West Quoddy; workers at lobster factories at Fox Harbour and Malagash, N.S.

Hathaway, Ernest J., Mrs., Toronto, Ont.

7P-749 b&w 2. ca. 1890-1929.
Portraits of Messrs. Bliss Carman and R.H. Hathaway.

Hatheway, Leslie G., Mrs., Ottawa, Ont.

7P-751 b&w 3. [ca. 18-]-1914.
Portraits of Captain S.J. Bogart and Maria L. Bogart; group photo of Midshipmen who graduated from the R.C.N. College at Halifax, N.S., serving aboard H.M.S. *Berwick*.

Haultain, H.E.T., Toronto, Ont.

196P-42 total 70. n.d.
H.E.T. Haultain, individual and group; Louis B. Stewart; James Brebner; C.H. Mitchell; the infrasizer, Haultain's invention, views and pictures of process; scrapbook, probably of MacLeod, Alta., group; individual, scenic, technical, quarry and topographical photographs; photos of Barkerville and Yellowstone Mine, B.C.

Hawkins, T. Hartley, Ottawa, Ont., public servant.

7P-753 b&w 394, coul. 364, total 958. 1909-1957.
Events such as the visits of the Prince of Wales, and of King George VI, to Ottawa, Ont.; the "On to Ottawa" trek of unemployed men in 1935; activities of the railway mail service of the Post Office Department; aspects of the Sixth Commonwealth Mining and Metallurgical Congress, 1957; activities of the Hawkins and Woodside families; views of Ottawa, Renfrew, Kingston, Port Arthur, Ont.; Vancouver, B.C.; group of members of the Civil Service Commission.

Haynes, William, Stonington, Conn.

7P-752 b&w 34. 1928-1929.
Views of various places in Nova Scotia and on Cape Breton Island; photos by William Haynes.

Hays, Charles Melville, (1856-1912), railway executive.

7P-754 b&w 143. 1910.
Activities of Mr. C.M. Hays, president of the Grand Trunk Pacific Railway, and party during annual inspection trip of the G.T.P. system, August - September 1910.

Hayter, Henry Winston, (1900-1974), Edmonton, Alta., aviator.

7P-755 b&w 42. 1922-1940.
Aspects of the aviation career of Mr. H.W. Hayter in Western Canada and the Northwest Territories.

Hayward, Lawrence, (b. 1930), Elgin, Ont.

8P-5 Original, b&w [2,500], col [2,454], total [4,954]. 1963-1977.
The collection consists of colored and black and white slides depicting sculptural works; the slides are arranged alphabetically by sculptors such as: Philippe Hébert, Jacobin Jones, Alfred Laliberté, Florence Wyle, Alfred Howell, R. Tait McKenzie and Elenor Milne; and by buildings such as: the Bank of Montreal in Ottawa and Toronto, Ont.; the Basilica, Quebec, Que.; Dominion Public Building, Hamilton, Ont.; and McLaughlin Estate, Oshawa, Ont.; photos by Lawrence Hayward.

Hayward Studios, Montreal, Que., photographers.

7P-756 b&w 100,000. ca. 1915-1950.
Views in and around Montreal, Que.; activities, personnel and facilities of firms such as Canadian Vickers Ltd., Canada Steamship Lines, and Steinberg's Ltd., Montreal, Que.

Hazelgrove, A. Ronald, Kingston, Ont., nylon works supervisor.

7P-757 b&w 1. ca. 1880-1900.
View of Old Arts Building, Queen's University, Kingston, Ont.

Hazelgrove, Ronald, ([1913]-1978), Kingston, Ont., librarian.

75P-11 b&w [1,000]. ca. 1960-1970.
Slides of stone buildings in Kingston and Frontenac County.

Heaslip, Robert Thomas, (b. 1919), Thornhill, Ont., military officer and aerospace executive.

7P-758 b&w 9. 1945-1967.
Aspects of the career of R.T. Heaslip as a helicopter pilot in the R.C.A.F.

Hebrew Sick Benefit Association, (est. 1906), Winnipeg, Man.

7P-759 b&w 1. 1946.
Fortieth anniversary dinner of the Hebrew Sick Benefit Association, Winnipeg, Man., 26 October 1946.

Hector Centre, Pictou, N.S.

31P-110 Copies, b&w 2. ca. 1890.
Ship *Helga* and Barque *Swanhilda*.

Heels, C.H., collectionneur.

7P-760 n.&b. 247. 1870-1938, 1950-1960.
Locomotives du Grand Tronc, ca. 1886-1938; locomotives du Canadien Pacifique, ca. 1881-1960; locomotives de la compagnie Temiskaming and Northern Ontario, 1917-1922; locomotives du Midland Railway, 1875-1906; locomotives du Canadian Northern, 1908; locomotives du Northern Railway, du South Eastern et du Great Pacific Eastern; trains sur la ligne transcontinentale, 1911; accidents ferroviaires.

Heeney, Arnold Danforth Patrick, (1902-1970), public servant.

7P-761 b&w 188. 1900-1970.
Activities of Mr. Arnold D.P. Heeney as clerk of the Privy Council and Secretary to the cabinet, Under-Secretary of State for External Affairs, Canadian Ambassador to the United States, and Canadian Chairman of the Permanent Joint Board on Defence; portraits of various members of the Heeney family.

Hehner, Eric O.W., (b. 1913), Ottawa, Ont., lawyer.

7P-763 b&w 47. 1894-1944.
Portraits of Sir Wilfrid and Lady Laurier and of members of the Wartime Industries Control Board.

Heikkila, Vihtor, Downsview, Ont.

7P-764 b&w 2. ca. 1945-1947.
Children's Christmas Parties organized by the Yritys Athletic Club, Toronto, Ont.

Hein, Lester C., Port Washington, N.Y., collector.

7P-762 b&w 21, col. 21, total 42. 1899.
Stereographs by B.W. Kilburn of St. John's Nfld., Montreal, Que., Vancouver B.C., Nelson, Cranbrook, B.C., and of C.P.R. operations in British Columbia.

Helbecque, Raymond G., Ottawa, Ont.

7P-765 b&w 9. ca. 1917-1918.
Curtiss JN-4(CAN) aircraft of the Royal Flying Corps, Leaside, Ont.

Hellmen, Fee, (1918-), TaTa Creek, B.C., watchman.

333P-21 Copies, b&w 14. 1934-1937.
TaTa Creek, B.C.; John Lambi House; Fee Hellman.

Henderson, Alexander, (1831-1913), Montreal, Que., photographer.

7P-766 b&w 22. ca. 1863-1875.
Views of Tadoussac, Montreal, Lake Memphremagog and area, Beauport, Que.; shipbuilding at Dorchester, N.B.; photos by Alexander Henderson.

18P-4 Original, b&w 106. ca. 1870-ca. 1885.
Views of Montmorency Falls, Quebec City, Montreal, by Henderson; also views of Chicago, Denver, Salt Lake City and San Francisco.

18P-24 Original, b&w 26. ca. 1870-ca. 1880.
Views in province of Quebec, Montreal, and British Columbia.

113P-5 n.&b. 38. ca. 1863-1869.
Photos de paysages canadiens provenant surtout du Québec; photos de rues et d'édifices lors de violentes tempêtes de neige et de la fonte des neiges, Montréal.

123P-4 b&w 90. 1863-1879.
Three albums: Canadian views and studies photographed from nature ca. 1865; wrought iron railroad bridges constructed and erected for the government of the Dominion of Canada on the line of the Q, M, O and O Railway; and one untitled album; views of Montreal, St. Lawrence River, St. Ann's, Ottawa River, Lac des Isles, Lake Salmon River, Maskinonge River, Lake of 1,000 Islands, St. Maurice River, Manitou Falls, Restigouche River, Truro, N.S., Saguenay River, Kamouraska, Montmorency; Metis.

327P-2 total 800. 1858-1900.
Boats, city views, buildings, street scenes, farms and farming, Indians, landscapes, railways, rural architecture, villages; mostly Quebec and Maritimes, some photographs of western trips to British Columbia; a few portraits.

Henderson, L.J., Mrs., Toronto, Ont.

7P-767 b&w 7. ca. 1890-1943.
Portraits of Sir Charles G.D. Roberts, his parents and his brother Theodore G. Roberts.

Hendrie, William, (Senior), (1831-1906), Hamilton, Ont.

45P-7 Original, b&w 19. [n.d.].
Interior of Holmstead, the Hendrie home.

Hendrie family, Hamilton, Ont.

45P-5 Original, b&w [300]. 1899-1902.
Interior of the Hendrie home "Gateside", various hunting and fishing vacations by the Hendrie family, 1899-1902, Hendrie horses, members of the Hendrie family, cartes-de-visite.

Hendry, Janet, Dryden, Ont.

7P-768 b&w 1. ca. 1940.
Portraits of Corporal James Hendry, G.C., No. 1 Tunnelling Company, R.C.E.

Hendry, Thomas Best, (b. 1929), Toronto, Ont., playwright and theatre administrator.

7P-769 b&w 46. ca. 1961-1965.
Activities of Mr. Tom Hendry as playwright and theatre administrator; scenes from various plays directed by Mr. Hendry; exterior and interior views of the Manitoba Theatre Centre, Winnipeg, Man.

Heney, J. Bower L., Ottawa, Ont.

7P-771 b&w 324. ca. 1925-1935.
Views and buildings in and around Ottawa, Ont.; photos by J.G. Heney and S.J. Jarvis.

Henry, D., Miss, Red Deer, Alta.

7P-770 b&w 17. 1921.
Oil drilling operations, Norman Wells, N.W.T.; activities of the Junkers F-13 aircraft G-CADP "Vic" and G-CADQ "René" of Imperial Oil Co.; portrait of Mr. David Henry.

Henry, Eugene M., Ottawa, Ont., consultant.

7P-772 b&w 14. ca. 1880-1930.
Views of Oshawa, Ont.

Herbert, Ivor John Caradoc, (1851-1933), military officer.

7P-773 b&w 1. ca. 1875-1885.
Portrait of Lady Albertina Herbert, wife of Major-General I.J.C. Herbert.

Hermon, E.B., Vancouver, B.C., engineer.

12P-4 b&w 140. 1903.
Construction of Lake Buntzen Power Plant, Burrard Inlet, 1903.

Héroux, George, (d. 1957), Trois-Rivières (Québec), photographe.

315P-1 total [10,000]. 1930-1957.
Photographies d'individus de la région.

Herridge, Herbert Wilfred, (1895-1973), member of Parliament.

7P-774 b&w 1. ca. 1968.
Miss Nancy Greene with members of the Royal Canadian Legion.

Hetherington, George A., (1851-1911), Saint John, N.B., physician.

7P-775 b&w 336. ca. 1883-1886.
Views of various places in Europe, Canada and the United States.

Hicklin, Ralph, (1923-1970), Toronto, Ont., Canadian ballet and theatre critic.

18P-69 Original, col. 27. ca. 1963.
Ryerson Polytechnical Institute, Toronto, Ont., convocation and demolition of old building.

Hicklin, Ross, Chatham, Ont.

7P-776 b&w 14. ca. 1930.
Interior views of the home of Dr. T.K. Holmes, Chatham, Ont.

Hicks, A.R., Beaconsfield, Que.

7P-777 b&w 4. ca. 1895-1930.
Portraits of the Marquess of Aberdeen and Lady Aberdeen.

Hicks, James Henry, Winnipeg, Man., prospector.

9P-28 b&w 66. 1910-1925.
Photographs of family members and of Penniac Gold Mine, Man.

Higginson, T.B., Scarborough, Ont.

7P-778 b&w 43. ca. 1860-75.
Views of Montreal, Que.; photos by Alexander Henderson.

Higgonson's Plaster and Marble Dust Works, Newburgh, N.Y.

31P-85 Copies, b&w 1. ca. 1900.
Higgonson's plant.

Higgs, David C., Toronto, Ont.

7P-779 b&w 4. ca. 1966-1968.
Portuguese-Canadian Festival 'Senhora Da Monte', Madeira Park, Toronto, Ont.

Hileman, T.J., Kalispell, Montana, professional photographer.

11P-7 b&w 39. ca. 1920-1930.
Negatives of portraits of Blood and South Peigan Indians.

Hilger, Jone, Bismark, N.D.

7P-780 b&w 1. ca. 1860-1865.
Portrait of Chief Standing Buffalo of the Sioux Tribe.

Hill, A. Edward, Vancouver, B.C., physician.

7P-781 b&w 70, col. 70, total 140. 1918-1945.
Private and commercial aircraft and balloons, Montreal, Que., and Toronto, Ont.; aircraft and operations of the R.C.A.F., Nfld.

Hill, Isabel Louise, Fredericton, N.B., historian.

7P-782 b&w 42. ca. 1870-1880.
Views of various towns along the Saint John river from Fredericton to Edmundston, N.B.; photos probably by Mr. Henry G.C. Ketchum, Chief Engineer of the New Brunswick Railway.

Hill, Shuldham H., Ottawa, Ont., military officer.

7P-786 b&w 14. ca. 1860-1911.
Cartes-de-visite; portraits of various residents of Quebec, Que., and Halifax, N.S.; photos by William Chase, T.C. Doane, Ellisson & Co., J.E. Livernois, C. Smeaton, W. Webb; group photo of Canadian cadets with trophies won in rifle matches in England, 1911.

Hill family.

334P-24 Copies, b&w 5. ca. 1905.
Family home; hardware store.

Hillman, Aleck B., Ottawa, Ont., military officer.

7P-785 b&w 143, col. 114, total 257. 1946-1974.
Aerial views of Halifax, N.S.; survey flights of No. 413 Squadron, R.C.A.F., in the Northwest Territories; Avro CF-100 and Canadair Sabre Aircraft of the R.C.A.F.; funeral procession of Major-General George P. Vanier, Ottawa, Ont.

Hills, Albert, Pointe-Gatineau, Que.

7P-783 b&w 9. 1890-1901.
Stereographs of the South African War; portrait of Field Marshal Lord Roberts.

Hills, Arthur J., (1879-1971), railroad executive and public servant.

7P-784 b&w 113, col. 1, total 114. ca. 1850-1919.
Daguerreotype portraits of unidentified couple; activities of Mr. A.J. Hills as a member of the Canada Labour Relations Board and as a member of various sporting clubs in Montreal, Que., and Toronto, Ont.; portraits of the family and friends of Mr. Hills.

Hillyard, Len, photographer.

339P-2 Original, []. 1930-1965.
The development of Saskatoon; the construction of Bessborough Hotel and the building of the Broadway Bridge and other significant landmarks are dealt with.

Hime, Humphrey Lloyd, (1833-1903), Toronto, Ont., photographer and businessman.

9P-29 Original, b&w 36. 1858.
The Red River Settlement taken for the Assiniboine and Saskatchewan Exploring Expedition.

Hime, Humphrey Lloyd, (1833-1903), Toronto, Ont., photographer and businessman.
(Cont'd/Suite)

18P-9 Original, b&w 37. 1858.
Assiniboine and Saskatchewan Exploring Expedition of 1858.

Hime, Maurice W., Seattle, Wash.

7P-787 b&w 4. ca. 1870-1920.
Troops of the Queen's Own Rifles of Canada at Fort Gary, Man.; arch welcoming the Marquis of Lorne to Winnipeg, Man.; photo of SS *Chicora* by James Egan; monument commemorating the battle of Ridgeway, Toronto, Ont.

Himmelman, George, Capt., (b. 1881), Lunenburg, N.S., ships' captain.

31P-40 Original, b&w 15. ca. 1925-1945.
Career of Captain G. Himmelman; schooners *Lila B. Boutilier, Canusa,* and *Pilgrim;* trawler *Geraldine S,.*

Hinchley, Harry, Renfrew, Ont., historian.

7P-788 b&w 288. 1860-1974.
Events and views in and around Renfrew, Ont.; portraits of individuals and group photos of organizations active in Renfrew, Ont.

Hines, Sherman, Halifax, N.S., photographer.

7P-789 b&w 5. ca. 1890-1910.
Interior view of the photographic studio of Gauvin & Gentzell, Halifax, N.S.

Hinman, Caroline B., (1854-1966), Summit, N.J., conducted tour guide.

166P-5 Original, b&w [4,500], col. [100], total [4,600]. 1913-1956.
Original prints collected by Caroline B. Hinman pertaining to pack trips in the Canadian Rockies ca. 1913-1940; original slides by Caroline B. Hinman of motor trips in the Canadian Rockies 1946-1956.

Hiscocks, Bettie, Ottawa, Ont.

7P-790 b&w 1. 1941-1943.
Rt. Hon. Winston Churchill and Hon. W.L. MacKenzie King; photo by Toronto Star Syndicate.

Historical Society of Ottawa, Ottawa, Ont.

7P-791 b&w 2. 1971.
Statue of Colonel John By, Ottawa, Ont.

Hoag, Robert, Oakville, Ont.

7P-793 b&w 3. 1945-1947.
Consolidated Liberator and Bristol Bolingbroke aircraft of the R.C.A.F.

Hoare, Robert, (1878-1964), Bowden, Alta., photographer.

13P-4 b&w 823. ca. 1906-1931.
Photographs taken in Bowden, Alberta relating to: individual portraits, agriculture, transportation, buildings, groups, and of Innisfail and Olds, Alta.

Hockey Hall of Fame, Toronto, Ont.

7P-792 b&w 1,161. 1877-1970.
Activities of Canadian athletes, portraits of individual athletes and members of the Hockey Hall of Fame, and group photos of teams competing in many types of sports in both national and international competitions.

Hoferichter, Norbert R., (b. 1939), Port Credit, Ont., photographer.

7P-794 b&w 864. 1972.
Scenics, poverty, pollution, family life and old age in Canada; photos by Mr. N.R. Hoferichter, Canadian professional photographer of the year in 1970 and 1971.

Hoffer, Clara, Hoffer, Sask.

7P-795 b&w 31, col. 2, total 33. 1920-1975.
Activities on the farm of Israel Hoffer, Hoffer, Sask.; portraits of members of the Hoffer family.

Hogan, Lyla, Ottawa, Ont.

7P-796 b&w 1. 1897.
Sir Wilfrid Laurier and Sir Louis Davies with the Prime Ministers of Australia and New Zealand during visit to the estate of Rt. Hon. W.E. Gladstone, Hawarden, Wales.

Holden, Alan T., St. Catharines, Ont.

7P-797 b&w 3. 1861-1899.
Group photo of veterans of the War of 1812, Toronto, Ont., 1861; photo by William Armstrong; group photo of members of the 44th Regiment, Niagara, Ont., 1899; portrait of Lieutenant-Colonel E.A. Cruickshank.

Holder, Richard B., Aurora, Ont., photographer.

7P-798 b&w 50,000. ca. 1935-1945.
Views of buildings in and around Aurora and Newmarket, Ont.; portraits of residents of Newmarket, Ont.

Holland.

334P-41 Copies, b&w 1. 1906.
Trap-shooting in Moody Park, New Westminster, B.C.

Holland, L.J., Mrs., Winnipeg, Man.

9P-30 b&w 14. 1924-1977.
Photographs of 28th Brownie Pack, St. James, Man.

Hollick-Kenyon, Herbert, (b. 1897), Vancouver, B.C., aviator.

7P-799 b&w 14. ca. 1928-1940.
Activities of Mr. Herbert Hollick-Kenyon as pilot with Western Canada Airways Ltd., Canadian Airways Ltd., and with the Lincoln Ellsworth Expedition to the Antarctic; portraits of Mr. Hollick-Kenyon.

Holmes, Alice S.

7P-800 b&w 1. ca. 1900-1924.
Portrait of Mr. James Yates Egan.

Holroyde, H.

7P-801 b&w 12. 1914-1918.
Various types of Allied military aircraft used during World War One.

Holt, Bernard N., St. Catharines, Ont., public servant.

7P-802 b&w 12. 1914-1925.
Departure of the 7th Battery, C.F.A., St. Catharines, Ont. 1914; panoramic views of various German-held positions facing Canadian troops in France and Belgium, 1917-1918; construction of the Welland Canal, Ont., 1925.

Home Bank of Canada (The), (1903-1923), Toronto, Ont., chartered bank.

7P-803 b&w 25. 1923-1932.
Views of Moose Jaw, Tantallon, Sask.; Howe Sound, B.C.; annual meeting of the Chartered Institute of Secretaries, 1932; portrait of Mr. Isaac E. Weldon.

Honey, F.I., Sainte-Anne-de-Bellevue, Que.

7P-804 b&w 1. ca. 1918.
Portrait of Lieutenant S.L. Honey, V.C. D.C.M., M.M., 78th Battalion, C.E.F.

Hood, A.S., Yarmouth, N.S., photographer.

31P-86 Original, b&w 1. 1873.
Western Counties' Railroad.

Hoodspith, Randolph B., Ottawa, Ont.

7P-805 b&w 2. 1939.
Blackburn Shark II aircraft of No. 6(TB) Squadron, R.C.A.F., Jericho Beach, B.C.

Hoover, Frederick A., La Jolla, Calif.

7P-806 b&w 3. 1911-1914.
Mr. Glenn Curtiss after making first successful seaplane flight from San Diego Bay, Calif., 1911; Messrs. Glenn Curtiss and Henry Ford, Hammondsport, N.Y., 1914; portrait of Mr. Glenn Curtiss.

Hope, Lois, Ottawa, Ont.

7P-807 b&w 1. 1910.
View looking west from Kent St. along Laurier Ave. West, Ottawa, Ont.

Hôpital de l'Hôtel-Dieu de Québec, (f. 1639), Québec (Québec), centre hospitalier.

171P-1 Originaux, n.&b. [1,000], coul. [300], total [1,300]. 1877 à nos jours.
Stéréogrammes de 1877: administration de l'onction des malades, communion, services du dîner, église de l'Hôtel-Dieu, photos de Louis-Prudent Vallée. Rue Charlevoix, Québec, 1929; vues intérieures de l'Hôtel-Dieu, 1892-1959. Groupe de médecins de l'Hôtel-Dieu, 1899 à nos jours; vues extérieures de l'Hôtel-Dieu, 1892 à nos jours; l'Honorable John Sharples, ca. 1909; le docteur Michel-Delphis Brochus, ca. 1899; portraits d'infirmières laïques, 1950-1972.

Hopper, Wilfred, Burnaby, B.C.

7P-808 b&w 37. 1938-1940.
Visit of H.M. George VI and Queen Elizabeth to Vancouver, B.C.; activities, equipment and personnel of No. 111 (CAC) Squadron, R.C.A.F., Sea Island, B.C.; Blackburn Shark III aircraft of No. 6 (BR) Squadron, R.C.A.F., Jericho Beach, B.C.

Horetzky, Charles George, (1840-1900), surveyor and photographer.

7P-809 b&w 1. 1871.
Party of surveyors at the Elbow of the North Saskatchewan River, N.W.T., September 1871; photo by Charles G. Horetzky.

Horn, John, Montreal, Que., collector.

18P-33 b&w 8. ca. 1865-ca. 1915.
Portraits of Governors General of Canada.

Horsdal, Paul, Ottawa, Ont.

7P-810 b&w 280,800. 1930-1971.
Portraits by Paul Horsdal of Canadians prominent in various fields of public life and of citizens of Ottawa, Ont.

Horsey, E.M., Ottawa, Ont.

7P-812 b&w 2. 1915.
Blessing of colours of the 38th Battalion, C.E.F., by Capt. the Rev. H.I. Horsey, Ottawa, Ont., August 1915.

Horsfield, Richard E., (b. 1895), Duncan, B.C., author and public servant.

7P-811 b&w 43. 1918-1943.
Views of northern British Columbia; activities of the R.C.M.P. in northern British Columbia; aircraft of No. 118 Squadron, R.C.A.F.; portraits of Mr. R.E. Horsfield.

House of Memories Museum, Latchford, Ont.

7P-813 b&w 49. 1900-1950.
Visit of Sir Wilfrid Laurier to Cobalt, Ont.; views of Latchford, Haileybury, Cobalt, Porcupine, Timagami, Elk Lake, Ont.; Mont Laurier, Que.

Howard, John, (Ottawa, Ont.).

7P-814 b&w 2. 1918.
Group photo of Course 28, No. 4 School of Military Aeronautics, R.F.C., Toronto, Ont., 26 March 1918.

Howard, John, (1877-ca. 1969), Farm near Whitewood, Sask., farmer and amateur photographer.

10P-8 b&w 125. 1903-1929.
Glass negatives; farming scenes, homesteading scenes, sports, family events in the Whitewood, Sask., area.

Howse family, Nicola Valley, B.C., settlers.

12P-20 b&w 68. 1880-1910.
Albert Elgin Howse and family; house, views of Nicola Valley, family activities.

Hudson, H. Paul, Ottawa, Ont.

> 7P-815 b&w 24. 1942-1945.
> Vickers - Supermarine Spitfire aircraft and pilots of No. 412
> (Falcon) Squadron, R.C.A.F., England; Consolidated Liberator
> aircraft of No. 5 Operational Training Unit, R.C.A.F., Boundary
> Bay, B.C.

Huff, D.R., Williamsburg, Ont.

> 7P-816 b&w 3516. ca. 1900.
> Views in and around Iroquois and Morrisburg, Ont.; portraits of
> residents of Iroquois and area; photos by Ira W. Beckstead.

Hughes, Nelson, Renfrew, Ont.

> 7P-817 b&w 2. ca. 1905.
> Views of the C.P.R. station and the public school, Renfrew, Ont.

Hughes, Richard, Kamloops, B.C.

> 7P-818 b&w 2. ca. 1877.
> Portrait of Mr. Alexander Murray; photo by S.H. Parsons.

Hughson, Hugh M., Mrs., Ottawa, Ont.

> 7P-820 b&w 24. 1917-1918.
> Various types of aircraft built by the Sopwith Aircraft Co.,
> Kingston-on-Thames and Brooklands, England, 1917-1918.

Hughson and Company, Albany, N.Y., lumber dealers.

> 7P-819 b&w 1. 1881.
> Tintype photo of Gertrude E. Hughson and Mary P. Strain.

Hugill, John W., Calgary, Alta.

> 1P-44 Original, b&w 31. 1897.
> Ruins after the Windsor, N.S., fire of October 17, 1897.

Hume, John Alex, Ottawa, Ont., journalist.

> 7P-822 b&w 12. 1920-1945.
> Portraits of Hon. R.L. Borden, R.B. Bennett, W.L. Mackenzie King,
> Ernest Lapointe, C.D. Howe, and Mr. J. Alex Hume.

Hume, John F., (b. 1904), Lewiston, Idaho.

> 12P-15 b&w [292], col. 1, total [293]. 1880-1920.
> Portraits, stores and boats concerned with life of John F. Hume Sr
> (1860-1935), merchant and steamer entrepreneur in Kootenay
> District.

Hume, John J., Ottawa, Ont., public servant.

> 7P-823 b&w 13. ca. 1937.
> Views of St. John's, Bay Bulls, Brigus, Ferryland, Petty Harbour,
> Logy Bay, Pough Cove, Nfld.; photos by W.R. MacAskill and A.C.
> Shelton.

Humphrys, Elizabeth, Ottawa, Ont.

> 7P-824 b&w 1. ca. 1885-1920.
> Portrait of Mr. A.D. DeCelles, Parliamentary Librarian, Ottawa,
> Ont.; photo by W.J. Topley.

Hunt, George, Ottawa, Ont.

> 7P-825 b&w 14. ca. 1941-1945.
> Various types of aircraft of the R.C.A.F. during World War Two.

Hunter, A.W., (1908-), East Kootenay, B.C., real estate.

> 333P-5 Original, b&w 376. ca. 1890-1950.
> Fort Steele scenes; Brewery and Wildhorse Creeks, B.C.; Kootenay
> Indians; Sullivan Mine, B.C.; Crowsnest Pioneer School; B.C./Alta.
> border; A.W. Hunter people, Fort Steele, B.C.; Hollywood movie
> set, 1920; East Kootenay area scenes, B.C.; Spruce Mills,
> Lumberton, B.C.; Victoria, B.C., scenes; New Westminster, B.C.,
> scenes; Barkerville, B.C., scenes and Historic Markers; San Marino,
> California, scenes; Virginia City, Montana; World's Fair, Chicago,
> ca. 1899; Southern Alberta scenes; old machinery and automobiles;
> Sarcee, Blackfoot and Blood Indians; Invermere, B.C.; Golden,
> B.C.; Medicine Hat, Alta.; Fort Garry, Manitoba.

Hunter, George, Toronto, Ont., photographer.

> 7P-826 b&w 1,410, col. 125, total 1,535. 1959-1972.
> Aerial views of Fogo, St. John's, Churchill Falls, Nfld.; Quebec,
> Montreal, Que.; Toronto, Hamilton, London, Goderich, Ont.;
> Calgary, Edmonton, Alta.; Vancouver, Victoria, B.C.; activities and
> personnel of Air Canada; photos by George Hunter.

Hunter, James Blake, (b. 1876), Ottawa, Ont., public servant.

> 7P-827 b&w 8. 1902-1908.
> Naval and military review during tercentenary celebrations,
> Quebec, Que., 24 July 1908; view of Centre Block of the
> Parliament Buildings, Ottawa, Ont.; portraits of the Duke and
> Duchess of Connaught (Princess Louise) and of liberal members of
> the Parliament.

Huron Expositor, Seaforth, Ont., newspaper.

> 7P-828 b&w 19. ca. 1865-1905.
> Views, and group photos of local organizations, Seaforth, Ont.

Hyndman, R. Mrs., Hamiota, Man.

> 7P-829 b&w 1. ca. 1876.
> Group of York Pioneers, Toronto, Ont.; photo by Hunter & Co.

Hynek, Barbara, White Rock, B.C., librarian.

> 334P-17 b&w 28. 1976-1977.
> Houses and stores in New Westminster, B.C.; railroad stations,
> *Royal Hudson* (locomotive).

Icarus, Order of.

> 7P-830 b&w 217. 1973.
> Third annual investiture of the Order of Icarus, Calgary, Alta.;
> portraits of Messrs. C.H. Dickins, S.R. McMillan, A.M. McMullen,
> S.A. Tomlinson, M.W. Ward, T.F. Williams; photos by Bill Onions.

Ide, V.R., Toronto, Ont.

> 7P-831 b&w 1. ca. 1918.
> Portrait of Lieutenant W.L. Algie, V.C., 20th Battalion, C.E.F.

Imlah, W.E., Québec (Québec), ingénieur militaire.

> 134P-2 n.&b. 1. [n.d.].
> Lt. Col. W.E. Imlah du Royal Canadian Artillery, ca. 1888-1893.

Imperial Oil Ltd., Toronto, Ont.

> 7P-833 b&w 31653, col. 4555, total 36208. ca. 1880-1971.
> All aspects of the petroleum industry in Canada, illustrated by the operations of Imperial Oil Limited and its predecessors; exploration, extraction, refining, research, distribution, sales, consumption by various forms of transportation; views of various posts of the North West Mounted Police in Western Canada; photographers include Messrs. Harry Pollard, Gilbert Milne, and Ron Cole.

Information Canada, (1970), Ottawa (Ont.).

> 7P-1946 Originaux, n.&b. 844, coul. 354, total 1,198. 1911-1974.
> Funérailles de Louis St. Laurent, 28 juillet, 1973, photos prises par Marc Ellefsen, Chicoutimi (Québec); participation canadienne à diverses expositions et foires internationales, 1927-1967; Exposition de l'Energie atomique du Canada au Congrès inter-américain de radiologie, Lima, Pérou, nov. 1958; vues des édifices du Parlement, Ottawa (Ont.), photos prises par Chris Lund; portraits de Pierre Elliott Trudeau par Y. Karsh; de leurs altesses royales la reine Elizabeth et le prince Philip par Cavouk, Toronto (Ont.), 1974.

Ingall, Gertrude L., Ottawa, Ont.

> 7P-834 b&w 5. 1895-1916.
> Raft of squared timber on the Ottawa River, Ottawa, Ont.; review of troops by H.R.H. the Duke of Connaught, Ottawa, Ont., 24 May 1916; portraits of Sir James and Lady Harriet Le Moine.

Inglis, James, Montreal, Que., photographer.

> 7P-835 b&w 1. ca. 1860-1870.
> View of Beaver Hall Hill, Montreal, Que.; photo by James Inglis.

Innes-Taylor, Allan, Whitehorse, Yukon, conservationist and historian.

> 7P-837 b&w 1. ca. 1898-1910.
> Group of unidentified people from Klondike, Yukon, ca. 1898-1910.

Inness, Ronald, Halifax, N.S.

> 7P-836 b&w 555. 1900-1955.
> Various passenger ships of the Allan Line, Cunard Line, Cunard White Star Line, and Canadian Pacific Steamships Line.

Innis, Harold Adams, (1894-1952), Toronto, Ont., political economist and historian.

> 7P-838 b&w 3. ca. 1930-1952.
> Portraits of Mr. Harold A. Innis.

Institutions d'enseignement francophones du Nouveau-Brunswick, (1890).

> 15P-6 n.&b. [250]. 1900.
> Notre-Dame d'Acadie de Moncton, collège de Bathurst, collège de Sainte-Anne de Church Point, écoles publiques.

International Association of Machinists, (est. 1898), Ottawa, Ont.

> 7P-842 b&w 1. ca. 1900-1905.
> Group of railway workers, Moose Jaw, Sask.; photo by N.J. Porter.

International Civil Aviation Organization, Montreal, Que.

> 7P-839 b&w 1,939, col. 4, total 1,943. 1944-1961.
> Annual conferences of the International Civil Aviation Organization; Montreal, Que.; photos by Arless, Editorial Associates Ltd., Graetz, National Film Board, International Civil Aviation Organization.

International Federation of Library Associations, Toronto, Ont.

> 196P-9 b&w 1. 1977.
> Banquet, August 15, 1977.

International Grenfell Association, Ottawa, Ont.

> 7P-840 b&w 50. ca. 1900-1930.
> Views of Newfoundland and Labrador.

International Harvester Co. of Canada, Hamilton, Ont.

> 7P-841 b&w 3. ca. 1890-1901.
> Portraits of Messrs. George Washington Carmack, Tagish Charlie, and Skookum Jim.

International Labour Organization, Geneva, Switzerland.

> 7P-843 b&w 23. 1940-1968.
> Canadian participation in activities of the International Labour Organization; group photos of Canadian delegations to annual I.L.O. conferences; portraits of various officials of the Department of Labour and of the Canadian Labour Congress; events of I.L.O. Week at Expo '67, Montreal, Que.

Irish, King, Toronto, Ont., cinematographer.

> 7P-844 b&w 4. ca. 1911-1930.
> Portraits of Mr. King Irish and family.

Irvine, John A., (1868-1928), Granville Ferry and Halifax, N.S., and Calgary, Alta., insurance and real estate executive.

> 1P-18 b&w (500). ca. 1895-1905.
> Views of Halifax including churches, schools and other public buildings, houses, street scenes, ships in the harbour, Point Pleasant Park, the Northwest Arm, sports events and Micmac encampments; views of various Nova Scotia locations including Fort Anne, Clementsport, Granville Ferry and Smith's Cove; YMCA Maritime Boys' Camp, Goat Island, Annapolis River; unidentified individual and group portraits; photographers: Gauvin and Gentzell, O'Donnell W.D., Kelly and Co., John A. Irvine.

Irvine, W. Robert.

> 7P-845 b&w 11. 1965.
> Raising of the new Canadian flag at the Canadian Embassy, Mexico City, Mexico.

Irving, George Frederick, (1896-1965), Woodstock, N.B., soldier.

> 7P-846 b&w 5. 1916-1918.
> Personnel and activities of the 65th Battery, C.F.A., Woodstock, N.B., and in England, 1916-1918.

Irving House Historic Centre, (1964 to date), New Westminster, B.C., local history museum.

334P-30 Copies, b&w 89. ca. 1860-ca. 1915.
New Westminster scenes: parks, stores, main streets and buildings; events: May Day, Queen's Birthday, state visits, etc.; industries: logging, canning, fishing; portraits: mayors, sports groups, school groups, etc.; ships: steamboats and ferries; bridge-building: construction of Fraser River Rail Bridge.

Irwin, A. Mrs., Bobcaygeon, Ont.

7P-847 b&w 1. [n.d.].
View of School Section No. 1, Harvey, Ont.

Isaac, Michael V., Halifax, N.S., owner of used furniture store.

1P-21 Original, b&w 31. ca. 1895.
Photo of the house on Robie St., Halifax, about to be demolished, in which the collection was found; University of King's College football team, Halifax; album of unidentified individuals, houses and churches, some of which were photographed in Massachusetts.

Isabelle, Laurent, (1928-), Ottawa (Ont.), secrétaire de la faculté de psychologie.

303P-13 n.&b. 6. ca. 1964.
Dr. Laurent Isabelle à une conférence et avec des étudiants.

Isom, E.W., Mrs., Newport, Vt.

7P-848 b&w 25. ca. 1907-1914.
Views of Prince Rupert, Alert Bay, B.C.; Dawson, Yukon; photo of Rt. Rev. Isaac Stringer, Bishop of the Yukon; photos by E.W. Isom.

Itomlenski, Alexander, Roxboro, Que.

7P-849 b&w 115. 1919.
Visit to Canada of H.R.H. the Prince of Wales.

Iveson, Frank, (1851-1935), Metcalfe, Ont.

7P-850 b&w 37. 1865-1920.
Views of buildings and various activities in and around Metcalfe, Ont.

Jack.

334P-33 Copies, b&w 2. 1898.
Store under construction; Indian band disembarking from steamer.

Jackson, John R., Ottawa, Ont., military officer.

7P-851 b&w 1. ca. 1965.
Presentation to Mrs. J.L. Coupal of Ottawa, Ont., of second prize in playwriting contest sponsored by Theatre Guild of St. Louis, Mo.

Jackson, Mrs. J.R., Saanichton, B.C.

7P-852 b&w 59. ca. 1860-1914.
Group of settlers at Telfordville, Alta.; portraits of various members of the British Royal family, and of Messrs. Douglas and Basil Breton.

Jackson, R.E., Ottawa, Ont.

7P-853 b&w 2. 1897.
View of the Parliament Buildings, Ottawa, Ont.; photo by G.R. Lancefield; composite photo of ministers of the federal Cabinet of 1896-1897, and of ministers of the Quebec Cabinet of 1897.

Jacobs, Captain.

7P-854 b&w 1167. 1860-1969.
Activities of the 1st Battalion, Prince Consort's Own Rifle Brigade, in Canada; views of Tadoussac, Quebec, Montreal, Que., Ottawa, Kingston, Hamilton, Grimsby, Ont.; portraits of various senior officers of the British Army stationed in Canada.

Jacobson, Leon, Syracuse, N.Y., dealer in photographica.

7P-855 b&w 494. ca. 1858-1900.
Views of St. John's, Nfld.; Quebec, Montreal, Que.; Ottawa, Port Hope, Niagara Falls, Ont.; Yale, Victoria, B.C.; ambrotype portrait of Capt. R.C. Price; portrait of Louis Riel; photos by S.H. Parsons, L.P. Vallée, Alexander Henderson, James Inglis, J.G. Parks, William J. Notman, H. Hollister, S. Barrett, Robert Maynard, E. Anthony.

James, George W., Chatham, Ont., photographer.

7P-856 b&w 772. 1936-1965.
Visits of Lord Tweedsmuir to Chatham, Ont., in 1936, and of Queen Elizabeth II in 1959; visits of Hons. John Diefenbaker and Lester B. Pearson to Chatham, Ont. in 1958; various floods and fires in southwestern Ontario; agricultural activity in Elgin and Kent counties; views of Chatham, Blenheim, Erieau, Wallaceburg, Dresden, Point Pelee, Buxton, Tilbury, Ont.; photos by George W. James.

James, Reginald Heber, Maj., (1876-1951), military officer.

7P-857 b&w 11. 1890-1944.
Views of Trinity, Paradise, Channel, Flat Islands, Nfld.; interior of church, Placentia, Nfld.; prison camp at Riding Mountain, Man.; portraits of Major R.H. James.

James, W.J., (ca. 1890-ca. 1930), Prince Albert, Sask., photography studio.

10P-10 Original, b&w [2,575]. ca. 1890-1930.
Street scenes, cities, towns, buildings, scenery, sporting events, official events, conventions, personalities, agricultural activities, animals.

James, William, (b. 1866-d. 1948), Toronto, Ont., freelance news photographer.

140P-15 b&w [6,000]. 1906-1948.
A wide-ranging collection of newsworthy and day-to-day events in the City and surrounding areas; extensive series on the following notable events: the aftermath of the Toronto fire of 1904; the 1917 Halifax Explosion; the first aeroplane flight at Weston (1910); the Toronto street car strike of 1919; the burning of the SS *Noronic* (1949); the changing face of the City is recorded in extensive aerial views; shots of the waterfront, City parks, the Islands and close-ups of many buildings both commercial and residential; extensive series of such Institutions as the Jockey Club, University of Toronto and the C.N.E.; many photographs of the Eaton Family, Sir Henry Pellatt and his Casa Loma, the Grange, and many distinguished visitors to the City; First War, troop recruitment, parades, munitions production and Armistice Day celebrations; photographs of areas such as Oakville, Muskoka, Niagara, Ottawa and Northern Ontario.

Jamieson, E.L., Lanark, Ont.

7P-858 b&w 6. [n.d.].
Views of Herron Mills and other places in Lanark County, Ont.

Jamieson, Elmer, (fl. 1905), Banff, Alta., packer and cowboy.

166P-38 Copies, b&w 74. 1937.
Copies of prints by R.M. Patterson taken during a trip into
Kananaskis Valley, Alta.; country around Buffalo Head Ranch,
1937.

Jandrew, Cyrus, B., Mrs., Ottawa, Ont.

7P-859 b&w 12. 1900-1913.
Views of Ladysmith, Thorne Centre, Que.; lumbering and maple
sugar processing in Quebec; group photos of Rev. C. Reid with
members of his family and other clergymen.

Janes, Simeon Heman, (1843-1913), Toronto, Ont., real estate operator and
financier.

18P-63 Original, b&w 15. ca. 1890.
Janes' houses in Toronto (chiefly "Benvenuto") and Port Hope.

Jarvis, Ann Frances, (b. 1830), Toronto, Ont.

7P-860 b&w 1. [n.d.].
Portrait of Ann Frances Jarvis.

Jarvis, Catherine G., Kanata, Ont.

7P-861 b&w 1. 1888.
A.H. Jarvis Bookstore and Palace Bakery, corner of Laurier and
Bank Sts., Ottawa, Ont.

Jarvis, Edward Aemilius, (1860-1940), Toronto, Ont., banker.

7P-862 b&w 5. ca. 1867-1876.
Portraits of Hons. J.H. Cameron, R.E. Caron, P.J.O. Chauveau,
Joseph Howe, L.J. Papineau; photos by William Notman.

Jarvis, Julia, Toronto, Ont.

7P-863 b&w 2. 1958.
Plaque marking site of North West Company Trading Post, Rainy
Lake, Ont.

Jarvis, Samuel J., (1863-1952), Ottawa, Ont., photographer.

7P-864 b&w 321. [n.d.].
Events and views in and around Ottawa, Ont.; views of various
places in British Columbia; composite portraits of members of the
Supreme Court of Canada, of Liberal Members of Parliament, and
of Mayors of Ottawa, Ont.; photos by S.J. Jarvis.

Jaworski, Joachim (Jack), (b. 1914), Vancouver, B.C., military officer.

7P-865 b&w 94. ca. 1936-1970.
Operations of Canadian Airways Ltd. in Northern Quebec,
1936-37; all aspects of the career of Mr. Jaworski as an officer in
the Royal Canadian Air Force, 1940-63.

Jean, J.A. Albert, Cie. Ltee, Montreal, Que.

7P-866 b&w 1. 1939.
Group photo of Rt. Hon. R.B. Bennett with Sir Edward Beatty and
associates Montreal, Que., 24 February 1939.

Jefferson, Harry, (d. 1912), amateur photographer.

18P-78 Original, b&w 15. 1906-1911.
Scenes in Swansea and Humber River areas of Toronto.

Jenkins, Frank Tristram, (1895-1973), aerial surveyor.

7P-867 b&w 550. ca. 1920-1960.
Activities of Mr. F.I. Jenkins as aerial forest surveyor in Ontario,
Quebec and Newfoundland.

Jennings.

334P-42 b&w 1. ca. 1955.
New Westminster Public Library: Carnegie building.

Jennings, William, (1888-1973), Ottawa, Ont., soldier and servant.

7P-868 b&w 25. 1943-1944.
Various aspects of the Quebec Conferences, Quebec, Que., August
1943 and September 1944; photos by the National Film Board.

Jessop, Cyril, (1881-1967), Winnipeg and Gladstone, Man., photographer.

9P-31 b&w 219. 1915-1917.
Agricultural scenes commissioned by Provincial Dept. of Agriculture
and Immigration.

Jewell family, Fort Steele, B.C., lumber mill operator.

333P-2 Original, b&w 4. ca. 1912.
Jewell Lumber Mill, Fort Steele, B.C.

Jewett, B.L., Dr., Fredericton, N.B., physician and surgeon.

7P-872 b&w 1. ca. 1898-1901.
Group of unidentified men preparing to leave for the Klondike.

Jewish Historical Society of Western Canada Inc., (est. 1966), Winnipeg,
Man.

9P-32 b&w [2,600]. 1880 to date.
Jewish immigration and settlement in Western Canada.

305P-1 b&w [2,681]. ca. 1880 to date.
Jewish life and activities in both eastern Europe and western
Canada including religion: synagogues, ceremonies, rabbis, cantors;
education: schools, classes, teachers; organizations and societies:
loan, welfare, social, cultural, educational, political; Canadian
Jewish Congress; industry and commerce: factories, retail outlets;
personalities: political, in medicine, authors, social, early pioneers;
families: groups in both western Canada and eastern Europe; social
life and customs: immigration; western Canada: Winnipeg,
Saskatoon, Regina, Calgary, Edmonton, Vancouver, Edenbridge,
Lipton, Hoffer, Wapella, Hirsch; eastern Europe: families, people in
occupations.

Jewish National Fund of Canada, (est. 1906), philanthropic organization.

7P-869 b&w 232, col. 18, total 250. 1958-1971.
Fund-raising activities of the Jewish National Fund of Canada; projects in Israel financed by the Jewish National Fund of Canada; portraits of officials of the Jewish National Fund of Canada.

Jewish Public Library, Montreal, Que.

7P-870 b&w 1. ca. 1912.
Portrait by B.W. Leeson of woman belonging to the Flathead Tribe, Vancouver Island, B.C.

Jewish War Veterans of Canada, (est. 1968), Montreal, Que.

7P-871 b&w 96, col. 1, total 97. 1968-1973.
Activities of the Jewish War Veterans of Canada.

Jewitt, William Gladstone, aviator.

7P-873 b&w 4. ca. 1929-1960.
Aspects of the aviation career of Mr. W.G. Jewitt; portraits of Mr. W.G. Jewitt.

Joan Perkal Books, Sherman Oaks, Calif.

7P-1404 b&w 44. 1915-1918.
Views of construction around harbour, Halifax, N.S., 1915-1918; photos by Gauvin and Gentzel.

Joannidi, S.N.C.

9P-33 b&w 977. 1906-1950.
Views of Winnipeg, Man., and Western Canada.

Jobin, Dennis T., Hull, Que.

7P-874 b&w 56. ca. 1860-1890.
Cartes-de-visite, tintype and cabinet portraits of unidentified men, women and children, Ontario; photos by J.W. Armstrong, J.F. Bryce, J.B. Cook, S.J. Dixon, James Esson, Farmer Bros., Gagen and Fraser, C. Gall & Co., C.W. Hill, T.S. Hill, W.H. Kahrs, Park Brothers, T.E. Perkins, E. Poole, Hunter & Co., H.E. Simpson, J.W. Townsend, J.C. Walker.

Joel, Miss, Winnipeg, Man.

7P-875 b&w 8. 1913-1914.
Views of Port Nelson, Man.

Johnson, David, Hamilton, Ont.

7P-876 b&w 1. ca. 1905-1910.
C.N.R. freight train derailment in Northern Ontario.

Johnson, Eric Arthur, Ottawa, Ont., military officer.

7P-877 b&w 1. ca. 1945.
Consolidated Liberator G.R. VI T aircraft 574 of No. 168(HT) Squadron, R.C.A.F., Rockcliffe, Ont.

Johnson, Henry A., Halifax, N.S., public servant.

7P-878 b&w 36. 1870-1877.
Fortifications in and around Halifax, N.S.

Johnson, Herbert Stanley.

9P-34 b&w 11. 1904-1915.
Views of Northern Manitoba.

Johnson, William Main, (1887-1959), Toronto, Ont., journalist.

18P-90 Original, b&w 115. 1914-1930.
European tour with Hon. N.W. Rowell (to whom Johnson was private secretary, 1912-1918), 1916; portraits of Johnson's associates.

Johnston, Clifford M., (1897-1951), Ottawa, Ont., Electrical engineer and amateur photographer.

7P-879 b&w 9,880. 1917-1948.
Photos by Mr. Clifford Johnston of various landscapes, cities and villages in Britain, France and Belgium, views in and around Ottawa, Ont., and along the St. Lawrence River in Quebec.

Johnston, Margot, Kingsmere, Que.

7P-881 b&w 2. ca. 1845-1933.
Daguerreotype portrait of unidentified man; troops of the 1st Battalion, Seaforth Highlanders of Canada, during manoeuvres on Vancouver Island, B.C.

Johnston family, Ottawa, Ont.

7P-880 b&w 110. ca. 1867-1910.
Views of Hull, Aylmer, Que.; Ottawa, Almonte, Snake Creek, Ont.; portraits of members of the Johnston, Cross and Fairbairn families, and of various Methodist and Presbyterian clergymen; photos by C. Binks, J.W. Boyce, J.H. Bunting, B. Charron, L.N. Dorion, Edwards & Harrison, S.B. Fell, D.C. Ferguson, F.X. Filteau, S.J. Jarvis, A. Lockwood, C.W. Parker, Pittaway & Jarvis, N. Runions, G.A. Snider, E. Spencer, H. Sproule, Stiff Brothers, C.B. Taggart, J.D. Wallis.

Johnstone, Barbara, Winnipeg, Man.

9P-35 total 272. 1956-1963.
Views of Manitoba.

Jones, A.G.E., Tunbridge Wells, England, professor.

7P-882 col. 8. ca. 1968.
Views of Shernfold Park and St. Alban's Church, Frant, Sussex, England; memorial in St. Alban's Church commemorating Lieutenant-Colonel John By.

Jones, Arthur Stanley, (b. 1885), Saskatoon, Sask., manufacturer.

18P-97 Copies, b&w 19. 1905-1917.
Jones' homestead near North Battleford, Sask.

Jones, Colin, Ottawa, Ont., public servant and photographer.

7P-883 b&w 4. 1964.
Hon. John N. Turner at political meeting, Ottawa, Ont.; photos by Colin Jones.

Jones, Francis, Ottawa, Ont., artist.

7P-884 b&w 22. ca. 1870-1900.
Portraits of various members of the Austin, Jones and Macpherson families; photos by J.J. Abbott, J.E. Livernois, Alvira Lockwood, J.L. Jones, Ernest Rice, Rice and Bennett, G.A. Snider.

Jones, H.W., Mrs., Georgetown, Texas, retired.

12P-13 b&w 34. 1920-1940.
Views of Anyox, B.C., including smelter, ships, machinery and buildings.

Jones, J.G., policeman (R.N.W.M.P.).

9P-36 b&w 60. 1908-1914.
Photographs relating to "M" Division, R.N.W.M.P. in Northern Manitoba.
Provenance: Mrs. Freda L. Garez, Edmonton.

Jones family, Toronto, Ont.

196P-6 b&w 2. 1911-1913.
Faculty of Medicine, First Graduate Class in five-year course, 1913; Medical Society Executive, 1911-1912.

Jordan, Henri Kew, (1880-1949), Brantford, Ont., choral conductor.

149P-12 b&w [10]. ca. 1920-1940.
Photographs of Jordan with the Schubert Choir of Brantford.

Jordon, Mabel, (1900-), Perry Creek, B.C.

333P-11 Copies, b&w 5. 1930-1950.
Perry Creek, B.C.

Joss, Robert A., Montreal, Que.

7P-885 b&w 143. 1919-1946.
Vickers Vimy aircraft of Captain John Alcock and Lieutenant Arthur Whitten Brown, St. John's, Nfld., 1919; various types of civil aircraft, Montreal, Que., 1937; various types of R.C.A.F. aircraft, 1943-45.

Judd, William Wallace, (b. 1883), Toronto, Ont., clergyman.

18P-93 Copies, b&w 11. ca. 1899-ca. 1900.
Toronto scenes in areas where Judd lived.

Jupp, Ursula, Victoria, B.C., historian, collector.

12P-10 b&w 262. 1880-1930.
Todd family activities, portraits, homes, occupations; Compton family; H. Lauder Ramsey family; views of Victoria; one tintype.

Kaellgren, Peter, Ottawa, Ont., public servant.

7P-886 b&w 3. 1907-1910.
Views of the Royal Alexandra Theatre, Toronto, Ont., and of Port Arthur, Ont.

Kamloops Museum Association Collection, (1936-), Kamloops, B.C.

91P-1 b&w 6,500, col. 300, total 6,800. 1865-.
Photos of persons, places, organizations, etc., of Kamloops and district, including a large number prior to 1900.

Kangas, Victor, (1902-1973), Montreal, Que., carpenter and amateur archivist.

7P-887 b&w 34. 1923-1969.
Activities of Mr. Victor Kangas and of The Finnish Organization of Canada; portraits of members of the Kangas family.

Kaplansky, Kalmen, (b. 1912), Ottawa, Ont., labour leader.

7P-888 b&w 5. 1941-1947.
Presentation of ambulance to the British Red Cross by the Workmen's Circle, Camp Yungvelt, near Toronto, Ont., August 1941; officials and display of the Jewish Labour Committee at the annual convention of the Trades and Labour Congress, 1947; photo by Lloyd Bloom.

Karachun, Doris, Trenton, Ont.

7P-889 b&w 1. ca. 1880-1890.
Portrait of Gabriel Dumont.

Karsh, Yousuf, (b. 1908), Ottawa, Ont., photographer.

7P-890 b&w 54. 1938-1970.
Portraits by Mr. Karsh of internationally known statesmen, members of royalty, clerics, scientists, physicians, artists, authors, actors, composers, musicians, astronauts.

Katholy, Karl, Potsdam, Germany, education, archaeology.

200P-19 Original, b&w 14. 1929-1930.
14 snapshots about Greece.

Katnich, Steven, Vancouver, B.C.

7P-891 col. 1. 1968.
Moccasin which belonged to Louis Riel.

Kaufmann, Hans, (1874-1929), Grindelwald, Switzerland, Alpine climbing guide.

166P-39 Copies, b&w 71. 1901-1908.
Copies of photographs collected by Hans Kaufmann; CPR Swiss guides, mountaineers; early mountaineering in the Canadian Rockies and Selkirks, 1901-1908.

Kay, Dave, (1898), Fort Steele, B.C. and Cranbrook, B.C., printer.

333P-14 Copies, b&w 6. 1895-1960.
Fort Steele, B.C.; petroglyphs near Cranbrook, B.C.

Kaye (Kysilewsky), Vladimir Julian, (1896-1976), Ottawa, Ont., public servant and academic.

7P-892 b&w 316. 1890-1975.
Activities of Ukrainian settlers in Manitoba, Saskatchewan and Alberta; portraits and group photos of Ukrainian settlers and their families in Manitoba, Saskatchewan and Alberta; aspects of the career of Dr. V.J. Kaye with the Canadian Citizenship Branch and with the University of Ottawa; activities of Mrs. Olena Kysilewska as president of the World Federation of Ukrainian Womens' Organizations.

Kearney, John D., (b. 1893), Ottawa, Ont., diplomat and judge.

7P-893 b&w 3. ca. 1941-1945.
Activities of Mr. J.D. Kearney as Canadian High Commissioner in Eire, 1941-45.

Keefer, Charles A.

7P-894 b&w 330, col. 34, total 364. 1937.
Activities of Dogrib Indians around Fort Rae, Fort Providence, Fort Wrigley, N.W.T.; views of Yellowknife, Aklavik, N.W.T.; Whitehorse, Y.T.; portraits of various Dogrib Indians; photos by

Keefer, Charles A.
(Cont'd/Suite)

 C.A. Keefer.

Keefer, Samuel.

 7P-895 b&w 14. 1850.
 Views in and around Quebec, Que.

 7P-896 b&w 1. ca. 1850-1880.
 Portrait of Mr. Samuel Keefer; photo attributed to W.J. Topley.

Keen, George, (1869-1953), Brantford, Ont., co-operative leader.

 7P-897 b&w 1. ca. 1904-1945.
 Portrait of Mr. George Keen.

Keir, Ernest F., (1878-1941), Vernon County, Wisc., photographer and prospector.

 7P-898 b&w 196. 1898.
 Photos by Ernest F. Keir illustrating his journey to the Klondike via Skagway and the Chilkoot Pass, March-April 1898; views of Skagway, Juneau, Alaska; Dawson, Yukon; snow slide in the Chilkoot Pass, April 1898; mining operations along various creeks in the Yukon Territory.
 Ref./Réf.: Diary of E.F. Keir. Report on collection by A.J. Birrell.

Keith, Gerald, Lancaster, N.B.

 7P-899 b&w 3. ca. 1878-1896.
 Portraits of Hons. A.T. Galt, A.J. Smith and S.L. Tilley; photo by Jarvis Studio.

Kelley, Viola, Hollywood, Fla.

 7P-900 b&w 160. 1907.
 Aircraft and kites of the Aerial Experimental Association, including J.A.D. McCurdy's *Silver Dart,* at Hammondsport, N.Y., and Baddeck, N.S.

Kelso, John Joseph, (1864-1935), Toronto, Ont., child welfare worker.

 7P-901 b&w 4,628. 1898-1930.
 Activities of immigrant families and slum conditions, Toronto, Ont.; activities of the Children's Aid Society in Ontario, and of Mr. J.J. Kelso as Ontario Superintendent of Neglected and Dependent Children.

Kemp, A.T. Mr., Leroy, Sask.

 7P-902 b&w 3. [1917-1919].
 Fokker D. VII Aircraft of the German Air Force; portrait of Captain John Alcock, R.F.C.

Kempton, Gilbert, Liverpool, N.S., photographer.

 31P-87 Original, b&w [170]. ca. 1900-1925.
 Primarily glass plate negatives; views of Liverpool, unidentified portraits.

Kendrick, H.J., Lubbock, Texas.

 7P-903 b&w 1. 1918.
 Group photo of personnel of the 8th Overseas Draft, C.E.F., January 1918; photo by Percy E. McDonald.

Kennedy, Leo, (b. 1907), Norwalk, Conn., poet and journalist.

 7P-904 b&w 8. 1929-1950.
 Activities of Mr. Leo Kennedy and his relatives, Verdun, Que.; Chicago, Ill.; Norwalk, Conn.

Kennedy, M., Canal Flats, B.C.

 333P-38 Original, b&w 3. ca. 1928.
 C.P.R. Mill, Canal Flats, B.C.

Kennedy, Margaret, Winnipeg, Man., photographer.

 9P-37 b&w 134. ca. 1955.
 Views of Manitoba.

Kennelly, Hazel Loreen M., Toronto, Ont.

 196P-7 b&w 1. 1914.
 University of Toronto, Graduating Class in Arts, 1914.

Kenney, Charles W., Mrs., Buckingham, Que.

 7P-905 b&w 62. ca. 1880-1930.
 Views of Templeton and Buckingham, Que.; residences of various members of the MacLaren family, Buckingham, Que.; views of the North Pacific Lumber Company, Barnet, B.C.; photos by Rod Leger; Canadian Photo Co.; Stanley Park Photographers; A.G. Stackhouse.

Kenney, James Francis, (1884-1946), Ottawa, Ont., archivist and author.

 7P-906 b&w 1. ca. 1925-1935.
 View of the Victoria Memorial Museum, Ottawa, Ont.

Kenny, Brendan J., (1939-), St. John's, Nfld., grocer.

 38P-7 b&w 246. [1890-1975].
 Views of St. John's (including a large group of local business firms) prior to 1950.

Kenny, Randall Y., Peterborough, Ont., physician.

 7P-907 b&w 1. ca. 1914-1918.
 Personnel of No. 2 Stationary Hospital, R.C.A.M.C., receiving the 1914 Star, France.

Kerr, John, (fl. 1870-1940), soldier, policeman.

 9P-38 b&w 14. 1868-1929.
 Family photographs and early scenes of Winnipeg, Man.

Kerr, John Andrew, (1850-1940), Perth, Ont., soldier and guide.

 7P-908 b&w 1. 1869.
 Portrait of Mr. J.A. Kerr, Montreal, Que.

Kerr, Muriel, Ottawa, Ont.

 7P-909 b&w 1. ca. 1930-1940.
 Portrait by Karsh of Agnes C. Macphail, M.P.

Kershaw family, Fort Steele, B.C. and Cranbrook, B.C., storekeepers.

 333P-7 Original, b&w 33. 1898-1972.
 Family members; Kershaw businesses and acquaintances, Fort
 Steele, B.C. and Cranbrook, B.C.

Kidd, Kenneth Earl, (b. 1906), Peterborough, Ont., archaeologist.

 7P-910 b&w 135. ca. 1850-1950.
 Ceremony marking 150th anniversary of H.M. Chapel of the
 Mohawks, Brantford, Ont.; Indian ceremony of "Burying the
 Hatchet", Penetanguishene, Ont.; Indian game of snowsnake; views
 of Saint John, N.B.; Barrie, Brantford, Cookstown, Moose Factory,
 Ottawa, Toronto, Ont.; Gleichen, Alta.; Field, B.C.; portrait of Rev.
 H.W. Snell.

Kidd, Martha Ann, Peterborough, Ont.

 7P-911 b&w 280. 1860-1969.
 Events in and around Peterborough, Ont.; views of Lakefield,
 Keene, Norwood, Peterborough, Ont.; portraits of Mr. Samuel
 Strickland and Mrs. Catherine Parr Traill; photos by Elliot and The
 Roy Studio.

Kidd, W.L., (Ashton, Ont).

 7P-912 b&w 405. 1916-1918.
 Personnel and activities of No. 7 Canadian General Hospital,
 Etaples, France; examples of various types of wounds suffered by
 Canadian soldiers during World War One.

Kierans, Eric William, (b. 1914), Montreal, Que., politician and economist.

 7P-913 b&w 216, col. 30, total 246. 1914-1971.
 Activities of Eric Kierans as student at Loyola College, Montreal,
 Que.; as Quebec Minister of Revenue 1963-65 and Minister of
 Health 1965-66; as candidate for the leadership of the Liberal
 Party of Canada 1968; as federal Postmaster General and Minister
 of Communications 1968-71.

Kindle, Edward Martin, (1869-1940), Ottawa, Ont., paleontologist and
geologist.

 7P-914 b&w 130. 1889-1910.
 Views of various places in the Yukon Territory and in Alaska;
 sealing and mining operations in Alaska; activities of E.M. Kindle
 as student at Yale University, and as member of the Cornell
 University expedition to Greenland in 1896; portrait of Dr. E.M.
 Kindle.

King, Andrew, Halifax, N.S., Canadian militia officer.

 1P-71 Original, b&w 4. 1885.
 Encampment of the Halifax Provisional Battalion at Medicine Hat,
 Alta. during the Northwest Rebellion of 1885; irregulars on
 horseback in the same expedition; group of Cree and traders at
 Medicine Hat, Alta., 1885.

King, Donna, Toronto, Ont.

 7P-915 b&w 3. 1920-1930.
 Group photo of staff of the Ontario Motion Picture Bureau, Bronte,
 Ont.; portraits of Harry Blake and Donna King.

King, W.F., Ottawa (Ont.).

 131P-6 Originaux, n.&b. 85. ca. 1905.
 Expédition canadienne pour l'observation d'une éclipse totale du
 soleil, Hamilton Inlet, Labrador; le bâteau à vapeur du gouvernement

King Edward, départ de Québec; Pointe aux Esquimaux,
Havre-St-Pierre et Labrador, 1905; installation des appareils
d'observation et du camp, Pointe aux Esquimaux et Havre-St-Pierre
(Québec); photos par Marsh, Near, Plaskett, Howell, Collins,
Lajeunesse, Aldows, Lyman, Kavanagh, Maunder, Gautier, Upton;
Québec vu de Lévis, 1905; les chutes Montmorency (Québec),
1905; locomotive du N.S.P.R. & N.Co. no. 96, Clark City,
Saguenay (Québec).

King, W.M.., Oakville, Ont.

 47P-4 Original, b&w 7. 1905.
 Photos of King and family; Grand Trunk Railway bridge; Oakville
 Fair; two unidentified commercial establishments.

King, William Lyon Mackenzie, Rt. Hon., (1874-1950), Ottawa, Ont.,
Prime Minister of Canada.

 7P-916 b&w [25,000]. ca. 1867-1950.
 Activities of W.L. Mackenzie King as university student 1895-1900,
 Deputy Minister of Labour 1900-1908, Minister of Labour
 1909-1911, Rockfeller Foundation consultant 1914-1917; Prime
 Minister of Canada 1921-1926, 1926-1930, 1935-1948; activities
 and portraits of the relatives and friends of W.L. Mackenzie King.

Kings College, Windsor, N.S.

 31P-49 Copies, b&w 1. ca. 1920.
 Kings College.

Kingsford, William, (1819-1898), engineer and historian.

 7P-917 b&w 2. ca. 1866-1898.
 Portraits by William Notman of Mr. William Kingsford.

Kingston, Ont.

 75P-12 b&w [3,000]. ca. 1860-1970.
 Buildings, street scenes, events, prominent persons, monuments and
 transportation in Kingston, Ont.

Kinnear, A. Muriel, Ottawa, Ont., archivist.

 7P-918 b&w 5. ca. 1890-1943.
 Views of the Augustinian Monastery, Tracadie, N.S.; Fort Edward,
 Windsor, N.S.; former residence of Cornelius Krieghoff, Québec,
 Que.; composite photo of officers of "B" Battery, R.C.A., Quebec,
 Que., 1890.

Kinnear, James G., King, Ont.

 7P-919 b&w 3. ca. 1900.
 Views of Kinnears Mills, Que., and King, Ont.

Kinred, Sheila, Halifax, N.S.

 31P-50 Copies, b&w 2. ca. 1890.
 Portraits of Thomas Killam and Duncan Johnson.

Kipp, Yvonne, Ottawa, Ont.

 7P-920 b&w 11. 1941.
 Train wreck on the C.P.R. line between Chapleau, Ont., and
 Winnipeg, Man., July 1941.

Kirk, Elsie, New Westminster, B.C.

334P-26 Copies, b&w 10. ca. 1893-1940.
H.T. Kirk's family portraits, hardware store, and home.

Kirkwood, Kenneth Porter, (1899-1968), Ottawa, Ont., diplomat and author.

7P-921 b&w 25. ca. 1943-1957.
Career of Mr. K.P. Kirkwood as First Secretary of Canadian Legations in Brazil, Argentina and Chile, 1941-43, as High Commissioner to Pakistan 1952-54, as Canadian Ambassador to Egypt 1954-56, and as High Commissioner to New Zealand, 1956-57.

Kirwan, John, Ottawa, Ont., teacher.

7P-922 b&w 170. ca. 1866-1935.
Construction of the Parliament Buildings, Ottawa, Ont., 1866; views by John Woodruff of Ottawa, Ont., 1907; aerial views by the R.C.A.F. of various cities and regions of Canada, 1925-35.

Kitchen, Ruth, Aurora, Ont.

7P-923 b&w 63. 1900-1910.
Views of Saint John, N.B.; Brandon, Man.; Calgary, Alta.

Klein, Abraham Moses, (1902-1972), Montreal, Que., poet.

7P-924 b&w 115. ca. 1922-1972.
Activities of Mr. A.M. Klein, his family and friends, Montreal, Que.

Klotz, Oskar, (1878-1936), Toronto, Ont., pathologist.

7P-925 b&w 4. ca. 1902-1936.
Portraits of Drs. Oskar Klotz, Frederick G. Banting, and Major John McCrae.

Knapp, Martha de Jong, (ca. 1906-), Winnipeg, Man., author.

9P-80 b&w 250. 1891-1956.
Photos of Klaas de Jong, market gardener from East Kildonan, Manitoba; his vegetable crops and farm workers; his family and friends; most of the photos are for the period 1910-1930; some of the photos are reproduced in *Cauliflower Crown,* the memoirs of Klaas de Jong, 1872-1959.

Knight, Stanley Neil, (b. 1906), London, Ont., air engineer.

7P-926 b&w 41. ca. 1930-40.
Activities of Mr. S.N. Knight as air engineer with Western Canada Airways and with Ontario Provincial Air Service in Northern Ontario and the Northwest Territories.

Knowles, Stanley Howard, (b. 1908), Ottawa, Ont., politician.

7P-927 b&w 1. 1929.
Group photo of delegates to student Christian Methodist conference, Jasper, Alta., 20-27 June 1929.

Knox, Wilbert George Melvin, (b. 1911), Vancouver, B.C., aviator.

7P-929 b&w 10. ca. 1932-71.
Career of Captain W.G.M. Knox as pilot with Canadian Pacific Airlines and CP Air, ca. 1932-71.

Knox College, (1858-), Toronto, Ont., education of Presbyterian ministers.

317P-3 b&w 100. 1872-.
Graduating classes (group photos).

317P-4 b&w 22. [n.d.].
Knox Monthly staff, K.C.; F.R.C. Champions; K.C. Soccer Team; K.C. Undergraduate Assoc.; K.C. Alumni Assoc.; K.C. students in dining hall; faculty and men in residence in old K.C., K.C. Students Missionary Society; K.C. Missionary and Theological Society; K.C. Theological and Literary Society; K.C. Metaphysical and Literary Society; Summer School; K.C. Literary Society.

Knox Presbyterian Church, Manotick, Ont.

7P-928 b&w 1. ca. 1850-65.
Daguerreotype portrait of Rev. Donald McKenzie.

Kohashigawa, K., Coaldale, Alta.

7P-930 b&w 1. 1910.
Messrs. Kohashigawa and Takayesu, immigrants from Okinawa, Japan, Lethbridge, Alta.

Kouri, P.J., Regina, Sask.

7P-931 b&w 9. ca. 1882-1910.
SS *Alberta,* SS *Marquis* and SS *Saskatchewan* on the Saskatchewan River.

Krieber, Hans Johann, (b. 1925), Ste. Foy, Que., photographer.

7P-932 b&w 1,208, col. 5, total 1,213. ca. 1962-1974.
Activities of immigrants in various occupations in Montreal and Quebec, Que.; aspects of life in the province of Quebec: landscapes, pollution, family life, portraiture; photos by Johann H. Krieber.

Kysilewska, Olena, (1869-1956), Ottawa, Ont., Ukrainian activist.

7P-933 b&w 300. ca. 1917-1956.
Aspects of the life and career of Mrs. Olena Kysilewska, prominent Ukrainian stateswoman and member of the Ukrainian Canadian community.

La Have Outfitting Co., (est. 1912), La Have, N.S., shipchandlers.

31P-77 Copies, b&w 11. ca. 1900, 1917.
Italy Cross United Church, fish plant workers, Lunenburg Marine Railway, shipbuilding at Yarmouth, Davison Lumber Co. camp, Bridgewater Drill Hall.
Provenance: Mr. Teleen Gray, La Have, N.S.

La Marco, A.J., Teterboro, N.J., aeronautical engineer.

7P-942 b&w 20. 1940-1951.
Various types of civil and military aircraft produced by De Havilland Aircraft of Canada Ltd., Downsview, Ont., and by Canadair Ltd., Cartierville, Que.

La Rocque, Antoine-B., Lucerne, Que.

7P-965 b&w 20. ca. 1850-1895.
Portraits of various members of the LaRoque family, particularly Chevalier Alfred de LaRoque of the Pontifical Zouaves.

La Société historique du Comté de Shefford, Granby (Québec).

344P-1 total [35,000]. ca. 1865-1978.
Photos de familles, de maisons, de parcs, de paysages, d'événements politiques, historiques et sociaux; une importante collection de 7,000 photos sur les bâtiments de la ville de Granby (Québec).

Laberge, Albert, (1871-1960), Montréal (Québec), romancier, conteur, journaliste.

7P-934 b&w 8. [1871-1937].
Aspects of lives of painter Charles Gill and writer Albert Laberge.

185P-16 n.&b. 30. ca. 1905-1933.
Photographies des amis de Laberge, dont la plupart sont des écrivains et artistes québécois.

Lacasse (famille), Tecumseh (Ont.), éditeurs de *La Feuille d'Erable*.

185P-2 n.&b. 80. 1884-1974.
Photos de la famille du sénateur Gustave Lacasse et des organismes canadiens-français auxquels il a participé dont; Canadian Weekly Newspaper Association, la Société des Artisans, l'Ecole normale d'Ottawa et autres.

Lachance, Vernon, Ottawa, Ont., R.C.M.P. constable.

7P-935 b&w 2. ca. 1875-1886.
View of Fort Edmonton, Alta., 1876; portrait of Colonel A.G. Irvine, N.W.M.P.

Lackner, M., Cumberland, Ont.

7P-936 b&w 1. [n.d.].
Interior view of Laurier House, Ottawa, Ont.

Lady Stanley Institute Nurses' Alumni, Ottawa, Ont.

7P-938 b&w 9. 1913-1924.
Graduating classes of the Lady Stanley Institute for Trained Nurses, Ottawa, Ont.; portraits of doctors on staff of the County of Carleton General Protestant Hospital, Ottawa, Ont.

Lafferty, Victor, Fort Providence, N.W.T.

7P-939 b&w 1. 1921.
Junkers F.13 aircraft *Rene* and *Vic* of Imperial Oil Company, Fort Providence, N.W.T.

Laflamme, Joseph Clovis Kemner, Mgr, (1849-1910), Québec (Québec), professeur.

131P-5 Originaux, []. ca. 1863-1910.
Vues de l'Université Laval, du Séminaire de Québec et du Port de Québec, 1863; vues intérieures et extérieures du Petit et du Grand Séminaire de Québec et de la chapelle, ca. 1863 à 1910; l'incendie du Séminaire, 1865; vues intérieures et extérieures de l'Université Laval, ca. 1876-1910; les camps d'été du séminaire, le Petit-Cap, Saint-Joachim (Québec), 1868-1870, et Maizerets, 1893; excursions à l'Ile-à-deux-Têtes, 1892-1895, aux Chûtes Larose, Saint-Féréol, 1898, aux Sept-Chûtes, Saint-Féréol, 1896-1898, chûtes Sainte-Anne-de-Beaupré, 1896-1898, Lac à Philippe (Québec), 1895-1896; vues intérieures et extérieures du Château Bellevue, Saint-Joachim (Québec).

Laforce, Marcel, Quebec, Que.

7P-940 b&w 7. 1964.
Views aboard C.G.S. *Ernest Lapointe* during reenactment of voyage of C.G.S. *Queen Victoria* from Quebec, Que., to Charlottetown, P.E.I., carrying Canadian delegation to the Charlottetown Conference.

Lake family, East Kootenay area, B.C., ranchers.

333P-41 Copies, b&w 39. 1915-1925.
Invermere area, B.C.; logging; Lake family; petroglyphs; Athalmer, B.C.; Cranbrook, B.C.; C.P.R. Station, Fort Steele, B.C.

L'Alliance Canadienne, (est. 1953), Toronto, Ont.

7P-941 b&w 206, col. 8, total 214. ca. 1951-1961.
Visit to Canada of H.R.H. Princess Elizabeth, 1951; activities of Mme Madeleine Fohy Saint-Hilaire as official of L'Alliance Canadienne; views of Niagara Falls, Hamilton, Ottawa, Ont.; Quebec, Que.; filming of Alfred Hitchcock's Motion Picture *I Confess*, Quebec, Que.

Lamarre-Lacourse, Germaine, Shawinigan (Québec).

185P-5 n.&b. 37. [1880-1930].
Photographies de membres de la famille Saint-Louis prises à Grand-Mère, Québec et aux Etats-Unis; la mère de Madame Lamarre-Lacourse appartenait à cette famille.

Lamb, Eileen, Pierrefonds, Que., photographer.

7P-943 col. 342. 1965-1971.
Shipping activity, Montreal, Que.; views of various communities in Newfoundland and the Maritime Provinces; photos by Eileen Lamb.

Lamb, Henry John, (1871-), army officer.

7P-944 b&w 114. 1915-1918.
Aerial views of German positions on the Western Front during World War One.

Lamb, William Kaye, (b. 1904), Ottawa, Ont., archivist and librarian.

7P-945 b&w 544. ca. 1860-1967.
Sailing vessels and steamships which have plied Canadian waters or have visited Canadian ports; group photo of Canadian delegates to the Extraordinary Congress of the International Congress on Archives, Washington, D.C., 1966; presentation of award to Dr. W.K. Lamb by the Administrative Management Society, 1967; portraits of Rev. J.C. Goodfellow, Dr. R.A. Mackay, Mr. Gurdit Singh.

Lambart, Evelyn, Pierrefonds, Que.

7P-946 b&w 2821. ca. 1850-1955.
Views of Ottawa, Ont.; activities of Mr. F.H.J. Lambart and other members of the Lambart family; daguerreotype and tintype portraits of various members of the Lambart family.

Lambart, H., Grenville, Que.

7P-947 b&w 10. ca. 1865-1900.
Views of Port Arthur, Ont.; wreck of SS *Algoma*, Isle Royale, Ont., 1885; photos by J.F. Cooke; construction activity on shore of Lake Superior, Ont.; photo by C.P.[?] O'Meara; Rev. James Fraser and family, ca. 1865; photo by H.K. Sheldon.

Lambert, Augustin Emanuel, (d. 1917), Radisson, Sask., soldier.

7P-948 b&w 7. ca. 1910-1917.
View of Radisson, Sask.; portrait of Private A.E. Lambert, 9th
C.M.R.; grave of Private A.E. Lambert, France.

Lamberti, Carlo, (b. 1882), Toronto, Ont., marble cutter and musician.

7P-949 b&w 10. 1974.
Mr. and Mrs. Carlo Lamberti at home, Toronto, Ont.

Lamoureux, Wilfred L., Ottawa, Ont., commissionaire.

7P-950 b&w 2. 1941-1944.
Group photos of officers of the R.C.N.V.R. and of personnel of the
W.R.C.N.S., Ottawa, Ont.

Lampman, Archibald, (1861-1899), Ottawa, Ont., poet.

7P-951 b&w 5. ca. 1898-1900.
Portraits of Miss Helen Keller, and Messrs. W.H. Drummond,
William Kingsford, Peter McArthur, Gilbert Parker.

Lanark County Museum, Lanark, Ont.

7P-952 b&w 1. 1866.
Militia force leaving Prescott, Ont., June 1866.

Lance, Beatrice (Longstaff), Beschill-on-Sea, Sussex, England.

166P-37 Original, b&w 83. 1903.
Original negatives by Beatrice Longstaff Lance; scenic views of the
Rocky Mountains taken during pack trips.

Lanctot, Gustave, (1883-1975), Ottawa, Ont., archivist and historian.

7P-953 b&w 95. ca. 1870-1971.
Views of Quebec, Trois-Rivières, Montreal, Que.; Ottawa, Ont.;
portraits of Hons. Maurice Duplessis and Mackenzie King, and of
Major Gustave Lanctot and Dr. Wolfred Nelson; group photos of
various societies and teams to which Gustave Lanctot belonged as
a student at Oxford University, England.

303P-11 n.&b. 36. 1939.
Restauration de Port-Royal (N.-E.); édifices, portes, cheminées,
armoiries, etc.

Langevin, Edouard-Joseph, (1833-1909), Quebec, Que., public servant.

7P-954 b&w 98. [1850-1900].
Portraits by William Notman, J.E. Livernois and W.J. Topley of
members of the Langevin family, in particular Sir Hector Langevin.

Langevin, Hector Louis, (1826-1906), Quebec, Que., politician.

7P-955 b&w 48. ca. 1864-1871.
Views of Victoria and of various parts of the Cariboo District, B.C.,
by Frederick Dally.

Languedoc, Adele De Guerry, Ottawa, Ont., librarian.

7P-956 b&w 2. 1889.
Portraits of Mr. James Grant, and by J.L. Jones of Dr. Sewell,
Quebec, Que.

Lansdale, Robert, Toronto, Ont.

196P-47 total 40. 1898, 1924, 1925, 1968, 1973.
John McCaul, G.P. Young, James Brebner, Fisher Rare Book
Library, Medical Science Building; School of Practical Science,
Milling Building, Soldiers Tower, University of Toronto Medical
Society 1898; scrapbook of University exhibit at Wembley, 1924.

Lansdowne, Henry Charles Keith Petty-Fitzmaurice, Marquess of,
(1845-1927), Governor General of Canada, 1883-1888.

7P-957 b&w 52. ca. 1887.
Views of Ottawa, Ont., by W.J. Topley.

Lanthier, Joseph Antonio, (1887-1967), Winnipeg, Man., furrier.

7P-958 b&w 4. 1910-1930.
Exterior view of Lanthier Furs, Winnipeg, Man.; portrait of Mr.
and Mrs. J.A. Lanthier.

Lapierre, André, Ottawa (Ont.), professeur de linguistique.

185P-10 n.&b. 35. 1977.
Photographies d'enseignes et de plaques regroupées dans un album
intitulé *Enquête préliminaire sur le français des comtés unis de
Prescott-Russell (Ontario),* janvier à mars 1977.

LaPierre, Dorothy, Halifax, N.S.

1P-45 Original, b&w 5. ca. 1875.
Views of Halifax, including the Public Gardens, Point Pleasant
Park and the Northwest Arm; photographer: Notman.

Laplante, Oswald, Windsor, Ont.

7P-959 b&w 3. ca. 1940-1945.
H.M.C. Ships *Mahone* and *Penetang;* group photo of Ship's
Company of H.M.C.S. *Penetang.*

Lapointe, Ernest, (1876-1941), Quebec, Que., politician and cabinet
minister.

7P-960 b&w 28. 1926-39.
Group photos of delegates to the Imperial Conferences of 1926 and
1937, London, England; Hons. Ernest Lapointe and Mackenzie
King, Matane, Que., 1934; banquet marking the thirty-fifth
anniversary of Hon. Ernest Lapointe's election to Parliament,
Quebec, Que., 18 February 1939; portraits of Hon. Ernest Lapointe
and Mme. Lapointe; photos by J.A. Castonguay, Paul Horsdal,
Photo Moderne; Turcotte & Gousse.

Lapointe, Pierre-Louis, Hull, Que., historian.

7P-961 b&w 228. ca. 1890-1956.
Views and events in and around Hull, Aylmer, Buckingham, Que.;
lumbering operations at the MacLaren Mill, Buckingham, Que.;
group photos of delegates to annual conventions of *l'Union
Catholique des Cultivateurs,* Quebec.

Laport, Edmund Abner, (b. 1902), Ringoes, N.J., engineer.

7P-962 Original, []. 1942-44.
Types of military electronic equipment manufactured by R.C.A.
Victor Ltd., Montreal, Que.

Larden, A.W.J., North Bay, Ont.

7P-963 b&w 1. [n.d.].
Portrait of F/S A.W.J. Larden, G.M., R.C.A.F.

Larente, Arthur, Westmount, Que., film producer.

7P-964 b&w 6. ca. 1910-70.
Journée nationale du film parlant français, Montreal, Que., 20 February 1932; portraits of Messrs. Arthur Larente and Ernest Ouimet.

Larsen, Henry Asbjorn, (1899-1964), R.C.M.P. officer.

7P-966 b&w 4,545. ca. 1924-1961.
Career of Inspector Henry A. Larsen, R.C.M.P., particularly as commander of the R.C.M.P. patrol vessel *St. Roch*.

Larsen, Ole, Chatham, N.B., photographer.

46P-4 b&w 1,000. 1880-1910.
Lumbering along the Miramichi; views of other North Shore communities, including Campbellton, Dalhousie.

Larson, E.G., Ottawa, Ont.

7P-967 b&w 2. ca. 1860-1939.
Carriage used by H.R.H. the Prince of Wales, during his visit to Canada in 1860; portrait of Mr. George Sutherland.

Lascelles, Jessie L., Toronto, Ont.

7P-968 b&w 1. 1916.
Group photo of various Canadian officers of the Royal Flying Corps, Reading, England, January 1916.

Latchford, Francis Robert, (1854-1939), lawyer, politician and judge.

7P-969 b&w 135. 1903-1924.
Construction of the Temiskaming and Northern Ontario Railway; views in and around Hull, Que.

Laubach, Grace, Victoria, B.C.

7P-970 b&w 24. 1916-1917.
Photos by the Canadian War Records Office of various aspects of Canadian Military operations in France and Belgium, 1916-17.

Laurier, Henri, Montreal, Que.

7P-971 b&w 457. ca. 1890-1914.
Visit to Canada of the Duke and Duchess of Cornwall and York, 1901; visit of Sir Wilfrid and Lady Laurier to the Toronto Reform Association, Toronto, Ont., 1901; photo by Josiah Bruce; Sir Wilfrid Laurier at G.T.P. Railway sod-turning ceremony; Fort William, Ont., 1905; visit of Hon. William Templeman to Fernie, B.C., 1908; portraits of various relatives, friends and colleagues of Sir Wilfrid Laurier, photos by Bassano, Kennedy, Montminy, Savannah.

Laurier, Robert, Montreal, Que., lawyer.

7P-973 b&w 1. ca. 1922.
Portrait of Henri Wilfred Laurier, nephew of Sir Wilfrid Laurier, Ottawa, Ont.

Laurier, Wilfrid, (1841-1919), Prime Minister of Canada 1896-1911.

7P-974 b&w 11. ca. 1890-1919.
Reunion of former classmates of Sir Wilfrid Laurier, Arthabaska, Que., ca. 1898; Sir Wilfrid Laurier speaking during the federal election campaign of 1911; view of Arthabaskaville, Que.; funeral of Sir Wilfrid Laurier, Ottawa, Ont., 1919; portrait by Pittaway and Jarvis of Sir Wilfrid Laurier.

Laurier House, Ottawa, Ont.

7P-972 b&w 17. 1896-1968.
Sir Wilfrid Laurier taking part in the federal election campaigns of 1896 and 1908; tomb of Sir Wilfrid Laurier in Notre Dame Cemetary, Vanier, Ont.; visits of various foreign heads of state to Laurier House, Ottawa, Ont., 1962-68; portraits of Sir Wilfrid Laurier, Rt. Hon. Mackenzie King, Lady Byng, and Lady Tweedsmuir.

Laurin, François, (-1977), Ottawa (Ont.), étudiant.

185P-4 n.&b. [350], coul. [300], total 650. 1974-1976.
Photographies et diapositives des oeuvres de Joseph Saint-Charles, utilisées dans le cadre de la préparation d'une thèse *Joseph Saint-Charles, peintre canadien, 1868-1956,* présentée à l'Université d'Ottawa.

Lavoie, Yvon, Ottawa, Ont., public servant.

7P-975 b&w 15. 1874-1932.
Curtiss HS2L Flying Boat *La Vigilance* of Captain Stuart Graham, Riviere Du Loup, Que., 7 June 1919; Mr. A.S. Belaney ("Grey Owl") and associates, 2 November 1929; group photo of delegates to Imperial Economic Conference, Ottawa, Ont., July 1932.

Lawrie Wagon and Carriage Co. Ltd., (est. 1890), Winnipeg, Man., wagon manufacturers.

9P-39 b&w 52. [n.d.].
Photographs of wagon and truck bodies.
Provenance: Lawrie Wagon and Carriage Co.

Lawson, K., Dr., Toronto, Ont.

7P-976 b&w 3. 1945.
Vickers Supermarine Spitfire F.R. XIV B aircraft of No. 414 (Sarnia Imperials) Squadron, R.C.A.F., Celle, Germany, May 1945.

Le Clair, Eleanor, Ottawa, Ont.

7P-982 b&w 5. 1880-1890.
Views of Elgin, Ont.; gathering of maple sap, Elgin, Ont.; portrait of Mr. Ranson Baker.

Le Soleil, Quebec, Que., newspaper.

7P-992 b&w 1. 1943.
Induction of M. Gérard Morrisset into The Royal Society of Canada, Quebec, Que., 1943; photo by Photo Moderne.

Leach, Frederic, Bro., Berens River, Man., Catholic priest.

9P-40 b&w 18. ca. 1930.
Photographs of Berens River and other Lake Winnipeg settlements, Man.

Leach, Wilson George, (b. 1923), military officer and surgeon.

7P-977 b&w 11. 1943-1972.
Career of Brigadier-General W.G. Leach as flying instructor and flight surgeon in the R.C.A.F. and Canadian Forces.

Leacock, Stephen Butler, (1869-1944), economist, historian and humourist.

7P-980 b&w 7. 1887-1964.
Views of Mr. Stephen B. Leacock's home at Old Brewery Bay, Orillia, Ont.; presentation of the original manuscript of *Sunshine Sketches of a Little Town* to the Stephen Leacock Memorial Home, Orillia, Ont., 1964; portraits of Stephen and Beatrix Leacock.

95P-1 b&w 215. 1874-1944.
Portraits of Leacock by Karsh, Jacques Notman; snap shots of family members and environs of Orillia; pictures saved by Leacock.

Leacock, Stephen Butler, Associates, Orillia, Ont.

7P-978 b&w 1. 1969.
Scene from the play '*Behind the Beyond*' at Old Brewery Bay, Orillia, Ont., June 1969.

Leacock, Stephen Butler, Memorial Home, (1869-1944), Orillia, Ont., writer.

7P-979 b&w 95. 1875-1968.
Activities of Mr. Stephen Leacock in his home at Old Brewery Bay, Orillia, Ont.; photos by Karsh; first Leacock Medal dinner, Orillia, Ont.; views of Orillia, Ont.; portraits of Mr. Stephen Leacock, of various friends and colleagues, and of recipients of the Leacock Medal.

Leash, H.E.

334P-43 Copies, b&w 1. ca. 1918.
New Westminster Fire Dept. drawn up outside City Market.

Leclair, Denise, Vanier, Ont., secretary.

7P-981 b&w 1. 1910.
Interior view of Mr. John Dazé's general store, Arnprior, Ont.

Leech, Alice, Ottawa, Ont.

7P-983 b&w 133. 1898 - 1949.
Prospecting, activities of Mr. Tom Payne at Desperation and Pensive Lakes, N.W.T.; construction of the Hudson Bay Railway; first crew at shaft of the Consolidated Mine, Yellowknife, N.W.T. 1938; views of Churchill, Cranberry Portage, Flin Flon, The Pas, Man.; Cooking Lake, Alta.; Fort Smith, Port Radium, Yellowknife, N.W.T.; portraits of various members of the Payne family.

Lefebvre, J.B., Mme, Montreal, Que.

7P-984 b&w 3. ca. 1846-1880.
Views of the Citadel, Quebec, Que.; portrait of Dr. Wolfred Nelson.

Lefebvre, Rosario, (1897-1975), Québec (Québec), professeur.

131P-4 Originaux, n.&b. [1,300], coul. [10], total [1,310]. 1908-1971.
Portraits de plusieurs abbés, évêques et cardinaux ca. 1918-1943; portraits d'élèves du Petit Séminaire de Québec, ca. 1911-1934; photos de mariages célébrés par Rosario Lefebvre, Québec, 1923-1925; photos par Jules-Ernest Livernois, M.A. Montminy et Vandry; vues de Beauport (Québec) 1938; voyages à Rome, Italie,

1936-1939; vues de la ville de Québec, ca. 1908-1929; Congrès Eucharistique, Québec, 1923-1938; Congrès Marial, Québec, 1929; ancienne basilique de Sainte-Anne-de-Beaupré en 1920, Beaupré (Québec); chantiers Maritimes, Lauzon (Québec), 1920; camp d'été du Séminaire de Québec, le Petit-Cap, Saint-Joachim, ca. 1915-1920; le «R-100», ballon dirigeable à Québec, 1930; vues du Saguenay, de la Beauce, de la Gaspésie et du Lac St-Jean (Québec), 1922-1934; voyages à Régina (Sask.), Victoria (C.-B.), et Québec (Québec) 1930; Notre-Dame-du-Portage et Saint-Tite-des-Caps (Québec), ca. 1949-1950; Ecrasement d'un DC-3, Sault-au-Cochon, Beaupré (Québec) 1949; voyage à Venise, Italie, 1931, France (Marseille et Paris), Saint-Domingue et Afrique, ca. 1955-1971.

Léger, Jules, Madame, Ottawa, Ont.

7P-985 b&w 5. ca. 1860-70.
Ambrotype and tintype portraits of Mgr. Ignace Bourget and Sir Georges Etienne Cartier.

Legere, Norman D., Montreal, Que., soldier.

7P-986 b&w 1. 1941.
Fragments of track excavated along C.N.R. route near Victoria Bridge, Montreal, Que.

Legg, Herbert K., Creston, B.C., customs official.

7P-987 b&w 50. ca. 1920-70.
Views of Churchill, Man.; views of various customs houses in British Columbia; group photos of Customs and Excise personnel at Calgary, Alta., 1925 and at Rykerts, B.C., 1970.

Lehman, Reginald J., North Bay, Ont.

7P-988 b&w 128. 1943-45.
Joint R.C.A.F./U.S.A.A.F. trials of flight exposure suits, Dartmouth, N.S., 1943-44; activities of first R.C.A.F. course for rescue parachutists, Alberta, 1944; various types of R.C.A.F. land and air sea rescue equipment, 1943-45.

Leigh, Zebulon Lewis, (b. 1906), Grimsby, Ont., aviator and military officer.

7P-989 b&w 11. ca. 1928-50.
Aspects of the career of G/C Z.L. Leigh with Canadian Airways, Trans-Canada Air Lines, and with the R.C.A.F., particularly the award to him of the Trans-Canada (McKee) Trophy in 1946.

Leighton, T., (1905), Wycliffe, B.C.

333P-43 Copies, b&w 2. ca. 1920.
Shay woodburning engine; Wycliffe, B.C.

Lemay, J.-E., (1906-1967), Chicoutimi (Québec).

335P-1 Originaux, []. 1906-1967.
Fonds constitué majoritairement de portraits d'individus, de familles, de groupes; quelques sites de Chicoutimi, des monuments, des rues; des photos de passeports, de cartes mortuaires, de communiants, de mariages, de licences; quelques photos pour des journaux locaux.

Lemieux, Lucien, (1878-1963), Quebec, Que., librarian.

7P-990 b&w [400]. ca. 1880-1953.
Views of Quebec, Bonaventure Island, Que.; portraits of various members of the Lemieux family, and of clergy and politicians active in Quebec; photos by J.L. Jones, Livernois, Rice.

Lemieux, Rodolphe, (1866-1937), Ottawa (Ont.), membre du parlement canadien 1896-1930; sénateur 1930-1937.

7P-991 b&w 238. ca. 1896-1911.
Portraits of various colleagues and friends of Hon. Rodolphe Lemieux.

185P-9 n.&b. 18. 1866-1910.
Entre autres, quatre photos d'une assemblée électorale à l'Islet (6 octobre 1908) où on voit Sir Wilfrid Laurier; des portraits des amis de Lemieux; un bureau de poste militaire (ca. 1910); une statue au studio de L. Philippe Hébert (ca. 1904).

Lemire, Roland, Trois-Rivières (Québec), photographe.

353P-1 total [1,000]. 1910 à nos jours.
Collection du photographe Héroux 1910-1935 et la collection personnelle de Roland Lemire 1940 à nos jours.

Lennox and Addington Historical Society, (1907-), Napanee, Ont., preserving and recording local history.

22P-1 total [8,000]. ca. 1880.
People, places, and events in the history of Lennox and Addington County, Ont.

Les Oblates Missionnaires de Marie-Immaculée, (f. 1952), Trois-Rivières (Québec).

331P-1 total [1,500]. 1952 à nos jours.
Personnes responsables de la fondation de l'Institut et de son implantation dans différents pays; travail réalisé par les membres dans plusieurs diocèses; les coutumes typiques et événements marquants de ces mêmes pays.

Lester-Garland, George Henry, Bath, England, clergyman.

7P-993 b&w 3. ca. 1955.
Residence of the Lester-Garland family, Trinity, Nfld., ca. 1955; photos by G.H. Lester-Garland.

Lethbridge Community Services Department, Sir Alexander Galt Museum, Lethbridge, Alta.

7P-994 b&w 86. ca. 1900.
Lake of the Woods; hunting; industrial fishing and other industries.

Letourneau, Henri, Saint-Boniface, Man., curator of Musée de Saint-Boniface.

9P-41 b&w 40. ca. 1880-1924.
Metis and French Canadian personalities.

Letourneau, J., Mrs., Montreal, Que.

7P-995 b&w 2. 1967.
Saddle alleged to have belonged to M. Louis Riel.

Letson, E. Marguerite, (b. 1887), Port Medway and Halifax, N. S., school teacher and principal.

1P-1 Original, b&w 66. 1906, ca. 1948.
Historic houses and views of Port Medway, N.S., by E. Marguerite Letson.

Leurs, Hubert, Aylmer, Que., public servant.

7P-996 b&w 1. ca. 1900.
View of St. Joseph's Oratory, Montreal, Que.; photo by Albert Dumas.

Levasseur, Nazaire, (1848-1927), Quebec, Que., journalist, soldier, public servant.

7P-997 b&w 15. 1906-1907.
Voyage of C.G.S. *Arctic* under command of Captain J.E. Berner to the Arctic Archipelago, N.W.T., 1906-07.

Levi, S. Gershon, (b. 1905), rabbi.

7P-998 b&w 5. 1940-1944.
Activities of Rabbi S. Gershon Levi and other Jewish Chaplains of the Canadian Army in Britain and Northwest Europe, 1940-44.

Lewis, Collis, Mrs., Richmond, Ont.

7P-999 b&w 2. ca. 1840-1854.
Portraits of Colonel G.T. Burke, Mayor of Richmond, Ont.

Lewis, David, (b. 1909), politician.

7P-1000 b&w 1. 1970.
Portrait of Mr. David Lewis, M.P.; Leader of the New Democratic Party.

Lewrey, Norman, Ottawa, Ont., engineer.

7P-1001 b&w 63. 1939.
First trans-Atlantic mail flight by Short Empire Flying Boat G-AFCV *Caribou* of Imperial Airways Ltd., August 1939.

Liberal Party of Canada, Ottawa, Ont., political party.

7P-1002 b&w 10,052, col. 397, total 10,449. 1948-1968.
Leadership conventions of the Liberal Party of Canada, 1948-68; various aspects of the activities of the Liberal Party of Canada; portraits of Sir Wilfrid Laurier; Hons. W.L. Mackenzie King, Louis S. St. Laurent, Lester B. Pearson, Pierre E. Trudeau and other members of the Liberal Party of Canada.

Lidstone, F.C., Dawson City, Yukon.

7P-1003 b&w 23. 1902-1904.
Aspects of the Klondike Gold Rush; views in and around Dawson, Yukon Photos by W.P. Kelly, Kinsey and Kinsey.

Lieberman, Samuel S., Edmonton, Alta., judge.

7P-1004 b&w 1. 1920.
Group photo by W.J. Oliver of members of the Edmonton Eskimos Football Club, Edmonton, Alta.

Lieux et édifices, Maritimes.

15P-4 n.&b. [500], coul. [150], total [650]. 1900.
Sites historiques, villes et villages, églises, habitations, granges, ponts, moulins, cimetières, clôtures; photos touchant le domaine de la civilisation matérielle.

Lightfoot, Frederick, S., Huntington Station, N.Y., collector.

 7P-1005 b&w 12. ca. 1860-1870.
 Views of Barkerville, B.C.; band of the Victoria Rifles, Montreal,
 Que.; photo by C.W. Graham.

Lindsay, Crawford, (1847-1928).

 134P-3 n.&b. 58. 1870-1906.
 Militaires de la Quebec Volunteer Field Battery (Q.V.F.B.), 1886;
 camp de la Q.V.F.B., 1870; Crawford Lindsay, 1870; camp de la
 Quebec Battery of Artillery, Ile d'Orléans, 1871 et 1875; artilleurs
 sur l'Ile d'Orléans le 20 déc. 1873; Sergent Hame, gagnant de la
 médaille de bronze de Lord Dufferin (1872-1878) pour le meilleur
 résultat des artilleurs du Dominion, groupe d'officiers artilleurs,
 1880, photos de Jules Ernest Livernois; groupe d'artilleurs au camp
 de Lévis pendant l'inspection du major-général Luard, juillet 1881;
 groupe d'artilleurs en tenu de route au camp de Lévis, le 6 juillet
 1883; groupe d'officiers du camp Saint-Joseph de Lévis, le 12 juillet
 1884; camp à Saint-Thomas de Montmagny, juillet 1888; batterie
 de campagne de Québec (Crawford Lindsay), ca. 1891, photos de
 Jones, Québec (Québec); Lieut. E. Lobbate, Q.I.B., photos Jules
 Ernest Livernois.

Lindsay, Robert, (1883-1962), Laurier, Man., farmer, photographer.

 9P-42 b&w 52. 1905-1908.
 Photographs of lumbering in the Riding Mountains and farm
 scenes near Laurier, Man.
 Provenance: Nelson Harvey, Winnipeg.

Lineham, Mrs. D.K., Midnapore, Alta.

 7P-1006 b&w 3. ca. 1890-1908.
 Midnapore Woolen Mills, Midnapore, Alta.

Link, Henry David, Saskatoon, Sask., military officer.

 7P-1007 b&w 1. 1943.
 Portrait of F/O H.D. Link, G.M., R.C.A.F.

Lisle, Robert, McGuire Air Force Base, N.J., physician and collector.

 7P-1008 b&w 1. ca. 1852.
 Daguerreotype view of Montreal, Que.

Littell, Walter J., Burford, Ont., printer.

 7P-1011 b&w 1. ca. 1900.
 View of the Armoury, Burford, Ont.

Little, Margaret E., Lakefield, Ont.

 7P-1009 b&w 3. [n.d.].
 View of residence at No. 270 Brock St., Peterborough, Ont.

Littleton, Harry, Fenelon Falls, Ont.

 7P-1010 b&w 8. ca. 1880-1900.
 Views of Fenelon Falls, Ont., and of the steamships *Dominion,
 Manita, Maple Leaf, Sunbeam.*

Livernois, Jules Ernest, Quebec, Que., photographer.

 7P-1012 b&w 1775. ca. 1880-1930.
 Tercentenary celebrations, Quebec, Que., 1908; departure of Hon.
 R.B. Bennett aboard C.P.S. *Empress of Australia,* Quebec, Que.,
 1930; views in and around Quebec, Que., in Champlain,

Montmorency and Portneuf counties, Que., and along the route of
the Quebec and Lake St. John Railway, Que.; photos by J.E.
Livernois Ltee.

Livres et auteurs canadiens/québécois, (1960-1976), Montréal (Québec) et
Québec (Québec), publication des comptes rendus des livres récents.

 185P-15 n.&b. [400]. 1962-1971.
 Photographies des auteurs canadiens-français et québécois en ordre
 alphabétique.

Lizotte, M.L.V., St. Hubert, Que., member of the canadian forces.

 7P-1013 b&w 2. ca. 1918.
 Portraits of Lieutenant Jean Brillant, V.C., M.C. and Corporal
 Joseph Kaeble, V.C., M.M., 22nd Battalion, C.E.F.

Local History Department, (est. 1967), Saskatoon, Sask.

 339P-1 b&w 3950. 1882 to date.
 The growth and development of Saskatoon since its beginning as a
 Temperance Colony in 1882: street scenes, buildings, and a
 biographical collection of various personages.

Lochead, Allan Grant, (b. 1890), Ottawa, Ont., bacteriologist.

 7P-1014 b&w 81. 1911-1963.
 Views of Ruhleben internment camp, Germany, 1914-18; aspects
 of the career of Dr. A.G. Lochead with the Department of
 Agriculture, Ottawa, Ont., 1923-55; composite photo of the
 graduating class of 1911; McGill University, Montreal, Que.

Locke, Ralphine and Helen Grier.

 166P-46 Original, b&w 19. ca. 1899.
 Original albumin prints collected by Locke and Grier; views along
 CPR grade in the Selkirks and the Rocky Mountains, ca. 1899.

Logan, John Daniel, (1869-1929), Halifax, N.S. and Toronto, Ont., editor
and author.

 31P-98 Original, b&w 36. ca. 1920-1929.
 Autographed portraits of numerous actors, actresses, singers, and
 composers.

Logan, William Edmond, Sir, (1798-1875), provincial geologist.

 18P-35 Original, b&w 40. ca. 1871.
 Views in B.C. by Notman.

Lomen Brothers, (1908-1934), Nome, Alaska, professional photographers.

 11P-1 b&w 3,485. ca. 1900-1935.
 Negatives on western and south-western Alaska; dog sleds and
 racing; Arctic exploration and expeditions; steamships and
 schooners; gold mining; Nome buildings and industries; reindeer
 herds and industry; various Alaska towns, all phases of Eskimo life,
 including fine portrait material.

London and Middlesex Historical Society, London, Ont.

 7P-1015 b&w 1. ca. 1874-1885.
 Brough's Bridge and Hellmuth Ladies' College, London, Ont.;
 stereograph by Joshua Garnier, Jr.

London Public Library and Art Museum, Toronto, Ont.

196P-55 total 19. n.d., 1916, 1924, 1940-1954.
Miscellaneous University of Toronto buildings; Ontario Veterinary College, 1916; postcards and magazine clippings of University College, n.d., 1916, 1940 1954; Wycliffe College; Knox College; Emmanuel College; Hart House; Victoria College; Trinity College; Convocation Hall.

Longley, C.F., Halifax, N.S.

31P-10 Original, b&w 5. 1914-1918.
Press story of the Great War.

Lordly family, Chester, N.S.

1P-7 Original, b&w [90]. ca. 1860-1880.
Tintypes, photographs of the Lordly family and friends, a few Canadian politicians.

Lorne, John Douglas Sutherland Campbell, Marquess of, (1845-1914), Governor General of Canada, 1878-1883.

7P-1016 b&w 2. 1878-1879.
Ceremony of swearing in the Marquess of Lorne as Governor General of Canada, Ottawa, Ont., 1878; Ball held in honour of the Marquess of Lorne at the Windsor Hotel, Montreal, Que., 1879.

Lorne Pierce Collection.

75P-13 b&w [350]. ca. 1910-1960.
Family photographs, and persons connected with literature and the arts primarily in Canada.

Lothian, George Bayliss, (b. 1909), Perth, Ont., aviator.

7P-1017 b&w 24. 1929-1968.
Career of Mr. G.B. Lothian with the Aero Club of British Columbia, with Trans-Canada Air Lines and Air Canada and as Chief of the I.C.A.O. mission to Nepal.

Louise Caroline Alberta, H.R.H. Princess, (1848-1939).

7P-1018 b&w 123. 1878-1883.
Interior and exterior views of Rideau Hall, Ottawa, Ont.; photos by W.J. Topley; views of Victoria, New Westminster, Nanaimo, Yale, B.C.; studio scenes of hunting in Canada; photos by William Notman, W.J. Topley, Robert Maynard.

Lovello, Vincent, (b. 1924), Toronto, Ont., photographer.

7P-1019 b&w 25. 1972-1975.
Activities of the Italian community, Toronto, Ont.; photos by Vincent Lovello.

Low, Estelle, Ottawa, Ont.

7P-1020 b&w 3. 1903-1904.
C.G.S. *Neptune* in the Hamilton River, Labrador, 1903; Eskimo family aboard C.G.S. *Neptune*, N.W.T., ca. 1904; photos by A.P. Low.

Lowe, Freeman Henry Hetherington, (1871-1958), Ninette, Man., farmer.

9P-43 b&w 133. ca. 1890-ca. 1903.
Photographs of Ninette, Man.
Provenance: Mrs. K.C. Offer, Ninette Manitoba.

Lower, Arthur Reginald Marsden, Dr., (b. 1889), Kingston, Ont., educator and historian.

7P-1021 b&w 79. ca. 1910-1971.
Career of Dr. A.R.M. Lower as student and instructor at the University of Toronto, as R.N.V.R. officer, as archivist at the Public Archives of Canada, and as student and professor at Tufts College, Harvard University, University of Manitoba, and Queen's University, 1914-59; activities of relatives, colleagues and friends of Dr. A.R.M. Lower.

75P-8 b&w [650]. ca. 1850-ca. 1950.
Family photographs, general photographs of many aspects of Canadian history and geography collected for use in a general high school textbook which he co-authored.

Lowes Studio, (f. 1950-1960), Pembroke, Ont., photographic studio.

7P-1022 b&w 5. [1950-1960].
The sawmill and dock of the Consolidated Paper Corporation Ltd., Pembroke, Ont.

Lowrey, Thomas Gordon, (b. 1892), Ottawa, Ont., newspaperman.

7P-1024 b&w 6. 1921-1948.
Group photos of members of the Ottawa Rugby Football Team of 1921, and of the Ottawa Rough Riders football team of 1948.

Lowry, D. Hallie, Almonte, Ont.

7P-1023 b&w 171. ca. 1890-1965.
Views in and around Almonte, Appleton, Pakenham, Ont.; lumbering activity in the Ottawa Valley; aspects of the career of Dr. James Naismith, inventor of basketball.

Lucas, Arthur, military officer.

7P-1025 b&w 13. 1865-1895.
Activities and personnel of the Governor General's Body Guard and of the North West Mounted Police during the Northwest Rebellion of 1885; views of Duck Lake, Fish Creek, N.W.T., 1885; Commissioner L.W. Herchmer and N.W.M.P. personnel with Almighty Voice of the Cree Tribe, N.W.T., ca. 1895.

Lucas, Glenn, Carp, Ont., clergyman.

7P-1026 b&w 16. ca. 1876-1959.
Exterior and interior views of St. Paul's Methodist Church and St. Andrews Presbyterian Church and their manses, Carp, Ont.; portraits of various Methodist, Presbyterian and United Church Ministers who served at Carp, Ont.

Lucas, Leslie, Ottawa, Ont., public servant.

7P-1027 b&w 23. 1968-1970.
Autographed portraits of prominent singers and musicians appearing in the Tremblay Concerts, Ottawa, Ont., 1968-1970: Pearl Bailey, Maurice Chevalier, Van Cliburn, Emil Gilels, Liberace, Leontyne Price, Elizabeth Schwarzkopf, Teresa Stratas, Joan Sutherland.

Lugrin Studio, Saint John, N.B., photographers.

7P-1028 b&w 6. 1885-1942.
Portrait by A.L. Lugrin of Mr. C.T. Lugrin; group photo of various members of the Hanson and Sinclair families; portraits of

Lugrin Studio, Saint John, N.B., photographers.
(Cont'd/Suite)

unidentified children.

Luke, L. William, Toronto, Ont.

7P-1029 b&w 1. 1943.
Damaged float of Blackburn Shark III aircraft 547 'J' of No. 7
(BR) Squadron, R.C.A.F. Prince Rupert, B.C., 29 January 1943.

Lummis, Floyd Bert, Peterborough, Ont.

7P-1030 b&w 1. ca. 1940.
Portrait of F/S F.B. Lummis, G.M., R.C.A.F.

Lumsden, Elliott, (fl. 1905-1915), Murray River, P.E.I., photographer.

5P-1 b&w 207. ca. 1905-1915.
Village scenes, local industries, group and individual portraits from
Southern Kings County, P.E.I., especially Murray Harbour and
Murray River.

Lunenburg Outfitting Co., (1917-1970), Lunenburg, N.S., ship chandlers.

31P-76 b&w 51. ca. 1860-1940.
Wilfred Knickle family history.

Lupson, Arnold, (d. 1951), Calgary, Alta., employee of Great West
Saddlery Company, Calgary.

11P-2 b&w 1,094. ca. 1920-1940.
Negatives taken by Lupson of Blackfoot, Sarcee, Stony, Blood and
Peigan Indians; includes portraits, costumes, dwellings, ceremonies,
daily life, participation in stampedes and royal visits.

Lyle, B.

334P-44 Copies, b&w 1. ca. 1895.
Steamboat *Gladys*.

Lyman, Dot (White), Banff, Alta.

166P-41 Original, b&w 62. ca. 1890-1905.
Original prints collected by Dot Lyman; Banff people; views of
Banff townsite and surrounding area, ca. 1890-1905.

Lynch, Francis Christopher Chisholm, (1884-[1963]), Ottawa, Ont., public
servant.

7P-1031 b&w 21. 1937.
Cave in which were found skeletons alleged to be those of the crew
of La Salle's Ship *Griffon*, Manitoulin Island.

Lynch, Francis Joseph, (fl. 1870-1900), engineer.

7P-1032 b&w 20. ca. 1874-1894.
Views of St. Mary's Roman Catholic Church, Cemetary, Presbytery,
Academy and Convent, Newcastle, N.B., ca. 1874; construction of
various bridges along Contracts 10 and 21 of the Intercolonial
Railway in New Brunswick, ca. 1874; pair of unidentified Indians,
Rat Portage, Ont., 1881; photo by J.K. Salter; government
inspection of the Parry Sound Colonization Railroad, Ont., 1894.

Lyonde, Louis Laurier, Toronto, Ont., photographer.

7P-1033 b&w [52,000]. 1929-1949.
Portraits of provincial and municipal politicians and officials, and
of prominent members of various professions and occupations,
Toronto, Ont., photos by F.W. and L.L. Lyonde.

MacAskill, Wallace R., (1890-1956), St. Peter's, N.S., photographer.

7P-1035 b&w 1. ca. 1915-1925.
Views of Cape La Ronde, N.S.; photo by W.R. MacAskill.

MacBeth, Madge, (1883-1965), Toronto, Ont., journalist, author.

7P-1036 b&w 19. (1915-1925).
Views of various lakes, mountains and campsites in the Rockies.

MacCormack, J., (fl. 1940-1945), Maitland, Ont., air force officer.

7P-1044 b&w 142. 1941-1942.
Views of various military aircraft used by the R.C.A.F. in Eastern
Canada during 1941-1942, including the Avro Anson, Bristol
Bolingbroke, Cessna Crane, Fleet Finch, Handley Page, Hampden,
Hawker Hurricane, North American Harvard, Lockheed Hudson
and North American Mitchell.

MacDonald, Alexander, E., Dr., (1892), Toronto, Ont., ophthalmologist.

7P-1052 b&w 47. 1910-1960.
Views of the Tidal Bore, Moncton N.B.; various events in Dr. A.E.
MacDonald's career, including several international congresses on
ophtalmology.

MacDonald, D., (1897-), Calgary, Alta., Kitchener, B.C., and Cranbrook,
B.C.

333P-30 Original, b&w 14. 1912-1925.
First Calgary Stampede; Sash and Door Lumber Co., Kitchener,
B.C.; Cranbrook, B.C.

MacDonald, Ena, Ottawa, Ont.

7P-1054 b&w 87. 1900-1914.
Views of Halifax, N.S.; photos by the Notman Studio.

Macdonald, Hugh John, Sir, (1850-1929), Winnipeg, Man., politician.

7P-1055 b&w 3. [1850-1855].
Portraits of John A. Macdonald, Isabella Macdonald, and Hugh
John Macdonald.

MacDonald, James Edward Hervey, (1873-1932), Toronto, Ont., artist.

7P-1056 b&w 2. [n.d.].
Portrait of J.E.H. MacDonald; group portrait of J.E.H. MacDonald
and others.

Macdonald, John Alexander, Sir, (1815-1891), premier ministre du
Canada.

7P-1057 n.&b. 4. 1864.
Portraits de Sir John Alexander Macdonald avec sa femme et son
fils; portraits de Sir John A. MacDonald à Québec (Québec);
photo par Ellisson, 1864 et par Pittaway et Jarvis.

MacDonald, Robert James, Ottawa, Ont.

7P-1061 b&w 1. [n.d.].
Portrait of Mr. and Mrs. Pollock.

MacDonald, Vincent C., (1897-1964), Halifax, N.S., judge.

31P-14 Original, b&w 25. ca. 1948-1964.
Career of V.C. MacDonald.

MacDonald Funeral.

7P-1051 b&w 3. 1891.
Views of the Memorial Service for Sir John A. Macdonald in the Parliament Buildings, and the Funeral cortege leaving Parliament Hill, Ottawa, Ont.

Macdonald of Earnscliffe, Susan Agnes, Baroness, (1836-1920), Ottawa, Ont.

7P-1060 b&w 18. [1857-1929].
Portraits of members of the Macdonald family, including Sir John A., Hugh John and Lady Macdonald; portraits of politicians active during Sir John A. Macdonald's career; view of the artisan's dormitory at the Port Royal Habitation, Annapolis Royal, N.S., ca. 1910.

Macdonell, Archibald Cameron, Maj. Gen. Sir, (1864-1941), military officer.

7P-1062 Copies, b&w 22. 1900-1930.
Portrait of Major General A.C. MacDonell, and activities of the general.

MacDougall, E., (1858-1938), Maitland, N.S., master mariner.

31P-26 b&w 26. ca. 1900-.
Ships and ships' masters.

MacDougall, F.A., Toronto, Ont., public servant.

7P-1067 Copies, b&w 12. [n.d.].
Portrait of F.A. MacDougall, Deputy Minister, Ontario Department of Lands and Forests, with various Ontario politicians; activities of the Ontario Department of Lands and Forests.

MacDougall, Miss.

7P-1064 b&w 4. 1872.
Mourning ribbon with a portrait of Sir Georges E. Cartier.

MacDougall, Peter, Rockcliffe, Ont.

7P-1068 Copies, b&w 4. ca. 1880-ca. 1933.
Views of buildings in Rockcliffe, Ont.; two group portraits of unidentified persons; album of unidentified family; group portrait of the Aberdeens; Montreal Maroons Hockey Team of the 1932-1933 season; portraits of Mr. Allen Keefer; Mr. C.H. Keefer and family; four generations of the Keefer family, ca. 1880-1913.

MacDougall, R.J., (1900-1972), Ottawa, Ontario and Fort Steele, B.C., mining engineer.

333P-1 Original, b&w 291. 1885-1945.
Charles Mair, relatives and acquaintances, houses, persons unknown, Scrip Commission, 1899; buildings, scenery and New Zealand prints; R.J. MacDougall's relatives, surveying expedition, Fort Steele people and buildings.

MacEachern, George, Sydney, N.S., trade unionist, political activist.

31P-113 Original, b&w 1. 1977.
Portrait of G. MacEachern.

MacGillivray, Dougald, Dr., (d. 1937).

31P-51 Original, b&w [20]. ca. 1925-1937.
Portraits of Dalhousie University governors and professors, signed portraits of President Wilson and President Roosevelt, Rear Admiral Sims, Field Marshall Lord Allenby, Lord Byng of Vimy, King George VI and Queen Elizabeth; Canadian memorial at Vimy, France, and Greek ruins at Paestum, Italy.

MacInnis, George A., Yarmouth, N.S.

7P-1085 b&w 1. 1855.
Group photo of merchants, Yarmouth, N.S., 1855; photo by William Chase.

MacInnis, Gerald Lester, Ottawa, Ont.

7P-1086 Copies, b&w 9. 1968.
Presentation of the McKee Trophy to G.L. MacInnis; group photograph of the McKee Trophy Winners, 1968; portrait of G.L. MacInnis.

MacInnis, Grace, (b. 1905), Vancouver, B.C., politician.

7P-1087 b&w 8. [n.d.].
Unveiling of portrait of Mr. J.S. Woodsworth, Ottawa, Ont.; group photo of Mr. J.S. Woodsworth and family.

MacIntyre, Duncan Eberts, (1885-[1977]), Wakefield, Que., military officer, author.

7P-1088 b&w 4. 1870-1875.
Factor John MacIntyre and family, Fort William, Ont.

MacIntyre, John, (1817-1899), Fort William, Ont., fur trader.

7P-1089 b&w 9. [1870-1895].
MacIntyre home at Fort William, Ont., ca. 1890; portraits of Sir George Simpson, Harriet Dufferin, Sir Charles Windham, Lord Milton, Daisy Fitzwilliam, John MacIntyre, Lord Dufferin, and A.G. Archibald.

MacKay, Ottawa, Ont.

7P-1091 b&w 55. [n.d.].
Lantern slides of various automobiles, and portraits of the Women's Canadian Club, Ottawa, Ont.

Mackay, B.R., (n. 1885), Ottawa (Ont.), géologue.

7P-1092 n.&b. 1. ca. 1925-1935.
Manoir de colonel John Macdonell, Glengarry Point, Ont.

Mackay, Dan, Ottawa, Ont.

7P-1093 Copies, b&w 22. 1940.
Portraits of personnel and views of the Cameron Highlanders of Ottawa at Camp Borden, Ont., and in Iceland.

Mackay, Donald, Toronto, Ont.

 7P-1094 b&w 216. 1921-1922.
 Portraits of and views of family activities of the Mackay family, and of Dr. Healey Willan, composer.

MacKay, Donald Cameron, (1920-1975), Halifax, N.S., artist.

 31P-28 b&w 2. ca. 1945.
 Photographs of two theatre productions of *Sam Slick* at Amherst and Overlaid, N.S.

MacKay, George Walker, (1880-1972), New Glasgow, N.S., civil engineer.

 1P-23 Original, b&w [1,000]. ca. 1870-1944.
 Salt mining at Malagash, N.S.; coal mining in Pictou Co., N.S.; goldmining operations, accomodations and recreation at one of the Hollinger Corp. gold mines in Northern Ontario; Nova Scotia scenery, parks and historic sites and houses; views of Halifax including the waterfront and ships in the harbour; buildings in Ottawa, Ont., and Montreal, Que.; family and friends of George Walker MacKay; photographers: Dodge, T. and R. Annand, George R. Waldren.

Mackay, W.B.F., Dr., Kingston, Ont.

 7P-1096 b&w 313. 1928-1945.
 Views of the wreckage of various Lockheed Hudson aircraft of No. 3 Operational Training Unit, R.C.A.F., Debert, Nova Scotia; Dr. W.B.F. Mackay at various stages of his R.C.A.F. career 1941-1945; various aircraft of No. 1, Central Navigation School, Rivers, Man., and No. 7, Operational Training Unit, R.C.A.F., Debert, Nova Scotia, 1941-1945; various R.C.A.F. and private aircraft at Winnipeg, Man., 1928-1930.

MacKelvie, John, Keene, Ont.

 7P-1097 b&w 6. [n.d.].
 Views of Keene, Ontario.

MacKenzie, Ian A., Hon., (1890-1949), British Columbia, politician and lawyer.

 7P-1101 b&w 8. [n.d.].
 Portrait of Hon. Ian A. MacKenzie.

Mackenzie, Mary, Ottawa, Ont.

 7P-1100 Copies, b&w 5. 1888-1908.
 Interior of a drugstore at an unidentified place; portrait of Lydia E. Pinkham; Lower Boom, Fort William, Que.

Mackenzie, R., Dundee, Scotland.

 7P-1102 Copies, b&w 1. [n.d.].
 Portrait of Lieutenant Hugh Mackenzie, V.C., 7th Canadian Machine Gun Company.

MacKenzie, Simon, (d. 1970), Halifax, N.S., naval officer.

 31P-13 b&w [1,300]. ca. 1900-1970.
 British and American naval vessels.

MacKenzie, William Roy, (1882-1957), St. Louis, Mo., River John, N.S., English professor and folklorist.

 31P-35 Original, b&w 1. 1898.
 Freshman class, Dalhousie University.

MacKeracher, Barry, Vernon, Ont.

 7P-1103 b&w 89. 1890-1910.
 Views of Ottawa, Ont., and environs by an unknown photographer.

Mackie, Irwin Cameron, (1881-1970), Sydney, N.S., engineer.

 31P-120 Original, b&w 22. ca. 1901.
 Dalhousie University graduates' portraits.

MacKinnon, E., (1907-), Cranbrook, B.C., foundryman.

 333P-35 Copies, b&w 2. 1905-1920.
 Archie MacKinnon, Cranbrook Foundry.

MacKinnon, James Angus, Hon., ministre.

 7P-1105 b&w 265. ca. 1900-1952.
 Voyage en Amérique Latine de l'Honorable James Angus MacKinnon; activités de la famille MacKinnon en Alberta.

MacLachlan, Lorne E., Ottawa, Ont., medical doctor.

 16P-10 []. ca. [1920-1940].
 Lantern slides, chiefly hand-painted by Emily Warren, R.B.A., 1869-1965.

MacLaughlin, J.B.

 7P-1110 b&w 1. ca. 1860-1872.
 Portrait of Cornelius Krieghoff.

MacLaurin, C.R., Ottawa, Ont.

 7P-1112 Copies, b&w 3. 1920, 1945.
 Donald MacLaurin driving the delivery wagon of MacLaurin's store and post office, Britannia, Ont., 1945; portrait of Constable Cameron Roy MacLaurin, R.N.W.M.P., at Lansdowne Park, Ottawa, Ont., 1920; congregation of Britannia, United Church, Ottawa, Ont., 1945.

MacLean, John, Rev., (1851-1928), clergyman, missionary and author.

 7P-1120 b&w 409. (1851-1928).
 Portraits and scenes connected with the private and public life of Rev. John MacLean, methodist, missionary and writer.

MacLennan, Charles, (1920-1977), River John, N.S., engineer.

 31P-111 Copies, b&w 6. ca. 1895-1920.
 Launching of Tern Schooner *Mary F. Anderson.*

MacLeod, Anna E. and James O., Scotsburn, N.S.

 31P-2 Original, b&w [65]. ca. 1904-1915.
 Dalhousie University graduates portraits.

MacLeod, Hector, (b. 1902), Liverpool, N.S.

 31P-19 Copies, b&w 3.
 Topsail schooner *Atrato.*

MacLeod, Margaret Arnett, (1878-1966), Winnipeg, Man., writer.

9P-44 b&w 118. ca. 1870-ca. 1940.
Photographs collected to illustrate her works on Cuthbert Grant and the Red River Settlement, Man.

MacMechan, Archibald McKellar, (1890-1933), Halifax, N.S., scholar and author.

31P-9 b&w 215. ca. 1880-1930.
Ships masters, ships; Dalhousie College, Halifax, N.S.

MacMillan, Bertha, Ottawa, Ont.

7P-1123 Copies, b&w 1. ca. 1926.
School section No. 10, East Hawkesbury Public School, Prescott County, Ont.

MacMillan, George Boyd, (1881-1953), Alloa, Scotland, author, journalist.

7P-1124 b&w 2. ca. 1925.
George B. MacMillan in his garden at Alloa, Scotland; Home of George B. MacMillan on Prince Edward Island.

MacNamara, Charles, Arnprior, Ont.

8P-2 b&w [300]. ca. 1895-1915.
Lumbering in the Ottawa Valley and in Quebec; views of private home and town of Arnprior, the McLauchlin Lumber Yards Co.

MacNaughton, Alan A., (n. 1903), orateur de la Chambre des Communes.

7P-1129 n.&b. 600, coul. 10, total 610. 1950-70.
Campagne électorale de l'Hon. Alan MacNaughton dans Mont-Royal, Montréal (Québec); activités de l'Hon. Alan MacNaughton comme orateur de la Chambre des Communes et pendant ses voyages à l'étranger.

MacNeil, Alison F., Mme, Kingston (Ont.).

7P-1130 n.&b. 12. [n.d.].
Bustes des généraux A.W. Currie et H.D.G. Crerar.

MacNeil, John Alexander, (1876-1964), Toronto, Ont., newspaperman.

16P-11 b&w [300]. 1900-1960.
A collection of photographs primarily of twentieth-century American, Canadian and British actors, actresses and other theatrical personalities.

MacPhail, Agnes Campbell, (1890-1954), member of parliament, teacher.

7P-1132 b&w 5. [n.d.].
View of a sleigh and horse; portrait of an unidentified group; portraits of Agnes C. MacPhail.

MacPhail, Andrew, Sir, (1864-1938), Montreal, Que., author, pathologist.

7P-1133 b&w 96. 1914-1918.
Views of various cities and towns in Belgium, France and England during the First World War; portraits of Sir Andrew MacPhail.

MacPherson, Alexander F., Toronto, Ont.

7P-1134 Copies, b&w 5. [n.d.].
Cluny House near Kingston, Ont.; portraits of Rev. Machar of St. Andrews Church, Kingston, Ont.; John A. Macdonald; Mrs. Allan

MacPherson, and Allan MacPherson of Napanee, Ont.

MacPherson, Hugh, Edinburgh, Scotland.

7P-1135 col. 1. ca. 1968.
Site of the family home of Sir John A. Macdonald, one mile from Rogart, Sutherland, Scotland.

MacPherson, Kenneth R., Willowdale, Ont., public servant, author.

7P-1136 b&w 5. 1890-1941.
Various sealing ships of Bowring Bros. and of Baine Johnston and Co., St. John's, Nfld., ca. 1890-1910; views of H.M.C. Ships *Arrowhead, Gananoque, Windflower,* 1941.

MacPherson, Robert George, (1866-1926), Vancouver, B.C., member of parliament.

7P-1137 b&w 24. ca. 1903-1926.
Views of cable station, B.C.; a view of an unidentified railway train; portraits and group portraits of Charlie Moon, and of members of the MacPherson family.

MacPherson, William Molson, (1848-1933), Montreal, Que., businessman, banker.

7P-1138 b&w 116. ca. 1888.
Views along the route of the Canadian Pacific Railway through British Columbia, ca. 1888.

Macredie, John Robert Clarke, (1879-1932), Ontario, Saskatchewan, Alberta, engineer.

7P-1143 b&w 378. 1903-1919.
Progress photographs of various Canadian Pacific and Canadian Northern Railway bridges in Ontario, Saskatchewan and Alberta.

MacRitchie, John James, (1883-1960), Halifax, N.S., civil servant.

1P-22 Original, b&w 48. ca. 1950.
Nova Scotia Department of Health Public Health hospitals and staff.

MacTavish, Newton McFaul, (1877-1941), Toronto, Ont., journalist.

18P-77 Original, b&w 16. ca. 1875-ca. 1925.
Portraits of statemen and MacTavish's colleagues.

Madill, Henry Harrison, Toronto, Ont.

196P-10 Original, []. 1917-1939, 1970.
COTC officers at Toronto and Niagara; Jarvis Collegiate Cadet Corps; Polish army at Toronto and Niagara; Queen's Own Rifles, reunion, 1970.

Maennling, Jean, Ottawa, Ont.

7P-1144 b&w 12. 1867-1873.
Stereographs of Ottawa, Ont. and vicinity; Balton, Que.; Niagara Falls, Ont.; Montmorency Falls, Que.
Provenance: Mrs. Jean Maernling, RR 2, Ottawa, Ont.

Magrath, Charles Alexander, (1860-1949), Ottawa, Ont., surveyor and public servant.

7P-1145 b&w 206. [ca. 1800]-1936.
Various residences and memorials connected with the Galt family;

Magrath, Charles Alexander, (1860-1949), Ottawa, Ont., surveyor and public servant.
(Cont'd/Suite)

> views of Lethbridge, Alta., 1885; views of various villages in Newfoundland and Labrador, 1933-1934; photos by Holloway; portraits of various members of the International Joint Commission, 1911-1936.

Magro, Joseph, Mrs., Calumet City, Ill.

> 7P-1146 Copies, b&w 1. 1848.
> Portrait of Sir James A. Grant, 30 May 1848; daguerreotype by R.S. Cook, Quebec, C.E.

Maheux, J.T. Arthur, Abbé, (1884-1967), Quebec, Que., clergyman.

> 7P-1147 b&w 9. [n.d.].
> Photographs of Abbé J.T. Arthur Maheux, Archbishop of Quebec.

Mailhot, Charles-Edouard, abbé.

> 7P-213 n.&b. 1. [n.d.].
> Portrait de l'abbé Charles-Edouard Mailhot.

Maillard, F.J., London, England.

> 7P-1148 b&w 2,573. 1946-1960.
> Photographs of Canada House, London, England, and of visitors and sundry Ambassadors.

Maine Historical Society.

> 1P-47 Original, b&w 12. ca. 1890, 1906.
> Dedication of a memorial tower at Louisbourg, N.S., 1906; views of Blomidon, Canard, Cape Split, Grand Pré, Wolfville and the Gaspereau Valley, N.S.

Mainguy, E. Rollo, (b. 1901), Ottawa, Ont., naval service officer.

> 7P-1149 b&w 172. 1945-1955.
> Various aspects of the career of Vice Admiral E. Rollo Mainguy, Royal Canadian Navy.

Mair, Charles, (1838-1927), Ottawa, Ont., poet, public servant.

> 7P-1150 b&w 7. 1919-1936.
> Photographs of the site of Mair's birthplace; the Charles Mair Memorial, 1936; Mair at Fort Steele, B.C. 1919.

Maison St. Mars, Longueuil, P.Q.

> 7P-1151 b&w 1. 1932.
> Detail of the wall of the Maison St. Mars, Longueuil, Que.
> Provenance: unknown.

Majestic Theatre, (-1929), Halifax, N.S.

> 31P-65 Original, b&w 1. 1929.
> Last matinee audience, 1929.

Makishi, Anno, (ca. 1880-1960), Drumheller, Alta., miner and farmer.

> 7P-1152 b&w 2. [1919].
> Midland Vale Coal Mine, Drumheller, Alta.

Makowski, William B., (b. 1924), Calgary, Alta., teacher and writer.

> 7P-1153 b&w 2. 1914, 1967.
> Roman Catholic Church, Barry's Bay, Ont. 1914; interior of Holy Rosary Polish Roman Catholic Church, Edmonton, Alta. 1967.
> Provenance: PAC MSS DIVISION MG31 H57.

Malaher, G.W., (ca. 1900-), Winnipeg, Man., forest ranger.

> 9P-45 b&w 45. 1912-ca. 1959.
> Photographs of Northern Manitoba and Forestry Conservation Youth Training Camps in Sandilands Forest Reserve, Man.
> Provenance: G.W. Malaher, Winnipeg.

Mallett, Jane, (b. ca. 1900), Toronto, Ont., actress.

> 7P-1154 b&w 7. 1972-1974.
> Play at Hart House Theatre, University of Toronto, Toronto, Ont.; portraits of Jane Mallett and of her husband Frederick John Mallett.
> Provenance: PAC MSS DIVISION MG30 D210.

Mallon, Hugh Vincent, (1910-), Toronto, Ont., priest, teacher.

> 200P-3 Original, b&w 13. 1880-1952.
> Portraits of staff and alumni, St. Michael's College, group photographs of student activities, sports and drama.
> Ref./Réf.: Table of contents for scrapbook.

> 200P-4 Original, b&w 15. 1950-1952.
> Photographs of St. Michael's College and of centennial events, most taken by Michael Burns, Toronto.
> Ref./Réf.: Table of contents for scrapbook.

Malott, Richard Kenneth, (b. 1927), Ottawa, Ont., military officer, curator.

> 7P-1156 b&w 98, col. 156, total 254. 1919-1973.
> Transatlantic flights and attempted flights of John Alcock and Arthur W. Brown, Harry Hawker and Kenneth Mackenzie-Grieve and Fred Raynham, St. John's, Nfld., 1919; activities of the International Commission of Control and Supervision in South Vietnam, 1973; photos by Major R.K. Malott.

Maltese Canadian Society of Toronto, (1922-1974), Toronto, Ont., social and charitable society.

> 7P-1157 b&w 8. 1934-1950.
> Parades and meetings of the Maltese Canadian Society of Toronto, Ont.

Manitoba - Architectural Survey, (1964-1973), Man.

> 9P-47 b&w [6,900], col. [6,200], total [13,100]. 1964-1973.
> Photographs of buildings of architectural and historic importance in Manitoba.

Manitoba - Personalities.

> 9P-18 b&w [7,000]. 1850-.
> Portraits of prominent individuals in the Red River Settlement and Manitoba.

Manitoba Communities.

> 9P-48 b&w [15,500]. 1870 to date.
> Photographs of buildings, citizens and events in Manitoba cities, towns and villages.

Manitoba Highways.

9P-49 b&w 2,073. 1914-1960.
Photographs of roads, bridges and miscellaneous scenes in
Manitoba.

Manitoba Museum of Man, Winnipeg, Man., museum.

7P-1158 b&w 1. ca. 1875.
Portrait of Lieutenant Colonel William Nassau Kennedy.

Manitoba Photo Library Collection, Winnipeg, Man.

9P-50 b&w [20,000]. 1948 to date.
Photographs of buildings, industries, events, parks, camp grounds
and tourism in Manitoba.

Manitoba settlement.

9P-51 b&w 213. ca. 1928.
Department of Immigration and Colonization; photographs of
farms in Manitoba, Saskatchewan and Alberta.

Manitoba Telephone System, Winnipeg, Man.

9P-54 b&w 130. ca. 1907-1965.
Buildings, equipment and staff of the Telephone System.

Manitoba Water Surveys.

9P-53 b&w 522. 1911-1940.
Photographs of hydro development, flood scenes and water surveys
in Manitoba.

Mann, Stella C., Sydney (N.-E.).

7P-1159 n.&b. 3. ca. 1885-1961.
Portrait de Charles Grant; le Schooner *Moonlight* à Fouchu,
Cap-Breton (N.-E.), ca. 1906; le naufrage du *Delawana II,* 1961.

Manning, Ralph V., Ottawa, Ont., museum curator.

7P-1160 col. 8. 1965.
Views of Gillies Mills, Herron Mills, Ont.

Manning family, Toronto, Ont.

18P-47 Original, 24. ca. 1875-ca. 1885.
Portraits of Manning family and friends.

Manoir Richelieu, La Malbaie (Québec).

7P-1161 n.&b. 4. 1878-1929.
Le Club de golf de Montréal (Québec), 1882.

Maple Leaf Gardens, Toronto (Ont.).

7P-1162 Copies, n.&b. 43. 1931-1935.
Construction du Maple Leaf Gardens, Toronto (Ont.), 1931;
activités sportives: hockey, baseball et crosse canadienne.

Marconi, Guglielmo, (1874-1937), London, England, inventor and
businessman.

7P-1163 b&w 23. 8 December 1901.
Photographs at Cabot Tower, Signal Hill, St. John's, Nfld., and at
Poldhu Station, Cornwall, England on the occasion of the first
Marconi radio message across the Atlantic, 8 December 1901;
photographs of the wireless equipment; portrait of G. Marconi.

Marion, Lucette, Ottawa, Ont.

7P-1164 b&w 1. 1892.
Composite photograph of the members of the Quebec Legislature,
1892.

Marion, Séraphin, (n. 1896), Ottawa (Ont.), auteur et professeur.

7P-1165 n.&b. 1. 1928.
Membres de la Société Royale du Canada et de l'Association
Historique Canadienne, Winnipeg (Man.), 28 mai 1928: F. Audet,
L.-P. Geoffrion, Rev. Hugolin-Marie Lemay, Chanoine H.-A. Scott,
Victor Morin, Mgr Camille Roy, Placide Bertrand, Fr.
Marie-Victorin, Aegidius Fauteux, abbé Lionel Groulx, abbé
Azarie Couillard-Després.

303P-10 n.&b. [70]. 1898-ca. 1965.
Membres de la famille; enfance; collation de diplôme; voyages
(St. Boniface (Man.) Victoria (C.-B.); Paris, Biarritz, Fr.);
réceptions; groupes de Canadiens illustres.

Maritime Conference of the United Church, Halifax, N.S.

24P-1 b&w [500]. ca. 1860 to date.
Identified portraits and group photos of various clergymen of the
Presbyterian and Methodist churches; graduating classes of Pine
Hill ca. 1869-ca. 1969; various views of Pine Hill buildings, the
Northwest Arm, Halifax, N.S.; various United Church churches in
the Maritimes; photos by Notman Studio of Halifax, N.S., Gauvin
and Gentzell, Climo.

Maritime Telegraph and Telephone Co. Ltd., Halifax, N.S.

1P-72 Original, b&w 35. ca. 1970.
Street scenes in various Nova Scotia communities.

Markowitz, Jacob, (1901-1969), Toronto, Ont., medical doctor.

196P-12 b&w 7. ca. 1920-1965.
Photos covering Dr. Markowitz's career as student, doctor and
surgeon while prisoner of war.

Markwick, William A.G., Ottawa, Ont.

7P-1166 Copies, b&w 1. ca. 1923.
"Canada Bread Boy" William A.G. Markwick [age 2], Ottawa,
Ontario.

Marlatt, R.H., Mrs., Delta, B.C.

7P-1167 b&w 54. 1899.
Views of Winnipeg, Man., Vancouver, Victoria and Yale, B.C.;
views along the Canadian Pacific Railway Route through the
Selkirk Range of mountains; and portraits of West Coast Indians.

Marquet, Maurice C., Abbotsford, B.C., serviceman.

> 7P-1168 b&w 1. 1967.
> Portrait of F/S M.C. Marquet, G.M.

Marshall, G.L., Kanata, Ont.

> 7P-1169 Copies, b&w 8. 1940-1944.
> Various damaged training aircraft of the R.C.A.F.

Marsters, J.H., Westmount, Que.

> 7P-1170 Copies, b&w 1. 1945.
> Vickers-Supermarine Spitfire P.R. XI aircraft of No. 39
> Reconnaissance Wing, Second Tactical Air Force, Germany.
> Provenance: Mr. J.H. Marsters, 235 Metcalfe St., Westmount, P.Q.

Martin, Maureen R., (d. 1977), Ottawa, Ont.

> 7P-1171 Copies, b&w 20. 1910-1954.
> Fokker Universal aircraft at Island Falls, Sask., 1929; Fairchild
> C-19 aircraft, Edmonton, Alta., 1954; Goldfields and hotel,
> Goldfields, Alta., 1954; F/S Vernon Martin during R.C.A.F. flying
> training, 1940; portrait of F/S Vernon Martin and members of the
> W.H.B. Martin family; King George VI and Queen Elizabeth
> during the 1939 Royal Tour of Canada; activities of Bawden and
> Grace Martin and their family, Ottawa, Ont.; portrait of
> Wentworth Martin, 1910-1912; the Roman Catholic Church at St.
> Andrews East, Quebec, ca. 1912.

Martin, Paul-Joseph-James, Hon., (n. 1903), Ottawa (Ont.), ministre au
cabinet fédéral.

> 7P-1172 n.&b. 6,421, coul. 85, total 6,506. 1947-1969.
> Activités de l'Hon. Paul Martin dans l'exercice de ses fonctions
> comme secrétaire d'Etat aux Affaires extérieures, 1963-1968.

Mason, Herbert G., Peterborough, Ont., salesman.

> 7P-1173 b&w 58. 1872-1946.
> Militia camps at Barriefield and Petawawa, Ont., 1902-1913;
> activities of the 3rd (the Prince of Wales') Canadian Dragoons,
> 1899-1945; military procession during the Coronation of H.M. King
> George VI, London, England, 1911; troops of the 80th Battalion,
> C.E.F., en route to Britain, 1916; group photos of personnel of the
> 3rd (Prince of Wales) Canadian Dragoons, 1898-1933.

Massenet, Bruno, photographe.

> 113P-8 n.&b. 31. ca. 1969.
> Photos montrant l'Association ambulancière Saint-Jean à l'oeuvre
> et illustrant l'architecture de la Maison Saint-Jean, Montréal
> (Québec).

Massey, Charles Vincent, H.E., (1887-), Governor General of Canada,
1952-1959.

> 7P-1178 b&w 21. 1935-1937.
> Activities of H.E. Charles Vincent Massey as High Commissioner
> for Canada, London, England; portraits of H.E. Charles Vincent
> Massey, Mr. Ross MacLean.

Massey, Hart, Port Hope (Ont.).

> 7P-1176 n.&b. 10,907, coul. 432, total 11339. ca. 1880-1960.
> Photos de voyages en Europe, aux Etats-Unis et en Egypte;
> résidence de Toronto (Ont.), activités familiales, anniversaires, la
> famille Massey.

Massey and Flanders, Architects, (b. 1954), Ottawa, Ont., architects.

> 7P-1175 b&w 1865. 1950-1969.
> Architectural photographs of buildings designed by the Massey and
> Flanders Architectural Firm of Ottawa, Ont.

Massey (famille).

> 7P-1174 n.&b. 1,932, coul. 9, total 1,941. ca. 1900-1950.
> Soldats en Angleterre pendant la 2e guerre mondiale; portraits de
> Chester D. Massey, Lionel Massey et Vincent Massey.

Massey Museum, Massey, Ont., museum.

> 7P-1177 Copies, b&w 17. 1900-1912.
> Views of Massey, Ont., and of activities there during the period
> 1900-1912.
> Provenance: Massey Museum, Massey, Ontario.

Massicotte, Edmond-Joseph, (1875-1929), Montreal, Que., artist.

> 7P-1179 b&w 2. ca. 1900-1929.
> Portraits of Edmond-J. Massicotte, Montreal, Que.

Massicotte, Edouard Zotique, (1867-1947), Montréal (Québec), archiviste
et historien.

> 113P-1 n.&b. [1,065]. 1850-1941.
> Cortège de la Saint-Jean-Baptiste; photos des maquettes et des
> chars tels qu'ils furent réalisés et qu'ils apparurent dans le défilé;
> portraits d'individus en particulier de notaires et de médecins
> québécois.

Mather, Leslie, (1898-1971), Banff, Alta., garage and boathouse operator.

> 166P-49 b&w 120. ca. 1922-1930.
> Original prints by Leslie Mather; family photographs; Banff people
> and events; views of Banff townsite, particularly regarding Mather
> boathouse.

Mather family, Fort Steele, B.C., hotel proprieters.

> 333P-16 Original, b&w 3. 1905-1910.
> Family members.

Mathers - Rice - Jessop, (fl. 1890-1910), Alberta and Saskatchewan,
photographers.

> 7P-1180 b&w 57. 1890-1910.
> Farms in the vicinity of Gladstone, Man. (photographs by Cyril
> Jessop); land settlement and farms around Stettler, Alta., and
> Carlisle, Estevan and Moose Jaw, Sask. (photos by Rice Studios);
> views of Edmonton, Vegreville, and Calgary, Alta. (photos by
> Charles W. Mathers).

Mathers, Charles W., photographer.

> 9P-55 b&w 27. 1902.
> Photographs from booklet *Far North*.

Mathewson, F. Stanton, Ottawa, Ont.

> 7P-1184 b&w 3. [n.d.].
> Christ Church Cathedral, Montreal, Que.; wharves, Montreal, Que.;
> an unidentified group photo.

Mathieu, Olivier Elzéor, (1853-1929), Québec (Québec), professeur.

131P-3 Originaux, n.&b. 54. 1905-1908.
Portraits de S.A.R. le Prince de Galles au Petit Cap, Saint-Joachim, 1908; le château Bellevue, Saint-Joachim, 1908; le duc de Norfolk, le Délégué apostolique et Mgr Bégin à Saint-Joachim, 1908; S.E. Lord Grey et Mgr Mathieu à l'Ange Gardien, Saint-Joachim (Québec); les chûtes Sainte-Anne, Beaupré (Québec); vues intérieures et extérieures de l'église de Saint-Joachim (Québec), ca. 1908; vue extérieure de la vieille église de Sainte-Anne-de-Beaupré (Québec); vues extérieures et intérieures de la nouvelle église de Sainte-Anne-de-Beaupré (Québec); photos par Jules-Ernest Livernois.

Matsumoto, Isamu, Vancouver, B.C., shipbuilder.

7P-1181 b&w 1. 1946.
Embarkation of Japanese-Canadian internees, Slocan City, B.C., 1946.

Matthes, Tinchen, (1891-1927), Manitou, Man.

7P-1182 b&w 4, col. 1, total 5. 1910-1974.
Portraits of various Mennonite families in the Caucasus, U.S.S.R.

Matthews, James Skitt, Major, (1878-1970), Kitsilano Beach, B.C., Vancouver city archivist.

7P-1183 b&w 2. ca. 1862, 1932.
Kitsilano Beach, Vancouver, B.C., July 16, 1932; SS *Ploughboy* alongside grain elevator at Collingwood, Ont., ca. 1862.

Matthews family, New Westminster, B.C.

334P-45 Copies, b&w 37. 1898-ca. 1910.
Views of New Westminster in winter, canneries (interiors), fishing scenes, stores, streets, parks.

Mattingly, A., Stittsville, Ont.

7P-1185 b&w 23. 1887-1904.
Views of Lennoxville, Que., Fort Frances, Ont., St. Andrews, Man. and of various Canadian Pacific Railway locomotives; construction of the Canadian Pacific Railway in Western Canada; Canadian Pacific Railway Engine No. 1991.

Maunder, John, St. John's, Nfld., artist and designer of fine books.

7P-1186 b&w [2,000]. 1901-ca. 1965.
Various transatlantic flights originating or terminating in Newfoundland and portraits of some of their pilots and crew, notably that of Alcock and Brown, 1919-1937; views of St. John's Nfld., including the burning of the Mount Cashel Orphanage and the unveiling of the Great War Memorial; views of fishing schooners, sealing ships including the Newfoundland Sealing Fleet Disaster of 1914; freighters, passenger ships, freighters and warships in the harbour, St. John's, Nfld., 1910-ca. 1965; funeral of Captain Bob Bartlett, Brigus, Nfld. (restricted until 1997).

Mavor, James, (1854-1925), Toronto, Ont., professor of political economy.

16P-13 b&w 30. 1899-1910.
Doukhobor life in Alberta and British Columbia; Mavor's trip to China, Japan and Korea, 1910; photos of Yasnaya Polyana, Tolstoy's estate.

May, Barbara, Ottawa, Ont.

7P-1187 b&w 80. ca. 1895-ca. 1940.
Ruins of the Manitoba Hotel, Winnipeg, Man., February 1899; Seigniory Club and Log Lodge, Montebello, Que.; steamers *PRINCESS* and *CITY OF SELKIRK* on Lake Winnipeg, Man.; portraits of Thomas Higginson, Col. Wm. Higginson and Lt. Col. Thom Higginson, John T. Lewis family, Geo. Simpson family, Martin Albright family and Robert Robertson, and Hertel families; views of Forbes Home, St. Andrews East, Que.; the Martin Albright Home; the Executive Committee of the Argintine Historical Society, 1937; horse and wagon; Ottawa Valley Hunt Club at Connaught Park, Aylmer, Que.; Eskimos at Hay River and Cape Wolstenholme, N.W.T.; portrait of Dr. E.J. Peck, pioneer Anglican Missionary to the Eskimos; the Choir and Minister of St. Bartholomew's Anglican Church, Ottawa, Ont., 1921; portrait of the Prince of Wales and Earl of Willingdon, 1927; views of threshing, Oberon, Man., ca. 1900-1910.

May, Wilfred Reid, (1896-1952), Edmonton, Alta., aviator.

7P-1188 b&w 299. 1912-1950.
Events in the aviation career of Wilfred R. "Wop" May; aircraft of Commercial Airways and of Western Canada Airways; the May-Horner Mercy flight to Fort Vermilion, Alta., 1929; flying operations from Fort McMurray, Alta.; portrait of W.R. May. Provenance: D. May, c/o Boy Scouts of Canada, 14205-109 Ave., Edmonton, Alta.

Mayer, Charles, (1902-1971), Montreal, Que., author and sports commentator.

7P-1189 b&w 985. 1925-1962.
The first meeting of the National Advisory Council on Fitness and Amateur Sport; views of various amateur and professional sporting activities and events, including hockey, baseball, boxing, horse racing, wrestling, and cycling; portraits of various players and officials of Le Club de Hockey Canadien of Montreal; portraits of various French Canadian athletes and sporting officials.

McAloney, Elsie (Campbell), (d. 1975), Halifax, N.S., musician, music patron.

1P-46 b&w [250]. ca. 1880-1971.
Elsie Campbell McAloney, her family, friends and known musicians; return of Canadian troops to Halifax, 1919; group photos, Halifax County Academy and Halifax Conservatory of Music; various Nova Scotia scenes; Elsie Campbell McAloney at conventions and social events.

McArthur, D.C., Ottawa, Ont.

7P-1034 b&w 3. 1908.
Stereograph views of tercentenary celebrations at Quebec City, Quebec, 1908; "Lover's Walk", Parliament Hill, Ottawa, Ont.

McBratney, Helen L., Smiths Falls, Ont.

7P-1037 b&w 2. ca. 1900-1914.
M.J. Wilson and Sons' store, 302 Wellington St., Ottawa, Ont.

McBride, Berta A., Peterborough, Ont.

7P-1038 b&w 1. ca. 1865.
View of house on lot 7 of third concession, Smith Township, Peterborough County, Ont.

McBride, H.W., Prince George, B.C., Hudson's Bay Company agent.

92P-15 b&w 14. ca. 1911-12.
Scenes along Fraser River; Fort George; Hudson's Bay Company buildings, Nechaco River, Mile 102, Mile 142 and Mile 189 along Grand Trunk Pacific Railway route.
Provenance: Geoffrey M. Footner, Baltimore, Maryland.

McCann, Edward, Montreal, Que., curator.

7P-1039 b&w 196. 1860-1915.
Views of Saint John N.B.; Quebec, Monteal, Que.; Kingston, Toronto, Hamilton, Niagara Falls, Ont.; Banff, Alta.; Fraser River, B.C.; portraits of various unidentified citizens of Montreal, Que.; photos by J. McClure & Co., J.R. Woodburn, Ellisson & Co., L.-P. Vallée, J.G. Parks, A. Henderson, J.S. Climo, Isaac Erb, Jones Inglis.

McCartney, Gordon, Ottawa, Ont., chauffeur.

7P-1040 b&w 1,300. 1877-1907.
Views in Ontario (1877, 1902-1907); views in Quebec (1902-1907); views in New Brunswick (1903); views in Manitoba (1877-1902); views in Alberta and Saskatchewan (1903-1907).

McClearn Co. Ltd., Liverpool, N.S., photographers.

31P-88 Original, b&w 1. ca. 1900.
Schooner *H.H. Silver* and other vessels in Liverpool Harbour.

McClennan, Charles A., Pictou and Truro, N.S., photographer.

31P-89 Original, b&w 13. ca. 1885-1890.
Cartes-de-visite.

McClung, Mark, Ottawa, Ont., public servant.

7P-1041 b&w 1. 1947.
Portrait of Mrs. Nellie L. McClung, Victoria, B.C., 1947.

McConachie, George William Grant, (1909-1965), Edmonton, Alta., businessman, aviator.

7P-1042 b&w 20. [1920-1965].
Aspects of the career of Mr. Grant McConachie as President of Yukon Southern Air Transport and of Canadian Pacific Airlines.

McCormick, Dan, Massena, N.Y.

7P-1043 b&w 1. [n.d.].
View of the passenger ship *Sirius*.

McCracken, Budd, Burford, Ont.

7P-1046 Copies, b&w 3. [n.d.].
Mill at Burford, Ont.

McCracken, George W., (1905-), Kingston and Ottawa, Ont., public servant.

7P-1047 b&w 16. [n.d.].
Views of the collieries at Lethbridge and Canmore, Alta.; portrait of Hon. J. Watson MacNaught, P.C., O.C.; views of the Dominion Coal Board, Ottawa, Ont.

McCrae, John, (1872-1918), Montreal, Que., physician and poet.

7P-1045 Copies, b&w 7. 1900-1916.
John McCrae with various other persons.

McCullough, C.R., (1865-1947), Hamilton, Ont., educator.

7P-1048 b&w 1. 1904.
Portrait of Mr. William Henry Drummond, 1904; photo by J.E. Purdy, Boston, Mass.

McCully, Richard T., (d. 1974), Moncton, N.B., photographer.

32P-3 b&w 375. 1931-1939.
Airview photographs of New Brunswick and Nova Scotia showing farms, homes, institutions, docks, factories, businesses, and topographic details.

McCurdy, Avis Marshall, Hamilton, Ont. and Halifax, N.S.

31P-38 Original, b&w 73. [n.d.].
Dalhousie University student and alumni activities.

McCurry, Harry Orr et Dorothy L., (1889-1964, 1889-1973), Ottawa (Ont.), fonctionnaire, musicien.

7P-1049 n.&b. 118. ca. 1890-ca.1950.
Sports d'hiver à Ottawa, Ont.; portraits de membres de la famille Jenkins; Lord et Lady Aberdeen; Archibald Lampman et des membres de sa famille, Ottawa, Ont., ca. 1895 par W.J. Topley; divers artistes et sculpteurs canadiens; portrait de Natalie Lampman, fille d'Archibald Lampman, ca. 1905; William Lyon Mackenzie King sur un navire non-identifié.

McCurry family, (ca. 1890-1970), Ottawa, Ont., involved in various choral and orchestral groups in Ottawa.

149P-13 b&w [20]. ca. 1930-1960.
Various family photographs.

McDermid Studios Ltd., (1906-1966), Edmonton, Alta., professional photographers.

11P-13 b&w [22,060]. ca. 1906-1960.
Negatives including Byron-May Company prints, 1906-1912; Alberta personalities, scenes and events.

92P-16 b&w 2,530. 1930-1949.
Student activities, University of Alberta.

McDermott, Louis, Fort Erie, Ont.

7P-1050 b&w 2. 1900-1970.
Résidence de E.A. Cruikshank, Fort Erie, Ont.; portrait de Julia Cruikshank.

McDonald, C.D. Mrs., Long Beach, Calif.

7P-1053 Copies, b&w 1. [n.d.].
Portrait of Private James Peter Robertson, V.C.

McDonald, J.E., (d. 1964), Victoria, B.C., lighthouse keeper; C.N.R. dock agent.

> 12P-26 b&w 2,472, col. 409, total 3,151. 1880-1965.
> Family activities; relations in England; trips to Europe, Hawaii, Mesopotamia and England; views of Cape Breton; B.C. Coast lighthouses and Indian settlements.

McDonald, Marion and Mary, Ottawa, Ont.

> 7P-1058 b&w 1. [n.d.].
> Hand colored photograph of Sister Marion McDonald.

McDonald, Percy.

> 7P-1059 b&w 3. [n.d.].
> Views of Fort Churchill, Man., and of Masonic carvings in the walls of the Fort.

McDougall.

> 7P-1063 Copies, b&w 18. [n.d.].
> Views of logging operations; views of Lanark Township, Ont.

McDougall, A.H., Montreal, Que.

> 7P-1065 b&w 4. ca. 1914.
> Divisional Engineers and Signal Company, Second Division, C.E.F., Landsdowne Park, Ottawa, Ont.; photo by J.D. Wallis.

McDougall, C., Ottawa, Ont.

> 7P-1066 b&w 69. 1955-1960.
> Portrait of Andrew G.L. McNaughton; views of and construction of the South Saskatchewan dam and site; opening of the dam, Moosomin, Saskatchewan, 1955.

McElhinney, M.G., Dr., Ottawa, Ont.

> 7P-1069 b&w 3. 1903.
> Black Chute, Chats Falls, Ont.; Sturgeon Chute, Pontiac County, Que.; SS *Maude* with timber raft on the Ottawa River.

McEwen, C.M., Mme., Toronto, Ont.

> 7P-1070 n.&b. 128. ca. 1910-ca. 1927.
> Siège utilisé par l'Honorable William Miller, orateur du Sénat de 1883-1887; les édifices du Parlement, Ottawa, Ont., ca. 1910; la construction du Camp Borden, Ont., 1914-1917; les édifices du Parlement pendant la reconstruction, Ottawa, Ont., 1916; le Victoria Memorial Museum, Ottawa, Ont.; dépouille mortelle de Sir Wilfrid Laurier en chapelle ardente au Victoria Memorial Museum, Ottawa, Ont., 1919; quartiers des mariés Camp Borden, Ont., ca. 1927.

McFarlane, Brian, Toronto, Ont.

> 7P-1071 n.&b. 94. 1931-1970.
> Brian McFarlane et Frank (King) Clancy, 1968; divers aspects du jeu de hockey et quelques personnalités du hockey; les Maple Leafs de Toronto pendant le camp d'entraînement, 1931; portrait de Conn Smythe et Dick Irvin dans une salle des joueurs; et de Frank (King) Clancy des événements reliés au Maple Leaf Gardens, Toronto, Ont., 1955-1968; Carl Pederson travaillant sur plusieurs trophées de la Ligue nationale de hockey.

McGee, Frank, Ottawa, Ont.

> 7P-1073 b&w 39. [1860-1890].
> Views of Yarmouth, N.S.; portraits of Sir Leonard Tilly, Mrs. James Aikenhead, and of various unidentified men and women.

McGee, Thomas D'Arcy, (Hon.), (1825-1868), Montreal, Que., journalist and member of parliament.

> 7P-1074 b&w 1. ca. 1868.
> Portrait of the Honourable Thomas D'Arcy McGee, by Notnam's Studios, Montreal, Que.

McGiffin, J.S., Mrs.

> 7P-1075 b&w 1. 1882.
> Chopping bee on a farm on the Third Concession of Dummer Township, Peterborough County, Ont.

McGill, Frank S., (1894-), Ottawa, Ont., air force officer.

> 7P-1076 b&w 1. 1919.
> Captain A. Roy Brown, R.A.F., at Officer's Convalescent Hospital, 462 Jarvis St. Toronto, Ont., May 1919.

McGill, Herbert F., Halstead, England.

> 7P-1077 b&w 1. [n.d.].
> Portrait of Mrs. Elizabeth McGill, wife of Hon. Peter McGill, Montreal, Que.

McGill University Archives, Montreal, Que.

> 7P-1078 b&w 1042. 1881-1967.
> Views of the Maritime Provinces of Canada and of various parts of the United States of America, ca. 1930; photographic study of audio-visual and multi-media aspects of selected national and theme buildings at Expo'67, Montreal, Que., 1967; the first hockey team of McGill University, 1881; the football team of McGill University, 1890; a group of athletes representing Oxford and Cambridge Universities, McGill University and the University of Toronto, 1901.

McGillivray, Charles A., Braintree, Mass.

> 7P-1079 Copies, b&w 3. [n.d.].
> Portrait of Private Charles A. MacGillivray; Congressional Medal of Honor.

McGlashan, Clarke, Ottawa, Ont.

> 7P-1080 Copies, b&w 1. [n.d.].
> Portrait of Leonard Lee McGlashan, Founder of the Ontario Silver Company, Niagara Falls, Ont.

McGreevy, Brian I., Victoria, B.C.

> 7P-1081 b&w 1. ca. 1857.
> Group portrait of John A. Macdonald, Georges-Etienne Cartier, and Lieutenant Colonel John George Irvine.

McGregor, Gordon Roy, (1901-1971), Montreal, Que., aviator, president of Air Canada.

> 7P-1082 Copies, b&w 17. [1944-1969].
> Portraits of Gordon R. MacGregor.

McGuire F.R., Capt., Ottawa, Ont.

> 7P-1083 Copies, b&w 2. 1914-1918.
> "Taking off Australian Light Cruiser *Sydney* at sea - 3 points red (port)"; "Taking Off Australian Light Cruiser at sea - 3 points green (starboard)".

McIlraith, George J., Hon., (1908-), Rockcliffe, Ont., homme politique.

> 7P-1084 n.&b. 30. 1938.
> Photos composites de députés de la Chambre des Communes; vues du congrès du Parti Conservateur; portraits de leaders conservateurs: l'Honorable Arthur Meighen, l'Honorable R.B. Bennett, et le Dr. R.J. Manion.

McIlwraith, Thomas Forsyth, (1899-1964), Toronto, Ont., anthropologist.

> 16P-9 b&w [500]. 1920-1924.
> Photographs taken by T.F. McIlwraith to illustrate the way of life and artifacts of the Bella Coola Indians in B.C.; includes portraits of individual Indians, grave markers and grave houses, petroglyphs, pictographs, masks, costumes, and carvings in wood; also includes views of the Bella Coola Indian villages, both modern and abandoned, and their environs; photographs taken by Harlan Ingersoll Smith, 1920-23, of the Bella Coola Indians and their villages; prints by A.H. Richardson of unidentified Indians.

McIntyre, Stanley, [Middleville, Ont.].

> 7P-1090 Copies, b&w 7. ca. 1910.
> Views of Lanark Township, Ont.

Mckay, Robert Alexander, (b. 1894), Ottawa, Ont., public servant.

> 7P-1095 b&w 7. 1941-1943.
> Prints from the National Film Board's "WRF" series showing wartime activities in Canada.

McKendry, B.R., Calgary, Alta.

> 7P-1098 Copies, b&w 4. 1941-1943.
> North American Harvard II, Cessna Crane IIA, Fairey Battle I: aircraft of the R.C.A.F.

McKendry, Jean, Ottawa, Ont.

> 7P-1099 b&w 92. ca. 1860-1914.
> Portraits of various unidentified residents of Kingston, Kemptville, Belleville, Ottawa, Toronto, Ontario; photos by Sheldon & Davis, J.W. Powell, W.P. Bell & Son, K.W. Snider, W.L. Richardson, Ezekel Morrison, Pittaway & Jarvis, W.J. Topley, D.A. Weese & Co., Murray & Son, J.J. Millikan, T.E. Perkins.

McKinlay family, (1870-1900), H.B.C. Factor, Indian agent, farmer.

> 228P-3 b&w 100. 1870-1900.
> Album of cartes-de-visite of McKinlay family, Dr. Rae, explorer, Captain Williams Francis Butler, Ogden family, H.B.C., Manson family, H.B.C., Judge Malcolm McLeod, Lower Canada, Hamilton family, H.B.C.

McKinley, John, Hull, Que.

> 7P-1104 b&w 1. 1852.
> Jenny Lind and her husband on their honeymoon.

McKnight, Wes, radio broadcaster.

> 7P-1106 Copies, b&w 80. ca. 1926-1965.
> Sporting personalities and events covered by Wes McKnight for radio broadcasts.

McLaren, F.E., Richmond, B.C.

> 7P-1107 Copies, b&w 1. [n.d.].
> S/L F.E. McLaren, G.M., R.C.A.F.

McLaren, J.W., Goderich, Ont.

> 7P-1108 Copies, b&w 2. ca. 1916.
> Princess Patricia's Canadian Light Infantry Comedy Team, World War I.

McLaughlin, D., Ottawa, Ont.

> 7P-1109 Copies, b&w 2. 1906.
> Timber cribs at Lac des Chats, Ont.

McLaughlin, Samuel, (1826-1914), Ottawa, Ont., photographer.

> 7P-1111 b&w 73. ca. 1855-1881.
> Views in and around Quebec, Que., ca. 1855-1858; construction of the Parliament Buildings, Ottawa, Ont., ca. 1860-1865; views in and around Tadoussac and Roberval, Que., 1881; photos by Samuel McLaughlin.

McLean, Alexander Daniel, (1896-1969), Ottawa, Ont., aviation consultant.

> 7P-1113 b&w 19. 1917-1950.
> Mr. McLean at Cooking Lake, Alta., with Charles Camsell and "Punch" Dickens; portrait of Alexander D. McLean; training of R.C.A.F. pilots, Camp Borden, Ont., ca. 1926; construction along the Alcan Highway, 1941; aerial photographs of Nova Scotia, 1920-1930; aircraft and landing strips in British Columbia; aerial views of the Yukon, Alaska and the Northwest Territories.

McLean, Bruce, Mrs., Cookstown, Ont.

> 7P-1114 Copies, b&w 3. ca. 1877-1900.
> Mr. J.P. Kidd and hunting party; portraits of Mrs. Hannah Drennan Oliver, and of Mr. and Mrs. James Oliver; photos by Thomas E. Perkins, Toronto, Ont.

McLean, E.H., Toronto, Ont., collector.

> 18P-22 b&w 15. ca. 1860.
> Glass stereographs; chiefly Niagara Falls.

McLean, Howard V., Belleville, Ont., military officer.

> 7P-1115 Copies, b&w 1. [n.d.].
> Portrait of F/O Howard V. McLean, G.M., R.C.A.F.

McLean, J.R., Hampton (N.-B.), studio de photographies.

> 7P-1116 b&w 2. ca. 1880.
> Portraits faits aux ateliers McLean, incluant des portraits d'enfants.

McLean family, Toronto, Ont.

> 18P-73 b&w 17. ca. 1860-ca. 1910.
> Portraits of McLean and Meredith families.

McLennan, F.D.

7P-1118 b&w 2. 1865, ca. 1925.
Residence of Reverend John Bethune, Williamstown, Ont., ca. 1925; group of residents of Cornwall, Ont., 24 May 1865, including Dr. W.C. Allan, Master Edward Allan, Messrs. Arthur McLean, Duncan McLennan, John Cameron, Dan Cameron, J.R. Woods, James Craig, Alex McLennan, John McKenzie, and D.E. McIntyre.

McLennan, Francis, Loretteville, Que.

7P-1117 b&w 114. ca. 1860-1880.
Views of various places and events in Canada and the United States of America, including the Chicago fire; Montreal, Que., Victoria, Esquimalt, New Westminster, Comox, Vancouver, Barkerville, Fraser River, Cariboo Road, and mining in the Cariboo, all in British Columbia; portraits of British Columbia Indians; H.M.S. *Sutlej;* views of Juan de Fuca Strait, B.C., and Niagara Falls, Ont.

McLennan, Roderick, (1823-1911), Toronto, Ont., engineer.

18P-45 Original, b&w 7. ca. 1872.
Canadian Pacific Railway exploration survey in British Columbia.

McLeod, Albert M., Sydney, N.S.

7P-1119 Copies, b&w 1. ca. 1870.
Portrait of Angus McAskill, "The Cape Breton Giant", and General Tom Thumb.

McMaster University, Hamilton, Ont.

7P-1121 b&w 4. 1916.
Views of Camp Borden, Ont.; portraits of officers and staff of the 6th Infantry Battalion.

McMeckan family, Picton, Ont.

18P-25 Original, b&w 158. ca. 1860-ca. 1880.
Portraits of McMeckan family and friends.

McMillan, Alexander, (1812-1862), Brockville, Ont., militia officer.

7P-1122 b&w 1. [n.d.].
Tintype of unidentified member of the 42nd Brockville Infantry Battalion.

McMillan, Neil Lamont, Toronto, Ont., chemist.

18P-72 Copies, b&w 8. ca. 1916-ca. 1930.
McMillan's shops on Vaughan Rd. and their vicinity.

McMillan, Stanley Ransom, (b. 1904), Edmonton, Alta., aviator.

7P-1125 Copies, b&w 22. ca. 1929-1960.
Wiley Post at Edmonton, Alta. 1933; portrait of S.R. McMillan; McMillan as C/O of 413 Squadron in Ceylon; views of aerial prospecting; portraits of W. Leigh Brintnell and Harry Hayter during the 1930's; McMillan beside Fokker Super Universal Aircraft.

McMullen, Archie, Seba Beach, Alta., aviator.

7P-1126 Copies, b&w 13. 1928-1930.
Views of early Canadian Aviation, including flights and aircraft of Great Western Airways; Stinson Detroiter Aircraft; O.H. 60X Moths Aircraft; portraits of Archie McMullen; view of a skin

canoe.

McNabb, Grace, Ottawa (Ont.), journaliste.

7P-1127 n.&b. 180. 1956.
Construction de la voie maritime du Saint-Laurent.

McNaughton, Andrew George Latta, Gen., (n. 1887), militaire.

7P-1128 n.&b. 335. ca. 1861-1967.
Visite du maréchal Smuts, Ottawa (Ont.), 1945; tous les aspects de la carrière du général A.G.L. McNaughton; portraits du général A.G.L. McNaughton et de sa famille; portraits du général Sir Sam Hughes.

McNeely, Verna, Toronto, Ont.

196P-39 b&w 40. n.d.
Various sites in China and Japan.

McNeill, John, Rev., (1854-1933), Toronto, Ont., clergyman.

7P-1131 b&w 1. ca. 1908.
Portrait of Reverend John McNeill with two unidentified persons, Toronto, Ont.

McNeill, William Everett, (1876-1959), Kingston, Ont., Registrar of Queen's University.

75P-9 b&w [200]. ca. 1900.
Views of Oxford England; Western Canada school slides; slides for Shakespeare lectures; theatre, art; miscellaneous slides including one of Queen's University students or graduates.

McQuarrie, Joseph P., London, Ont., clergyman.

7P-1139 b&w 1. 1916.
Group photo of the Third Divisional Signals Company, C.E.F., Ottawa, Ont., 2 March 1916.

McQueen, William, Toronto, Ont.

196P-38 b&w 1. 1892.
University of Toronto Graduating class 1892.

McQuinn, I.M. (Ted), Moncton, N.B.

7P-1140 b&w 1. 1927.
Composite photo of members of the Canadian National Recreation System Baseball Team, Moncton, N.B., 1927; photo by McElwain Studio.

McWilliams, James L., Moose Jaw, Sask.

7P-1141 Copies, b&w 3. 1915-1917.
1st C.M.R. Mounted Pipe Band, 1915; 46th Brigade Pipe Band at Hersin-Copigny, 1917; Bugle Band of the 46th Brigade probably at Bramshot Camp, 1916.

Mead, Bert W., Edmonton, Alta., aviator.

7P-1190 b&w 11. [n.d.].
Bert Mead with various aircraft.
Provenance: B.W. Mead, 6904-94B Ave., Edmonton, Alta.

Measures, W. Howard, (1894-), Aylmer, Que., government official.

 7P-1191 b&w 202. 1920-1964.
 Views and portraits of events and various personalities involved in the international life of Canada during the period 1920-1964; Prime Minister Nehru of India and Mrs. Indira Ghandi at Queenston Power House, Ont., October 23, 1949; Prime Ministers W.L. Mackenzie King and Winston Churchill at No. 10 Downing Street, London, England, August 21, 1941; members of the Permanent Joint Board on Defence, Ottawa, Ont., August 26, 1940.

Medd, S.T., Peterborough, Ont.

 7P-1192 b&w 1. 1915.
 Officers of the 8th C.M.R., Ottawa, Ontario, 1915.

Media Club of Canada, (1904).

 7P-1193 n.&b. 398, coul. 4, total 402. 1904-1975.
 Congrès trisannuels du Canadian Women's Press Club et du Media Club of Canada, 1904-1975; portraits de Emily Murphy, Nellie L. McClung et Lotta Dempsey; photos prises par McDermid, Brewer Studio, Gilbert Milne et La Presse Canadienne.

Medical Council of Canada, (1912-), Ottawa, Ont.

 7P-1194 b&w 10907. 1900-1954.
 Portraits of members of the Medical Council of Canada.

Medland, Margaret, Ottawa, Ont.

 7P-1195 b&w 6. 1913.
 Portraits of Eskimos by Robert Flaherty.

Meech, Asa, (19th Century), Ottawa, Ont.

 7P-1196 Copies, b&w 2. [n.d.].
 Asa Meech and friend.

Meech, L.M., Weston, Ont.

 7P-1197 Copies, b&w 1. [n.d.].
 Portrait of Sergeant J. Pearson, V.C.

Meek, John F., Orangeville, Ont.

 7P-1198 b&w 1. [n.d.].
 Portrait of Sir Frederick W. Borden.

Meek, R.J., Ladner, B.C., military officer.

 7P-1199 Copies, b&w 1. [n.d.].
 Portrait of P/O R.J. Meek, G.M., R.C.A.F.

Meekren, R.J., (fl. 1900-1920), soldier.

 7P-1072 b&w 131. 1915-1918.
 Views of the Prisoner of War Camp at Stendhal, Germany, 1915-1918, and portraits of prisoners.

Mefsut, Paul, Ottawa, Ont.

 7P-1200 b&w 10. 1967.
 The opening of the Hellenic Community Centre, 1315 Prince of Wales Drive, Ottawa, Ont., 1967.

Memorial University of Newfoundland Folklore and Language Archives [MUNFLA], (1968-to date), St. John's, Nfld., archive of the folklore department.

 39P-1 Original, b&w 1,400, col. 1,000, total 2,400. 1968-to date.
 Newfoundland material culture, primarily architecture, gravestones, and artifacts associated with the fishery; ethnographic material, including mumming and children's games; views of informants.

Menard, Jean, (b. 1930), Ottawa, Ont., author.

 7P-1201 Copies, b&w 1. [n.d.].
 Group photograph of Juge Larue, l'Abbé Aurélien Auger, l'Abbé Casgrain, and l'Abbé Bélanger.

Mendelsohn, A., Brig. Gen., Ottawa, Ont., military officer.

 7P-1202 b&w 1. 1941.
 Personnel of the 3rd Divisional Workshop, R.C.O.C., Pirbright, Surrey, England, Oct. 1941.

Menier, Georges, Mme.

 7P-1203 n.&b. 849. 1903-1923.
 Le domaine d'Henri Menier à l'Ile d'Anticosti (Québec).

Mercer, A.

 334P-22 Copies, b&w 1. 1911.
 Queensborough School, New Westminster, B.C.

Meredith, Colborne Powell, (1874-1966), Ottawa, Ont., military officer and architect.

 7P-1204 b&w 1611. ca. 1915-ca. 1925.
 Activities at Petawawa, Ont.; military Camp during the First World War; views of old buildings in Ontario; portraits of the Meredith family, including the Graves, the Powells, and Robert Drought; portraits of M.J. Griffin, Colonel Stephen Jarvis, and L.J. Power; historic buildings of Ontario photographed during an architectural survey of Ontario, 1925.

Merkley family, Morrisburg, Ont.

 7P-1205 b&w 1. ca. 1900.
 Portrait of Helen Flagg Merkley, Henry G. Merkley, and Norah Crysler.

Merrifield, Nelson, Thunder Bay, Ont.

 7P-1206 b&w 1. 1920 or 1926.
 Curtiss JN-4 Aircraft G - CAAA *Jerry* of Mr. R.J. Groome, Regina or Grenfell, Sask., 24 May 1920 or 1926.

Merrilees, A. Andrew, Toronto, Ont., businessman, collector.

 7P-1207 b&w 2,134. ca. 1880-1918.
 Group photos of members of the Ontario Legislature, Toronto, Ont.; photos by Josiah Bruce; group photos of units of the Canadian Expeditionary Force and Royal Air Force, Toronto, Niagara, Camp Borden, Ont., 1914-1918; photos by the Panoramic Camera Company.

Mersereau, Jacob Y., Chatham, Newcastle, N.B., photographer.

 46P-3 b&w 1,000. 1880-1915.
 Lumbering activities and views along the Miramichi; shipping during the 1890's; survey of New Brunswick bridges.

Metcalfe, Willis, Milford, Ont.

7P-1208 Copies, b&w 93. ca. 1870-ca. 1967.
Views of Deseronto, Picton, Collingwood, Garden Island, Point Traverse, Waupoos and Port Milford, Ont.; women pulling a plough at Portage La Prairie, Man.; Junkers aircraft *Bremen* after trans-Atlantic flight, Greenly Island, Que.; hop-picking at Bloomfield, Ont.; steamers and schooners in the Bay of Quinte area and at the Bay of Quinte railway station at Deseronto, Ont.

Michael Schreier, (b. 1949), Ottawa, Ont., photographer, instructor of photography.

123P-6 b&w 24, col. 8, total 31. 1974-1977.
In Quiet Celebration, "1975", a portfolio of 24 toned gelatin silver portraits; woman and child in various activities, swimming, taking photographs, with bicycle; eight cibachrome prints; plants, portraits, children, urban landscape, Rideau Hall greenhouse.

Michaud, Joseph W., Berthierville (Québec), photographe.

7P-1209 n.&b. 540. ca. 1940-ca. 1957.
Trois séries de photographies couvrant, en genéral, les sujets suivants: vieilles églises, vieilles maisons, vieux moulins; toutes les photographies sont prises à l'est de Montréal.

Michell, William Arthur Rupert, (b. 1879), surgeon.

7P-1210 b&w 421. 1907-1908.
Various aspects of Edward Shackleton's Expedition to the Antarctic, 1907-1908.

Michener, Daniel Roland, S.E., (n. 1900), gouverneur général du Canada.

7P-1211 n.&b. 4. ca. 1960.
Ambassadeurs et chefs d'Etat rencontrant les Micheners.

Michener, Norah Willis, Toronto, Ont.

7P-1212 b&w 20, col. 22, total 42. 1948-1973.
Views of Nursing Station, Fort George, Que., 1948; visit of H.R.H. Queen Elizabeth II to Ottawa, Ont., 1973; portraits of Hon. Roland and Mrs. Michener, Hon. Ross Macdonald, Hon. W. Earl and Mrs. Rowe, Mme George Vanier and Mme Charles de Gaulle; photos by Cavouk.

Michigan, Department of State, History Division, Lansing, Mich.

7P-1213 b&w 6, col. 3, total 9. 1935-1957.
Various views of the Canadian Rockies, Manitoba, and Quebec.

Micklethwaite, John, Toronto (Ont.).

7P-1214 Originaux, n.&b. [1,000]. ca.1885-1920.
Vues de Toronto (Ont.) et de Muskoka (Ont.); dîner chez Sir Robert Laird Borden; photos prises par Frank W. Micklethwaite.

Mihaychuk, Andrew.

9P-56 b&w 68. 1910-1971.
Photographs of Vita, Man., and Arbakka, Man.

Millar, David, Ottawa, Ont., historian.

7P-1215 Copies, b&w 4,427. 1880-1920.
Views of the Winnipeg General Strike, 1919, and of personalities involved in it; views of Western Canada especially illustrative of Canadian Labour history.

Miller, Archie, Irving House Historic Centre, New Westminster, B.C., museum curator.

334P-25 Copies, b&w 86. 1970-1973.
Houses, churches and public buildings in New Westminster of historical/architectural significance.

Miller, David, Mrs., Ottawa, Ont.

7P-1216 b&w 2. 1873, ca. 1910.
Portraits of Mr. Spratt, an engineer on the Rideau Canal, Ottawa, Ont., and of five men from Brethour Drug Store (place unknown) including Brethour and G.R.D. Douglas Lyon, ca. 1910.

Miller, Evelyn, Montreal, Que.

7P-1217 b&w 1. 1906.
Montreal Amateur Athletic Association skating rink, Montreal, Que., 1906.

Miller, Florence, Pontiac County, Que.

7P-1218 Copies, b&w 1. ca. 1880.
Old Fort William in the Ottawa River District, Pontiac County, Quebec, ca. 1880.

Miller, Mabel, Burford, Ont.

7P-1219 Copies, b&w 6. ca. 1890-1900.
Views in and around Burford, Ont.; activities of the Alpha Tennis Club at Burford, Ont.

Millman, Thomas, Dr., (fl. 1850-1875), Toronto, Ont., physician.

7P-1220 b&w 95. 1872-1875, ca. 1890.
Official photographs from the North American Boundary Commission, 1872-1875; views of London, England; Paris, France; and Edinburgh Scotland; views of Western Canada along the Canadian Pacific Railway route; portraits of Dr. Millman.

Mills, Belle, Merrickville, Ont.

7P-1221 Copies, b&w 28. 1900-1910.
Views of Merrickville, Ont. and Telegraph Creek, B.C.

Mills, John M., Toronto, Ont.

7P-1222 b&w 2. [n.d.].
Views of SS *Rideau King,* and SS *Rideau Queen,* near Chaffeys Locks, Ont.

Milne, David Brown, (1882-1953).

7P-1223 b&w 108. 1900-1957.
Activities of David & Milne, painter, and his family; events and activities in his career; the Milne residence and portraits of David B. Milne, May Milne, and friends and relatives.

Milne, Gilbert A., Toronto, Ont., photographer.

8P-13 b&w [926]. 1946-1950.
Portraits of William Lyon MacKenzie King and Ontario government personalities, Toronto, Ont.; events, buildings and street scenes in Toronto, Ont., including CBC and University of Toronto; photos by Gilbert A. Milne.

Milne, J.M., Montreal, Que.

7P-1224 Copies, b&w 77. 1896, ca. 1910.
Views of communities along the routes of the Grand Trunk
Railway, and Grand Trunk Pacific Railway, between Montreal,
Que. and Prince Rupert, B.C., and views of the rolling stock of
these Railways; views of harvesting operations at Hamiota, Man.,
1896.

Milne, James, Merrickville, Ont.

7P-1225 Copies, b&w 52. ca. 1880-ca. 1965.
Views of Merrickville and Ottawa, Ont.; views of the old school
house and of the Methodist Church, Merrickville, Ont.; The Mill at
Burrits Rapids, Ont.; residence of John McCallum in the village of
Eglinton (Toronto), Ont., 1912; teachers and pupils of the
Secondary School No. 2, Montague Township, Lanark County,
Ont., 1888; the Richardson farm, Montague Township, near
Merrickville, Ont., 1894; SS *James Surfit* on the Rideau River, Ont.

Milne, Robert, Hamilton, Ont., photgrapher.

7P-1226 b&w 2. 1859.
Group photos of members of the Wesleyan Conference, Brick Street
Church, Hamilton, Ont., June 1859; photos by Robert Milne.

Mineau, Jacqueline, Ottawa, Ont.

7P-1227 b&w 16. 1860-1910.
Scenes in the garden of Sir Wilfrid Laurier's home, Arthabaska,
Que.; portraits of various Senators and Members of Parliament,
and of Lady Aberdeen and Lady Laurier.

Minifie, James M., (1900-1974), Victoria, B.C., broadcaster, author.

7P-1228 b&w 502. ca. 1914-ca. 1960.
Portraits of James M. Minifie during his career as Washington,
D.C., correspondent for the Canadian Broadcasting Corporation;
various activities of and events in the life of James M. Minifie.

**Ministère des Communications du Québec. Division de la Documentation
photographique,** Québec (Québec).

342P-1 Originaux, total 150,000. 1941-1969.
Les principaux thèmes sont: l'agriculture, la colonisation
(défrichement), les usines, les monuments, les manoirs, les enfants,
les érablières, les croix de chemin, les calvaires, les mines, les
expositions et différentes activités au Musée du Québec à Québec,
les ressources hydrauliques, les chantiers maritimes, les ponts
couverts, l'ornithologie, l'artisanat, l'industrie du papier, les réserves
indiennes, les maisons, la sylviculture, la coupe de la glace, les
filatures, les musées, les fonderies, les chapelles, les hôpitaux, les
scènes de la vie familiales ... Ces photos ont d'abord été prises par
des agronomes et des ingénieurs forestiers et miniers et ensuite par
une équipe de photographes.

Minnesota Historical Society, St. Paul, Minn.

7P-1229 b&w 45. ca. 1901.
Views of Fort Chipewyan, Fort Resolution, Fort Rae, Fort
Simpson, Fort Norman, Fort Good Hope, N.W.T.; views of various
portages on the Slave River, N.W.T.; trading activity along the
Mackenzie River, N.W.T.; portraits of Indians and Eskimos; photos
by C.W. Mathers.

Missori, Marco, (1890-1970), Toronto (Ont.), agent de voyage.

7P-1230 n.&b. 20. 1916, ca. 1960.
Activités de Marco Missori dans son agence de voyage, Toronto
(Ont.), et dans des associations italo-canadiennes, Toronto (Ont.).

Mitchell, Charles Hamilton, (1872-1941), Toronto, Ont., engineer, military
officer.

7P-1231 b&w 523. 1915-1918.
British official photographs of military operations in France and
Italy, 1915-1918.

Mitchell, Coulson Norman, Capt., (b. 1889), Beaconsfield, Que., military
officer.

7P-1232 b&w 2. ca. 1918.
Portrait of Captain C.N. Mitchell, V.C., R.C.E.

Mitchell, Thomas, photographer.

7P-1233 b&w 107. 1875.
Photographs taken by Thomas Mitchell along the coasts of
Greenland and Baffin Island during the Nares Expedition of 1875.

Mitchell-Turner Air Photos.

7P-1234 b&w 17. 1916.
Air photos of Canadian troops in action around Courcelette,
France, September 1916.

Miyagawa, George Sutekichi, (1899), Vancouver, B.C.

7P-1235 b&w 16. 1916-1947.
July First Celebrations by the Japanese community, Vancouver,
B.C.; the Miyagawa home, family, and activities; Mr. S.
Miyagawa's World War II Internment Card.

Miyazaki, Masajiro, Dr., (1899-), Lillooet, B.C., osteopath.

7P-1236 Copies, b&w 13. 1924-1943.
Portrait of the Vancouver Chapter of the Japanese Students
Christian Association of North America, 1924; University of British
Columbia graduation banquet held at Ruji Chop Suey, Vancouver,
B.C., 1933; views of a Japanese evacuation settlement, 1943; group
portraits of Japanese Student Club of the University of British
Columbia Annual Graduation Banquets 1934-1939.

Moar, Jack, Edmonton, Alta.

7P-1237 Copies, b&w 12. ca. 1928-1940.
Views of various aircraft flown in Canada by Mr. Jack Moar.

Moffat, Leo.

7P-1238 Copies, b&w 1. [n.d.].
Portrait of Grandma Turnball and Walter Turnball.

Moffat family, Fort Steele, B.C.

333P-37 Original, b&w 7. ca. 1901.
Moffat family.

Moir, L.H., Los Angeles, Calif.

7P-1239 b&w 1. ca. 1858.
View of Quebec, Que.

Moirs Ltd., (1830-1960), Halifax, N.S., candy manufacture.

1P-48 Original, b&w [250], col. 4, total [254]. 1893-1960.
Moirs Ltd. factory, personnel, social gatherings and displays in
exhibitions; process of manufacturing candy at Moirs; dams at

Moirs Ltd., (1830-1960), Halifax, N.S., candy manufacture. (Cont'd/Suite)

Kearney Lake, Quarry Lake and Paper Mill Lake, Halifax Co., N.S.; views of Halifax, N.S.; photographers: Moss Studio, Climo, McLaughlin, Gauvin and Gentzell, Lee Wamboldt, Wamboldt - Waterfield, H.P. Snider, Harry Cochrane, Tom Martin, Cliff Maxwell, Pulsifer Bros., Ken Moreash, Jack Dodge.

Mole, Dennis A., Ottawa, Ont., public servant.

7P-1240 b&w 8. 1951, 1957.
H.R.H. Princess Elizabeth's visit to Calgary, Alta., 1951; first flight of Canadair Argus aircraft, Montreal, Que., 1957.

Molson, Kenneth M., Toronto, Ont., historian, author.

7P-1241 b&w 375. 1915-1973.
Aircraft and personnel of the Curtiss Aviation School, Toronto, Ont., 1915; aircraft, personnel and operations of the Canadian Air Board and the Ontario Provincial Air Service in Ontario, 1920-1924; various types of civil and commercial aircraft in Canada, 1926-1973; views of Rivière-du-Loup, Rouyn, Que.

Moncton Museum Inc., Sports Photos Collection, Moncton, N.B.

337P-4 b&w [54]. ca. 1898-1955.
Collection of photographs pertaining to sports in the Greater Moncton Area put together by the Moncton Museum Inc.

Montague, Percival John, Toronto, Ont.

196P-48 b&w 5. 1903-1905.
University of Toronto Track Team inter-University Champions 1903; Senior Art, Mulock Cup Champions 1903; University of Toronto graduating class, 1904; University College class Executive 1904; varsity Busines and editorial Board 1903/04.

Montgomery, H. Tully, Reverend Canon, (1885-1965), Banff, Alta., Anglican Church minister.

166P-24 Original, b&w 288. ca. 1920-1955.
Original prints collected by Rev. Canon H. Tully Montgomery; Banff events, people and visitors; church staff and visitors; Rev. Montgomery and family with visiting dignitaries.

Montizambert, Frederick, Dr., (1843-1929), Montreal, Que., public servant.

7P-1242 b&w 1. ca. 1900.
Portrait of Dr. Frederick Montizambert.

Montminy, J.V.

7P-1243 n.&b. 9. [n.d.].
Cartes de visite, vues de la ville d'Ottawa (Ont.); photos prises par la compagnie Stiff Brothers.

Montréal, Montréal (Québec).

7P-1244 b&w 10. ca. 1915-ca. 1930.
Wreckage of a railway trestle at Uno, Man., 2 September 1915; Canadian Government ship *Arctic,* Baffin Island, 1922; Felixstowe F.3 Flying Boat of the Canadian Air Board, Jericho Beach, B.C., ca. 1921; views of trail riding and skiing in Banff National Park.

113P-3 n.&b. 60. 1900-1930.
Photos de monuments, de maisons historiques et de scènes de rues.

Montreal Album, Montreal, Que.

7P-1245 b&w 1. [n.d.].
View of Montreal, Que.

Montreal Book Auctions, Montreal, Que.

7P-1246 b&w 124. ca. 1860-1917.
Views of the Cartridge Factory, Dominion Arsenals, Quebec, Que., 1885-1917; No. 6 Upper Dominion Mining Camp near Dawson, Yukon; a military group; approximately 87 identified and unidentified Cabinet portraits.

Montreal Star, Montréal (Québec), quotidien.

7P-1249 n.&b. 2. 1908, 1967.
Tricentenaire de la ville de Québec; messe solennelle; photo prise par H.O. Dodge; Dominion-Provincial Conference, Ottawa (Ont.), 1967.

Moore, Delbert C., Hamilton, Ont., military officer.

7P-1247 Copies, b&w 1. [n.d.].
Portrait of Flight Sergeant Delbert C. Moore, G.M., R.C.A.F.

Moore, E.I., Fort Steele, B.C.

333P-19 Copies, b&w 1. ca. 1914.
Fort Steele people, B.C.

Moore, Philip A., (1879-1951), Banff, Alta., CPR lecturer, bungalow camp operator.

166P-19 Original, b&w 354, col. 55, total 409. ca. 1890-1930.
Original material by Philip Moore; Banff people, views of Banff townsite, family photographs; negatives and transparancies by Mary Schaffer includes Rocky Mountain scenics, pack trips, plant specimens, and world travel, ca. 1906.

Moore, Tom, (1878-1946), labour leader.

7P-1250 b&w 4. 1917-1927.
Group photo of delegates to the 33rd Annual Convention of the Trades and Labour Congress of Canada, Ottawa, Ont., September 1917.

Moorhead, W.G., Goderich, Ont.

7P-1251 b&w 12. 1914-1918.
Battlefield views around Lens, Lievin, and Vimy Ridge, France.

Moose Jaw Public Library, Moose Jaw, Sask., public library.

163P-1 total [2,500]. 1883 to date.
The development of Moose Jaw from 1883; agriculture in the rural area surrounding Moose Jaw; subjects include: streets, buildings, industries, community leaders, and events, sports teams, and agricultural machinery.

Morant, Nicholas, Banff, Alta.

7P-1252 Copies, b&w 17. [n.d.].
Views of mud homes in Man.; oil wells; nuns with vestments; typesetters; Upper Fort Garry, Man., gate; C.P.R. train; Cornell aircraft trainer; logging train.

Morgan, Harry, Wales, Ont., CNR construction worker.

7P-1253 b&w 247. ca. 1911.
Canadian Northern Railway construction scenes.

Morgan, Ian C., Westmount, Que., military officer.

7P-1254 Copies, b&w 4. ca. 1917-ca. 1920.
Mr. Harold M. Morgan's flying boat at Senneville, Que., ca. 1920;
Curtiss JN-4 aircraft of the Royal Flying Corps, ca. 1917.

Morisset, Jean-Paul, Ottawa, Ont.

7P-1257 b&w 66. 1967.
Views of architectural structures and ornamentation in Quebec.

Morisset, P., Ottawa, Ont.

7P-1256 b&w 2. 1970.
The Manor House, Boucherville, Que.; an old stone house next to
the Manor House, Boucherville, Que.

Morning, Isaac, (fl. 1865), Simcoe, Ont., photographer.

7P-1258 b&w 2. ca. 1865.
Ambrotype of an unidentified young man; tintype of unidentified
young woman.

Morris, Edmond.

7P-1255 b&w 1. ca. 1865.
Portrait of Hon. George Brown.

Morris, Edmund Montague, (1871-1913), artist.

9P-57 b&w [700]. ca. 1903-ca. 1905.
Portraits of Plains Indians.

Morris, Rita, New Westminster, B.C., librarian.

334P-19 b&w 8. 1976-1977.
New Westminster; churches, houses, public buildings.

Morris, William, Hon., (1786-1858), Perth (Ont.), homme politique.

7P-1259 b&w 1. [n.d.].
Candélabre présenté à l'Hon. William Morris; photo prise par J.
Moir.

Morrison, Harold R.W., Ottawa, Ont.

7P-1260 b&w 13. 1973.
The Sharpshooters' Monument, Ottawa, Ont.; the South African
War Monument, Ottawa, Ont.

Morrison, J., Lumberton, B.C., lumber mill owner.

333P-34 Original, b&w 30. 1921-1930.
B.C. Spruce Mills, Lumberton, B.C.

Morrow, James, Lunenberg, N.S.

7P-1261 b&w 1180. ca. 1890-1900.
Views of Lunenburg, N.S.; activities such as shipbuilding and
fishing in and around Lunenberg, N.S.; portraits of various
unidentified residents of Lunenberg, N.S.; photos by Lewis A.

Hirtle.

Morse, Charles, (1860-ca. 1945), Ottawa, Ont., barrister.

7P-1262 b&w 1. [n.d.].
Portrait of Mr. Charles Morse.

Morse, William Inglis, (1874-1952), Cambridge, Mass., and Paradise, N.S.,
scholar.

31P-101 b&w 13. 1888-1930.
Portraits of Bliss Carman; view of Peterborough Cathedral,
England; portrait of W.I. Morse by Francis Dodd, 1927.

Mortimer-Lamb, Harold, (1872-1970), Montreal, Que., Vancouver, B.C.,
photographer, critic of photography.

123P-3 b&w 5. 1907-1912.
Platinum prints: four portraits; Laura Muntz Lyall, Southam Sisters
(Montreal), Lady Drummond and unknown young child; landscape
entitled *The Pool.*

Morton, L.C.P., Lachine, Que.

7P-1263 b&w 4. [1885-1920].
View of Cut Knife Creek, N.W.T., ca. 1885; military cemetary,
Battleford, Sask., ca. 1885; group photo of officers of the Queen's
Own Rifles, ca. 1885; portrait of General Sir W.D. Otter, 1920.

Motherwell, William Richard, Hon., (1860-1943), Sask., politician and
cabinet minister.

7P-1264 []. [1925-1928].
Hon. Mackenzie King and William R. Motherwell at the unveiling
of a plaque at the William Saunders Building, Dominion
Experimental Farm, Ottawa, Ont.; delegates to the World Poultry
Congress, Calgary, Alta., 26 August 1927; Hon. William R.
Motherwell, Rotterdam, the Netherlands, 1928.

Mount, Marie, Montréal (Québec).

7P-1265 n.&b. 1. 3 avril 1907.
Drame *Les victimes de l'idéal* qui a eu lieu au sénat le 3 avril 1907,
Ottawa (Ont.).

Mount Allison University, (est. 1843), Sackville, N.B., educational
institution.

32P-4 b&w 3,154. 1854-1975.
Photographs of buildings, faculty and students, and guests.

Mount St. Vincent University, Halifax, N.S.

340P-1 b&w 51, col. 1, total 52. 1925-.
The presidents of the University: Mother Mary Evaristus Moran,
first president and founder 1925-1944; Sister Maria Rosaria
Gorman, 1944-1954; Sister Francis d'Assissi McCarthy, 1954-1965;
presidents and vice-chancellors: Sister Catherine Wallace,
1965-1974; Sister Mary Albertus Haggarty, 1974-1978; Doctor E.
Margaret Fulton, 1978- ; royal coat of arms of Mount St. Vincent
University; original buildings and grounds of the University and
the ruins after destruction by fire, 1951; chairpersons of the
Corporation and Mothers general of the Sisters of Charity: Mother
Mary Berchman, 1925-1926; Mother Mary Louise Meehan,
1926-1944; Mother Mary Evaristus Moran, 1944-1950; Mother
Stella Maria Reiser, 1950-1962; and chairperson Sister Irene
Farmer, 1962-1968; chairpersons of the Board of Governors: John
H. Dickey, Q.C., 1966-1972; Florence I. Wall, 1972-1975; Mrs.
Richard Goldbloom, 1977-.

Mount Zion Masonic Lodge (No. 28), (1815-), Mount Zion, Ont., secret society.

7P-1266 b&w 1. 1869.
Composite photograph of the Masonic members attending the Twentieth Annual Convention of the Grand Lodge of Canada, A.F. and A.M. Montreal, Que., 14 July 1869.

Moylan, William Michael, (1868-1959), Toronto, Ont., printer.

200P-5 Original, b&w 4. 1890-1900.
Head and shoulder portraits of Rev. Edmund Francis Murray, organist of St. Basil's Parish; James Carayon Robertson, one of the editors of the first edition of *St. Basil's Hynm Book,* who died at Carstairs, Alberta, 4 March 1905, aged 41; William O'Connor who in his 20's and 30's was active in St. Basil's Catholic Union and St. Basil's Conference of the St. Vincent de Paul Society; P.J. O'Connell, Basso in the parish choir.
Ref./Réf.: Table of Contents made for W.M. Moylan's Scrapbook.

Muirhead, Arnold Gillies, (1903-), Arnprior, Ont., businessman.

7P-1267 Copies, b&w 239. ca. 1868-1974.
Excursion car at St. Pierre Wye, M.T.C.; fire in Gillies Bros. Ltd. lumber yard; white pine in Algonquin Park, Ont.; lumbering near Fort Coulonge, Que.; John Cockburn, boat builder; lumber mill at Temagami, Ont.; sawmill of the Consolidated Paper Co. Ltd., Pembroke, Ont.; demolition of smoke stack, Gillies Lumber Co.; log jam, Montreal River, Ont.; views of the Herron-Gillies Mill at Lanark, Ont., of Carleton Place, Caledonia Springs, Perth, Kingston, Hamilton, Chatham, Orillia, Owensound, Braeside and Gillies, Ont. and Ile aux Ruaux, Que.; the Gillies Lumber Mills, Braeside, Ont.; the Gillies Sawmill, Carleton Place, Ont.

Mulcahy, Stan, Ottawa, Ont., journalist.

7P-1268 Copies, b&w 11. 1964.
Confederation Centennial Ceremonies at Charlottetown, P.E.I.

Mulherin, Herbert W., Canterbury, Victoria, Australia.

7P-1269 Copies, b&w 1. [n.d.].
Portrait of Lieutenant-Colonel Herbert W. Mulherin, G.M.

Mullock, Vernon P., Halifax, N.S., accountant.

1P-49 Original, b&w 27. ca. 1885-ca. 1930.
Mullock family of Springfield, Annapolis Co., N.S., and Melrose, Mass.; unidentified individuals, mainly from New Hampshire and Massachussetts; group of Sioux with Black Bull at Moose Jaw, Sask., 1885; Baptist and Methodist churches, Springfield, N.S.

Mulock, William, Sir, (1844-1944), Toronto, Ont., cabinet minister.

18P-18 Original, b&w 13. ca. 1900.
Portraits of Sir William and Lady Mulock.

196P-56 b&w 7. n.d., 1934.
Miscellaneous; cornerstone ceremony; presentation of Queen's Own Rifles; Book of Remembrance; Peace Tower, Ottawa (etching); Old St. Pauls; Newmarket.

Munro, D.G., Mrs., Ottawa, Ont.

7P-1270 b&w 22. ca. 1860-ca. 1911.
Portraits of numerous Ottawa dignitaries; construction of the Library of Parliament, Ottawa, Ont., 1872; portrait of John or Edward T. Munro by Alvira Lockwood.

Munro, Douglas John, Fort Qu'Appelle and Lipton, Sask., professional photographer.

10P-9 b&w 155. 1903-1907.
Glass negatives, homestead scenes, towns, communities, buildings of Lipton, Qu'Appelle, and Fort Qu'Appelle, Sask.

Munro, George Reid, (1887-1920), surveyor.

7P-1271 b&w 429. 1908-1909.
Views of the building of the Hudson Bay Railway, views of the Quebec Fire.

Munro, Raymond Alan, (b. 1921), Edmonton, Alta., journalist and aviator.

7P-1272 b&w 2,838, col. 174, total 3,012. 1941-1974.
A variety of subjects covering Mr. Munro's career including personal family photographs; first investiture of the Order of Icarus, Mexico, 1946; hot air ballooning; employees of the Toronto Star, 1946; staff of the Vancouver Province, 1949; parachuting on to the North Pole, 1969; search for the Lost Creek Mine, B.C., 1949; general aviation; medal of the Order of Icarus; news photographs from the period 1942-1952 including the Quebec Conference, Que., 1944; Franklin D. Roosevelt's Funeral, 1945; political activities in Vancouver, B.C., and Toronto, Ont.; portrait of Jerry Collonna, Charles Boyer, Edgar Bergen, General Andrew McNaughton, Lord Beaver Brook, John G. Diefenbaker, "Red" Hill, Marion Anderson.

Munro, William Bennett, (1875-1957), Cambridge, Mass., historian, author.

7P-1273 b&w 1. ca. 1864.
Portrait of Gen. Don Juan M. Almonte.

Murchie, A.

334P-12 Copies, b&w 1. ca. 1890.
Steamboat excursion.

Murdoch, R., (1925-), East Kootenay area, B.C., fireman.

333P-18 Copies, b&w 33. 1915-1930.
Bull River, B.C.; Warner, B.C.; postcards of East Kootenay area, B.C.

Murphy, Charles, Hon., (1862-1935), Ottawa (Ont.), ministre, sénateur.

7P-1274 n.&b. 28. 1868, 1916.
Edifices du Parlement, Ottawa, Ont., 1916; édifice de l'assemblée législative du Manitoba, Winnipeg (Man.); portraits de l'Hon. Thomas D'Arcy McGee; photos prises par William Notman.

Murphy, Joseph J., Ottawa, Ont., public servant.

7P-1276 b&w 12. ca. 1870-1904.
Portraits of Lieut. Col. G.S. Ryerson, Hon. E.J. Davis, Abbé H.K. Casgrain, Sir Alexander Campbell, and Messrs. Alex Kirkwood, J.J. Murphy and J.J. McGee; photos by Josiah Bruce, Toronto, Ont., and J.E. Livernois, Quebec.

Murray, Alexa, White Rock, B.C.

7P-1277 Copies, b&w 1. [n.d.].
Portrait of piper James Cleland Richardson, V.C., 16th Canadian Infantry Battalion.

Murray, Edmund Francis, (1844-1925), Toronto, Ont., Catholic priest, organist.

200P-13 Original, b&w 68. 1865-1900.
Photographs of priests and other friends of the compiler; includes one tintype, unidentified; photographers besides those in Toronto include: W. Farmer, Hamilton, Ont.; Notman Gallery, Albany, N.H.; H.C. Wallace, Manchester, N.H.; Sallows, Goderich, Ont.; Bracy Diehl, Detroit; W.C. Adams, Owen Sound, Ont.; Milne, Hamilton, Ont.; S.I. Souder, Charleston, S.C., Joseph I. See, St. Catharines, Ont.; Watson, Detroit; Thos. Charles (T.S. Hill operator) St. Catharines, Ont.; Dixon, Owen Sound, Ont.

Murray, G.B. & Son, (fl. 1889-1895), Brockville, Ont., photographic studio.

7P-1278 b&w 2. 1853, ca. 1863.
Views of Brockville, Ont.

Murray, L.F., Ottawa, Ont.

7P-1279 Copies, b&w 10. ca. 1900-1945.
Portrait of Miss Georgina Post, Boer War Army Matron ca. 1900; activities of the Department of National Defence during World War I, 1914-1918; Onagawa Bay, Honshu, Japan, 9 August 1945; site where Lieutenant Robert Hampton Gray, R.C.N.V.R., won the Victoria Cross; Major B.H. Geary, V.C. with his mother and brother.

Murray, Leonard Warren, Rear Admiral, (1896-1971), Halifax, N.S.; Ottawa, Ont., naval officer.

7P-1280 b&w 64. 1911-1970.
Photographs covering the public career of Rear Admiral L.W. Murray, R.C.N.

Murray, William Ewart Gladstone, (1892-1970), Ottawa, Ont., public servant, publicist.

7P-1281 b&w 22. [n.d.].
Activities of the Canadian Broadcasting Corporation and of the British Broadcasting Corporation; portraits of Stanley Baldwin and of Lorne Greene.

Muscowitch, Alex S., (1900), Winnipeg, Man., farmer.

7P-1282 b&w 59, col. 5, total 64. 1915-1975.
Activities of Alex S. Muscowitch as a member of the Shriner's Club, as a farmer, and as a mechanic, 1915-1930; views of the Jewish Colony at Hirsch, Sask., 1975; Alex M. Muscovitch, his family and his friends at home and at work, 1922-1971.

Musée de l'artillerie royale canadienne, Shilo (Man.).

7P-1283 Copies, n.&b. 105. 1889-1912.
Camp annuel de l'Association canadienne de l'artillerie du Dominion; le camp de Petawawa (Ont); portraits de certains officiers de l'Artillerie royale canadienne.

Musée Laurier, Arthabaska, Que.

7P-1284 Copies, b&w 1. 1897.
Group portrait of Sir Wilfrid Laurier, Dr. D.E. Lecavalier, Felix Faure (President of the Republic of France), and Hector Fabre, Paris, France, 1897.

Mutual Benefit Society of St. Joseph, (est. 1886), Kitchener, Ont., insurance agency.

7P-1286 b&w 2. 1936, 1961.
Group photos of the fiftieth and seventy-fifth Anniversary celebrations of the Mutual Benefit Society of St. Joseph, Kitchener, Ont.

Mynarski, Andrew V.C., West Kildonan, Man.

7P-1287 b&w 4. 1946.
Mrs. Andrew Mynarski at the First Citizenship Ceremony in Ottawa, Ont., 1946; portrait of Andrew V.C. Mynarski.

N.E. Thing Co., Ltd., Downsview, Ont.

7P-1297 b&w 1. 1972-1973.
Hockey team sponsored by N.E. Thing Co.

Naftel, William, Ottawa, Ont., historian.

7P-1288 Copies, b&w 1. ca. 1909.
SS *Earl Grey*.

Nakamura, Richard Yoshio, (1924), Regina, Sask., photographer.

7P-1289 Copies, b&w 4. ca. 1950-1951.
Views of Eskimo camp, Hebron, Labrador; portrait of L.A.C. Richard Yoshio Nakamura, R.C.A.F.

Nakashian, (Nakash), A. George, (d. 1974), Montréal (Québec), photographe.

7P-1290 n.&b. 32,865. 1944-1973.
Portraits de personnalités montréalaises et québécoises connues pour leur activité comme homme d'église, écrivain, médecin, homme politique ou homme d'affaire; cardinal Paul-Emile Léger, Louis St. Laurent, Camilien Houde, Claude-Henri Grignon et Henri Gazon.

National Ballet Guild of Canada.

7P-1291 b&w 7. ca. 1967-1968.
Ballet performances of *Romeo and Juliet*.

National Congress of Italian-Canadians, (est. 1974), Ottawa, Ont.

7P-1292 b&w 122. 1974.
Founding of the National Congress of Italian-Canadians, Ottawa, Ont.

National Council of Women of Canada, (1893), Ottawa, Ont., federation of women's societies.

7P-1293 b&w 37. 1955, 1960.
Triennial conference, Istanbul City Hall, Turkey; portraits, group photographs; photos by B & I Photography, Montreal, Que., and Len Hillyard, Saskatoon, Sask.

National Farm Radio Forum, (1940-1965), radio broadcasting.

7P-1294 b&w 24. 1941-1951.
Indian and Canadian Farm Forums; national meeting April 1958; portraits of Montreal Farm Forum Board and secretaries.

National Liberal Federation, (1932-1964), Ottawa, Ont., political organization.

7P-1296 b&w 800. ca. 1948-1968.
Hon. Louis Stephen St. Laurent with Young Liberals, 1948-1958; activities of Young Liberals; portraits of Hon. Lester Bowles Pearson, 1948-1968; some photos by Capital Press.

Nedza, Michal, (b. 1900), community leader.

7P-1298 b&w 1. 1934.
Sixth Convention of Polish Alliance of Canada, Toronto, Ont.

Neikrug Galleries, New York, N.Y.

7P-1299 b&w 19. ca. 1855-1867.
Group ambrotype at Niagara Falls, Ont., ca. 1855-65; H.M.S. *Aurora* at Quebec and in winter quarters 1866-1867; Niagara Falls, Ont., Montreal, Que.

Nelson, A.V.H., Mrs.

7P-1300 b&w 2. 1880-1910; 1915.
View from Major's Hill Park towards Chaudière Falls, Ottawa River; Binks and Wallis photo of opening of Billings Bridge, Ottawa, Ont., 2 Sept. 1915.

Neptune Theatre Foundation, (est. 1963), Halifax, N.S.

31P-57 Original, b&w [4,500], col. [75], total [4,575]. 1963-1976.
Neptune productions; portraits of staff, numerous Second Stage productions; publicity material.

Nesbitt, Rankin, Toronto, Ont.

196P-54 total 4. n.d.
Rankin Nesbitt, individual and family; Beatty House, University College.

New Brunswick Museum, (est. 1842), Saint John, N.B.

7P-1301 b&w 1. [n.d.].
Celtic Cross, Partridge Island, Saint John, N.B.

New Brunswick Museum, (est.1842), Saint John, N.B.

2P-1 b&w 8,000. 1860 to present.
City of Saint John: streets, churches, court house, custom house, fire dept., fire of 1877, Fort Howe, Fort Dufferin, Harbour scenes; views of Saint John, industries, Reversing Falls, cantilever and suspension bridges, etc.; portraits; transportation: carriages, wagons, sleds, streetcars, railway; military: South African War, World War I, World War II; various places in New Brunswick; covered bridges throughout New Brunswick; lumbering, fishing, farming.

New Iceland Collection.

9P-58 b&w 461. ca. 1880-1960.
Views of Icelandic settlement and people.
Provenance: R.J. Asgeirsson.

New Play Society, (1946-1971), Toronto, Ont., professional theatre company.

16P-14 b&w [400]. 1946-1960.
Production and publicity photographs of theatrical performances staged at the Royal Ontario Museum Theatre, the Royal Alexandra Theatre, the Eaton Auditorium, and the Avenue Road Theatre.

New Westminster City Hall, (1860-), New Westminster, B.C.

334P-5 Copies, b&w 24. ca. 1880-1964.
Portraits of New Westminster mayors.

New Westminster City Police, New Westminster, B.C.

334P-18 Copies, b&w 6. ca. 1920-1947.
Police group portraits and station; car accident.

New York Rangers Hockey Club, (est. 1926), New York, N.Y., professional hockey team.

7P-1305 b&w 64, col. 16, total 80. 1968, 1970-71.
Team and player portraits.

Newcombe & Baird, Halifax, N.S., photographers.

31P-90 Original, b&w 1. ca. 1890.
Carte-de-visite.

Newfoundland.

38P-11 b&w 117. 1890-1900.
An extensive collection of views of western, northeastern and central Newfoundland prior to development of the pulp and paper industries; some of James Vey, photographer of St. John's.

Newman, Archibald Hamilton, (b. 1905), Ottawa, Ont., journalist.

7P-1302 b&w 47. 1940-1960.
Rideau Kiwanis, Elson Club, Toronto, Ont.; visit of Viscount Alexander of Tunis, Governor General of Canada to Polymer Corporation; portraits of Viscount Alexander of Tunis, Governor General of Canada, Charles G.D. Roberts, Charlotte E. Whitton, Archibald H. Newman, Margaret (Creswick) Newman.

Newnham, Jervois Arthur, (1852-1941), Moosonee, Ont., clergyman, bishop.

7P-1303 b&w [27]. 1893-1903.
Trading posts, Indian camps, ships *Lady Head,* and *Mink;* Bishop and Mrs. Newnham, Moosonee, Ont.

Newton, J.W.

9P-59 b&w 96. 1920's-1930's.
Photographs of Winnipeg and surrounding area.

Newton, Neil, (b. 1933), Enniskillen, Ont., photographer.

7P-1304 b&w 10,862, col. 640, total 11,502. 1953-1975.
Activities and staff of Radio Station CHUM, Toronto, Ont., 1960-1965; various aspects of rural life in and around Enniskillen, Haydon, Hampton, Tyrone, Kirby, Ont., 1972-1975; portraits of members of the Newton family and of other individuals; photos by Neil Newton.

Nicholas, Tressilian C., Cambridge, England, geologist.

7P-1306 b&w 12. 1913.
International Geological Congress tour of N.S.

Nicholls and Parkin Popular Photograph Parlors, Winnipeg, Man., photographers.

7P-1308 b&w 1. ca. 1866-ca. 1876.
Portrait of unidentified woman, Winnipeg, Man., by Nicholls and

Nicholls and Parkin Popular Photograph Parlors, Winnipeg, Man., photographers.
(Cont'd/Suite)

Parkin Popular Photograph Parlors.

Nicholson, Leonard Hanson, (b. 1904), Woodlawn, Ont., commissioner (retired) of the Royal Canadian Mounted Police.

7P-1307 b&w 24. 1929-1967.
Boy Scout World Jamboree, Greece, 1965; portraits of Leonard Hanson Nicholson.

Nicoll, Marion, Ottawa, Ont.

7P-1309 b&w 57. [n.d.].
World War I army hospital; army dispensary; Presbyterian Church, Pakenham, Ont.; portraits by various photographers in Quebec, Montreal, North Bay, Regina, Ottawa, Arnprior, Almonte, Perth, Brockville, Pembroke and Smiths Falls.

Nicolson, G.B.

7P-1310 b&w 1. ca. 1840-1850.
Daguerreotype portrait of George Keefer.

Nield, A., Dover, Ky., collector.

7P-1311 b&w 2. 1859-1860.
Views of New Westminster, B.C.; portrait of Captain R.M. Parsons.

Nishima, C., Lethbridge, Alta.

7P-1312 b&w 1. 1929.
Group portrait of officers of the Japanese Vegetable Farmers' Cooperative, Lethbridge, Alta.

Niven, Alexander, (1836-1911), Haliburton, Ont., surveyor.

7P-1313 b&w 29. 1896-1898.
Alexander Niven's party surveying boundary line between Algoma and Nipissing Districts, Ont., 1896-1898.

Noble, George, (1879-1965), Banff, Alta., professional photographer.

166P-1 Original, b&w [10,100]. 1908-1957.
Prints and negatives by George Noble; commercial portraits of Banff people; Rocky Mountain scenics.

Noble, John E., Ottawa, Ont., public servant.

7P-1314 b&w 39. 1941-1942.
Artists, craftsmen and committee who made Canada's Book of Remembrance; portraits of William Lyon Mackenzie King and Dr. O.D. Skelton.

Nordegg, Martin, (1868-1948), Alberta, financier, prospector.

7P-1315 b&w 34, col. 3, total 37. 1910-1959.
Cowboys; views of Nordegg, Alta., 1944-1959, David Thompson Bridge, Rocky Mountain House, Alta., Port Sudan, Sudan; portaits of Martin Nordegg and Philip House.

Norfolk County Historical Society, (est. 1900), Simcoe, Ont.

7P-1316 b&w 12. 1910-1930.
Alligator tugs manufactured by West and Peachey and Sons, Simcoe, Ont.

Norrish, Wilbert Henry, (1892-1972), Dominion Land Surveyor.

7P-1317 b&w 1,564. 1890-1960.
Photographs relating to career of Wilbert Henry Norrish; Armstrong Scott, locomotive engineer with Grand Trunk Railway Co.

North, Dick, Dawson, Yukon.

7P-1318 b&w 1. ca. 1929-1930.
Ross River Trading Post, Ross River, Yukon, showing missionary John Martin and possibly trapper Albert Johnson.

North American Boundary Commission, (1872-1875).

9P-4 b&w 272. 1872-1874.
Photographs taken along the International Boundary from Lake of the Woods, Ont., to the Rocky Mountains.

North American Conference on Conservation of Natural Resources, Washington, D.C.

7P-1319 b&w 1. 1909.
Portraits of delegates to the North American Conference on Conservation of Natural Resources, Washington, D.C., 18-23 February 1909.

Northwest Ontario Community.

146P-1 total [500]. [1890-1930].
Various small collections and individual photos of persons (mainly of the local Finnish community), events and features of northwestern Ontario particularly in and around Thunder Bay city.

Noseworthy, Joseph William, (1888-1956), Toronto, Ont., politician (Member of Parliament).

7P-1320 b&w 11.
Portraits of Joseph William Noseworthy.

Notman, James Geoffrey, Mme, (n. 1901).

7P-1322 n.&b. 17. ca. 1940-1950.
Vues intérieures d'une usine de munitions; la conférence «Atome et Paix», 8-20 août, 1955; carrières de J.G. Notman.

Notman, William, (1826-1891), Montréal, Que., photographer.

7P-1323 n.&b. 12. ca. 1868.
Vues de Montréal (Québec); la Citadelle de Québec, vue de la pointe de Lévy, Québec (Québec); les chutes Montmorency et les chutes Lorrette (Québec); photos photo-studio «Le Chasseur»; photos prises par William Notman.

8P-7 b&w [200]. ca. 1850-ca. 1870.
Stereographs; views of Fraser River, Kamloops and Lytton, B.C.; Toronto, Niagara Falls, Kingston and Hamilton, Ont.; Quebec, Montreal, Rivière du Loup, Sainte-Anne, Saguenay River, Chaudière River and Lake Memphremagog, Que.; Halifax, N.S.; Saint John, N.B.; photos by William Notman.

Notman, William, (1826-1891), Montreal, Que., photographer. (Cont'd/Suite)

18P-3 Original, b&w 148. ca. 1860-ca. 1870.
Scenes and buildings in Quebec and Ontario including Ottawa River and St. Lawrence River, Niagara Falls, Quebec, Montreal, Toronto, Ottawa; some by Notman and Fraser and some by Alexander Henderson.

31P-91 Original, b&w 37. ca. 1885-1890.
Cartes-de-visites, Dalhousie University students.

123P-5 b&w [162]. 1865-1887.
Stereographs, albumen silver prints, composite paste-up albumen silver and gouache, oil and gouache on albumen silver; landscapes: Banff, Buffalo, Silver Heights, Winnipeg, Lake Superior, Canmore, Mount Stephen, Bow Valley from CPR Hotel, Banff, ice cave in the Great Glacier, East End Calgary, Fraser Canyon showing four tunnels above Spuzzam; cabinet portraits of unidentified sitters, adults and children; Notman and Fraser group portrait (composite paste-up); painter albumen silver print of infant, painting done by Eugène L'Africain.

327P-1 total [500,000]. 1856-1934.
Subjects include: boats, buildings and interiors, cities, villages, street scenes, construction of Victoria Bridge, domestic life, farming, hunting and fishing, Indians, industries, landscapes, lumbering, railway construction, sports, transportation - Newfoundland to British Columbia.

334P-4 Copies, b&w 8. 1887.
Ewen's cannery (interior and exterior); train, railroad depot, Royal City Saw Mills, Royal City Planning Mills, general view of New Westminster, B.C.

Notman Studio of Halifax, (1869-1925), Halifax, N.S., photographic studio.

1P-76 Original, b&w [4,500]. ca. 1869-ca. 1920.
Military installations and housing in Halifax, N.S.; various views of Halifax, including public buildings, houses, street scenes, Public Gardens, Point Pleasant Park, Northwest Arm, harbour and general views; ships; sports; South African War Veterans; Nova Scotia militia; various Nova Scotia communities; portraits.

304P-1 b&w [130]. 1870-1890's.
Military portraits by Notman Studio of Halifax N.S.

Notre Dame du Sacre Coeur Convent, (1869-), Ottawa, Ont.

7P-1324 b&w 3. [n.d.].
Views of Notre Dame du Sacre Coeur Convent, Ottawa, Ont.

Nouveau Parti Démocratique, parti politique.

7P-1325 n.&b. 1. 1965.
Portrait de Thomas Clement Douglas.

Nova Scotia - Agriculture, Halifax, N.S.

1P-87 Original, b&w [40]. 1905-1946.
Box carts, dyke land, orchards, oxen, windmills, etc.

Nova Scotia - Army, Halifax, N.S.

1P-80 Original, b&w [350]. 1880-1970.
Armouries, barracks, headquarters, Ordnance yard, soldiers, battalions and regiments, forts.

Nova Scotia - Furnishings, Halifax, N.S.

1P-83 Original, b&w 13. 1922-1961.
Busts, china, door furnishings, etc.

Nova Scotia - Furniture, Halifax, N.S.

1P-81 Original, b&w 23. 1925-1961.
Chairs, clocks, desks, etc.

Nova Scotia - Group Photographs.

1P-92 b&w [300]. 1861-1965.
Groups: mainly Nova Scotian.

Nova Scotia - Handicrafts, Halifax, N.S.

1P-82 Original, b&w 11. 1932-1938.
Handicrafts: looms, pottery, samplers, violins, etc.

Nova Scotia - Indians, Halifax, N.S.

1P-86 Original, b&w 37. 1885-1953.
Indians and crafts.

Nova Scotia - Industries, Halifax, N.S.

1P-88 b&w 130. 1890-1975.
Factories, fishing, mining, steel mills, shipyards, etc.

Nova Scotia - Interior Decoration, Halifax, N.S.

1P-84 Original, b&w 64. 1880-1961.
Acadia Grove, Admiralty House, etc.

Nova Scotia - Navy, Halifax, N.S.

1P-79 Original, b&w [200]. 1875-1970.
Admiralty House, aircraft carriers, buildings, cadets, drydock, dockyard, naval bases and ships.

Nova Scotia - People, Halifax, N.S.

1P-91 b&w [1,800]. 1870-1975.
Photos of individuals.

Nova Scotia - Places, Halifax, N.S.

1P-77 b&w [2,400]. 1880-.
Aerial views and general views of bridges, buildings, businesses, cemeteries, churches, fires, harbour, hospitals, hotels, houses, markets, schools, special events, streets, waterfront in Nova Scotia.

Nova Scotia - Ships and Shipping, Halifax, N.S.

1P-85 b&w [300]. 1889-1956.
Ships and shipping; material dealing with the same.

Nova Scotia - Sports, Halifax, N.S.

> 1P-90 b&w [100]. 1870-1969.
> Sports: baseball, basketball, bicycling, boating, boxing, cricket, curling, hockey, moose hunting, polo, quoits, rowing, sailing, snowshoeing, skating, tennis, track, tug of war, yachting, etc.

Nova Scotia - Transportation and Communication, Halifax, N.S.

> 1P-89 b&w [200]. 1886-1970.
> Airplanes, automobiles, bridges, canals, Canso causeway, carriages, railways, stagecoaches, streetcars, telegraphs, etc.

Nova Scotia, Department of Public Works, Halifax, N.S.

> 1P-94 b&w (700). 1954-1971.
> Construction of public buildings in Nova Scotia, including hospitals, schools, tourist bureaus, liquor commissions, provincial office buildings and Keltic Lodge, Ingonish, N.S.

Nova Scotia Communications and Information Centre, (est. 1946), Halifax, N.S.

> 1P-50 Original, b&w [8,000]. 1946-1974.
> Nova Scotia scenery, communities, agriculture and industry, parks and historic sites, sports and recreation.

Nova Scotia Drama League (N.S.D.L.), (est. 1948), Halifax, N.S.

> 31P-61 Original, b&w 256. ca. 1969-1972.
> Nova Scotia Finals, the Dominion Drama Festival, Antigonish, N.S., 1969, other N.S.D.L. activities, Antigonish, N.S., 1973; portraits of Drama Festival adjudicators and participants in the N.S.D.L. Workshop, 1972.

Nova Scotia Federation of Labour (N.S.F.L.), (est. 1919).

> 31P-116 Original, b&w 44. ca. 1919-1973.
> N.S.F.L. executives and conventions.

Nova Scotia Light and Power Co. Ltd., (1917-1972), Halifax, N.S.

> 1P-24 b&w [5,000]. 1867-1971.
> Early power plants in Halifax, N.S.; street transportation in Halifax; construction of Nova Scotia Light and Power Co. plants, including those at Water St., Halifax and Tuft's Cove, N.S.; transformers, cables, lines and dams; repair of electrical cable after the Halifax explosion, 1917; Nova Scotia Light and Power Co. social functions; ships serviced in Halifax during World War II; construction of power facilities in New Brunswick.

Nulty, Joseph H., Trenton, Ont.

> 7P-1326 b&w 1,172. ca. 1925-1955.
> Views of ships, shipyards and town, Trenton, Ont.

Nurse, W.H., Vancouver B.C.

> 7P-1327 b&w 4. ca. 1945.
> Tree-planting ceremony at grave of June Catherine Nurse Law, R.C.A.F., Mountain View Cemetery, Vancouver, B.C.

Nutt, David C., (b. 1919), arctic explorer, professor.

> 7P-1328 Copies, b&w 31. 1955-1961.
> Views of air bases, tunnels, and buildings in the far north.

Oaks, H.A., Mrs., Rosedale, Ont.

> 7P-1329 b&w 754. ca. 1920-1945.
> Eielsen Search Mission 1929; Ontario Provincial Air Service; Patricia Airways and Exploration, Western Canada Airways Ltd., portraits of H.A. Oaks, Al Cheesman, Bernt Balchen, Sammy A. Tomlinson, Pat Reid.

Oakville Bridges, Oakville, Ont.

> 47P-5 b&w 21, col. 1, total 22. 1870-1968.
> Several bridges spanning the Sixteen Mile Creek in Oakville; two iron bridges; radial bridge.

Oakville Churches, Oakville, Ont.

> 47P-6 b&w 33. 1860-1971.
> Exterior and interior of 12 churches taken at various stages of construction.

Oakville commerce and industry, Oakville, Ont.

> 47P-7 b&w 31. 1897-1950.
> Various industries including mills, foundry, tannery, factory, warehouses, carriage works.

Oakville Groups, Oakville, Ont.

> 47P-8 b&w 26. 1860-1920.
> Oakville groups including church, school, parades, families, bands.

Oakville Harbour, Oakville, Ont.

> 47P-9 b&w 23. 1880-1898.
> Harbour commercial activities such as shipping, lighthouse, tannery, warehouse; Baptism and water sports; Bronte Harbour.

> 47P-10 b&w 33, col. 2, total 35. 1900-ca. 1960.
> Oakville Harbour, piers and lakefront; Bronte Harbour; Stone hooking, radial bridge, shore line winter and summer.

Oakville Hotels, Oakville, Ont.

> 47P-11 b&w 14. 1890-1960.
> Twelve hotels, some still standing.

Oakville Houses, Oakville, Ont.

> 47P-12 b&w 65. 1890-1960.
> Oakville houses.

Oakville Individuals, Oakville, Ont.

> 47P-13 Original, []. ca. 1860-ca. 1900.
> People who lived in Oakville.

Oakville Parks, Oakville, Ont.

> 47P-14 b&w 12. 1897-1960.
> Lakeside, George's Square, and Reservoir parks.

Oakville Public Buildings, Oakville, Ont.

> 47P-15 b&w 19, col. 2, total 21. 1887-1960.
> Various public buildings and halls.

Oakville Schools, Oakville, Ont.

47P-16 b&w 18. 1860-1960.
Oakville schools and school classes.

Oakville Shipping, Oakville, Ont.

47P-17 b&w 28. 1887-1900's.
Commercial and pleasure craft including one daguerreotype of Wm. Chisholm's schooner *Brittania*.

Oakville Shops, Banks and Offices, Oakville, Ont.

47P-18 b&w 36. ca. 1880-ca. 1950.
Commercial establishments mainly located on the main street (Colborne, now Lakeshore).

Oakville Streets, Oakville, Ont.

47P-20 b&w 23. 1890-1960.
Principal streets, Oakville, Ont.

Oakville Transportation, Oakville, Ont.

47P-21 b&w 9, col. 1, total 10. 1890-1912.
Railway station, C.P.R. train, radial car, station, horse-drawn bus.

Oakwell, Sydney, Rev., Spencerville, Ont., clergyman.

7P-1330 Copies, b&w 4. [n.d.].
Presbyterian Church Roebuck, Ontario Methodist Church, Spencerville, Ont.

Oblats de Marie-Immaculée, (f.1816), Ottawa, Ont.

193P-1 Originaux, n.&b. [30,000]. 1850-.
Personnes: pères et frères de la Congrégation des Oblats de Marie-Immaculée; lieux: endroits où ont oeuvré ces personnes, Canada (en particulier le Grand Nord Canadien et les missions indiennes) et les pays de mission (Bolivie, Chili, Afrique du Sud, Lesotho [Basutoland], Sri Lanka [Ceylan], etc.

O'Brien, A.H.

7P-1331 b&w 3. ca. 1860.
Views of the Parliament Buildings under construction, Ottawa, Ont., ca. 1860; photos by Samuel McLaughlin.

O'Brien, Osmond, (1870-1900), Noel, N.S., shipbuilder.

31P-81 b&w 2. ca. 1880, 1890.
Sailing vessels at Noel, N.S., ca. 1890; unidentified steamer, ca. 1880.

O'Brien, Walter J., Ottawa, Ont.

7P-1332 Copies, b&w 1. 1890.
Crowd in front of Our Lady of the Visitation Church (Roman Catholic), South Gloucester, Ont.

O'Donnell, W.D., Halifax, N.S., photographer.

31P-92 Original, b&w 5. ca. 1885.
Cartes-de-visite, Dalhousie University students.

Office de télécommunication éducative de l'Ontario, (1970-), Toronto (Ont.), fournir une gamme de services éducatifs et culturels.

185P-1 n.&b. 100. 1890-1965.
Copies des photos de Blind River, de Hearst, de River Valley, de Rockland, de Sault Ste. Marie, de Timmins, de Val Gagné et de Welland utilisées pour l'émission *Villages et Visages*.

Office National du Film, (l'), (f. 1939).

7P-1295 n.&b. 338,726, coul. 19,643, total 358,369. 1875-1895, 1925-1975.
Paysages urbains et ruraux; individus et événements; activités économiques, politiques et sociales au Canada; activités de représentants du Canada à l'étranger; portraits de la Princesse Juliana, des Très Hon . Clarence D. Howe et William Lyon Mackenzie King, du Dr. Frederick Grant Banting, et de Franklin Delano Roosevelt, Sir Winston L.S. Churchill et James Layton Ralston.

Ogilvie, William, (1846-1912), Winnipeg, Man., land surveyor and public servant.

7P-1335 n.&b. 89. ca. 1887-1910.
Paysages du Yukon et de l'Alaska; bateaux à vapeur sur la rivière Yukon, Yukon, ca. 1902; embacle sur la rivière Yukon, Yukon; le Lac Louise, Alta., photos prises par William Ogilvie.

18P-38 Original, b&w 42. 1895-1897.
Yukon Territory.

Ogilvy, Charles, Ltd., (est. 1887), Ottawa, Ont., department store.

7P-1333 b&w 1. ca. 1887.
Ogilvy's first store, second from corner, Rideau and Mosgrove Sts., Ottawa, Ont.

Ogilvy, Stewart M., Yonkers, N.Y.

7P-1334 b&w 39. 1908-1910.
Views of construction of the National Transcontinental Railway near Good Lake, Ont.; portraits of workers on this railway; portraits of R.W. Ogilvy at work on the railway.

O'Grady, Gerald F. de Courcy, Winnipeg, Man.

7P-1336 b&w 12. 1889-1890.
Views of Fredericton, N.B.; Ottawa, Ont.; Wallaceburg, Ont.

O'Hanley, John Lawrence Power, (1829-1912), Ottawa, Ont., civil engineer.

7P-1337 Original, b&w 8. ca. 1895-1905.
Views of New Liskeard, Ont.; garden party, June 23rd 1905; tree planting; portrait of Lady Isabel Aberdeen on St. Patrick's Day, 1898, by Topley; group portraits of men.

Oil Chemical and Atomic Workers International Union - Local 9-825, Halifax, N.S.

31P-115 Original, b&w 6. 1974-1976.
Local picket lines, 1974, executive, 1976, and Labour Day parade floats.

Oldford, Henry R., Ottawa, Ont., public servant.

7P-1338 Copies, b&w 1. ca. 1941.
SS *CANCALAIS* of the Shaw Steamship Company, Halifax, N.S., Master: H.R. Oldford.

O'Leary, Peter Michael, (1850-1929), Montreal, Que., priest and chaplain.

7P-1339 b&w 1. ca. 1917.
Portrait of Lieutenant-Colonel P.M. O'Leary, C.E.F.

Oliver, Howard, St. John's, Nfld.

38P-8 col. 20. 1976.
United Church at Greens Harbour, Trinity Bay, Nfld.
Provenance: Greens Harbour Historic Church Association.

Oliver, William J., (1888-1954), Calgary, Alta., professional photographer.

11P-3 b&w 1,159. 1911-1942.
Negatives of petroleum industry, southern Alberta; Calgary
buildings, views, personalities and stampede; official and royal
visits; political, ranching and agricultural scenes and personalities;
Sarcee and Stony Indian personalities, ceremonies and views;
Wainwright national park and N.W.M.P. veterans.

Olivier, Daniel, (n. 1949), Montréal (Québec), bibliothécaire.

113P-12 n.&b. 34. ca. 1860-1950.
Photographies et négatifs du bibliophile Philéas Gagnon à diverses
époques de sa vie, son épouse, ses enfants, son père, sa maison, la
côte de Beaupré (Québec) et Tourouvre du Perche, France.
Réf./Réf.: Fichier Fonds Philéas. Gagnon, dressé par Daniel.
Olivier.

Olson, Rick, (1935-), Windermere, B.C., and Calgary, Alta., salesman.

333P-4 Original, b&w 21. ca. 1920.
Plains Indians; Shuswap Indians.

O'Meara, J.E., Toronto, Ont., public servant.

7P-1340 b&w 3. [1890-1910].
Views of Bryson, Que., by A. McLean.

O'Neil, James G., Hamilton, Ont.

7P-1341 b&w 175. ca. 1917-ca. 1919.
Construction of the Quebec Bridge, Quebec, Que., 1917; personnel
and activities of the Canadian Expeditionary Force (Siberia),
Vladivostok, Russia, 1919; portrait of Dr. Wellington M. Carrick;
photo by Fink.

Ontario, Archives of Ontario, Toronto, Ont.

7P-1342 b&w 168. 1898-1972.
Activities of Hungarian and Roumanian settlers in Western
Canada; views of various cities and towns in Manitoba and
Saskatchewan; unveiling of plaque commemorating R.F.C./R.A.F.;
flying training activity during World War I; Long Branch, Ont.,
1969; views of Pickering Township, Ont., 1972; views of
Grand'Mere, Que., 1915.

Ontario, Department of Crown Lands.

18P-23 Original, b&w 218. 1900.
Album entitled "Glimpses of Northern Ontario as seen by
exploration parties under instructions from the Department of
Crown Lands".

Ontario, Legislature.

18P-57 Original, b&w 42. 1899.
Scenes on the Algoma Legislative Tour, June 1899; photographs by
Park and Co., Brantford, Ont.

Ontario, Ministère des Terres et Forêts, Toronto (Ont.).

7P-1343 n.&b. 104. [n.d.].
Le service aérien de la province de l'Ontario; les activités du
Ministère des terres et forêts de la province de l'Ontario; portraits
de A. MacDougall, sous-ministre de ce ministère, et de George
Phillips.

Ontario, Ministère du Tourisme et de l'Information, Toronto (Ont.).

7P-1345 n.&b. 1. [n.d.].
Monument commémoratif à Charles Sangster.

Ontario Agricultural College, (est. 1882), Guelph, Ont.

7P-1347 b&w 108. 1894-1968.
Activities, facilities, equipment, faculty members and students of
the Poultry Science Department of Ontario Agricultural College,
Guelph, Ont., 1894-1968.

Ontario Hydro, (est. 1906), Toronto, Ont., generation and transmission of
electricity.

7P-1346 b&w 3. [1870-1918].
Portrait of Messrs. Frank and Walter Moberly; group photo of
members of No. 40 Course, A.C.O.S., R.A.F.

316P-1 b&w [160,000], col. [64,000], total [224,000]. 1906 to present.
Construction progress photos of all Ontario Hydro built generating
stations, control dams, transmission lines, substations; as well as
photos of personnel, equipment, vehicles, buildings.

Ontario Labour Committee for Human Rights, (est. 1947), Toronto, Ont.

7P-1348 b&w 71. 1948-1965.
C.C.F. Summer School Race Relations Program, Haliburton, Ont.,
1948; Civil Rights display at National Conference of the Jewish
Labour Committee of Canada, Toronto, Ont., 1950; Amalgamated
Clothing Workers of America Education Conference, Kitchener,
Ont., 1952; Fair Employment Practices Conference of the Ontario
Federation of Labour, Brantford, Ont., 1953; portraits of Messrs.
David Archer, Donald Montgomery.

Ontario Motor League, Toronto Club, Toronto, Ont.

18P-54 Copies, b&w 14. 1902-1918.
Motor cars and motor club in Toronto.

Oppen, Jean, Mrs., Ottawa, Ont.

7P-1349 Copies, b&w 20. [n.d.].
Residents of Niagara Falls, Ont.

Orchard, C.D., (1893-1973), Victoria, B.C., B.C. forest service.

12P-2 b&w 321, col. 1, total 322. 1930-1960.
Logging on B.C. North Coast; B.C. Pulp, Port Alice, 1948;
Universal lumber and box, 1953; official functions as Chief Forester
(1941-58) and Deputy Minister (1945-58).

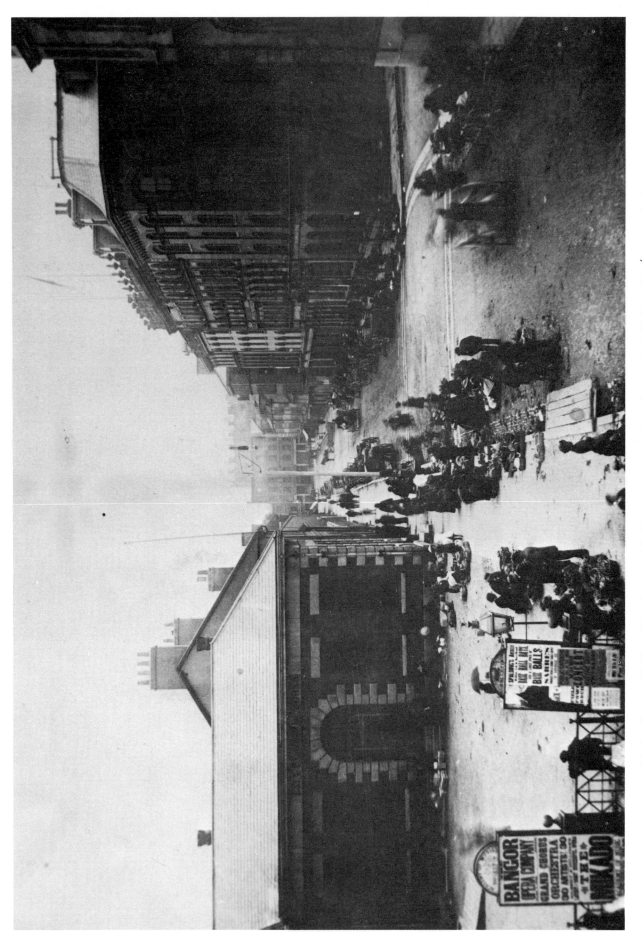

Market Day at Halifax, N.S., Corner of Bedford Row and Cheapside, 1886. Photo by Notman. Public Archives of Nova Scotia, IP.

Le jour du marché à Halifax (N.-É.), au coin de Bedford Row et Cheapside, 1886. Photo prise par Notman. Public Archives of Nova Scotia, IP.

Lunenburg Harbour, Lunenburg, N.S., 1898.
Anonymous. Public Archives of Nova Scotia, IP.

Le havre de Lunenburg, Lunenburg (N.-É.), 1898.
Anonyme. Public Archives of Nova Scotia, IP.

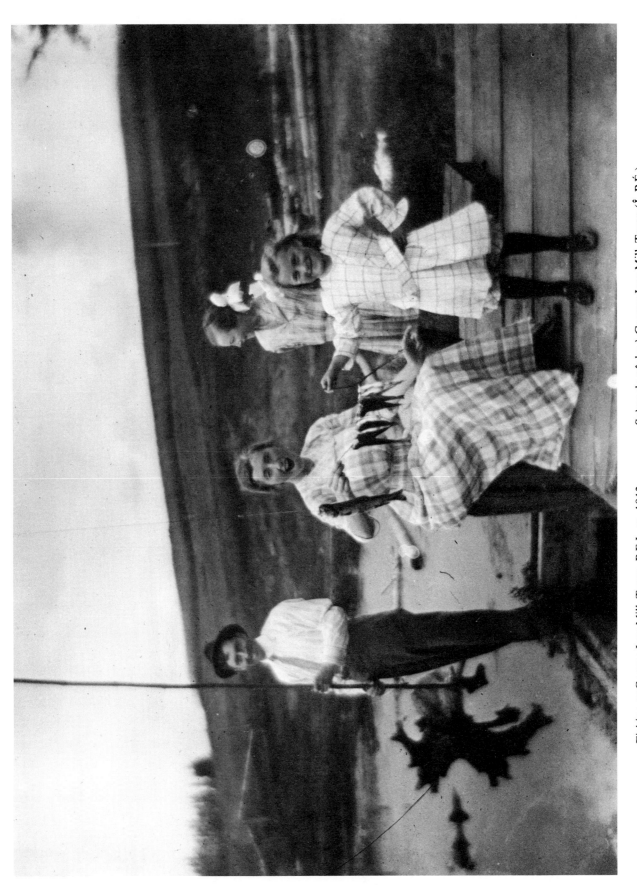

Fishing at George Ives Mill, Tryon, P.E.I. ca. 1912. Photographer and collection: Mrs. Millie Gamble, accession no. 2667, item 18. Public Archives of Prince Edward Island, 5P-2.

Scène de pêche à George Ives Mill, Tryon (Î.-P.-É.), vers 1912. Photographe et collection: Mᵐᵉ Millie Gamble. Acquisition n° 2667, article n° 18. Public Archives of Prince Edward Island, 5P-2.

Murray Harbour, P.E.I., ca. 1915. Photographer and collection: Elliott Lumsden, accession no. 2689, item 122. Public Archives of Prince Edward Island, 5P-1.

Murray harbour (Î.-P.-É.), vers 1915. Photographe et collection: Elliott Lumsden. Acquisition n° 2689, article n° 122. Public Archives of Prince Edward Island, 5P-1.

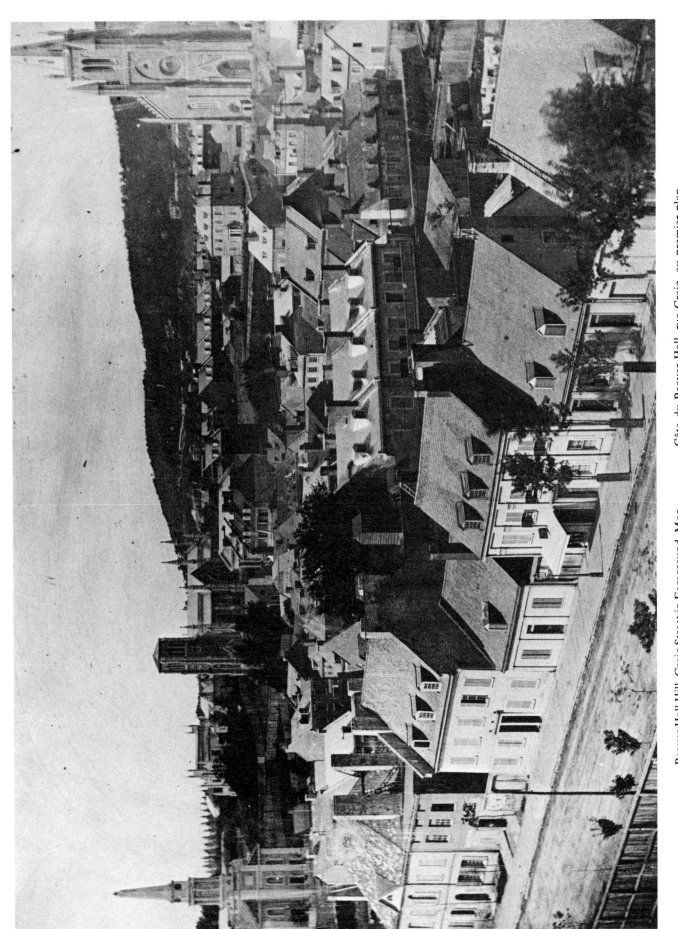

Beaver Hall Hill, Craig Street in Foreground, Mon-
tréal, Qué., ca. 1852. Daguerreotype. Anonymous.
Robert Lisle Collection. Public Archives of
Canada, 7P-1008. Negative no. C 47354.

Côte du Beaver Hall, rue Craig, au premier plan,
Montréal (Qué.), vers 1852. Daguerréotype. Ano-
nyme. Collection Robert Lisle. Archives publiques
du Canada, 7P-1008. (Négatif n° C 47354)

Mrs. Wickstad (Lady Young), 1869. Photographer and collection: William James Topley. Public Archives of Canada, 7P-83. Negative no. D 2075.

Mᵐᵉ Wickstad (Lady Young), 1869. Photographe et collection: William James Topley. Archives publiques du Canada, 7P-83. (Négatif nᵒ D 2075)

John G. Diefenbaker and Lester B. Pearson at Government House for a State Dinner the Evening before Opening of Parliament, Ottawa, Ont., 14 January 1959. Photographer and collection: Duncan Cameron. Public Archives of Canada, 7P-256. Negative no. 7904.

John G. Diefenbaker et Lester B. Pearson, à la résidence du gouverneur général, lors d'un dîner d'État la veille de l'ouverture du Parlement, Ottawa (Ont.), le 14 janvier 1959. Photographe et collection: Duncan Cameron. Archives publiques du Canada, 7P-256. (Négatif n° 7904)

V-E Day Celebrations on Parliament Hill, Ottawa, Ont., 8 May 1945. Anonymous. Department of National Defence Collection. Public Archives of Canada, 7P-1976. Negative no. Z-3849-17.

Les célébrations du jour de la victoire sur la colline du Parlement, Ottawa (Ont.), le 8 mai 1945. Anonyme. Collection du ministère de la Défense nationale. Archives publiques du Canada, 7P-1976.

Leaving Jeffery's Hotel, Rockingham, Ont. Photographer and collection: Charles Macnamara, accession no. 2271 S.5051. Archives of Ontario, 8P-2.

Des clients quittent le Jeffery's Hotel, Rockingham (Ont.). Photographe et collection: Charles Macnamara. Acquisition n° 2271 S.5051. Archives of Ontario, 8P-2.

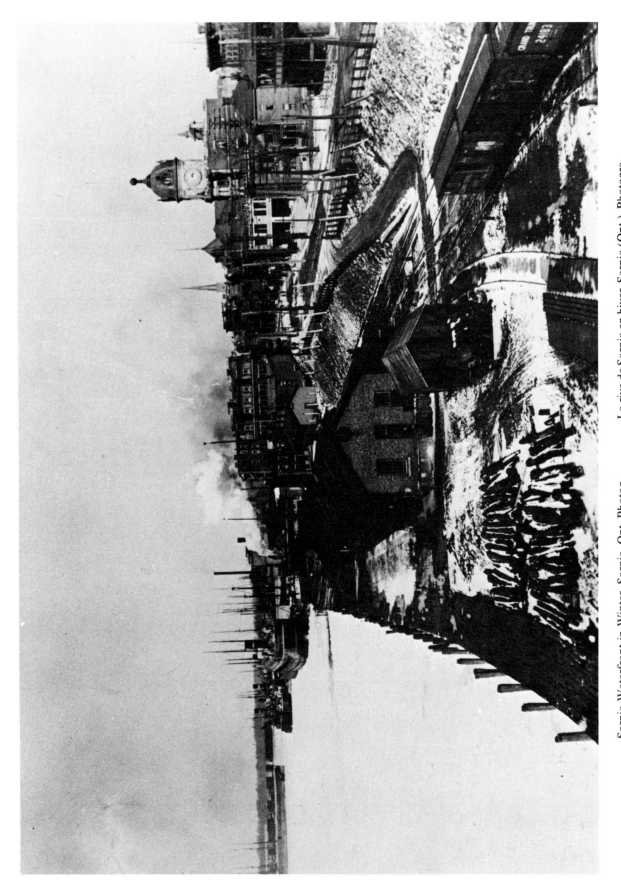

Sarnia Waterfront in Winter, Sarnia, Ont. Photographer and collection: John Boyd, accession no. 9912-5-10. Archives of Ontario, 8P-6.

La rive de Sarnia en hiver, Sarnia (Ont.). Photographe et collection: John Boyd. Acquisition n° 9912-5-10. Archives of Ontario, 8P-6.

Presentation of Petition by the Political Equality League for Enfranchisement of Women, 23 December 1915. (Bottom row, left to right: Dr. Mary Crawford and Mrs. Amelia Burrit; top row, left to right: Mrs. A.V. Thomas and F.J. Dixon.) Photo by Foote and James. Events Collection no. 173/3. Provincial Archives of Manitoba, 9P.

Présentation d'une pétition par la Political Equality League for Enfranchisement of Women, le 23 décembre 1915. Première rangée, de gauche à droite: M^{me} Mary Crawford et M^{me} Amelia Burrit; seconde rangée, de gauche à droite: M^{mes} A.V. Thomas et F.J. Dixon. Photo prise par Foote and James. Collection Events n° 173/3. Provincial Archives of Manitoba, 9P.

Joe Wacha and His Wife Plastering House, Six Miles North of Vita, Man., 1916. Photographer and collection: W.J. Sisler, no. 118. Provincial Archives of Manitoba, 9P-67.

Joe Wacha et son épouse plâtrant leur maison, six milles au nord de Vita (Man.), 1916. Photographe et collection: W.J. Sisler. Nº 118. Provincial Archives of Manitoba, 9P-67.

Skiing, St. Luke District. Poles Are Made from Poplar Trees, ca. 1910. Photographer and collection: John Howard, photo no. A 6188. Saskatchewan Archives Board, 10P-8.

Une promenade à ski, district de St. Luke, au nord de Whitewood (Sask.), vers 1910. Les bâtons sont en branches de peuplier. Photographe et collection: John Howard. Photo nº A 6188. Saskatchewan Archives Board, 10P-8.

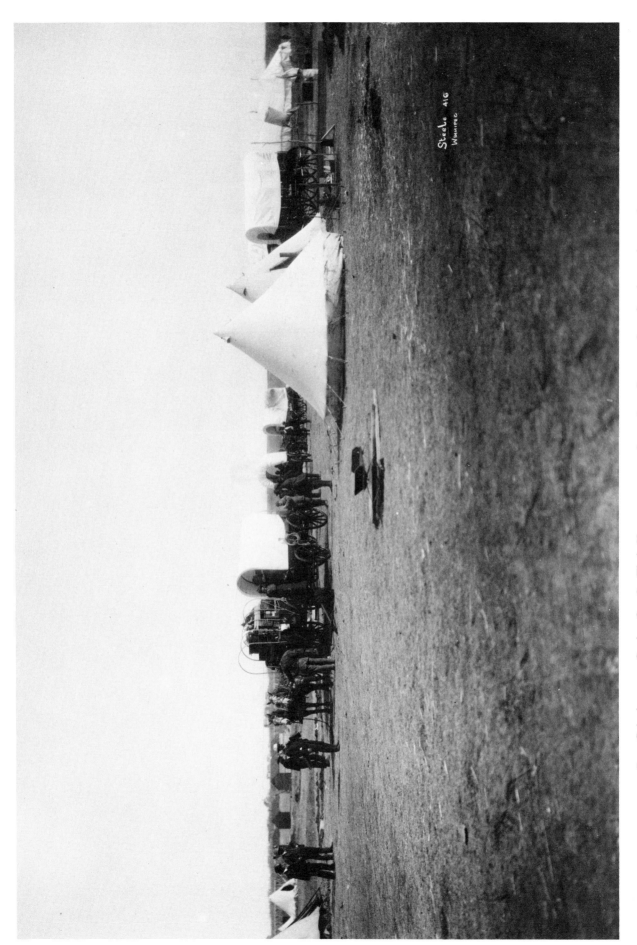

Barr Colonists upon Setting Out for Their Home-
steads, Saskatoon, Sask., April 1903. Photo by
Steele, photo no. B 970. Saskatchewan Archives·
Board, 10P.

Les colons Barr sur le point de partir vers leurs
terres, Saskatoon (Sask.), avril 1903. Photo prise
par Steele, photo n° B 970. Saskatchewan Archives
Board, 10P.

Drifter Getting onto Train, June 1931. Photographer and collection: McDermid Studios Ltd., file no. 12955(b). Glenbow-Alberta Institute, 11P-13.

Vagabond montant dans un train, juin 1931. Photographe et collection: McDermid Studios Ltd. Dossier n° 12955(b). Glenbow-Alberta Institute, 11P-13.

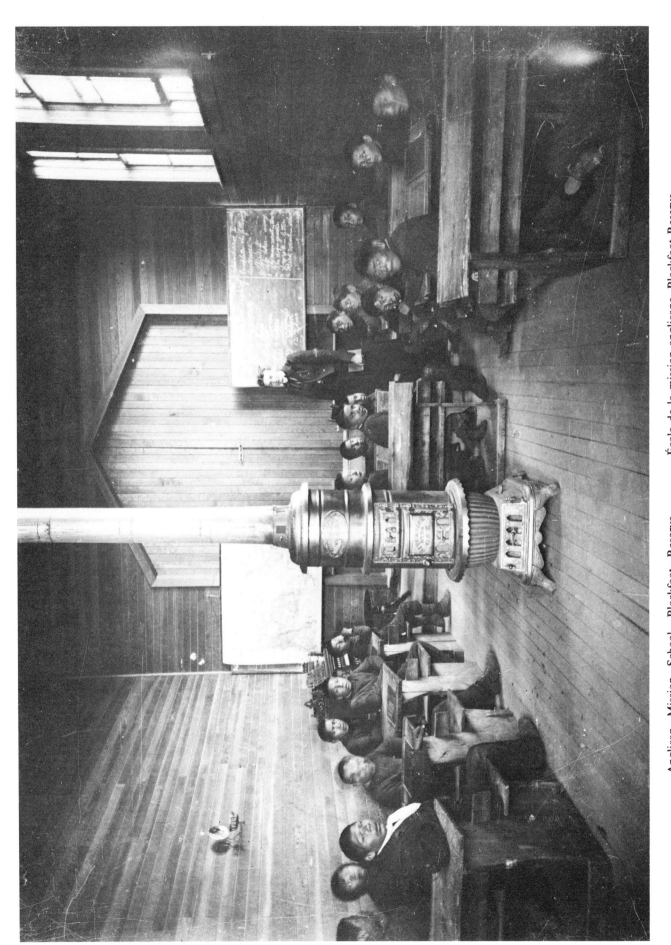

Anglican Mission School, Blackfoot Reserve, Southern Alberta, ca. 1900. Photographer and collection: Canon H.W. Gibbon Stocken, file no. NC-5-61. Glenbow-Alberta Institute, 11P-6.

École de la mission anglicane, Blackfoot Reserve (Sud de l'Alb.), vers 1900. Photographe et collection: H.W. Gibbon Stocken. Dossier n° NC-5-61. Glenbow-Alberta Institute, 11P-6.

(532) HOME STEADING NEAR LLOYDMINSTER, ALTA.

MATHERS
PHOTO
EDMONTON

Homesteading near Lloydminster, Alta. E. Brown
Collection, item B.661. Provincial Archives of Al-
berta, 13P-1.

La récolte près de Lloydminster (Alb.). Collection
Ernest Brown, article nᵒ B.661. Provincial Archives
of Alberta, 13P-1.

Imperial Oil. Leduc No. 1 Well. Leduc Oil Fields, 13 February 1947 (this was the day that the Leduc no. 1 blew in). Harry Pollard Collection, item P.2721. Provincial Archives of Alberta, 13P-2.

Imperial Oil. Puits Leduc nº 1. Champs pétrolifères Leduc (Alb.), le 13 février 1947 (le jour où le puits nº 1 explosa). Collection Harry Pollard, article nº P.2721. Provincial Archives of Alberta, 13P-2.

University of Toronto Gates, College St., West Side of Yonge St., Toronto, Ont., ca. 1875. Anonymous, accession E 3-2a. Metropolitan Toronto Library, 18P.

Grilles de l'université de Toronto, rue College du côté ouest de la rue Yonge, Toronto (Ont.), vers 1875. Anonyme, acquisition nᵒ E 3-2a. Metropolitan Toronto Library, 18P.

Yonge St., Queen to College Sts., West Side between Queen and Albert Sts., 1872. Shows row of shops known as Cameron Block and later as Page's Block. Photo by R.W. Anderson. Accession B 12-16b. Metropolitan Toronto Library, 18P.

Vue de la rue Yonge, des rues Queen à College, prise du côté ouest entre les rues Queen et Albert, Toronto (Ont.), 1872. On y voit une série de boutiques appelées Cameron Block et plus tard Page's Block. Photo prise par R.W. Anderson, acquisition nᵒ B 12-16b. Metropolitan Toronto Library, 18P.

Three Children Seated, Austria, ca. 1905. Gum bichromate print. Photographer and collection: Heinrich Kühn. The National Gallery of Canada, 123P-1.

Trois enfants assis, Autriche, vers 1905. Gomme bichromatée. Photographe et collection Heinrich Kühn. Galerie nationale du Canada, 123P-1.

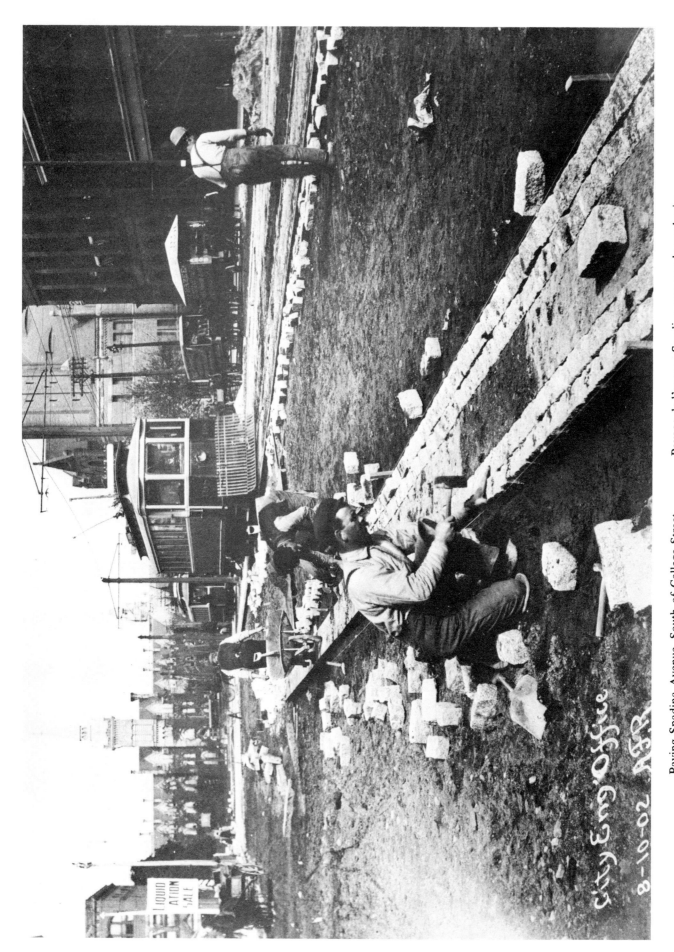

Paving Spadina Avenue, South of College Street Looking North, Toronto, Ont., 10 June 1902. Anonymous. City Engineer's Collection, Vol. 3, p. 67. City of Toronto Archives, 140P-9.

Pavage de l'avenue Spadina, vue vers le nord prise de la rue College sud, Toronto (Ont.), le 10 juin 1902. Anonyme. Collection City Engineer, vol. 3, p. 67. City of Toronto Archives, 140P-9.

[Decorative Cushion Cover], ca. 1890. Cyanotype
on cloth. Anonymous. The National Gallery of
Canada, 123P-1.

[Taie de coussin décorative], vers 1890. Cyanotype
sur tissu. Anonyme. Galerie nationale du Canada,
123P-1.

Arthur Lismer Teaching a Drawing Class at the Art Gallery of Toronto, Toronto, Ont., 10 May 1934. Photo by Arthur S. Goss. Department of Public Works Collection, Art Gallery Series no. 34. City of Toronto Archives, 140P-11

Arthur Lismer donnant une leçon de dessin à l'Art Gallery of Toronto, Toronto (Ont.), le 10 mai 1934. Photo prise par Arthur S. Goss. Collection du ministère des Travaux publics, Art Gallery Series, n⁰ 34. City of Toronto Archives, 140P-11

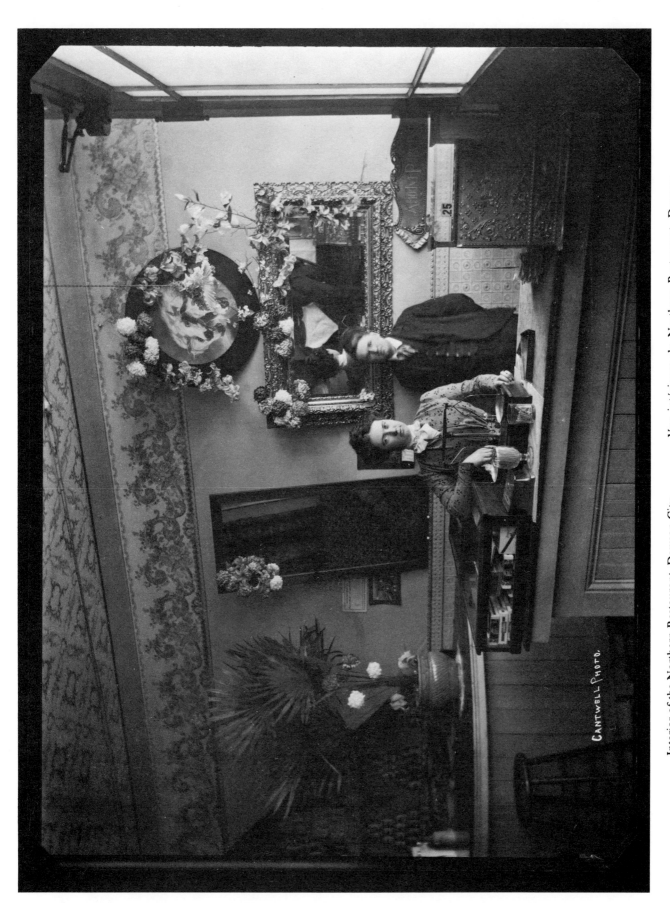

Interior of the Northern Restaurant, Dawson City, Y.T., ca. 1900. Photo by Cantwell. Adams and Larkin Collection. Temporary print no. 52. Yukon Archives, 161P-1.

Vue intérieure du Northern Restaurant, Dawson City (Yukon), vers 1900. Photo prise par Cantwell. Collection Adams & Larkin. Numéro temporaire de l'épreuve: 52. Yukon Archives, 161P-1.

Sternwheeler *Whitehorse* and Workmen after Completing Its Construction Just 43 Days after the Keels Were Laid in Time for the Opening of Navigation on the Yukon River, Whitehorse Shipyard, Whitehorse, Y.T., May 1901. Photographer and collection: H.C. Barley, print no. 5550. Yukon Archives, 161P-1.

Le vapeur à aubes *Whitehorse* et les ouvriers à la fin des travaux de construction, quarante-trois jours après la mise en chantier, à temps pour l'ouverture de la navigation sur la rivière Yukon, chantier naval Whitehorse, Whitehorse (Yukon). Photographe et collection: H.C. Barley. Photo n° 5550. Yukon Archives, 161P-1.

Panoramic View Looking North on Main Street from 7th Avenue, Vancouver, B.C., 1889. Photographer and collection: Bailey Brothers. Bailey Brothers Collection, item 36. Vancouver Public Library, 300P-1.

Vue de la rue Main vers le nord, prise de la 7e avenue, Vancouver (C.-B.), 1889. Photographe et collection: Bailey Brothers. Article no 36. Vancouver Public Library, 300P-1.

Panoramic View Looking North on Granville from Georgia, Tally-Ho Wagon, Vancouver, B.C., 1905. Photographer and collection: Philip Timms. Philip Timms Collection, item 5204. Vancouver Public Library, 300P-1.

Vue de la rue Granville vers le nord, prise de la rue Georgia, calèche Tally-Ho, Vancouver (C.-B.), 1905. Photographe et collection: Philip Timms. Article nᵒ 5204. Vancouver Public Library, 300P-1.

Ordre de Jacques-Cartier, (1926-1965), fraternal society.

7P-1350 b&w 3. ca. 1927-ca. 1952.
Henri Bourassa lying in state; portrait of Dr. Rodolphe Tanguay; portrait of Abbé Maurice Baudoux.

Orillia Public Library, Orillia, Ont.

7P-1351 b&w 2. ca. 1876-1886.
Residence of Mr. W.P. Leacock, father of Stephen Leacock, Egypt, Ont.

Orr family, Barkerville, B.C., settlers.

12P-17 b&w 45. 1910-1915.
Activities of Orr family, especially the sisters, views of Barkerville, 83 mile house, and various homesteads.

Osberg, Edith, Ottawa, Ont.

7P-1352 Copies, b&w 1. ca. 1921-ca. 1925.
Portrait of William Irvine, M.P.

Ostrom, Ethel, Alexandria, Ont.

7P-1353 Copies, b&w 1. 1895.
Bishop Alexander Macdonell's guard of Honour, Dec. 1895.

Ottawa and District Labour Council, (est. 1897), Ottawa, Ont.

7P-1361 b&w 1. 1950.
Portrait of Mr. Percy R. Bengough.

Ottawa Board of Education, Ottawa, Ont.

7P-1354 b&w 6. 1971.
Views of various French-language secondary schools operated by the Ottawa Board of Education, Ottawa, Ont.

Ottawa Camera Club, (est. 1896), Ottawa, Ont.

7P-1355 b&w 256. 1896-1970.
Prints from the Ottawa Camera Club exhibit: "Seventy-five years of Photography".

Ottawa Citizen (the), Ottawa, Ont.

7P-1356 b&w [180,000]. 1972-1975.
News events and personalities covered by *Citizen;* photographers in and around Ottawa, Ont., 1972-1975.

Ottawa Historical Society, Ottawa, Ont.

7P-1357 Copies, b&w 1. 1911.
Sir Frederick Borden with officers of the Canadian Contingent, at the Coronation of H.M. George V, London, England, 1911.

Ottawa Horticultural Society, Ottawa, Ont.

7P-1358 b&w 3. 1895-1897.
Flower shows in Ottawa, Ont.

Ottawa Jewish Historical Society, Ottawa, Ont.

7P-1359 b&w 186. ca. 1890-1960.
Cultural activities of the Jewish community in Ottawa, Perth, Metcalfe and Toronto, Ont.; views of businesses and commercial buildings owned by members of the Jewish community in Ottawa; photos by Karsh and the Levendel Studio.

Ottawa Journal, Ottawa (Ont.).

7P-1360 n.&b. 150. ca. 1940-1950.
Alexandre de Tunis pendant plusieurs cérémonies officielles; W.L.M. King à son bureau; diverses photos d'hommes politiques et de dignitaires canadiens et étrangers, 1945-1950.

Ottawa Little Theatre, (est. 1913), Ottawa, Ont.

7P-1362 b&w 1. ca. 1960.
Group photograph of George Blackburn, Mrs. Roy MacGregor Watt, Mimi Edgell, Yousuf Karsh by Studio C. Marcil, Ottawa, Ont.

Ottawa Local Council of Women, (est. 1894), Ottawa, Ont.

7P-1363 b&w 3. 1944, 1955.
Annual Meeting of the National Council of Women, 1955; 50th Anniversary of the Ottawa Local Council of Women, 1944.

Ottawa Public Library, Ottawa, Ont.

7P-1364 Copies, b&w 1. ca. 1950-ca. 1960.
Honeywell Farm, Britannia, Ottawa, Ont.

Ottawa Teacher's College, Ottawa (Ont.).

303P-16 n.&b. 9. 1886-1911.
Mosaïques; groupes de finissants et d'écoliers.

Otter, William Dillon, (1843-1929), military officer.

7P-1365 b&w 130. 1887-1909.
Militia operations, facilities and personnel, Ottawa, Petawawa, Toronto, Niagara, Ont.; activities of the Otter family and friends.

Ouellet, Jacques, Rivière du Loup, Que.

7P-1366 Copies, b&w 1. [n.d.].
The entrance of Manoir de l'Ile-aux-Grues, Que.

Ouimet, Gédéon, Hon., (1823-1905), premier ministre du Québec.

7P-1367 b&w 2. [n.d.].
Portraits; Philippe, comte de Paris et J.E. Livernois.

Ouimet, Paul G., Ottawa, Ont., public servant.

7P-1368 b&w 14. 1860-1914.
Hon. Gédéon Ouimet and members of the Provincial Cabinet, Quebec City, Que., 1873; portraits of Hons. G.E. Cartier and John A. Macdonald, and of various prominent French-Canadian musicians, singers, actresses and sculptors: Hector Dansereau, Alfred Laliberté, Béatrice LaPalme, Juliette Gauthier, Rose MacMillan.

Ouimet, Raphaël, (1875-1954), Montréal (Québec), journaliste et éditeur.

113P-11 n.&b. 121. ca. 1875-1940.
Portraits d'individus reliés à l'histoire canadienne - française.

Outram, Alan A., Toronto, Ont., soldier.

7P-1369 b&w 83. 1919.
Activities of 68th Battery, R.C.A. in Northern Russia.

Owen, Cambridge.

7P-1370 b&w 14. 1895-1898.
Views of statue of Sir John A. Macdonald, unidentified streams, railway bridge, office interior, militia camp, church of Marie Reine du Monde in Montreal, Que.; also three views of troops in [Halifax], N.S., possibly headed for Boer War, by Lancefield of Ottawa, Ont.

Owen, Elizabeth G., (1909-1972), Halifax, N.S.

1P-51 Original, b&w 28. ca. 1890-ca. 1930.
Portraits and group photographs of the Owen family of Lunenburg and Halifax, N.S.; views of Lunenburg, N.S.; King's College School and students, Windsor, N.S.; photographers: Notman, Climo, Gauvin and Gentzell, E.A. Moss, Sponagle.

Owens Art Gallery, Mount Allison University, (est. 1884), Sackville, N.B., art gallery.

32P-5 b&w [2,000]. 1970-1978.
Photographic record of the permanent collection of the Gallery.

Ower, Dr. John James, (1886-1962), Edmonton, Alta., Professor of Pathology, Dean of Medicine, University of Alberta.

92P-18 b&w 563. ca. 1914-1940.
Military hospital, 1914-18; student days, Alberta Provincial Laboratory and University of Alberta Staff, medical staff, University of Alberta Hospital, ca. 1940; portraits; Medical Corps in World War I - France, holidays in France, Germany and Switzerland.

Pacific Press Ltd., Vancouver, B.C.

7P-1371 b&w 3. ca. 1955.
Activities of Press photographer R.A. Munro during investigation of police affairs, Vancouver, B.C.

Pacific Western Airlines, (est. 1953), Vancouver, B.C., scheduled air carrier.

7P-1372 b&w 33. [1953-1960].
Operations of Pacific Western Airlines.

Packard, Frank Lucius, (1877-1942), author.

7P-1373 b&w 193. 1897-1935.
Portraits of Frank L. Packard, William Faversham; stills from movies based on Frank L. Packard's novels; *The Sin that was His; The Miracle Man; Greater Love Hath No Man.*

Painter family collection, (1877-1957), Banff, Alta., architect.

166P-13 Original, b&w 892. ca. 1912-1953.
Original prints and negatives collected by the Walter S. Painter family; family photographs; Painter home and gardens; construction and views of the Banff Springs Hotel, 1905-1913; interior and exterior views of the Lake Louise Chalet, ca. 1915.

Pammett, Howard T., Ottawa, Ont., public servant, historian.

7P-1374 b&w 290. ca. 1860-ca. 1930.
Rideau Lake Navigation Co., ca. 1900; Trent Valley Navigation Co. Ltd.; Curtis Bros. Brickyard, Peterborough, Ont.; Blacksmith Shop, Whitby, Ont., 1894; Sturgeon Lake Lumber Co., Prince Albert, Sask., 1906; SS *Cruiser,* SS *Stoney Lake,* H.M.S. *Kingfisher,* SS *Esturion,* SS *Empress,* SS *Rideau Queen* and other unidentified vessels; views of Minaki, Grand Falls, N.B.; Peterborough, ca. 1870-1910, Fenelon Falls, Trent Valley, Cobalt, 1907, Muskoka, 1907, Niagara Falls, ca. 1875, ca. 1877-1900, Lake Couching, ca. 1881, Bobcaygeon, Toronto, ca. 1877-1900, Ottawa, 1870, ca. 1877-1900, Ont.; Quebec, ca. 1875, ca. 1877-1900, Montreal, ca. 1877-1900, Que.; Albany, N.Y., ca. 1877-1900; Chaudiere Falls, ca. 1860; Col. S. Strickland, family and residence, Lakefield, Ont.; cartoon of Sir Wilfrid Laurier; Ralph Wade and family, Robert Wade and family, Mrs. Stewart; Ashburnham Public School, ca. 1900; Ashburn Kindergarten; C.N.R. construction camp, Cowichan Lake, B.C., 1912; ploughing match, Red Deer Hill, Sask., 1915; house corral; R.C.M.P. officer; Laurentide Inn, Grand'mere, Que.; portraits of 34th Battalion, Whitby, Ont., 1880; Harvesting near Bobcaygeon, ca. 1900; hunting camp, ca. 1900; photos by B.W. Kilburn, W. Notman, W.J. Topley, London Stereo Co., L.P. Vallee, Geo Baker, S. Davis, E.H.T. Anthony, G.E. Whiten, Notman and Fraser; some stereographs.

Panet, Antoine de Lotbinière, Maj., Ottawa, Ont.

7P-1375 Original, b&w 406. 1904-1942.
Career of Major-General E. de B. Panet, 1904-1941; Artillery Competition, Shoeburyness, England, 1907; Tercentenary celebrations, Quebec City, 1908; trials of *Baddeck No. 1* aircraft, Petawawa, Ont., 1909; visit of H.R.H. the Prince of Wales, 1927.

Panoramic Camera Co., Toronto, Ont.

7P-1376 b&w 1. 1914.
1st Battalion, Canadian Expeditionary Force, Valcartier, Que., 1914; photo by the Panoramic Camera Co.

Papineau, Louis Joseph, Hon., (1786-1871), Montebello (Québec), homme politique.

7P-1377 n.&b. 4. ca. 1852-1910.
Manoir Papineau, Montebello (Québec); daguerréotypes de Louis Joseph Amédée Papineau, de Mary Eleanor Westcott et de Louis-Joseph Papineau.

Papineau, Talbot Mercer, (1883-1917), military officer.

7P-1378 b&w 4. 1915-1916.
Captain T.M. Papineau with dog "Bobs" and horse "Queen Bee", France, 1915-1916; portrait of Captain T.M. Papineau, 1916.

Paris, Cyril, (b. 1904), Banff, Alta., restauranteur.

166P-8 Original, b&w [2,300]. ca. 1925-1940.
Original negatives and prints by Cyril Paris and Fulton Dunsmore; skiing in the Banff area ca. 1925-1940; family photographs; Banff people.

Paris, George, (1872-1960), Banff, Alta., barber, professional photographer.

166P-9 Original, b&w [1,740]. ca. 1897-1930.
Original prints and negatives by George Paris; Banff people and events; views of Banff townsite and surrounding area; travel photographs and winter sports.

Park, Edward P., Brantford, Ont., photographer.

7P-1379 b&w 39. 1899-1911.
Tour of the Algoma District by members of the Ontario Legislature, 1899; group of British Newspaper editors at the Brant Monument, Brantford, Ont., 1911; photos by Park & Co.

Park, Seth, Brantford (Ont.), photographe.

7P-1380 n.&b. 14. ca. 1850-1860.
Portraits (daguerréotypes) non-identifiés.

Parker, David W., (1886), Ottawa, Ont., public servant.

7P-1381 b&w 5. ca. 1914-1920.
Portraits of David W. Barker, 73rd Battery, Canadian Field Artillery.

Parker, G. Albert, (1910-1971), Moncton and Southeastern New Brunswick, insurance underwriter.

337P-1 Copies, b&w 313, col. 176, total 589. 1758-1971.
Slides represent an outstanding pictorial history of Moncton and vicinity photos taken over a forty year period ca. 1930-1971; last shots taken only months before his death.

Parker, John E., Vancouver, B.C.

7P-1382 b&w 7. 1904-1916.
Baseball team of Fort Rouge School, Winnipeg, Man., 1904; hockey arena, Portland, Or., 1916; portrait of Del Irvine of the Portland Rosebuds hockey team.

Parker, John Primrose, (b. 1907), North Sydney, N.S., mariner.

7P-1383 Copies, b&w 18. 1886-1911.
Views of Sydney, St. Peters, Port Morien, Port Hastings, Baddeck, N.S.; vessels in Cape Breton, N.S.; portraits of Captains C.M. Burchill and Matthew Ryan.

Parker Eakins Co. Ltd., (est. 1874), Yarmouth, N.S.

31P-68 Original, b&w 37. ca. 1870-1920.
Cartes-de-visites from Capt. J.E. Kinney Papers.

Parkin, George Robert, Sir, (1846-1922), educator and author.

7P-1384 b&w [100]. 1876-1922.
Aspects of the career of Sir George R. Parkin at Upper Canada college, Toronto, Ont., 1895-1902, and at Goring-on-Thames, England, 1906-1922; portraits of members of the Parkin, Fisher and Massey families.

Parkin, Raleigh, (n. 1896), Montréal (Québec).

7P-1385 n.&b. 114. ca. 1860-1930.
Sir George Robert Parkin et Lady Annie Connell Parkin avec des membres de leur famille et des familles Grant, Massey et MacDonnell; portraits de Sir Edward Peacock, ca. 1901; photo de J. Fraser Bryce; de Sir Amuel Way; de William Van Horne; vues de Waterloo Row, Fredericton (N.-B.) et de la maison Rhodes, Oxford, Angleterre.

Parsons, Johnson Lindsay Rowlett, (b. 1876), Regina, Sask., military officer.

7P-1386 b&w 1. ca. 1914-ca. 1918.
Group portrait of Headquarters Staff, 1st Canadian Division, World War I.

Parsons, S.H., St. John's, Nfld., publisher.

7P-1912 b&w 1. [1890].
Stereo-sized card photograph of St. John's Harbour, Nfld.

Paterson, R.W.

9P-61 b&w 686. 1924-1931.
Photographs of Northern Manitoba.

Patrick, George, Ottawa, Ont., military officer.

7P-1388 Copies, b&w 2. ca. 1917.
Medals of Captain (acting Major) O.M. Learmouth, V.C.; portrait of O.M. Learmouth and friend.

Pattias, Fortunato, Toronto, Ont.

7P-1387 Copies, b&w 10. 1971.
Views of festival of l'Associazione Nazionale Alpini d'Italia, Toronto, 1971.

Patton, George E., (d. 1976), Toronto, Ont.

7P-1389 b&w 280. ca. 1925-1940.
Activities of George Patton, Director of the Ontario Motion Picture Bureau, including shootings, staff, equipment, etc.; making of the film *Carry on Sergeant,* Trenton, Ontario, 1927; portraits of George Patton and colleagues, Mary Pickford.

Paulson family.

334P-13 Copies, b&w 5. 1910-ca. 1923.
Fraser Hotel interior and bar; family excursion and home.

Payzant, Florence (Belcher), Dartmouth, N.S.

1P-52 Original, b&w 96. 1939-1941.
Early Nova Scotia furniture illustrating a paper entitled "Old Furniture Made in Nova Scotia".

Peagam, F.R., Prince Rupert, B.C.

7P-1390 Copies, b&w 1. 1939.
Blackburn Shark III aircraft 525 of No. 6 (TB) Squadron, R.C.A.F., Jericho Beach, B.C., May-June, 1939.

Peake & Whittingham, Toronto, Ont., photographers.

7P-1391 b&w [4,650]. [1910-50].
Public buildings, residences, commercial businesses in and around Toronto, Ont.

Pearce, A. Douglas, Ottawa, Ont., public servant.

7P-1392 Copies, b&w 95. ca. 1934-1950.
Various R.C.A.F. and commercial aircraft in Canada.

Pearce, William, (1848-1930), Calgary, Alta., surveyor and statistician.

92P-19 b&w 105. 1858-1902.
Photographs collected by William Pearce for history of Western Canada.
Ref./Réf.: "Guide to Photographs, William Pearce Papers,

Pearce, William, (1848-1930), Calgary, Alta., surveyor and statistician. (Cont'd/Suite)

1858-1902." University of Alberta Archives, Autumn, 1974.

Pearse, Charles, Ottawa, Ont., public servant.

7P-1393 Copies, b&w 1.
Portrait of Air Commodore K.L.B. Hodson, O.B.E., D.F.C., C.D., R.C.A.F.

Pearson, Lester Bowles, Très Hon., (1897-1972), premier ministre du Canada.

7P-1394 n.&b. 2,911. 1914-1972.
La vie et la carrière de l'Hon. Lester B. Pearson, 1914-1968; portrait de Sir Wilfrid Laurier, ca. 1890-1896, Valleyfield (Québec); photo prise par James Martin; portraits de l'Hon. Lester B. Pearson, de sa famille, de ses collègues et amis, dont plusieurs chefs d'Etat.

Peck, Mary, Ottawa, Ont.

7P-1395 b&w 35. 1910-1915.
Views of Cranbrook, Creston, Bull River, Erickson, Dutch Creek, Wild Horse River, Windermere, Horsethief Glacier, B.C.; activities of the Peck, Cartwright, McCowan and Wilson families.

Pedersen, C.T., Pacifica, Calif., mariner.

7P-1396 b&w 16. ca. 1920-1930.
Ships *Baychimo, Herman, Arctic, Maud, Patterson,* active in Arctic waters off the coast of Alaska.

Pederson, Carl, Montreal, Que., engraver.

7P-1397 Copies, b&w 23. ca. 1960-1970.
Carl Pederson working on the National Hockey League trophies.

Pelletier, Louis Philippe, (1857-1928), homme politique et avocat.

7P-1398 n.&b. 1. [n.d.].
Portrait de M. et Mme Louis-Philippe Pelletier; photo prise par Lafayette.

Pelletier, Winnifred, Buckingham, Que.

7P-1399 b&w 60. ca. 1880-ca. 1900.
Humorous stereographs; biblical scenes by International Stereoscopic View Co., N.Y.; views of Queen's College, Oxford, N.S.; Grand Hotel, Dartmouth, N.S.; Windsor Castle, Diamond Jubilee, London, England, 1897, Victorian scenes; Chilkoot Pass, B.C., Whitehorse Rapids, Yukon; some photos by B.W. Kilburn.

Penttinen, Lauri, Willowdale, Ont.

7P-1400 b&w 80. [1920-1965].
Activities of the "YRITYS" (Finnish-Canadian) Athletic Club, Toronto, Ont.

Perch, David G., Ottawa, Ont.

7P-1401 b&w 2. 1880-ca. 1900.
Public hanging allegedly taking place at Windsor Ont.; photos by Frank G. Kiborn, Ridgetown.

Perepeluk, Wasyl John, (b. 1900), merchant and community leader.

7P-1402 b&w 69, col. 14, total 83. [1900-1974].
Views of Flin Flon, Rocketon, Man.; Ukrainian settlement activity near Sifton, Man.

Pères Franciscains, Montréal (Québec).

328P-1 Originaux, n.&b. [5,000], coul. 100, total [5,100]. 1890 nos jours.
Photos concernant les Franciscains et leurs oeuvres soit au Canada, soit en provenance de leurs missions (Chine, Japon, Corée, Pérou, Terre-Sainte).

Pères Oblats de Marie Immaculée des Territoires du Nord-Ouest, Edmonton, Alta.

13P-9 b&w [2,000]. ca. 1890-1960.
Portraits of Missionaries, churches, religious groups and ceremonies in North Saskatchewan and Central and Southern Alberta, schools.

Performing Arts Collection.

7P-1403 b&w 196. ca. 1959-ca. 1973.
Drama, opera, ballet, music productions across Canada.

Perry, M. Eugenie, (1880-1958), Victoria, B.C., writer.

12P-3 b&w 139. 1880-1950.
Family portraits; views of Victoria, Vancouver Island, wildlife in Canadian rockies and B.C.; delegates to Canadian Authors Assn. conferences in 1936 and 1941.

Perry, R.G., Montreal, Que.

7P-1405 Copies, b&w 3. 1919.
Return of Princess Patricia's Canadian Light Infantry to Ottawa, Ont., 18 March 1919.

Personnalités acadiennes, Maritimes.

15P-3 n.&b. 1,000. 1890.
Photos d'individus classées par ordre alphabétique; plusieurs photos de groupes et de familles.

Peterborough Centennial Museum and Archives Collection, (est.1971), Peterborough, Ont.

7P-1406 Copies, b&w 9. 1884-1951.
View of Peterborough, Ont., 1948; parade of 57th Regiment, Peterborough, Ont.; views of Young's Point and Keene, Ont.; interiors of City Engineer's office and Baker's barber shop, Peterborough, Ont.; portrait of Orde family, West Woodlands, Ont.

158P-2 b&w [2,326]. ca. 1850-ca. 1900.
Events, buildings, prominent personalities and street scenes in Peterborough District, Ont.

Peters, Frederic Hatheway, (b. 1883), Ottawa, Ont., Surveyor-General of Canada.

7P-1407 b&w 250. 1885, ca. 1900-1945.
Northwest Rebellion battlegrounds at Duck Lake and Fish Creek, N.W.T., 1885, by J.A. Brock, Brandon, Man.; portrait of Col. James Peters, R.C.A., n.d.; views of Ottawa River, Hydrographic Service;

Peters, Frederic Hatheway, (b. 1883), Ottawa, Ont., Surveyor-General of Canada.
(Cont'd/Suite)

Surveys in the Canadian Rockies ca. 1900-1945.

Peters, H., (d. 1922), Timmins, Ont., photographer.

8P-15 b&w 129. 1911-1914.
Street scenes, buildings and events in Timmins, Porcupine and Golden City, Ont.; photos by H. Peters.

Peterson, Harold L.

7P-1408 b&w 1. ca. 1930-ca. 1935.
Harold L. Peterson during Quaker Oats Bicycle Tour from Saskatchewan to Brownsville, Texas, by A. Rogers.

Peterson, T.A. Mrs., Edmonton, Alta., nurse.

92P-20 b&w 58. 1910-1959.
University of Alberta Hospital; facilities, staff.

Petrie, Alfred E.H., (b. 1912), Ottawa, Ont., public servant.

7P-1409 b&w 1. [n.d.].
Bow River Falls on the Bow River, Banff, Alta.

Petrie, H. Leslie, Col., London, Ont., military officer.

7P-1410 b&w 100. 1943-1945, 1963.
Views of Wolseley Barracks, London, Ont.; portraits of Col. H.L. Petrie, M.C., Major Paul Triquet, V.C., Officers of No. 1 District Depot, Wolseley Barracks, London, Ont.

Petrigo, Walter, Calgary, Alta., photographer.

7P-1411 b&w 1, col. 24, total 25. ca. 1965-1975.
Landscapes in Alberta; portraits of Rt. Hon. John G. Diefenbaker, Chief Dan George, Mr. Burl Ives; photos by Walter Petrigo.

Peyto, E.W. (Bill), (1869-1943), Banff, Alta., outfitter and trail guide; park warden.

166P-21 Original, b&w 313. ca. 1900-1940.
Original prints and negatives collected by E.W. (Bill) Peyto; pack trips in Rocky Mountains; views of Rocky Mountains.

Phelps, Edward, Toronto, Ont.

196P-40 b&w 8. 1936-1939.
University of Toronto, Trinity College Literary Institute Council, 1936; Trinity College Literary Institute 1937-38, 1938-39; Trinity College Athletics Association 1937-38, 1938-39; Trinity College Board of Stewards 1938-1939; Delta Upsilon Fraternity 1936-37, 1938-39.

Phillips, Allan S., Windsor, Ont.

7P-1412 Copies, b&w 8. 1942-1944.
Aircraft, personnel and operations of No. 625 Squadron, R.A.F., Kelstern, Lines., England.

Phillips, Frank, Seaforth, Ont.

7P-1413 b&w 2. ca. 1900.
Views of Stobies' Egg Emporium and Devereux Wagon Works, Seaforth, Ont.

Phillips, George Hector Reid, (1893-1977), Orangeville, Ont., aviator.

7P-1414 Copies, b&w 2. 1933-1942.
Portraits of Messrs. George H.R. Phillips and George Gill.

Phillips, Gordon George, (b. 1927), Ottawa, Ont., public servant and genealogist.

7P-1415 b&w 217. [1865-1939].
Scenes of activities and views in Lauder, Melgund, Napinka, Hartney, Birch River, and Grand Pre, Man.; unidentified farm scene; portrait of Mr. and Mrs. Patterson, ca. 1900; farm machinery and cars, Lauder, Man., 1918.
Ref./Réf.: Caption list for 1974-421.

Phillips, Lazarus, (b. 1895), Montreal, Que., lawyer and senator.

7P-1416 b&w 25. 1904-1966.
Activities of Lazarus Phillips in business, financial and community affairs, and in federal politics.

Phipps, Welland Wilfred, (b. 1922), Ottawa, Ont., aviator.

7P-1417 col. 10. ca. 1963-1971.
Aspects of the career of Mr. W.W. Phipps with Atlas Aviation Ltd. in the Northwest Territories, ca. 1963-1971.

Photo-Montreal, Montreal, Que., photo-documentation project.

7P-1419 b&w 1,106. 1971-1972.
Various aspects of the city of Montreal, Que., 1971-1972: street scenes; architecture; slums; citizens; views of Caughnawauga, Que.; photos by Photo-Montreal project photographers.
Ref./Réf.: List of photographers.

Photographic Stores Ltd., Ottawa, Ont., photographic supply store.

7P-1418 b&w 4. [1940-1962].
Composite group portraits of 19th Parliament, 22nd Parliament and 24th Parliament, Ottawa Ont.

Photos Duplain, Enr., Saint-Raymond, comté de Portneuf (Québec), studio de photographie.

345P-1 Originaux, []. 1900-1970.
Photos de mariages, d'événements politiques, sportifs, culturels, sociaux de même que de catastrophes telles que des inondations, des accidents, des incendies; photos publicitaires, de chantiers de bûcherons, du comté de Portneuf (Québec).

Pickford and Black Ltd., (est. 1870), Halifax, N.S., steamship agents.

31P-71 Copies, b&w 1. ca. 1940.
Consolidated type steam engine.

Pickings, Harry B., Halifax, N.S., surveyor.

7P-1420 b&w 506. 1904-1910.
Views of Montreal, Que. and Halifax, N.S.; scenes of mining in N.S.; family activities, groups of friends.

Pickthall, Marjorie Lowry Christie, (1883-1922), Toronto, Ont., British Columbia, author.

<u>18P-34</u> Original, b&w 20. ca. 1920.
Scenes in B.C., chiefly Vancouver Island.

Pictou County Trades and Labor Council.

<u>31P-117</u> Original, b&w 1. 1915.
Labour Day picnic, 1915.

Pier One Theatre, (1971-1974), Halifax, N.S.

<u>31P-63</u> Original, b&w [155]. [n.d.].
Numerous Pier One productions.

Pietropaulo, Vincenzo, Toronto, Ont., photographer.

<u>7P-1421</u> b&w 20. 1971-1974.
Activities of the Italian community, Toronto, Ont., 1971-1974; photos by Vincenzo Pietropaulo.

Pike, Frederick R., banker.

<u>7P-1422</u> b&w 29. 1904-1943.
Branches and personnel of the Merchant's Bank of Canada, Souris, Man.; Vegreville, Castor, Brooks, Wetaskiwin, Alta., 1904-1917; view of Peace River Crossing, Alta.; photo by G.B. Cliff; group photos of branch managers of The Merchants Bank of Canada, 1919 and 1926; photos by McDermid Studio, Edmonton, and Jessop, Winnipeg.

Pikulin, Michael Alan.

<u>7P-1423</u> n.&b. 54. 1973-1974.
Petite ferme en Ontario; manifestation contre la guerre du Vietnam, Toronto (Ont.); portraits, Angela, 1973.

Pilcher, Samuel.

<u>7P-1424</u> col. 8. ca. 1907.
Views of Field, B.C.; Banff, Alta.; view of SS *Canada*.

Pilot, Dorothy, Hull, Que.

<u>7P-1425</u> b&w 3. ca. 1880-1919.
Ridea Canal Locks, Ottawa, Ont.; house near Alexandra Bridge, Hull, Que., 1929; photo by W.H.C. Carriere; portrait of H.M. King George VI; photo by Karsh.

Pinard, Arthur A., Ottawa, Ont., military officer.

<u>7P-1426</u> b&w 1. 1903.
Last raft of Square Timber on the Ottawa River passing Sand Point, Ont., 30 June 1903.

Pinchbeck family, (1860-1900), Cariboo, B.C., farmer, innkeeper, policeman.

<u>228P-5</u> b&w 4. 1860-1900.
Homesteads, upper and lower ranches, gristmill, view of farm.

Pitseolak, Peter, (1902-1973), Cape Dorset, N.W.T., hunter and leader of his people.

<u>327P-3</u> total 1,500. ca. 1945-ca. 1965.
Snap shots of family and friends, hunting and whaling scenes,

camp life, interiors of tents and huts, snowscapes, supply ships, whaling boats, aeroplanes, dog teams, igloos. Many portraits.

Pittaway, Alfred George, (1858-1930), Ottawa, Ont., photographer.

<u>7P-1427</u> b&w 3. 1903-1934.
Group photo of delegates to the Interprovincial Conference, Ottawa, Ont., 1903; portraits of Sir Arthur Doughty and Mr. Adam Shortt.

Pittaway and Jarvis, Ottawa, Ont., photographers.

<u>7P-1428</u> b&w 7. 1864-1916.
Views of Ottawa, Ont.; fire damage to Centre Block of Parliament Buildings, Ottawa, Ont., 1916; composite photos of delegates to the Quebec Conference of 1864, and of members of the Supreme Court of Canada, 1894; portrait of Sir Wilfrid Laurier; photos by A.G. Pittaway and S.J. Jarvis.

Pittman, Harold Herbert, (1889-1972), Wauchope, Sask.

<u>10P-14</u> b&w 36. [n.d.].
Birds and animals of south-eastern Saskatchewan.

Plaut, W. Gunther, (b. 1912), Toronto, Ont., rabbi, author.

<u>7P-1429</u> b&w 36. ca. 1944-1968.
Activities of W. Gunther Plaut in the 104th Infantry Division of the American army during WW II; portraits of Rabbi W. Gunther Plaut.
Ref./Réf.: MSS. Finding Aid No. 1019.

Polish Alliance Friendly Society of Canada, (est. 1922), Toronto, Ont.

<u>7P-1430</u> b&w 882. ca. 1915-1965.
Reunion and congresses of the Polish Alliance; portraits of members of executive committees.

Polish Canadian Pioneer Survey, Winnipeg, Man.

<u>9P-62</u> b&w 84. 1905-1972.
Photographs of Polish Community in Winnipeg and Western Canada.

Pollard, Arthur V., Victoria, B.C.

<u>7P-1431</u> b&w 114. 1880-1960.
Various ships on the coast of British Columbia; activities of Indians on Vancouver Island, B.C.

Pollard, Harry, (1881-1968), Calgary, Alta., photographer.

<u>13P-2</u> b&w 10,123. ca. 1899-1954.
Photographs relating to Alberta including: Indians (individual portraits and groups), individual portraits, trading posts, early police, Riel Rebellion, oil and oil promotion, miscellaneous historic buildings and scenes (mostly Calgary), ranching, farming, mining, lumbering, Alpine Club of Canada, mountains, Alaska, "Trail of '98", Army, Navy and Air Force.

Polson, Kathleen.

<u>7P-1432</u> b&w 4. ca. 1859.
Troops of the 71st Regiment, Quebec Que.; views of the Citadel and of Montmorency Falls, Quebec, Que.; photos possibly by William Denny.

Pontiac Historical Society, Shawville, Que.

7P-1433 Copies, b&w 27. 1860-1927.
Views of various buildings in Shawville, Que.; portraits of
prominent individuals and group portraits of various clubs and
organizations from Shawville.

Ponting, A.H., Carleton Place, Ont.

7P-1434 b&w 22. 1927.
Various Canadian and American civil and military aircraft,
including those of the Ford-Stout Reliability Tour, Lindbergh Field,
Ottawa, Ont.

Ponton, William Nisbet, (1856-1939), Belleville, Ont., lawyer, military
officer.

7P-1435 b&w 102. [1860-1950].
Views of Ponton family life; C.E.F. Camp at Valcartier, Que, 1914;
C.E.F. Camp and officers and men at Salisbury Plain, Wilts.,
England, 1914-1915; Queen's Canadian Military Hospital, at
Shorncliffe, Kent, England, c. 1917; postcards of Toronto, Niagara,
Ont.; portraits of members of Ponton family and unidentified
people by photographers in Belleville, Peterboro, Toronto.

Poole, F.N., Tara, Ont., photographer.

18P-40 Original, b&w 18. 1893.
Tara, Ont., and Southampton, Ont.

Pope, Beatrice, Quebec, Que.

7P-1436 b&w 1. ca. 1860.
Views of Queen's Wharf, Quebec, Que.

Pope, Joseph, (1854-1926), Ottawa, Ont., public servant.

7P-1437 b&w 146. 1901.
Aspects of the visit to Canada of the Duke and Duchess of
Cornwall and York, 1901.

Porsild, Alf Erling, Dr., (b. 1901), Ottawa, Ont., botanist and public
servant.

7P-1438 b&w 40. 1945.
Views of Dr. A.E. Porsild's trip to Siberia, Russia and Finland,
1945.

Port Arthur Album.

7P-1439 b&w 25. ca. 1870-ca. 1910.
Views of Port Arthur, Ont., by Lane ca. 1870; visit of Sir Wilfrid
Laurier to Port Arthur 10 July 1910.

Port Stanley, Ont.

18P-26 Original, b&w 13. 1905.
Views of cottage and cottagers.

Porter, N.J., (fl. 1903), Moose Jaw, Sask., photographer.

7P-1440 b&w 69. ca. 1903.
Views of Moose Jaw, Sask., and district.
Ref./Réf.: MSS. Finding Aid No. 370.

Potter, Jean, Ottawa (Ont.).

7P-1441 n.&b. 3. 1916, 1928.
Visites du Club Rotary à la ferme expérimentale, Ottawa (Ont.),
1916; et au Parlement, Ottawa (Ont.), 1928.

Potter, Ray A., Tipton, Iowa.

7P-1442 Copies, b&w 1. ca. 1917.
Portrait of Sergeant F.J. Hobson, V.C.

Pouliot, Jean-François, (1890-1969), member of parliament, senator.

7P-1443 b&w 255. 1925-1969.
Portraits of the Pouliot family, and of various federal politicians.

Pounden, Charles Edward, Lethbridge, Alta., R.C.M.P. constable.

7P-1444 Copies, b&w 7. 1894-1924.
Views of K. Division Post, Royal Canadian Mounted Police,
Lethbridge, Alta., 1924; D. and M. Division, Macleod, 1894;
funeral of R.C.M.P. officer; view of unidentified field R.C.M.P.
post; R.C.M.P. group; view of Independent Order of Odd Fellows,
Montreal, Que., 1911.

Poussette, Henry Rivington, (b. 1872), public servant.

7P-1445 b&w 354. 1906-1942.
Views of South Africa, Argentina, Brazil; activities of the Poussette
family; portraits of Mr. H.R. Poussette, his family and friends.

Powell, Alan, Ottawa, Ont., antiquarian.

7P-1446 b&w 1. 1911.
Nomination Day, Digby, N.S., Sept. 14, 1911.

Powell, C. Berkeley, Ottawa, Ont.

7P-1447 b&w 191. ca. 1880-ca. 1901.
Views of visit of Duke and Duchess of Cornwall and York to
Ottawa, Ont., 1901, by Pittaway; portraits of Marquess of
Lansdowne, 1887, of Marquess of Dufferin, ca. 1880, of Lord
Lisgar, ca. 1880, all by Topley; Capt. Eric Streatfield, Marquis of
Lorne, Lord Minto, Maj. Gen. E.T.H. Hutton, Mr. C.B. Powell.

Powell, J.W., (fl. 1880-1890's), Kingston, Ont., photographer.

75P-14 b&w [5,000]. ca. 1880-1900.
Portraits of persons in Kingston and surrounding area.

Powell, Walter, Syracuse, N.Y.

7P-1448 b&w 1. ca. 1895-ca. 1910.
Portrait of Countess and Baron Magri, by Gauvin and Gentzel,
Halifax, N.S.

Power, Charles Gavan, (1888-1968), Québec, Que., lawyer and politician.

7P-1449 b&w 19. 1915-1945.
Group portraits of R.C.A.F. Air Council; British Commonwealth
Air Training Plan Group, Laval University Group; portraits of C.G.
Power, C.G. Ralston, A.L. McDonald, S. St. Laurent, Jean
Marchand.

Power, William Pendleton, Ottawa, Ont., public servant.

7P-1450 b&w 15. [1862-1945].
Activities of Hon. C.G. Power as Member of Parliament and
Cabinet Minister, 1924-1944; group photos of Cabinet Ministers
and Members of Parliament.

Powley, Gordon W., Toronto, Ont., photographer.

8P-12 Original, b&w 3,000. ca. 1940-ca. 1960.
Portraits of prominent people in the Toronto area, Ont.; street
scenes in Toronto, Ont.; photos by Gordon W. Powley.

Preble, Norman A., Needham, Mass.

7P-1451 b&w 18. 1903.
Views of Athabaska Landing, Fort Chipewyan, Grand Rapids,
Alta.; Fort Resolution, N.W.T.; church of England missions along
the Athabaska River; various aspects of marine navigation on the
Athabaska River.

Presbyterian Church in Canada.

317P-1 b&w 668, col. 22, total 690. ca. 1870 to present.
Presbyterian groups and individuals, churches, buildings.

Presbyterian Church in Canada - Colleges, (1875-), education.

317P-5 b&w 2. 1917.
Presbyterian College (Montreal) Graduating Class 1917;
Presbyterian Union Theological College, Pyeng Young, 1917.

Press Library (the), Vancouver, B.C.

7P-1452 b&w 8. [n.d.].
Views of Saint John, N.B., Saskatoon, Sask., and a snowdrift on
the Hudson Bay Railway.

Preston, G. Violet, Ottawa, Ont.

7P-1453 b&w 3. 1902-1905.
Group portraits of Avondale Hockey Club, 1901-02; Star Lacrosse
Club, Ottawa, Ont., 1903-04; Victoria Harbour Hockey Club, 1905.

Price, Agnes, Ottawa, Ont., public servant.

7P-1454 b&w 8. ca. 1894-1905.
Views in Grenfell, Sask., including baseball, soccer and curling
teams.

Price, Basil, Knowlton, Que., miltary officer.

7P-1455 b&w 1. 1917.
Group photo of Headquarters Staff, School of Instruction, C.E.F.,
Bramshoft, Hants, England, Aug. 1917.

Price, Henry Edward, (b. 1918), Rexdale, Ont., photographer.

7P-1456 Copies, b&w 36. 1941-1945.
Activities and associates of Cpl. Harry E. Price, Senior Public
Relations Photographer, No. 6 Bomber Group, R.C.A.F., Yorkshire,
England; equipment and activities of same Bomber group.

Princess Patricia's Canadian Light Infantry, (est. 1914).

7P-1457 b&w 2. 1917-1918.
Troops of the P.P.C.L.I. with colours, France, July, 1917, and
resting during advance east of Arras, France, Sept. 1918.

Prior-Wandesforde, Maureen E., Evington, Carlow, Ireland.

7P-1458 b&w 45. [1880-1890].
Views of landslide at Quebec, 1888; Canadian military activities;
scenes in Ottawa, Ont.; Montreal and Quebec, Que.

Pritchard, James, Wakefield, Que., physician.

7P-1459 b&w 198. ca. 1880-1916.
Views of hay farming, portraits of officers and men, 20th
Ottawa-Carleton Battalion, C.E.F., Ottawa, Ont., Apr. 27, 1916;
portraits of McGill graduating class, Medicine, 1894; portraits of
J.M. McCrea, Dr. J. Pritchard.

Pritzker, Lee, Oakville, Ont., collector.

7P-1460 b&w 6. [ca. 1865-1870].
Group portraits of: Caughnawaga Indian Lacrosse Team, Montreal,
Que., 1869, by James Inglis; "Paris Crew" Rowing Four, Saint
John, N.B., ca. 1870; "Tyne Crew" Rowing Four, Saint John, N.B.,
1870, by Notman; scenes in Woodstock, Ont.

Professional Photographers of Canada Inc., (est. 1947).

7P-1461 b&w 450, col. 399, total 849. 1969-1976.
Award-winning prints from the Annual Print Show of the
Professional Photographers of Canada Inc., 1969-1976.

Progressive Conservative Party of Canada, Ottawa, Ont., political party.

7P-1462 b&w 5,934. ca. 1942-1968.
Conventions of the Progressive Conservative Party of Canada;
activities and portraits of Hons. John Bracken, George A. Drew and
Rt. Hon. John G. Diefenbaker.

Propp, Daniel, Vancouver, B.C., photographer and teacher.

7P-1463 b&w 5. 1972.
Views around Vancouver, B.C., 1972; photographs by various
schoolchildren from Vancouver, B.C.

Proulx, Roger, Toronto, Ont.

7P-1464 Copies, b&w 58. [ca. 1896-1948].
Portraits and group photos of prominent Canadian hockey players,
teams and officials.

Provincial Archives of British Columbia, Victoria, B.C.

334P-9 Copies, b&w 354. ca. 1860-1933.
New Westminster Scenes: streets, buildings, churches, schools,
parks, monuments, general views; Events: May Day, Queen's
Birthday, sports, state visits, etc.; Portraits: sports and school
groups, May Queens, etc.; Misc.: Indians, ships, shipbuilding,
railroad, bridge construction.

Provincial Archives of New Brunswick, Fredericton, N.B., archives.

46P-1 b&w 25,000. 1860-1978.
Community life, buildings and street scenes; portraits; lumbering
activities; marine and land transport, particularly the carrying
trade; Miramichi, Fredericton, and the North Shore, N.B.

Provincial Archives of Newfoundland, St. John's, Nfld.

4P-1 Original, b&w 17,000. 1886-1978.
Views of daily life in Newfoundland; urban, rural and coastal communities; public buildings; personalities; industries and natural scenery; marine and land transport, including shipbuilding, shipping, fishing, whaling, sealing and railroad transport; early trans-Atlantic aviation; marine research; political and social events; photographs by Holloway Studios, James Vey, and S.H. Parsons et al.
Ref./Réf.: Subject card index.

Provincial Reference Library, St. John's, Nfld.

38P-9 b&w 16. 1955-1957.
Sir Archibald Nye (U.K. High Commissioner to Canada) during an official visit to Newfoundland (photos by *The Daily News,* St. John's); Government House annual garden party, August 1957, St. John's (U.S.A.F. photos); Government House annual garden party, 1955, Daily News photos.

Puccini, Abramo, (1873-1952), Toronto, Ont., manufacturer.

18P-92 Copies, b&w 7. 1908-1946.
Family portraits.

Pullen, Hugh Francis, (b. 1905), Halifax, N.S., naval officer and historian.

7P-1465 b&w 7. 1966.
Unveiling of Memorial in Halifax, N.S., to the officers and men of the U.S.S. *Chesapeake,* who died there following her battle with the *Shannon* in 1883.

Pullen, Thomas C., Ottawa, Ont.

7P-1466 Copies, b&w 4. ca. 1885-ca. 1890.
Main Street, Grenfell, Sask., ca. 1887; "Hope Farm" of Mr. Percy Skriuce near Grenfell, Sask., 1886; "Pixholme" farm, near Grenfell, Sask., 1886; Grenfell, Sask., ca. 1890.

Punch, Terrence, school teacher.

1P-73 Original, b&w 30. 1913-ca. 1955.
Innes family and house, Porter's Lake, N.S.; rowing race on Northwest Arm, Halifax N.S., Diamond Jubilee Regatta, 1927; Scout Company of the 63rd Regiment, 1916; Halifax Capitals baseball team, 1913-14.

Purvis, F., New Westminster, B.C.

334P-10 Copies, b&w 1. ca. 1910.
West End School.

Putnam, G.G., Vancouver, B.C., photographer.

7P-1467 b&w 1. 1939.
H.M. King George V and Queen Elizabeth at Hope, B.C., 31 May 1939; photo by G.G. Putnam.

Quebec and Lake St. John Railway Company, (f.1869), Quebec, Que.

18P-6 b&w 227. ca. 1880-ca. 1890.
Quebec and Lake St. John Railway equipment and views along routes, Saguenay River, Batiscan River, Lac Edouard, Tadoussac, Que.

Quebec Battlefields Association, (est. 1908), Ottawa, Ont., fund-raising organization.

7P-1468 b&w 2. 1908.
Visit of H.R.H. the Prince of Wales to St. Joachim, Que.; portrait of the Hon. S.N. Parent.

Queen's Hotel, (closed 1927), Toronto, Ont.

18P-19 Original, b&w 6. 1927.
Interiors, chiefly furnishings.

Queen's Own Rifles of Canada Trust Fund (The), (1954), Toronto, Ont., museum.

82P-1 b&w [350], col. [90], total [440]. 1860 to date.
Royalty and vice-royalty, British war notables, regimental memorials, groups and individuals, centennial photographs and misc.

Queen's University, (est. 1841), Kingston, Ont.

7P-1469 b&w 221. 1901; 1915-1949.
Views of Flin-Flon, Man.; 1915.

75P-10 b&w [2,000], col. [400], total [2,400]. ca. 1860-1976.
Individuals, buildings, classes, teams, associations and events.

Query, Frères, (ca. 1880-1930), Montréal (Québec), photographes.

113P-4 n.&b. 54. 1906.
Photos de la résidence d'été de Sir Rodolphe Forget à Saint-Irénée-les-bains, comté de Charlevoix.

Quick, Norman Charles, Ottawa, Ont., cinematographer.

7P-1470 b&w 53. ca. 1925-ca. 1967.
Aspects of the careers of Canadian motion picture cameramen C.J. and Norman C. Quick, including Norman Quick as a Canadian Army photographer and a National Film Baord photographer; personnel of the N.F.B. Still Photo Division, Ottawa, Ont.

Quipp, C.H., Mrs.

7P-1471 b&w 1. 1878.
Curling match on the St. Lawrence River, Montreal, Que., 1878; combination photograph by Notman and Sandham, Montreal, Que.

Quirt, Bessie, Orillia (Ont.).

7P-1472 Copies, n.&b. 9. ca. 1930.
Vues de Shingle Point Mission (T.N.-O.); et de Hay River (T.N.-O); école esquimaude, missionnaires anglicans enseignants aux Esquimaux.

R.H. Trueman and Company, Vancouver, Revelstoke, B.C., professional photographers.

166P-48 b&w 9. ca. 1895 to 1910.
Banff Springs Hotel; Banff townsite and surrounding area by R.H. Trueman and Company.

Rabin, Joseph, (1892-1968), Ottawa, Ont., cantor.

7P-1473 b&w 26. [1925-1967].
Activities of the Rabin family in Lithuania, in Kirkland Lake and in Ottawa, Ont.; activities of Congregation Adath Jeshuron, Ottawa, Ont.; portraits of Joseph Rabin.

Racicot, Vincent, Vernon, B.C.

7P-1474 b&w 8. ca. 1900.
Prospectors en route to Whitehorse, Yukon.

Racine, Marie-Paule, Hull, Que.

7P-1475 b&w 1. 1916.
View of Restigouche harbour, N.B.

Rackham, William, (b.1869).

9P-63 b&w 223. 1910-1925.
Photographs of Northern Manitoba.

Raddall, Thomas Head, (b. 1903), Liverpool, N.S., writer.

31P-18 Original, b&w [1,600], col. [5], total [1,605]. ca. 1900-1976.
Career of Raddall and his research on the *Titanic* Disaster, Grey Owl, gold mining in Nova Scotia, Sable Island, Fort Cumberland and Louisbourg, N.S., World War I, Raddall family, etc.

Rae, John, (1813-1893), physician and explorer.

7P-1476 b&w 1. 1889.
Portrait of Dr. John Rae, 1889.

Rafton-Canning, A., (fl. 1900-1914), Lethbridge, Alta., professional photographer.

11P-5 b&w 685. 1911-1912.
Negatives of agricultural scenes and events, Lethbridge area; fairs, industries, railroads, irrigation, personalities and events, Lethbridge and area; Blood Indians; Crowsnest Pass and Milk River region.

Ralston, James Layton, Hon., (1881-1948), ministre.

7P-1477 n.&b. 2,407. 1914-1944.
Ouverture de l'aéroport de New York (N.Y.), 1939; visite de l'Hon. J.L. Ralston dans des manufactures endommagées par un bombardement, Angleterre, ca. 1941; portraits de J.L. Ralston avec son épouse; portrait (ferrotype) de John Wimburne Laurie, photo prise par W.J. Notman.

Randall, Robert Cheetham, (n. 1908), Vancouver (C.-B.), aviateur.

7P-1478 n.&b. 54. ca. 1928-1956.
Robert C. Randall avec différents types d'avions de la Northern Airways, de la Mackenzie Air Service et de la Yukon Southern Air; le Waco 10, le Lockheed Lakestar et le Stinson SM-2AA Junior.

Rankin, Niall, London, England, professional photographer.

166P-42 Original, b&w 61. ca. 1935.
Original prints by Niall Rankin; scenery and skiing in the Skoki area of Banff National Park, ca. 1935.

Rasminsky, Louis, (n. 1908), Ottawa (Ont.), Gouverneur de la Banque du Canada.

7P-1479 Copies, n.&b. 81. [n.d.].
Différentes étapes dans la vie et la carrière de Louis Rasminsky à Ottawa (Ont.); en Italie et en Suisse; portraits de Louis Rasminsky.

Rassemblements acadiens, Maritimes,.

15P-5 n.&b. 500. 1905.
Evénements collectifs d'intérêt pour les Acadiens: congrès patriotiques et religieux, fêtes nationales, visites, voyages.

Rawson, Bernard Anderson, Capt., (b. 1907), Orange Park, Fla., aviator.

7P-1480 Copies, b&w 9. ca. 1932-1969.
Activities of Captain B.A. Rawson as pilot with Trans-Canada Air Lines and Canadian Pacific Airlines, 1938-1960.

Ray, Marcel, Toronto, Ont., musician and photographer.

7P-1481 b&w 42,276. 1954-1958.
Portraits of Canadian musical and artistic personalities, 1954-1958.

Rayfield, Victor C., Hamilton (Ont.), commis.

7P-1482 n.&b. 1. ca. 1935-1945.
Portrait du capitaine W.L. Rayfield, V.C.

Rea, (Hermanos), Cigar Factory, Toronto, Ont.

18P-50 Original, b&w 9. 1963.
Workers making cigars.

Reany, Meredith, London, Ont.

7P-1483 b&w 1. ca. 1921-1940.
Portrait of Agnes C. Macphail, M.P.

Redonda Bay, Redonda Bay, B.C.

12P-19 b&w 17. 1940-1969.
Views of logging and canning operations.

Reed, T.F. Harper, (1878-1965), B.C., surveyor, Indian agent.

12P-23 b&w 162. 1920-1960.
Views of Northern B.C. and Yukon, Dease Lake, Atlin, Liard River, Stikine, Teslin, and Telegraph Creek; Alaska-Canada Boundary Survey.

Reed, Thomas Arthur, (1871-1958), Toronto, Ont., historian of Toronto and collector.

18P-2 b&w 1281. 1857-ca. 1955.
Toronto buildings and scenes, some portraits.

Reford, Robert, Montreal, Que.

7P-1484 b&w 841. [1885-1890].
Views of the Canadian West; views of Fort Simpson, N.W.T.; Japanese immigrants on the West Coast; portraits of various individuals.

Regiment of Canadian Guards, (1953-1970), CFB Petawawa, Ont.

7P-1485 b&w 4020. 1954-1968.
Activities and personnel of the Regiment of Canadian Guards in Canada, West Germany and Cyprus, 1954-1968.

Reid, D. Smith, Moncton, N.B., photographer.

7P-1486 b&w 4. 1931.
Views of birthplace of Rt. Hon. R.B. Bennett, Hopewell Hill, N.B., November 1931; photos by Reid Studio.

Reid, Harold B., (d. 1977), Moncton, N.B., photographer and newsreel cameraman.

337P-3 Copies, b&w 91, col. 1, total 92. 1920-51.
Photographs of Southeastern New Brunswick including Greater Moncton Area and Shediac plus Military Units at Camp Sussex (Sussex, N.B.), ca. 1920-1951.

Reid, Robert Sutor, Ottawa (Ont.).

7P-1487 n.&b. 1. 1890.
Portrait du Baron Stanley of Preston, mars 1890.

Reid, Thomas Mayne, (1895-1954), Toronto, Ont., aviator and executive.

7P-1489 b&w 55. 1917-1952.
Activities of Mr. T.M. Reid as pilot with Ontario Provincial Air Service, Northern Aerial Mineral Explorations Co., and Imperial Oil Ltd.; Eskimos; portraits of Messrs. T.M. Reid, R. Reid and Sammy A. Tomlinson; views of Baker Lake, Chesterfield Inlet, N.W.T., Churchill, Man.

Reid, W. Harold, Rev., St. Andrews East, Que., clergyman.

7P-1490 b&w 79. 1917-1919.
Engine of the Carillon and Grenville Railway; wireless stations at Barrington and North Sydney, N.S., 1917-1919; activities of C.G.S. *J.A. McKee.*

Reid Studio, Moncton (N.-B.), studio de photographie.

7P-1275 n.&b. 4. 1931.
Lieu de naissance du Très Honorable Richard Bedford Bennett, Hopewell Hill (N.-B.), novembre 1931, photos Reid Studio, Moncton (N.-B.).

Reilly, John Hardisty, (b. 1921), St. Albert, Alta., aviator.

7P-1491 b&w 18, col. 5, total 23. 1939-1971.
Various types of military and commercial aircraft flown by Mr. J.H. Reilly; portraits of Mr. J.H. Reilly, Mrs. Molly Reilly.

Reinhardt, Carl, (1876-1962), surveyor and engineer.

7P-1492 b&w 55. 1899-1928.
Mining activity at Cobalt, Kirkland Lake, Silver Cliff, Cross Lake, Ont.; construction of the Canadian Northern Railway in the Rainy River District of Ontario; activities of Mr. Carl Reinhardt as surveyor and engineer; views of Montreal, Que.; Perth, Ont.; portraits of various members of the Reinhardt family.

Rempel, John I., (1905-), Toronto, Ont., Architect.

18P-13 Original, b&w 1453. ca. 1950-ca. 1965.
Illustrate types of buildings and construction methods and tools; chiefly nineteenth century Ontario.

Renaud, M.

7P-1493 b&w 1. [n.d.].
Grave of Grand Trunk Railway engineer Alonzo Dixon, who was killed at Windsor Station, Que., on Oct. 21, 1860.

Renaud, Osias, Sainte-Agathe, Que., photographer.

7P-1494 Copies, b&w 46. ca. 1890-ca. 1910.
Views in Sainte-Agathe, Que., and environs; portraits taken in the studio of Osias Renaud, Sainte-Agathe, Que.

Rennie, George, Kitchener, Ont.

7P-1495 b&w 2. ca. 1940-1943.
Portraits of Sergeant John Rennie, G.C.

Resource Rangers Leadership Training Camp, Albion Hills, Ont.

18P-74 Original, b&w 64. 1964.
Camp activities.

Rhodes, Edgar N., Ottawa, Ont., real estate and insurance executive.

7P-1496 b&w 2. 1904, 1916.
Temporary quarters of House of Commons after the fire of 1916; portrait of E.M. Rhodes, Premier of Nova Scotia, 1904.

Rhodes, Harold L., Vancouver, B.C.

7P-1498 Copies, b&w 1. 1942.
Wreckage of Blackburn Shark III aircraft 526 Fg:N of No. 7 (BR) Squadron, R.C.A.F., Prince Rupert, B.C., Sept. 3, 1942.

Rhodes, Henry G., (n. ca. 1911), Ottawa (Ont.).

7P-1497 n.&b. 5. 1945-1946.
Henry G. Rhodes s'adressant à un groupe de travailleurs; portraits de membres de la United Auto Workers, Ottawa (Ont.).

Rice, Lewis, Truro, Wolfville, and New Glasgow, N.S., photographer.

31P-93 Original, b&w 1. ca. 1885.
Carte-de-visite.

Rice, Margaret, Halifax, N.S.

31P-52 Original, b&w 10. ca. 1920.
Queens County, views.

Richard Ward, (d. 1977), Halifax, N.S., insurance agent.

31P-100 Original, b&w 4. 1943-1945.
Violist Richard Crooks, Bary Ensemble, and soprano Zinka Milanou.

Richardson, Arthur John Hampson, (b. 1916), Ottawa, Ont., public servant.

7P-1499 b&w 12. ca. 1870-1880.
Stereo views of Quebec, Montreal, Tadoussac, Que.; photos by William Notman, L.-P. Vallée, J.G. Parks.

Richardson, Bruce Harder, (1891-1971), Victoria, B.C., military officer.

7P-1500 b&w 9. 1859-1918.
Views of battlefields, France, from the air, 1917-18; No. 1
(Duchess of Westminster's) Red Cross Hospital, Le Touquet,
France, 1918; survivors of the War of 1812, Toronto, Ont., 1859;
portraits of Bruce Harder Richardson.

Richardson, Evelyn (Fox), (1902-1976), Bon Portage Island, N.S., author.

1P-93 Original, b&w [800], col. [20], total [820]. ca. 1890-1968.
Evelyn Fox Richardson, her family and friends; Emerald Isle, Shag
Harbour and Barrington, N.S.; Bon Portage Island and lighthouse;
N.S. and the activities of Evelyn Richardson's family on the island;
Bedford, N.S. and the Bedford Magazine explosion, 1945; boating
scenes.

Richardson, H.E., (1905-), East Kootenay area, B.C.

333P-13 Original, b&w 6. 1915-1930.
Windermere, B.C.; East Kootenay area, B.C.

Riddiford, Walter G., (d. 1951), London (Ont.), militaire et homme
d'église.

7P-1501 n.&b. 246. 1914-1918.
Participation canadienne à la première guerre mondiale:
cimetières, débarquement, embarquement, hôpitaux.

Rider-Rider, William, Barking, Essex, Angleterre, militaire et photographe.

7P-1502 n.&b. 249. 1917-1919.
Séries "O" du gouvernement canadien annotées par le Lieutenant
William Rider-Rider; portrait du Lieutenant William Rider-Rider.

Riel Rebellion, (1885).

9P-60 b&w 321. 1885.
Photographs of the North West Rebellion.
Provenance: Canadian Illustrated War News and Public Archives
of Canada.

Righton, C., (1905-), Kimberley, B.C. and Wildhorse Creek, B.C., miner.

333P-36 Original, b&w 3. 1900-1930.
Shay Logging Engine; North Star Mine House; Wildhorse Creek,
B.C.

Riley, Barbara, Ottawa (Ont.), fonctionnaire.

7P-1503 n.&b. 1. 1905-1912.
Vue de la résidence de Thomas Martin; photo prise par Andrew
Wilson.

Riley, John, Martin River, Ont., public servant.

7P-1504 b&w 13. ca. 1916.
Lumbering operations in Ontario; portrait of Mr. William MacKay;
view of Diver, Ont.

Riley, Marjorie, Ottawa, Ont.

7P-1505 b&w 28. 1885.
Views of Brandon, Man.

Rindisbacher, Peter, (1806-1834), artist.

9P-64 b&w 34. 1820's.
Photographs of his paintings of Hudson Bay and Red River
Settlement.

Rinehart, F.A., (fl. 1890's), Omaha, Neb., photographer.

9P-79 b&w 23. ca. 1898.
Portraits of Indians.

Rinfret, Bertha, Ottawa, Ont.

7P-1506 b&w 2. 1956.
Portraits of Bob Nandor and Yvon Robert, Ottawa, Ont., 1956.

Ritchie's Sport Shop, Ottawa (Ont.).

7P-1507 Copies, n.&b. 7. 1900-1925.
Photographie composite de l'équipe de hockey et de crosse
d'Ottawa (Ont.), photo de A.G. Pittaway.

Ritley family, Halifax, N.S.,.

31P-53 Original, b&w 10. ca. 1900-1940.
Ritley family history.

Roach, P.A., Windsor, N.S.

31P-54 Original, b&w 61. ca. 1900-1930.
Roach and Freeman families.

Robb Engineering Co. Ltd., (est. 1865), Amherst, N.S.

31P-67 b&w [375], col. 1, total [376]. ca. 1914-1965.
Robb construction projects throughout Eastern Canada, views of
the plant, catalogue photos, Robb family and views of Amherst,
N.S.

Robert Frank, (b. 1924), Mabou, N.S., photographer, film-maker.

123P-8 b&w 49. 1948-.
Portraits and places in the U.S.A.; photographs which appeared in
The Americans; San Francisco; New York city; Hoboken, New
Jersey; Beaufort, South Carolina; Chicago; St. Helena, South
Carolina; Hollywood, California; Los Angeles, California; New
Orleans, Louisiana; Bunker Hill, Los Angeles; Butte, Montana;
Ogallala and North Platte, Nebraska; Blackfoot, Idaho; Columbia,
South Carolina; Flagstaff, Arizona; Long Beach, Caifornia;
McClellanville, South Carolina; Sante Fé, New Mexico; Memphis,
Tennessee; Salt Lake City, Utah; Washington, D.C.; Del Rio le
Bell Isle, Detroit; photographs *not* published in *The Americans* in
N.G.C. collection: *Bastille,* Paris, 1950; *Woolworth, NYC, 1954,;
Paris 1949; London, 1952.*

Roberts, A.B., Ashton, Ont.

7P-1508 Copies, b&w 12. ca. 1870-ca. 1880.
Views of Ottawa, Niagara Falls, Ont., Quebec, Que., by W.J.
Topley.
Ref./Réf.: caption list.

Roberts, Joan.

7P-1509 b&w 3. [n.d.].
Group photo of students, Kings College, Windsor, N.S.; portrait of
Mr. T.G. Roberts.

Roberts, John A., Dr., (1860-1920), Cariboo, B.C., public transport, river steamers.

228P-1 b&w 6. 1862-1909.
River paddlewheel steamers *Enterprise*, 1862; *BX*, 1910; *BC Express*, 1920; *Chilcotin*, 1910; *Charlotte*, 1896; *Chilco* (renamed *Nechako*), 1909; *Victoria*, 1868.

Roberts, Marian, Wakefield, Que.

7P-1510 b&w 25. ca. 1900-1915.
International Marine Signal Co., Ottawa, Ont.; Ottawa Carbide Co., Lac Meach, Que.; portraits of Wilson family and of Rupert Brooke.

Roberts, Sir Charles George Douglas, (1860-1943), New Brunswick and Toronto, Ont., poet and novelist.

75P-15 b&w [400]. ca. 1890-1943.
Family photographs, friends, literary figures and homes.

Roberts, Vaughan Maurice, (1864-1941), Toronto, Ont., engineer.

18P-39 Original, b&w 68. 1913-1931.
Toronto waterfront and harbour.

Robertson, Anne S., Ottawa, Ont.

7P-1511 b&w 1. 1912.
Robert Borden and Wilfrid Laurier with members of Central Canada Exhibition Assn., Lansdowne Park, Ottawa, Ont., 1912, by G.B. Lancefield.

Robertson, Hugh B., Halifax, N.S., president of a wholesale hardware company.

1P-53 Copies, b&w 71. ca. 1934.
Album of buildings and other structures, mainly in Great Britain and France, and the construction of ocean terminals in Halifax, N.S.

Robertson, Hugh Shaw, Toronto, Ont.

196P-50 b&w 1. 1939.
50th Anniversary reunion dinner, class of 1889, University of Toronto, June 1939.

Robertson, John Ross, (1841-1918), Toronto, Ont., publisher and collector.

18P-1 b&w 1060. ca. 1860-1916.
Canadian sites, buildings, and portraits: chiefly Toronto.

18P-7 b&w 1202. ca. 1855-1918.
Canadian sites, buildings, portraits and monuments; most are coloured with water colour.

18P-11 Original, b&w 117. ca. 1900-ca. 1905.
Cities and buildings associated with John Graves Simcoe; chiefly Devon, Wolford, Honiton and Exeter.

18P-15 b&w 20. ca. 1900-1921.
Penetanguishene Tercentenary, 1921; Toronto and Canadian buildings and portraits.

18P-79 Original, b&w 19. ca. 1888.
Robertson's House in Toronto; Telegram (newspaper) building.

Robertson, Lois, Barrie, Ont.

7P-1512 Copies, b&w 2. 1882, ca. 1929.
View of the studios of Pittaway and Jarvis, photographers, Ottawa, Ont., 1882; portrait of Alfred G. Pittaway, ca. 1929.

Robertson, Melvin Norman Williams, (b. 1914), Burford, Ont., military officer and historian.

7P-1513 b&w 47. 1880-1942.
Opening of Brantford Airport, [1930]; view of Ford Tri-Motor, and Airship *R-100*, St. Hubert, Que., 1930; views and activities of No. 3 Initial Training School, R.C.A.F., Victoriaville, Que., 1942; James Young and pupils at Ethel Public School, Ethel, Ont., 1880; scenes in and around Burford, Ont., ca. 1905, 1920; portrait of Lt. W.J. Dalziel, R.F.C. Wapella, Sask.

Robertson, Peter David Williams, (1944-), Ottawa, Ont., public servant.

7P-1514 b&w 18, col. 3, total 21. 1948.
De Haviland Vampire III Aircraft of No. 54 Squadron R.A.F., following first Trans-Atlantic Jet Flight, R.C.A.F. station Goose Bay, Labrador.

Robertson, William & Son, Ltd., (est. 1871), Halifax, N.S., hardware merchant.

31P-70 Copies, b&w 12. ca. 1900-1960.
Company history.

Robinson, Benjamin, (1892-1968), Montréal (Québec), juge.

7P-1515 n.&b. 4, coul. 5, total 9. ca. 1920-1969.
Cérémonie d'investiture du juge Robinson à la Cour supérieur, Montréal (Québec), 1960; portraits du juge Benjamin Robinson.

Robson Lang Leathers Ltd., (est. 1865), Oshawa, Ont., tannery.

7P-1516 b&w 10. [1865-1963].
Views of plants of Robson Lang Leathers Ltd., in Kitchener and Oshawa, Ont.; portraits of Charles and James Robson.

Roebuck, H.A., North Bay, Ont.

7P-1517 b&w 9. 1865-1917.
Personnel of the 13th Royal Regiment of Hamilton, sent to Prescott, Ont., during May, 1865; placing of colours of various C.E.F. battalions in churches at Bramshott and Witley, England, ca. 1917.

Roebuck, John Arthur, (1801-1879), Angleterre, homme politique.

7P-1893 n.&b. 9. 1862-1863.
Lord F. Paulet et le personnel, Montréal (Québec), 1862; le Major-Général James Lindsay et le personnel, Montréal (Québec), 1863; photos de William Notman.

Rogers, Joseph S., Halifax, N.S., photographer.

1P-14 b&w 52. 1871.
Photograph album advertising Halifax businesses; Halifax stores, street scenes, public buildings and scenery.

Rogers, Marion G., Ottawa, Ont., historian and writer.

 7P-1518 b&w 74. 1885-1970.
 Portraits by Pittaway & Jarvis, Ottawa, Ont., Notman, Townend;
 churches in the Ottawa Valley, Ont., 1970; Billings Bridge, Ont.,
 flood, 1914; portraits of Carss family, of Christopher Chapman
 Rogers, Sara Ann Willis; view of Soldiers' Graves, Battleford,
 Sask., 1885; view of Band "The Serenaders", Ottawa, Ont., 1927.

Rohland, Terry, St. John's, Nfld.

 7P-1519 Copies, b&w 1. ca. 1930-ca. 1940.
 General 102-A Aristocrat aircraft CF-AL9.

Rolland, Roch, Saint-Ours, Que.

 7P-1520 b&w 1,036. ca. 1850-ca. 1890.
 Election meeting in Longueuil, Que., 1858; portraits of members of
 Kierzkowski, de Salaberry families, Saint-Ours, Que.

Romanet, Louis Auguste, (1880-1964), Edmonton, Alta., Hudson's Bay
Company Manager, fur trader, oil company agent.

 92P-21 b&w 860. [n.d.].
 Photographs collected by Louis Romanet for his book *Kabluk of
 the Eskimo,* mostly from the Department of Interior and from his
 friend, Gaston Herodier; photographs of transportation and the fur
 trade in the Mackenzie River system were taken by Louis Romanet
 and other Hudson's Bay Company employees.
 Ref./Réf.: "A Guide to the Papers of Louis Auguste Romanet,
 1890's, 1900-45." University of Alberta Archives, Winter, 1975.

Romkey, G.E. & Co., West Dublin, N.S.

 31P-80 b&w 1. 1895.
 Drying fish at West Dublin, N.S.

Rood, James Lindsay, (b. 1911), Lachine, Que., aviator.

 7P-1521 b&w 12. [n.d.].
 Portraits of J.L. Rood.

Roome, Richard Edward Graham, (b. 1892), Halifax, N.S., army officer.

 31P-24 Original, b&w 275. ca. 1914-1970.
 Career of Brigadier R.E.G. Roome, including the Mesopotamian
 Campaign, World War I.

Roosevelt, Theodore, (1858-1919), President of the United States.

 7P-1522 b&w 1. 1904.
 Portrait of President Theodore Roosevelt presented to Dr. A.G.
 Doughty, Dominion Archivist, in 1907.

Roper, M. Carol, Halifax, N.S., school teacher.

 1P-74 Original, b&w [100]. 1901-1955.
 Shipbuilding at Industrial Shipping Co., Mahone Bay, N.S.;
 portraits of various individuals, mainly from Halifax; Lunenburg
 harbour, N.S.; buildings and harbour views, Halifax and
 Dartmouth, N.S.; students at Halifax Academy and Dalhousie
 University, Halifax, N.S.; photographers: J.E. Knickle, Gauvin and
 Gentzell, Harry J. Moss, Notman, J.C.M. Hayward, Sponagle,
 Graham.

Roscoe, Peter, Winnipeg (Man.).

 7P-1523 Copies, n.&b. 2. 1901-1924.
 Portraits de la famille Roscoe.
 Ref./Réf.: Biographie par Dr. V.J. Kaye.

Roseberg, Louis, (b. 1893), Montreal, Que., sociologist, demographer.

 7P-1524 Original, b&w 1,224. 1910-1965.
 Louis Rosenberg, his family and friends; Jewish colonization in
 Western Canada, 1910-1940; Jewish community life in Lipton,
 Edenbridge, Regina, Sask., Narcisse, Sommerfeld, Man.;
 Co-operative Commonwealth Federation meeting, Calgary, Alta.,
 1931.

Rosenberg, Stuart E., (b. 1922), Toronto, Ont., rabbi and author.

 7P-1525 b&w 660, col. 65, total 725. ca. 1950-1970.
 Professional activities and career of Stuart Rosenberg; portraits of
 Dr. Rosenberg, Toronto, Ont.

Rosenblatt, Joe, (b. 1933), Toronto, Ont., poet, artist.

 7P-1526 b&w 1, col. 1, total 2. [1960-1970].
 Portraits of Milton Acorn and Joe Rosenblatt.

Rosewarne, Robert Victor, (1925-1974), Ottawa, Ont., public servant.

 7P-1527 b&w 17. [1860-1880's].
 Views of Parliament buildings and Rideau Hall, Ottawa, Ont., by
 Samuel McLaughlin.

Ross, Alexander, (1843-ca. 1940), Pictou, N.S., teacher.

 31P-22 Original, b&w 5. ca. 1868-1900.
 Portraits of A. Ross.

Ross, Douglas H., (1920-), Waldo, B.C. and Cranbrook, B.C., forester.

 333P-9 Copies, b&w 24. 1912-1935.
 Logging, Waldo, B.C. and Cranbrook, B.C.; woodburning shay
 engine; Crowsnest Landing, Waldo, B.C.

Ross, Eli M., Winnipeg, Man., investment manager.

 7P-1529 Copies, b&w 4. 1944.
 Collision damage to Boeing Fortress II A aircraft 9205 of No. 168
 (NT) Squadron, R.C.A.F., Predamack, Cornwall, Jan. 22, 1944;
 portrait of F/OS H.P. Hillcoat and E.M. Rosenbaum, No. 168
 (HT) Squadron, R.C.A.F.

Ross, Graham, Montréal (Québec), médecin.

 7P-1530 n.&b. 1. 1919.
 Portrait du docteur Norman Bethune accompagné d'associés à
 «Hospital for Sick Children», Londres, Angleterre.

Ross, W. Lawlor, Ottawa, Ont., public servant.

 7P-1531 Copies, b&w 2. ca. 1884-1921.
 Ottawa River steamers *Glide* and *Benito,* Calumet, Que.

Rossland, B.C.

 110P-1 b&w [1,900]. 1895-1976.
 Mines of Rossland; City of Rossland and surrounding area; sports
 activities in Rossland; group pictures, miners, families, picnics, etc.;

Rossland, B.C.
(Cont'd/Suite)

Rossland fire scenes; underground photos; school pictures; buildings of Rossland; general views.

Rossland, B.C. - Mines, Rossland, B.C.

7P-1532 b&w 11. 1895-1900.
Activity at the Le Roy, California Centre Star, War Eagle and Southern Star Mines, Rossland, B.C.

Roth, Michael M.

7P-1533 b&w 93. 1945.
Forced march of allied prisoners of war through Northern Germany April-May, 1945.

Rourke, James Ernest, Ottawa, Ont.

7P-1534 b&w 103. ca. 1900-1914.
Views along the route of the Canadian Pacific Railway through British Columbia; various battleships and cruisers of the Imperial Japanese Navy.

Rove, William, (1880-1970), Halifax, N.S., naval architect.

31P-5 Original, b&w 23. ca. 1930-1960.
Ships and shipbuilding, including a photograph of the *Bluenose.*

Rowe, J.Y., Qualicum Beach (C.-B).

7P-1535 n.&b. 1. ca. 1870-1880.
Maisons de la rue Augusta, Ottawa (Ont.); photo prise par W.J. Topley.

Roxborough, Myrtle, Ottawa, Ont.

7P-1536 b&w 1. 1937.
View of the Wellington-Elgin street area, Ottawa, Ont., 1937.

Roy, Anastase.

7P-1537 b&w 1. ca. 1874-1884.
Portrait of Chief Packinawatick, Maniwaki, Que.; photo by Anastase Roy.

Roy, Arthur, Hull, Que., photographer.

7P-1538 b&w 524. 1948-1949.
View of negotiations concerning entry of Newfoundland into Confederation, House of Commons, Ottawa, Ont., Oct. 6, 1948, by A. Roy, Hull, Que.; portraits of senators and Members of Parliament of the 21st Parliament, Ottawa, Ont., 1949, by A. Roy, Hull, Que.

Royal Canadian Academy of Arts, (est. 1880), Toronto, Ont.

7P-1539 b&w [90]. ca. 1880-ca. 1950.
Portraits of Hanging Committees for Royal Canadian Academy of Arts exhibitions, 1880, 1885; views of the Grange, Toronto, of exhibition at Art Museum of Toronto, 1918, by James and Son, Toronto, Ont.; views of galleries and exhibitions, portraits of art personalities, ca. 1910-1950.
Ref./Réf.: Partial Caption List.

Royal Canadian Corps of Signals Museum, Kingston, Ont.

7P-1540 b&w 4. 1914-1918.
The operations room, Canadian Corps Head Quarters, France, 16 May 1917; activities of the Royal Canadian Corps of Signals, France, 1914-1918.
Provenance: RCCS Museum, Vimy Barracks, Kingston, Ont.

7P-1975 b&w 24. 1903-1965.
Dawson, Y.T., 1903; panoramic view by Adams and Larkin; broadcasting station CHAK, Aklavik, N.W.T., ca. 1950-1959; Royal Canadian Corps of Signals station, Alert, N.W.T., ca. 1960-1965.

Royal Canadian Mounted Police Museum, Regina, Sask.

7P-1541 b&w 71. 1918-1919.
Activities and personnel of the Canadian Expeditionary Force (Siberia); views of Vladivostok, Siberia, 1918-1919.

Royal Engineers (Institution of the), Chatham, Angleterre.

7P-1542 Copies, n.&b. 80. 1860-1862.
Tracé du 49e parallèle en Colombie-Britannique et à Washington, É.-U.; photos prises par le Corps of Royal Engineers.

Royal Photo Service, St. John's, Nfld.

38P-10 b&w 26. ca. 1967.
A collection of photographs of the Gosling Memorial Library, St. John's; scenes of the library; dignitaries and events at the official closing of the building in 1967.

Royal Society of Canada, Ottawa, Ont.

7P-1543 b&w 1. 1971.
Portrait of Dr. H.E. Duckworth, President, Royal Society of Canada, 1971.

Royal Tour of 1860.

7P-1544 b&w 1. 1860.
H.R.H. the Prince of Wales and suite, Montreal, Que., 29 August 1860; photo by William Notman.

Royal Tour of 1901.

7P-1545 b&w 1. 1901.
Arrival of the Duke and Duchess of Cornwall and York at Hamilton, Ont.
Provenance: Estate of Sir Arthur Doughty.

Royal Tour of 1919.

7P-1546 b&w 236. 1919.
Visit of Canada of H.R.H. the Prince of Wales, 1919.
Ref./Réf.: List of Captions.

Royick, Alexander, Saskatoon, Sask., author.

7P-1547 b&w 2. [n.d.].
Portraits of Roderick and Sophia Horetzsky.

Rozmus, Karol, (1893-1969), Calgary, Alta., miner, farmer.

7P-1528 b&w 1. 1920.
View of Mr. Karol Rozmus in his automobile, Alta., 1920.

Rudisill, Richard, Albuquerque, N.M., historian.

　　7P-1548　Copies, col. 3. [n.d.].
　　Photos by Notman, Boorne, May, and William Birrell.

Rupert's Land Collection.

　　9P-66　b&w 198. 1912-1922.
　　Photographs of Anglican Missions and Churches in Manitoba.

Rushton, Ernest.

　　334P-21　Copies, b&w 5. ca. 1920-1925.
　　Lumber yard machinery; automobile; Iron Works Band.

Russel, J.H.G., (1862-1946), Winnipeg, Man., architect.

　　9P-65　b&w 118. ca. 1906-ca. 1920.
　　Photographs of Winnipeg business blocks, homes and churches.

Russell, Robert, Toronto, Ont.

　　7P-1549　b&w 326. 1855-1920.
　　Views of Salmon Arm and Union Bay, B.C.; Shipka, Crediton,
　　Jackson Point, Iroquois, Ont.; portrait of Mr. Edward Hanlan;
　　activities of the Traill family.

Russell Studio, (ca. 1907), Victoria, B.C., photographers.

　　334P-8　Copies, b&w 1. 1908.
　　B.C. Manufacturing baseball team.

Rutherford, Robert William, Capt., (1857-1928), Kingston, Ont., military
officer.

　　7P-1550　b&w 1. 1891.
　　Christmas card showing Captains R.W. Rutherford and W.E. Imlah
　　of "B" Battery, Regiment of Canadian Artillery, Kingston, Ont.,
　　December 1891.

Ruttan, H., Fort Steele, B.C.

　　333P-26　Original, b&w 7. 1895-1905.
　　Fort Steele, B.C. and people.

Ryan, James, Victoria, B.C., photographer.

　　7P-1551　b&w [95,030]. ca. 1960-1972.
　　Views of Victoria, B.C., and of B.C. politics and political figures;
　　photos by Jim Ryan.

Ryan, Patrick, Buckingham, Que.

　　7P-1552　b&w 49. 1870-1922.
　　Views of Buckingham and Masson, Que.; aftermath of landslides
　　at Notre-Dame-de-la-Salette, Que., 1903; strike at Buckingham,
　　Que., 1906.

Ryerson Polytechnical Institute, (1948), Toronto, Ont., education.

　　307P-1　b&w [1,000]. 1950-1962.
　　Activities of students and faculty connected with the Institute when
　　it was known as the Ryerson Institute of Technology; about 300
　　sundry photos scattered through general files.

Sadlier-Brown, Nowell, (b. 1908), Blind Bay, B.C., collector.

　　7P-1559　b&w 1. ca. 1860-1870.
　　Portrait of Mr. James Yould, Kentville, Que.

Saint Andrew's United Church, Peterborough, Ont.

　　7P-1553　b&w 1. ca. 1869.
　　View of St. Andrew's Presbyterian Church and Manse,
　　Peterborough, Ont.

Saint-Charles, Joseph, (1868-1956), peintre.

　　185P-13　n.&b. 167. 1880-1945.
　　Négatifs sur verre et photographies de l'homme, de sa famille, de
　　ses amis ainsi que de ses oeuvres, prises au Canada et en Europe;
　　des images de paysages et paysans d'Italie et de France dans les
　　années 1890.

Saint John Regional Library, Saint John, N.B.

　　7P-1555　Original, b&w 80. ca. 1895-1915.
　　Scenics taken across Canada, some of which were for the CPR.

St. John's Convent, Willowdale, Ont.

　　7P-1554　Copies, b&w 2. 1885.
　　Soldiers convalescing after the Northwest Rebellion at the hospital
　　of the Order of St. John The Divine, Moose Jaw, Sask.; portrait of
　　the Mother Foundress of the Order of St. John the Divine.

St. Laurent, Louis Stephen, (1882-1973), Quebec, Que., Prime Minister of
Canada 1948-1957.

　　7P-1556　b&w 6,916. ca. 1875-1963.
　　Portrait of Rt. Hon. Louis St. Laurent with Laurier cane, Ottawa,
　　Ont. 1948; photo by Bill and Jean Newton; photographs of Louis
　　St. Laurent, his family, his teachers, St. Charles Seminary in
　　Sherbrooke, Que., his wife and children, family homes, his public
　　life from 1942-1957, visits and events, his private life, wedding,
　　and family pictures.

St. Laurent, William, (1845-1890), Quebec, Que., commercial agent.

　　7P-1557　b&w 4. ca. 1879-1881.
　　Aspects of Mr. William St. Laurent's visit to Russia, ca. 1879-1881.

St. Lawrence Seaway Authority, Montreal, Que.; Ottawa, Ont.

　　7P-1558　b&w 30,701. 1894-1966.
　　Views of the Sault Ste. Marie Canal, Ont., ca. 1894; views of the
　　Welland Canal, Ont., ca. 1927-1940; ice conditions on the Niagara
　　River, Ont., 1924-1925; aspects of the construction of the St.
　　Lawrence Seaway; Ont. and Que., 1954-1966.

St. Michael's College, (1852-), Toronto, Ont., education.

　　200P-6　Original, b&w 3. 1934.
　　Three snapshots taken at Windsor in 1934 showing Cardinal
　　Villeneuve and Rev. James Donlon, of Assumption College.
　　Ref./Réf.: Table of contents for the scrapbook.

　　200P-10　Original, b&w 384. 1944-1947.
　　Snapshots and photographs of students and students activities at
　　St. Michael's College, Loretto College and St. Joseph's College,
　　Toronto, Ont.

St. Michael's Hospital Archives, (est. 1892), Toronto, Ont.

318P-1 Original, b&w [500]. 1892-.
Exteriors and interior of hospital building; clinical teaching of student nurses; graduates of nursing school, staff members.

Saint Patrick's Band, (est. 1873), Halifax, N.S.

31P-55 Original, b&w 1. 1898.
Band members.

Saint-Pierre, Maurice, Collection, Bromptonville (Québec).

347P-1 n.&b. 26. ca. 1910-1930.
Photos publicitaires ayant appartenu à la Brompton Lumber and Manufacturing Co. montrant des édifices construits ou en construction au moyen de produits de la compagnie.

St. Stephen's-in-the-Fields Anglican Church, (f. 1858), Toronto, Ont.

18P-91 Original, b&w 8. 1895-1896.
Young men's bible class at Beaver Dams Camp, Ont.

Sair, Samuel, (1905-1973), Winnipeg, Man., businessman.

7P-1560 b&w 1. 1965.
Portrait of Mr. Samuel Sair, Winnipeg, Man., 1965.

Sallows, Reuben R., Ottawa, Ont., public servant.

7P-1561 Original, b&w 42. ca. 1856, 1900-1910.
Views of Goderich, Ont.

Salmon, James Victor, (1911-1958), Toronto, Ont., businessman and amateur photographer.

18P-12 b&w [13,000]. 1950-1958, ca. 1870-1950.
Toronto sites and buildings; Toronto Public Transportation vehicles; suburban development in Etobicoke, North York and York boroughs.

Salton, George F., Ottawa, Ont., public servant.

7P-1562 Original, b&w 19. ca. 1865-1875.
Cartes de visite; portrait of Mgr. Ignace Bourget; photos by Desmarais, Archambault, Côté and Livernois.

Sandler, Martin W., Newton (Mass.).

7P-1563 Originaux, n.&b. 14. ca. 1900-1910.
Vues de Montréal et de Québec (Québec); de l'église méthodiste Saint-Jacques et de l'église Notre-Dame, Montréal (Québec); du monument Strathcona Horse au Carré Dominion, Montréal (Québec); photos d'immigrants dans les plaines des Etats-Unis, ca. 1900 et dans les villes des Etats-Unis, ca. 1900; photos prises par le docteur Thomas S. Bronson de Montréal (Québec).

Sanson, Norman B., (1862-1949), Banff, Alta., meteorologist and museum curator.

166P-2 b&w [8,000]. 1890-1949.
Banff people, events and buildings; views of Banff townsite and surrounding area, 1890-1945; snowshoe trips, horse trips and hikes in Banff National Park, 1920-1945; snow surveys and scientific trips; flora and fauna of the mountain areas; Kootenay and Waterton National Parks; Calgary-Cochrane area; Alpine Club of Canada climbs and camps, 1917-1940; British and European homes, schools and churches.

Sardinian (Ship), (built 1877), Quebec, Que.

31P-112 Copies, b&w 1. 1896.
Sardinian at Liverpool, N.S.

Sarrault, Henri, Fort Smith, N.W.T., priest.

7P-1564 Copies, b&w 5. 1921-1935.
Junkers aircraft G - CADP "Vic" and G - CADQ "Rene" of Imperial Oil Co., Fort Providence, N.W.T.

Sasaki, Steve, Vancouver, B.C.

7P-1565 Original, b&w 1. ca. 1943.
Tashme B.C. over flow camp, a non-denominational camp.

Saskatchewan, Department of Agriculture, Regina, Sask.

10P-2 Original, b&w [815]. ca. 1905-1930.
Agricultural machinery, farming operations, farm animals, farm scenes, fields of grain, grain exhibits, logging, exhibits, better farming trains, automobiles, towns, cities, bridges and ferries, grain elevators, Government House, Legislative building, University of Saskatchewan buildings, school buildings, Department of Agriculture officials, premiers, members of the Legislative Assembly, Indians.

Saskatchewan, Department of Agriculture, Livestock Branch, Regina, Sask.

10P-3 Original, b&w 30. ca. 1920-1942.
Cattle, horses, agricultural subjects.

Saskatchewan, Department of Education, Regina, Sask.

10P-6 Original, b&w [200]. ca. 1904-1928.
School officials, teachers, school buildings, classrooms, University of Saskatchewan buildings, grain, Dr. Charles Saunders, Edward VIII as Prince of Wales, Boy Scouts.

Saskatchewan, Department of Highways, Regina, Sask.

10P-4 Original, b&w [350]. ca. 1907-1926.
Road and highway construction, road making machinery, bridges and culverts, irrigation and drainage ditches, rivers and creeks, towns and cities, animals.

Saskatchewan, Department of Highways, Ferry Branch, Regina, Sask.

10P-5 Original, b&w [1185]. 1914-1937.
Ferries, roads, and bridges.

Saskatchewan, Photographic Art Services, Regina, Sask.

10P-7 Original, b&w [12,500]. ca. 1946-1962.
Government officials, members of the Legislative Assembly, official openings, royal visits, urban and rural events, cities, towns, communities, Saskatchewan scenery, buildings, industrial activities, agricultural activites.

Saskatchewan Archives, Regina, Sask.

7P-1566 b&w 21. 1878-ca. 1925.
Bar room interiors of Windsor Hotel in Saskatoon and Zimmerman Hotel in Radisson, Sask.; Indian Council Assiniboines near Fort Walsh, Prince Albert, Sask.; Lacrosse team, hockey at Radville, Sask.; entrance of Saskatchewan to Confederation 1905; Inauguration ceremonies, views of Regina, portraits; arrival of Barr Colonists, Saskatoon, Sask.; portraits of Rev. Isaac M. Barr and

Saskatchewan Archives, Regina, Sask.
 (Cont'd/Suite)

 Associates, Count Paul O. D'Esterhazy.

Saskatchewan Wheat Pool, (est. 1924), Regina, Sask., a farmers'
co-operative organization for marketing grain.

 10P-12 Original, b&w [1,500], col. 20, total [1,520]. ca. 1907-1967.
 Agricultural operations, agricultural machinery, farming scenes,
 grain elevators, Wheat Pool officials, delegates to conventions,
 On-to-Ottawa treks, 1942 and 1959.

Sault Ste. Marie and 49th Field Regiment R.C.A. Historical Society,
 (1952-), Sault Ste. Marie, Ont.

 121P-1 b&w [3500]. 1880-1929.
 Construction of ship canal; Paper Co., Algoma Steel, street scenes;
 schools, hotels, churches, buildings, etc.; pioneers (local) of Sault
 Ste. Marie or area.

Saunders, Charles E., (1867-1937), Ottawa (Ont.), chimiste et céréaliste du
dominion.

 7P-1568 n.&b. 7. ca. 1900-1915.
 Photos d'un champ de céréales et d'un laboratoire; portrait de Dr.
 Charles E. Saunders.

Saunders, Sylvia, Toronto, Ont.

 196P-37 b&w 1. 1890.
 University of Toronto Graduation class 1890.

Sauvageau, Alain, Cap-de-la-Madeleine (Québec).

 351P-1 total [1,000]. 1893 à nos jours.
 Photographies appartenant à la famille de Juliette Hart et Béatrice
 Hart Gilbert.

Sauve, Maurice, (b. 1923), Ottawa, Ont., cabinet minister.

 7P-1569 b&w 1. ca. 1908-1918.
 Group photo of Liberal Party Workers in Quebec, ca. 1908-1918.

Savage, John A., Mrs., Haverhill, Mass.

 7P-1570 b&w 161. 1918-1920.
 Mineral exploration in and around Fort Chimo, Que.; Cape Dorset,
 Lake Harbour, Port Burwell, Baker Lake, N.W.T.

Savage, Marion Creelman, (1886-1975), Montreal, Que.

 7P-1571 b&w 3. ca. 1875-1925.
 Portraits of Maggie Jennings, Isabel and Marion Creelman; photos
 by W.A. Cooper, W.H. Burgess.

Scadding, Henry, (1813-1901), Toronto, Ont., Anglican clergyman.

 196P-15 b&w [500]. 1860-1890.
 Views of British and German historic sites and pictures of royalty,
 views of Toronto (ca. 1870) and pictures of Canadian notables.

Scarth, Marion and Jessie, Ottawa, Ont.

 7P-1572 b&w 1. [n.d.].
 Portrait of Mrs. W.B. Scarth.

Schleyer, George W., Fredericton, N.B., photographer.

 31P-94 b&w 1. 1881.
 Carte-de-visite.

Schmalz, William Henry Eugene, Kitchener, Ont.

 7P-1573 b&w 2. 1900-1910.
 Skating rink on Gaukel Street decorated for a Kermesse, Berlin,
 Ont.; portrait of Louise and Martha Oelschlager.

Schneider, Stuart, Teaneck, N.J.

 7P-1574 b&w 1. 1891.
 View of St. John's, Nfld., 1891; photo by S.H. Parsons.

Schull, Joseph, Saint-Eustache-sur-le-lac, Que., author.

 7P-1575 b&w 1. 1907.
 Sir Wilfrid and Lady Laurier at Colonial Conference, London,
 England, 1907.

Schuster, Nigel, Edinburgh, Scotland, naval officer.

 7P-1576 b&w 100. 1898.
 Photographs of the Yukon taken by Mr. Edward Bruce while
 prospecting for gold in 1898.

Scollard, Robert Joseph, (1908-), Toronto, Ont., priest, librarian archivist.

 200P-7 Original, b&w 10. 1870-1931.
 Snapshots of novices at St. Basil's Novitiate, Toronto, 1927-1931;
 one unidentified portrait of a priest by Notman and Fraser, [1870];
 two portraits of priest, one by Freeland, Toronto, the other by
 Lyonde, Toronto.

Scott, Desiré Elise, Ottawa, Ont.

 7P-1577 b&w 1. 1943.
 Portrait of Dr. Duncan Campbell Scott, Ottawa, Ont., 1943; photo
 by Karsh.

Scott, Duncan Campbell, (1862-1947), Ottawa, Ont., civil servant and poet.

 196P-16 b&w 40. 1875-ca. 1945.
 Photos of Scott at all stages of his career; includes some snapshots
 of Scott with such other poets as Alfred Noyes, Rupert Brooke and
 Sir Charles G.D. Roberts; one portrait signed Karsh; several are by
 M.O. Hammond.

Scott, E.B.

 12P-14 b&w 50. 1900-1915.
 Logging on Vancouver Island; Jordan River Lumber Co.,
 Michiganpuget Sound Lumber Co., Victoria, B.C.

Scott, George T, Hespeler, Ont., military officer.

 7P-1578 b&w 22. 1917-1918.
 Aircraft and airships of the R.N.A.S. and R.A.F. in Britain and
 France, 1917-1918.

Scott, Lloyd E.W., (1911-1968), Toronto, Ont., commercial artist.

 7P-1579 Original, b&w 1,173, col. 178 total 1,351. 1902-1965.
 Family photos of Mr. Lloyd Scott; trips taken by Mr. Scott to
 Labrador and Newfoundland 1953, 1960's, views of Beaverton,

Scott, Lloyd E.W., (1911-1968), Toronto, Ont., commercial artist. (Cont'd/Suite)

Ont., in mid 1960's and of Lake Simcoe, Ont.; public school, Ralla, N.D., May 5, 1902; photos by Pasonault; portraits of officers of the Dramatic Society, Brandon Collegiate Institute, Brandon, Man., 1927-1928.

Scott, W.L., Ottawa, Ont.

7P-1581 b&w 37. ca. 1886-ca. 1912.
Scenes in Trappist Monastery, Oka, Que., including portrait of Dom Anthony, Abbot; some photos by Mallette and Gordon, Montreal, Que.; scenes of skiers, cyclists, campers, picnickers and outings on the Ottawa, River, Ont., on Stone Island near Gananoque, Ont., and area; portraits of Scott family, Ottawa, Ont., by Topley, others by S.J. Jarvis, residents of Brockville, Prescott, Ont.; flashlight photograph of Ottawa Amateur Orchestral Society, 1898 by S.J. Jarvis; view of aftermath of fire, St. John's, Nfld., 1892; members of Ottawa Lawn Tennis Club, Ont.; Sir Wilfrid Laurier and others at Eucharistic Congress, Montreal, Que., 1910; inaugural meeting of Ontario Children's Aid Society, Toronto, Ont., 1912.

Scott, William D., Ottawa, Ont., public servant.

7P-1580 b&w 202. ca. 1913.
Views of cities and towns in New Brunswick, Quebec, Ontario, Manitoba, Saskatchewan, Alberta and British Columbia.

Scott Paper Co., (1924-1972), Sheet Harbour, N.S.

31P-74 b&w 23. 1930-1956, 1963.
Scott Paper plant at Sheet Harbour, N.S., 1930, 1963; Sheet Harbour flood, Jan. 7, 1956.

Scribner's Sons, Charles, New York, N.Y.

7P-1582 Original, b&w 4. [n.d.].
Views of Ashcroft, B.C., Digby, N.S., Indians fishing in rapids, Sault Ste-Marie, Ont., camp on Emerald Summit Lake, Rockies; photo by E.D. Whymper.

Sculptors Society of Canada, (est. 1931), Toronto, Ont.

7P-1583 Original, b&w 290, col. 18, total 308. ca. 1930-1960.
Sculptors and sculptures of Frances Loring, Florence Wyle, Emmanuel Hahn, Eliz. Wynn Wood, Henri Hébert, Alfred Laliberté.

Seagrim, Herbert Walter, (b. 1912), Montreal, Que., aviator.

7P-1584 Copies, b&w 19. ca. 1935-1970.
Seagrim with Wings Ltd., 1934-37; Seagrim flying Boeing 707 and DC 8, ca. 1960-66; portraits of H.W. Seagrim.

Seaner, N.B., Ottawa, Ont.

7P-1585 Original, b&w 5. ca. 1870-1930's.
Views of the West Block, Parliament Buildings, Ottawa, Ont.; Ottawa Hockey Club, 1891-1892; Lacrosse team; former Ottawa hockey players.

Segwun Steamship Museum, Gravenhurst, Ont.

8P-3 b&w [1,300]. ca. 1885-1969.
Views of steamships and steamboats; *Muskoka, Kahshe, Kawartha, Huntsville Lakes* and *Lake of Bays;* Lakes Nipissing, Simcoe, Timagami, Temiscamingue, Magnetawan, Montreal, Pickerel Rivers and *Georgian Bay.*

Seleshko, Matthew, (b. 1893), Toronto, Ont., community worker.

7P-1587 Original, b&w 4602. 1945-1965.
Activities of the Ukrainian community in the Toronto area; photos by Mr. M. Seleshko; Kozak Ukrainian Rest Camp, near Toronto, Ont., 1958; visit of General Myron Kapustiansky; 60th anniversary of Ukrainian settlement in Canada, Winnipeg, Man., 1951; Ukrainian National Federation Camp at Acton, Ont., 1958.

Sellar, Robert Watson, (1894-1965), Ottawa, Ont., public servant.

7P-1586 b&w 16. 1860-1900.
Views of Huntingdon, Que.; group photos of various organizations, Huntingdon, Que.

Semak, Michael, (n. ca. 1934), Pickering (Ont.), photographe.

7P-1588 n.&b. 44. ca. 1971.
Photos et portraits artistiques du photographe Michael Semak.

Séminaire de Nicolet, (1803), Nicolet (Québec).

324P-1 n.&b. [6,650], coul. [3,350], total [10,000]. ca. 1850 à nos jours.
Ferrotypes, daguerréotypes, stéréogrammes et photos diverses illustrant la vie quotidienne au séminaire de Nicolet.

Seymour, Horace L., Ottawa, Ont.

7P-1589 Copies, b&w 25. 1920-1940.
Views of Ottawa, Ont., and Montreal, Que.

Seymour, Murton Adams, (1892-1977), St. Catharines, Ont., aviator.

7P-1590 Copies, b&w 10. [1914-1940].
Seymour with Curtiss biplane in Vancouver, B.C.; views of Curtiss JN4 Jenny aircraft; portraits of of Murton A. Seymour.

Shaw, Edith, Ottawa, Ont.

7P-1591 b&w 1. ca. 1919-1932.
Portrait of Sir Henry Thornton.

Shaw, Nell, Burford, Ont.

7P-1593 b&w 2. ca. 1900-ca. 1903.
Pupils of Upper Canada College after pillowfight, Toronto, Ont., March 1902; portrait of Master W.G.A. Shaw.

Shaw, Nellie, Fordingbridge, Hants, England.

7P-1594 b&w 1. ca. 1915.
Portrait of Corporal J.H. Tombs, V.C.

Shaw Festival Theatre, Niagara-on-the-Lake, Ont.

7P-1592 b&w 30. 1976.
Scenes from the plays *Mrs. Warren's Profession, The Apple Cart, The Admirable Crichton* and *Arms and the Man,* Shaw Festival Theatre, Niagara-on-the-Lake, Ont., 1976; photos by Robert C. Ragsdale.

Shenston, Thomas Strachan, (1822-1895), Woodstock and Brantford, Ont., author and local official.

18P-42 b&w 35. ca. 1865-1871.
Brantford Orphans' Home, staff and inmates.

Shenstone, Beverley Strahan, (b. 1906), Kyrenia, Cyprus, aeronautical engineer.

7P-1595 Copies, b&w 34. 1928-1929.
R.C.A.F. aircraft and operations, Camp Borden, Ont.; aircraft display, Canadian National Exhibition, Toronto, Ont.

Shepherd, R.W., Como, Que.

7P-1596 b&w 8. 1860-1913.
Various steamships of the Ottawa River Navigation Company.

Shepherd, R.W., Mrs., Como, Que.

7P-1597 b&w 72. ca. 1890-1905.
Views by Mr. Robin Gray of Montreal, Que., and Iroquois, Ont.

Sheriffs, A.J., Hubbards, N.S.

7P-1598 Original, b&w 33. ca. 1860-1932.
Tintypes and cartes-de-visite of unidentified residents of N.S.

Sherry, Agnes B., Ottawa, Ont.

7P-1599 b&w 179. 1898-1905.
Views of Dawson, Yukon; various unidentified portraits by photographers in Ottawa, Pembroke and Kingston, Ont.

Sherwood, Arthur Percy, (1854-1940), Ottawa, Ont., public servant.

7P-1600 Copies, b&w 132. 1870-1941.
Views of Ottawa, Ont., St. John's Nfld.; funeral of Sir John Thompson, Halifax, N.S.; activities and personnel of the Dominion Police, Ottawa, Ont.; aspects of the Confederation Jubilee celebrations, Ottawa, Ont.; A.P. Sherwood at an International Canadian-U.S. Boy Scouts meeting; portrait of Hugh John Macdonald, portrait of Sherwood; Library of Parliament under construction, Ottawa, Ont.

Sherwood, H. Crossley, Ottawa, Ont., public servant.

7P-1601 b&w 36. ca. 1940-ca. 1965.
Portraits of various members of federal Parliament, Ottawa, Ont., 1940-1965.

Sherwood, Helen.

7P-1602 b&w 4. ca. 1922.
Views of display and advertising truck promoting immigration to Canada and Canadian products, London, England, ca. 1922.

Sherwood, Livius P., Ottawa, Ont., barrister.

7P-1603 Original, []. 1919.
Group photo of the Overseas Military Council of Canada, London, England.

Shiels, Michael Joseph, Toronto, Ont., cinematographer.

7P-1604 b&w 82. ca. 1918-1923.
Views of Queenston, Toronto, Ont.; fruit-growing in the Niagara Peninsula, Ont.; activities of Mr. M.J. Shiels as cinematographer for Pathescope Ltd. in Ontario.

Shipman, N.C., Ottawa, Ont.

7P-1605 Original, b&w 256. ca. 1860-1910.
Photos of J.C. Shipman, father of N.C. Shipman, and of his family; construction of Lachine Canal, Basin No. 4, Montreal, Que., ca.1877, by S. McLaughlin; portraits of Ottawa String Orchestral Group, of Ottawa Government Printing Bureau, 1893, 1901, and of Emma Topley.

Shortill, R.M., Onoway, Alta.

7P-1606 Copies, b&w 275. 1918-1963.
Various types of commercial, private and military aircraft in Canada.

Shortreed, Robert, Edmonton, Alta.

7P-1607 Copies, b&w 11. 1914-1919.
Departure of the 101st Battalion from Edmonton, Alta., August 1914; photo by Frasch; personnel and activities of the 2nd Canadian Siege Battery in France and Germany, 1917-19; presentation of colours to the 49th and 51st Battalions, Edmonton, Alta., 1919.

Shortt-Haydon Collection.

75P-16 Copies, b&w [3,000]. [n.d.].
People, places and events (primarily Canadian and British).

Showalter, H.A., Dr., chemist.

7P-1608 Original, b&w 3. ca. 1953.
Showalter at Shakespearian Festival Opening, Stratford, Ont.; Showalter and unidentified man; Showalter and Donald Gordon.

Showler, John Gavin, (b. 1912), military officer, aviator.

7P-1609 Copies, b&w 8. 1915-1957.
Showler on Muskox 1946; Showler receiving McKee Trophy 1957; R.C.A.F. C-47; G-CAWD after crash; portraits of J.G. Showler.

Shute, Elizabeth, Ottawa, Ont.

7P-1610 b&w 1. 1912.
Cyclone damage in Regina, Sask., 1912.

Shuttleworth, Gertrude, Toronto, Ont., singer.

7P-1611 Original, b&w 2. ca. 1896.
Portraits of A.S. Vogt, founder and first conductor of Toronto Mendelssohn Choir, and of E.B. Shuttleworth, wholesale druggist and Professor of chemistry at University of Toronto.

Siemens, Abe, Abbotsford, B.C.

7P-1612 Copies, b&w 1. ca. 1945.
Consolidated Liberator B VI aircraft EW 218, 'WO' of No. 5 O.T.U., R.C.A.F., Abbotsford, B.C.

Sifton, Arthur Lewis, Rt. Hon., (1859-1921), jurist and politician.

7P-1613 b&w 307. 1900-1920.
Residence of Premier A.L. Sifton, Edmonton, Alta.; activities of the Sifton family and friends.

Sifton, Clifford, Sir, (1861-1929), Toronto, Ont., cabinet minister.

18P-21 Original, b&w 40. 1914-1918.
French battlefields; album presented to Sifton on visit to France.

Sifton, Nellie, Dutton, Ont.

7P-1614 b&w 1. ca. 1917.
Portrait of Lance-Sergeant E.W. Sifton, V.C.

Sigouin, Leon, Rev., Quebec, Que., priest.

7P-1615 b&w 1. ca. 1942.
View of la Chapelle de Saint-Jean-Baptiste, Caughnawauga, Que., ca.1942.

Silverthorn, Mary, Toronto, Ont.

196P-44 total 2. n.d.
University College, exterior, from south and southwest.

Silverthorne, F.G., Brantford, Ont.

7P-1616 Original, b&w 1. 1945.
Sinisei soldiers who volunteered for Pacific training, Brantford, Ont., June 1945.

Simeon Perkins House, Liverpool, N.S.

31P-56 Copies, b&w 1. ca. 1960.
View of S. Perkin's house.

Simm, Donald, Toronto, Ont.

7P-1617 b&w 161. 1942-1943.
Construction of the Alaska Highway through Northern British Columbia and Yukon 1942-1943.

Simmons, Donald B., Bainsville, Ont.

7P-1618 b&w 10. 1933-1944.
Visit of General Italo Balbo's squadron of the Royal Italian Air Force to Shediac, N.B., 1933; General Aircraft Monospar aircraft of Eastern Canada Airlines Ltd.; Mr. J.C. Folkins, 1944.

Simonite, Charles Edward, (ca. 1880-), Winnipeg, Man., real estate, city alderman.

9P-78 b&w 9. 1930-1955.
Members of city councils, committees and Winnipeg Police Department.

Simpson, Beatrix, Westmount, Que.

7P-1619 b&w 3. ca. 1907.
Cree fishing camp, Jackfish, Ont.; SS *Duchess of York,* Carillon, Que.

Simpson, James, (1873-1938), Toronto, Ont., journalist, labour leader, politician.

18P-51 Original, b&w 89. ca. 1896-ca. 1935.
Potraits of Simpson and his colleagues; events at which Simpson was present as labour leader or Toronto politician.

Simpson, James, Sr., (1874-1972), Banff, Alta., outfitter and trail guide.

166P-6 Original, b&w [2,940], col. 15, total [2,955]. ca. 1912-1930.
Original prints and transparencies collected by Jimmy Simpson; pack trips and hunting trips, 1912-1920; Banff Winter Carnival; Rocky Mountain scenics.

Sims, Arthur George, (b. 1907), Montreal, Que., aviator.

7P-1620 b&w 182. 1929-1960.
Scenes from bush flying days in 1930's, Dominion Skyways 1933-38, Commercial Airways; Newfoundland Skyways; aircraft, personnel and operations of Dominion Skyways Ltd., Rouyn-Noranda, Que.; operations and personnel of Commercial Airways, 1929-31; miscellaneous aircraft from 1930's; Newfoundland Skyways Aircraft; skinning seals, Labrador settlements; portrait of A.G. Sims.

Simzer, Earl D.

7P-1621 b&w 300. 1925-1935.
Various steamships passing through canal locks on the St. Lawrence River near Cardinal, Ont., and Ogdensburg, N.Y.

Sise, Hazen, (1906-1974), Montreal, Que., architect.

7P-1622 Original, b&w 7,457, col. 1023, total 8,480. 1850-1973.
Portraits and family snapshots of Hazen Sise, his family and his ancestors; UNESCO headquarters building in Paris; London Philharmonic Orchestra; pictures of the Porteus family estate on the island of Orleans, Que.; trip to Poland in early 60's; contract with Historic Sites; trips with historical architectural groups; historical houses in Ottawa region; views of Italy; architecture shot in Europe, 1966; Bonsecours beautification project in Montreal, Que.; European cities and life in 1930's; Spanish Civil War.

Sisler, William James, (1870-1956), Winnipeg, Man., teacher.

9P-67 b&w 205. ca. 1905-ca. 1920.
Photographs of ethnic settlements in the Interlake area of Manitoba.

9P-83 b&w 256. ca. 1905-ca. 1920.
Photographs of ethnic settlements in the Interlake area of Manitoba and schools in Winnipeg.

Sissons, Charles Bruce, (1879-1965), Toronto, Ont., university professor.

7P-1623 Original, b&w 32. ca. 1860-ca. 1960.
View of house; portraits of J.S. Woodsworth, C.B. Sissons, Jonathan Sissons, Mrs. Peter Shaver, Peter Shaver, Margaret Ann Shaver Sissons; unidentified carte de visite portraits possibly of the Shaver family; photos by J. Penrose, Toronto, Ont.; Turner, Toronto, Ont.; D.C. Butchart, Toronto, Ont.; G. McConkey, Toronto, Ont.; H. Noverre, Toronto, Ont.; J.H. Griffiths, London, Ont.; Burkes, Stratford, Ont.

Sisters of St. Joseph of the Diocese of Toronto of Upper Canada, (est. 1851), Willowdale, Ont., education, nursing.

319P-1 b&w [200]. 1851-.
Sisters and priests; Mrs. Elmsley; Sister Antoinette McDonell; Gertrude Lawler, member of the Senate of University of Toronto, 1910; convents and buildings.

Sisters Servants of Mary Immaculate, (est. 1892), Toronto, Ont., teaching, nursing.

338P-1 b&w [10,000]. 1910-.
General councils, provincial councils, members of the community, church dignitaries, civil dignitaries, lay and clerical friends of the community, houses and mission centers, churches; graduates of the high schools, students including music, kindergarten, elementary and secondary, summer catechetical classes, seminars, retreats, social works, programs of special civic and religious days, missions in Brazil, Ukraine, France, United States and Yugoslavia; special albums of the Sisters' work in the different Eparchies, Edmonton, Saskatoon, Winnipeg, Toronto and Christ the King Province; albums of the musicals and albums of individual houses and the work done.

Sixteen Mile Creek, Oakville, Ont.

47P-19 Original, b&w 10. 1897-1920.
Sixteen Mile Creek.

Sjostedt, Jessie, Ottawa, Ont.

7P-1624 b&w 80. ca. 1905.
Views of Sault Ste. Marie, Ont.

Skinner, L.B., Chelsea, Que.

7P-1625 Copies, b&w 15. 1934-1935.
Thomas Payne, Uranium mine, Hottah Lakemines, Ltd., N.W.T. 1934; geological survey group; Fred Joliffe, 1935; views of Fort Smith and McMurray, N.W.T.; cook house, Beaverlodge Lake, N.W.T.; Hottah Lake Mines Ltd.; group portrait, Thomas Payne, L.B. Skinner and Nell Campbell self portrait.

Skirrow, George "Lucky", (fl. 1925), Banff, Alta., boatman.

166P-33 Original, b&w 172. 1923-1962.
Original prints collected by Lucky Skirrow; fishing, boats and dam construction at Lake Minnewanka, Banff National Park.

Skuce, G.O., Mrs., Ottawa, Ont.

7P-1626 Original, b&w 1. 1914.
Portrait of members of the War Canoe Crew, Brittania Boating Club, Ottawa, Ont., 1914; photo by A.G. Pittaway.

Skuce, Lester, Osgoode, Ont.

7P-1627 Original, b&w 7. ca. 1880.
Portraits of unidentified people.

Slack, W, Ottawa, Ont.

7P-1628 Original, b&w 1. 1918.
Staff of Records Office, Department of Militia and Defence, Ottawa, Ont., 1918.

Sladen, Arthur F., Ottawa, Ont., public servant.

7P-1629 b&w 14. ca. 1900-ca. 1927.
Portraits of Duke of Connaught, ca. 1915; Earl and Lady Minto and staff; Baron and Lady Byng of Vimy; Lady Ruby Elliott; scenes of Earl of Minto and staff and of Duke of Connaught and party, Rideau Hall, Ottawa, Ont., ca.1900, by Topley and Pittaway; visit of Prince of Wales and Stanley Baldwin, Rideau Hall, Ottawa, Ont., 1927.

Slattery, Beatrice C., Peterborough, Ont.

7P-1630 b&w 1. ca. 1903.
View of Toronto Transit Commission streetcar No. 347, Toronto, Ont.

Sloan, John Charles, (b. 1924), Ottawa, Ont., military officer, aviator.

7P-1631 Copies, b&w 12. ca. 1946-1955.
J.C. Sloan with various naval aircraft.

Slocomb family, Port George, N.S.

1P-54 Original, b&w [140]. ca. 1865-ca. 1900.
Photographs and tintypes; Slocomb family of Port George, N.S.; relatives and friends of Slocomb family; portraits of various individuals; Baptist church, Liverpool, N.S.; unidentified grocery store interior.

Smeaton, Charles, Quebec, Que., photographer.

7P-1632 b&w 10. [1860-1870].
Views of Quebec, Que.; photos by Charles Smeaton.

Smith, Arthur Y., Ottawa, Ont.

7P-1633 Original, b&w 15. 1940-1950.
Views of Eddy's from Parliament Hill, Ottawa, Ont.; woods by Fred Ashton; abstract, table tops, composite; portraits of the son of Arthur Y. Smith.

Smith, C.E. Stanfield, Winnipeg, Man., public servant.

7P-1634 b&w 315. 1920-1925.
Views of Winnipeg, Man.; Saskatoon, Sask.; Edmonton, Falher, Grande Prairie, Sexsmith, Smith, Alta.; Fort Providence, Fort Smith, N.W.T.; views along the route of the Edmonton, Dunvegan & British Columbia Railway; activities of Ukrainian settlers, Mundare, Alta.; operations at the Dominion Experimental Farm, Beaverlodge, Alta.

Smith, Charles Lyman, Boston, Mass.

7P-1635 Original, b&w 24. 1903.
Charles L. Smith's photos of his trip to Newfoundland and Nova Scotia, 1903.

Smith, Deane C.

7P-1636 Original, b&w 91. 1920-1932.
Views of Cold Lake, Flin Flon, the Pas, and Churchill, Man., as photo-post cards.

Smith, Edith M., Ottawa, Ont.

7P-1637 b&w 1. 1930.
Composite photo of H.M. Airship *R-100* and her commander R.S. Booth, 1930.

Smith, Elizabeth, Perth, Ont.

7P-1638 b&w 2. 1888.
Group photo of staff of the Geological Survey of Canada, Ottawa, Ont.; portrait of Mr. A.E. Barlow.

Smith, H.D., Summerside, P.E.I.

7P-1639 Copies, b&w 3. 1907.
First automobile in Dawson, Yukon; portraits of Hugh Smith and
Irene Wilson.

Smith, Henry, (1859-1940), Charlottetown, P.E.I., court clerk and
antiquarian.

5P-4 b&w [200]. ca. 1860-1910.
Buildings, street scenes, portraits.

Smith, Herbert "Soapy", (1878-1948), Seebee and Banff, Alta., outfitter
and trail guide.

166P-32 Original, b&w 176. ca. 1930-1945.
Original prints collected by Soapy Smith of his pack trips and
hunting trips in the Rocky Mountains, ca. 1930-1945.

Smith, Larratt William, (1820-1905), Toronto, Ont., lawyer and financier.

18P-60 Original, b&w 35. ca. 1870-ca. 1900.
Portraits of Smith family and Bethune family; views of Roches
Point, Ont.

18P-64 Copies, b&w 8. ca. 1865-ca. 1870.
Portraits of Smith family and Bethune family.

Smith, Maurice, London, England, publisher.

7P-1640 Original, b&w 25. 1941-1943.
Various types of R.C.A.F. training aircraft used in the British
Commonwealth Air Training Plan.

Smith, Minnie C., Lachine, Que.

7P-1641 b&w 21. 1914.
Mobilization of troops on the campus of the University of Toronto,
Toronto, Ont., 1914.

Smith, Philip E.L., Montreal, Que.

7P-1642 Original, b&w 17. 1875-1895, 1905, 1950.
Views in Newfoundland of boat rigging and buildings; Fortune,
Grand Bank, Nfld.

Smith, Sidney, Toronto, Ont.

196P-41 total 65. 1933-1954.
Sidney Smith, individual and family; aerial photo, University of
Toronto, 1933; Hydro-Electric Power Commission of Ontario,
Niagara Generating Station and Forebay Canal; Sidney Smith
Hall.

Smith, Strathy, Toronto, Ont.

7P-1643 Original, b&w 161. ca. 1890-1910.
Views of Toronto, Ont., Quebec and Montreal, Que.

Smith, Thomas Benton, (1894-1955), soldier.

7P-1644 Original, b&w 19. ca. 1919.
No. 1 Canadian casualty clearing station, First World War.

Smith family.

334P-15 Copies, b&w 9. ca. 1915-1930.
Family Portraits, automobiles, wagon and horse team.

Smithsonian Institution, Washington, D.C.

7P-1645 b&w 2. ca. 1890.
Stanley Creek Bridge on the Canadian Pacific Railway, in B.C.;
west side, Mount Carroll, B.C., by Wm. Notman & Son.

Smyth, S.A., Calgary, Alta., professional photographer.

166P-45 Original, b&w 30. ca. 1890-1905.
Original prints by S.A. Smyth; views of Banff townsite and the
surrounding area, ca. 1890-1905.

Sneddon, Wilfred, Almonte, Ont.

7P-1646 Copies, b&w 23. ca. 1910.
Views of Almonte, Ont.

Snider family, Toronto, Ont., farmers.

18P-87 Copies, b&w 12. 1881-ca. 1930.
John C. Sniders's house in North York (Toronto); family portraits.

Société d'archéologie de Rivière-du-Loup, Rivière-du-Loup, Que.

7P-1647 b&w 1,310. [1886-1920].
Views of Rivière-du-Loup and area, political events, rural scenes,
Témiscouata Railway, Que.

Société historique de Saint-Boniface, (1902 à nos jours), Saint-Boniface
(Man.).

222P-1 total [3,000]. ca. 1850 à nos jours.
Ce fonds a trait surtout à la vie et aux membres de la collectivité
francophone (d'origine française, canadienne et métisse) du
Manitoba, et de l'Ouest en général.

Société Historique Nicolas-Denys (S.H.N.D.), (f. 1969), Bertrand (N.-B.).

341P-1 n.&b. [500], coul. [300 diapos.], total [800]. 1880 à nos jours.
Douze albums de personnages, d'étudiants de Shippagan (N.-B.),
d'une famille non-identifiée de Rogersville (N.-B.); vues de divers
endroits des Maritimes, de sites et d'événements historiques.

Société Radio-Canada, (1936), Ottawa (Ont.), radiodiffusion.

311P-1 n.&b. [9,572], coul. 366, total [9,938]. 1919-1977.
Toutes les phases de la radiodiffusion depuis la construction
jusq'aux émissions à l'extérieur.

Sommerer, Karl, Sudbury, Ont., photographer.

7P-1648 b&w 30. 1959-1973.
Canadian Grand Prix Races, Mosport, Ont., 1967, 1972; motorcycle
races, Mosport, Sudbury, Ont., 1970-1973; various subjects in and
around Sudbury, Capreol, French River, Naughton, Ont.; Peggy's
Cove, West Dover, N.S.; photos by Karl Sommerer.

South Africa.

1P-10 Original, b&w 24. 1898.
Album of photographs of towns and scenery in South Africa.

Spalding, J. Frederick, Vancouver, B.C.

7P-1649 col. 1. 1930-1934.
Memorial to Pauline Johnson, Stanley Park, Vancouver, B.C.; photo by J.F. Spalding.

Spear, Bertha, Ottawa, Ont.

7P-1651 b&w 15. ca. 1859-1925.
Views in and around Almonte and Appleton, Ont.; portraits of members of the Shipman family.

Spence, Charles, Cranbrook, B.C.

7P-1652 Original, []. ca. 1898.
Views of the Boer War, and military arrangements at Kingston, Ont.

Spencer, Elihu, Ottawa, Ont., photographer.

7P-1653 b&w 6. ca. 1860-1869.
Construction of the Parliament Buildings, Ottawa, Ont.; views of Ottawa, Ont.; photos by Elihu Spencer.

Spencer, Henry, Comox, B.C.

7P-1654 b&w 1. ca. 1925-1935.
Portrait of Mr. E.J. Garland, M.P.

Spencer, L.B., Westmount, Que.

7P-1655 b&w 1. 1886.
Portrait of Lady Agnes Macdonald, later Baroness Macdonald of Earnscliffe, Ottawa, Ont., January 1886; photo by W.J. Topley.

Spencer, Leonard, (b. 1901), Montreal, Que., radio engineer.

7P-1656 b&w 107. 1920-1960.
Development of radio and television broadcasting at various stations in Montreal, Que.

Spier, Jack, Montreal, Que.

7P-1657 b&w 97. 1880-1920.
Stereo views of Indian and Inuit life in Canada, and of various cities of Canada.

Spiteri, Ed, Calgary, Alta., photographer.

7P-1658 Original, b&w 75. 1972-1976.
Hutterite communities in Alberta; old and derelict buildings in Southern Alberta; Lethbridge and Spy Hill Provincial Gaols, Alta.

Sports Hall of Fame, Toronto, Ont.

7P-1659 Copies, b&w 5. [n.d.].
Portraits of Jack Purcell, Earl McCready, and Jack Guest.

Spreadbury, Alfred, police and military officer.

7P-1650 Original, b&w 33. ca. 1910.
8th Avenue, Calgary, Alta.; Spreadbury's daughters.

Spremo, Boris, Toronto, Ont., photographer.

7P-1660 b&w 31. 1965-1974.
News photographs by Boris Spremo in Toronto, Ont., in the United States and in South Vietnam, 1965-1974.

Spurr, Norman, Markham, Ont., photographer.

7P-1661 b&w 476, col. 124, total 610. 1968-1971.
Visit of H.R.H. Queen Elizabeth II to Ladysmith, B.C., 1971; views of Ladysmith, B.C.; last steam logging locomotive owned by McMillan-Bloedel Ltd., Chemainus, B.C.

Spurrill, Dan, Winnipeg, Man.

9P-68 b&w 93. 1965-1968.
Photographs of buildings in Manitoba of historic and architectural interest.

Standard Clay Products Ltd., (1903-1971), New Glasgow, N.S., clay products manufacturers.

31P-79 b&w [150]. ca. 1913-1960.
Construction of the New Glasgow plant, 1913; numerous construction sites; assorted company clay products; views of New Glasgow plant.

Stanfield, Robert Lorne, (b. 1914), Halifax, N.S., politician, leader of Progressive Conservative Party.

7P-1662 b&w 1. 1967.
Portrait of Mr. Robert L. Stanfield, M.P., Ottawa, Ont., 1967; photo by Yousuf Karsh.

Stanhope, Lady.

7P-1663 b&w 1. 1864.
Centre Block, Parliament Buildings, Ottawa, Ont.

Stanier, S. Edward P., Leeds, Yorks, England.

7P-1664 b&w 2. ca. 1890-ca. 1900.
View of Cannington Manor, Sask.; view of Uppington, Shropshire, England.

Staniforth, Alan, Ottawa, Ont., public servant.

7P-1665 b&w 19. 1918-1922.
Views of Kelowna, B.C., SS *Sicamous* and of Stanley Park, Vancouver, B.C.; threshing operations in Western Canada; activities of the Staniforth family; photos by Harry Staniforth.

Stanley, Ruby, Ottawa, Ont.

7P-1666 b&w 6. 1915-1919.
Toboggan slide and ski-jump, Rockcliffe, Ont.; aftermath of the fire in the Centre Block, Parliament Buildings, Ottawa, Ont., 1916.

Staples, Owen P., (1866-1949), Toronto, Ont., artist.

18P-76 Copies, b&w 10. 1890-ca. 1920.
Staples' house and vicinity.

Starke, Sarah G.E., (d.1973), Montreal, Que., theatre patron.

7P-1667 b&w 7. 1965.
Dominion Drama Festival, Brockville, Ont.

Station CKAC, Montreal, Que., radio station.

7P-1668 Copies, b&w 12. 1923-1973.
Interior of radio station CKAC, Montreal, Que., 1923; various types of radio broadcasting and receiving equipment; cast of the radio programme "Nazaire et Barnabé".

Steel, William Arthur, Lt. Col., (1890-1968), Ottawa, Ont., engineer, military officer.

7P-1669 Original, b&w 8,124. ca. 1914-1945.
Career of Lieutenant-Colonel W.A. Steel; personnel and activities of the Royal Canadian Corps of Signals and of the N.W.T. and Yukon Radio System.

Steele, A.M., Fort Steele, B.C.

333P-22 Original, b&w 1. 1909.
Adelaide Bailey Fingal-Smith.

Steele and Company, Winnipeg, Man., photographers.

7P-1670 b&w 2. 1903.
Views of Fort Garry, Man., and of the tent camp of the Barr Colonists, Saskatoon, Sask.

Stein, C.E., Wheatley, Ont.

7P-1671 b&w 1. [].
Views of SS *Stewart J. Cort.*

Stereograph, Toronto, Ont.

8P-10 b&w [800]. ca. 1858-ca. 1908.
Stereographs; sceneries, buildings, rural and street scenes of Roger's Pass, Selkirk Mountains, Vancouver and Victoria, B.C.; Queenston, Sault Ste. Marie, Simcoe, Toronto, Welland Canal, Windsor and Woodstock, Ont.; Quebec, Stanstead, Tadoussac, Saguenay River, St. Maurice and St. Lawrence River, Que.; Saint John, N.B.; Yarmouth, N.S.; Yukon; photos of steamships: SS *Ontario*, SS *Chicora, City of Toronto*, SS *Algeria*, SS *Montreal*, SS *G.B. Greene, Quebec.*

Stevens, Henry Herbert, (1878-1973), Vancouver, B.C., politician.

7P-1672 b&w 89. ca. 1911-1919.
Political career of Hon. H.H. Stevens as Member of Parliament, Minister of Trade and Commerce, Chairman of the Royal Commission on Price Spreads and Mass Buying, and leader of the Reconstruction Party.

Stevens, Ruth (Bovey), Wayzata, Minn.

166P-36 Original, b&w [100]. ca. 1930-1940.
Original photographs by the Stevens and Bovey families; hunting trips in the Waterton Lakes area of the Rocky Mountains, ca. 1930-1940.

Stevens, William H., Ottawa, Ont., film editor.

7P-1673 b&w 126. 1944-1945.
Construction of harbour and landing craft during World War II.

Stevenson, Leigh Forbes, (b. 1895), Vancouver, B.C., military officer.

7P-1674 Copies, b&w 1. 1921.
Group photo of the personnel of the Canadian Air Board, Victoria Beach, Man., July 1921.

Stewart, Dorothy, Ottawa, Ont.

7P-1675 b&w 3. ca. 1875.
Portrait of Lieutenant-Colonel David Ross, Quebec, Que.; photo by Ellisson; group photo of Colonel Knight and family, Quebec, Que.; photo by Livernois.

Stewart, Herbert Leslie, (1882-1953), Halifax, N.S., professor and editor.

31P-6 Original, b&w 1. ca. 1935.
H.L. Stewart making a broadcast.

Stewart, Hugh R., Ottawa, Ont., military officer.

7P-1676 b&w 31. ca. 1863-1945.
View of the Centre Block, Parliament Buildings, Ottawa, Ont.; aspects of Captain Joseph Bernier's expedition to the Northwest Territories, 1906-1907; portraits of Admiral and Mrs. H.W. Bayfield, Lord and Lady Dufferin, Hon. J.C. Pope, Sir Wilfrid Laurier, Sir Louis Davies, and Mr. Leonard Brockington.

Stewart, James S., Rev., White Mud, Man., clergyman.

7P-1677 Original, b&w 530. ca. 1900-ca. 1930.
Slide series on astronomy, archaeology of bible lands; Presbyterian missions in Canada and abroad.

Stewart, John James, (1844-1907), Truro and Halifax, N.S., newspaper editor.

31P-16 Original, b&w 1. [n.d.].
Stewart's residence, Halifax.

Stewart, John Smith, (1878-1970), Lethbridge, Alta., military officer, dentist, politician.

7P-1678 Original, b&w 80. 1900-1968.
Mobilization of the 20th and 25th Batteries, C.F.A., Calgary, Alta., 1914; liberation of Mons, Belgium, Nov. 1918; pilgrimage of Canadian veterans to Mons, Belgium, Nov. 1968.

Stewart, Sheila, Rockcliffe, Ont.

7P-1679 b&w 1. ca. 1873-1883.
Portrait of Captain John Stewart, Princess Louise Dragoon Guards, Ottawa, Ont.

Stewart, Walter P., (b. 1924), Ottawa, Ont., photo-journalist.

7P-1680 b&w 63. 1936-1971.
Views of Whitehorse, Yukon, 1950; views on the Prairies, 1936; opening of the National Arts Centre, Ottawa, Ont., 1969; London - Victoria Air Race (Ottawa section, April 1971).

Stitt, Donald Monroe, (b. 1924), Scarborough, Ont., photographer.

7P-1681 Copies, b&w 1. ca. 1954.
Portrait of Petty Officer Donald M. Stitt, R.C.N.

Stocken, Canon Harry Gibbon, (1858-1955), Anglican missionary on Blackfoot and Sarcee reserves.

> 11P-6 b&w 61. ca. 1900-1910.
> Negatives of life on Blackfoot Indian reserve near Gleichen, Alta.: scenes of Anglican mission and portraits of Blackfoot Indians.

Stone, Edgar J., (1897-1977), Toronto, Ont., radio and stage director.

> 7P-1682 Copies, b&w 2. [n.d.].
> Portraits of Mr. Edgar J. Stone.

Story, Norah, (b. 1902), Ottawa, Ont., archivist and historian.

> 7P-1683 b&w 10. [n.d.].
> Views of St. Joseph, Ont.

Stratford and Perth County Archives, Stratford, Ont.

> 7P-1684 Original, []. ca. 1895-1925.
> Views of Stratford, Ont.; portraits of various people from Stratford, Ont.

Stride Studios, (ca. 1920), New Westminster, B.C., photographers.

> 334P-2 Copies, b&w 6. ca. 1900-ca. 1954.
> Girls' basketball team; *Surrey* (Ferryboat); cars, wagons, trucks and bulldozers; City Hall staff; high school under construction; opening of the Pattullo Bridge.

Strong, Elmer T., Kanata, Ont.

> 7P-1685 Copies, b&w 1. n.d.
> "Pointer" going through Rapids, n.d.

Stuart, Ronald Neil, Gravesend, Kent, England, military officer.

> 7P-1686 Copies, b&w 1. ca. 1917.
> Portrait of Commander R.N. Stuart, V.C.

Studio Boutet, La Pocatière (Québec).

> 349P-1 total [14,000]. 1950 à nos jours.
> Photos de mariages, d'événements locaux, photos publicitaires et portraits.

Studio Gendreau, La Pocatière (Québec).

> 348P-1 total 16,500. 1947 à nos jours.
> Ensemble de photographies de personnes et d'événements.

Studio Impact, Ottawa, Ont.

> 7P-1687 b&w 191,000, col. 9000, total 200,000. 25 April 1970 - 15 October 1973.
> News photographs taken for the Ottawa newspaper *Le Droit*.

Studio Jac-Guy, Montreal, Que.

> 7P-1688 b&w 25,002, col. 6500, total 31,502. 1900-1967.
> Photos by M. Guy Roy of entertainers, Radio-Canada personalities, and officials of Hydro-Québec, Montreal, Que.

Studio Jean-Paul, Saint-Pascal (Québec), photographie commerciale.

> 350P-1 total [100,000]. 1905 à nos jours.
> Photographies des activités à Saint-Pascal et des clients du studio.

Studio Max Sauer, Montréal (Québec), studio de photographies.

> 7P-1567 n.&b. 1. 1966.
> Le premier ministre Pierre Elliott Trudeau; photo prise par Jean-Pierre Cucuel.

Studio Notman d'Halifax, (ca. 1865-1925), Halifax (N.-E.), studio de photographie.

> 7P-1321 n.&b. 540. ca. 1890-1914.
> Personnel et activités de plusieurs régiments canadiens et britanniques, Halifax (N.-E.).

Stursberg, Peter, (b. 1913), Ottawa, Ont., journalist and author.

> 7P-1689 b&w 28. 1907-1923.
> Race tiffin [Mr. W.A. Stursberg third from left], Foochow, China, 1907; Redpath Chautauqua at Lexington, Kentucky, July 1923.

Suarez, Andrew L., Mississauga, Ont.

> 7P-1690 Copies, b&w 9. 1944-1945.
> Consolidated Liberator aircraft and aircrew of Nos 10 and 11 (BR) Squadrons, RCAF, Gander, Nfld., and Dartmouth, N.S.

Sutherland, John, Ottawa, Ont., contractor.

> 7P-1691 b&w 3. [n.d.].
> Ottawa Gas Works under construction, Ottawa, Ont.

Sutherland, Robert Franklin, (1859-1922), member of Parliament, jurist.

> 7P-1692 b&w 10. 1905-1909.
> Ceremony in the Senate Chambers, Parliament Buildings, Ottawa, Ont.; view of the Centre Block Parliament Buildings, Ottawa, Ont.; portraits of Hon. R.F. Sutherland, Lady Laurier, and a group portrait of Lady Aylesworth, Sir Frederick Borden, Mrs. Oliver, Hon. R.F. Sutherland and Sir Wilfrid and Lady Laurier.

Swain, L.G., Yarmouth, N.S., photographer.

> 31P-95 Original, b&w 1. ca. 1890.
> Unidentified group.

Swannell, F., B.C., surveyor.

> 7P-1693 Original, []. ca. 1908-1955.
> Land and river surveys in B.C.

Swettenham, John Alexander, (b. 1920), Ottawa, Ont., public servant, author.

> 7P-1694 b&w 7. 1918-1968.
> Mounting of guard by Royal 22e Regiment at Buckingham Palace, London, England, 1940; view of Canadian Corps Headquarters, Leatherhead, England, ca. 1941; launching of first volume of John Swettenham's biography, Toronto, Ont., 1968; portrait of Major-General J.H. Elmsley.

Swindell, Dorothy M.E., Victoria, B.C.

7P-1695 Original, b&w 2. 1906-1919.
Union Sunday School excursion aboard SS *Columbian,* Lake
Laberge, Yukon, 17 July 1906; wreck of SS *Columbian.*

Sydney, Susie, Hay River, N.W.T.

7P-1696 b&w 128. 1924-1953.
Views of Banks Island, Herschel Island, Victoria Island, Baillie
Island, Aklavik, Fort Smith, Fort Providence, N.W.T.; activities of
Inuit trappers on Banks Island, N.W.T.; activities of the
Klengenberg and Wolki families; photos by Susie Sydney.

Szilasi, Gabor, Montreal, Que., photographer.

7P-1697 b&w 27. 1970.
Views of Ile-aux-Coudres, Que.

Tabaret, Joseph Henri, Rev. Frère, (1828-1886), Ottawa (Ont.), homme
d'église, éducateur.

7P-1698 n.&b. 1. 1886.
Portrait du Rév. Frère Joseph Henri Tabaret; photo prise par W.J.
Topley.

Taché, Louis-Hippolyte, (1859-1927), Montréal (Québec), écrivain.

113P-7 n.&b. 32. ca. 1860-1890.
Portraits de personnalités marquantes des 25 premières années de
la Confédération canadienne.

Taconis, Kryn, Toronto (Ont.), photographe.

7P-1699 Originaux, n.&b. 32. 1945-1973.
Les hutterites à Sainte-Agathe (Man.); Fort McLeod (Alberta); et
à Pincher Creek (Alberta); la Hollande pendant l'occupation
allemande, 1944-1945; photos prises par Kryn Taconis.
Ref./Réf.: Liste de légendes écrites par Kryn Taconis.

Tanner, Douglas, Ottawa (Ont.).

7P-1700 n.&b. 72. ca. 1901.
Vues de différentes villes canadiennes; pêche, canotage et
promenades en raquette au Canada.

Tannhauser family, Fort Steele, B.C., jeweller.

333P-20 Original, b&w 25. 1897-1905.
Family members; Fort Steele, B.C.; Tannhauser acquaintances.

Tapper, Lawrence F., Ottawa, Ont., public servant.

7P-1701 Original, col. 124. 1974.
Jewish colony at Hirsch, Sask.

Tapper, Murray Harvey, (n. 1929), Winnipeg (Man.).

7P-1702 n.&b. 2. ca. 1965.
Présentation d'un prix à Nathan Steinberg à l'occasion d'un souper
organisé en son honneur, Université Bor iian, Tel Aviv, Israël.

Tardif, Thérèse, Ottawa (Ont.).

7P-1703 n.&b. 3. [n.d.].
Portraits de Thérèse Tardif; photos prises par A.J. Castonguay.

Tardivel, Louis, Loretteville (Québec).

7P-1704 n.&b. 1. ca. 1865.
Portrait de Louis Riel; photo prise par Baldwin, Keesville (N.Y.).

Tarte, Joseph.

7P-1705 n.&b. 1. 1879.
Bal en l'honneur du Marquis de Lorne, Montréal (Québec).

Taschereau, André, (b. 1897), Quebec, Que., judge.

7P-1706 b&w 6. 1952-1953.
Annual meeting of the Canadian Bar Association, Quebec, Que.,
September 1953; photos by Photo Moderne.

Tash, Roy, Toronto, Ont., cinematographer and photographer.

7P-1707 b&w 30. ca. 1930-1960.
Roy Tash portraits of various world figures, including Lord
Bessborough, R.B. Bennett, W.L.M. King, King George VI, Charles
de Gaulle, Earl of Athlone, Roy Thompson, etc.

Tata, Sam, Montreal, Que., photographer.

7P-1708 b&w 52. 1948-1974.
Aspects of daily life in Montreal, Que.; London, England; Paris,
France; Tokyo, Japan; Hong Kong, Shanghai, China; portraits of
Robert Charlebois, Leonard Cohen, Gratien Gélinas, Irving Layton,
Claude Jutra, Hugh Hood, Norman McLaren, Alice Munro, P.K.
Page, Françoise Loranger, Jean-Louis Roux, Jacques de
Tonnancourt, Michel Tremblay, Gilles Vigneault; photos by Sam
Tata.

Taylor, Albert C., Ottawa, Ont., public servant.

7P-1709 b&w 2. 1938.
Group photo of trainees at No. 2 Technical Training School,
R.C.A.F., Camp Borden, Ont., 1938.

Taylor, George Thomas, (1838-1913), Fredericton, N.B., photographer.

46P-2 b&w 1,200. 1860-1910.
Fredericton street scenes, public and residential buildings,
businesses; hunting and fishing expedition, sports, transportations;
portraits of prominent Fredericton citizens; social events.

Taylor, Thomas Griffith, (1880-1963), Australia, Chicago, Ill., Toronto,
Ont., geographer.

16P-17 b&w ca. 15 cm. ca. 1900-1963.
Portraits of Vietnamese (ca. 1920); radar rainstorms; photograph
of the members of the main party of the British Antarctic
Expedition, 1910-1913, photographed at Cape Evans by H.G.
Ponting, April 1911.

Telfer, John W., Ottawa, Ont.

7P-1710 b&w 35. ca. 1867-1877.
Blacksmith Shop, Aylmer, Que., ca. 1877; view of SS *Lady Grey;*
carte-de-visite and ferrotype; portraits of various unidentified
individuals.

Tesla, Iwan, Ottawa, Ont., professor.

7P-1711 b&w 3. 1926-1969.
View of farm buildings, Theodore, Sask.; group photo of
congregation of Ukrainian Greek Catholic Church, Stornoway,

Tesla, Iwan, Ottawa, Ont., professor.
(Cont'd/Suite)

Sask.

Tessier, Roger, Shawinigan (Québec).

352P-1 total [75,000]. 1932 à nos jours.
Photos sur la région de Sainte-Anne-de-la-Pérade dont toutes celles publiées par les Amis de Sainte-Anne.

The Gazette, Montreal, Que.

7P-1248 b&w 275,710, col. 607, total 276,317. 1938-1972.
Political, cultural, sports, social and other news events in and around Montreal, Que., 1938-1972; photos by *Gazette* photographers.

The Halifax Herald Limited (Formerly the Nova Scotian), (est. 1824), Halifax, N.S., newspaper publishing company.

1P-40 Original, b&w [12,000]. ca. 1950-1967.
Societies, conventions, hospitals, schools, theatres, universities, army, navy, ships, sports and recreation, portraits, and social events published in the *Chronicle-Herald* and the *Mail-Stair.*

The Madawaska Club Ltd., Go-Home Bay, Georgian Bay, Ont.

196P-11 Original, []. [n.d.].
Photographs of the Madawaska Club, Go-Home Bay, Georgian Bay; the buildings and cottages; general scenery; University of Toronto professors and families.

The Royal Bank of Canada, (1864), Montreal, Que, banking.

323P-1 b&w [5,225], col. [275], total [5,500]. 1880 to present.
Photographs of bank branches, domestic and international, including the branches of The Northern Crown Bank, Quebec Bank, Union Bank of Canada, Traders Bank of Canada and The Union Bank of Halifax which were taken over by the Royal Bank; subjects include advertising, teller cages, vaults, outstanding architectural features, automobiles and dress styles; people include bank staff, individually and in groups, directors of the bank; publication photographs include negatives and proofs used in various bank publications such as Annual Reports, the corporate history, information booklets for the public.
Ref./Réf.: Catalogue card files - by geographic location (by province, then town), date, subject, people, publication.

The *Star-Phoenix,* (est. 1928), Saskatoon, Sask., newspaper.

10P-13 b&w [20,000]. 1945-1973.
Local news events covered by the *Star-Phoenix.*

The University of King's College Library, (est. 1789), Halifax, N.S.

302P-1 b&w [50]. ca. 1860.
Groups and buildings dealing with the University in Windsor, N.S., and Halifax, N.S.; the University in the "Navy" period during World War II; photographs by: Lewis Rice & Co. Windsor & Wolfville, N.S.; Stevens, Windsor, N.S.; Moreash, Halifax, N.S.; Graham, Wolfville, N.S.; Gauvin & Gentzel, Halifax, N.S.

Theatre Arts Guild, (est. 1931), Halifax, N.S.

31P-60 Original, b&w [90]. ca. 1932-1960.
Theatre Arts Guild productions and members.

Théâtre du Nouveau Monde, Montreal, Que.

7P-1712 Copies, b&w 750. 1951-1967.
Views and photo reportage of all the plays presented by the Théâtre du Nouveau Monde during the period 1951-1967; the majority of the photographs are by Henri Paul.

Therrien, Armand, Saint-Pascal-de-Maizerets, Que.

31P-41 b&w [720]. [n.d.].
British, American and Canadian naval vessels; world merchant ships.

Thierbach, Otto, (b. 1897), Montreal, Que., stonemason.

7P-1713 b&w 13. ca. 1940-ca. 1945.
Activities of internees at internment camp, Fredericton, N.B., 1940-1945.

Thomas, A. Vernon, (1875-1950), Winnipeg, Man., writer.

9P-69 b&w 21. 1910.
Photographs of Northern Manitoba.

Thomas, David L., Parry Sound, Ont.

8P-4 Original, b&w [950]. ca. 1850-ca. 1960.
Events, buildings, streets and people of Parry Sound and district, Ont.

Thomas, Gladys, Strathroy, Ont.

7P-1714 b&w 950. 1908-1930.
Ranching activity in and around Crawling Valley, Alta., ca. 1910; aspects of the Calgary Stampede, Calgary, Alta., 1912 and 1919; views of Gleichen, Camp Sarcee, Lloydminster, Alta.; Smithers, B.C.; portraits and activities of various members of the Davies and Thomas families.

Thomas, Gordon Evan, Ottawa, Ont., public servant, photographer.

7P-1715 col. 1. 1973.
Portrait of MWO Gordon Thomas, C.A.F., Ottawa, Ont.

Thomas, Sandra, Ottawa, Ont.

7P-1716 b&w 21. ca. 1914-1927.
Photos by Mr. John Hornby of his activities in the Northwest Territories; portrait of Mr. John Hornby.

Thompson, A.H., Mrs., Como, Que.

7P-1717 b&w 4. 1894-1911.
Group photos of employees of T. Eaton Co., Toronto, Ont.

Thompson, Elizabeth J., Toronto, Ont.

18P-28 b&w 12. ca. 1907.
Fort York, Toronto, Ont.

Thompson, F.K., Yonkers, N.Y.

7P-1718 b&w 30. ca. 1920.
Views of Niagara Falls, N.Y.

Thompson, Fred W., (b. 1900), Chicago, Ill., I.W.W. organizer.

31P-119 Copies, b&w 1. 1918.
Highschool graduation photo.

Thompson, Marjorie J., Richibucto, N.B.

7P-1719 b&w 1. ca. 1902.
View of Atlin, B.C.

Thompson, Phillip W., Oakville, Ont., journalist.

7P-1720 b&w 4. ca. 1857-1925.
Portraits of Mr. T. Phillips Thompson; group photo of Mr. and
Mrs. William Thompson and family.

Thompson, R.T., Victoria, B.C.

7P-1723 b&w 2. ca. 1870-1880.
Portraits of Mr. and Mrs. Samuel Thompson and family.

Thompson, Richard Rowland, (1877-1908), soldier.

7P-1722 b&w 4. ca. 1901.
Portraits of Private and Mrs. R.R. Thompson.

Thompson, Robert Norman, (b. 1914), Red Deer, Alta., politician, educator.

7P-1721 b&w 34. 1951-1967.
Views of the Avro Canada Jetliner aircraft CF-EJD; Mr. Robert N.
Thompson, M.P.; and Emperor Haile Selassie of Ethiopia.

Thoms, Elise, Ottawa, Ont.

7P-1724 b&w 1, col. 18, total 19. ca. 1903-1910, 1972.
View of Christ Church Cathedral, Ottawa, Ont., ca. 1903-1910;
views of Fort George, Ont., 1972.

Thomson, Malcolm M., Ottawa, Ont., public servant.

7P-1725 b&w 1. 1939.
Group portrait of the staff of the Dominion Observatory and of the
Geodetic Survey of Canada, 28 November 1939, Ottawa, Ont.
Ref./Réf.: Key to photo.

Thorington, J. Monroe, Dr., (fl. 1895), Philadelphia, Penn., opthamologist.

166P-44 b&w 36. 1899-1931, 1871, 1951.
Original and copy prints collected by J.M. Thorington;
mountaineers and mountain explorers; Thorington mountaineering
expeditions, 1904-1931.

Thorpe, Victor N., (b. 1912), Kentville, N.S., lawyer.

1P-75 b&w 8. ca. 1900-1938.
Commission on Federal Statutes, 1902-1906; Nova Scotia
Legislative Assembly, 1904; Canadian Legion conventions, 1932,
1938; graduating class, Acadia College, Wolfville, N.S., 1902;
Canadian Army photographs, Boer War and World War I.

Threlfall, Frederick W., Maple Ridge, B.C., military non-commissioned
officer.

7P-1726 Copies, b&w 7. ca. 1943.
View of R.C.A.F. Station, Ladder Lake, Sask.; Fairchild FC2W
and Canadian Vickers Vedette aircraft of the R.C.A.F.; basket of
homing pigeons carried by R.C.A.F. aircraft, Dartmouth, N.S.;

portraits of members of R.C.A.F. courses Nos. 1 and 3 in pigeon
handling, 1943.

Thurber, Robert, Ville Le Moyne, Que., photographer.

7P-1727 b&w 10. 1890-1915.
Sightseeing bus, Toronto, Ont., 1912; photo by H.E. Poole;
portraits and group photos of unidentified individuals and families,
Montreal and Longueuil, Que.; photos by J.A. Dumas, P.J.
D'Aoust.

Tigert, Thomas, Toronto, Ont.

7P-1728 b&w 25. 1931-1934.
Views of various gold mines in Northern Ontario, 1931-1934.

Tilley, Mary, Toronto, Ont., secretary, United Church of Canada Committee
on Archives, Victoria University.

1P-55 Original, b&w 37. 1887-1895.
Various individuals, from Halifax and Waugh River, N.S.; Halifax
schools and students; Dalhousie University students and professors;
Halifax YMCA activities; Halifax and vicinity buildings and scenes;
photographers: Gauvin and Gentzell, William Notman, W.D.
O'Donnell, W. Chase.

Tilley, Samuel Leonard, (1818-1896), Saint John, N.B., politician, cabinet
minister.

7P-1729 b&w 5. ca. 1860-ca. 1870.
Portraits of Alex W. Graham, and of James Miller Lyle.

Tillott, Lorna, Eye, Suffolk, England.

7P-1730 b&w 2. ca. 1917-1918.
Portraits of Lieutenant G.M. Flowerdew, V.C.

Timmis, Reginald Symonds, (1884-[1962]), Aurora, Ont., military officer.

7P-1731 b&w 3020. 1901-1962.
Military and equestrian activities and family life of Colonel R.S.
Timmis, D.S.O., 1901-1962; many photos by Colonel Timmis.

Timms & Howard, Syracuse, N.Y., photographic studio.

7P-1732 b&w 42. ca. 1861-ca. 1927.
Views of locomotives used by various Canadian railways, primarily
in the period 1870-1890.

Tintypes and photographs.

1P-2 Original, b&w 117. 1860 - ca. 1875.
Album of carte-de-visite photographs and tintypes; portraits of
European royalty, Canadian and American political figures;
individuals from Halifax, N.S., New Brunswick and New York;
public buildings and views of Halifax, N.S.

Tognotti, Allan, Trail, B.C.

7P-1733 b&w 9. 1890-1920.
Activities of the Italian community, Trail, B.C., 1890-1920.

Tomlinson, Samuel Anthony, (1900-1973), Calgary, Alta., air engineer.

7P-1734 b&w 248. ca. 1914-1970.
Activities of Mr. S.A. Tomlinson as air engineer with the Ontario
Provincial Air Service, Patricia Airways, Western Canada Airways,

Tomlinson, Samuel Anthony, (1900-1973), Calgary, Alta., air engineer. (Cont'd/Suite)

Canadian Airways, Canadian Pacific Airlines, Austin Airways.

Topley, William James, (1845-1930), Ottawa, Ont., photographer.

7P-83　　Original, b&w 150,000. 1868-1923.
Views in and around Ottawa, Belleville, Dundas, Grimsby, Ont.; portraits of Governors-General, Prime Ministers, Senators, Members of Parliament, civil servants and residents of Ottawa, Ont., 1868-1923; photos by William James Topley.
Ref./Réf.: Card Index.

18P-5　　Original, b&w 56. ca. 1875-ca. 1880.
Views of Ottawa and vicinity, and of province of Quebec.

Toronto, Ont.

18P-29　　Original, b&w 22. ca. 1924.
Published set of photographs showing principal buildings and parks of Toronto.

18P-89　　b&w 1674. ca. 1860-1977.
Buildings; street scenes; portraits; some Canadian views and portraits.

Toronto, Ont., East End Day Nursery, (1892-1959), Toronto, Ont.

18P-48　　Original, b&w 104. ca. 1903-ca. 1959.
Buildings, children and events of the day nursery.

Toronto, Ont., Fire, 1904, Toronto, Ont.

18P-80　　Original, b&w 18. 1904.
Aftermath of fire.

Toronto, Ont., High Park Sanitarium, (1906-), Toronto, Ont.

18P-70　　Copies, b&w 17. ca. 1899-ca. 1950.
Sanitarium, staff, and High Park mineral baths.

Toronto, Ont., Monuments.

18P-20　　Original, b&w 20. ca. 1922.
Monuments in Toronto.

Toronto, Stereographs, Toronto, Ont.

18P-32　　Original, b&w [60]. ca. 1880-ca. 1910.
Toronto buildings, streets and events.

Toronto Board of Education, (1847), Toronto, Ont., education.

140P-17　　b&w 56. 1913-1934.
Various activities of the Board of interest to the City Government including the High Park Forest School, "Little Mothers" classes, medical and dental clinics for children.

143P-1　　total [4,200]. ca. 1890 to date.
Employees, pupils, trustees, and buildings of the Toronto Board of Education, its predecessors, and related associations such as teachers' groups; special events, including sports events, reunions, royal tours.

Toronto Camera Club, (est. 1885), Toronto, Ont.

7P-1735　　b&w 28. ca. 1870-1964.
Tour of the Eastman Kodak Ltd. plant by members of the Toronto Camera Club, Rochester, N.Y., 24 May 1954; group photo of the executive of the Toronto Camera Club, Toronto, Ont., ca. 1964; portraits of unidentified woman and children, ca. 1870.

Toronto City Hall, Toronto, Ont.

7P-1736　　b&w 320. 1890-1910.
Views of streets, bridges, sewers, wharfs, subways and other projects undertaken by the City Engineer's Office, Toronto, Ont.; views of damage caused by the great fire of April 1904, Toronto, Ont., photos by Josiah Bruce, F.W. Micklethwaite, City Engineer's Office.
Provenance: Toronto City Hall Archives.

Toronto Cricket, Skating and Curling Club, Toronto, Ont.

18P-67　　Original, b&w 13. 1931-1956.
Portraits of Skaters, Toronto Skating Club Carnival, 1956.

18P-83　　Original, b&w 17, col. 3, total 20. ca. 1964.
Views of club; carnival, 1964.

18P-95　　Original, b&w 30. ca. 1955-ca. 1960.
Construction of Club House, 1957; club views and events.

Toronto Daily Star, Toronto, Ont., newspaper.

7P-1737　　b&w 527,766. 1967-1975.
Political, cultural, social, sporting and news events in and around Toronto, Ont., 1967-1975; photos by Toronto Daily Star photographers.

Toronto-Dominion Bank, (1856-), Toronto, Ont.

320P-1　　b&w [500], col. [25], total [525]. 1903 to date.
Bank branches, interiors and exteriors; portraits of bank executives and directors; construction of the Dominion Bank's head office in 1913; street scenes; Bank of Toronto hockey teams 1903-1904.

Toronto Harbour Commission, (1911-), Toronto, Ont.

322P-3　　b&w [12,000], col. [1,000], total [13,000]. 1912-.
Photos taken by Arthur Beales to document works of Toronto Harbour Commission, 1914-1950; pictures include development, waterfront industries, construction, shipping, recreation and transportation.
Ref./Réf.: Photographer's chronological index, subject catalogue.

Toronto Harbour Commissioners, (1911-), Toronto, Ont.

7P-1738　　b&w 1,211, col. 5, total 1,216. 1910-1948.
Aspects of the development of the Port of Toronto, Ont., 1910-1948: construction, dredging, visits of dignitaries.

322P-1　　b&w [1,000]. 1971-.
Special events and port activities taken for Port public relations department by photographer Ray McFadden.

322P-2　　b&w 6,000. 1950-.
Waterfront development and special events by Les Baxter for THC.

Toronto Jewish Folk Choir (The), (est. 1925), Toronto, Ont., choir.

149P-14 b&w [10]. ca. 1930-1960.
Photographs of the choir throughout the years.

Toronto Public Library, (1883-), Toronto, Ont.

7P-1739 b&w 86. ca. 1890-1900.
Views of Brandon, Man.; Banff, Alta.; Field, Vancouver, Esquimault, B.C.; mining activity at Rossland, B.C.; Indian ceremonies in Alberta; photos by S.J. Thompson, Carpenter & Co., Truman & Caple, Bailey Bros.

18P-17 Original, b&w 28. 1884-ca. 1900.
Toronto scenes; sites associated with John Graves Simcoe in Wolford.

18P-88 Original, b&w 174. 1883-1977.
Portraits of board members and chief librarians; library buildings and events, including central library which in 1968 was separately established as Metropolitan Toronto Library.

Toronto Public Library, Beaches Branch, (1916-), Toronto, Ont.

18P-14 Original, b&w 12. 1885-1930.
Views of Beaches area in Toronto.

Toronto Public Library, Yorkville Branch, (est. 1884), Toronto, Ont.

18P-94 b&w 52. ca. 1860-1913.
Scenes in, and portraits of individuals associated with Yorkville area of Toronto.

Toronto Teacher's College, Toronto, Ont.

7P-1740 b&w 2. 1931.
Views of locks on the Welland Canal, Ont.

Toronto Telegram, (1876-1971), Toronto, Ont., newspaper.

7P-1741 b&w [9,000]. ca. 1950-ca. 1968.
News events in and around Toronto, Ont., 1950-1969; photos by Toronto Telegram photographers.

160P-1 b&w [350,000]. ca. 1925-1971.
General news, sports and recreation, personalities.

Toronto Transit Commission, Toronto, Ont.

7P-1742 b&w 1,189. 1920-1955.
Facilities, equipment and personnel of the Toronto Transit Commission, Toronto, Ont., 1920-1955.

Traill Family, Lakefield, Ont.

7P-1743 b&w 574. ca. 1860-1958.
Portraits of members of the Atwood, Hubbard, Page, Moodie, Strickland and Traill families, Lakefield, Ont., ca. 1860-1958.

Train, J.W., London, England.

7P-1744 Copies, b&w 1. ca. 1917.
Portrait of Sergeant C.W. Train, V.C.

Transportation - Manitoba.

9P-52 b&w [1,500]. 1860's-.
Photographs of modes of transportation in Western Canada.

Trevena, John E., Saskatoon, Sask.

7P-1745 b&w 6. ca. 1968.
Chapel, school and ruins of St. Peter's Mission near Great Falls, Mont.

Trinity Medical School, Toronto, Ont.

196P-2 col. 1. 1966.
Trinity Medical School, 1966.

Tripp, Leonard John, (b. 1896), Newmarket, Ont., aviator.

7P-1746 Copies, b&w 5. ca. 1923-1962.
Portraits of L.J. Tripp; L.J. Tripp with DH-60 Moth of St. Catharines Flying Club, 1929.

Trudel, Géraldine, Ottawa (Ont.).

7P-1747 Copies, n.&b. 3. 1962-1968.
Remise du trophée Trans-Canada à Weldy Phipps, Montebello (Québec) 1962; portrait de l'Hon. Pierre Elliott Trudeau avec Weldy Phipps, Grise Fiord (T. N.-O.) 1968.

Tucker, M. Grace, (b. 1902), Vancouver, B.C., missionary.

7P-1748 b&w 10, col. 1, total 11. 1942-1944.
Activities of Japanese-Canadian families evacuated to Slocan City, B.C., 1942-1944.

Tucker family, Halifax, N.S., commission merchants.

1P-17 Original, b&w 60. ca. 1908-1939.
Tucker family and their home "Pine Grove" at Halifax; Northwest Arm and Purcell's Cove, Halifax; other views of Halifax, including Public Gardens, "Gorsebrook" and All Saints' Cathedral; visit of King George VI and Queen Elizabeth to Halifax, 1939.

Tudhope, John Henry, (1891-1956), Ottawa, Ont., aviator, public servant.

7P-1749 b&w 9. ca. 1916-1940.
CF-CCT Lockheed 12A; CF-CCH Stearman Junion Speedmail; Bellanca CH 300 Pacemaker, RCAF; Pitcairn autogyro; portraits of John Henry Tudhope.

Tupper, Charles, Sir, (1821-1915), Halifax, N.S., Prime Minister.

7P-1750 b&w 1. 1915.
Portrait of Sir Charles Tupper, 15 September 1915.

Tupper, William Johnston, (1862-1947), Winnipeg, Man., lawyer, statesman.

7P-1751 b&w 10. ca. 1885-1914.
Visit of H.R.H. the Duke of Connaught to Vancouver, B.C., 1912; group photo of officers and men of the Halifax Provisional Battalion, Medicine Hat, Alta., 1885; portrait of Mr. W.J. Tupper.

Turk, Sidney, Ottawa, Ont.; Vancouver, B.C.

 7P-1753 b&w 94. ca. 1909.
 Views in and around Moose Jaw, Sask., ca. 1909; photos by E.L.
 Rice.

Turnbull, A.D., (b. 1904), Trail; Victoria, B.C., engineer; minister of health and welfare.

 12P-7 b&w 42. 1950-51.
 Official functions as minister of Health and Welfare, 1950-51.

Turnbull, Duncan R., Ottawa, Ont., public servant.

 7P-1752 col. 3. 1967-1969.
 View of Mount Kobau, B.C.

Turner, Fort Steele, B.C.

 333P-24 Copies, b&w 1. 1897.
 Horse race at Fort Steele, B.C.

Turner, B.H. (Jack), (1900-), O'Leary, P.E.I., farmer.

 5P-3 b&w 197. 1910-1965.
 Village scenes, O'Leary, P.E.I.; W.W.I., Canadian Expeditionary
 Force in France.

Turner, F. Leonard, Ottawa, Ont., public servant.

 7P-1754 b&w 2. n.d.
 View of Stewart Street from a point on the Rideau River, Ottawa,
 Ont.

Turner, Percival Stanley, (b. 1916), Montreal, Que., military officer, aviator.

 7P-1755 b&w 25. ca. 1940-1945.
 Activities of G/C P.S. Turner as pilot with Nos. 242, 145, 411, 249
 Squadrons, R.A.F., and No. 417 Squadron and No. 127 Wing,
 R.C.A.F., in Britain, North Africa, Italy and Northwest Europe,
 1940-1945.

Turner, Thomas H., Ottawa, Ont., public servant.

 7P-1756 b&w 24. 1950.
 Funeral procession of Rt. Hon. W.L. Mackenzie King; photos by
 T.H. Turner.

Tweed, Thomas William, (1908-1971), Toronto, Ont., actor and author.

 7P-1757 b&w 73, col. 2, total 75. ca. 1935-1971.
 Acting career and family life of Mr. Tommy Tweed.

Tweedsmuir, John Buchan, first Baron, (1875-1940), Ottawa, Ont.

 75P-4 b&w [800]. ca. 1910-1940.
 Family photographs, photographs taken during Buchan's political
 career and his term as Governor General of Canada.

Twist, John L., Lakefield, Ont.

 7P-1758 b&w 86. ca. 1880-1925.
 Views in and around Lakefield, Ont.; views of homesteads of
 Susanna Moodie and Sam Strickland; portraits of various members
 of the Strickland family.

Tyner family, Toronto, Ont.

 18P-41 b&w 3. ca. 1855-ca. 1865.
 Portraits of Adam Clarke Tyner (1840-1867), Christopher Tyner
 (ca. 1835-1878) and Richard James Tyner (1829-1857).

Tyrrell, Joseph Burr, (1858-1957), Weston, Ont., Ottawa, Ont., Toronto, Ont., Dawson City, Yukon, geologist, mining consultant.

 16P-18 b&w [4,500]. ca. 1880-1957.
 Landscape and settlements in Saskatchewan, Alberta, n.w.
 Manitoba, 1883-1897, taken on expeditions for Geological Survey
 of Canada; Barren Lands, 1893-1894, taken during expeditions for
 Geological Survey; includes Indian and Inuit photos, mass
 migration of cariboo; Klondike, 1898-1905; includes Dawson City
 and mining properties in Klondike; mining properties and environs
 in B.C., Nfld., Manitoba, and northern Ontario, including Kirkland
 Lake Gold Mine; 1906-1941; document surveys done for various
 mining syndicates; Maplewood Apple Orchards, operated by Tyrrell
 and Sons (now Metro Toronto Zoo in Scarborough) 1921-1954;
 family life, including early Weston scenes and some Ottawa ones,
 vacation trips, professional life (i.e. group photos of associations),
 1880's-1957.

Uchida, Matasaburo, (b. 1900), Vancouver, B.C., physician.

 7P-1759 b&w 14. 1942-1945.
 Activities and staff of the Slocan Community Hospital, New
 Denver, B.C., 1942-1945.

Ukrainian Canadian Committee, (est. 1940).

 7P-1760 b&w 18. 1943-1949.
 Members and activities of the Ukrainian Canadian Servicemens'
 Association, England, 1943-1945; officials and activities of the
 Ukrainian Canadian Relief Fund, West Germany, 1949.

Ukrainian Free Academy of Science, Winnipeg, Man.

 7P-1761 b&w 1. 1968.
 Opening of the Archives and Library of the Ukrainian Free
 Academy of Science, Winnipeg, Man., 17 November 1968; photo
 by Charles Krasnopera.

Ukrainian National Youth Federation of Canada, (est. 1934).

 7P-1762 b&w 823. 1946-1964.
 Group photos of members of various branches of the Ukrainian
 National Youth Federation of Canada, and of delegates to annual
 conventions of the Federation, 1946-1964.

Underhill, Frank Hawkins, (1889-1971), Toronto, Ottawa, Ont., historian, professor, author.

 7P-1763 b&w 180, col. 7, total 187. 1891-1958.
 Career of Frank Underhill as history professor at the University of
 Saskatchewan and the University of Toronto; as a founding
 member of the C.C.F. Party and as curator of Laurier House,
 1914-1959; portraits of Frank Underhill, his family and friends.

United Church of Canada Central Archives, Toronto, Ont.

 7P-1764 b&w 191. 1900-1925.
 Stereo views of Victoria, Vancouver and various unidentified places
 in British Columbia.

United Electrical, Radio and Machine Workers of America, Don Mills, Ont., labour union.

7P-1765 b&w 624. 1937-1974.
Activities of the United Electrical, Radio and Machine Workers of America Union in Ontario and Quebec, 1937-1974: conventions, parades, demonstrations, strikes, community work; portraits and group photos of individual members and various locals of the United Electrical, Radio and Machine Workers of America.

United Packinghouse Workers, Toronto, Ont., labour union.

7P-1766 b&w 55. 1942-1947.
Meetings and parades of the United Packinghouse Workers Union, 1942-1947.

United Steelworkers of America, labour union.

7P-1767 b&w 6. 1935-1958.
Activities of Mr. M.J. Fenwick as organizer of the United Steelworkers of America Union in Canada.

Université de Moncton, (f. 1963), Moncton (N.-B.), maison d'enseignement supérieur.

15P-1 n.&b. [1,000], coul. [200], total [1,200]. 1963.
Edifices de l'Université de Moncton, groupes de professeurs, d'étudiants, équipes sportives; événements spéciaux: visites, fêtes; étapes de construction et d'aménagement du campus; ensembles musicaux: orchestres, fanfares.

Université d'Ottawa, Collège Bruyère, Ottawa (Ont.).

303P-8 n.&b. 34. 1931-1968.
Mosaïques de finissants.

Université d'Ottawa, Département de diététique et sciences domestiques, Ottawa (Ont.).

303P-6 n.&b. 28. 1960-1969.
Mosaïques de finissants; membres du personnel; locaux d'enseignement; rénovations; chapelle et cafétéria.

Université d'Ottawa, Ecole de bibliothécaires, Ottawa (Ont.).

303P-2 n.&b. [121], coul. [336], total [457]. 1961-1970.
Photographies individuelles et de groupes; finissants et personnel de l'école dans leur milieu de travail et au cours de fêtes; édifices.

Université d'Ottawa, Ecole des sciences de l'activité physique et du loisir, Ottawa (Ont.).

303P-3 n.&b. 16. 1963.
Site et équipement d'une colonie de vacances du lac du Petit Poisson Blanc (Québec).

Université d'Ottawa, Ecole des sciences infirmières, Ottawa (Ont.).

303P-5 n.&b. [400]. 1936-1969.
Groupe de finissants; photographies individuelles; édifices; mosaïques de photos de finissants.

Université d'Ottawa, Enseignement et recherche, vice-recteur, Ottawa (Ont.).

303P-12 coul. 18. 1970.
Vues de la villa de Cannes et des oeuvres de peintres célèbres possédées par Richard Anacréon, dit le Jeune, libraire parisien.

Université d'Ottawa, Faculté de Droit coutumier, Ottawa (Ont.).

303P-17 n.&b. [300]. 1961-1975.
Photographies individuelles provenant de mosaïques de photos de finissants.

Université d'Ottawa, Faculté de médecine, Ottawa (Ont.).

303P-14 n.&b. 10. ca. 1942-1955.
Chancelier, recteur, régent; groupes d'étudiants; cours de médecine, de biologie et de chirurgie.

Université d'Ottawa, Faculté d'éducation (Ecole normale), Ottawa (Ont.).

303P-4 n.&b. [170]. 1939-1968.
Groupes d'étudiants et de sportifs de l'Ecole normale, professeurs, édifices, Ottawa (Ont.).

Université d'Ottawa, Relations extérieures, Ottawa (Ont.).

303P-1 n.&b. [400], coul. 2, total [402]. ca. 1950-ca. 1964.
Photographies individuelles des personnages officiels et des professeurs; cérémonies importantes: audiences papales, célébrations religieuses; groupes: bureau des gouverneurs, conseil de la faculté de médecine; cours de médecine, de biologie, de chirurgie, de génie; édifices temporaires et permanents, salles de classes, cafétérias, ateliers, laboratoires, etc.

Université d'Ottawa, Ressources financières, Ottawa (Ont.).

303P-7 n.&b. 18. ca. 1960-1968.
Edifices temporaires et permanents; personnages; vues de la ville d'Ottawa à vol d'oiseau.

Université d'Ottawa, Service des sports, Ottawa (Ont.).

303P-15 n.&b. [2,000]. 1960-1977.
Sports pratiqués à l'université; équipes sportives féminines et masculines; meneuses de bans; personnel du service; compétitions et tournois; festivités faisant suite aux rencontres sportives.

Université Saint-Joseph, (1864-1963), Saint-Joseph de Memramcook (N.-B.) et Moncton (à partir de 1953), maison d'enseignement supérieur.

15P-2 n.&b. [150]. 1890-1963.
Personnel enseignant, groupes d'étudiants, activités socio-culturelles; différents édifices de l'Université Saint-Joseph.

University College Archives, Toronto, Ont., archive.

321P-1 b&w [12,000], col. [2,000], total [14,000]. 1842-.
Photos of land and buildings, construction and demolition, professors and staff through history of institution; groups, student activities, graduations, dramatic and debating activities, residences, parties.

University of Alberta, Dept. of Geology, Edmonton, Alta.

92P-12 b&w 3,224. ca. 1912-1960.
Field trips, slides, photographs prepared for theses, portraits and landscapes by John A. Allan and staff members.

University of Alberta, Dept. of Mineral Engineering, Edmonton, Alta.

92P-17 b&w 328. ca. 1915-1964.
Portraits of professors and alumni, tar sands project, teaching slides of mining extraction and processing.

University of Alberta, Faculty of Agriculture, (est. 1915), Edmonton, Alta.

92P-1 b&w 220. 1950-1968.
Portraits of professors and students, facilities on campus, ca. 1962-1968.

University of Alberta, Faculty of Extension, (est. 1911), Edmonton, Alta.

92P-9 b&w 1,020. 1912-1961.
Activities of the Faculty, 1912-ca. 1960; instructors and students at Banff School of Fine Arts, 1955-61; Farm Young People's Week, 1920-53.

University of Alberta, Library, Edmonton, Alta.

92P-14 b&w 382. 1908-1966.
University of Alberta: campus, officials, staff, events.

University of Alberta, Publications Office, Edmonton, Alta., official publications of the University of Alberta.

92P-23 total 3,792. ca. 1950-1970.
Events on campus, portraits of staff, students and visitors to the University of Alberta, Edmonton, Alta.

University of Alberta Mixed Chorus, Edmonton, Alta.

92P-22 b&w 166. 1957-1974.
University Mixed Chorus activities, 1957-1974; concerts, formal portraits, rehearsals, tours (informal shots).

University of Ottawa Library, Ottawa, Ont.

7P-1768 b&w 525. 1890-1942.
Views of British Columbia, 1894-1896; aspects of the Wakeham Expedition to Hudson Bay, 1897, and of the Low Expedition to Hudson Bay, 1903; exhibition at St. Joseph Oratory marking the three hundredth anniversary of the founding of Montreal, Que., 1942; photos by F.E. Marsan.

University of St. Michael's College, (1852-), Toronto, Ont., education.

200P-14 Original, b&w 8. 1922-1961.
Group photographs of members of the General Chapters of the Basilian Fathers held at St. Michael's College in 1922, 1942, 1948, 1954, 1960 and 1961; all identified.

University of St. Michael's College Archives, (1852-), Toronto, Ont.

200P-8 Copies, b&w [2,500-3,000], col. perhaps [100], total [2,500-3,000]. 1860-1977.
St. Michael's College, its staff, students and friends; photographers represented in the collection are: ca. 1870-1875, P.W. Hynes, Toronto, R. Milne, Hamilton, Stanton, Toronto, W. O'Connor, Toronto, B.J. Smith, Detroit; ca. 1880-1890, J.H. Lemaitre, Toronto, McMillan, Dundas, Ont., Whitmore, Detroit, Murdoch Bros., Windsor, Ont., William Craig, Owen Sound, Ont., T. Bauslaugh, Paris, Ont., Farmer Bros., Hamilton, Ont., J. Hodge, Stonehouse, Devon, England.

200P-18 b&w [2,500-3,000]. 1860 to date.
St. Michael's College, its staff, students, and friends; William Michael Moulan, 1868-1959, photos dated 1892-1906; Hugh Vincent Mallon, b. 1910, photos dated 1875-1952 Cardinal Villeneuve in Toronto June, 1934; Robert Joseph Scollard, born 1908, photos dated 1925-1930; Basilian Fathers, general chapters, 1922-1961; Michael Joseph Ferguson, 1839, 1913, album of portraits of associates and friends presented to him around 1900; Edmund Francis Murray, 1844-1925, album of portraits of associates and friends presented to him around 1900; Richard

Thomas Burke, 1859-1941, family photographs, including 3 tintypes, 1860-1900; scrapbook kept by Winnifred (Killoran) Brown with notes of family, chiefly of her son Edward Killoran Brown, 1905-1951.

University of Saskatchewan Institute for Northern Studies, Saskatoon, Sask.

7P-1769 b&w 138. 1927-1928.
Views of Prince Rupert, Hazelton, B.C., and of various towns in Northern Alberta and along the Mackenzie River, N.W.T.; activities of various Indian tribes on the coast of British Columbia.

University of Toronto, C.O.T.C., Toronto, Ont.

196P-33 b&w 200. 1860-.
Military groups, at University of Toronto, Niagara and elsewhere; includes "K" Company, Queen's Own Rifles.

University of Toronto, Department of Alumni Affairs, Toronto, Ont.

196P-57 b&w 13. n.d.
8x10" views of nine buildings: Engineering Building, Loretto College, New College, New Victoria Residence, Superintendents Building, University Bookstore, University Settlement House, Women's Athletic Building.

University of Toronto, Department of Electrical Engineering, Toronto, Ont.

196P-64 b&w 10. 1958-1959.
Building of Victoria Bridge, Montreal, Que.

University of Toronto, Department of Information, Toronto, Ont.

196P-34 b&w 10,000. 1850-1944.
Photographs of University grounds and buildings; glass negatives and black and white prints; Arena, Anatomy Building, Baldwin House, Biological Building, Botany Building, Banting Institute, C.O.T.C. Headquarters, Chemical Building, Connaught Laboratories, Convocation Hall, Dental College, Engineering Building, Electrical Building, Fraternity House, 80 St. George, Forestry Building, University of Toronto Farm, Gull Lake Surveying Camp, Guelph Agricultural College, Hart House, Household Science Building, Hygiene Building, Heating Tunnel, Insulin Building, Knox College, Library, Music Building, Mechanical Building, Medical Building, Milling Building, Mining and Chemistry Building, McMaster College, Observatory, O.C.E., Pathological Building, Pharmacy Building, Physics Building, Park House, Parliament Buildings, Psychiatric Building, Power House, Psychology Building, University Residence (16 in all), Royal Ontario Museum, Royal Astronomical Building, Simcoe Hall, Toronto General Hospital, Trinity College, University College, University of Toronto Press, Victoria College, Women's Union, Wycliffe, Whitney Hall, Toronto Conservatory of Music.

University of Toronto, Engineering Alumni Association, Toronto, Ont.

196P-58 col. 1. n.d.
School of Practical Science ("Little Red School House").

University of Toronto, Erindale College, Toronto, Ont.

196P-23 b&w 23. 1967.
Erindale College, preliminary building, the Gravel Pit, buildings on Mississauga Road.

University of Toronto, Faculty of Food Sciences, Toronto, Ont.

196P-16 b&w 4. n.d., 1932, 1968.
Faculty of Food Sciences, n.d., first annual meeting, Ontario Dietetic Association, Toronto, 1932; fifteenth Annual Meeting American Dietetic Association, Toronto 1932; Faculty of Food Sciences, graduating class, 1968.

University of Toronto, Faculty of Forestry, Toronto, Ont.

196P-36 total [10,000]. 1800's.
Faculty of Forestry graduating classes, staff and faculty, teaching photos and slides, group photos, athletic teams, faculty activities and related associations.

University of Toronto, Faculty of Music, Toronto, Ont.

196P-29 b&w 21. 1954-1977.
Graduating class, 1954-1964, 1967, 1969-1972, 1974-1977.

University of Toronto, Hart House, Toronto, Ont.

196P-65 b&w 5. 1954-1963.
Hart House Glee Club, 1961-1963; Hart House House Committee, 1956-57; Finnish student visit to Canada, 1954.

University of Toronto, Hart House Chess Club, Toronto, Ont.

196P-22 b&w 34. 1947-1950,1973.
Chess matches versus McGill, Beaches, Cornell; simultaneous chess matches; individual chess team members.

University of Toronto, Hart House Theatre, Toronto, Ont.

196P-32 b&w 3,000, col. 1,000, total 4,000. 1919-1970.
Production photographs and slides of Hart House Theatre; actors, actresses and directors.

University of Toronto, Information Services, Toronto, Ont.

196P-21 b&w 13, col. 24, total 37. 1917-1971.
Miscellaneous photographs of buildings and people including aerial photos, Convocation proceedings, Governing Council, Hart House, Robarts Library, Power Plant, Physics Building, Engineering Building, Sigmund Samuel Library, Convocation Hall.

University of Toronto, Library, Photocopy Unit, Toronto, Ont.

196P-60 b&w 159. 1966.
Laidlaw Library, New College Library, Scarborough College, School of Practical Science, Biology Building (Demolition), Old Medical Building, Medical Sciences Building; internal and external views,.

University of Toronto, McLennan Physical Laboratories, Toronto, Ont.

196P-63 b&w 9. 1923-1931.
Colford division, American Chemical Society, 6th Colford Symposium 1928; British Association for the Advancement of Science, Section "A", Toronto 1924; International Mathematical Convention, Toronto, August 1924; Royal Society of Canada Fellows' Meeting, 1923; Garden party, University farm 1931; Barbara McLennan, James Faed, J.J. Thomson.

University of Toronto, Office of the Registrar, Toronto, Ont.

196P-15 total 5,000. 1914-1918.
Head and shoulders portraits of University of Toronto Students and Faculty who served in World War I.

University of Toronto, Office of the Vice-President and Provost, Toronto, Ont.

196P-59 b&w 1. n.d.
Cody, Henry J.

University of Toronto, Ontario School of Practical Science, Toronto, Ont.

196P-53 total 1. 1906.
Class of 1906.

University of Toronto, School of Hygiene, Toronto, Ont.

196P-66 b&w 40. 1946-1956.
Graduating photographs, diploma in public health, 1946, 1948-1950; diploma in Dental Public Health, 1949, 1950; diploma in Veterinary Public Health, 1950; certificate in Public Health, 1950; Master of Applied Science, 1950; Master of Applied Science in Sanitary Engineering, 1949; Post-graduate class, School of Hygiene, 1951-1953, 1956; unidentified (6).

University of Toronto, Sigmund Samuel Library, Toronto, Ont.

196P-62 b&w 60. 1951-1959.
Construction, 1953; interior and Opening, 1954; group shots, 1959; McMaster University, Arts and Science Convocation, 1951.

University of Toronto, Student Administrative Council, Varsity (newspaper), Toronto, Ont.

196P-24 b&w 7. 1905-06,1915-16, 1917-18.
Varsity Editorial and Business Board; Varsity Staff.

University of Toronto, Students Administrative Council, Toronto, Ont.

196P-25 b&w 11. 1914-1917.
Students Administrative Council.

University of Toronto, University College, Toronto, Ont.

196P-27 b&w 34. 1882-1920.
University College Literary and Scientific Society; library, airphoto pre-1910; circulation desk 1892-1910; Moss Hall, interior and exterior; University College after fire of 1890; University College; Cloister; main door; West end; Convocation procession 1920; Debating Society; Executive committee 1905; Graduating class, modern languages, 1883.

University of Toronto, University College Literary and Scientific Society, Toronto, Ont.

196P-52 b&w 1. 1877/78.
University College Literary and Scientific Society 1877-1878.

University of Toronto, University of Toronto Union, Toronto, Ont.

196P-61 b&w 4. 1905-1911.
University of Toronto Union Executive 1905/06, 1907/08, 1909/10, 1910/11.

University of Toronto, University of Trinity College, Toronto, Ont.

196P-30 b&w 57. n.d.
Photographs of buildings, provosts, chancellors, staff of Trinity College.

University of Toronto, University of Victoria College Library, Toronto, Ont.

196P-45 b&w 3. ca. 1921.
University College exterior; in winter; from west; main door, 1921.

University of Toronto Athletic Association, Toronto, Ont.

196P-14 b&w 95, col. 2, total 97. 1850-1971.
Directorate, University of Toronto Athletic Association 1893-1894, 1906-1907; University of Toronto Gymnasium Committee; School of Practical Science Athletic Association, Executive Committee 1903-1904; School of Practical Science Rugby Football Teams, Mulock Cup Champs, 1899; 2nd Varsity Football Club 1892 (A77-0043); athletic teams, Directorates of University of Toronto Athletic Association; presidents; University of Toronto Athletic Association (includes football, rugger, track and field, rowing, soccer, squash, water polo, lacrosse, tennis, swimming, basketball, gymnasium) (A73-0046).

University of Toronto Collection, Toronto, Ont.

196P-26 b&w 77. 1882-1927.
Varsity editorial and business board, n.d., 1882-1883; University of Toronto graduating class, n.d., 1883, 1889, 1890, 1897, 1899, 1903, 1905; Class Executive 1905; Mathematical and Physical society, 1901/1902, 1927/1928; University of Toronto Air photo, 1918; Students on King's College circle (A77-0046); miscellaneous buildings, St. George Campus, Biology Building, Convocation Hall, University College, Sigmund Samuel Library (A77-0045), Convocation Hall 1910; University Arms, 1917 (A73-0015); miscellaneous buildings on campus; some individual and group portraits (A65-0018).

University of Toronto Faculty of Applied Science, 1911 Graduating class, Toronto, Ont.

196P-17 b&w 237. 1911.
Individual head and shoulders portraits of 1911 graduating class, Faculty of Applied Science.

University of Toronto Faculty of Education, Toronto, Ont.

196P-20 b&w 41. 1914-1953.
Faculty of Education 1915-1916 (B73-0032); Staff and students, 1914-1917, 1920-1922, 1924-1931, 1938, 1953; summer session 1943, class executive 1922 (A74-0003); Graduating class 1920; Faculty of Education 1920; Ontario College of Education, Staff and students 1925, 1928, 1929, 1931, 1934, 1935, 1938, 1942, (A76-0014).

University of Toronto Faculty of Nursing, Toronto, Ont.

196P-28 b&w 150, col. 150, total 300. 1920-1974.
Material dealing with 50th anniversary of the Faculty of Nursing, 1974 (A73-0011); individual and group portraits of nursing classes; graduate nurses in family and medical environments, including nursing hospitals in Portugal, Burma and Africa (A73-0053).

University of Toronto Library, Toronto, Ont.

196P-31 b&w 172. 1850-ca. 1920.
Staff and faculty, University of Toronto (A73-0003).

University of Toronto Library, Exhibition Unit, Toronto, Ont.

196P-13 b&w 6, col. 1, total 7. n.d.
Portraits of Walter Barwick, Senate Library Committee 1890-1892; H.H. Langton Chief Librarian 1890-1923; W.S. Wallace, Chief Librarian 1923-1954; W.H. Van Der Smissen, Librarian 1890; John Robarts.

University of Toronto Physical Plant Department, Toronto, Ont.

196P-18 b&w 38, col. 69, total 107. ca. 1926-1971.
University Bookstore 1956; undated photographs of buildings: Archives, Arts, Botany, Forestry, Gull Lake, Knox College, Press Building, Superintendent's Building, University College Men's Residence, University College (A75-0049); original photos of houses on Sussex and Huron Streets (A73-0045); internal and external photographs of building of Varsity Arena, from excavation to completion (A74-0017).

University of Utah, Salt Lake City, Utah, educational institution.

7P-1770 b&w 17. ca. 1920-1935.
Views of Quebec and Montreal, Que., and Toronto, Ont.

University Women's Club of Winnipeg, (1909-), Winnipeg, Man.

9P-70 b&w 34. 1909-1974.
Photographs of the Club's house (home of Rev. C.W. Gordon) and Club activities.

Upper Canada College, Toronto, Ont.

196P-19 b&w 48. 1919-1965.
Athletic teams, 1961-1965; Cadet Corps officers, 1962-1965; unidentified theatrical production, portraits of principals, unidentified group photographs (A76-0003); Upper Canada College; the House (A74-0018).

Upper Ottawa Improvement Company, Ottawa, Ont.

7P-1771 b&w 999. [n.d.].
Views of various log booms and dams along the Ottawa River between Lake Timiskaming and Ottawa, Ont.; operations, buildings, personnel and ships of the Upper Ottawa Improvement Company.

Upton, William Ross, Vancouver, B.C.

7P-1772 b&w 2. ca. 1865.
Portrait of Mr. and Mrs. William Ross Upton.

Vachon, Joseph Pierre Romeo, (1898-1954), Ottawa, Ont., aviator, public servant.

7P-1773 b&w 366. 1919-1974.
Activities of M. Romeo Vachon as pilot and administrator with Laurentide Air Services Ltd., Canadian Transcontinental Airways, Canadian Airways, Quebec Air Ltd., Trans-Canada Air Lines, and the Canadian Transportation Commission, 1922-1954; portraits of Romeo Vachon and various colleagues.

Vallance, Sydney, (b. 1893), Calgary, Alta., lawyer.

166P-25 Original, b&w 264. ca. 1930-1950.
Original prints by Sydney Vallance; Rocky Mountain scenics; Sunshine ski area, Alta.

Vallée, Louis-Prudent, Quebec, Que., photographer.

7P-1774 b&w 8. ca. 1870-1880.
Views in and around Quebec, Que., ca. 1870-1880; photos by L.-P. Vallée.

Vallée, Louis-Prudent, Quebec, Que., photographer.
(Cont'd/Suite)

8P-9 b&w 18. ca. 1865-1875.
Stereographs; views of Tadoussac, Lorette Falls, Levis and Quebec City: e.g. Citadel, Notre-Dame Cathedral and St. Paul Cathedral, Que.; photos by Louis-Prudent Vallée.

Van Buren, Henry, Port Hope, Ont., collector.

7P-1775 b&w 17. 1900-1912.
Views of Halifax, Cape Blomidon, N.S.; Kennebecasis River, N.B.; Tadoussac, Sillery, Que.; Priceville, Ont.; views of steamships *Assinaboia* and *St. George;* portrait of Mr. H. Ardagh.

Van Zeggeren, Frederick, Saint-Basile-Le-Grand, Que.

7P-1780 b&w 6. ca. 1870-1899.
Exterior and interior views of house on Côte Saint-Antoine, Montreal, Que., ca. 1870; photos by A. Anderson; group photo of young people, Petit Métis, Que., 1899.

Vancouver City Archives, Vancouver, B.C.

7P-1776 b&w 1. 1930.
Canadian Track and Field Championships, Toronto, Ont., 9 August 1930.

Vancouver Public Library, Vancouver, B.C.

7P-1777 b&w 230. 1895-1933.
Views of Halifax, N.S.; Saint John, N.B.; Quebec, Montreal, Que.; Ottawa, Toronto, Niagara Falls, Ont.; Winnipeg, Man.; Victoria, Vancouver, B.C., 1895-1933.

334P-29 Copies, b&w 138. ca. 1900-1942.
New Westminster scenes: streets, buildings, parks, waterfront, market, etc.; portraits: individuals, school groups; fairgrounds,.

Vancouver Public Library Collection, Vancouver, B.C.

300P-1 b&w [200,000]. ca. 1870 to date.
This large collection deals with the history of British Columbia and the Yukon; events, street scenes, prominent people in the Vancouver area; collection includes the works of many photographers such as: Philip Timms, Percy Bentley, Mattie Gunterman, and Leonard Frank.

Vanier, Georges Philias, (1888-1967), Governor General of Canada, 1959-1967.

7P-1778 b&w 6372. 1900-1967.
Military and diplomatic career of Major-General G.P. Vanier; activities of Major-General Vanier as Governor General of Canada, 1959-1967; portraits of various members of the Vanier family, 1900-1967.

Vanier Institute of the Family, (est. 1965), Ottawa, Ont.

7P-1779 b&w 27. ca. 1965-1971.
Portraits of various members of the Board of Directors of the Vanier Institute of the Family, ca. 1965-1971.

Vaughan, Wilfrid Eldred, (b. 1905), Toronto, Ont., executive.

7P-1781 b&w 17. ca. 1946.
Filming of the motion picture *Bush Pilot,* Ontario, ca. 1946.

Vaux, George, Bryn Mawr, Pa., historian and collector.

7P-1782 b&w 7. ca. 1899.
Views of the Rocky Mountains.

Venables family, New Westminster, B.C.

334P-27 Copies, b&w 17. ca. 1890-1910.
Texas Lake Ice and Cold Storage Co., Cleeve Canning Co., ship *Cleev,* ship *War Comox* : - launching; lacrosse match, 1902; New Westminster scenes: market, City Hall, park; portraits: Percy and Richard Venables; group of men; unidentified Indian (male).

Victoria Press Ltd., Victoria, B.C.

7P-1783 b&w 115. 1940-1960.
Views of Victoria, B.C.; Construction of the Alcan Co. smelter, Kitimat, B.C.; coverage of various news events across Canada by Canadian Press photographers.

Victorian Order of Nurses, Ottawa, Ont.

7P-1784 b&w 1. 1898.
Group photo of members of the Victorian Order of Nurses who accompanied the Yukon Field Force to the Yukon, 1898.

Viets, Robert B., Ottawa, Ont., public servant.

7P-1785 b&w 5. ca. 1908-1918.
Ball at Royal Military College, Kingston, Ont.; Viets family wedding, ca. 1910; group photo of personnel of the 38th Battalion, C.E.F.

Vincent, Carl Roy, (b. 1939), Stittsville, Ont., public servant, author.

7P-1786 b&w 42. ca. 1929-1939.
Views of Cookshire, Que.; Kapuskasing, Ont.; tidal wave diaster, Newfoundland, 1929; search for survivors of SS *Viking,* Nfld., 1931; visit of H.M. King George VI and Queen Elizabeth to Newfoundland, 1939; Blackburn Shark and Fleet Fawn aircraft of the R.C.A.F.

Von Brentani, Mario, (n. 1908), Montréal (Québec), peintre et éditeur.

7P-199 b&w 31. 1965-1968.
Activities of the German-Canadian Community, Montreal, Que., 1965-1968.

7P-203 n.&b. 1,556, cou. 10, total 1,566. ca. 1960-1975.
Les activités sociales de la communauté canadienne-allemande, Montréal (Québec); photos utilisées par le journal *Montrealer Nachrichtear,* Montréal (Québec).

Voorhis, Ernest, (1859-1933), Ottawa, Ont., clergyman, public servant.

7P-1787 b&w 3. [1888].
View of Fort Churchill, Man.; view of grave of Mr. Archibald Lampman, Ottawa, Ont.; portrait of Dr. Ernest Voorhis.

Vorkony, Lazslo, Montreal, Que., photographer.

7P-1788 b&w 43,177, col. 606, total 43,783. ca. 1957-1966.
Portraits of Hungarian musicians, scientists and writers, and of prominent Hungarian-Canadians, ca. 1957-1966; photos by Lazslo Vorkony.

Waddell, William J., Calgary (Alberta).

7P-1789 Copies, n.&b. 44. 1921.
Vol des avions Junkers «Rene» et «Vic» de la Compagnie Imperial Oil vers le fleuve Mackenzie; forages, Bear Island (T.N.-O.).

Waddell family, Toronto, Ont.

196P-51 b&w 12. 1903-1905.
University of Toronto, graduating class, Arts, 1903; University College Class Executive, 1905; Croft House, University College from east, and west, 1905; University College, from southwest, from east, main door, 1905.

Wadds Bros., (ca. 1895), Vancouver, B.C., photographers.

334P-1 Copies, b&w 1. ca. 1905.
Columbia Street, New Westminster, main shopping area.

Wade, Constance E., Halifax, N.S.

1P-56 Original, b&w 9. ca. 1868-ca. 1885.
Tintypes of Wade family of Halifax, N.S.

Wade, Maxwell C., Ottawa (Ont.).

7P-1790 n.&b. 6. 1901.
Vues d'une arche érigée à l'occasion de la visite du duc et de la duchesse de Cornwall et de York, Montréal (Québec).

Wadmore, Robinson Lyndhurst, (1855-1915), militaire.

7P-1791 n.&b. 2. ca. 1885-1910.
Arche de bienvenue pour les militaires revenant de la campagne contre Louis Riel dans l'ouest canadien, Stanley Barracks, Toronto (Ont.); militaires appelés pour combattre des grévistes à Halifax (N.-E.).

Walcott, C.D.

7P-1792 Original, b&w 17. 1912.
Terrain in the vicinity of Mount Robson, B.C. 1912; photos by C.D. Walcott.

Walker, David, Dartmouth (N.-É.), océanographe.

7P-1793 n.&b. 161. ca. 1900.
Vues de la vallée d'Annapolis (N.-E); chemins de fer et gares.

Walker, Kay, Ottawa (Ont.).

7P-1794 Copies, n.&b. 2. 1935.
Portraits de F/L C.C. Walker, C.A.R.C., Ottawa (Ont.) 1935.

Wall, Ray, Calgary, Alta., professional photographer.

11P-10 Original, b&w 198. ca. 1911.
Buildings and industries in Calgary and Diamond City, Alta.

Wallace, George, Ottawa (Ont.).

7P-1796 Copies, n.&b. 61. 1900-1910.
Vues du village de Hornings Mill (Ont.).

Wallace, Joseph W., Toronto, Ont.

7P-1795 Original, b&w 81. ca. 1940.
Views of Ottawa, Ont., and vicinity taken during a trip by Mr. Wallace; detail of the stone carving in the Parliament Buildings and Victoria Museum, Ottawa, Ont.

Wallace, Mary Elisabeth, Toronto, Ont.

196P-3 b&w 1. 1897.
University of Toronto, Graduating Class in Arts, 1897.

Wallace, William Stewart, (1884-1970), Toronto, Ont., librarian and author.

16P-19 b&w 15. ca. 1860-1935.
Fur-trader, Cuthbert Grant (d. 1799) and his Métis descendants; tintypes, photos of older portraits, and several snapshots from the 1930's.

Walsh, Harry, (b. 1913), Winnipeg, Man., lawyer.

7P-1798 Original, b&w 6. 1937-1965.
Harry Walsh and his partner Harry Micay; portrait of Harry Walsh; 1937 law class, University of Manitoba, Winnipeg, Man.; Y.M.H.A. Board of Directors, Winnipeg, Man. 1953-54; Hon. E.J. McMurray.

Walter, Arnold, Dr., (1902-1973), Toronto, Ont., teacher.

149P-15 b&w [50]. ca. 1930-1970.
Basically family photographs.

Walter Moorhouse Collection, (1884-1977), Oakville, Ont., architect.

47P-1 Original, b&w 149. 1925-1971.
Buildings in Oakville, Ont., including domestic, commercial and industrial, many of which have since been demolished.

Walters, Angus, (1881-1968), Lunenburg, N.S., master mariner.

31P-20 Copies, b&w 1. ca. 1935.
Angus Walters and *Bluenose* crew.
Provenance: Bernard J. Walters, Lunenburg, N.S.

Walton, Avis, Victoria, B.C.

7P-1797 Copies, b&w 375. 1898-1940.
Chautauqua in Preeceville, Sask. 1931; views of Winnipeg, Point du Bois, Man.; Prince of Wales' visit to Winnipeg, Man.; wedding of Miss Elsie Cantell; election campaign for Mr. C.F. Gray for mayor 1919-20; Bonnington Falls, B.C. 1899; middleclass life in Winnipeg, Man.; friends and relatives of the C.F. Gray family, the Rooke family and the Curran family; Westinghouse power plants; social life; flood in Winnipeg, Man.

Ward, A.M., Ottawa, Ont.

7P-1799 Original, b&w 8. ca. 1870-1910.
J.L. Bremner family, 1910; Ward family, 1908; J.L. Bremner residence, 1906; Minnie Bremner, 1900; John Bremner, ca. 1870.

Ward, Amos P., (1900-1915), Rockport, N.B., master mariner.

31P-17 Original, b&w 44. ca. 1910-1925.
Ward family.

Ward, Howard, Ottawa, Ont.

7P-1800 Original, b&w 15. 1951, 1952.
Macdonald Brier Curling Championship meets at Halifax, N.S.,
1951, and Winnipeg, Man. 1952.

Ward, Howard H.

7P-1801 Copies, n.&b. 1. 1903.
Portrait of the Scottish Curling Team which toured Canada,
Winnipeg, Man., 1903; photo by Bryant Studio.

Ward, James, Apple Hill, Ont.

7P-1802 Copies, b&w 22. [n.d.].
Canadian National Railways and Grand Trunk Railway cranes,
swing bridge, water tower, power installations, C.N.R. engines:
2190, 2195, 2450, 2446.

Ward, Maxwell William, (b. 1921), Edmonton, Alta., executive, aviator.

7P-1803 Copies, b&w 19. ca. 1946-1974.
Max Ward with various planes he has owned and flown, and
Wardair.

Ward family, East Kootenay area, B.C., pharmacist.

333P-15 Original, b&w 11. ca. 1920.
Radium, B.C.; C.P.R. photos; Wardner, B.C.

Warden, John Weightman, (1871-1942), Victoria, B.C., soldier.

7P-1804 Original, b&w 4. 1918.
Advance of Dunsterforce through the Caucasus to Baku, U.S.S.R.

Warner, D.K., Mrs., Ottawa, Ont.

7P-1806 Copies, b&w 126. 1900's-1969.
View of St. Columba Church, Kirk Hill, Ont., 1969; Morrisburg,
Ont., agriculture, wedding, Camp Borden activities, Mont-Royal,
Que., portraits and family pictures of the Warner, Baker, and
Robertson families; 4th. Can. R.E.C.C.E. Regt., Rotterdam,
Holland; 1916, 1928, 1931 Fords, 1952 Oldsmobile; V.E.
celebration in Ottawa, Ont.; Crysler's farm monument and Cannon
Osnabruck Baptist Church; views of Ontario and Alberta; military
regiments; touring car, Vancouver, B.C.; Mystic, Que., 1913;
wedding pictures 1949.

Warner, Dorothy J., Ottawa, Ont.

7P-1805 Original, b&w 1. 1948.
Ceremony marking entry into Confederation of Newfoundland,
Ottawa, Ont., 1948; photo by Malcolm Crosby Photographs,
Ottawa, Ont.

Warner, Hilton J., Ottawa, Ont.

7P-1807 Copies, b&w 30. 1928-1945.
Personnel of the 4th Princess Louise Dragoon Guards in Italy and
Northwest Europe 1944-45; V.E. Day celebrations, Alexandria,
Ont., 8 May, 1945; scenes in Rotterdam, Netherlands, 1945;
portrait of trooper Hilton J. Warner, 4th. P.L.D.G.

Warner, Howard Willard, Ottawa, Ont.

7P-1808 Original, b&w 9. 1972-1973.
Unveiling of memorial cairn which marks the site of the home of
the parents of Sir John A. Macdonald, Rogart, Sutherlanshire,
Scotland.

Warner, Iris, Whitehorse, Yukon.

7P-1809 Copies, b&w [66]. 1890's-1960's.
Scenes in Dawson, Yukon 1925; steamers in the Yukon; various
Yukon views; Klondyke Gold Rush at Bennett Lake, Yukon 1898;
Toky Henderson at Carcross as a boy with the discoverers of gold
in Klondyke, Yukon; first greyhound bus, Jacquot's Post, Yukon;
views of Atlin Inn, Atlin B.C.; Roman Catholic Church, Dawson;
Yukon, N.W.M. Police; views of Whitehorse, Yukon; SS *Kino,
Casca, Klondike, Nasutlin* and *Bonanza King,* 1936-1960.

Warren, Stewart Wesley, Ottawa, Ont., public servant.

7P-1810 b&w 27. ca. 1860-1920.
Fire damaged ruins of Centre Block of Parliament Buildings,
Ottawa, Ont., 1916; activities and portraits of various members of
the Warren family.

Watkins, E.J., Ottawa, Ont.

7P-1811 Copies, b&w 8. 1912-1916.
Views of Chelsea, Que.; St. Lawrence Canal at Morrisburg, Ont.;
Parliament Hill, Nepean Point, Ottawa, Ont.

Watson, Arnold and Elizabeth Lees, Pottstown, Pa.

1P-57 b&w 39. 1910-1970.
Graves at Halifax of victims of the SS *Titanic* sinking; wreckage of
the SS *Titanic* at Public Archives of Nova Scotia; U.S. Coast
Guard Cutter *Modoc,* on which the first memorial service for the
victims of the SS *Titanic* was held; U.S. Coast Guard cutters which
patrolled the ice danger area after the SS *Titanic* sank.

Watson, Donald Netterville (Don), (b. 1921), Vancouver, B.C., President
Pacific Western Airlines.

7P-1812 Copies, b&w 66. ca. 1935-1965.
Saskatchewan Government Air Ambulance Service; Ontario Central
Airlines and aircraft from 1930-40's.

Watson, H., Manotick, Ont.

7P-1813 Copies, b&w 15. ca. 1890-ca. 1938.
Rideau waterways riverboats: SS *Quebec,* SS *Wanikiwan,* SS *Rideau
Queen,* SS *Buena Vista,* SS *James Swift,* SS *Loretta,* SS *Arawanna,*
SS *Saint Louis,* SS *Col. By,* SS *Westport,* SS *Sport,* SS *Rideau King,*
and SS *Quinte Queen.*

Watson, James, Ottawa, Ont.

7P-1814 Original, b&w 3. [n.d.].
H.R.H. the Princess of Wales; H.R.H. the Prince of Wales; H.M.
Queen Victoria and Princess Beatrice.

Watson, William Gerald, (1892-1974), Vancouver, B.C., flying officer,
public servant.

7P-1815 Original, b&w 2. 1918.
Aircrew of No. 211 Squadron, R.A.F., France, 13 November, 1918;
portrait of W.G. Watson, R.A.F., London, England, 1918.

Watt, Robert D., Ottawa, Ont., public servant.

7P-1816 b&w 16. 1876-1897.
View of the McFaul home, Gilead, Ont., 1876; portraits of various
members of the Greer family, Picton, Ont.

Watts, Ruth Jenkins, missionary.

> 7P-1817 Original, b&w 64. 1921.
> Photos by R.J. Watts in China: various missionaries, missions and mission activities, famine struck China.

Waugh, R.F., Ottawa, Ont.

> 7P-1818 Original, b&w 350. 1910-1921.
> Views of the Ojibwa way of life at Long Lake, Ont.

Weaver, Wilfred E., Simcoe, Ont.

> 7P-1819 Copies, b&w 10. 1918.
> Portraits of the Canadian Field Artillery, Mons, Belgium.

Weber, Harvey L.

> 9P-71 b&w 177. 1909-1930.
> Photographs of freighting and mining developments in Northern Manitoba.

Weber, M.A., Gatineau Point, Que.

> 7P-1820 Original, b&w 6. 1937.
> Hudson's Bay Co. store, Cameron Bay, N.W.T.; Coppermine Eskimos trading furs at H.B.C. store; aircraft at Yellowknife, N.W.T.

Webster, J.C. Dr., Shediac, N.B.

> 7P-1821 Original, b&w 1. [n.d.].
> Portrait of Mr. William Botsford.

Webster, K.G.T., (1871-1942), Yarmouth, N.S., educator.

> 31P-8 b&w [50]. ca. 1920-1940.
> European castles.

Weir, Ernest Austin, (1886-1968), Toronto, Ont., broadcaster.

> 7P-1822 Original, b&w 359. 1911-1956.
> Pioneering in radio, launching SS *Lady Rodney,* displays at Wembley Exhibition, England, 1924, 1925; Weir's trip in mid B.C., 1911; construction on Grand Trunk Pacific Railway and Prince Rupert Railway; farmer, marketing town in England, 1928; *R-100* at St. Hubert, July 31-Aug. 1, 1930; portraits of W.D. Robb and wife; Sir Henry Thornton.

Weir, T.N., (1915-), Cranbrook, B.C. and Fairmont, B.C., writer.

> 333P-12 Copies, b&w 7. 1895-1910.
> Cranbrook, B.C.; Fairmont, B.C.

Wellman, Frank, (d. 1919), Banff and Morley, Alta., trail guide, rancher, businessman.

> 166P-28 Original, b&w 237. ca. 1900-1920.
> Original prints collected by Frank Wellman; family photographs; Banff area people; pack trips in Rocky Mountains; Indians of Morley, Alta.

Welty, Emil Jerome, (1888-1962), Toronto, Ont., Catholic priest, university professor.

> 200P-15 b&w 900. 1919-1955.
> Basilian Fathers summer house for scholastics: Bala, Muskoka,

1919, Evelyn Island, Parry Sound, 1920; Corbeau's Island, Georgian Bay, 1921; Strawberry Island, Lake Simcoe, 1922, 1923 and about 1950; St. Michael's College and Toronto views taken between 1935 and 1955; family photographs, friends, places visited, and copies of published photographs.

Werely, Mrs., Ottawa, Ont.

> 7P-1823 Original, b&w 1. 1900.
> Hull-Ottawa fire 1900 by W.H. Connor.

West, Roland Burgess, (b. 1919), Milton, Ont., military pilot.

> 7P-1824 Copies, b&w 10. ca. 1945-1961.
> R.B. West with various aircraft.

Western Canada Aviation Museum Collection, (1974-).

> 9P-72 b&w 459. 1914 to date.
> Photographs relating to the development of aviation in Western Canada.

Weston family, Toronto, Ont.

> 18P-62 Original, b&w 4. ca. 1895-ca. 1915.
> Portraits and views of George Weston's bread factory and Joseph Weston's butcher shop.

West's Studio Ltd., (est. 1918), Regina, Sask., photographic studio.

> 10P-11 Original, b&w [750]. ca. 1914-1968.
> Personalities, government officials, members of the Legislative Assembly, city officials, members of City Council of Regina, Sask., official openings and events, sporting events, buildings, conventions, banquets, royal visits.

Wethey, H.D.W., Ottawa, Ont., public servant.

> 7P-1825 b&w 232. 1890-1910.
> Canadian Society of Civil Engineers Pacific Coast trip, 1906; views of Winnipeg, Man., Medicine Hat, Cochrane, Banff, Frank, Arrowhead, MacLeod, Crownest Mountain, Alta., Nakusp, Victoria, Bonnington, Trail, B.C.; streets, buildings, office interior, railways, constructions, agriculture, steamers, irrigation, trade show, Indians, factories and hydro-electric plants across Canada.

Wetmore, Donald, ([b. 1902]), Halifax, N.S.

> 31P-59 Original, 145. 1952-1965.
> Kings College Dramatic Club, 1890, Truro Community Theatre, 1950, Dominion Drama Festival, 1958, N.S.; Regional Dominion Drama Festival productions, College St. Anne productions, Annapolis District Drama Group productions, Acadia Playhouse, 1968, Pierre Lefevre, 1952, Jack Medhurst.

Wetton, Thomas Charles, immigration promoter.

> 9P-73 b&w 327. 1911-1913.
> Scenes in Prairie Provinces along the route of Canadian Northern Railway.

Wheatley, Frank M., (1902-1971), Bankhead and Banff, Alta., mine operator.

> 166P-40 b&w 67. 1898, 1906-1928.
> Original and copy prints collected by Frank Wheatley; views of Bankhead Mine, Banff National Park; views of town of Bankhead, Alta.

Wheeler, A.O., Ottawa, Ont.

7P-1826 Copies, b&w 7. ca. 1860-1920.
Portraits of Mrs. Josephine Bousefield, Clara and Minnie Macoun, John and Ellen Macoun, Emmaline S. Wheeler, E.O. Wheeler with Mrs. C. Wheeler and A.O. Wheeler.

Wheeler, J.A., (fl. 1889-1896), Cowansville and Knowlton, Que., photographer.

7P-1827 b&w 1. [n.d.].
Portrait of an unidentified women in an advertising jacket.

Wheelhouse Maritime Museum, Ottawa, Ont.

7P-1828 b&w 46. ca. 1887-1907.
Portraits of various members of the Pridham family, Montreal, Que.; Ottawa, Toronto, Ont.; Winnipeg, Man., ca. 1887-1907; photos by G.C. Arless, Lalonde & Son, Summerhays & Walford, A.G. Pittaway, W.J. Topley, Simpson Bros., T.E. Perkins, F.W. Parkin, C. Harding, E.J.G. Smith, J.C. Walker & Co.

White, David, Sudbury, Suffolk, England.

7P-1829 b&w 1. 1915.
Training camp at Valcartier, Que., 1915.

White, David M., Sr., (d. 1940), Banff, Alta., merchant.

166P-34 Original, b&w 154. ca. 1910-1940.
Original prints collected by Dave White Sr. concerning curling in Banff, ca. 1910-1940.

White, Harold, Toronto, Ont.

7P-1830 Copies, b&w 51. ca. 1946.
Photos of the filming of the motion picture *Bush Pilot*.

White, Jeanne I., Ottawa, Ont., public servant.

7P-1831 b&w 5. 1899-1902.
General R.S. Baden-Powell and Colonel S.B. Steele, Pretoria, South Africa; group photo of members of the South African Constabulary, 1902.

White, Lewis E., Halifax, N.S., pharmacist.

1P-20 Original, b&w 49. ca. 1870-ca. 1900.
Family photo album of unidentified individuals from Halifax, N.S., Ontario and the eastern United States.

White, Robert Allan (Bud), (b. 1928), Ottawa, Ont., military officer and pilot.

7P-1832 Copies, b&w 14. ca. 1914-1968.
Events surrounding setting of absolute altitude record by R.A. White in a CF-104; portraits of Thomas M. White and of R.A. White.

White, William Charles, (1873-1960), China and Toronto, Ont., Anglican Bishop, and archeologist.

16P-20 b&w [450]. 1897-ca. 1945.
Chinese artifacts, turn of the century, photos of Chinese missions at Fuhkien, Honan etc., photos for Bishop White's book on the Chinese Jews, photos of Bishop White's later career; Lantern slides of life in China ca. 1900.

Whitehead, Alfred, Dr., (1887-1974), Montreal, Que. and Sackville, N.B., composer, organist and teacher.

149P-16 b&w [50]. ca. 1920-1970.
Photographs of choirs he directed in Montreal and of his honorary doctorate from Queen's University.

Whitehouse, W., Mrs., Prince Rupert, B.C.

7P-1833 Original, b&w 36. 1956, 1958.
H.M.C.S. *Jonquiere,* H.M.C.S. *Oshawa.*

Whitelaw, W.M., professor.

7P-1834 Original, b&w 1. 1936.
Blockhouse, Merrickville, Ont.; photo by W.M. Whitelaw.

Whiteley, A., Ottawa (Ont.).

7P-1835 Originaux, n.&b. 30. [n.d.].
Portraits du rév. Carpenter et sa famille; vues de missions sur la rivière Saint-Paul, Salmon Bay et Bonne Espérance (Québec); bateau hôpital SS *Strathcona.*

Whiteside, Don, Ottawa (Ont.).

7P-1836 Originaux, n.&b. 78. [n.d.].
Vues de Chatham et Erieau, Ont.; scènes de rues, édifices, fabrication du sucre d'érable, golf, tennis.

Whitton, Charlotte Elizabeth, (1896-1975), Ottawa (Ont.), maire d'Ottawa (Ont.).

7P-1837 Originaux, n.&b. 1. 1955.
Dévoilement du buste commémoratif d'Agnès C. MacPhail, Chambre des Communes, édifice du Parlement, Ottawa (Ont.), 5 mars 1955 en présence de Margaret Aiken, Charlotte E. Whitton, Cairine Wilson, Ellen Fairclough.

Whyte, Catharine (Robb), (b. 1907), Banff, Alta., artist.

166P-10 Original, b&w [1,000]. 1887-1960.
Original prints and negatives collected by Catharine Whyte (Robb); Banff people and events; views of Banff townsite and surrounding area; movie making in Banff area 1922-1924; aerial photographs of Calgary to Banff area.

Whyte, Peter, (1905-1966), Banff, Alta., artist.

166P-23 Original, b&w [300]. ca. 1920-1950.
Original prints collected by Peter Whyte; scenic views of the Rocky Mountains; animals; family photographs.

Wilgress, Dana L., (1892-1969), Ottawa (Ont.), fonctionnaire.

7P-1838 Originaux, n.&b. 12. 1950-1951.
Réunion des hauts commissaires du Commonwealth à Londres, Angleterre, en mars 1951; portraits de conférences politiques internationales dans lesquelles D.L. Wilgress apparaît.

Wilkinson, Heber, Burlington (Ont.).

7P-1839 Copies, n.&b. 2. [n.d.].
Etalage d'artisanat esquimau et indien; portrait d'Arthur Duc de Connaught et de l'évêque I. Stringer.

Willan, Healey, Toronto (Ont.).

7P-1840 Copies, n.&b. 2. ca. 1890.
Portraits du Dr. Healey Willan.

Willan, James Healey, (1880-1968), London, England and Toronto, Ont., composer, organist and teacher.

149P-17 b&w [200]. 1885-1968.
Photographs from his youth, his family and friends, and his various church and teaching positions.

Willan, Mary, Londres, Angleterre.

7P-1841 Originaux, n.&b. 15. ca. 1880-1900.
Portraits du Dr. Healy Willan et de sa parenté.

Williams, Charles A., (d. 1962), Toronto, Ont., journalist.

18P-52 Original, b&w 93. 1904-1942.
Toronto, chiefly harbour and ships; Ontario scenes.

Williams, Eileen, Ottawa (Ont.).

7P-1842 Originaux, n.&b. 113. 1897-1917.
Retour de la guerre des Boers de la Section I de la Compagnie «D» en oct. 1900 à bord du bateau SS *Idaho;* la 1ère Guerre Mondiale en Mauritanie; Drill Hall, Ottawa (Ont.), 15 mars 1897; camp du 77.ème bataillon outre mer du corps expéditionnaire canadien, Rockliffe, Ottawa (Ont.), 1er oct. ca. 1914-1917; portraits de «Our Boys In Khaki» les héros outaouais dans la guerre des Boers, 1899-1900; Lord et Lady Aberdeen, mai 1897.

Williams, Fred A.

7P-1843 Original, b&w 16. 1915.
Ranching in Alberta; the cavey, dip, shutes, branding, wranglers, Bow River fishing, chuckwagon, bedwagon, dinner time.

Williams, Thomas Frederic, (n. 1885), Woodstock (Ont.), aviateur.

7P-1844 Copies, n.&b. 26. ca. 1914-ca. 1945.
Thomas Frederic Williams et différents avions qu'il a pilotés.

Williamson, G.F., Vancouver (C.-B.).

7P-1845 Copies, n.&b. 10. 1942.
Avion Blackburn Shark II de l'Escadron No. 122, corps d'aviation royal canadien, Patricia Bay (C.-B.), 1942.

Williamson, M.F., Toronto (Ont.).

7P-1846 Originaux, n.&b. 300. 1914-1917.
Vues de Salonique, Grèce; l'hôpital général canadien no. 4, Salonique Grèce; portraits de Ruby G. Peterkin.

Willis-O'Connor, Henry, (1886-1957), Ottawa, Ont., military officer.

7P-1847 b&w 669, col. 8, total 677. ca. 1880-1957.
Views of Lake Louise, Alta.; views of various rooms inside the Citadel, Quebec, Que., 1943; photos by U.S. Army Signal Corps; portraits of Rt. Hon. Winston Churchill, President Franklin Roosevelt, of various Governors General of Canada served by Colonel Willis-O'Connor, and of members of the Willis-O'Connor family.

Willows, Mabel M., Carleton Place, Ont.

7P-1848 Original, b&w 2. 1880.
Portraits of Robert Knowles.

Wilson, A.W., Sewickley (Penns.).

7P-1850 Originaux, n.&b. 1. ca. 1885.
Portrait de W.A. Wilson, avec deux soldats, bataillon Midland.

Wilson, Arthur Haliburton, (n. 1899), Vancouver (C.-B.).

7P-1849 Originaux, n.&b. 1. ca. 1928.
Avion de la British Columbia Airways Ltd.

Wilson, Barbara M., Ottawa (Ont.).

7P-1851 Copies, n.&b. 1. ca. 1875-1885.
Magasin de F.J. Wilson et Compagnie, Buckingham (Québec).

Wilson, Bernard, (n. 1908), Ottawa (Ont.), fonctionnaire.

7P-1852 Originaux, n.&b. 8. 1943-1948.
Labour Relations Board: réunions de comités.

Wilson, D.S., Toronto (Ont.).

7P-1855 Originaux, n.&b. [212]. [n.d.].
Portrait de Charles Gruppe, ca. 1920; vaisseaux navals de la première guerre mondiale; vaisseaux dans les eaux canadiennes, ca. 1914-19; salle d'opération salle d'opération pendant une intervention chimiqicale; portraits du personnel infirmier, ca. 1900-20; Carl Reinhardt travaillant sur les lignes de chemin de fer Ontario and Rainy River avec l'équipage; portrait de Carl Reinhardt.

Wilson, Hilda, Ottawa (Ont.).

7P-1856 Originaux, n.&b. 54. ca. 1870, 1900-1910.
Old Manse, Lanark (Ont.); église presbytérienne, St-Andrew; Chevrolet 1927, Lanark (Ont.), 1908; portraits de Etta Kirst Wilson, James Wilson, Effie Gilbert, Hilda Wilson, Cora Kirst, Muriel Stewart, John McLean et de pasteurs de Lanark.

Wilson, John Armistead, (1879-1954), Ottawa (Ont.), fonctionnaire.

7P-1857 n.&b. 12. [].
Portraits de J.A. Wilson.

Wilson, Marian, (n. 1926), Toronto (Ont.), administrateur artistique.

7P-1858 Originaux, n.&b 7. ca. 1967.
Production de «Tindebox» par le Toronto Children's Theatre; Ginette Reno et Donald Lautrec.

Wilson, Norman D., Toronto, Ont.

7P-1859 b&w 370. ca. 1910-1915.
Views in and around Ottawa, Ont., and Hull, Que.

Wilson, Ross, Vancouver, B.C.

12P-12 b&w 64. 1890-1915.
Sidney Island farming activities, buildings, and views, regatta on the gorge, Douglas St. parade.

Wilson, T.S., Michel, B.C.

<u>333P-29</u> Copies, b&w 6. 1910-1925.
Trains; Michel, B.C.

Wilson, Tom, (1859-1933), Banff, Alta., outfitter and trail guide.

<u>166P-16</u> Copies, b&w 511. 1861-1930.
Copies of negatives and prints collected by Tom Wilson; Stony Indians; Banff people and events; views of Banff townsite and surrounding area.
Provenance: Wilson family.

Wilson-Croft.

<u>7P-1854</u> Copies, b&w 59. ca. 1880-1950.
Township of Lanark: Hopetown School, Bullock's School pupils, sugar bush operations at Don Pretty's, parlour scene, corn cutting, picnic at Clyde River, Ont.; blacksmith shops, Stewart's mill, views of Hopetown, cheese factories, Croft's lumber and shingle mill, Middleville school, Middleville churches, Croft's store; photos of T. Stewart and family, friends, Croft family and friends.

Windsor, Ont., family portraits, Windsor, Ont.

<u>200P-9</u> b&w 74. 1880-1900.
Works of Detroit and Windsor photographers, including portrait of Sir John A. Macdonald.

Windsor Furniture Co., (1882-1933), Windsor, N.S., furniture manufacturers.

<u>31P-78</u> Copies, b&w 5. ca. 1900.
Windsor Furniture Co. plant.

Windsor Star, (the), Windsor (Ont.), journal.

<u>7P-1860</u> Originaux, n.&b. 145,290. ca. 1965-1970.
Windsor (Ont.) et villes et villages environnants ca. 1965-1968 et du 15 juillet 1969 au 8 février 1970; personnes et événements.

Winkler, Howard Waldemar, (1891-1970), Morden (Man.), homme politique.

<u>7P-1861</u> Originaux, n.&b. 1. 1933.
Visite de W.L. Mackenzie King à la résidence de Howard W. Winkler.

Winnipeg, Man.

<u>9P-74</u> b&w [10,000]. 1870 to date.
Photographs of buildings, events and social life in Winnipeg.

Winnipeg Free Press, (1874-), Winnipeg, Man., newspaper.

<u>9P-75</u> b&w [25,000]. 1948 to date.
Collection of negatives taken by staff photographers for use in a daily newspaper item of social, political and sports interest for Winnipeg and the Province of Manitoba.

Wiseman, Beverley, Brookline (Mass.).

<u>7P-1862</u> Originaux, n.&b. 21. 1894, ca. 1925-1935.
Vues de la rivière Metabachowan près de Chicoutimi (Québec), sept. 1894; vues de la péninsule gaspésienne montrant la côte et des villages côtiers, ca. 1925-1935.

Wolfe, George, Chatham, Ont.

<u>7P-1863</u> Original, []. ca. 1915-1940.
Views of Chatham, Ont.

Wolff (famille), Ottawa (Ont.).

<u>7P-1864</u> Originaux, n.&b. 60. ca. 1860-1920.
Portraits de la famille Sparks.

Woman's Canadian Historical Society, (est. 1896), Toronto, Ont., study of Canadian history and literature.

<u>314P-1</u> b&w 10. [n.d.].
Woman's Canadian Historical Society, Toronto, Ont.,.

Women's Musical Club, (1905-), Winnipeg, Man.

<u>9P-76</u> b&w 54. ca. 1950-ca. 1960.
Photographs of guest artists.

Wood, Alice, Ottawa, Ont.

<u>7P-1866</u> b&w 37. ca. 1890-1900.
Portraits of various residents of Ottawa, Perth, Winchester, Ont.; Montreal, Que.; photos by A.G. Pittaway, S.J. Jarvis, J.D. Wallis, G.A. Snider, C.B. Taggart, Ezekiel Morrison, N.M. Trickey, J.A. Dagenais.

Wood, S.T., Rockcliffe (Ont.).

<u>7P-1867</u> Originaux, []. [n.d.].
Vues du Yukon.

Wood, William Charles Henry, (1864-1947), Québec (Québec), historien et archiviste.

<u>7P-1868</u> Originaux, n.&b. 16. ca. 1900-1910.
Voiliers à Saint John (N.-B.) et à Toronto (Ont.); portrait d'un curé de l'Ile aux Coudres.

Wood family, Sackville, N.B.

<u>32P-6</u> b&w 64. ca. 1910.
Family portraits.

Woodham, Sidney J., Ottawa (Ont.).

<u>7P-1869</u> Copies, n.&b. 31. 1940.
Opérations de fret aérien de la Canadian Airways Ltd. à Beauchêne (Québec).

Wooding, H.

<u>7P-1870</u> Originaux, n.&b. 4. ca. 1865-1910.
Portrait de Thomas D'Arcy McGee; la bibliothèque, l'édifice central, et l'édifice de l'est du Parlement, Ottawa (Ont.) ca. 1895-1910; photos prises par Samuel McLaughlin.

Woodruff, Bernard J., Manotick (Ont.).

<u>7P-1871</u> Copies, n.&b. 1. ca. 1890.
Portrait de Mr John Woodruff.

Woods, Frank, (ca. 1920-), Dundas, Ont.

 <u>45P-3</u> Copies, b&w [3,500]. ca. 1868-1977.
 Hamilton and area scenes, buildings and street scapes.

Woods, Jean, Ottawa (Ont.).

 <u>185P-7</u> n.&b. 8. 1919-1937.
 Photographies de famille de Jean Woods qui illustrent sa vie
 d'étudiante à l'école Guigues, à l'Académie de la Salle, et à
 l'Université d'Ottawa; trois photos du reposoir de la Fête-Dieu en
 1927 devant la maison du dr Joseph Woods dans la Basse-Ville
 d'Ottawa.

Woodside, Henry Joseph, (1859-1929), Ottawa (Ont.), journaliste,
militaire, agent d'assurance.

 <u>7P-1872</u> Originaux, n.&b. 2,088, coul. 13, total 2,101. ca. 1880-1920.
 Vues de Port Arthur (Ont.); portraits du lieutenant-colonel Robert
 Baden-Powell, de Robert Henderson, d'officiers du Queen's
 Own Rifles; équipes de hockey de Victoria et de Winnipeg de
 1892, 1894; équipe de fusilliers du 96.ème bataillon, 1892; divers
 aspects de la carrière de H.J. Woodside; portraits de parents et
 d'amis de H.J. Woodside, ca. 1880-1914; rivière des Outaouais,
 1909; photos de famille, Bob Henderson; épave du bateau *Crofton
 Hall;* Col. A.P. Connally, 1908.

Woodsworth, James Shaver, (1874-1942), Winnipeg (Man.), Chef de la
fédération co-opérative du Commonwealth.

 <u>7P-1874</u> n.&b. 278. 1909.
 Album de photos de la famille J.S. Woodsworth; activités politiques
 de Woodsworth; All People's Mission; portraits de J.S.
 Woodsworth et de Lucy Staples; exposition du «Forward
 Movement» au Congrès des missionnaires laïcs, Massey Hall,
 Toronto (Ont.), 1909.

Woodsworth, Mr, Saskatoon (Sask.).

 <u>7P-1873</u> Copies, n.&b. 2. [n.d.].
 Danse du soleil et offrandes sacrées à la réserve indienne du Lac
 Witcheken au nord de Spiritwood (Sask.).

Woolford, Lily, Ottawa (Ont.).

 <u>7P-1876</u> Copies, n.&b. 1. 1921.
 Colonne de glace au carré de la Confédération, Ottawa (Ont.).

Wooll, G.R., St.Catherines (Ont.).

 <u>7P-1875</u> Originaux, n.&b. 2. 1919.
 Avion Vickers Vimy de John Alcock et Arthur Brown après leur vol
 trans-atlantique, Clifden, Irlande, 16 juin 1919; Elmvale, résidence
 du Major J.A. Heather, Clifden, Irlande, 16 juin 1919.

Woollcombe, George P., Mme, Ottawa (Ont.).

 <u>7P-1877</u> Originaux, n.&b. 2. 1896-ca. 1925.
 Portrait de Campbell Stewart par E.O. Hoppé ca. 1925; photos du
 rév. George P. Woollcombe avec des élèves du collège Ashbury,
 Ottawa (Ont.) par A.G. Pittaway, 1896-1900.

Worden, O.O., Toronto (Ont.).

 <u>7P-1878</u> Copies, n.&b. 2. ca. 1890.
 Portraits de la famille Balmer; John, Margaret, George, W.J. et
 Robert.

Wrathall, Jack R., Prince Rupert (C.-B.).

 <u>7P-1879</u> Originaux, n.&b. 2,430, coul. 3, total 2,433. ca. 1910-1930.
 Prince Rupert (C.-B.) et le Grand Tronc du Pacifique à Prince
 Rupert (C.-B.).

Wright, Fort Steele, B.C.

 <u>333P-27</u> Original, b&w 5. 1895-1910.
 Fort Steele, B.C. and people; Kootenay Indians,.

Wright, Charles H., Halifax, N.S., manager and engineer.

 <u>1P-4</u> Original, b&w 65. ca. 1948.
 Historic sites and monuments in Nova Scotia, including Port Royal,
 Port LaTour, Fort Pt., LaHave, Fort Pt., Guysborough, Sainte-Anne
 (Englishtown), St. Peter's, and the sites of early fortifications in
 Halifax, N.S.; photos by C.H. Wright, R.T. McCully, Frederick
 Morrison.

Wright, Jerauld George, (b. 1917), Ottawa, Ont., military officer, scientist.

 <u>7P-1880</u> Copies, b&w 12. 1940-1968.
 R-Theta Navigation Computer System; portrait of J.G. Wright.

Wurtele, W.F., Ottawa (Ont.).

 <u>7P-1881</u> Copie, n.&b. 1. ca. 1900.
 Portrait de Jonathan Wurtele.

Yarmouth Iron Foundry Agency, Yarmouth, N.S.

 <u>31P-96</u> Original, b&w 1. ca. 1885.
 Store front and staff.

Yates, K.

 <u>334P-32</u> Copies, b&w 1. ca. 1912.
 Wagon and horse teams.

Yesterday Antiques, Ottawa, Ont.

 <u>7P-1882</u> b&w 1. ca. 1901.
 Accounting Office of the Department of the Interior, Ottawa, Ont.,
 ca. 1901; Mr. C.H. Beddoe is standing at left.

Yorath, Dennis Kestell, (b. 1905), Calgary, Alta., executive, aviator.

 <u>7P-1883</u> b&w 10. 1929-1950.
 Activities of Mr. D.K. Yorath as member of the Calgary Flying
 Club, managing director of No. 5 E.F.T.S., R.C.A.F., High River,
 Alta., 1929-1941; presentation of the McKee Trophy to Mr. D.K.
 Yorath, Ottawa, Ont., 1950; photos by Capital Press, Wilfred
 Doucette.

York University Archives, Gaby Collection, Glendon Hall, Toronto, Ont.

 <u>196P-5</u> b&w 29. n.d.
 Twenty-six (26) interior, three (3) exterior (grounds) photographs
 of Glendon Hall.

Young, Ann M., Ottawa, Ont.

 <u>7P-1884</u> b&w 26. 1855-1910.
 Portraits of various unidentified residents of Yarmouth, Windsor,
 Clark's Harbour, Halifax, N.S.; Ottawa, Pembroke, Ont.,
 1855-1910; photos by A.S. Hood, L.G. Swain, W.M. Brannen, J.W.

Young, Ann M., Ottawa, Ont.
(Cont'd/Suite)

Borden, W.D. O'Donnell, O'Donnell & McLaughlin, W.J. Topley, Pittaway & Jarvis, Lancefield Abell Ltd., Harding, Robson.

Young, Franklin Inglee, (1909-1973), Toronto, Ont., aviator.

7P-1885 b&w 14. 1928-1965.
Activities of Mr. F.I. Young as pilot with Elliot Air Service, Trans-Canada Air Lines, organizer of the C.N.E. National Air Show, and winner of the McKee Trophy for 1953.

Young, J. Mrs., Montreal, Que.

7P-1886 b&w 1. ca. 1918.
Portrait of Private J.F. Young, V.C.

Young, Leda, Ottawa, Ont.

7P-1887 b&w 51. ca. 1860-1870.
Cartes-de-visite portraits of unidentified residents of Belleville, Toronto, Guelph, Stratford, St. Thomas, Ont.; photos by Allen Bros., J.A. Brock & Co., D. Campbell, G.F. Maitland, W. Marshall, Notman and Fraser, John Owen.

Young Men's Christian Association, (est. 1912), Toronto, Ont.

7P-1888 b&w 2,500. 1940-1945.
Y.M.C.A. services and activities for Canadian military personnel in Britain, 1940-1945.

Young Women's Christian Association of Canada, (est. 1893), Toronto, Ont.

7P-1889 b&w 322. 1900-1955.
International conferences of the Young Women's Christian Association; educational activities and summer camps of the Y.W.C.A. of Canada.

Yukon Archives Photograph Collection, (est. 1971), Whitehorse, Yukon.

161P-1 b&w [16,000]. 1887-1978.
Klondike Gold Rush and the Trail of '98 from Skagway and Dyea to Dawson, Yukon; street and riverfront scenes; celebrations and special events; interiors of businesses and homes; social life and sports; mining activity and dredges; sternwheelers; stagelines; roadhouses; aviation; railroad and Alaska Highway/Canal Project construction; North West Mounted Police; Yukon personalities and native people; this composite collection represents the work of professional and amateur photographers such as: E.A. Hegg; Larss and Duclos; A. Vogee; H.C. Barley; E.O. Ellingsen; J. Doody; Winter and Pond; E.J. Hamacher; Adams and Larkin; Kinsey and Kinsey; H.J. Woodside; A.C. Hirschfeld; H.D. Banks; Case and Draper; Curtis; Cantwell; Callerman; R.A. Carter; Wolfe; Goetzman; I.T. Mizony; Muirhead; Seaton; L. Irvine; W.S. Hare; R. Harrington; R.S. Finnie; G. Johnston; and Tidd.

Yukon Consolidated Gold Corporation.

7P-1890 b&w 556. 1906-1916.
Dredging operations and equipment of the Yukon Consolidated Gold Corporation in the Yukon Territory, 1906-1916; photos by E.A. Austin and A.K. Schellinger.
Ref./Réf.: NPC Finding Aid FA-7.

Zellers, Ltd., Halifax, N.S., Department store.

31P-97 Copies, b&w 4. 1945.
Halifax, VE Day Riots.

Zimmerman, Adam Hartley, (b. 1902), Ottawa, Ont., public servant.

7P-1891 b&w 66. 1899.
Visit to the Algoma district by members of the Ontario Legislature, 1899.

Zinck, Hilda, Mahone Bay, N.S., hotel owner.

1P-16 Original, b&w 15. ca. 1860-ca. 1880.
Unidentified individual portraits, group photos and scenes.

Zurakowski, Janusz, (b. 1914), Barry's Bay, Ont., aviator.

7P-1892 b&w 17. ca. 1940-1959.
Aspects of the career of Jan Zurakowski in the Royal Air Force during World War II and with Gloster Aircraft Limited and with Avro Canada Limited, 1946-1959.

Zwicker & Co. Ltd., (est. 1789), Lunenburg, N.S., merchants.

31P-69 Original, b&w 7. [n.d.].
West Indies, Gralston and Co., Frith's Saltworks, Ramon Cortada & Co.

153 Mile House Store, (1900), Cariboo, B.C., Retail store, post office.

228P-2 b&w [2], col. [36], total [38]. 1920-1978.
153 Mile House general views.

67th (Varsity) Battery Association, Toronto, Ont.

196P-1 b&w 1. 1916.
67th Battery, C.F.A., University of Toronto, June 1916.

CATALOGUE – BY – REPOSITORIES

———————

CATALOGUE PAR DÉPÔT

1P - Public Archives of Nova Scotia, Halifax, N.S.

Akins, Thomas B.	1P-3
Armstrong, Ernest Howard	1P-27
Baker, Edgar C.	1P-5
Banfield, A.W., Rev.	1P-28
Blois, Evelyn	1P-58
Bollinger, E.A.	1P-29
Bonneau, J.C.	1P-59
Byers, J.W.	1P-60
Cameron, Donald A.	1P-61
Canada, Department of Transport, Coast Guard, Aids and Waterways	1P-30
Chergwin, W.L.	1P-62
Christian, J.H. Mrs.	1P-31
Clark, Charles	1P-8
Coates, E.E.	1P-64
Commissioner of National Parks for Canada	1P-6
Connolly, Earl, Mrs.	1P-65
Connors, Thomas	1P-32
Coward, Elizabeth (Ruggles)	1P-11
Cox, Dorothy Gordon	1P-66
Craick, W.A.	1P-67
Cuthbertson, Eileen (Odevaine)	1P-68
Davidson, T.G.M.	1P-69
Densmore, Mattie,	1P-70
Derengoski, W. A.,	1P-33
Digby County, N.S.	1P-19
Dumaresq, J. Philip	1P-34
Eaton, Arthur Wentworth Hamilton	1P-35
Fader family	1P-36
Fairbanks family	1P-9
Flahiff, Margaret, Sister	1P-37
Frish, Neil A.	1P-38
Gelling family	1P-13
Godard, George	1P-12
Graves, Wesley G.	1P-39
Halifax, N.S. - Places	1P-78
Halifax Citadel	1P-15
Halifax (City)	1P-63
Halifax Local Council of Women	1P-41
Halifax Relief Commission	1P-42
Halifax School for the Blind	1P-25
Harris, Robert E.	1P-43
Hartling, Philip	1P-26
Hugill, John W.	1P-44
Irvine, John A.	1P-18
Isaac, Michael V.	1P-21
King, Andrew	1P-71
LaPierre, Dorothy	1P-45
Letson, E. Marguerite	1P-1
Lordly family	1P-7
MacKay, George Walker	1P-23
MacRitchie, John James	1P-22
Maine Historical Society	1P-47
Maritime Telegraph and Telephone Co. Ltd.	1P-72
McAloney, Elsie (Campbell)	1P-46
Moirs Ltd.	1P-48
Mullock, Vernon P.	1P-49
Notman Studio of Halifax	1P-76
Nova Scotia - Agriculture	1P-87
Nova Scotia - Army	1P-80
Nova Scotia - Furnishings	1P-83
Nova Scotia - Furniture	1P-81
Nova Scotia - Group Photographs	1P-92
Nova Scotia - Handicrafts	1P-82
Nova Scotia - Indians	1P-86
Nova Scotia - Industries	1P-88
Nova Scotia - Interior Decoration	1P-84
Nova Scotia - Navy	1P-79
Nova Scotia - People	1P-91
Nova Scotia - Places	1P-77
Nova Scotia - Ships and Shipping	1P-85
Nova Scotia - Sports	1P-90
Nova Scotia - Transportation and Communication	1P-89
Nova Scotia, Department of Public Works	1P-94
Nova Scotia Communications and Information Centre	1P-50
Nova Scotia Light and Power Co. Ltd.	1P-24
Owen, Elizabeth G.	1P-51
Payzant, Florence (Belcher)	1P-52
Punch, Terrence	1P-73
Richardson, Evelyn (Fox)	1P-93
Robertson, Hugh B.	1P-53
Rogers, Joseph S.	1P-14
Roper, M. Carol	1P-74
Slocomb family	1P-54
South Africa	1P-10
The Halifax Herald Limited (Formerly the Nova Scotian)	1P-40
Thorpe, Victor N.	1P-75
Tilley, Mary	1P-55
Tintypes and photographs	1P-2
Tucker family	1P-17
Wade, Constance E.	1P-56
Watson, Arnold and Elizabeth Lees	1P-57
White, Lewis E.	1P-20
Wright, Charles H.	1P-4
Zinck, Hilda	1P-16

2P - New Brunswick Museum, Saint John, N.B.

New Brunswick Museum	2P-1

4P - Provincial Archives of Newfoundland and Labrador, St. John's, Nfld.

Provincial Archives of Newfoundland	4P-1

5P - Public Archives of Prince Edward Island, Charlottetown, P.E.I.

Baxter, H.	5P-8
Bayer, J.A.S.	5P-9
Charlottetown Camera Club	5P-6
Charlottetown Camera Club	5P-5
Craswell, O.C.	5P-7
Gamble, Millie	5P-2
Lumsden, Elliott	5P-1
Smith, Henry	5P-4
Turner, B.H. (Jack)	5P-3

7P - Public Archives of Canada/Archives publiques du Canada, Ottawa (Ont.)

Abel, G.C.	7P-1
Adamson, Agar Stewart Allan Masterton	7P-2
Affleck, Minnie	7P-3
Air Canada	7P-4
Albertype Company	7P-5
Alessio, Orio J.	7P-6
Alexander of Tunis, Harold, Viscount	7P-7
Alexandra Studio	7P-8
Allan, Andrew Edward Fairbairn	7P-9
Allard, Alexandrine	7P-10
Allard, D.M.	7P-11
Allard, Joseph Arthur	7P-12
Allen, Phillip E.	7P-13
Allison, Gordon H.	7P-14
Allison, R.S.	7P-15
Almon, Albert	7P-16
Amateur Athletic Union of Canada	7P-17
Ames, A.J.	7P-18
Amundsen, Roals	7P-19
Anderson, A.H., Maj.	7P-20
Anderson, Douglas E.	7P-21
Anderson, Frederick	7P-22
Anderson, Rudolph Martin	7P-23
Andressen, John	7P-24
Anglin, Frank	7P-25
Annetts, Helen	7P-26
Anticosti Island	7P-28
Appleby, Arthur W.	7P-29
Appleton, W.S.	7P-30
Archer, Anthony S.	7P-31
Archer, Violet	7P-32
Archibald, William Munroe	7P-33
Archives du séminaire de Rimouski	7P-34
Arless, Richard	7P-35
Armitage, Mona	7P-36
Armstrong, Agnes	7P-37
Armstrong, Alan	7P-38
Armstrong, Frederick Henry	7P-39
Armstrong, Harry William Dudley	7P-40
Armstrong, Neil J.	7P-41
Armstrong, Omar	7P-42
Art Gallery of Ontario	7P-43
Arthur, Eric Ross	7P-44
Arthur, Richard M.	7P-45
Association of American Editorial Cartoonists	7P-46
Attanyi, Anthony	7P-47
Audet, Francis Joseph	7P-48
Audette, Louis de la Chesnaye	7P-49
August, E.M., Miss	7P-50
Austin, Bradley Sherwood	7P-51
Austin, Jacob (Jack)	7P-52
Aylan-Parker, Ronald	7P-53
Ayre, Charles P.	7P-54
Babbage, Richard Henry	7P-55
Baber, John	7P-56
Bach, Bertram	7P-57
Badanai, Hubert (Umberto)	7P-58
Badgley, C.W.	7P-59
Bahlawan, W.	7P-60
Baker, D.H.	7P-61
Baker, Raymond F.	7P-62
Baker, Russell	7P-63
Balchen, Bernt	7P-64
Ballantyne, Charles Calguhoun	7P-65
Balsdon, Allan	7P-66
Bank of Nova Scotia	7P-67
Barclay, R.G.	7P-68
Barker, William	7P-69
Barkham, B.	7P-70
Barnes, A.	7P-76
Barnett, Mary G.	7P-73
Barnett, Sydney	7P-74
Barnhart (famille)	7P-75
Bartlett, Hazel L.	7P-71
Bartlett, Robert	7P-72
Bass, W.R.	7P-77
Bataillon Mackenzie - Papineau	7P-79
Bateson, W.J.	7P-78
Battleford, Sask. - Settlement	7P-832
Baudry, C.	7P-80
Beach, D.M.	7P-82
Beale, A.M.	7P-84
Beals, C.S.	7P-85
Beament, Harold	7P-86
Beaton, Cecil	7P-88
Beaton, Neil S.	7P-87
Beattie, Stewart	7P-89
Beauchesne, Arthur	7P-90
Beaudet, Jean-Marie	7P-91
Beaudoin, Louis-René	7P-92
Beaulieu, Jean-Paul	7P-93
Beaumont, Charles	7P-94
Beck, Geoffrey Ronald	7P-95
Becker, Lavy M	7P-96
Beckstead, Ira W.	7P-97
Beeching, Charles	7P-98
Beet, Harry Churchill	7P-100
Béique, Frédéric Liguori	7P-101
Belfie, William G	7P-102
Bell, James McKintosh	7P-103
Bell, Ken	7P-104
Bell, Richard Albert	7P-105
Bell Canada	7P-99
Bellemare, Raphael	7P-106
Belson, W.R.	7P-107

7P - Public Archives of Canada/Archives
publiques du Canada, Ottawa (Ont.)

155

Bengough, Percy — 7P-109
Benjamin, Walter R. — 7P-110
Bennett, Percy — 7P-112
Bennett, Richard Bedford — 7P-111
Bennie, H.T. — 7P-113
Bergevin, A.F. — 7P-114
Bergh, Philip, Mme — 7P-115
Bernay, M. L. — 7P-116
Bernhardt, P. — 7P-117
Bernier, Joseph-Elzéar — 7P-118
Berry, A. Matt — 7P-119
Bertcly, Leo W. — 7P-121
Bessborough, Vere Brabazon Ponsonby, Comte de — 7P-123
Bessborough, Vere Brabazon Ponsonby, Mme — 7P-122
Bethel, V.M. — 7P-120
Beurling, George F. — 7P-124
Bibaud, François Marie Uncas Maximilien — 7P-125
Biberovich, Ladislaus — 7P-126
Bibliothèque municipale de Montréal — 7P-127
Biehler, J.A — 7P-128
Biesenthal, Clarence — 7P-129
Big Bear; Poundmaker — 7P-130
Big Bend Highway — 7P-1142
Bigelow, E.A. — 7P-131
Biggar, Henry P — 7P-132
Billinsky, S. — 7P-133
Birch, Arthur Nonus — 7P-134
Birch, J. Edgar — 7P-135
Bird, Florence Bayard — 7P-136
Birks, Henry et Fils Ltée. — 7P-137
Birmingham, W.H. — 7P-138
Bishop, Billy — 7P-139
Bishop, W.A. et W.G. Barker — 7P-140
Bithel, V.W. — 7P-141
Black, Harry — 7P-142
Blackman, D.A. — 7P-143
Bloom, Lloyd — 7P-144
Blouin, Jules — 7P-145
Blount, Austin Ernest — 7P-146
Blyth, M. — 7P-147
Bobcaygeon Historical Museum — 7P-149
Bodrug, John — 7P-150
Boeing Company — 7P-151
Boggis, Michael A. — 7P-152
Boivin, (famille) — 7P-153
Bompas, J.G.G. — 7P-154
Bonar, James Charles — 7P-163
Bond, Courtney Claude Joseph — 7P-164
Boorne & May — 7P-156
Borbridge, H.B. — 7P-157
Borden, Lorris Elijah — 7P-159
Borden, Robert Laird, Sir — 7P-160
Borden-Clarke — 7P-158
Borrett, R.G. — 7P-162
Borrowman, R.E. — 7P-171
Bossy, Walter J., — 7P-165
Bostock, H.S. — 7P-173
Bothwell, Marjorie — 7P-166
Boucher de LaBruère, Joseph L.O. Montarville — 7P-170
Bourassa, Anne — 7P-167
Bourchier (famille) — 7P-168
Bourdon, Louis-Honoré — 7P-169
Bourgeau, G.R. — 7P-172
Bourinot, A.S — 7P-176
Bourke, Rosalind T. — 7P-175
Bourque, F.L — 7P-174
Bovey, Wilfrid — 7P-177
Bowell, Mackenzie, Sir — 7P-178
Bowen, R.C. — 7P-179
Bowles — 7P-180
Bowles, R.S. — 7P-181
Boyd, E.D.H. — 7P-182
Boyd, John — 7P-186
Boyd, John H. — 7P-187
Boyd, Mossom — 7P-183

Boyd, Mossom & Co. — 7P-184
Boyd, Sheila A. — 7P-185
Bracken, John — 7P-188
Bradford, William — 7P-190
Bradley, H. Mme — 7P-189
Bradley, William Inglis — 7P-191
Branley, Bill — 7P-192
Brant, Joseph — 7P-196
Brant County Museum — 7P-197
Brant (famille) — 7P-195
Brant I.O.D.E. — 7P-193
Brault, Lucien — 7P-194
Breen (famille) — 7P-198
Brennan, R.L. — 7P-202
Brereton, C.R. — 7P-200
Breton, William E. — 7P-201
Brintnell, W. Leigh — 7P-204
Brisker, M. — 7P-205
Bristol, Helen Marcelle (Harrison) — 7P-206
Briston, J.F. — 7P-207
British Columbia Security Commission — 7P-208
British Empire Exhibition — 7P-209
British Railways — 7P-210
Bronson Home — 7P-211
Broomfield, George — 7P-212
Brough, J.N. — 7P-215
Brouillard, George — 7P-214
Brown, Cecil W. — 7P-223
Brown, Ernest — 7P-217
Brown, Ernest Mme — 7P-251
Brown, Francis Roy — 7P-216
Brown, H. Leslie — 7P-221
Brown, Helen — 7P-220
Brown, Howard M. — 7P-222
Brown, J.T. Mme — 7P-218
Brown, Robert, Mme — 7P-224
Brown, Roy R. — 7P-225
Bruce Mines (Ont.) — 7P-226
Bruckhof, W. & Comp — 7P-227
Bruer, Léonard — 7P-81
Brunn, Chris — 7P-228
Buchanan, Isaac — 7P-230
Buchanan, K.M. — 7P-229
Bucke, Richard M. — 7P-231
Buller, F.J. Mme — 7P-232
Bullman, Allan — 7P-233
Buntin, Gillies & Co. — 7P-234
Burbidge, Maurice — 7P-235
Burdock-Love, F.J. — 7P-236
Burian, Yvonne — 7P-237
Burkholder, Ted — 7P-238
Burn, George — 7P-239
Burpee, E.L.H. — 7P-240
Burpee, Lawrence Johnston — 7P-241
Burritt, B. — 7P-242
Burt, Alfred Leroy — 7P-243
Burton, Holmes — 7P-244
Bush, Hazel — 7P-245
Bushnell, Ernest L. — 7P-246
Butterfield, Daniel — 7P-247
Button, M.O. — 7P-248
Byng De Vimy, Julian Hedworth George Byng, Vicomte — 7P-249
Bytown Glass — 7P-250
C.T.V. Television Network — 7P-301
Caldwell, Ewan R. — 7P-252
Caldwell, John F. — 7P-253
Callaghan-Bagshaw Inc. — 7P-254
Calvin, Delano Dexter — 7P-255
Cameron, Duncan — 7P-256
Cameron, Evan Guthrie — 7P-257
Cameron, Stanley — 7P-258
Campbell, Archibald M. — 7P-259
Campbell, Donald J. — 7P-260
Campbell, Nina — 7P-261
Camsell, Charles — 7P-262
Canada, Archives publiques du Canada — 7P-1910
Canada, Archives territoriales du Yukon — 7P-1973

Canada, Atlantic Tidal Power Programming Board — 7P-1921
Canada, Bureau du Conseil Privé — 7P-1922
Canada, Bureau du Premier Ministre — 7P-1960
Canada, Centennial Commission — 7P-1898
Canada, Central Mortgage and Housing Corporation — 7P-1899
Canada, Chambre du Sénat — 7P-1896
Canada, Chambre du Sénat, Comité sénatorial sur la pauvreté — 7P-1897
Canada, Commission de la capitale nationale — 7P-1951
Canada, Commission royale d'enquête sur le statut de la femme — 7P-1968
Canada, Conseil national de recherches du Canada — 7P-1957
Canada, Department of Agriculture — 7P-1901
Canada, Department of Energy, Mines and Resources — 7P-1903
Canada, Department of Finance — 7P-1905
Canada, Department of Immigration and Colonization — 7P-1906
Canada, Department of Indian Affairs and Northern Development — 7P-1904
Canada, Department of Justice — 7P-1927
Canada, Department of Labour — 7P-1928
Canada, Department of Military and Defense — 7P-1933
Canada, Department of Munitions and Supply — 7P-1934
Canada, Department of National Defence — 7P-1976
Canada, Department of Naval Service — 7P-1974
Canada, Department of the Environment — 7P-1917
Canada, Department of the Interior — 7P-1926
Canada, Department of the Solicitor-General, Royal Canadian Mounted Police — 7P-1938
Canada, Department of the Solicitor-General Penitentiary Branch — 7P-1937
Canada, Department of Transport — 7P-1911
Canada, Dominion-Provincial Conference on Reconstruction — 7P-1941
Canada, Eastern Rockies Forest Conservation Board — 7P-1942
Canada, Economic Council of Canada, National Productivity Council — 7P-1956
Canada, Energie Mines et Ressources, Commission géologique du Canada — 7P-1916
Canada, Energy Mines and Resources, International Boundary Commission — 7P-1913
Canada, Food Prices Review Board — 7P-1943
Canada, House of Commons — 7P-1945
Canada, Les musées nationaux — 7P-1909
Canada, Library of Parliament — 7P-1947
Canada, Ministère de la Marine et des Pêcheries — 7P-1930
Canada, Ministère de la Santé nationale et du Bien-être social — 7P-1931
Canada, Ministère de l'Emploi et de l'Immigration — 7P-1929
Canada, Ministère de l'Industrie et du Commerce — 7P-1907
Canada, Ministère des Affaires des anciens combattants — 7P-1940
Canada, Ministère des Affaires extérieures — 7P-1918
Canada, Ministère des Postes — 7P-1961
Canada, Ministère des Travaux publics — 7P-1935
Canada, Ministère du Revenu national (Douane et Accise) — 7P-1932
Canada, Musée canadien de la guerre — 7P-1908
Canada, Mutual Aid Board — 7P-1949
Canada, National Battlefields Commission — 7P-1950
Canada, National Harbours Board — 7P-1953
Canada, National Library of Canada — 7P-1952
Canada, National Museums, National Museum of Science and Technology — 7P-1948
Canada, National Museums Corporation, National Gallery of Canada — 7P-1954

7P - Public Archives of Canada/Archives
publiques du Canada, Ottawa (Ont.)

156

Canada, Northern Ontario Pipe Line Crown Corporation	7P-1958	Cannon, T.			
		Cantin, Louise	7P-307	Company of Young Canadians	7P-1900
Canada, Office of the Secretary to the Governor General	7P-1970	Caouette, David-Real	7P-308	Conférence de Bruxelles de 1920	7P-380
		Card, R.C.	7P-309	Conklin, Maurice	7P-381
Canada, Resources for Tomorrow Conference	7P-1902	Carling, J. Innes	7P-310	Connor, Harry	7P-382
		Carroll, E. Gary	7P-311	Connor, W.M.	7P-383
Canada, Royal Commission into the Non-Medical Use of Drugs (Le Dain Commission)	7P-1966	Carson, Percy A.	7P-312	Constantine, Charles Francis	7P-384
		Cartier, George-Etienne, Hon. Sir	7P-313	Constantine, Henrietta	7P-385
		Cartier, Joseph-Louis	7P-314	Cook, George Douglas	7P-386
Canada, Royal Commission Investigating Halifax Disorders	7P-1964	Cartwright, John Robert	7P-315	Cook, Sidney Jabez	7P-387
		Carty, Olive E.	7P-316	Cook, Terry	7P-388
Canada, Royal Commission on Bilingualism and Biculturalism	7P-1962	Case and Draper	7P-317	Coombs, Douglas	7P-389
		Casgrain, Marie Thérèse (Forget)	7P-319	Cooper, Richard J.G.	7P-390
Canada, Royal Commission on Farm Machinery	7P-1963	Cass, Samuel	7P-318	Cooperative Commonwealth Federation	7P-391
		Castonguay, Jules Alexander	7P-320	Copland, A.D.	7P-392
Canada, Royal Commission on Newfoundland Finances	7P-1965	Catherwood, Frederick J.	7P-321	Corless, C.V.	7P-393
		Cauchon, Noulan	7P-322	Cornell University Archives	7P-394
Canada, Royal Commission on Pilotage	7P-1967	Cavoukian (Cavouk), Artin	7P-323	Côté, J.G.	7P-396
Canada, St. Lawrence River Joint Board of Engineers	7P-1969	Central Canada Veterinary Association	7P-324	Côté, Ernest A., Madame	7P-395
		Century Village Museum	7P-325	Cottingham, William McOuat, Hon.	7P-397
Canada, Secrétariat d'Etat	7P-1971	Challies, John Bow	7P-326	Cotton, William Henry	7P-398
Canada, Treasury Board	7P-1285	Champagne, Harvey Joseph Moise	7P-327	Couchman, Arthur	7P-399
Canada, Wartime Prices and Trade Board	7P-1972	Champlain Studio	7P-328	Coughlin, Mary	7P-400
Canada Air Board	7P-1919	Chandler, Albert	7P-329	Coutlee, Charles R.	7P-401
Canada Airport Inquiry Commission	7P-1920	Chapman, George Arthur Emerson, Maj.	7P-330	Covert, Earl	7P-402
Canada Atlantic Railway Old Boys' Association	7P-263	Chapman, M., Mrs.	7P-331	Cowan, E.M., Mrs.	7P-403
		Chapple, F.G., Mrs.	7P-332	Cowan, James A.	7P-404
Canada Foundation	7P-264	Chard, C.S.	7P-333	Craib, Peter	7P-405
Canada House	7P-265	Charlottetown Conference	7P-334	Crain, Harold F.	7P-406
Canada National Museums of Canada, National Museum of Natural Science	7P-1955	Charlton, John Andrew	7P-335	Craven Foundation	7P-407
		Chesterton, Lillian	7P-336	Crawford, Isabella Valancy	7P-408
Canada Steamship Lines	7P-266	Chevrier, Lionel	7P-337	Crawley Film Ltd.	7P-409
Canada's Aviation Hall of Fame	7P-269	Chiel, Arthur A.	7P-338	Crerar, Henry Duncan Graham	7P-410
Canadian Association of Amateur Oarsmen	7P-267	Chien d'or, le	7P-339	Creston Valley Archives	7P-411
		Chipman, Kenneth Gordon	7P-340	Cropp, Marjorie E.	7P-412
Canadian Authors' Association	7P-268	Chisamore, Lloyd	7P-341	Crosby, R.T., Mrs.	7P-413
Canadian Baptist Archives	7P-270	Chisholm, George Brock	7P-342	Crossley, H.N.	7P-414
Canadian Christian Council for the Resettlement of Refugees	7P-271	Christensen, J.	7P-343	Cruickshank, Ernest Alexander	7P-415
		Christie, Duncan H.	7P-344	Cruickshank, Gwen	7P-416
Canadian Citizenship Council	7P-272	Chuchla, Walter F.	7P-345	Cryderman, Raymond L.	7P-417
Canadian Commission for UNESCO	7P-273	Churchill, Gordon M.	7P-346	Cunningham, Walter	7P-418
Canadian Conference of the Arts	7P-274	Clark, Lily	7P-347	Curiosity Shop	7P-419
Canadian Dental Association	7P-275	Clarke, Borden	7P-348	Curran, John Edward Gardiner	7P-420
Canadian Federation of Agriculture	7P-276	Clarke, Katharine	7P-349	Currie, Arthur William	7P-421
Canadian Federation of Business & Professional Women's Clubs	7P-288	Clarke, Roger F.	7P-350	Currie, Garner O.	7P-422
		Claxton, Brooke	7P-351	Currie, Thomas R.	7P-423
Canadian Federation of Music Teachers' Associations	7P-277	Clay, Charles	7P-352	Currier, Cyril	7P-424
		Clay, Rush	7P-353	Curtis, Mrs. G.S.	7P-425
Canadian Federation of University Women	7P-278	Clearihue, Joyce	7P-354	Curtis, Wilfrid Austin	7P-426
		Clementt, Amelia	7P-355	Curylo, Frederick A.	7P-427
Canadian Figure Skating Association	7P-279	Clercs de Saint-Viateur de Montréal	7P-356	Curzon, George Nathanel, 1st Marquis	7P-428
Canadian Film Institute	7P-280	Cleverdon, Catherine L.	7P-357	Cuthbertson, George Adrian	7P-429
Canadian Forestry Association	7P-281	Clougher, Nugent M.	7P-358	Cutts, Anson Bailey	7P-430
Canadian Government Exhibition Commission	7P-1944	Coates, David Mervin	7P-359	Cyriax, Richard Julius	7P-431
		Coburn, C.C., Mrs.	7P-360	Dahl, E.H.	7P-447
Canadian Hadassah-Wizo	7P-282	Coderre, Joan E.	7P-361	Dale, F.N.	7P-446
Canadian Institute on Public Affairs	7P-283	Cody, H.J., Mrs.	7P-362	Dale, Jack	7P-445
Canadian Intercollegiate Athletic Union	7P-284	Cogswell, A.R.	7P-363	Dalgleish, J.B.	7P-444
Canadian Interfaith Conference	7P-285	Cohen, Horace and Lyon	7P-364	Dalglish, Alex	7P-443
Canadian Labour Congress	7P-289	Coldwell, Major James William	7P-365	Dallinger, Henry	7P-442
Canadian Ladies' Golf Association	7P-286	Cole, Jean	7P-366	Dallyn, Gordon Mealey	7P-441
Canadian Marconi Company	7P-287	Colebrook, F.H., Mrs.	7P-367	D'Altroy, R.	7P-440
Canadian Mothercraft Society	7P-290	Collier, F.C.	7P-368	Daly, Harold M.	7P-439
Canadian National Exhibition	7P-291	Colombie-Britannique, Archives provinciales	7P-369	Dalziel, W.J.	7P-438
Canadian National Railway	7P-292		7P-371	Dandurand and Marchand families	7P-437
Canadian Overseas Telecommunications Corporation	7P-293	Colombie-Britannique, Yukon, Alaska - Autoroute	7P-370	D'Angelo family	7P-436
		Columbia River Valley	7P-372	Daniels, G.	7P-435
Canadian Pacific Airlines	7P-294	Colwell, Wayne	7P-373	Darling, Gordon J.	7P-434
Canadian Pacific Railway	7P-295	Comer, George	7P-374	Darragh, Harold	7P-433
Canadian Press	7P-296	Cominco Ltd.	7P-375	Daviault, Georges A.	7P-432
Canadian Ski Museum	7P-297	Comité de la Grande Fête de Hull	7P-376	Davies, Boldwen	7P-448
Canadian Soccer Association	7P-298	Commercial and Press Photographers Association of Canada	7P-377	Davies, Frank Thomas	7P-450
Canadian Society of Microbiologists	7P-299			Davies, Raymond Arthur	7P-451
Canadian Teachers' Federation	7P-300	Commission canadienne du transport	7P-1894	Davies Book Co. Ltd.	7P-449
Canadian Theatre Centre	7P-302	Commission des chemins de fer	7P-148	Davis, H.P.	7P-452
Canadian Tribune	7P-303	Commonwealth War Graves Commission	7P-378	Davis, J.S.	7P-454
Canadian Vickers Limited	7P-304	Compagnie d'assurance-vie métropolitaine	7P-379	Davis, Jake	7P-453
Canadian Water Ski Association	7P-305			Davison, A.W.	7P-455
Canadian Writers Foundation Inc.	7P-306			Dawson, George M.	7P-456
				Day, Bernhard	7P-457

De Cruz, Hugh Emil	7P-460	Eckstein, Simon Layble	7P-537	Fotheringham, John Taylor	7P-614
De Havilland Aircraft of Canada	7P-462	Edelstein, E.R.F.	7P-538	Fowler, Walter Warren	7P-615
De Lorme, Louis Alfred	7P-465	Edmonds, Mabel and Sarah	7P-539	Fox-Movietone	7P-616
Deckson, W.A.	7P-459	Edwards, Howard	7P-540	Framed Portraits	7P-617
D'Egville, Geoffrey	7P-461	Edwards, R.G.	7P-541	Fraser, Geoffrey	7P-621
Deja, Ron	7P-463	Edwards, W.S	7P-543	Fraser, H. Douglas, Mrs.	7P-618
Delisle, Georges	7P-464	Edwards, William B.	7P-542	Fraser, Helen G.	7P-619
Demers, M.C.	7P-466	Edy Brothers	7P-544	Fraser, Ronald	7P-620
Denholm Angling Club	7P-467	Egerton, Frank, (Mrs.)	7P-546	Frechette, Louis-Honoré	7P-622
Denison, George Taylor III	7P-468	Eldorado Mining & Refining Ltd.	7P-545	Freiman, Lawrence	7P-623
Denison, M.	7P-469	Eldred, Doris E.	7P-547	Frolick, Stanley William	7P-624
Denley, Norman	7P-470	Elgin, Earl of	7P-548	Frontier College	7P-625
Denman, Harold	7P-471	Eliot, Charles W	7P-549	Frost, Patricia	7P-626
Denny, William	7P-472	Ellefsen, Marc	7P-550	Fryer, Enid	7P-627
Dependants Allowance Board	7P-473	Elliott, J. Davis	7P-551	Fryer-Keighley Collection	7P-628
Desbiens, Raymond	7P-474	Elliott, W.E.	7P-552	Fuller, Howard	7P-629
Desmond, L.A.	7P-475	Ellis, W.	7P-553	Fullerton, Elmer Garfield	7P-630
Désy, Jean	7P-476	Ells, Sidney Clarke	7P-554	Fulton, E. Davie	7P-631
Det Kongelige Bibliotek	7P-477	Elmer, V.	7P-555	Fushimi, Prince of Japan	7P-632
Detroit Marine Historical Society	7P-478	Empry, Gino	7P-556	Futvoye, E.M., Mrs.	7P-633
Dettloff, Claude P.	7P-479	England, L. (Mrs.)	7P-557	GAF Corporation	7P-634
Deyglun, Henri	7P-480	Eno, John C.	7P-558	Gallaway, William E.	7P-635
Di Giulio, Donald	7P-484	Entomological Society of Canada	7P-559	Galt, Alexander Tilloch	7P-636
Dibdin, Hanry G.	7P-488	Epstein, David	7P-560	Gamble, Alvan	7P-637
Dibney, Dora	7P-487	Erkan, Ismet	7P-561	Gammon, Arthur, Mrs	7P-638
Dickins, Clennell Haggerston	7P-486	Esson, James	7P-562	Gariepy, Edgar	7P-639
Dickson, J.R.	7P-485	Ewers, W.G. (Mrs.)	7P-563	Garrett, Roland S.	7P-640
Diefenbaker, John George	7P-489	Exposition universelle de Bruxelles	7P-565	Gaskell, I.	7P-641
Dillon, M.	7P-483	Eykyn, D.A.D.	7P-564	Gates, H.L.	7P-642
Diocese of the Arctic	7P-482	Fabien, J. Henri	7P-566	Gatineau Historical Society	7P-643
Dixon, Frederick A.	7P-481	Fackenheim, Emil L.	7P-567	Gaudard, Pierre	7P-644
Dodge family	7P-490	Fahlman, M.	7P-568	Gaudette, Alice	7P-645
Dolan, D. Leo	7P-491	Falardeau, Antoine-Sebastien	7P-569	Gault, E.F.	7P-646
Dominion Bridge Company of Canada	7P-492	Falconar-Stewart, Nita	7P-570	Gault, W. Leo	7P-647
Dominion Drama Festival	7P-494	Famee Furlane Association	7P-571	Gauthier, Clarence	7P-648
Dominion of Canada Rifle Association	7P-493	Fanshawe College	7P-572	Gauthier, Juliette	7P-649
Dominion-Wide Photographs Ltd.	7P-495	Farman, Violet	7P-573	Geggie, N.S.	7P-650
Donald, E.F.	7P-496	Faulkner, Jenifer	7P-574	Gely, Gabriel	7P-651
Donnachie, Dave	7P-497	Fayle, L.U.	7P-575	Gemmill family	7P-652
Donnell, Robert	7P-498	Feagan, Isabelle Anne	7P-576	General Motors of Canada Co. Ltd.	7P-653
Doolittle, G.A.	7P-499	Fédération des femmes libérales du		Geogevich, Alex S.	7P-654
Dore, William G.	7P-500	Canada	7P-1865	Gertsman, S. Lillian	7P-655
Dorion, Best A.	7P-501	Federation of Canadian Archers	7P-577	Gervais, H.G.	7P-656
Dornan, Harold Alexander	7P-502	Fee, Norman	7P-578	Gibbon, Murray	7P-657
Dornbush, Trevor	7P-503	Ferland, A.	7P-579	Gibbons, Alan O., Mrs.	7P-658
Doucet, H.E.T.	7P-504	Fernet-Martel, Florence	7P-580	Gibbs, S.	7P-659
Doughty, Arthur George, Sir	7P-508	Fesenko, Michael	7P-581	Gibson, William Hewison	7P-660
Douglas, George Mellis	7P-505	Fielding, P.S.	7P-582	Gilbert, Albert	7P-661
Douglas, H.T.	7P-506	Filey, Michael	7P-583	Gilbert, Walter Edwin	7P-662
Douglas, Robert	7P-507	Fillmore, W.E.	7P-584	Gilchrist, Varge	7P-663
Dowson, William C.H.	7P-509	Findlay, A.A.W. (Mrs.)	7P-585	Gilchrist, W.A., Mrs.	7P-664
Doyle, Charles Hastings	7P-510	Finland, George Harold	7P-586	Gillespie, A.	7P-665
Dragon, George E.	7P-511	Finner, Francis	7P-587	Gilmour, Thomas Chalmers	7P-666
Drew, George Alexander	7P-512	Finnish Canadian Rest Home Association	7P-588	Giroux, Albert	7P-667
Drewitt, Lillian	7P-513	Finnish Organization of Canada	7P-589	Giroux, Sylvio	7P-668
Dryden, J.W.	7P-514	First Slovak Radio Club in Canada	7P-590	Gittel, Arch A.	7P-669
Dubé, Raymond	7P-515	Firth, Edith G.	7P-591	Gladish, William M.	7P-670
Duberger	7P-516	Fischer, Sarah	7P-592	Gleason, Arthur A.	7P-671
Ducharme	7P-517	Fitzpatrick, Charles	7P-593	Glenbow Foundation, Glenbow-Alberta	
Dudeney, Gertrude	7P-518	Fitzsimmons, Ernie	7P-594	Institute	7P-672
Duff, Lyman Poore, Sir	7P-519	Flavelle, Joseph Wesley	7P-595	Globe and Mail Ltd., The	7P-673
Dufferin, Harriet Georgiana, Lady	7P-528	Fleet, Max and Neil Newton	7P-596	Gloucestershire Regiment	7P-674
Dufferin and Sappers' Bridges	7P-529	Fleming, R.B., & Co. Ltd.	7P-597	Glover, Donald A.	7P-675
Dumouchel, Jean	7P-520	Fleming, Roy F.	7P-598	Glynn, Hugh	7P-676
Dunlap, Clarence Rupert	7P-527	Fleming, Sandford	7P-599	Godin, Aimé et Raoul	7P-677
Dunlop, Edward Arunah	7P-530	Fletcher, W.A.	7P-600	Goodeve, H.T., Mrs.	7P-678
Dunlop, R.G.	7P-531	Floral Show 1974	7P-601	Gordon, Jacob	7P-679
Dunn, G.	7P-532	Flowers, J.F.	7P-602	Gordon, Norman G.	7P-680
Dunn, Oscar	7P-521	Fokes, Roy	7P-603	Gorman, Joseph	7P-681
Duplessis, Edgar	7P-522	Forbes, C. Mrs.	7P-604	Gorman, Thomas Patrick	7P-682
Dupuis, Frank J.	7P-523	Fordyce, Patrick C.	7P-605	Goulden, Robert A.	7P-683
Durand, Paul	7P-524	Forest City Coins	7P-606	Goulden, W. Taylor	7P-684
Durnford, Hugh	7P-525	Forester, Norman Gladstone	7P-607	Grace, W.J.	7P-685
Durocher, Lyman	7P-526	Forsey, Eugene	7P-608	Graham, Dorothea	7P-686
E. & H.T. Anthony & Co.	7P-27	Forward, Dorothy	7P-609	Graham, Eleanor	7P-687
Easson, A.	7P-533	Fosbery, K.G.	7P-610	Graham, Stuart	7P-688
Easson, J.G.	7P-534	Foster, George Eulas	7P-611	Grand Trunk Railway Co.	7P-689
Eckert, K.	7P-535	Foster, Margaret C.	7P-612	Grant, Charity	7P-690
Eckman, C.M.	7P-536	Foster, Ralph E.	7P-613	Grant, Maude	7P-691

7P - Public Archives of Canada/Archives
publiques du Canada, Ottawa (Ont.)

158

Grant, William Lawson	7P-693	Henry, Eugene M.	7P-772	Jackson, Mrs. J.R.	7P-852	
Grantmyre, Barbara	7P-694	Herbert, Ivor John Caradoc	7P-773	Jackson, R.E.	7P-853	
Graphic Antiquity	7P-695	Herridge, Herbert Wilfred	7P-774	Jacobs, Captain	7P-854	
Graver, Nicholas M.	7P-696	Hetherington, George A.	7P-775	Jacobson, Leon	7P-855	
Gray, Charles F.	7P-698	Hicklin, Ross	7P-776	James, George W.	7P-856	
Gray, Jack	7P-697	Hicks, A.R.	7P-777	James, Reginald Heber, Maj.	7P-857	
Gray, John, Mrs.	7P-699	Higginson, T.B.	7P-778	Jamieson, E.L.	7P-858	
Great Lakes Historical Society	7P-700	Higgs, David C.	7P-779	Jandrew, Cyrus, B., Mrs.	7P-859	
Greely, Adolphus Washington, Lt.	7P-701	Hilger, Jone	7P-780	Jarvis, Ann Frances	7P-860	
Green, T.B., Mrs.	7P-702	Hill, A. Edward	7P-781	Jarvis, Catherine G.	7P-861	
Greenaway, Keith Rogers, Brig. Gen.	7P-703	Hill, Isabel Louise	7P-782	Jarvis, Edward Aemilius	7P-862	
Greenhill, Ralph Ackland	7P-704	Hill, Shuldham H.	7P-786	Jarvis, Julia	7P-863	
Greenlees, Stephen, Mrs.	7P-705	Hillman, Aleck B.	7P-785	Jarvis, Samuel J.	7P-864	
Greer, George S.	7P-706	Hills, Albert	7P-783	Jaworski, Joachim (Jack)	7P-865	
Gregg, Milton Fowler	7P-707	Hills, Arthur J.	7P-784	Jean, J.A. Albert, Cie. Ltee	7P-866	
Grice, Arthur D.	7P-708	Hime, Maurice W.	7P-787	Jenkins, Frank Tristram	7P-867	
Griffin, Peter	7P-709	Hinchley, Harry	7P-788	Jennings, William	7P-868	
Griffis, C.H.R.	7P-710	Hines, Sherman	7P-789	Jewett, B.L., Dr.	7P-872	
Grittani, Giuseppe	7P-711	Hiscocks, Bettie	7P-790	Jewish National Fund of Canada	7P-869	
Groh, Phillip	7P-712	Historical Society of Ottawa	7P-791	Jewish Public Library	7P-870	
Grohovaz, Giovanni Angelo	7P-713	Hoag, Robert	7P-793	Jewish War Veterans of Canada	7P-871	
Grosvenor, Len	7P-714	Hockey Hall of Fame	7P-792	Jewitt, William Gladstone	7P-873	
Groupe des Sept	7P-716	Hoferichter, Norbert R.	7P-794	Joan Perkal Books	7P-1404	
Groves, R. James	7P-715	Hoffer, Clara	7P-795	Jobin, Dennis T.	7P-874	
Guillet, Edwin Clarence	7P-719	Hogan, Lyla	7P-796	Joel, Miss	7P-875	
Gunn, Norman A.	7P-718	Holden, Alan T.	7P-797	Johnson, David	7P-876	
Gustafson, David	7P-717	Holder, Richard B.	7P-798	Johnson, Eric Arthur	7P-877	
Haines, Durwards M.	7P-720	Hollick-Kenyon, Herbert	7P-799	Johnson, Henry A.	7P-878	
Halcro, W.A.	7P-721	Holmes, Alice S.	7P-800	Johnston, Clifford M.	7P-879	
Hale, Reginald B.	7P-722	Holroyde, H	7P-801	Johnston, Margot	7P-881	
Haliburton, Thomas Chandler	7P-723	Holt, Bernard N.	7P-802	Johnston family	7P-880	
Halkett, Margaret	7P-724	Home Bank of Canada (The)	7P-803	Jones, A.G.E.	7P-882	
Hall, Emmett Matthew	7P-725	Honey, F.I.	7P-804	Jones, Colin	7P-883	
Hall, Janet	7P-726	Hoodspith, Randolph B.	7P-805	Jones, Francis	7P-884	
Halle, André	7P-727	Hoover, Frederick A.	7P-806	Joss, Robert A.	7P-885	
Halliday, D.	7P-728	Hope, Lois	7P-807	Kaellgren, Peter	7P-886	
Halliday, Milton S.	7P-729	Hopper, Wilfred	7P-808	Kangas, Victor	7P-887	
Halliday, W.E. Durrant	7P-730	Horetzky, Charles George	7P-809	Kaplansky, Kalmen	7P-888	
Hambourg, Clement	7P-731	Horsdal, Paul	7P-810	Karachun, Doris	7P-889	
Hamilton, S. Ross	7P-732	Horsey, E.M.	7P-812	Karsh, Yousuf	7P-890	
Hamilton, W. Raymond,	7P-733	Horsfield, Richard E.	7P-811	Katnich, Steven	7P-891	
Hamilton, Zachary, M.	7P-734	House of Memories Museum	7P-813	Kaye (Kysilewsky), Vladimir Julian	7P-892	
Hand, Kenneth H.	7P-735	Howard, John	7P-814	Kearney, John D.	7P-893	
Hand, Stella	7P-736	Hudson, H. Paul	7P-815	Keefer, Charles A.	7P-894	
Handford, Arthur L.	7P-737	Huff, D.R.	7P-816	Keefer, Samuel	7P-895	
Hanson, Richard Burpee, Hon.	7P-738	Hughes, Nelson	7P-817	Keefer, Samuel	7P-896	
Hardy, Una M.	7P-739	Hughes, Richard	7P-818	Keen, George	7P-897	
Hare, Mary P.	7P-740	Hughson, Hugh M., Mrs.	7P-820	Keir, Ernest F.	7P-898	
Harley, Mr.	7P-741	Hughson and Company	7P-819	Keith, Gerald	7P-899	
Harlow, Frederica, Gallery Inc.	7P-742	Hume, John Alex	7P-822	Kelley, Viola	7P-900	
Harmer, William Morell	7P-743	Hume, John J.	7P-823	Kelso, John Joseph	7P-901	
Harms, William L.	7P-744	Humphrys, Elizabeth	7P-824	Kemp, A.T. Mr.	7P-902	
Harries, James Leslie	7P-745	Hunt, George	7P-825	Kendrick, H.J.	7P-903	
Harrington, Richard Walter	7P-746	Hunter, George	7P-826	Kennedy, Leo	7P-904	
Harris, Gladys M.	7P-747	Hunter, James Blake	7P-827	Kenney, Charles W., Mrs.	7P-905	
Harris, Lawren Stewart	7P-748	Huron Expositor	7P-828	Kenney, James Francis	7P-906	
Harrison, William Joseph	7P-750	Hyndman, R. Mrs.	7P-829	Kenny, Randall Y.	7P-907	
Hathaway, Ernest J., Mrs.	7P-749	Icarus, Order of	7P-830	Kerr, John Andrew	7P-908	
Hatheway, Leslie G., Mrs.	7P-751	Ide, V.R.	7P-831	Kerr, Muriel	7P-909	
Hawkins, T. Hartley	7P-753	Imperial Oil Ltd.	7P-833	Kidd, Kenneth Earl	7P-910	
Haynes, William	7P-752	Information Canada	7P-1946	Kidd, Martha Ann	7P-911	
Hays, Charles Melville	7P-754	Ingall, Gertrude L.	7P-834	Kidd, W.L.	7P-912	
Hayter, Henry Winston	7P-755	Inglis, James	7P-835	Kierans, Eric William	7P-913	
Hayward Studios	7P-756	Innes-Taylor, Allan	7P-837	Kindle, Edward Martin	7P-914	
Hazelgrove, A. Ronald	7P-757	Inness, Ronald	7P-836	King, Donna	7P-915	
Heaslip, Robert Thomas	7P-758	Innis, Harold Adams	7P-838	King, William Lyon Mackenzie, Rt. Hon.	7P-916	
Hebrew Sick Benefit Association	7P-759	International Association of Machinists	7P-842	Kingsford, William	7P-917	
Heels, C.H.	7P-760	International Civil Aviation Organization	7P-839	Kinnear, A. Muriel	7P-918	
Heeney, Arnold Danforth Patrick	7P-761	International Grenfell Association	7P-840	Kinnear, James G.	7P-919	
Hehner, Eric O.W.	7P-763	International Harvester Co. of Canada	7P-841	Kipp, Yvonne	7P-920	
Heikkila, Vihtor,	7P-764	International Labour Organization	7P-843	Kirkwood, Kenneth Porter	7P-921	
Hein, Lester C.	7P-762	Irish, King	7P-844	Kirwan, John	7P-922	
Helbecque, Raymond G.	7P-765	Irvine, W. Robert	7P-845	Kitchen, Ruth	7P-923	
Henderson, Alexander	7P-766	Irving, George Frederick	7P-846	Klein, Abraham Moses	7P-924	
Henderson, L.J., Mrs.	7P-767	Irwin, A. Mrs.	7P-847	Klotz, Oskar	7P-925	
Hendry, Janet	7P-768	Isom, E.W., Mrs.	7P-848	Knight, Stanley Neil	7P-926	
Hendry, Thomas Best	7P-769	Itomlenski, Alexander	7P-849	Knowles, Stanley Howard	7P-927	
Heney, J. Bower L.	7P-771	Iveson, Frank	7P-850	Knox, Wilbert George Melvin	7P-929	
Henry, D., Miss	7P-770	Jackson, John R.	7P-851	Knox Presbyterian Church	7P-928	

Kouri, P.J.	7P-931	Lisle, Robert	7P-1008
Krieber, Hans Johann	7P-932	Littell, Walter J.	7P-1011
Kysilewska, Olena	7P-933	Little, Margaret E.	7P-1009
La Marco, A.J.	7P-942	Littleton, Harry	7P-1010
La Rocque, Antoine-B.	7P-965	Livernois, Jules Ernest	7P-1012
Laberge, Albert	7P-934	Lizotte, M.L.V.	7P-1013
Lachance, Vernon	7P-935	Lochead, Allan Grant	7P-1014
Lackner, M.	7P-936	London and Middlesex Historical Society	7P-1015
Lady Stanley Institute Nurses' Alumni	7P-938	Lorne, John Douglas Sutherland	
Lafferty, Victor	7P-939	Campbell, Marquess of	7P-1016
Laforce, Marcel	7P-940	Lothian, George Bayliss	7P-1017
L'Alliance canadienne	7P-941	Louise Caroline Alberta, H.R.H. Princess	7P-1018
Lamb, Eileen	7P-943	Lovello, Vincent	7P-1019
Lamb, Henry John	7P-944	Low, Estelle	7P-1020
Lamb, William Kaye	7P-945	Lower, Arthur Reginald Marsden, Dr.	7P-1021
Lambart, Evelyn	7P-946	Lowes Studio	7P-1022
Lambart, H.	7P-947	Lowrey, Thomas Gordon	7P-1024
Lambert, Augustin Emanuel	7P-948	Lowry, D. Hallie	7P-1023
Lamberti, Carlo	7P-949	Lucas, Arthur	7P-1025
Lamoureux, Wilfred L.	7P-950	Lucas, Glenn	7P-1026
Lampman, Archibald	7P-951	Lucas, Leslie	7P-1027
Lanark County Museum	7P-952	Lugrin Studio	7P-1028
Lanctot, Gustave,	7P-953	Luke, L. William	7P-1029
Langevin, Edouard-Joseph	7P-954	Lummis, Floyd Bert	7P-1030
Langevin, Hector Louis	7P-955	Lynch, Francis Christopher Chisholm	7P-1031
Languedoc, Adele De Guerry	7P-956	Lynch, Francis Joseph	7P-1032
Lansdowne, Henry Charles Keith		Lyonde, Louis Laurier	7P-1033
Petty-Fitzmaurice, Marquess of	7P-957	MacAskill, Wallace R.	7P-1035
Lanthier, Joseph Antonio	7P-958	MacBeth, Madge	7P-1036
Laplante, Oswald	7P-959	MacCormack, J.	7P-1044
Lapointe, Ernest	7P-960	MacDonald, Alexander, E., Dr.	7P-1052
Lapointe, Pierre-Louis	7P-961	MacDonald, Ena	7P-1054
Laport, Edmund Abner	7P-962	Macdonald, Hugh John, Sir	7P-1055
Larden, A.W.J.	7P-963	MacDonald, James Edward Hervey	7P-1056
Larente, Arthur	7P-964	Macdonald, John Alexander, Sir	7P-1057
Larsen, Henry Asbjorn	7P-966	MacDonald, Robert James	7P-1061
Larson, E.G.	7P-967	MacDonald Funeral	7P-1051
Lascelles, Jessie L.	7P-968	Macdonald of Earnscliffe, Susan Agnes,	
Latchford, Francis Robert	7P-969	Baroness	7P-1060
Laubach, Grace	7P-970	Macdonell, Archibald Cameron, Maj.	
Laurier, Henri	7P-971	Gen. Sir	7P-1062
Laurier, Robert	7P-973	MacDougall, F.A.,	7P-1067
Laurier, Wilfrid	7P-974	MacDougall, Miss	7P-1064
Laurier House	7P-972	MacDougall, Peter	7P-1068
Lavoie, Yvon	7P-975	MacInnis, George A.	7P-1085
Lawson, K., Dr.	7P-976	MacInnis, Gerald Lester	7P-1086
Le Clair, Eleanor,	7P-982	MacInnis, Grace	7P-1087
Le Soleil	7P-992	MacIntyre, Duncan Eberts	7P-1088
Leach, Wilson George	7P-977	MacIntyre, John	7P-1089
Leacock, Stephen Butler	7P-980	MacKay	7P-1091
Leacock, Stephen Butler, Associates	7P-978	Mackay, B.R.	7P-1092
Leacock, Stephen Butler, Memorial Home	7P-979	Mackay, Dan	7P-1093
Leclair, Denise	7P-981	Mackay, Donald	7P-1094
Leech, Alice	7P-983	Mackay, W.B.F., Dr.	7P-1096
Lefebvre, J.B., Madame	7P-984	MacKelvie, John	7P-1097
Léger, Jules, Madame	7P-985	MacKenzie, Ian A., Hon.	7P-1101
Légère, Norman D.	7P-986	Mackenzie, Mary	7P-1100
Legg, Herbert K.	7P-987	Mackenzie, R.	7P-1102
Lehman, Reginald J.	7P-988	MacKeracher, Barry	7P-1103
Leigh, Zebulon Lewis	7P-989	MacKinnon, James Angus, Hon.	7P-1105
Lemieux, Lucien	7P-990	MacLaughlin, J.B.	7P-1110
Lemieux, Rodolphe	7P-991	MacLaurin, C.R.	7P-1112
Lester-Garland, George Henry	7P-993	MacLean, John, Rev.	7P-1120
Lethbridge Community Services		MacMillan, Bertha	7P-1123
Department, Sir Alexander Galt		MacMillan, George Boyd	7P-1124
Museum	7P-994	MacNaughton, Alan A.	7P-1129
Letourneau, J., Mrs.	7P-995	MacNeil, Alison F., Mme	7P-1130
Leurs, Hubert	7P-996	MacPhail, Agnes Campbell	7P-1132
Levasseur, Nazaire	7P-997	MacPhail, Andrew, Sir	7P-1133
Levi, S. Gershon	7P-998	MacPherson, Alexander F.	7P-1134
Lewis, Collis, Mrs.	7P-999	MacPherson, Hugh	7P-1135
Lewis, David	7P-1000	MacPherson, Kenneth R.	7P-1136
Lewrey, Norman	7P-1001	MacPherson, Robert George	7P-1137
Liberal Party of Canada	7P-1002	MacPherson, William Molson	7P-1138
Lidstone, F.C.	7P-1003	Macredie, John Robert Clarke	7P-1143
Lieberman, Samuel S.	7P-1004	Maernling, Jean	7P-1144
Lightfoot, Frederick, S.	7P-1005	Magrath, Charles Alexander	7P-1145
Lineham, Mrs. D.K.	7P-1006	Magro, Joseph, Mrs.	7P-1146
Link, Henry David	7P-1007	Maheux, J.T. Arthur, abbé	7P-1147

Mailhot, Charles-Edouard, abbé	7P-213
Maillard, F.J.	7P-1148
Mainguy, E. Rollo	7P-1149
Mair, Charles	7P-1150
Maison St. Mars	7P-1151
Makishi, Anno	7P-1152
Makowski, William B.	7P-1153
Mallett, Jane	7P-1154
Malott, Richard Kenneth	7P-1156
Maltese Canadian Society of Toronto	7P-1157
Manitoba Museum of Man	7P-1158
Mann, Stella C.	7P-1159
Manning, Ralph V.	7P-1160
Manoir Richelieu	7P-1161
Maple Leaf Gardens	7P-1162
Marconi, Guglielmo	7P-1163
Marion, Lucette	7P-1164
Marion, Séraphin	7P-1165
Markwick, William A.G.	7P-1166
Marlatt, R.H., Mrs.	7P-1167
Marquet, Maurice C.	7P-1168
Marshall, G.L.	7P-1169
Marsters, J.H.	7P-1170
Martin, Maureen R.	7P-1171
Martin, Paul-Joseph-James, Hon.	7P-1172
Mason, Herbert G.	7P-1173
Massey, Charles Vincent, H.E.	7P-1178
Massey, Hart	7P-1176
Massey and Flanders, Architects	7P-1175
Massey (famille)	7P-1174
Massey Museum	7P-1177
Massicotte, Edmond-Joseph	7P-1179
Mathers - Rice - Jessop	7P-1180
Mathewson, F. Stanton	7P-1184
Matsumoto, Isamu	7P-1181
Matthes, Tinchen	7P-1182
Matthews, James Skitt, Major	7P-1183
Mattingly, A.	7P-1185
Maunder, John	7P-1186
May, Barbara	7P-1187
May, Wilfred Reid	7P-1188
Mayer, Charles	7P-1189
McArthur, D.C.	7P-1034
McBratney, Helen L.	7P-1037
McBride, Berta A.	7P-1038
McCann, Edward	7P-1039
McCartney, Gordon	7P-1040
McClung, Mark	7P-1041
McConachie, George William Grant	7P-1042
McCormick, Dan	7P-1043
McCracken, Budd	7P-1046
McCracken, George W.	7P-1047
McCrae, John	7P-1045
McCullough, C.R.	7P-1048
McCurry, Harry Orr et Dorothy L.	7P-1049
McDermott, Louis	7P-1050
McDonald, C.D. Mrs.	7P-1053
McDonald, Marion and Mary	7P-1058
McDonald, Percy	7P-1059
McDougall	7P-1063
McDougall, A.H.	7P-1065
McDougall, C.	7P-1066
McElhinney, M.G., Dr.	7P-1069
McEwen, C.M., Mme.	7P-1070
McFarlane, Brian	7P-1071
McGee, Frank	7P-1073
McGee, Thomas D'Arcy, (Hon.)	7P-1074
McGiffin, J.S., Mrs.	7P-1075
McGill, Frank S.	7P-1076
McGill, Herbert F.	7P-1077
McGill University Archives	7P-1078
McGillivray, Charles A.	7P-1079
McGlashan, Clarke	7P-1080
McGreevy, Brian I.	7P-1081
McGregor, Gordon Roy	7P-1082
McGuire F.R., Capt.	7P-1083
McIlraith, George J., Hon.	7P-1084
McIntyre, Stanley,	7P-1090
Mckay, Robert Alexander	7P-1095

7P - Public Archives of Canada/Archives
 publiques du Canada, Ottawa (Ont.)

160

McKendry, Jean		Montizambert, Frederick, dr.	7P-1242	Notre-Dame-du-Sacré-Coeur Convent	7P-1324
McKinley, John	7P-1099	Montminy, J.V.	7P-1243	Nouveau parti démocratique	7P-1325
McKnight, Wes	7P-1104	Montreal, Que	7P-1244	Nulty, Joseph H.	7P-1326
McLaren, F.E.	7P-1106	Montreal Album	7P-1245	Nurse, W.H.	7P-1327
McLaren, J.W.	7P-1107	Montreal Book Auctions	7P-1246	Nutt, David C.	7P-1328
McLaughlin, D.	7P-1108	Montreal Star	7P-1249	Oaks, H.A., Mrs.	7P-1329
McLaughlin, Samuel	7P-1109	Moore, Delbert C.	7P-1247	Oakwell, Sydney, Rev.	7P-1330
McLean, Alexander Daniel	7P-1111	Moore, Tom	7P-1250	O'Brien, A.H.	7P-1331
McLean, Bruce, Mrs.	7P-1113	Moorhead, W.G.	7P-1251	O'Brien, Walter J.	7P-1332
McLean, Howard V.	7P-1114	Morant, Nicholas	7P-1252	Office national du film, (l')	7P-1295
McLean, J.R.	7P-1115	Morgan, Harry	7P-1253	Ogilvie, William	7P-1335
McLennan, F.D.	7P-1116	Morgan, Ian C.	7P-1254	Ogilvy, Charles, Ltd.	7P-1333
McLennan, Francis	7P-1118	Morisset, Jean-Paul	7P-1257	Ogilvy, Stewart M.	7P-1334
McLeod, Albert M.	7P-1117	Morisset, P.	7P-1256	O'Grady, Gerald F. de Courcy	7P-1336
McMaster University	7P-1119	Morning, Isaac	7P-1258	O'Hanley, John Lawrence Power	7P-1337
McMillan, Alexander	7P-1121	Morris, Edmond	7P-1255	Oldford, Henry R.	7P-1338
McMillan, Stanley Ransom	7P-1122	Morris, William, Hon.	7P-1259	O'Leary, Peter Michael	7P-1339
McMullen, Archie	7P-1125	Morrison, Harold R.W.	7P-1260	O'Meara, J.E.	7P-1340
McNabb, Grace	7P-1126	Morrow, James	7P-1261	O'Neil, James G.	7P-1341
McNaughton, Andrew George Latta,	7P-1127	Morse, Charles		Ontario, Archives of Ontario	7P-1342
Gen.		Morton, L.C.P.	7P-1262	Ontario, Ministère des Terres et Forêts	7P-1343
McNeill, John, Rev.	7P-1128	Motherwell, William Richard, Hon.	7P-1263	Ontario, Ministère du Tourisme et de	
McQuarrie, Joseph P.	7P-1131	Mount, Marie	7P-1264	l'Information	7P-1345
McQuinn, I.M. (Ted)	7P-1139	Mount Zion Masonic Lodge (No. 28)	7P-1265	Ontario Agricultural College	7P-1347
McWilliams, James L.	7P-1140	Muirhead, Arnold Gillies	7P-1266	Ontario Hydro	7P-1346
Mead, Bert W.	7P-1141	Mulcahy, Stan	7P-1267	Ontario Labour Committee for Human	
Measures, W. Howard	7P-1190	Mulherin, Herbert W.	7P-1268	Rights	7P-1348
Medd, S.T.	7P-1191	Munro, D.G., Mrs.	7P-1269	Oppen, Jean, Mrs.	7P-1349
Media Club of Canada	7P-1192	Munro, George Reid	7P-1270	Ordre de Jacques Cartier	7P-1350
Medical Council of Canada	7P-1193	Munro, Raymond Alan	7P-1271	Orillia Public Library	7P-1351
Medland, Margaret	7P-1194	Munro, William Bennett	7P-1272	Osberg, Edith	7P-1352
Meech, Asa	7P-1195	Murphy, Charles, Hon.	7P-1273	Ostrom, Ethel	7P-1353
Meech, L.M.	7P-1196	Murphy, Joseph J.	7P-1274	Ottawa and District Labour Council	7P-1361
Meek, John F.	7P-1197	Murray, Alexa	7P-1276	Ottawa Board of Education	7P-1354
Meek, R.J.	7P-1198	Murray, G.B. & Son	7P-1277	Ottawa Camera Club	7P-1355
Meekren, R.J.	7P-1199	Murray, L.F.	7P-1278	**Ottawa Citizen** (the)	7P-1356
Mefsut, Paul	7P-1072	Murray, Leonard Warren, Rear Admiral	7P-1279	Ottawa Historical Society	7P-1357
Ménard, Jean	7P-1200	Murray, William Ewart Gladstone	7P-1280	Ottawa Horticultural Society	7P-1358
Mendelsohn, A., Brig. gen.	7P-1201	Muscowitch, Alex S.	7P-1281	Ottawa Jewish Historical Society	7P-1359
Menier, Georges, Madame	7P-1202	Musée de l'artillerie royale canadienne	7P-1282	**Ottawa Journal**	7P-1360
Meredith, Colborne Powell	7P-1203	Musée Laurier	7P-1283	Ottawa Little Theatre	7P-1362
Merkley family	7P-1204	Mutual Benefit Society of St. Joseph	7P-1286	Ottawa Local Council of Women	7P-1363
Merrifield, Nelson	7P-1205	Mynarski, Andrew V.C.	7P-1287	Ottawa Public Library	7P-1364
Merrilees, A. Andrew	7P-1206	N.E. Thing Co., Ltd.	7P-1297	Otter, William Dillon	7P-1365
Metcalfe, Willis	7P-1207	Naftel, William	7P-1288	Ouellet, Jacques	7P-1366
Michaud, Joseph W.	7P-1208	Nakamura, Richard Yoshio	7P-1289	Ouimet, Gédéon, Hon.	7P-1367
Michell, William Arthur Rupert	7P-1209	Nakashian, (Nakash), A. George	7P-1290	Ouimet, Paul G.	7P-1368
Michener, Daniel Roland, S.E.	7P-1210	National Ballet Guild of Canada	7P-1291	Outram, Alan A.	7P-1369
Michener, Norah Willis	7P-1211	National Congress of Italian-Canadians	7P-1292	Owen, Cambridge	7P-1370
Michigan, Department of State, History	7P-1212	National Council of Women of Canada	7P-1293	Pacific Press Ltd.	7P-1371
Division		National Farm Radio Forum	7P-1294	Pacific Western Airlines	7P-1372
Micklethwaite, John	7P-1213	National Liberal Federation	7P-1296	Packard, Frank Lucius	7P-1373
Millar, David	7P-1214	Nedza, Michal	7P-1298	Pammett, Howard T.	7P-1374
Miller, David, Mrs.	7P-1215	Neikrug Galleries	7P-1299	Panet, Antoine de Lotbinière, Maj.	7P-1375
Miller, Evelyn	7P-1216	Nelson, A.V.H., Mrs.	7P-1300	Panoramic Camera Co.	7P-1376
Miller, Florence	7P-1217	New Brunswick Museum	7P-1301	Papineau, Louis Joseph, Hon.	7P-1377
Miller, Mabel	7P-1218	New York Rangers Hockey Club	7P-1305	Papineau, Talbot Mercer	7P-1378
Millman, Thomas, Dr.	7P-1219	Newman, Archibald Hamilton	7P-1302	Park, Edward P.	7P-1379
Mills, Belle	7P-1220	Newnham, Jervois Arthur	7P-1303	Park, Seth	7P-1380
Mills, John M.	7P-1221	Newton, Neil	7P-1304	Parker, David W.	7P-1381
Milne, David Brown	7P-1222	Nicholas, Tressilian C.	7P-1306	Parker, John E.	7P-1382
Milne, J.M.	7P-1223	Nicholls and Parkin Popular Photograph		Parker, John Primrose	7P-1383
Milne, James	7P-1224	Parlors		Parkin, George Robert, Sir	7P-1384
Milne, Robert	7P-1225	Nicholson, Leonard Hanson	7P-1308	Parkin, Raleigh	7P-1385
Mineau, Jacqueline	7P-1226	Nicoll, Marion	7P-1307	Parsons, Johnson Lindsay Rowlett	7P-1386
Minifie, James M.	7P-1227	Nicolson, G.B.	7P-1309	Parsons, S.H.	7P-1912
Minnesota Historical Society	7P-1228	Nield, A.	7P-1310	Patrick, George	7P-1388
Missori, Marco	7P-1229	Nishima, C.	7P-1311	Pattias, Fortunato	7P-1387
Mitchell, Charles Hamilton	7P-1230	Niven, Alexander	7P-1312	Patton, George E.	7P-1389
Mitchell, Coulson Norman, Capt.	7P-1231	Noble, John E.	7P-1313	Peagam, F.R.	7P-1390
Mitchell, Thomas	7P-1232	Nordegg, Martin	7P-1314	Peake & Whittingham	7P-1391
Mitchell-Turner Air Photos	7P-1233	Norfolk County Historical Society	7P-1315	Pearce, A. Douglas	7P-1392
Miyagawa, George Sutekichi	7P-1234	Norrish, Wilbert Henry	7P-1316	Pearse, Charles	7P-1393
Miyazaki, Masajiro, Dr.	7P-1235	North, Dick	7P-1317	Pearson, Lester Bowles, Très Hon.	7P-1394
Moar, Jack	7P-1236	North American Conference on		Peck, Mary	7P-1395
Moffat, Leo	7P-1237	Conservation of Natural Resources	7P-1318	Pedersen, C.T.	7P-1396
Moir, L.H.	7P-1238	Noseworthy, Joseph William	7P-1319	Pederson, Carl	7P-1397
Mole, Dennis A.	7P-1239	Notman, James Geoffrey, Mme	7P-1320	Pelletier, Louis Philippe	7P-1398
Molson, Kenneth M.	7P-1240	Notman, William	7P-1322	Pelletier, Winnifred	7P-1399
			7P-1241		7P-1323

7P - Public Archives of Canada/Archives
 publiques du Canada, Ottawa (Ont.)

161

Perch, David G.	7P-1401
Perepeluk, Wasyl John	7P-1402
Performing Arts Collection	7P-1403
Perry, R.G.	7P-1405
Peterborough Centennial Museum and Archives Collection	7P-1406
Peters, Frederic Hatheway	7P-1407
Peterson, Harold L	7P-1408
Petrie, Alfred E.H.	7P-1409
Petrie, H. Leslie, Col.	7P-1410
Petrigo, Walter	7P-1411
Phillips, Allan S.	7P-1412
Phillips, Frank	7P-1413
Phillips, George Hector Reid	7P-1414
Phillips, Gordon George	7P-1415
Phillips, Lazarus	7P-1416
Phipps, Welland Wilfred	7P-1417
Photo-Montreal	7P-1419
Photographic Stores Ltd.	7P-1418
Pickings, Harry B.	7P-1420
Pietropaulo, Vincenzo	7P-1421
Pike, Frederick R.	7P-1422
Pikulin, Michael Alan	7P-1423
Pilcher, Samuel	7P-1424
Pilot, Dorothy	7P-1425
Pinard, Arthur A.	7P-1426
Pittaway, Alfred George	7P-1427
Pittaway and Jarvis	7P-1428
Plaut, W. Gunther	7P-1429
Polish Alliance Friendly Society of Canada	7P-1430
Pollard, Arthur V.	7P-1431
Polson, Kathleen	7P-1432
Pontiac Historical Society	7P-1433
Ponting, A.H.	7P-1434
Ponton, William Nisbet	7P-1435
Pope, Beatrice	7P-1436
Pope, Joseph	7P-1437
Porsild, Alf Erling, Dr.	7P-1438
Port Arthur Album	7P-1439
Porter, N.J.	7P-1440
Potter, Jean	7P-1441
Potter, Ray A.	7P-1442
Pouliot, Jean-François	7P-1443
Pounden, Charles Edward	7P-1444
Poussette, Henry Rivington	7P-1445
Powell, Alan	7P-1446
Powell, C. Berkeley	7P-1447
Powell, Walter	7P-1448
Power, Charles Gavan	7P-1449
Power, William Pendleton	7P-1450
Preble, Norman A.	7P-1451
Press Library (the)	7P-1452
Preston, G. Violet	7P-1453
Price, Agnes	7P-1454
Price, Basil	7P-1455
Price, Henry Edward	7P-1456
Princess Patricia's Canadian Light Infantry	7P-1457
Prior-Wandesforde, Maureen E.	7P-1458
Pritchard, James	7P-1459
Pritzker, Lee	7P-1460
Professional Photographers of Canada Inc.	7P-1461
Progressive Conservative Party of Canada	7P-1462
Propp, Daniel	7P-1463
Proulx, Roger	7P-1464
Pullen, Hugh Francis	7P-1465
Pullen, Thomas C.	7P-1466
Putnam, G.G.	7P-1467
Quebec Battlefields Association	7P-1468
Queen's University	7P-1469
Quick, Norman Charles	7P-1470
Quipp, C.H., Mrs.	7P-1471
Quirt, Bessie	7P-1472
Rabin, Joseph	7P-1473
Racicot, Vincent	7P-1474
Racine, Marie-Paule	7P-1475
Rae, John	7P-1476
Ralston, James Layton, Hon.	7P-1477
Randall, Robert Cheetham	7P-1478
Rasminsky, Louis	7P-1479
Rawson, Bernard Anderson, Capt.	7P-1480
Ray, Marcel	7P-1481
Rayfield, Victor C.	7P-1482
Reany, Meredith	7P-1483
Reford, Robert	7P-1484
Regiment of Canadian Guards	7P-1485
Reid, D. Smith	7P-1486
Reid, Robert Sutor	7P-1487
Reid, Thomas Mayne	7P-1489
Reid, W. Harold, Rev.	7P-1490
Reid Studio	7P-1275
Reilly, John Hardisty	7P-1491
Reinhardt, Carl	7P-1492
Renaud, M.	7P-1493
Renaud, Osias	7P-1494
Rennie, George	7P-1495
Rhodes, Edgar N.	7P-1496
Rhodes, Harold L.	7P-1498
Rhodes, Henry G.	7P-1497
Richardson, Arthur John Hampson	7P-1499
Richardson, Bruce Harder	7P-1500
Riddiford, Walter G.	7P-1501
Rider-Rider, William	7P-1502
Riley, Barbara	7P-1503
Riley, John	7P-1504
Riley, Marjorie	7P-1505
Rinfret, Bertha	7P-1506
Ritchie's Sport Shop	7P-1507
Roberts, A.B.	7P-1508
Roberts, Joan	7P-1509
Roberts, Marian	7P-1510
Robertson, Anne S.	7P-1511
Robertson, Lois	7P-1512
Robertson, Melvin Norman Williams	7P-1513
Robertson, Peter David Williams	7P-1514
Robinson, Benjamin	7P-1515
Robson Lang Leathers Ltd.	7P-1516
Roebuck, H.A.	7P-1517
Roebuck, John Arthur	7P-1893
Rogers, Marion G.	7P-1518
Rohland, Terry	7P-1519
Rolland, Roch	7P-1520
Rood, James Lindsay	7P-1521
Roosevelt, Theodore	7P-1522
Roscoe, Peter	7P-1523
Roseberg, Louis	7P-1524
Rosenberg, Stuart E.	7P-1525
Rosenblatt, Joe	7P-1526
Rosewarne, Robert Victor	7P-1527
Ross, Eli M.	7P-1529
Ross, Graham	7P-1530
Ross, W. Lawlor	7P-1531
Rossland, B.C. - Mines	7P-1532
Roth, Michael M	7P-1533
Rourke, James Ernest	7P-1534
Rowe, J.Y.	7P-1535
Roxborough, Myrtle	7P-1536
Roy, Anastase	7P-1537
Roy, Arthur	7P-1538
Royal Canadian Academy of Arts	7P-1539
Royal Canadian Corps of Signals Museum	7P-1540
Royal Canadian Corps of Signals Museum	7P-1975
Royal Canadian Mounted Police Museum	7P-1541
Royal Engineers (Institution of the)	7P-1542
Royal Society of Canada	7P-1543
Royal Tour of 1860	7P-1544
Royal Tour of 1901	7P-1545
Royal Tour of 1919	7P-1546
Royick, Alexander	7P-1547
Rozmus, Karol	7P-1528
Rudisill, Richard	7P-1548
Russell, Robert	7P-1549
Rutherford, Robert William, Capt.	7P-1550
Ryan, James	7P-1551
Ryan, Patrick	7P-1552
Sadlier-Brown, Nowell	7P-1559
Saint Andrew's United Church	7P-1553
Saint John Regional Library	7P-1555
St. John's Convent	7P-1554
St. Laurent, Louis Stephen	7P-1556
St. Laurent, William	7P-1557
St. Lawrence Seaway Authority	7P-1558
Sair, Samuel	7P-1560
Sallows, Reuben R.	7P-1561
Salton, George F.	7P-1562
Sandler, Martin W.	7P-1563
Sarrault, Henri	7P-1564
Sasaki, Steve	7P-1565
Saskatchewan Archives	7P-1566
Saunders, Charles E.	7P-1568
Sauve, Maurice	7P-1569
Savage, John A., Mrs.	7P-1570
Savage, Marion Greelman	7P-1571
Scarth, Marion and Jessie	7P-1572
Schmalz, William Henry Eugene	7P-1573
Schneider, Stuart	7P-1574
Schull, Joseph	7P-1575
Schuster, Nigel	7P-1576
Scott, Desiré Elise	7P-1577
Scott, George T	7P-1578
Scott, Lloyd E.W.	7P-1579
Scott, W.L.	7P-1581
Scott, William D.	7P-1580
Scribner's Sons, Charles	7P-1582
Sculptors Society of Canada	7P-1583
Seagrim, Herbert Walter	7P-1584
Seaner, N.B.	7P-1585
Seleshko, Matthew	7P-1587
Sellar, Robert Watson	7P-1586
Semak, Michael	7P-1588
Seymour, Horace L.	7P-1589
Seymour, Murton Adams	7P-1590
Shaw, Edith	7P-1591
Shaw, Nell	7P-1593
Shaw, Nellie	7P-1594
Shaw Festival Theatre	7P-1592
Shenstone, Beverley Strahan	7P-1595
Shepherd, R.W.	7P-1596
Shepherd, R.W., Mrs.	7P-1597
Sheriffs, A.J.	7P-1598
Sherry, Agnes B.	7P-1599
Sherwood, Arthur Percy	7P-1600
Sherwood, H. Crossley	7P-1601
Sherwood, Helen	7P-1602
Sherwood, Livius P.	7P-1603
Shiels, Michael Joseph	7P-1604
Shipman, N.C.	7P-1605
Shortill, R.M.	7P-1606
Shortreed, Robert	7P-1607
Showalter, H.A., Dr.	7P-1608
Showler, John Gavin	7P-1609
Shute, Elizabeth	7P-1610
Shuttleworth, Gertrude	7P-1611
Siemens, Abe	7P-1612
Sifton, Arthur Lewis, Rt. Hon.	7P-1613
Sifton, Nellie	7P-1614
Sigouin, Leon, Rev.	7P-1615
Silverthorne, F.G.	7P-1616
Simm, Donald	7P-1617
Simmons, Donald B.	7P-1618
Simpson, Beatrix	7P-1619
Sims, Arthur George	7P-1620
Simzer, Earl D.	7P-1621
Sise, Hazen	7P-1622
Sissons, Charles Bruce	7P-1623
Sjostedt, Jessie	7P-1624
Skinner, L.B.	7P-1625
Skuce, G.O., Mrs.	7P-1626
Skuce, Lester	7P-1627
Slack, W	7P-1628
Sladen, Arthur F.	7P-1629
Slattery, Beatrice C.	7P-1630
Sloan, John Charles	7P-1631

7P - Public Archives of Canada/Archives
publiques du Canada, Ottawa (Ont.)

162

	
Smith, Arthur Y.	7P-1633
Smith, C.E. Stanfield	7P-1634
Smith, Charles Lyman	7P-1635
Smith, Deane C	7P-1636
Smith, Edith M.	7P-1637
Smith, Elizabeth	7P-1638
Smith, H.D.	7P-1639
Smith, Maurice	7P-1640
Smith, Minnie C.	7P-1641
Smith, Philip E.L.	7P-1642
Smith, Strathy	7P-1643
Smith, Thomas Benton	7P-1644
Smithsonian Institution	7P-1645
Sneddon, Wilfred	7P-1646
Société d'archéologie de Rivière-du-Loup	7P-1647
Sommerer, Karl	7P-1648
Spalding, J. Frederick	7P-1649
Spear, Bertha	7P-1651
Spence, Charles	7P-1652
Spencer, Elihu	7P-1653
Spencer, Henry	7P-1654
Spencer, L.B.	7P-1655
Spencer, Leonard	7P-1656
Spier, Jack	7P-1657
Spiteri, Ed	7P-1658
Sports Hall of Fame	7P-1659
Spreadbury, Alfred	7P-1650
Spremo, Boris,	7P-1660
Spurr, Norman	7P-1661
Stanfield, Robert Lorne	7P-1662
Stanhope, Lady	7P-1663
Stanier, S. Edward P.	7P-1664
Staniforth, Alan	7P-1665
Stanley, Ruby	7P-1666
Starke, Sarah G.E.	7P-1667
Station CKAC	7P-1668
Steel, William Arthur, Lt. Col.	7P-1669
Steele and Company	7P-1670
Stein, C.E.	7P-1671
Stevens, Henry Herbert	7P-1672
Stevens, William H.	7P-1673
Stevenson, Leigh Forbes	7P-1674
Stewart, Dorothy	7P-1675
Stewart, Hugh R.	7P-1676
Stewart, James S., Rev.,	7P-1677
Stewart, John Smith	7P-1678
Stewart, Sheila	7P-1679
Stewart, Walter P.,	7P-1680
Stitt, Donald Monroe	7P-1681
Stone, Edgar J.	7P-1682
Story, Norah	7P-1683
Stratford and Perth County Archives	7P-1684
Strong, Elmer T.	7P-1685
Stuart, Ronald Neil	7P-1686
Studio Impact	7P-1687
Studio Jac-Guy	7P-1688
Studio Max Sauer	7P-1567
Studio Notman d'Halifax	7P-1321
Stursberg, Peter	7P-1689
Suarez, Andrew L.	7P-1690
Sutherland, John	7P-1691
Sutherland, Robert Franklin	7P-1692
Swannell, F.	7P-1693
Swettenham, John Alexander	7P-1694
Swindell, Dorothy M.E.	7P-1695
Sydney, Susie	7P-1696
Szilasi, Gabor	7P-1697
Tabaret, Joseph Henri, Rev. Frère	7P-1698
Taconis, Kryn	7P-1699
Tanner, Douglas	7P-1700
Tapper, Lawrence F.	7P-1701
Tapper, Murray Harvey	7P-1702
Tardif, Thérèse	7P-1703
Tardivel, Louis	7P-1704
Tarte, Joseph	7P-1705
Taschereau, André	7P-1706
Tash, Roy	7P-1707
Tata, Sam	7P-1708
Taylor, Albert C.	7P-1709
Telfer, John W.	7P-1710
Tesla, Iwan	7P-1711
The Gazette	7P-1248
Théâtre du Nouveau Monde	7P-1712
Thierbach, Otto	7P-1713
Thomas, Gladys	7P-1714
Thomas, Gordon Evan	7P-1715
Thomas, Sandra	7P-1716
Thompson, A.H., Mrs.	7P-1717
Thompson, F.K.	7P-1718
Thompson, Marjorie J.	7P-1719
Thompson, Phillip W.	7P-1720
Thompson, R.T.	7P-1723
Thompson, Richard Rowland	7P-1722
Thompson, Robert Norman	7P-1721
Thoms, Elise	7P-1724
Thomson, Malcolm M.	7P-1725
Threlfall, Frederick W.	7P-1726
Thurber, Robert	7P-1727
Tigert, Thomas	7P-1728
Tilley, Samuel Leonard	7P-1729
Tillott, Lorna	7P-1730
Timmis, Reginald Symonds	7P-1731
Timms & Howard	7P-1732
Tognotti, Allan	7P-1733
Tomlinson, Samuel Anthony	7P-1734
Topley, William James	7P-83
Toronto Camera Club	7P-1735
Toronto City Hall	7P-1736
Toronto Daily Star	7P-1737
Toronto Harbour Commissioners	7P-1738
Toronto Public Library	7P-1739
Toronto Teacher's College	7P-1740
Toronto Telegram	7P-1741
Toronto Transit Commission	7P-1742
Traill Family	7P-1743
Train, J.W.	7P-1744
Trevena, John E.	7P-1745
Tripp, Leonard John	7P-1746
Trudel, Géraldine	7P-1747
Tucker, M. Grace	7P-1748
Tudhope, John Henry	7P-1749
Tupper, Charles, Sir	7P-1750
Tupper, William Johnston	7P-1751
Turk, Sidney	7P-1753
Turnbull, Duncan R.	7P-1752
Turner, F. Leonard	7P-1754
Turner, Percival Stanley	7P-1755
Turner, Thomas H.	7P-1756
Tweed, Thomas William	7P-1757
Twist, John L.	7P-1758
Uchida, Matasaburo	7P-1759
Ukrainian Canadian Committee	7P-1760
Ukrainian Free Academy of Science	7P-1761
Ukrainian National Youth Federation of Canada	7P-1762
Underhill, Frank Hawkins	7P-1763
United Church of Canada Central Archives	7P-1764
United Electrical, Radio and Machine Workers of America	7P-1765
United Packinghouse Workers	7P-1766
United Steelworkers of America	7P-1767
University of Ottawa Library	7P-1768
University of Saskatchewan Institute for Northern Studies	7P-1769
University of Utah	7P-1770
Upper Ottawa Improvement Company	7P-1771
Upton, William Ross	7P-1772
Vachon, Joseph Pierre Romeo	7P-1773
Vallée, Louis-Prudent	7P-1774
Van Buren, Henry	7P-1775
Van Zeggeren, Frederick	7P-1780
Vancouver City Archives	7P-1776
Vancouver Public Library	7P-1777
Vanier, Georges Philias	7P-1778
Vanier Institute of the Family	7P-1779
Vaughan, Wilfrid Eldred	7P-1781
Vaux, George	7P-1782
Victoria Press Ltd.	7P-1783
Victorian Order of Nurses	7P-1784
Viets, Robert B.	7P-1785
Vincent, Carl Roy	7P-1786
Von Brentani, Mario	7P-203
Von Brentani, Mario	7P-199
Voorhis, Ernest	7P-1787
Vorkony, Lazslo	7P-1788
Waddell, William J.	7P-1789
Wade, Maxwell C.	7P-1790
Wadmore, Robinson Lyndhurst	7P-1791
Walcott, C.D.	7P-1792
Walker, David	7P-1793
Walker, Kay	7P-1794
Wallace, George	7P-1796
Wallace, Joseph W.	7P-1795
Walsh, Harry	7P-1798
Walton, Avis	7P-1797
Ward, A.M.	7P-1799
Ward, Howard	7P-1800
Ward, Howard H.	7P-1801
Ward, James	7P-1802
Ward, Maxwell William	7P-1803
Warden, John Weightman	7P-1804
Warner, D.K., Mrs.	7P-1806
Warner, Dorothy J.	7P-1805
Warner, Hilton J.	7P-1807
Warner, Howard Willard	7P-1808
Warner, Iris	7P-1809
Warren, Stewart Wesley	7P-1810
Watkins, E.J.	7P-1811
Watson, Donald Netterville (Don)	7P-1812
Watson, H.	7P-1813
Watson, James	7P-1814
Watson, William Gerald	7P-1815
Watt, Robert D.	7P-1816
Watts, Ruth Jenkins	7P-1817
Wawgh, R.F.	7P-1818
Weaver, Wilfred E.	7P-1819
Weber, M.A.	7P-1820
Webster, J.C. Dr.	7P-1821
Weir, Ernest Austin	7P-1822
Werely, Mrs.	7P-1823
West, Roland Burgess,	7P-1824
Wethey, H.D.W.	7P-1825
Wheeler, A.O.	7P-1826
Wheeler, J.A.	7P-1827
Wheelhouse Maritime Museum	7P-1828
White, David	7P-1829
White, Harold	7P-1830
White, Jeanne I.	7P-1831
White, Robert Allan (Bud)	7P-1832
Whitehouse, W., Mrs.	7P-1833
Whiteley, A.	7P-1834
Whiteside, Don	7P-1835
Whitton, Charlotte Elizabeth	7P-1836
Wilgress, Dana L.	7P-1837
Wilkinson, Heber	7P-1838
Willan, Healey	7P-1839
Willan, Mary	7P-1840
Williams, Eileen	7P-1841
Williams, Fred A	7P-1842
Williams, Thomas Frederic	7P-1843
Williamson, G.F.	7P-1844
Williamson, M.F.	7P-1845
Willis-O'Connor, Henry	7P-1846
Willows, Mabel M.	7P-1847
Wilson, A.W.	7P-1848
Wilson, Arthur Haliburton	7P-1850
Wilson, Barbara M.	7P-1849
Wilson, Bernard	7P-1851
Wilson, D.S.	7P-1852
Wilson, Hilda	7P-1855
Wilson, John Armistead	7P-1856
Wilson, Marian	7P-1857
Wilson, Norman D.	7P-1858
Wilson-Croft	7P-1854
Windsor Star , (the)	7P-1860

7P - Public Archives of Canada/Archives
 publiques du Canada, Ottawa (Ont.)

163

Wiseman, Beverley	7P-1862
Wolfe, George	7P-1863
Wolff (famille)	7P-1864
Wood, Alice	7P-1866
Wood, S.T.	7P-1867
Wood, William Charles Henry	7P-1868
Woodham, Sidney J.	7P-1869
Wooding, H.	7P-1870
Woodruff, Bernard J.	7P-1871
Woodside, Henry Joseph	7P-1872
Woodsworth, James Shaver	7P-1874
Woodsworth, Mr	7P-1873
Woolford, Lily	7P-1876
Wooll, G.R.	7P-1875
Woollcombe, George P., Mme	7P-1877
Worden, O.O.	7P-1878
Wrathall, Jack R.	7P-1879
Wright, Jerauld George	7P-1880
Wurtele, W.F.	7P-1881
Yesterday Antiques	7P-1882
Yorath, Dennis Kestell	7P-1883
Young, Ann M.	7P-1884
Young, Franklin Inglee	7P-1885
Young, J. Mrs.	7P-1886
Young, Leda	7P-1887
Young Men's Christian Association	7P-1888
Young Women's Christian Association of Canada	7P-1889
Yukon Consolidated Gold Corporation	7P-1890
Zimmerman, Adam Hartley	7P-1891
Zurakowski, Janusz	7P-1892

8P - Archives of Ontario, 77 Grenville St., Queens' Park, Toronto, Ont.

Archives of Ontario Collection	8P-16
Bartle Brothers	8P-11
Boyd, John	8P-6
Donovan, Duncan	8P-14
Esson, James	8P-8
Hammond, Melvin Ormond	8P-1
Hayward, Lawrence	8P-5
MacNamara, Charles	8P-2
Milne, Gilbert A.	8P-13
Notman, William	8P-7
Peters, H.	8P-15
Powley, Gordon W.	8P-12
Segwun Steamship Museum	8P-3
Stereograph	8P-10
Thomas, David L.	8P-4
Vallée, Louis-Prudent	8P-9

9P - Provincial Archives of Manitoba, Winnipeg, Man.

Agriculture - Manitoba	9P-46
Baker, Frederick Clements	9P-1
Barber, George Thomas	9P-2
Bell, Frederick Charles	9P-3
Boissevain Community Archives Collection	9P-82
Bradell, David L.	9P-5
Burns, Thomas	9P-6
Campbell, John A.	9P-7
Canadian Army Photo Collection	9P-8
Canadian Women's Press Club	9P-9
Clare, F.A.	9P-10
Cockburn, W.H.	9P-77
Cowell, John	9P-11
Cowley, F.P.V.	9P-12
Crocker, Ernest	9P-13
Daly, George J.	9P-14
Davidson, George	9P-15
Dearing, W.E.	9P-16
Ewanchuk, Michael	9P-81
Fainstein, Clara	9P-17
Foote, Lewis Benjamin	9P-19
Garbutt, Dorothy	9P-20

Goodman, Gisli	9P-21
Green, John	9P-22
Grégoire, Félix	9P-23
Griffis, Edith	9P-24
Gunn, George H.	9P-25
Hall, Frank	9P-26
Hamilton, Zachary M.	9P-27
Hicks, James Henry	9P-28
Hime, Humphrey Lloyd	9P-29
Holland, L.J., Mrs.	9P-30
Jessop, Cyril	9P-31
Jewish Historical Society of Western Canada Inc.	9P-32
Joannidi, S.N.C.	9P-33
Johnson, Herbert Stanley	9P-34
Johnstone, Barbara	9P-35
Jones, J.G.	9P-36
Kennedy, Margaret	9P-37
Kerr, John	9P-38
Knapp, Martha de Jong	9P-80
Lawrie Wagon and Carriage Co. Ltd.	9P-39
Leach, Frederic, Bro.	9P-40
Letourneau, Henri	9P-41
Lindsay, Robert	9P-42
Lowe, Freeman Henry Hetherington	9P-43
MacLeod, Margaret Arnett	9P-44
Malaher, G.W.	9P-45
Manitoba - Architectural Survey	9P-47
Manitoba - Personalities	9P-18
Manitoba Communities	9P-48
Manitoba Highways	9P-49
Manitoba Photo Library Collection	9P-50
Manitoba settlement	9P-51
Manitoba Telephone System	9P-54
Manitoba Water Surveys	9P-53
Mathers, Charles W.	9P-55
Mihaychuk, Andrew	9P-56
Morris, Edmund Montague	9P-57
New Iceland Collection	9P-58
Newton, J.W.	9P-59
North American Boundary Commission	9P-4
Paterson, R.W.	9P-61
Polish Canadian Pioneer Survey	9P-62
Rackham, William	9P-63
Riel Rebellion	9P-60
Rindisbacher, Peter	9P-64
Rinehart, F.A.	9P-79
Rupert's Land Collection	9P-66
Russel, J.H.G.	9P-65
Simonite, Charles Edward	9P-78
Sisler, William James	9P-83
Sisler, William James	9P-67
Spurrill, Dan	9P-68
Thomas, A. Vernon	9P-69
Transportation - Manitoba	9P-52
University Women's Club of Winnipeg	9P-70
Weber, Harvey L.	9P-71
Western Canada Aviation Museum Collection	9P-72
Wetton, Thomas Charles	9P-73
Winnipeg, Man.	9P-74
Winnipeg Free Press	9P-75
Women's Musical Club	9P-76

10P - Saskatchewan Archives Board, Regina, Sask.

Howard, John,	10P-8
James, W.J.	10P-10
Munro, Douglas John	10P-9
Pittman, Harold Herbert	10P-14
Saskatchewan, Department of Agriculture	10P-2
Saskatchewan, Department of Agriculture, Livestock Branch	10P-3
Saskatchewan, Department of Education	10P-6
Saskatchewan, Department of Highways	10P-4
Saskatchewan, Department of Highways, Ferry Branch	10P-5

Saskatchewan, Photographic Art Services	10P-7
Saskatchewan Wheat Pool	10P-12
The **Star-Phoenix**	10P-13
West's Studio Ltd.	10P-11

11P - Glenbow-Alberta Institute, Calgary, Alta.

Biggs, Hugh Beynon	11P-12
Bird, R.A.	11P-4
Bruce, Robert Randolph	11P-11
Cameron, Benjamin Serby	11P-9
Gano, John Henry	11P-8
Hileman, T.J.	11P-7
Lomen Brothers	11P-1
Lupson, Arnold	11P-2
McDermid Studios Ltd.,	11P-13
Oliver, William J.	11P-3
Rafton-Canning, A.	11P-5
Stocken, Canon Harry Gibbon	11P-6
Wall, Ray	11P-10

12P - Provincial Archives of British Columbia, Victoria, B.C.

B.C. Department of Lands and Works, Water Rights Branch	12P-18
Blanchet, Guy	12P-22
Blenkinsop, Edward Weyman	12P-16
Bratt, Marion, Mrs.,	12P-25
Cass, John	12P-11
Church family	12P-6
Clark, Cecil	12P-9
Clearihue, J.B.	12P-27
Dodge, George Blanchard	12P-8
Eastcott, J.C., lieutenant surgeon	12P-21
Flewin, W.R.	12P-5
Grossman, John	12P-24
Hermon, E.B.	12P-4
Howse family	12P-20
Hume, John F.	12P-15
Jones, H.W., Mrs.	12P-13
Jupp, Ursula	12P-10
McDonald, J.E.	12P-26
Orchard, C.D.	12P-2
Orr family	12P-17
Perry, M. Eugenie	12P-3
Redonda Bay	12P-19
Reed, T.F. Harper	12P-23
Scott, E.B.	12P-14
Turnball, A.D.	12P-7
Wilson, Ross	12P-12

13P - Provincial Archives of Alberta, Edmonton, Alta.

Alberta, Department of Culture, Provincial Archives	13P-7
Alberta, Government Services, Bureau of Public Affairs	13P-6
Alberta Legislature Library	13P-10
Anglican Church of Canada, Diocese of Athabasca	13P-12
Anglican Church of Canada, Diocese of Edmonton	13P-11
Bamber, W. Harry	13P-5
Blyth, Alfred	13P-3
Brown, Ernest	13P-1
Edmonton Journal	13P-8
Fitzsimmons, Robert C.	13P-13
Hoare, Robert	13P-4
Pères Oblats de Marie Immaculée des Territoires du Nord-Ouest	13P-9
Pollard, Harry	13P-2

15P - Archives d'études, Moncton (N.-B.)

Institutions d'enseignement francophones du Nouveau-Brunswick	15P-6

Personnalités acadiennes 15P-3
Rassemblements acadiens, 15P-5
Université de Moncton 15P-1
Université Saint-Joseph 15P-2

16P - Thomas Fisher Rare Book Library, Toronto, Ont.

Alexander, William John 16P-1
Banting, Frederick Grant 16P-2
Birney, Earle 16P-3
Bland, John Otway Percy 16P-4
Bronowski, Jacob 16P-6
De La Roche, Mazo 16P-7
MacLachlan, Lorne E. 16P-10
MacNeil, John Alexander 16P-11
Mavor, James 16P-13
McIlwraith, Thomas Forsyth 16P-9
New Play Society 16P-14
Taylor, Thomas Griffith 16P-17
Tyrrell, Joseph Burr 16P-18
Wallace, William Stewart 16P-19
White, William Charles 16P-20

18P - Metropolitan Toronto Central Library, Toronto, Ont.

Aberdeen and Temair, John Campbell
 Hamilton Gordon, Marquess of 18P-16
Adamson, Anthony 18P-56
Albertype Company 18P-58
Allen, Orval W. 18P-96
Arthur, Eric Ross 18P-53
Baldwin, William Willcocks 18P-30
Band family 18P-82
Bethune, A.M. 18P-46
Blakey, Joseph Adamson 18P-10
Brigden family 18P-84
Canada, Legislative Assembly 18P-31
Church, Thomas Langton 18P-43
Coatsworth, Emerson 18P-59
Dally, Frederick 18P-8
Denison family 18P-68
Dent family 18P-61
Derry, Douglas M. 18P-27
Empringham, George 18P-55
Faulkner, Charles 18P-66
Fisken, John, and Co. 18P-75
Fitch, Stephen 18P-85
Fleming, Robert John 18P-71
Fletcher family 18P-49
Freeland, William Thomson 18P-36
Great Britain, Army, Rifle Brigade 18P-37
Greig family 18P-81
Guillet, Edwin Clarence 18P-44
Hamwood family 18P-86
Harman family 18P-65
Henderson, Alexander 18P-24
Henderson, Alexander 18P-4
Hicklin, Ralph 18P-69
Hime, Humphrey Lloyd 18P-9
Horn, John 18P-33
Janes, Simeon Heman 18P-63
Jefferson, Harry 18P-78
Johnson, William Main 18P-90
Jones, Arthur Stanley 18P-97
Judd, William Wallace 18P-93
Logan, William Edmond, Sir 18P-35
MacTavish, Newton McFaul 18P-77
Manning family 18P-47
McLean, E.H. 18P-22
McLean family 18P-73
McLennan, Roderick 18P-45
McMeckan family 18P-25
McMillan, Neil Lamont 18P-72
Mulock, William, Sir 18P-18
Notman, William 18P-3
Ogilvie, William 18P-38

Ontario, Department of Crown Lands 18P-23
Ontario, Legislature 18P-57
Ontario Motor League, Toronto Club 18P-54
Pickthall, Marjorie Lowry Christie 18P-34
Poole, F.N. 18P-40
Port Stanley, Ont. 18P-26
Puccini, Abramo 18P-92
Quebec and Lake St. John Railway
 Company 18P-6
Queen's Hotel 18P-19
Rea, (Hermanos), Cigar Factory 18P-50
Reed, Thomas Arthur 18P-2
Rempel, John I. 18P-13
Resource Rangers Leadership Training
 Camp 18P-74
Roberts, Vaughan Maurice 18P-39
Robertson, John Ross 18P-79
Robertson, John Ross 18P-1
Robertson, John Ross 18P-15
Robertson, John Ross 18P-11
Robertson, John Ross 18P-7
St. Stephen's-in-the-Fields Anglican
 Church 18P-91
Salmon, James Victor 18P-12
Shenston, Thomas Strachan 18P-42
Sifton, Clifford, Sir 18P-21
Simpson, James 18P-51
Smith, Larratt William 18P-64
Smith, Larratt William 18P-60
Snider family 18P-87
Staples, Owen P. 18P-76
Thompson, Elizabeth J. 18P-28
Topley, William James, 18P-5
Toronto, Ont. 18P-89
Toronto, Ont. 18P-29
Toronto, Ont., East End Day Nursery 18P-48
Toronto, Ont., Fire, 1904 18P-80
Toronto, Ont., High Park Sanitarium 18P-70
Toronto, Ont., Monuments 18P-20
Toronto, Stereographs 18P-32
Toronto Cricket, Skating and Curling
 Club 18P-83
Toronto Cricket, Skating and Curling
 Club 18P-95
Toronto Cricket, Skating and Curling
 Club 18P-67
Toronto Public Library 18P-88
Toronto Public Library 18P-17
Toronto Public Library, Beaches Branch 18P-14
Toronto Public Library, Yorkville Branch 18P-94
Tyner family 18P-41
Weston family 18P-62
Williams, Charles A. 18P-52

22P - Lennox and Addington Historical Society, Napanee, Ont.

Lennox and Addington Historical Society 22P-1

24P - United Church of Canada, Maritime Conference Archives, Halifax, N.S.

Maritime Conference of the United
 Church 24P-1

31P - Dalhousie University Archives, Halifax, N.S.

Acadia Gas Engine Co. 31P-75
Adams, Frank Dawson 31P-3
Amherst Internment Camp 31P-42
Archibald, Sanford 31P-33
Balcom, Samuel 31P-12
Ballon, Ellen 31P-99
Belmont (Barque) 31P-103
Best, J. Linden 31P-62
Bigelow, John 31P-104
Blackett, Arthur E., Dr. 31P-39

Bluenose (Schooner) 31P-105
Bridgewater Hospital Chorus and Drama
 Society 31P-64
Brodie, Fred 31P-114
Brown, Sibella 31P-43
Bruce, Charles Tory 31P-36
Burpee, Lawrence Johnston 31P-15
Campbell, G.D., and Sons 31P-66
Cashman, Caroline, Mrs. 31P-37
Clifford, Theodore A., Mrs. 31P-21
Colchester Historical Society 31P-106
Corston, James, Dr. 31P-23
Creighton family 31P-11
Cumberland County Council 31P-44
Cyril T (Schooner) 31P-107
Dalhousie University 31P-1
Dartmouth, N.S. 31P-45
Davison, Edward S. 31P-82
Dawson, Robert MacGregor 31P-25
Day, Frank Parker 31P-32
De Mille, James 31P-4
Dickie, Alfred 31P-73
Dimock family 31P-27
Dominion Chair Co. 31P-72
Dominion Drama Festival, Nova Scotia
 Region 31P-58
Donovan, Oscar Glennie 31P-31
Dunbrack, Charlotte S. 31P-46
Ernsberger 31P-83
Farquhar, George 31P-121
Faulkner, Dora 31P-30
Fillmore, Roscoe Alfred 31P-118
Fort Point, California, U.S.A. 31P-47
Halifax, N.S. - Places 31P-48
Halifax Photographic Co. 31P-84
Handy, Clifford 31P-108
Harrington, Charlotte Geddie 31P-29
Hector Centre 31P-110
Higgonson's Plaster and Marble Dust
 Works 31P-85
Himmelman, George, Capt. 31P-40
Hood, A.S. 31P-86
Kempton, Gilbert 31P-87
Kings College 31P-49
Kinred, Sheila 31P-50
La Have Outfitting Co. 31P-77
Logan, John Daniel 31P-98
Longley, C.F. 31P-10
Lunenburg Outfitting Co. 31P-76
MacDonald, Vincent C. 31P-14
MacDougall, E. 31P-26
MacEachern, George 31P-113
MacGillivray, Dougald, Dr. 31P-51
MacKay, Donald Cameron 31P-28
MacKenzie, Simon 31P-13
MacKenzie, William Roy 31P-35
Mackie, Irwin Cameron 31P-120
MacLennan, Charles 31P-111
MacLeod, Anna E. and James O. 31P-2
MacLeod, Hector 31P-19
MacMechan, Archibald McKellar 31P-9
Majestic Theatre 31P-65
McClearn Co. Ltd. 31P-88
McClennan, Charles A. 31P-89
McCurdy, Avis Marshall 31P-38
Morse, William Inglis 31P-101
Neptune Theatre Foundation 31P-57
Newcombe & Baird 31P-90
Notman, William 31P-91
Nova Scotia Drama League (N.S.D.L.) 31P-61
Nova Scotia Federation of Labour
 (N.S.F.L.) 31P-116
O'Brien, Osmond 31P-81
O'Donnell, W.D. 31P-92
Oil Chemical and Atomic Workers
 International Union - Local 9-825 31P-115
Parker Eakins Co. Ltd. 31P-68
Pickford and Black Ltd. 31P-71
Pictou County Trades and Labor Council 31P-117

Raddall, Thomas Head	31P-18
Rice, Lewis	31P-93
Rice, Margaret	31P-52
Richard Ward	31P-100
Ritley family	31P-53
Roach, P.A.	31P-54
Robb Engineering Co. Ltd.	31P-67
Robertson, William & Son, Ltd.	31P-70
Romkey, G.E. & Co.	31P-80
Roome, Richard Edward Graham	31P-24
Ross, Alexander	31P-22
Rove, William	31P-5
Saint Patrick's Band	31P-55
Sardinian (Ship)	31P-112
Schleyer, George W.	31P-94
Scott Paper Co.	31P-74
Simeon Perkins House	31P-56
Standard Clay Products Ltd.	31P-79
Stewart, Herbert Leslie	31P-6
Stewart, John James	31P-16
Swain, L.G.	31P-95
Theatre Arts Guild	31P-60
Therrien, Armand	31P-41
Thompson, Fred W.	31P-119
Walters, Angus	31P-20
Ward, Amos P.	31P-17
Webster, K.G.T.	31P-8
Wetmore, Donald	31P-59
Windsor Furniture Co.	31P-78
Yarmouth Iron Foundry Agency	31P-96
Zellers, Ltd.	31P-97
Zwicker & Co. Ltd.	31P-69

32P - Mount Allison University Archives, Sackville, N.B.

Archibald, Raymond Clare	32P-1
Bell family	32P-2
McCully, Richard T.	32P-3
Mount Allison University	32P-4
Owens Art Gallery, Mount Allison University	32P-5
Wood family	32P-6

38P - Provincial Reference Library, Newfoundland Public Library Services, St. John's, Nfld.

Caines, John	38P-1
Cox, Dudley	38P-2
Dominion Wabana Ore, Limited	38P-3
Evening Telegram	38P-4
Gordon, Victor (Capt.)	38P-5
Gosling, Laura M.E. (Nash)	38P-6
Kenny, Brendan J.	38P-7
Newfoundland	38P-11
Oliver, Howard	38P-8
Provincial Reference Library	38P-9
Royal Photo Service	38P-10

39P - Memorial University of Newfoundland, Folklore and Language Archives (MUNFLA), St. John's, Nfld.

Memorial University of Newfoundland Folklore and Language Archives [MUNFLA]	39P-1

45P - Hamilton Public Library, Hamilton, Ont.

Beckett Photography	45P-2
Brown, Adam	45P-6
Canadian Eclipse Expedition	45P-4
Hamilton, Ont.	45P-1
Hendrie, William, (Senior)	45P-7
Hendrie family	45P-5
Woods, Frank	45P-3

46P - Provincial Archives of New Brunswick/Archives provinciales du Nouveau-Brunswick, Fredericton

Courtois, Joseph, Rev.	46P-5
Larsen, Ole	46P-4
Mersereau, Jacob W.	46P-3
Provincial Archives of New Brunswick	46P-1
Taylor, George Thomas	46P-2

47P - Oakville Museum, Oakville, Ont.

Appelbe Teskey, Louise	47P-2
Davis family	47P-3
King, W.M..	47P-4
Oakville Bridges	47P-5
Oakville Churches	47P-6
Oakville commerce and industry	47P-7
Oakville Groups	47P-8
Oakville Harbour	47P-9
Oakville Harbour	47P-10
Oakville Hotels	47P-11
Oakville Houses	47P-12
Oakville Individuals	47P-13
Oakville Parks	47P-14
Oakville Public Buildings	47P-15
Oakville Schools	47P-16
Oakville Shipping	47P-17
Oakville Shops, Banks and Offices	47P-18
Oakville Streets	47P-20
Oakville Transportation	47P-21
Sixteen Mile Creek	47P-19
Walter Moorhouse Collection	47P-1

75P - Queen's University Archives, Kingston, Ont.

Benson, George Frederick	75P-1
Braidwood, Florence Gwendolyn (Lazier)	75P-2
Bruce, Herbert Alexander	75P-3
Chesterfield, A.A.	75P-5
Edgar, Mary Susanne	75P-6
Farm and Country Records	75P-7
Hazelgrove, Ronald	75P-11
Kingston, Ont.	75P-12
Lorne Pierce Collection	75P-13
Lower, Arthur Reginald Marsden, Dr.	75P-8
McNeill, William Everett	75P-9
Powell, J.W.	75P-14
Queen's University	75P-10
Roberts, Sir Charles George Douglas	75P-15
Shortt-Haydon Collection	75P-16
Tweedsmuir, John Buchan, first Baron	75P-4

81P - Royal Canadian Mounted Police Museum, Regina, Sask.

Adams, Frank, Mrs.	81P-1
Adams, John	81P-2
Alexander, W.M.	81P-3
Allard, Dorothy M.	81P-4
Alleya, W.J., Mrs.	81P-5
Anderson, Charles, Mrs.	81P-6
Anderson, E.A., Mrs.	81P-7

82P - Queen's Own Rifles, Regimental Museum, Toronto, Ont.

Queen's Own Rifles of Canada Trust Fund (The)	82P-1

91P - Kamloops Museum, Kamloops, B.C.

Kamloops Museum Association Collection	91P-1

92P - University of Alberta Archives (Rutherford Library), Edmonton, Alta.

Alberta Medical Association	92P-2
Anderson, Ethel Cameron	92P-3
Baker, Mrs. Frances (Stubbs)	92P-4
Baldwin, Charles O.	92P-5
Beamont, E.	92P-6
Blair, Sidney Martin	92P-7
Cameron, Alan Emerson	92P-8
Ferrier, R. Douglas	92P-10
Footner, Hulbert	92P-11
Gibson, Mrs. Helen (Beny)	92P-13
McBride, H.W.	92P-15
McDermid Studios	92P-16
Ower, Dr. John James	92P-18
Pearce, William	92P-19
Peterson, T.A. Mrs.	92P-20
Romanet, Louis Auguste	92P-21
University of Alberta, Dept. of Geology	92P-12
University of Alberta, Dept. of Mineral Engineering	92P-17
University of Alberta, Faculty of Agriculture	92P-1
University of Alberta, Faculty of Extension	92P-9
University of Alberta, Library	92P-14
University of Alberta, Publications Office	92P-23
University of Alberta Mixed Chorus	92P-22

95P - Stephen Leacock Memorial Home, Orillia, Ont.

Leacock, Stephen Butler	95P-1

104P - Beaton Institute of Cape Breton Studies, College of Cape Breton, Sydney, N. S.

Beaton Institute of Cape Breton Studies, College of Cape Breton	104P-1

110P - Rossland Historical Museum, Rossland, B.C.

Rossland, B.C.	110P-1

113P - Bibliothèque municipale de la ville de Montréal, Montréal (Québec)

Anonymes	113P-09
Doran, Harold J.	113P-6
Dyonnet, Edmond	113P-2
Henderson, Alexander	113P-5
Massenet, Bruno	113P-8
Massicotte, Edouard Zotique	113P-1
Montréal	113P-3
Olivier, Daniel	113P-12
Ouimet, Raphaël	113P-11
Query, Frères	113P-4
Taché, Louis-Hippolyte	113P-7

121P - Sault Ste. Marie Historical Society Museum, Sault Ste. Marie, Ont.

Sault Ste. Marie and 49th Field Regiment R.C.A. Historical Society	121P-1

123P - National Gallery of Canada/Galerie nationale du Canada, Ottawa (Ont.)

Ashton, F.G.	123P-2
Bourdeau, Robert	123P-9
Canada, National Museums, National Gallery of Canada Collection	123P-1
David Heath	123P-7
Henderson, Alexander	123P-4
Michael Schreier	123P-6
Mortimer-Lamb, Harold	123P-3

123P - National Gallery of Canada/Galerie
 nationale du Canada, Ottawa (Ont.)

166

Notman, William 123P-5
Robert Frank 123P-8

**131P - Archives du séminaire de Québec,
 Québec (Québec)**

Ambrotypes 131P-7
Archives du séminaire de Québec 131P-9
Benoit, Rosario, abbé 131P-2
Daguerréotypes 131P-8
Gauvreau, Robert 131P-1
King, W.F. 131P-6
Laflamme, Joseph Clovis Kemner, Mgr 131P-5
Lefebvre, Rosario 131P-4
Mathieu, Olivier Elzéor 131P-3

**134P - Musée du Royal 22e régiment, La
 Citadelle, Québec (Québec)**

Archives du musée du Royal 22e
 régiment 134P-1
Imlah, W.E. 134P-2
Lindsay, Crawford 134P-3

140P - City of Toronto Archives, Toronto, Ont.

Art Gallery of Toronto (now: Art Gallery
 of Ontario) 140P-16
City of Toronto Architect's Department 140P-1
City of Toronto Assessment Department 140P-2
City of Toronto Assessment Department,
 Real Estate Branch 140P-7
City of Toronto Buildings Department,
 Housing Section 140P-3
City of Toronto City Engineer's
 Department 140P-9
City of Toronto Department of Public
 Health 140P-4
City of Toronto Department of Public
 Works 140P-11
City of Toronto Department of Public
 Works, Miscellaneous Photographs 140P-12
City of Toronto Department of Public
 Works, Portraits 140P-13
City of Toronto Mayors 140P-10
City of Toronto Parks Department 140P-5
City of Toronto Planning Board 140P-18
City of Toronto Property Department 140P-6
City of Toronto Street Cleaning
 Department 140P-8
City of Toronto Water Works 140P-14
James, William 140P-15
Toronto Board of Education 140P-17

**143P - Archives of the Toronto Board of
 Education, Toronto, Ont.**

Toronto Board of Education 143P-1

**146P - Lakehead University Library, Thunder
 Bay, Ont.**

Northwest Ontario Community 146P-1

**149P - National Library of Canada/Bibliothèque
 nationale du Canada, Ottawa (Ont.)**

Adaskin, Murray 149P-1
Albani, Marie Louise Cécile Emma
 (Lajeunesse), Dame 149P-2
Brewer, George MacKenzie 149P-3
Carter, John 149P-4
Champagne, Claude 149P-5
Contant, Alexis 149P-6
Dainty, Ernest 149P-9
Donalda, Pauline (Lightstone) 149P-7
Eckhardt-Gramatte, Sonia Carmen 149P-8

Geiger-Torel, Herman 149P-10
Harriss, Charles Albert Edwin 149P-11
Jordan, Henri Kew 149P-12
McCurry family 149P-13
Toronto Jewish Folk Choir (The) 149P-14
Walter, Arnold, Dr. 149P-15
Whitehead, Alfred, Dr. 149P-16
Willan, James Healey 149P-17

**158P - Peterborough Centennial Museum and
 Archives, Peterborough, Ont.**

Denne, T.H.G. 158P-1
Peterborough Centennial Museum and
 Archives Collection 158P-2

**160P - York University Archives, Downsview,
 Ont.**

Toronto Telegram 160P-1

161P - Yukon Archives, Whitehorse, Yukon

Yukon Archives Photograph Collection 161P-1

**163P - Moose Jaw Public Library, Moose Jaw,
 Sask.**

Moose Jaw Public Library 163P-1

**166P - Archives of the Canadian Rockies, Banff,
 Alta.**

Alpine Club of Canada - Dr. Winthrop
 Ellsworth Stone Collection 166P-18
Alpine Club of Canada - Edward Feuz
 Jr. 166P-43
Alpine Club of Canada - Elizabeth
 Parker Collection 166P-22
Alpine Club of Canada - Frank W.
 Freeborn Collection 166P-4
Armbrister, Frederick 166P-30
Atkin, Gilbert M., Dr. 166P-31
Barnes, Elliott 166P-15
Brett, R.G., Dr., and family 166P-12
Brewster, F.O. (Pat) 166P-17
Brewster Transport Company 166P-14
Douglas, Howard, and family 166P-35
Feuz, Edward Jr. 166P-11
Gleason, Herbert W. 166P-47
Grassi, Lawrence 166P-29
Green, Hubert Unsworth 166P-26
Harding, Alice 166P-27
Harmon, Byron 166P-3
Harmon, Donald 166P-20
Harmon, Lloyd 166P-7
Hinman, Caroline B. 166P-5
Jamieson, Elmer 166P-38
Kaufmann, Hans 166P-39
Lance, Beatrice (Longstaff) 166P-37
Locke, Ralphine and Helen Grier 166P-46
Lyman, Dot (White) 166P-41
Mather, Leslie 166P-49
Montgomery, H. Tully, Reverend Canon 166P-24
Moore, Philip A. 166P-19
Noble, George 166P-1
Painter family collection 166P-13
Paris, Cyril 166P-8
Paris, George 166P-9
Peyto, E.W. (Bill) 166P-21
R.H. Trueman and Company 166P-48
Rankin, Niall 166P-42
Sanson, Norman B. 166P-2
Simpson, James, Sr. 166P-6
Skirrow, George "Lucky" 166P-33
Smith, Herbert "Soapy" 166P-32
Smyth, S.A. 166P-45

Stevens, Ruth (Bovey) 166P-36
Thorington, J. Monroe, Dr. 166P-44
Vallance, Sydney 166P-25
Wellman, Frank 166P-28
Wheatley, Frank M. 166P-40
White, David M., Sr. 166P-34
Whyte, Catharine (Robb) 166P-10
Whyte, Peter 166P-23
Wilson, Tom 166P-16

**171P - Archives du monastère de l'Hôtel-Dieu
 de Québec, Québec (Québec)**

Augustines du monastère de l'Hôtel-Dieu
 de Québec 171P-2
Bardy, Pierre-Martial, dr 171P-3
Hôpital de l'Hôtel-Dieu de Québec 171P-1

**185P - Centre de recherche en civilisation
 canadienne-française, Ottawa (Ont.)**

Barnard (famille) 185P-20
Barthe (famille) 185P-18
Begley, Michael 185P-6
Chapman, William 185P-17
Charbonneau, Blondine 185P-8
Cléroux, Alexina 185P-12
Coulombe, Danielle 185P-11
Dumoulin, J.L. 185P-3
Fabien, Henri Zotique 185P-19
Ferland, Albert 185P-14
Laberge, Albert 185P-16
Lacasse (famille) 185P-2
Lamarre-Lacourse, Germaine 185P-5
Lapierre, André 185P-10
Laurin, François 185P-4
Lemieux, Rodolphe 185P-9
Livres et auteurs canadiens/québécois 185P-15
Office de télécommunication éducative de
 l'Ontario 185P-1
Saint-Charles, Joseph 185P-13
Woods, Jean 185P-7

**193P - Archives Deschâtelets (Oblats de Marie-
 Immaculée), Ottawa (Ont.)**

Oblats de Marie-Immaculée 193P-1

**196P - University of Toronto Archives, Toronto,
 Ont.**

Beauregard, S.S.T. 196P-49
Blatz, William E 196P-5
Cody, Henry J. 196P-8
Cornell, Margaret 196P-43
Cowan, George Hoyle 196P-4
Fry, Frederick Ernest Joseph 196P-12
Goulding, William S. 196P-46
Grier, Col. Crawford G.M. 196P-35
Hammond, Melvin Ormond 196P-8
Haultain, H.E.T. 196P-42
International Federation of Library
 Associations 196P-9
Jones family 196P-6
Kennelly, Hazel Loreen M. 196P-7
Lansdale, Robert 196P-47
London Public Library and Art Museum 196P-55
Madill, Henry Harrison 196P-10
Markowitz, Jacob 196P-12
McNeely, Verna 196P-39
McQueen, William 196P-38
Montague, Percival John 196P-48
Mulock, William, Sir 196P-56
Nesbitt, Rankin 196P-54
Phelps, Edward 196P-40
Robertson, Hugh Shaw, 196P-50
Saunders, Sylvia 196P-37
Scadding, Henry 196P-15

Silverthorn, Mary | 196P-44
Smith, Sidney | 196P-41
The Madawaska Club Ltd. | 196P-11
Trinity Medical School | 196P-2
University of Toronto, C. O.T.C. | 196P-33
University of Toronto, Department of Alumni Affairs | 196P-57
University of Toronto, Department of Electrical Engineering | 196P-64
University of Toronto, Department of Information | 196P-34
University of Toronto, Engineering Alumni Association | 196P-58
University of Toronto, Erindale College | 196P-23
University of Toronto, Faculty of Food Sciences | 196P-16
University of Toronto, Faculty of Forestry | 196P-36
University of Toronto, Faculty of Music | 196P-29
University of Toronto, Hart House | 196P-65
University of Toronto, Hart House Chess Club | 196P-22
University of Toronto, Hart House Theatre | 196P-32
University of Toronto, Information Services | 196P-21
University of Toronto, Library, Photocopy Unit | 196P-60
University of Toronto, McLennan Physical Laboratories | 196P-63
University of Toronto, Office of the Registrar | 196P-15
University of Toronto, Office of the Vice-President and Provost | 196P-59
University of Toronto, Ontario School of Practical Science | 196P-53
University of Toronto, School of Hygiene | 196P-66
University of Toronto, Sigmund Samuel Library | 196P-62
University of Toronto, Student Administrative Council, Varsity (newspaper), | 196P-24
University of Toronto, Students Administrative Council | 196P-25
University of Toronto, University College | 196P-27
University of Toronto, University College Literary and Scientific Society | 196P-52
University of Toronto, University of Toronto Union | 196P-61
University of Toronto, University of Trinity College | 196P-30
University of Toronto, University of Victoria College Library | 196P-45
University of Toronto Athletic Association | 196P-14
University of Toronto Collection | 196P-26
University of Toronto Faculty of Applied Science, 1911 Graduating class | 196P-17
University of Toronto Faculty of Education | 196P-20
University of Toronto Faculty of Nursing | 196P-28
University of Toronto Library | 196P-31
University of Toronto Library, Exhibition Unit | 196P-13
University of Toronto Physical Plant Department | 196P-18
Upper Canada College | 196P-19
Waddell family | 196P-51
Wallace, Mary Elisabeth | 196P-3
York University Archives, Gaby Collection, Glendon Hall | 196P-5
67th (Varsity) Battery Association | 196P-1

200P - University of St. Michael's College Library, Toronto, Ont.
Abrey, Mabel | 200P-17
Brown, Winifred (Killoran) | 200P-1

Burke, Richard Thomas | 200P-11
Burke, Richard Thomas | 200P-2
Canadian Federation of Catholic Convent Alumni | 200P-16
Ferguson, Michael Joseph | 200P-12
Katholy, Karl | 200P-19
Mallon, Hugh Vincent | 200P-4
Mallon, Hugh Vincent | 200P-3
Moylan, William Michael | 200P-5
Murray, Edmund Francis | 200P-13
St. Michael's College | 200P-6
St. Michael's College | 200P-10
Scollard, Robert Joseph | 200P-7
University of St. Michael's College | 200P-14
University of St. Michael's College Archives | 200P-8
University of St. Michael's College Archives | 200P-18
Welty, Emil Jerome | 200P-15
Windsor, Ont., family portraits | 200P-9

208P - Archives des clercs de Saint-Viateur, Montréal (Québec)
Clercs de Saint-Viateur, Province de Montréal - Archives | 208P-1

221P - Archives provinciales des Clercs de Saint-Viateur de Joliette, Joliette (Québec)
Archives provinciales des Clercs de Saint-Viateur | 221P-1

222P - Archives de la Société historique de Saint-Boniface, Saint-Boniface, (Man.)
Société historique de Saint-Boniface | 222P-1

228P - Cariboo-Chilcotin Archives, Williams Lake, B.C.
Cariboo Stopping Houses, Wagon Road | 228P-4
McKinlay family | 228P-3
Pinchbeck family | 228P-5
Roberts, John A., Dr. | 228P-1
153 Mile House Store | 228P-2

300P - Vancouver Public Library, Vancouver, B.C.
Vancouver Public Library Collection | 300P-1

301P - Ottawa Diocesan Archives, Ottawa, Ont.
Anglican Church of Canada, Diocese of Ottawa, Archives | 301P-1

302P - University of King's College Library, Halifax, N.S.
The University of King's College Library | 302P-1

303P - Centre de documentation de La Presse, Montréal (Québec)
Canada, Défense nationale, officier de liaison avec l'Université d'Ottawa | 303P-9
Isabelle, Laurent | 303P-13
Lanctot, Gustave | 303P-11
Marion, Séraphin | 303P-10
Ottawa Teacher's College | 303P-16
Université d'Ottawa, Collège Bruyère | 303P-8
Université d'Ottawa, Département de diététique et sciences domestiques | 303P-6
Université d'Ottawa, Ecole de bibliothécaires | 303P-2

Université d'Ottawa, Ecole des sciences de l'activité physique et du loisir | 303P-3
Université d'Ottawa, Ecole des sciences infirmières | 303P-5
Université d'Ottawa, Enseignement et recherche, vice-recteur | 303P-12
Université d'Ottawa, Faculté de droit, Droit coutumier | 303P-17
Université d'Ottawa, Faculté de médecine | 303P-14
Université d'Ottawa, Faculté d'éducation (Ecole normale) | 303P-4
Université d'Ottawa, Relations extérieures | 303P-1
Université d'Ottawa, Ressources financières | 303P-7
Université d'Ottawa, Service des sports | 303P-15

304P - Army Museum, Halifax, N.S.
European War, 1914-1918 - decorations | 304P-2
Notman Studio of Halifax | 304P-1

305P - Jewish Historical Society of Western Canada Inc., Winnipeg, Man.
Jewish Historical Society of Western Canada Inc. | 305P-1

306P - Archives de l'Archidiocèse d'Ottawa, Ottawa (Ont.)
Eglise catholique du Canada, archidiocèse d'Ottawa | 306P-1

307P - Ryerson Institute Archives, Toronto, Ont.
Ryerson Polytechnical Institute | 307P-1

308P - Art Gallery of Ontario, Toronto, Ont.
Art Gallery of Ontario | 308P-2
Art Gallery of Ontario | 308P-1

309P - Bank of Nova Scotia Archives, Toronto, Ont.
Bank of Nova Scotia | 309P-1

310P - Archives of the Brothers of the Christian School of Ontario, Don Mills, Ont.
Brothers of the Christian Schools, Toronto Province | 310P-1

311P - Canadian Broadcasting Corporation Archives/Archives de la Société Radio-Canada, Ottawa, Ont.
Société Radio-Canada | 311P-1

312P - The Globe and Mail Library, Toronto, Ont.
Galbraith Collection | 312P-2
Globe and Mail Ltd. (The) | 312P-1

313P - Hartill Art Associates, London, Ont.
Hartill Art Associates | 313P-1

314P - Women's Canadian Historical Society, Toronto, Ont.
Woman's Canadian Historical Society | 314P-1

315P - Archives nationales du Québec, Centre régional de la Mauricie Bois-Francs, Trois-Rivières (Québec)

315P - Archives nationales du Québec, Centre régional de la Mauricie Bois-Francs, Trois-Rivières (Québec)

Héroux, George 315P-1

316P - Ontario Hydro Photo Library, Toronto, Ont.

Ontario Hydro 316P-1

317P - Archives of the Presbyterian Church in Canada, Toronto, Ont.

General Assembly of the Presbyterian Church in Canada 317P-2
Knox College 317P-4
Knox College 317P-3
Presbyterian Church in Canada 317P-1
Presbyterian Church in Canada - Colleges 317P-5

318P - St. Michael's Hospital Archives, Toronto, Ont.

St. Michael's Hospital Archives 318P-1

319P - Sisters of St. Joseph Archives, Willowdale, Ont.

Sisters of St. Joseph of the Diocese of Toronto of Upper Canada 319P-1

320P - Toronto Dominion Bank Archives, Toronto, Ont.

Toronto-Dominion Bank 320P-1

321P - University College Archives, University of Toronto, Toronto, Ont.

University College Archives 321P-1

322P - Toronto Harbour Commissioners, Toronto, Ont.

Toronto Harbour Commission 322P-3
Toronto Harbour Commissioners 322P-1
Toronto Harbour Commissioners 322P-2

323P - Royal Bank Historical Archives, Montreal, Que.

The Royal Bank of Canada 323P-1

324P - Archives du séminaire de Nicolet (Grand séminaire de Nicolet), Nicolet (Québec)

Séminaire de Nicolet 324P-1

325P - Service central des archives de la congrégation des Soeurs des Saints Noms de Jésus et de Marie, Outremont

Congrégation des Soeurs des Saints Noms de Jésus et de Marie 325P-1

326P - Centre Emilie Gamelin, Montréal (Québec)

Centre Emilie Gamelin 326P-1

327P - Notman Photographic Archives (McCord Museum), Montreal, Que.

Canadian Photographers 327P-4
Henderson, Alexander 327P-2
Notman, William 327P-1
Pitseolak, Peter 327P-3

328P - Archives des Franciscains, Montréal (Québec)

Pères Franciscains 328P-1

329P - Service des archives, Maison provinciale des Filles de la Charité du Sacré-Coeur de Jésus et de Marie, Sherbrooke

Congrégation des Filles de la Charité du Sacré-Coeur de Jésus 329P-1

330P - Bell Canada, Collection historique, Montréal, Québec

Bell Canada 330P-1

331P - Archives générales des Oblates Missionnaires de Marie-Immaculée, Trois-Rivières (Québec)

Les Oblates Missionnaires de Marie-Immaculée 331P-1

332P - National Research Council of Canada/Conseil national de recherches du Canada, Ottawa (Ont.)

Conseil national de recherches, Direction de l'information publique (D.I.P.), divisions du C.N.R.C. 332P-1

333P - Fort Steele Historic Park, Fort Steele, B.C.

Attree, E.H.L. 333P-23
Barr, George 333P-17
Boss, G. 333P-40
Brander, Maude 333P-32
Brown, Ernest 333P-10
Campbell, G.A. 333P-42
Dailey, H.C. 333P-6
Dempsey, W. 333P-3
Drayton, W.A., 333P-31
East Kootenay Area 333P-8
Eden 333P-28
Edwards, Ron 333P-39
Graham, H.P. 333P-25
Grant, M. 333P-33
Hellmen, Fee 333P-21
Hunter, A.W., 333P-5
Jewell family 333P-2
Jordon, Mabel 333P-11
Kay, Dave, 333P-14
Kennedy, M. 333P-38
Kershaw family 333P-7
Lake family 333P-41
Leighton, T. 333P-43
MacDonald, D., 333P-30
MacDougall, R.J. 333P-1
MacKinnon, E. 333P-35
Mather family 333P-16
Moffat family 333P-37
Moore, E.I. 333P-19
Morrison, J. 333P-34
Murdoch, R. 333P-18
Olson, Rick 333P-4
Richardson, H.E. 333P-13
Righton, C. 333P-36
Ross, Douglas H. 333P-9
Ruttan, H. 333P-26
Steele, A.M. 333P-22
Tannhauser family 333P-20
Turner 333P-24

Ward family 333P-15
Weir, T.N. 333P-12
Wilson, T.S. 333P-29
Wright 333P-27

334P - New Westminster Public Library, New Westminster, B.C.

Adams family 334P-34
Arnison, Lance 334P-23
Bracher family 334P-35
Brine, A.J 334P-16
British Photo Co. 334P-6
Calbick, Garth 334P-20
Christie, M. 334P-36
Clerihue 334P-37
Columbian (newspaper) 334P-28
Cooksley, William T. 334P-7
Cotton, E. 334P-38
Croton Studio 334P-3
Dawe, Harold 334P-14
Dawe, Mary 334P-39
Fraser River, B.C. 334P-31
Gunn, Ann 334P-40
Hill family 334P-24
Holland 334P-41
Hynek, Barbara 334P-17
Irving House Historic Centre 334P-30
Jack 334P-33
Jennings 334P-42
Kirk, Elsie 334P-26
Leash, H.E. 334P-43
Lyle, B. 334P-44
Matthews family 334P-45
Mercer, A. 334P-22
Miller, Archie 334P-25
Morris, Rita 334P-19
Murchie, A. 334P-12
New Westminster City Hall 334P-5
New Westminster City Police 334P-18
Notman, William 334P-4
Paulson family 334P-13
Provincial Archives of British Columbia 334P-9
Purvis, F. 334P-10
Rushton, Ernest 334P-21
Russell Studio 334P-8
Smith family 334P-15
Stride Studios 334P-2
Vancouver Public Library 334P-29
Venables family 334P-27
Wadds Bros. 334P-1
Yates, K. 334P-32

335P - Archives nationales du Québec, Centre régional du Saguenay - Lac Saint-Jean, Chicoutimi (Québec)

Lemay, J.-E. 335P-1

337P - Moncton Museum Inc., Moncton, N.B.

Carter, Joseph C., Prof. 337P-2
Moncton Museum Inc., Sports Photos Collection 337P-4
Parker, G. Albert 337P-1
Reid, Harold B. 337P-3

338P - Sisters Servants of Mary Immaculate Community Archives, Toronto, Ont.

Sisters Servants of Mary Immaculate 338P-1

339P - Saskatoon Public Library, Saskatoon, Sask.

Hillyard, Len 339P-2
Local History Department 339P-1

340P - **Mount St. Vincent University Archives, Halifax, N.S.**

Mount St. Vincent University 340P-1

341P - **Centre de documentation de la Société historique Nicolas-Denys, Bertrand (N.-B.)**

Société historique Nicolas-Denys
(S.H.N.D.) 341P-1

342P - **Division de la documentation photographique, Ministère des Communications du Québec, Québec (Québec)**

Ministère des Communications du
Québec. Division de la
documentation photographique 342P-1

343P - **Conseil Intermunicipal des loisirs du Témiscouata, Notre-Dame-du-Lac (Québec)**

Conseil intermunicipal des loisirs du
Témiscouata 343P-1

344P - **La Société historique du comté de Shefford, Granby (Québec)**

La Société historique du comté de
Shefford 344P-1

345P - **Photos Duplain, Enr., Saint Raymond, cté de Portneuf (Québec)**

Photos Duplain, Enr. 345P-1

346P - **Bishop's College School, Lennoxville (Québec)**

Bishop's College School 346P-1

347P - **Maurice Saint-Pierre, Bromptonville (Québec)**

Saint-Pierre, Maurice, Collection 347P-1

348P - **Studio Gendreau, La Pocatière, cté de Kamouraska (Québec)**

Studio Gendreau 348P-1

349P - **Studio Boutet, La Pocatière, cté de Kamouraska (Québec)**

Studio Boutet 349P-1

350P - **Studio Jean-Paul, Saint-Pascal, cté de Kamouraska (Québec)**

Studio Jean-Paul 350P-1

351P - **Alain Sauvageau, Cap-de-la-Madeleine (Québec)**

Sauvageau, Alain 351P-1

352P - **C.E.G.E.P. de Shawinigan, Shawinigan (Québec)**

Tessier, Roger 352P-1

353P - **Jean Fontaine, Plessisville (Québec)**

Lemire, Roland 353P-1

354P - **Roland Lemire, Trois-Rivières (Québec)**

Fontaine, Jean 354P-1

INDEX

Abbass Studio, photo., p.32 (7P-347)
Abbott, J.J., photo., p.57 (7P-686), p.72 (7P-884)
Abbott, John J.C., p.22 (7P-1903)
Abbott, John J.C., Sir, p.24 (7P-1907)
Abel, G.C., G.M., R.C.A.F., p.1 (7P-1)
Aberdeen, Ishbel Maria Morjoribanks, Hon.,
 (18P-16), p.51 (7P-591), p.57 (7P-685), p.65
 (7P-777), p.92 (7P-1049), p.98 (7P-1227),
 p.107 (7P-1337), p.150 (7P-1842)
Aberdeen and Temair, John Campbell Hamilton
 Gordon, Marquess of, p.1 (18P-16), p.51
 (7P-591), p.57 (7P-685), p.65 (7P-777), p.85
 (7P-1068), p.92 (7P-1049)
Aberdeen et de Temair, John Campbell Hamilton
 Gordon, Marquis de, p.150 (7P-1842)
Abitibi (Ont.) - vues, p.18 (7P-215)
Abrey, Mabel, p.1 (200P-17)
Acadia Gas Engine Co., Bridgewater, N.S., p.1
 (31P-75)
Acadia House, Halifax, N.S., p.105 (1P-84)
Acadia Playhouse, N.S., p.148 (31P-59)·
Acadiens aux Maritimes, p.112 (15P-3), p.118
 (15P-5)
Acier - Industrie et commerce - Nouvelle-Ecosse -
 Sydney, p.35 (7P-379)
Acier - Industrie et commerce - Ontario, p.13
 (7P-144)
Acier - Industrie et commerce - Ontario - Hamilton,
 p.35 (7P-379)
Acland, James, photo., p.5 (7P-44)
Acorn, Milton, p.122 (7P-1526)
Adams, Frank, Mrs., p.1 (81P-1)
Adams, Frank Dawson, p.1 (31P-3)
Adams, John, p.1 (81P-2)
Adams, photo., p.153 (161P-1)
Adams, W.C., photo., p.102 (200P-13)
Adams family, B.C., p.1 (334P-34)
Adamson, Agar Stewart Allan Masterton, p.1
 (7P-2)
Adamson, Anthony, p.1 (18P-56)
Adaskin, Harry, p.61 (7P-731)
Adaskin, Murray, and family, p.1 (149P-1)
Adath Jeshuron (Congregation), Ottawa, Ont.,
 p.118 (7P-1473)
Admiralty House, Halifax, N.S., p.105 (1P-79),
 p.105 (1P-84)
Aerial Experimental Association, p.74 (7P-900)
Aeronautics - generalities, p.36 (332P-1)
Aeronautique - generalités, p.36 (332P-1)
Aéronefs - Angleterre, p.12 (7P-139)
Aéronefs - Boeing, p.14 (7P-151)
Aéronefs - British Columbia Airways Ltd., p.150
 (7P-1849)
Aéronefs - Canada, p.1 (7P-4), p.7 (7P-63), p.8
 (7P-69), p.18 (7P-216), p.150 (7P-1844)
Aéronefs - Canadian Airways Ltd., p.17 (7P-200),
 p.151 (7P-1869)
Aéronefs - Colombie Britannique, p.12 (7P-128)
Aéronefs - Corps d'aviation Royal Canadien
 voir aussi
 Aircraft - Royal Canadian Air Force
Aéronefs - Corps d'aviation royal canadien, p.150
 (7P-1845)
Aéronefs - Etats-Unis, p.17 (7P-206)
Aéronefs - France, p.8 (7P-80)
Aéronefs - Imperial Oil Ltd., p.146 (7P-1789)
Aéronefs - Mackenzie Air Service, p.118 (7P-1478)
Aéronefs - Northern Airways, p.118 (7P-1478)
Aéronefs - Ontario, p.12 (7P-129), p.12 (7P-140),
 p.14 (7P-162)
Aéronefs - vols trans-atlantiques, p.152 (7P-1875)
Aeronefs - Western Canada Airways, p.17
 (7P-204)
Aéronefs - Yukon Southern Air, p.118 (7P-1478)
Aéroports - New York (N.Y.), p.118 (7P-1477)

Affleck, Minnie, sr., p.1 (7P-3)
Afrique - scènes, p.80 (131P-4)
Afrique du sud
 voir aussi
 South Africa
Afrique du sud - vues, p.35 (329P-1)
Agostini, Lucio, p.2 (7P-9)
Agriculture - Alberta, p.1 (13P-10), p.1 (13P-6),
 p.1 (13P-7), p.7 (13P-5), p.12 (11P-12), p.13
 (13P-3), p.18 (13P-1), p.51 (13P-13), p.66
 (13P-4), p.89 (9P-51), p.90 (7P-1180), p.104
 (7P-1312), p.114 (13P-2), p.150 (7P-1843)
Agriculture - British Columbia, p.32 (12P-6), p.39
 (7P-447)
Agriculture - Canada, p.22 (7P-1901), p.23
 (7P-1926), p.27 (7P-270), p.28 (7P-295), p.34
 (7P-359), p.48 (7P-547), p.49 (75P-7), p.105
 (327P-1), p.148 (7P-1825)
Agriculture - Canada (Western), p.22 (7P-1906),
 p.132 (7P-1665)
Agriculture - Manitoba, p.1 (9P-46), p.19 (7P-81),
 p.37 (9P-11), p.39 (7P-447), p.71 (9P-31),
 p.82 (9P-42), p.89 (9P-51), p.90 (7P-1180),
 p.91 (7P-1187), p.97 (7P-1208), p.98
 (7P-1224), p.113 (7P-1415)
Agriculture - New Brunswick, p.103 (2P-1)
Agriculture - Nova Scotia, p.49 (1P-36), p.105
 (1P-87), p.106 (1P-50)
Agriculture - Ontario, p.14 (7P-171), p.40
 (7P-435), p.70 (7P-856), p.93 (7P-1075), p.97
 (7P-1208), p.98 (7P-1225), p.110 (7P-1374),
 p.114 (7P-1423), p.151 (7P-1854)
Agriculture - Quebec, p.116 (7P-1459), p.147
 (7P-1806)
Agriculture - Saskatchewan, p.16 (9P-5), p.56
 (7P-664), p.59 (7P-706), p.59 (7P-710), p.61
 (18P-86), p.67 (10P-8), p.70 (10P-10), p.89
 (9P-51), p.90 (7P-1180), p.99 (163P-1), p.125
 (10P-2), p.125 (10P-3), p.125 (10P-7), p.126
 (10P-12), p.135 (7P-1711)
Aiken, Margaret, p.149 (7P-1837)
Aikenhead, James, Mrs., p.93 (7P-1073)
Aikins, James Cox et famille, p.8 (7P-73)
Air Canada, p.1 (7P-4), p.68 (7P-826), p.83
 (7P-1017)
Air Mail Service - Alberta - N.W.T., p.51 (13P-13)
Aircraft - accidents, p.23 (7P-1911)
Aircraft - Aerial Experimental Association, p.74
 (7P-900)
Aircraft - Alberta, p.90 (7P-1171), p.119
 (7P-1491)
Aircraft - British Columbia, p.4 (7P-33), p.38
 (7P-413), p.127 (7P-1590)
Aircraft - British Yukon Navigation Co., p.56
 (7P-665)
Aircraft - Canada, p.9 (7P-95), p.25 (7P-1948),
 p.30 (7P-322), p.38 (7P-417), p.95 (7P-1125),
 p.95 (7P-1190), p.98 (7P-1237), p.99
 (7P-1241), p.111 (7P-1392), p.115 (7P-1434),
 p.122 (7P-1519), p.128 (7P-1606), p.137
 (7P-1721), p.148 (7P-1824)
Aircraft - Canada (Northern), p.44 (7P-497), p.52
 (7P-607)
Aircraft - Canadair Ltd., p.76 (7P-942), p.99
 (7P-1240)
Aircraft - Canadian Air Board, p.99 (7P-1241)
Aircraft - Canadian Airways Ltd., p.53 (7P-615),
 p.56 (7P-662)
Aircraft - Canadian Pacific Airlines, p.28 (7P-294)
Aircraft - Canadian Pacific Airlines
 see also
 Canadian Pacific Airlines
Aircraft - Commercial Airways, p.91 (7P-1188),
 p.129 (7P-1620)
Aircraft - Consolidated Mining & Smelting Ltd.
 see also
 Consolidated Mining & Smelting Ltd.
Aircraft - Curtiss Aviation School, p.99 (7P-1241)

Aircraft - De Havilland Aircraft of Canada Ltd.,
 p.76 (7P-942)
Aircraft - Dominion Skyways Ltd., p.129
 (7P-1620)
Aircraft - Eastern Canada Airlines Ltd., p.129
 (7P-1618)
Aircraft - Elliot Air Service, p.153 (7P-1885)
Aircraft - France, p.9 (7P-95)
Aircraft - Germany, p.9 (7P-95), p.74 (7P-902)
Aircraft - Great Western Airways, p.95 (7P-1126)
Aircraft - Imperial Airways Ltd., p.81 (7P-1001)
Aircraft - Imperial Oil Ltd., p.44 (7P-496), p.54
 (7P-630), p.64 (7P-770), p.77 (7P-939), p.125
 (7P-1564)
Aircraft - mail, p.52 (7P-607), p.53 (7P-615), p.81
 (7P-1001)
Aircraft - naval, p.130 (7P-1631)
Aircraft - Newfoundland, p.51 (7P-584), p.73
 (7P-885)
Aircraft - Newfoundland Skyways, p.129
 (7P-1620)
Aircraft - North Battleford, Sask., p.55 (7P-641)
Aircraft - Northern Aerial (Mineral Exploration
 Ltd.), p.119 (7P-1489)
Aircraft - Northwest Territories, p.41 (7P-457),
 p.148 (7P-1820)
Aircraft - Ontario, p.38 (7P-405), p.62 (7P-740),
 p.65 (7P-781)
Aircraft - Ontario Central Airlines, p.147
 (7P-1812)
Aircraft - Ontario Provincial Air Service, p.99
 (7P-1241), p.119 (7P-1489)
Aircraft - Ontario Provincial Air Service
 see also
 Ontario Provincial Air Service
Aircraft - Quebec, p.65 (7P-781), p.73 (7P-885)
Aircraft - Royal Air Force, p.56 (7P-662), p.57
 (7P-680), p.113 (7P-1412), p.121 (7P-1514),
 p.126 (7P-1578), p.140 (7P-1755)
Aircraft - Royal Canadian Air Force, p.3 (7P-21),
 p.8 (7P-78), p.21 (7P-260), p.26 (7P-269),
 p.39 (7P-423), p.39 (7P-446), p.40 (7P-442),
 p.44 (7P-499), p.45 (7P-514), p.46 (7P-527),
 p.47 (7P-535), p.47 (7P-538), p.48 (7P-553),
 p.48 (7P-555), p.50 (7P-575), p.51 (7P-585),
 p.54 (7P-637), p.55 (7P-646), p.56 (7P-663),
 p.56 (7P-669), p.59 (7P-709), p.61 (7P-732),
 p.65 (7P-781), p.65 (7P-785), p.66 (7P-793),
 p.67 (7P-805), p.67 (7P-808), p.67 (7P-811),
 p.68 (7P-815), p.68 (7P-825), p.72 (7P-877),
 p.73 (7P-885), p.79 (7P-976), p.84 (7P-1029),
 p.84 (7P-1044), p.86 (7P-1096), p.90
 (7P-1169), p.90 (7P-1170), p.94 (7P-1098),
 p.110 (7P-1375), p.111 (7P-1390), p.111
 (7P-1392), p.116 (7P-1456), p.119 (7P-1498),
 p.122 (7P-1529), p.128 (7P-1595), p.128
 (7P-1612), p.131 (7P-1640), p.134 (7P-1690),
 p.137 (7P-1726), p.139 (7P-1749), p.140
 (7P-1755), p.145 (7P-1786), p.149 (7P-1832),
 p.150 (7P-1845)
Aircraft - Royal Flying Corps, p.64 (7P-765),
 p.100 (7P-1254)
Aircraft - Royal Naval Air Service, p.126
 (7P-1578)
Aircraft - St. Catharines Flying Club, p.139
 (7P-1746)
Aircraft - Saskatchewan, p.90 (7P-1171), p.96
 (7P-1206)
Aircraft - Saskatchewan Government Air
 Ambulance Service, p.147 (7P-1812)
Aircraft - Sopwith Aircraft Co., p.68 (7P-820)
Aircraft - Transatlantic Flights, p.121 (7P-1514)
Aircraft - Trans-Canada Air Lines, p.53 (7P-616),
 p.153 (7P-1885)
Aircraft - Trans-Canada Air Lines
 see also
 Trans-Canada Air Lines

Aircraft - Transatlantic Flights, p.30 (7P-317), p.51
(7P-584), p.54 (7P-640), p.88 (7P-1156), p.91
(7P-1186), p.97 (7P-1208)
Aircraft - United Air Transport Ltd., p.56 (7P-665)
Aircraft - United States, p.115 (7P-1434)
Aircraft - War Uses, p.67 (7P-801)
Aircraft - Wardair, p.147 (7P-1803)
Aircraft - Western Canada Airways Ltd., p.51
(7P-586), p.91 (7P-1188)
Aircraft - Western Canada Airways Ltd.
 see also
 Western Canada Airways Ltd.
Aircraft - Yukon, p.42 (7P-459)
Aircraft accidents - Royal Canadian Air Force,
 p.128 (7P-1609)
Aircraft Imperial Oil Ltd., p.119 (7P-1489)
Aircraft - Imperial Oil Ltd.
 see also
 Imperial Oil Ltd., Toronto, Ont.
Airports - Ontario - Brantford, p.121 (7P-1513)
Aiyansh (C.-B.) - vues, p.25 (7P-1935)
Akins, Thomas B., p.1 (1P-3)
Aklavik, N.W.T. - general views, p.51 (13P-13),
 p.73 (7P-894), p.135 (7P-1696)
Aksala (SS), p.9 (7P-94)
Alarie, photo., p.4 (131P-9)
Alaska - aerial views, p.94 (7P-1113)
Alaska - Gold Rush, p.38 (7P-409)
Alaska - scenes, p.75 (7P-914), p.82 (11P-1), p.112
 (7P-1396)
Alaska, Etats-Unis - scènes, p.107 (7P-1335)
Alaska-Canada Boundary Survey, p.118 (12P-23)
Alaska Highway, p.129 (7P-1617)
Alaska Highway Project, p.153 (161P-1)
Alaska (SS), p.2 (7P-13), p.23 (7P-1974)
Albani, Emma, p.1 (149P-2)
Albani-Gye, Emma, p.46 (7P-517)
Albany, N.Y. - general views, p.110 (7P-1374)
Albert Bay, B.C. - general views, p.70 (7P-848)
Alberta - individuals, p.1 (13P-7), p.13 (13P-3),
 p.18 (13P-1), p.92 (11P-13), p.114 (13P-2)
Alberta - missions, p.3 (13P-11), p.112 (13P-9)
Alberta - scenes, p.1 (13P-10), p.1 (13P-6), p.1
 (13P-7), p.3 (13P-12), p.21 (7P-262), p.32
 (7P-345), p.34 (7P-359), p.52 (7P-608), p.52
 (92P-11), p.68 (333P-5), p.86 (7P-1105), p.90
 (7P-1171), p.91 (16P-13), p.92 (7P-1040),
 p.112 (13P-9), p.113 (7P-1411), p.114
 (13P-2), p.127 (7P-1580), p.132 (7P-1658),
 p.133 (7P-1680), p.142 (7P-1769), p.147
 (7P-1806)
Alberta - settlement, p.70 (7P-852), p.90
 (7P-1180)
Alberta, Department of Culture, Provincial
 Archives, p.1 (13P-7)
Alberta, Government Services, Bureau of Public
 Affairs, p.1 (13P-6)
Alberta, Legislature Library, p.1 (13P-10)
Alberta Medical Association, Edmonton, Alta., p.1
 (92P-2)
Alberta (SS), p.76 (7P-931)
Albertype Company, p.2 (18P-58), p.2 (7P-5)
Albright, Martin, and family, p.91 (7P-1187)
Alcan Co., Kitimat, B.C., p.145 (7P-1783)
Alcan Highway - construction, p.94 (7P-1113)
Alcock, John, Capt., p.51 (7P-584), p.73 (7P-885),
 p.74 (7P-902), p.88 (7P-1156), p.91
 (7P-1186), p.152 (7P-1875)
Alderson, F.D., p.18 (7P-221)
Aldows, photo., p.75 (131P-6)
Alessio, Orio J., p.2 (7P-6)
Alexander, R.O., Maj. Gen., C.B., D.S.O., and
 family, p.6 (7P-53)
Alexander, W.M., p.2 (81P-3)
Alexander, William John and family, p.2 (16P-1)
Alexander of Tunis, Harold, Viscount, p.2 (7P-7),
 p.9 (7P-86), p.28 (7P-297), p.33 (7P-353),
 p.103 (7P-1302)

Alexander of Tunis, Harold, Viscount
 see also
 Alexandre de Tunis, Harold, Vicomte
Alexandra Studio, photo., p.2 (7P-8), p.37
 (7P-404)
Alexandre de Tunis, Harold, Vicomte
 voir aussi
 Alexander of Tunis, Harold, Viscount
Alexandre de Tunis, Harold Vicomte, p.109
 (7P-1360)
Alexandria, Ont. - general views, p.44 (8P-14)
Alfred, Paul, p.61 (8P-1)
Algeria (SS), p.133 (8P-10)
Algerine (H.M.S.), p.39 (7P-429)
Algie, W.L., Lt., p.68 (7P-831)
Algoma, Ont. - general views, p.153 (7P-1891)
Algoma District, Ont. - general views, p.104
 (7P-1313), p.111 (7P-1379)
Algoma (SS), p.77 (7P-947)
Algonquin Park, Ont. - general views, p.15
 (123P-9)
All-Canadian Congress of Labour, p.28 (7P-289)
Allan, Andrew Edward Fairbairn, p.2 (7P-9)
Allan, Edward, Master, p.95 (7P-1118)
Allan, John A., photo., p.141 (92P-12)
Allan, W.C., Dr., p.95 (7P-1118)
Allan Line, p.69 (7P-836)
Allard, A.B. Inspector, R.C.M.P., p.2 (7P-11)
Allard, Alexandrine, p.2 (7P-10)
Allard, D.M., p.2 (7P-11)
Allard, Dorothy M., p.2 (81P-4)
Allard, Joseph Arthur, p.2 (7P-12)
Allen, D.D., p.47 (7P-543)
Allen, Orval W., photo., p.2 (18P-96)
Allen, Phillip E., p.2 (7P-13)
Allen Bros., photo., p.153 (7P-1887)
Allenby, Lord, Field Marshall, p.85 (31P-51)
Alleya, W.J., Mrs., p.2 (81P-5)
Allison, Gordon H., p.2 (7P-14)
Allison, R.S., p.2 (7P-15)
Almighty Voice, Cree Indian, p.83 (7P-1025)
Almon, Albert, p.2 (7P-16)
Almonde, Ont. - individuals, p.104 (7P-1309)
Almonte, Don Juan M., Gen., p.101 (7P-1273)
Almonte, Ont. - general views, p.61 (7P-730), p.72
 (7P-880), p.83 (7P-1023), p.131 (7P-1646),
 p.132 (7P-1651)
Alpine Club of Canada, Alta., p.2 (166P-18), p.3
 (166P-22), p.3 (166P-4), p.3 (166P-43), p.62
 (166P-3), p.114 (13P-2), p.125 (166P-2)
Amalgamated Clothing Workers of America, p.108
 (7P-1348)
Amateur Athletic Union of Canada, p.3 (7P-17)
Ambrotypes, p.3 (131P-7), p.14 (7P-158), p.15
 (7P-167), p.15 (7P-170), p.18 (7P-223), p.20
 (7P-239), p.21 (7P-1910), p.28 (327P-4), p.29
 (337P-2), p.33 (208P-1), p.52 (7P-606), p.58
 (7P-695), p.59 (7P-704), p.70 (7P-855), p.80
 (7P-985), p.100 (7P-1258), p.103 (7P-1299)
American Chemical Society, p.143 (196P-63)
American Federation of Labour Congress, 1939,
 p.10 (7P-109)
American Photographers, photo., p.58 (1P-39)
Amérique du Sud - vues, p.86 (7P-1105)
Ames, A.J. & famille, p.3 (7P-18)
Ames, A.J., photo., p.3 (7P-18), p.6 (7P-50)
Amherst, N.S. - general views, p.120 (31P-67)
Amherst Internment Camp, Amherst, N.S., p.3
 (31P-42)
Amiens, France - general views, p.23 (7P-1933)
Amis de Sainte-Anne, Sainte-Anne-de-la-Pérade
 (Québec), p.136 (352P-1)
Amundsen, Roals, p.3 (7P-19)
Anacréon, Richard, p.141 (303P-12)
Anderson, A., photo., p.145 (7P-1780)
Anderson, A.H., Maj., p.3 (7P-20)
Anderson, Charles, Mrs., p.3 (81P-6)
Anderson, Douglas E., p.3 (7P-21)
Anderson, E.A., Mrs., p.3 (81P-7)

Anderson, Ethel Cameron, p.3 (92P-3)
Anderson, Frederick, photo., p.3 (7P-22)
Anderson, Marion, p.101 (7P-1272)
Anderson, Robert W., photo., p.4 (8P-16)
Anderson, Rudolph Martin, photo., p.3 (7P-23)
Anderson's Hollow (N.-B.) - vues, p.24 (7P-1930)
André, Alexis, Rév., p.12 (7P-130), p.36 (7P-384)
Andreassen, John, p.3 (7P-24)
Andrews-Newton, photo., p.24 (7P-1943)
Angers (famille), p.31 (185P-17)
Angleterre - vues, p.12 (7P-139)
Anglican Church of Canada, Diocese of Athabaska,
 Peace River, Alta., p.3 (13P-12)
Anglican Church of Canada, Diocese of Edmonton,
 Edmonton, Alta., p.3 (13P-11)
Anglican Church of Canada, Diocese of Ottawa,
 Archives, p.4 (301P-1)
Anglin, Frank, p.4 (7P-25)
Anglin, Margaret, p.4 (7P-25)
Anglin, T.W., p.4 (7P-25)
Animals - Alaska, p.82 (11P-1)
Animals - Alberta, p.8 (166P-15), p.45 (166P-35),
 p.59 (166P-26)
Animals - British Columbia, p.58 (333P-25)
Animals - Saskatchewan, p.70 (10P-10), p.114
 (10P-14), p.125 (10P-2), p.125 (10P-3), p.125
 (10P-4)
Annan, Ont. - general views, p.41 (7P-448)
Annapolis District Drama Group productions, N.S.,
 p.148 (31P-59)
Annapolis River, N.S. - general views, p.69 (1P-18)
Annapolis (vallée) (N.-E.) -vues, p.146 (7P-1793)
Annapolis Valley, N.S. - general views, p.49
 (1P-36), p.60 (1P-25)
Annetts, Helen, and family, p.4 (7P-26)
Anonymes - Bibliothèque de la Ville de Montréal,
 p.4 (113P-09)
Anonymous - Provincial Reference Library, Nfld.,
 p.103 (38P-11)
Anonymous - Public Archives of Nova Scotia,
 p.131 (1P-10), p.137 (1P-2)
Antarctic - general views, p.41 (7P-450)
Anthony, Dom, Abbot, p.127 (7P-1581)
Anthony, E. & H.T., & Co., New York, N.Y., p.46
 (7P-27)
Anthony, Edward, photo., p.54 (7P-634),
 p.70 (7P-855)
Anticosti (Ile) (Québec) - vues, p.96 (7P-1203)
Anticosti Island, Que., - general views, p.4 (7P-28)
Antigonish, N.S. - general views, p.41 (31P-82)
Anyox, B.C. - general views, p.73 (12P-13)
Appelbe Teskey, Louise, and family, p.4 (47P-2)
Appleby, Arthur W., p.4 (7P-29)
Appleton, Ont. - general views, p.83 (7P-1023),
 p.132 (7P-1651)
Appleton, W.S., p.4 (7P-30)
Aquitania (SS), p.42 (1P-70)
Arawanna (SS), p.147 (7P-1813)
Arbakka, Man. - general views, p.97 (9P-56)
Archambault, Edouard, p.9 (7P-92)
Archambault, photo., p.10 (7P-106), p.55
 (131P-1), p.125 (7P-1562)
Archer, Anthony S., photo., p.4 (7P-31)
Archer, David, p.108 (7P-1348)
Archer, Tony
 see
 Archer, Anthony S.
Archer, Violet, p.4 (7P-32)
Archibald, A.G., p.85 (7P-1089)
Archibald, Raymond Clare, and family, p.4
 (32P-1)
Archibald, Sanford, p.4 (31P-33)
Archibald, William Munroe, p.4 (7P-33)
Archidiocèse d'Ottawa (catholique romain), p.48
 (306P-1)
Archidiocese of Quebec (Roman Catholic), p.88
 (7P-1147)
Architecture - Brasilian, p.63 (313P-1)

Architecture - Canadian, p.32 (140P-1), p.39
 (7P-430), p.51 (7P-596), p.63 (313P-1), p.88
 (9P-47), p.90 (7P-1175), p.96 (39P-1), p.96
 (7P-1204), p.97 (334P-25), p.119 (18P-13),
 p.121 (18P-1), p.129 (7P-1622), p.132 (9P-68)
Architecture - European, p.63 (313P-1), p.129
 (7P-1622), p.148 (31P-8)
Architecture - Manitoba, p.88 (9P-47)
Architecture - Mexican, p.63 (313P-1)
Architecture - Québec, p.100 (7P-1257)
Architecture - québécoise, p.97 (7P-1209), p.113
 (7P-1419)
Architecture - rurale, p.64 (327P-2)
Archives du Musée du Royal 22ième Régiment,
 Québec (Québec), p.4 (134P-1)
Archives du Séminaire de Québec, p.4 (131P-9)
Archives du Séminaire de Rimouski, Rimouski
 (Québec), p.4 (7P-34)
Archives of Ontario Collection, Toronto, Ont., p.4
 (8P-16)
Archives Provinciales des Clercs de Saint-Viateur,
 Joliette (Québec), p.4 (221P-1)
Archives publiques (édifice), Ottawa (Ont.), p.21
 (7P-1910)
Arctic - general views, p.7 (16P-2), p.41 (7P-450)
Arctic Archipelago, N.W.T. - general views, p.81
 (7P-997)
Arctic (C.G.S.), p.11 (7P-118), p.81 (7P-997), p.99
 (7P-1244), p.112 (7P-1396)
Arctic Expedition, p.52 (7P-599)
Ardagh, H., p.145 (7P-1775)
"Ardwold" - Eaton's family - Toronto, Ont., p.53
 (18P-36)
Argentina - general views, p.115 (7P-1445)
Argintine Historical Society, Executive Committee,
 p.91 (7P-1187)
Arizona, United States - scenes, p.49 (7P-572)
Arless, G.C., photo., p.149 (7P-1828)
Arless, Richard, photo., p.5 (7P-35), p.69 (7P-839)
Armbrister, Frederick, photo., p.5 (166P-30)
Armistice Day - Nova Scotia -Halifax, p.42
 (1P-70)
Armistice Day - Ontario - Ottawa, p.30 (7P-316)
Armistice Day - Ontario - Toronto, p.70 (140P-15)
Armitage, Mona, p.5 (7P-36)
Armstrong, Agnes, p.5 (7P-37)
Armstrong, Alan, p.5 (7P-38)
Armstrong, Ernest Howard, p.5 (1P-27)
Armstrong, Frederick Henry, p.5 (7P-39)
Armstrong, Harry William Dudley, p.5 (7P-40)
Armstrong, J.W., photo., p.72 (7P-874)
Armstrong, Neil J., p.5 (7P-41)
Armstrong, Omar, p.5 (7P-42)
Armstrong, William, photo., p.4 (8P-16), p.66
 (7P-797)
Armstrong, William and family, p.5 (7P-43)
Army - Nova Scotia, p.105 (1P-80)
Arni, Urs G., photo., p.31 (7P-343)
Arnison, Lance, p.5 (334P-23)
Arnprior, Ont. - general views, p.80 (7P-981), p.87
 (8P-2)
Arnprior, Ont. - individuals, p.104 (7P-1309)
Arrowhead, Alta. - general views, p.148 (7P-1825)
Arrowhead (H.M.C.S.), p.87 (7P-1136)
Art - Study and teaching, p.5 (140P-16)
Art Gallery of Ontario, p.5 (140P-16), p.5
 (308P-1), p.5 (308P-2), p.5 (7P-43)
Art Gallery of Toronto
 see
 Art Gallery of Ontario
Art Museum of Toronto, Toronto, Ont., p.123
 (7P-1539)
Arth, Ferd, photo., p.50 (200P-12)
Arthabaskaville, Que. - general views, p.79
 (7P-974)
Arther, J., p.19 (7P-229)
Arthur, Eric Ross, p.5 (18P-53), p.5 (7P-44)
Arthur, H.R.H. Prince, p.31 (7P-344)
Arthur & Philbric, photo., p.50 (200P-12)

Arthur, Richard M., p.5 (7P-45)
Artillerie royale canadienne, p.102 (7P-1283)
Artists - Canada, p.83 (75P-13), p.112 (7P-1403)
Artists - Canadian, p.118 (7P-1481)
Artists - Ontario, p.123 (7P-1539)
Ashbridge's Bay, Ont. - general views, p.32
 (140P-9)
Ashcroft, B.C. - general views, p.29 (228P-4),
 p.127 (7P-1582)
Ashfield, James, photo., p.57 (7P-685)
Ashley & Crippen, photo., p.31 (7P-338)
Ashton, F.G., photo., p.5 (123P-2)
Ashton, Fred, p.130 (7P-1633)
Assinaboia (SS), p.145 (7P-1775)
Assiniboine and Saskatchewan Exploring
 Expedition, 1858, p.65 (9P-29), p.66 (18P-9)
Assiniboine Indians, p.125 (7P-1566)
Associate Committee on Army Medical Research,
 p.36 (7P-387)
Associated Screen News, photo., p.26 (7P-266),
 p.37 (7P-404)
Associated Screens News, photo., p.29 (7P-304)
Association ambulancière Saint-Jean, Montréal
 (Québec), p.90 (113P-8)
Association Historique Canadienne, Winnipeg
 (Man.), p.89 (7P-1165)
Association of American Editorial Cartoonists, p.5
 (7P-46)
Associazione Nazionale Alpini d'Italia, Toronto,
 p.111 (7P-1387)
Astley, Robert, photo., p.4 (8P-16)
Astrophysics - generalities, p.36 (332P-1)
Astrophysique - generalités, p.36 (332P-1)
Atget, Eugène, photo., p.25 (123P-1)
Athabasca, Alta. - general views, p.3 (13P-12)
Athabasca Lake, Alta. - general views, p.21
 (92P-8)
Athabasca River, Alta. - general views, p.50
 (92P-10)
Athabasca (Riviere) (Alberta) - vues, p.20
 (7P-241)
Athabasca Tar Sands, Alberta, p.48 (7P-554)
Athabaska Landing, Alta. - general views, p.116
 (7P-1451)
Athabaska River, Alta. - general views, p.116
 (7P-1451), p.141 (92P-12)
Athalmer, B.C. - general views, p.77 (333P-41)
Athlone, Alexander of Teck, Earl of, p.135
 (7P-1707)
Atkin, Gilbert M., Dr., p.6 (166P-31)
Atlas Aviation Ltd., p.113 (7P-1417)
Atlin, B.C. - general views, p.118 (12P-23), p.137
 (7P-1719), p.147 (7P-1809)
Atrato (schooner), p.86 (31P-19)
Attanyi, Anthony, photo., p.6 (7P-47)
Attree, E.H.L., p.6 (333P-23)
Atwood family, Ont., p.139 (7P-1743)
Aubert de Gaspé, Philippe, p.45 (7P-515)
Audet, F., p.89 (7P-1165)
Audet, Francis Joseph, p.6 (7P-48)
Audet, photo., p.4 (131P-9)
Audette, Louis de la Chesnaye et famille, p.6
 (7P-49)
Auger, Aurelien, Abbé, p.96 (7P-1201)
August, E.M., p.6 (7P-50)
Augustines
 voir aussi
 Monastères
Augustines du Monastère de l'Hôtel-Dieu de
 Québec, Québec, p.6 (171P-2)
Aura Lee Lake, Ont. - general views, p.47
 (7P-543)
Aurora, Ont. - general views, p.66 (7P-798)
Aurora (H.M.S.), p.103 (7P-1299)
Austin, Bradley Sherwood, p.6 (7P-51)
Austin, E.A., photo., p.153 (7P-1890)
Austin, Jacob (Jack), p.6 (7P-52), p.26 (7P-269)
Austin Airways Ltd., p.26 (7P-269), p.137
 (7P-1734)

Austin family, Ont., p.72 (7P-884)
Automobiles
 see also
 Transportation
Automobiles - American, p.38 (7P-407)
Automobiles - European, p.38 (7P-407)
Autriche - vues, p.24 (7P-1918)
Avalon Peninsula, Nfld. - general views, p.57
 (38P-6)
Avenue Road Theatre, p.103 (16P-14)
Aviation - Canada, p.7 (13P-5), p.63 (7P-755),
 p.110 (7P-1375)
Aviation - Canada (Western), p.148 (9P-72)
Aviation - Weston, Ont., p.70 (140P-15)
Avro Canada Ltd., p.153 (7P-1892)
Aylan-Parker, Ronald, p.6 (7P-53)
Aylen Lake, Ont. - general views, p.31 (7P-336)
Aylesworth, Lady, p.134 (7P-1692)
Aylmer, Que. - general views, p.62 (7P-743), p.72
 (7P-880), p.78 (7P-961), p.135 (7P-1710)
Ayre, Charles P., p.6 (7P-54)
Aznavour, Charles, p.43 (7P-480)

B & I Photography, photo., p.102 (7P-1293)
B.C. Pulp, Port Alice, B.C., p.108 (12P-2)
B.E.A.R. Exploration, p.41 (7P-457)
Babbage, Richard Henry, p.6 (7P-55)
Baber, Anna Maria, p.6 (7P-56)
Baber, John, p.6 (7P-56)
Bacchante (yacht), p.4 (7P-28)
Bach, Bertram, p.6 (7P-57)
Badanai, Hubert (Umberto), p.6 (7P-58)
Baddeck, N.S. - general views, p.111 (7P-1383)
Baddeck No. 1, p.110 (7P-1375)
Baden-Powell, Robert S., Gen., p.149 (7P-1831)
Baden-Powell, Robert S., Lt. Col., p.152 (7P-1872)
Badgley, C.W., p.6 (7P-59)
Baffin Island, N.W.T. - general views, p.45
 (7P-507), p.98 (7P-1233), p.99 (7P-1244)
Bahlawan, W., p.6 (7P-60)
Baie des Pères, Que. - general views, p.20 (7P-252)
Bailey, Pearl, p.83 (7P-1027)
Bailey Bros., photo., p.139 (7P-1739)
Baillie Island, N.W.T. - general views, p.135
 (7P-1696)
Baine Johnston and Co., St. John's, Nfld., p.87
 (7P-1136)
Baker, B.C. - general views, p.15 (333P-40)
Baker, D.H., p.6 (7P-61)
Baker, Edgar C., p.7 (1P-5)
Baker, Frances (Stubb), Mrs., p.7 (92P-4)
Baker, Frederick Clements, p.7 (9P-1)
Baker, Ranson, p.79 (7P-982)
Baker, Raymond F., p.7 (7P-62)
Baker, Russell, p.7 (7P-63)
Baker family, Ont., p.147 (7P-1806)
Baker Lake, N.W.T. - general views, p.55
 (7P-651), p.119 (7P-1489), p.126 (7P-1570)
Bakerville, B.C. - general views, p.68 (333P-5)
Bakerville Mine, B.C. - general views, p.63
 (196P-42)
Baku, U.S.S.R., p.147 (7P-1804)
Bala, Ont. - general views, p.148 (200P-15)
Balbo, Italo, Gen., p.129 (7P-1618)
Balchen, Bernt, p.7 (7P-64), p.106 (7P-1329)
Balcom, Samuel, p.7 (31P-12)
Baldurn, Stanley, p.130 (7P-1629)
Baldwin, Casey, p.26 (7P-269)
Baldwin, Charles O., p.7 (92P-5)
Baldwin, photo., p.135 (7P-1704)
Baldwin, Stanley, p.102 (7P-1281)

Baldwin, William Willcocks, and family, p.7
(18P-30)
Ballantyne, Charles Colquhoun, p.7 (7P-65)
Ballard, Harold, p.56 (7P-661)
Ballet National du Canada, p.10 (7P-104)
Ballon, Ellen, p.7 (31P-99)
Ballons - *R-100*, p.80 (131P-4)
Balloon - Ontario, p.65 (7P-781)
Balloon - Quebec, p.65 (7P-781)
Balloons - *R-100* , p.59 (7P-709), p.130 (7P-1637),
p.148 (7P-1822)
Balmer, George, p.152 (7P-1878)
Balmer, John, p.152 (7P-1878)
Balmer, Margaret, p.152 (7P-1878)
Balmer, Robert., p.152 (7P-1878)
Balmer, W.J., p.152 (7P-1878)
Balsdon, Allan, p.7 (7P-66)
Balton, Que. - general views, p.87 (7P-1144)
Bamber, W. Harry, and family, p.7 (13P-5)
Bamber, W. Harry, photo., p.7 (13P-5)
Band Family, Ont., p.7 (18P-82)
Banff, Alta. - aerial views, p.149 (166P-10)
Banff, Alta. - general views, p.5 (166P-30), p.6
(166P-31), p.8 (166P-15), p.13 (13P-3), p.17
(166P-12), p.17 (166P-14), p.17 (166P-17),
p.45 (166P-35), p.58 (166P-29), p.62
(166P-20), p.62 (166P-3), p.62 (166P-7), p.84
(166P-41), p.90 (166P-49), p.92 (7P-1039),
p.99 (166P-19), p.99 (166P-24), p.104
(166P-1), p.105 (123P-5), p.105 (123P-5),
p.110 (166P-8), p.110 (166P-9), p.114
(7P-1424), p.117 (166P-48), p.125 (166P-2),
p.131 (166P-45), p.139 (7P-1739), p.148
(166P-28), p.148 (7P-1825), p.149 (166P-10),
p.151 (166P-16)
Banff, Alta. - individuals, p.104 (166P-1), p.110
(166P-8)
Banff National Park, Alta. - general views, p.5
(166P-30), p.45 (166P-35), p.59 (166P-26),
p.62 (166P-7), p.99 (7P-1244), p.113
(166P-21), p.118 (166P-42), p.125 (166P-2),
p.130 (166P-45), p.148 (166P-40)
Banff Winter Carnival, Banff, Alta., p.129 (166P-6)
Banfield, A.W. Mrs., p.7 (1P-28)
Banfield, A.W. Rev., p.7 (1P-28)
Bank of Montreal, p.56 (7P-672)
Bank of Montreal, Ottawa, Ont., p.63 (8P-5)
Bank of Montreal, Toronto, Ont., p.63 (8P-5)
Bank of Nova Scotia, Toronto, Ont., p.7 (309P-1)
Bank of Toronto, p.138 (320P-1)
Bankhead, Alta. - general views, p.148 (166P-40)
Banks - Ontario - Toronto, p.7 (309P-1), p.138
(320P-1)
Banks, C., p.43 (7P-487)
Banks, H.D., photo., p.153 (161P-1)
Banks Island, N.W.T. - general views, p.135
(7P-1696), p.135 (7P-1696)
Banque de Nouvelle-Ecosse, Toronto (Ont.), p.7
(7P-67)
Banting, Frederick Grant, Dr., p.7 (16P-2), p.76
(7P-925), p.107 (7P-1295)
Banting (SS), p.7 (16P-2)
Barbeau, Marius, p.60 (7P-716)
Barber, George Thomas, p.8 (9P-2)
Barbier, C.A., photo., p.2 (7P-12)
Barclay, R.G., p.8 (7P-68)
Bardy, Marie Virginie Celina, p.8 (171P-3)
Bardy, Pierre-Marcial, Dr, p.8 (171P-3)
Bardy, Pierre-Marcial, Mme, p.8 (171P-3)
Barker, George, photo., p.54 (7P-635)
Barker, William G., p.8 (7P-69), p.12 (7P-140)
Barkerville, B.C. - general views, p.82 (7P-1005),
p.95 (7P-1117), p.109 (12P-17)
Barkerville (C.-B.) - vues, p.35 (7P-371)
Barkham, B., p.8 (7P-70)
Barley, H.C., photo., p.153 (161P-1)
Barlow, A.E., p.130 (7P-1638)
Barnard, Edouard-Andrew (famille), p.8 (185P-20)

Barnardo's (Dr.), farm for boys, Russell, Man.,
p.22 (7P-1906)
Barnes, A., p.8 (7P-76)
Barnes, Elliott, photo., p.8 (166P-15)
Barnett, Mary G., p.8 (7P-73)
Barnett, Sydney, p.8 (7P-74)
Barnhart, John, Dr., p.8 (7P-75)
Barnhart, W.S., et famille, p.8 (7P-75)
Barnston Island, B.C. - general views, p.59
(7P-710)
Barr, George, p.8 (333P-17)
Barr, Isaac M., Rev., p.125 (7P-1566)
Barr family, Sask., p.133 (7P-1670)
Barrett, S., photo., p.70 (7P-855)
Barrie, Ont. - general views, p.17 (7P-205), p.39
(7P-420), p.75 (7P-910)
Barriefield, Ont. - general views, p.90 (7P-1173)
Barrington, N.S. - general views, p.119 (7P-1490),
p.120 (1P-93)
Barrow-in-Furness, Angleterre - vues, p.24
(7P-1930)
Barthe, Marcelle, p.8 (185P-18)
Barthe (famille), p.8 (185P-18)
Bartle Brothers, photo., p.8 (8P-11)
Bartlett, Bob, Capt., p.91 (7P-1186)
Bartlett, Hazel L., p.8 (7P-71)
Bartlett, Robert, p.8 (7P-72)
Barwick, Walter, p.144 (196P-13)
Bary Ensemble, N.S., p.119 (31P-100)
Basilian Fathers, p.142 (200P-18), p.148
(200P-15)
Basiliques - Québec - Sainte-Anne-de-Beaupré, p.4
(134P-1), p.80 (131P-4), p.91 (131P-3)
Bass, W.R., p.8 (7P-77)
Bassano, Alta. - general views, p.56 (7P-672)
Bassano, photo., p.79 (7P-971)
Bataillon Mackenzie - Papineau, p.8 (7P-79)
Bateaux à vapeur, p.107 (7P-1335)
Bateson, W.J., p.8 (7P-78)
Bathurst Inlet (T.N.-O.) - vues, p.11 (7P-119)
Batiscan River, Que. - general views, p.117 (18P-6)
Battle of Ridgeway, Toronto, Ont. - Monument,
p.66 (7P-787)
Battleford, Sask. - general views, p.100 (7P-1263)
Battleford, Sask. - Settlement, p.8 (7P-832)
Baudoux, Maurice, Abbé, p.109 (7P-1350)
Baudry, C., p.8 (7P-80)
Baulu, Roger, p.9 (7P-91), p.43 (7P-480)
Bauslaugh, T., photo., p.142 (200P-8)
Baxter, H., photo., p.9 (5P-8)
Baxter, Les, photo., p.138 (322P-2)
Bay Bulls, Nfld. - general views, p.68 (7P-823)
Bay of Islands, Nfld., p.4 (7P-30)
Baychimo (SS), p.112 (7P-1396)
Bayer, J.A.S., photo., p.9 (5P-9)
Bayfield, H.W., Adm., p.133 (7P-1676)
Bayfield, H.W., Mrs., p.133 (7P-1676)
Bayley and Murphy, photo., p.49 (1P-36), p.49
(1P-9)
BC Express (Paddleboat), p.121 (228P-1)
Beach, D.M., p.9 (7P-82)
Beaches - Ontario - Toronto, p.32 (140P-11), p.33
(140P-6), p.51 (18P-85)
Beaconsfield, Ont. - fire, 1963, p.54 (7P-635)
Beale, A.M., p.9 (7P-84)
Beales, Arthur, photo., p.138 (322P-3)
Beals, C.S., p.9 (7P-85)
Beament, Harold, p.9 (7P-86)
Beamont, E., p.9 (92P-6)
Bear River, N.S. - general views, p.43 (1P-19)
Beaton, Cecil, photo., p.9 (7P-88)
Beaton, Neil S., photo., p.9 (7P-87)
Beaton Institute of Cape Breton Studies, College of
Cape Breton, Sydney, N.S., p.9 (104P-1)
Beatrice, Princess, p.147 (7P-1814)
Beattie, Stewart, p.9 (7P-89)
Beatty, Edward, Sir, p.71 (7P-866)
Beaubien, Gaspé, p.14 (7P-163)

Beauce (Québec) - vues, p.80 (131P-4)
Beauceville (Québec) - vues, p.25 (7P-1935)
Beauchesne, Arthur, p.9 (7P-90)
Beaudet, Jean-Marie, p.9 (7P-91)
Beaudoin, Louis-René, et famille, p.9 (7P-92)
Beaudry, photo., p.4 (131P-9)
Beaufort, S.C. - general views, p.120 (123P-8)
Beaugrand, Honoré, p.11 (7P-114)
Beaugrand dit Champagne
voir aussi
Champagne
Beaugrand *dit* Champagne family, p.30 (7P-328)
Beauharnois (Québec) - vues, p.25 (7P-1935)
Beaulieu, Jean-Paul, p.9 (7P-93)
Beaumont, Charles, p.9 (7P-94)
Beauport, Que. - general views, p.64 (7P-766)
Beauport (Québec) - vues, p.80 (131P-4)
Beaupré (Québec) - vues, p.80 (131P-4)
Beauregard, photo., p.55 (131P-1)
Beauregard, S.S.T., p.9 (196P-49)
Beaver Dams Camp, Ont., p.125 (18P-91)
Beaver Glacier, B.C. - general views, p.3 (166P-43)
Beaver Lodge - Austin, W.A., Ottawa, Ont., p.6
(7P-51)
Beaverlodge Lake, N.W.T. - general views, p.130
(7P-1625)
Beaverton, Ont. - general views, p.126 (7P-1579)
Beck, Adam, Sir, p.32 (140P-1)
Beck, Geoffrey Ronald, p.9 (7P-95)
Becker, Lavy M., p.9 (7P-96)
Beckett Photography, photo., p.10 (45P-2)
Beckstead, Ira W., photo., p.10 (7P-97), p.68
(7P-816)
Bédard, Roger, photo., p.4 (131P-9)
Beddoe, C.H., p.152 (7P-1882)
Bedford, N.S. - general views, p.5 (1P-27), p.120
(1P-93)
Bedford Magazine explosion - 1945, p.120 (1P-93)
Bedford Park, Toronto, Ont., p.19 (200P-1)
Beecham, Thomas, Sir, p.7 (31P-99)
Beechey (îles), T.N.-O. - vues, p.14 (7P-159)
Beeching, Charles, p.10 (7P-98)
Beere, Daniel, photo., p.4 (8P-16)
Beet, Harry Churchill, Lt. C.V., p.10 (7P-100)
Bégin, Mgr., p.91 (131P-3)
Begley, Michael, p.10 (185P-6)
Béique, Frederic Ligori, p.10 (7P-101)
Belaney, A.S., p.79 (7P-975)
Bélanger, Abbé, p.96 (7P-1201)
Belcher, Thomas Sherwood, p.1 (81P-2)
Belfie, William G., p.10 (7P-102)
Belgium - general views, p.72 (7P-879), p.87
(7P-1133)
Belgium - war memorials, p.35 (7P-378)
Bell, Alexander Graham, Dr., p.10 (330P-1), p.10
(7P-99)
Bell, Frederick Charles, p.10 (9P-3)
Bell, James McKintosh, p.10 (7P-103)
Bell, Richard Albert, p.10 (7P-105)
Bell, Robert, photo., p.21 (7P-1910), p.45 (7P-507)
Bell, W.P. & Son, photo., p.94 (7P-1099)
Bell Canada, p.10 (330P-1), p.10 (7P-99), p.34
(7P-362)
Bell Canada, Brantford (Ont.) - monument
commémoratif, p.16 (7P-197)
Bell family, N.B., p.10 (32P-2)
Bell Ken, photo., p.10 (7P-104)
Bella Bella, B.C. - general views, p.56 (7P-660)
Bella Coola Indians - B.C., p.94 (16P-9)
Bellegarde, Sask. - general views, p.50 (7P-579)
Bellemare, Raphael, p.10 (7P-106)
Belleville, Ont. - general views, p.16 (75P-2), p.94
(7P-1099), p.138 (7P-83)
Belleville, Ont. - individuals, p.153 (7P-1887)
Bellevue (Château), Saint-Joachim (Québec), p.77
(131P-5), p.91 (131P-3)
Belmont (Barque), p.10 (31P-103)
Belson, W.R., p.10 (7P-107)
Ben-Gurion, David, p.30 (7P-324)

Benamou, Jean-Pierre, p.10 (7P-108)
Benett, Capt., p.51 (7P-584)
Bengough, Percy, p.10 (7P-109)
Benito (SS), p.122 (7P-1531)
Benjamin, Walter R., p.10 (7P-110)
Bennett, B.C. - general views, p.42 (7P-459)
Bennett, Gertrude, p.29 (7P-313)
Bennett, Percy, p.10 (7P-112)
Bennett, Richard Bedford, Rt. Hon., p.22 (7P-1905), p.40 (7P-432), p.40 (7P-439), p.68 (7P-822), p.71 (7P-866), p.82 (7P-1012), p.94 (7P-1084), p.119 (7P-1486), p.135 (7P-1707)
Bennett, Richard Bedford, Très Hon., p.11 (7P-111), p.119 (7P-1275)
Bennett Lake, Yukon - general views, p.147 (7P-1809)
Bennie, H.T., p.11 (7P-113)
Benny Farm Gardens, Montréal (Québec), p.44 (113P-6)
Benoit, Rosario, Abbé, p.11 (131P-2)
Benson, George Frederick, and family, p.11 (75P-1)
Bent, P.E., Lt-Col., V.C., D.S.O., p.2 (7P-15)
Bentley, Percy, photo., p.145 (300P-1)
"Benvenuto" - Janes family, p.71 (18P-63)
Berchman, Mary, Rev. Mother, p.100 (340P-1)
Berens River, Man. - settlement, p.79 (9P-40)
Bergen, Edgar, p.101 (7P-1272)
Bergevin, A.F., p.11 (7P-114)
Bergh, Philip, Mme, p.11 (7P-115)
Berlin, Ont. - general views, p.126 (7P-1573)
Bermuda - general views, p.46 (7P-518)
Bernard, Jack, p.43 (7P-479)
Bernay, M.L., G.M., R.C.N., p.11 (7P-116)
Berner, J.E., Capt., p.81 (7P-997)
Bernhardt, P., p.11 (7P-117)
Bernier, John, Capt., p.133 (7P-1676)
Bernier, Joseph-Elzéar capt., p.11 (7P-118)
Bernier's Expedition, 1906-1907, p.133 (7P-1676)
Bernstein, Leonard, p.7 (31P-99)
Berry, A. Matt, p.11 (7P-119)
Berstadt, Charles, photo., p.59 (7P-704)
Bertcly, Leo W., p.11 (7P-121)
Berthierville, Que. - general views, p.34 (7P-362)
Berthierville (Québec) - vues, p.25 (7P-1935)
Berton, Pierre, p.7 (31P-63)
Bertram - Stubbs, O., photo., p.49 (1P-36)
Bertrand, Placide, p.89 (7P-1165)
Berval, Paul, p.43 (7P-480)
Berwick , (H.M.S.), p.63 (7P-751)
Berwyn, Alta. - general views, p.3 (13P-12)
Bessborough, Vere Brabazon Ponsonby, Comte de., p.11 (7P-123)
Bessborough, Vere Brabazon Ponsonby, Count of, p.25 (7P-1970), p.135 (7P-1707)
Bessborough, Vere Brabazon Ponsonby, Mme, p.11 (7P-122)
Best, Bev., photo., p.28 (7P-290)
Best, Charles, Dr., p.56 (7P-661)
Best, J. Linden, p.11 (31P-62)
Beth Shalom Congregation, Ottawa, Ont., p.47 (7P-537)
Bethel, V.M., p.11 (7P-120)
Bethune, A.M., and family, p.11 (18P-46)
Bethune, John, Rev., p.95 (7P-1118)
Bethune, Norman, Dr., p.122 (7P-1530)
Bethune family, Ont., p.131 (18P-60), p.131 (18P-64)
Bettridge, William, Rev., p.38 (7P-412)
Beurling, George F., p.11 (7P-124)
Biarritz, France - vues, p.89 (303P-10)
Bibaud, François Marie Uncas Maximilien, p.11 (7P-125)
Biberovich, Ladislaus, p.11 (7P-126)
Bibliothèque municipale de Montréal, Montréal (Québec), p.11 (7P-127)

Bibliothèque nationale (édifice), Ottawa (Ont.), p.21 (7P-1910)
Biehler, J.A., p.12 (7P-128)
Biesenthal, Clarence, p.12 (7P-129)
Big Bear, chef Cri, p.12 (7P-130)
Big Bear, Cree Chief, p.36 (7P-384)
Big Bend Highway, p.12 (7P-1142)
Big Creek, B.C. - scenes, p.32 (12P-6)
Big Grade Rockies, B.C. - general views, p.42 (7P-463)
Bigelow, E.A., p.12 (7P-131)
Biggar, Henry P., p.12 (7P-132)
Biggs, Hugh Beynon, p.12 (11P-12)
Billings Family, Ont., p.45 (7P-500)
Billinsky, S., p.12 (7P-133)
Bilodeau, Amédée, p.22 (7P-1927)
Binks, C., photo., p.72 (7P-880)
Binks and Wallis, photo., p.103 (7P-1300)
Binscarth District, Man. - general views, p.7 (9P-1)
Biological Sciences - generalities, p.36 (332P-1)
Birch, Arthur Nonus, p.12 (7P-134)
Birch, J. Edgar, p.12 (7P-135)
Birch River, Man. - general views, p.113 (7P-1415)
Bird, Florence Bayard, p.12 (7P-136)
Bird, John, p.12 (7P-136)
Bird, R.A. photo., p.12 (11P-4)
Birds - Canada, p.26 (7P-1955)
Birks, Henry et Fils Ltée., p.12 (7P-137)
Birmingham, W.H., p.12 (7P-138)
Birney, Earle, and family, p.12 (16P-3)
Birrell, Alice, p.5 (7P-39)
Birrell, John, p.5 (7P-39)
Birrell, William, photo., p.124 (7P-1548)
Bishop, William A., p.8 (7P-69), p.12 (7P-139), p.12 (7P-140)
Bishop's College School, Lennoxville (Québec), p.12 (346P-1)
Bishop's University Centennial Theatre, Lennoxville, Que., p.60 (7P-717)
Bisley, Angleterre - vues, p.14 (7P-160)
Bismarck (German Battleship), p.42 (7P-466)
Bithel, V.W., p.13 (7P-141)
Black, Constable, p.12 (7P-130), p.36 (7P-384)
Black, Harry, p.13 (7P-142)
Black, W.W., photo., p.10 (7P-102)
Black Bull, p.101 (7P-63)
Black Chute, Ont. - general views, p.93 (7P-1069)
Black Mountain, B.C. - general views, p.6 (12P-18)
Black Point, N.S. - general views, p.49 (1P-36)
Black River, N.B. - general views, p.43 (7P-475)
Black River, Que. - general views, p.46 (7P-526)
Blackburn, George, p.109 (7P-1362)
Blackett, Arthur E., Dr., p.13 (31P-39)
Blackfoot, Idaho - general views, p.120 (123P-8)
Blackfoot Indians, p.12 (11P-12), p.33 (7P-349), p.68 (333P-5), p.84 (11P-2), p.134 (11P-6)
Blackman, D.A., p.13 (7P-143)
Blackstone, Milton, p.61 (7P-731)
Blaine, Terry Mosher (Aislin), p.5 (7P-46)
Blair, Sidney Martin, p.13 (92P-7)
Blake, Edward, Hon., and family, p.5 (7P-37)
Blake, Harry, p.75 (7P-915)
Blakey, Joseph Adamson, photo., p.13 (18P-10)
Blanchet, Guy, and family, p.13 (12P-22)
Bland, John Otway Percy, and family, p.13 (16P-4)
Blasewits, Germany - general views, p.56 (7P-659)
Blatz, William E., p.13 (196P-5)
Blenheim, Ont. - general views, p.70 (7P-856)
Blenkinsop, Edward Weyman, p.13 (12P-16)
Blind River (Ont.) - vues, p.107 (185P-1)
Bliss, D.C.F., Lt. Col., p.3 (7P-20)
Blois, Evelyn, p.13 (1P-58)
Blomidon, N.S. - general views, p.35 (1P-6), p.88 (1P-47)
Blomidon (Cape), N.S. - general views, p.145 (7P-1775)
Blood Indians, p.65 (11P-7), p.68 (333P-5), p.84 (11P-2), p.118 (11P-5)

Bloom, Lloyd, photo., p.13 (7P-144), p.73 (7P-888)
Bloomfield, Ont. - general views, p.97 (7P-1208)
Blouin, Jules, photo., p.13 (7P-145)
Blount, Austin Ernest, p.13 (7P-146)
Bluenose (Schooner), p.13 (31P-105), p.123 (31P-5), p.146 (31P-20)
Bluenose Wharf, Halifax, N.S., p.46 (1P-34)
Blyth, Alfred, photo., p.13 (13P-3)
Blyth, M., p.13 (7P-147)
B'nai B'rith Society, Ottawa, Ont., p.55 (7P-655)
Bobcaygeon, Ont. - general views, p.110 (7P-1374)
Bobcaygeon Historical Museum, Bobcaygeon, Ont., p.13 (7P-149)
Bodrug, John, Rév., et famille, p.14 (7P-150)
Boeing (Company), Seattle (Wash.), p.14 (7P-151)
Bogart, Maria L., p.63 (7P-751)
Bogart, S.J., Capt., p.63 (7P-751)
Boggis, Michael A., p.14 (7P-152)
Bois - industrie et commerce - Ontario, p.8 (7P-77), p.13 (7P-142), p.16 (7P-184)
Bois - industrie et commerce - Québec, p.9 (7P-87)
Boissevain Community Archives Collection, p.14 (9P-82)
Boivin (famille) - Québec, p.14 (7P-153)
Bollinger, E.A., photo., p.14 (1P-29)
Bolton (Ont.) - vues, p.14 (7P-162)
Bompas, J.G.G., p.14 (7P-154)
Bompas, William C., p.14 (7P-154)
Bon Portage Island, N.S. - general views, p.120 (1P-93)
Bonanza King (SS), p.2 (7P-13), p.147 (7P-1809)
Bonar, James Charles, p.14 (7P-163)
Bonaventure Island, Que. - general views, p.40 (7P-434), p.52 (7P-601), p.80 (7P-990)
Bonavista (SS), p.4 (7P-30)
Bond, Courtney Claude Joseph, p.14 (7P-164)
Bond, Robert, Sir, p.52 (7P-608)
Bonneau, G.E., p.14 (007P-161)
Bonneau, J.C., p.14 (1P-59)
Bonnington, B.C. - general views, p.148 (7P-1825)
Bonnington Falls, B.C. - general views, p.146 (7P-1797)
Boorne and May, photo., p.14 (7P-156), p.18 (13P-1), p.124 (7P-1548)
Booth, R.S., p.130 (7P-1637)
Borbridge, H.B., p.14 (7P-157)
Borden, Frederick William, Hon. Sir, p.96 (7P-1198), p.109 (7P-1357), p.134 (7P-1692)
Borden, J.W., photo., p.152 (7P-1884)
Borden, Laura Bond, Lady, p.14 (7P-160)
Borden, Lorris Elijah, p.14 (7P-159)
Borden, Robert Clarence, p.24 (7P-1916)
Borden, Robert Laird, Rt. Hon. Sir, p.13 (7P-146), p.22 (7P-1903), p.24 (7P-1918), p.68 (7P-822), p.97 (7P-1214), p.121 (7P-1511)
Borden, Robert Laird, Très Hon. Sir, p.14 (7P-160), p.20 (7P-241)
Borden-Clarke, p.14 (7P-158)
Borrett, R.G., p.14 (7P-162)
Borrowman, R.E., p.14 (7P-171)
Boss, G., p.15 (333P-40)
Bossy, Walter J., et famille, p.15 (7P-165)
Bostock, H.S., p.15 (7P-173)
Bostock, William Douglas, photo., p.52 (7P-601)
Boston Bruins Hockey Club, p.34 (7P-361)
Bothwell, Marjorie, p.15 (7P-166)
Bothwell, Ont. - general views, p.17 (7P-205)
Botsford, William, p.148 (7P-1821)
Boucher de Labruere, Claude, Dr., p.15 (7P-170)
Boucher de Labruere, Joseph L.O. Montarville, p.15 (7P-170)
Boucher de Labruere, Pierre, p.15 (7P-170)
Boucher de Labruere, Rene, p.15 (7P-170)
Boucherville, Que. - general views, p.100 (7P-1256)
Boulton family - Ont., p.5 (308P-2)
Boundaries - Canada-United States, p.42 (7P-459), p.104 (9P-4)

Bourassa, Anne, p.15 (7P-167)
Bourassa, Henri, p.109 (7P-1350)
Bourassa, Napoleon, p.15 (7P-167)
Bourchier, famille (Ont.), p.15 (7P-168)
Bourdeau, Robert, photo., p.15 (123P-9)
Bourdon, Louis-Honoré, p.15 (7P-169)
Bourgeau, G.R., p.15 (7P-172)
Bourget, Ignace, Mgr., p.80 (7P-985), p.125 (7P-1562)
Bourinot, A.S., p.15 (7P-176)
Bourke, R., Lt., p.15 (7P-175)
Bourke, Rosalind T., p.15 (7P-175)
Bourque, F.L., p.15 (7P-174)
Bousefield, Josephine, p.149 (7P-1826)
Bovey, Wilfrid, p.15 (7P-177)
Bovey Family, Alta., photo., p.133 (166P-36)
Bow Lake, Alta. - general views, p.23 (7P-1926)
Bow River, Alta. - general views, p.113 (7P-1409), p.150 (7P-1843)
Bowden, Alta. - general views, p.66 (13P-4)
Bowell, Mackenzie, Sir, p.15 (7P-178), p.22 (7P-1903), p.31 (7P-332)
Bowen, R.C., p.15 (7P-179)
Bowles, p.15 (7P-180)
Bowles, R.S., Hon., p.15 (7P-181)
Bowness, p.56 (7P-666)
Bowring Bros., St. John's, Nfld., p.87 (7P-1136)
Boy Scout Movement - Canada, p.60 (7P-715)
Boy Scout World Jamboree, p.104 (7P-1307)
Boyce, J.W., photo., p.72 (7P-880)
Boyd, E.D.H., p.15 (7P-182)
Boyd, John, photo., p.15 (7P-186), p.16 (8P-6)
Boyd, John H., p.16 (7P-187)
Boyd, Mossom, p.16 (7P-183)
Boyd, Mossom & Co., Bobcaygeon, Ont., p.16 (7P-184)
Boyd, Mosson & Co., Bobcaygeon (Ont.), p.16 (7P-185)
Boyd, Sheila A., p.16 (7P-185)
Boyd, W.J., photo., p.41 (31P-82)
Boyer, Charles, p.101 (7P-1272)
Bracken, John, Hon., p.27 (9P-8), p.116 (7P-1462)
Bracken, John, Hon. et famille, p.16 (7P-188)
Bracker family, B.C., p.16 (334P-35)
Bradell, David L., p.16 (9P-5)
Bradford, William, photo., p.16 (7P-190)
Bradley, H. (famille), p.16 (7P-189)
Bradley, William Inglis, p.16 (7P-191)
Bradwin, E.W., Dr., p.53 (7P-625)
Braeside, Ont. - general views, p.101 (7P-1267)
Braidman, Florence Gwendolyn (Lazier)
 see also
 Lazier, Florence Gwendolyn
Braidwood, Florence Gwendolyn (Lazier), p.16 (75P-2)
Brampton (Ont.) - vues, p.14 (7P-162)
Brander, Maude, and family, p.16 (333P-32)
Brandon, Man. - general views, p.19 (11P-11), p.76 (7P-923), p.120 (7P-1505), p.139 (7P-1739)
Brandon (Man.) - vues, p.19 (7P-81)
Branley, Bill, p.16 (7P-192)
Brannen, W.M., photo., p.152 (7P-1884)
Brant, Joseph, p.16 (7P-196)
Brant, Joseph, et famille, p.16 (7P-195)
Brant County Museum, Brantford (Ont.), p.16 (7P-197)
Brant I.O.D.E., p.16 (7P-193)
Brant Monument, Brantford, Ont., p.111 (7P-1379)
Brantford, Ont. - general views, p.60 (7P-722), p.75 (7P-910)
Brantford, Ont. - scenes, p.61 (8P-1)
Brantford Orphans' Home, Brantford, Ont., p.127 (18P-42)
Bratt, Marion, Mrs., p.16 (12P-25)
Brault, Lucien, p.17 (7P-194)
Braves (des), Parc, Sainte-Foy (Québec), p.4 (134P-1)

Brazil - general views, p.115 (7P-1445)
Brebner, James, p.63 (196P-42), p.78 (196P-47)
Breen, John A., et famille, p.17 (7P-198)
Bremner, J.L., and family, p.146 (7P-1799)
Bremner, John, p.146 (7P-1799)
Bremner, Minnie, p.146 (7P-1799)
Brennan, R.L., p.17 (7P-202)
Brésil - vues, p.35 (329P-1)
Brethour, p.97 (7P-1216)
Breton, Alta. - general views, p.7 (13P-5)
Breton, Basil, p.70 (7P-852)
Breton, Douglas, p.70 (7P-852)
Brett, R.G., and family, p.17 (166P-12)
Brett family, Alta., p.17 (166P-12)
Brewer, George MacKenzie, and family, p.17 (149P-3)
Brewer, James, p.13 (7P-142)
Brewer Studio, photo., p.96 (7P-1193)
Brewery Creek, B.C. - general views, p.68 (333P-5)
Brewster, F.O. (Pat), p.17 (166P-17)
Brewster Transport Company, Banff, Alta., p.17 (166P-14)
Brezhnev, Leonid, p.30 (7P-324)
Bridges
 see also
 Ponts
Bridges - Alberta - Canadian Pacific Railways, p.18 (7P-221)
Bridges - Alberta (David Thompson), p.104 (7P-1315)
Bridges - British Columbia (Pattulo Bridge), p.134 (334P-2)
Bridges - British Columbia (Queensborough), p.38 (334P-3)
Bridges - Canada, p.44 (7P-492)
Bridges - Manitoba - Port Nelson, p.61 (7P-726)
Bridges - New Brunswick, p.103 (2P-1)
Bridges - Nova Scotia, p.105 (1P-77)
Bridges - Nova Scotia - Weymouth, p.5 (1P-27)
Bridges - Ontario - Oakville, p.106 (47P-5)
Bridges - Quebec - Montreal (Victoria), p.105 (327P-1)
Bridges - Quebec - Montreal (Victoria Bridge), p.142 (196P-64)
Bridges - Quebec - Quebec, p.16 (8P-6), p.108 (7P-1341)
Bridges - Saskatchewan, p.125 (10P-2), p.125 (10P-4), p.125 (10P-5)
Bridges - Saskatchewan - Saskatoon (Broadway), p.65 (339P-2)
Bridgetown, N.S. - general views, p.37 (1P-11)
Bridgewater, N.S. - general views, p.41 (31P-25), p.41 (31P-82)
Bridgewater Drill Hall, N.S., p.76 (31P-77)
Bridgewater Hospital Chorus and Drama Society, Bridgewater, N.S., p.17 (31P-64)
Brigden family, Ont., p.17 (18P-84)
Brigus, Nfld. - general views, p.68 (7P-823)
Brillant, Jean, Lt., p.82 (7P-1013)
Brind'amour, Yvette, p.43 (7P-480)
Brine, A.J., p.17 (334P-16)
Brinkworth, G.W., and family, p.1 (81P-1)
Brinkworth, G.W., photo., p.1 (81P-1)
Brintnell, W. Leigh, p.17 (7P-204), p.95 (7P-1125)
Brisker, M., and family, p.17 (7P-205)
Bristol, Angleterre - vues, p.14 (7P-160)
Bristol, Helen Marcelle (Harrison), p.17 (7P-206)
Briston, J.F., p.17 (7P-207)
Britannia, Ont. - general views, p.86 (7P-1112), p.109 (7P-1364)
British & Colonial Press, photo., p.29 (7P-314)
British Antarctic Expedition, 1910-1913, p.135 (16P-17)
British Association for the Advancement of Science, p.143 (196P-63)
British Broadcasting Corporation, p.18 (16P-6), p.102 (7P-1281)
British Chemical Factory, Trenton, Ont., p.51 (7P-595)

British Columbia - Gold Rush, p.38 (7P-409)
British Columbia - politics, p.124 (7P-1551)
British Columbia - scenes, p.9 (7P-82), p.12 (7P-1142), p.17 (334P-16), p.21 (7P-262), p.34 (7P-359), p.42 (333P-3), p.42 (7P-459), p.47 (7P-534), p.52 (7P-608), p.53 (334P-31), p.54 (7P-632), p.64 (18P-24), p.64 (327P-2), p.67 (7P-811), p.71 (7P-864), p.80 (7P-987), p.82 (18P-35), p.87 (7P-1138), p.91 (16P-13), p.95 (18P-45), p.114 (18P-34), p.123 (7P-1534), p.123 (7P-1542), p.127 (7P-1580), p.129 (7P-1617), p.134 (7P-1693), p.140 (7P-1764), p.142 (7P-1768), p.148 (7P-1822)
British Columbia, Department of Lands and Works, Water Rights Branch, p.6 (12P-18)
British Columbia Airways Ltd., p.150 (7P-1849)
British Columbia Security Commission, p.17 (7P-208)
British Columbia-Yukon-N.W.T. Boundary Survey, 1906-1908, p.44 (12P-8)
British Commonwealth Air Training Plan, p.115 (7P-1449), p.131 (7P-1640)
British Commonwealth Forestry Conference, p.23 (7P-1917)
British Empire Exhibition, Wembley, England, p.17 (7P-209), p.57 (38P-5)
British in Canada, p.22 (7P-1906)
British Photo Co., photo., p.17 (334P-6)
British Railways, p.17 (7P-210)
Brittania Boating Club, War Canoe Crew, p.130 (7P-1626)
Brittania (Schooner), p.107 (47P-17)
Brochus, Michel-Delphis, Dr., p.67 (171P-1)
Brock, Daniel de Lisle, p.151 (314P-1)
Brock, Isaac, Sir, p.151 (314P-1)
Brock, J.A., & Co., photo., p.153 (7P-1887)
Brock, J.A., photo., p.112 (7P-1407)
Brock, J.R., photo., p.42 (7P-470)
Brock, John, Col., p.151 (314P-1)
Brockinton, Leonard, p.133 (7P-1676)
Brockville, Ont. - general views, p.43 (7P-488), p.102 (7P-1278)
Brockville, Ont. - individuals, p.104 (7P-1309), p.127 (7P-1581)
Brodie, Fred, p.18 (31P-114)
Brompton Lumber and Manufacturing Co., p.125 (347P-1)
Bronowski, Jacob, p.18 (16P-6)
Bronson, Thomas S., photo., p.125 (7P-1563)
Bronson Home, Ottawa (Ont.), p.18 (7P-212)
Brook, Beaver, Lord, p.101 (7P-1272)
Brooke, Rupert, p.121 (7P-1510), p.126 (196P-16)
Brooks, Alta. - general views, p.114 (7P-1422)
Brooks, Bob, photo., p.22 (7P-1898)
Broomfield, George, p.18 (7P-211)
Brothers of the Christian Schools, Toronto Province, Don Mills, Ont., p.18 (310P-1)
Brough, J.N., p.18 (7P-215)
Brouillard, George, p.18 (7P-214)
Brown, A., Capt., p.152 (7P-1875)
Brown, A. Roy, Capt., p.93 (7P-1076)
Brown, Adam, p.18 (45P-6)
Brown, Arthur Whitten, Lt., p.51 (7P-584), p.73 (7P-885), p.88 (7P-1156), p.91 (7P-1186)
Brown, Edward Killoran, p.19 (200P-1), p.142 (200P-18)
Brown, Ernest, Mme, p.18 (7P-251)
Brown, Ernest, photo., p.18 (13P-1), p.18 (333P-10), p.18 (7P-217), p.37 (7P-396)
Brown, Francis Roy, p.18 (7P-216)
Brown, George, Hon., p.100 (7P-1255)
Brown, H. Leslie, p.18 (7P-221)
Brown, Helen, p.18 (7P-220)
Brown, Howard M., p.18 (7P-222)
Brown, J.T. Mme, p.18 (7P-218)
Brown, Richard, p.31 (1P-62)
Brown, Robert, Mme, p.18 (7P-224)
Brown, Roy, p.18 (7P-225)

Brown, Sibella, p.19 (31P-43)
Brown, Winifred (Killoran), and family, p.19
 (200P-1), p.142 (200P-18)
Browne, Cecil W., p.18 (7P-223)
Bruce, Charles Tory, p.19 (31P-36)
Bruce, Edward, p.126 (7P-1576)
Bruce, Herbert Alexander, p.19 (75P-3)
Bruce, Josiah, photo., p.79 (7P-971), p.96
 (7P-1207), p.101 (7P-1276), p.138 (7P-1736)
Bruce, Robert Randolph, p.19 (11P-11)
Bruce and Mickletwaite, photo., p.32 (140P-9)
Bruce Mines (Ont.) - vues, p.19 (7P-226)
Bruckhof, W. and Co., p.19 (7P-227)
Bruer, Leonard, p.19 (7P-81)
Bruun, Chris, photo., p.19 (7P-228)
Bryant, L.O., p.47 (7P-543)
Bryant Studio, photo., p.147 (7P-1801)
Bryce, J. Fraser, p.111 (7P-1385)
Bryce, J.F., photo., p.72 (7P-874)
Bryson, Que. - general views, p.108 (7P-1340)
Buchanan, Isaac, et famille, p.19 (7P-230)
Buchanan, K.M., p.19 (7P-229)
Bucke, Richard M. et famille, p.19 (7P-231)
Buckingham, Que. - general views, p.74 (7P-905),
 p.78 (7P-961), p.124 (7P-1552)
Buckingham Palace, London, England, p.134
 (7P-1694)
Buell, O.B., photo., p.36 (7P-384), p.42 (7P-470),
 p.54 (7P-638)
Buena Vista (SS), p.147 (7P-1813)
Buffalo, Alta. - general views, p.105 (123P-5)
Buffalo Head Ranch, p.71 (166P-38)
Bull River, B.C. - general views, p.21 (333P-42),
 p.101 (333P-18), p.112 (7P-1395)
Buller, F.J., Mme, p.19 (7P-232)
Bullman, Allan, p.19 (7P-233)
Bunker Hill, Los Angeles, Calif. - general views,
 p.120 (123P-8)
Buntin, Gillies et Co., Hamilton (Ont.), p.19
 (7P-234)
Bunting, J.H., photo., p.72 (7P-880)
Burbidge, Maurice, p.19 (7P-235)
Burchill, C.M., Capt., p.111 (7P-1383)
Burdock-Love, F.J., p.19 (7P-236)
Burford, Ont. - general views, p.82 (7P-1011), p.92
 (7P-1046), p.97 (7P-1219), p.121 (7P-1513)
Burgess, W.H., photo., p.58 (7P-696), p.126
 (7P-1571)
Burian, Yvonne, p.19 (7P-237)
Burke, G.T., Col., p.81 (7P-999)
Burke, Richard Thomas, p.19 (200P-11), p.19
 (200P-2)
Burke, Richard Thomas, and family, p.142
 (200P-18)
Burke family, Ont., p.19 (200P-11)
Burkes, photo., p.129 (7P-1623)
Burkholder, Ted, p.19 (7P-238)
Burleigh Falls, Ont. - scenes, p.49 (8P-8)
Burn, George et famille, p.20 (7P-239)
Burnhamthrope (Ont.) - vues, p.8 (7P-73)
Burns, Michael, photo., p.88 (200P-4)
Burns, Thomas, p.20 (9P-6)
Burpee, E.L.H., p.20 (7P-240)
Burpee, Lawrence Johnston, p.20 (31P-15), p.20
 (7P-241)
Burrits Rapids, Ont. - general views, p.98
 (7P-1225)
Burritt, B., p.20 (7P-242)
Burrows, W.R., and family, p.62 (7P-739)
Burt, Alfred Leroy, p.20 (7P-243)
Burton, Holmes, p.20 (7P-244)
Burwell, Port, Que. - general views, p.44 (7P-497)
Bush, Hazel, p.20 (7P-245)
Bushnell, Ernest L., p.20 (7P-246)
Butchart, D.C., photo., p.129 (7P-1623)
Butler, Williams Francis, Captain, p.94 (228P-3)
Butte, Mont. - general views, p.120 (123P-8)

Butterfield, Daniel, Maj. Gen., p.20 (7P-247)
Button, M.O., photo., p.20 (7P-248)
Buxton, Ont. - general views, p.70 (7P-856)
BX (Paddleboat), p.121 (228P-1)
By, John, Lt. Col., p.66 (31P-791), p.72 (7P-882)
Byers, J.W., p.20 (1P-60)
Byng, Marie Evelyn Moreton, Lady, p.2 (7P-11),
 p.79 (7P-972), p.130 (7P-1629)
Byng de Vimy, Julian Hedworth George Byng,
 Vicomte, p.20 (7P-249), p.26 (7P-1971)
Byng of Vimy, Julian Hedworth George Byng,
 Viscount, p.2 (7P-11), p.85 (31P-51), p.130
 (7P-1629)
Byron-May Co., photo., p.92 (11P-13)
Bytown Glass, Ottawa (Ont.), p.20 (7P-250)

C.T.V. Television Network, Toronto, Ont., p.20
 (7P-301)
Cable station, B.C. - general views, p.87 (7P-1137)
Cabot Tower, St. John's, Nfld., p.89 (7P-1163)
Caines, John, p.20 (38P-1)
Calbick, Garth, p.20 (334P-20)
Caldwell, Ewan R., p.20 (7P-252)
Caldwell, John F., p.20 (7P-253)
Caldwell family, Ont., p.20 (7P-252)
Caledonia, Ont. - general views, p.40 (7P-435)
Caledonia (flying boat), p.9 (7P-95)
Caledonia Springs, Ont. - general views, p.101
 (7P-1267)
Calgary, Alta. - aerial views, p.68 (7P-826)
Calgary, Alta. - general views, p.6 (7P-47), p.12
 (11P-4), p.13 (13P-3), p.19 (11P-11), p.30
 (7P-328), p.76 (7P-923), p.80 (7P-987), p.90
 (7P-1180), p.99 (7P-1240), p.105 (123P-5),
 p.108 (11P-3), p.114 (13P-2), p.125 (166P-2),
 p.132 (7P-1650), p.146 (11P-10), p.149
 (166P-10)
Calgary Alberta - vues, p.10 (7P-98), p.24
 (7P-1940)
Calgary Flying Club, Calgary, Alta., p.152
 (7P-1883)
Calgary Stampede, Alta., p.48 (7P-547), p.84
 (333P-30), p.108 (11P-3), p.136 (7P-1714)
Callaghan, Gordon F., photo., p.20 (7P-254)
Callaghan-Bagshaw Inc., photo., p.20 (7P-254)
Callahan, Harry, photo., p.25 (123P-1)
Callerman, photo., p.153 (161P-1)
Calmar, Alta. - general views, p.7 (13P-5)
Calumet, Que. - general views, p.122 (7P-1531)
Calumet (SS), p.16 (7P-183)
Calvin, Delano Dexter, p.21 (7P-255)
Calvin Co. Ltd., Toronto, Ont., p.21 (7P-255)
Cambria (flying boat), p.9 (7P-95)
Cameron, Alan Emerson, and family, p.21 (92P-8)
Cameron, Benjamin Serby, photo., p.21 (11P-9)
Cameron, Dan, p.95 (7P-1118)
Cameron, Donald A., p.21 (1P-61)
Cameron, Duncan, photo., p.21 (7P-256), p.22
 (7P-1960)
Cameron, Evan Guthrie, p.21 (7P-257)
Cameron, J.H., Hon., p.71 (7P-862), p.71 (7P-862)
Cameron, John, p.95 (7P-1118)
Cameron, Julia Margaret, photo., p.25 (123P-1)
Cameron, Stanley, p.21 (7P-258)
Camp Borden, Ont. - general views, p.42 (7P-469),
 p.51 (7P-585), p.93 (7P-1070), p.95
 (7P-1121), p.96 (7P-1207)
Camp Borden (Ont.) - vues, p.16 (7P-195)
Camp Sarcee, Alta. - general views, p.136
 (7P-1714)
Camp Sussex, Sussex, N.B., p.119 (337P-3)
Campbell, Alexander, Sir, p.101 (7P-1276)

Campbell, Archibald M., p.21 (7P-259)
Campbell, Charles, Dr., p.21 (7P-262)
Campbell, D., photo., p.153 (7P-1887)
Campbell, Donald J., p.21 (7P-260)
Campbell, G.A., p.21 (333P-42)
Campbell, G.D., p.21 (31P-66)
Campbell, George, Sir, p.46 (7P-517)
Campbell, John A., p.21 (9P-7)
Campbell, Neil, p.130 (7P-1625)
Campbell, Nina, p.21 (7P-261)
Campbell-Gray, photo., p.57 (38P-5)
Campbellton, New Brunswick - general views, p.79
 (46P-4)
Camrose, Atla. - general views, p.28 (7P-297)
Camsell, Charles, p.94 (7P-1113)
Canada - Architecture, Domestic, p.22 (7P-1899)
Canada - Centennial of Confederation, p.53
 (7P-621)
Canada - cities and villages, p.28 (327P-4), p.105
 (327P-1)
Canada - Confederation, p.128 (7P-1600)
Canada - Diplomatic and consular service, p.76
 (7P-921)
Canada - Diplomats, p.64 (7P-761)
Canada - general views, p.2 (18P-58), p.2 (7P-5),
 p.13 (12P-22), p.23 (7P-1926), p.28 (327P-4),
 p.30 (7P-320), p.40 (7P-441), p.42 (7P-461),
 p.54 (7P-635), p.65 (7P-775), p.66 (7P-794),
 p.76 (7P-922), p.95 (7P-1117), p.105
 (327P-1), p.121 (18P-7), p.124 (7P-1555),
 p.128 (75P-16), p.132 (7P-1657), p.145
 (7P-1783), p.148 (7P-1825)
Canada - Geography, p.83 (75P-8)
Canada - Governors-General, p.138 (7P-83)
Canada - histoire, p.50 (103P-11)
Canada - History, p.83 (75P-8)
Canada - individus, p.110 (113P-11)
Canada - Members of Parliament, p.138 (7P-83)
Canada - National parks, p.22 (7P-1904)
Canada - political parties - Progressive
 Conservative, p.54 (7P-631)
Canada - Politics and Government, p.1 (1P-3),
 p.64 (7P-761), p.72 (7P-883), p.75 (7P-913),
 p.75 (7P-916), p.112 (7P-1394), p.123
 (7P-1538), p.124 (7P-1556), p.133 (7P-1672),
 p.137 (1P-2)
Canada - Prime Ministers, p.138 (7P-83)
Canada - Public Affairs, p.21 (7P-256)
Canada - scenes, p.121 (18P-1)
Canada - Senat, p.14 (7P-163), p.15 (7P-173),
 p.100 (7P-1265)
Canada - Senators, p.138 (7P-83)
Canada - Social conditions, p.66 (7P-794)
Canada - vues, p.16 (7P-183), p.24 (7P-1929),
 p.35 (329P-1), p.107 (7P-1295), p.135
 (7P-1700)
Canada, Airport Inquiry Commission, p.26
 (7P-1920)
Canada, Archives publiques du Canada, p.21
 (7P-1910)
Canada, Archives territoriales du Yukon, p.21
 (7P-1973)
Canada, Armée, p.90 (7P-1174)
Canada, Army, p.17 (7P-207), p.23 (7P-1976),
 p.25 (7P-1908), p.27 (9P-8), p.90 (7P-1174),
 p.99 (7P-1246), p.114 (13P-2)
Canada, Army - Nova Scotia, p.105 (1P-80)
Canada, Army, Cameron Highlanders of Ottawa,
 p.61 (7P-733), p.85 (7P-1093)
Canada, Army, Canadian Corps Headquarters,
 Leatherhead, England, 1941, p.134 (7P-1694)
Canada, Army, Canadian Field Artillery, p.16
 (7P-183)
Canada, Army, Canadian Officers' Training Corps,
 p.22 (303P-9), p.87 (196P-10), p.142
 (196P-33)
Canada, Army, Governor-General's Foot Guards,
 Escort Company, p.55 (7P-647)

Canada, Army, No. 1 District Depot, Wolseley Barracks, p.113 (7P-1410)

Canada, Army, North Western Europe, 1944-1945, p.10 (7P-104)

Canada, Army, Officer Cadet Training Unit, p.59 (7P-707)

Canada, Army, Princess Louise's Dragoon Guards, p.14 (7P-157), p.57 (7P-684), p.147 (7P-1807)

Canada, Army, Princess Patricia's Canadian Light Infantry, p.112 (7P-1405)

Canada, Army, Queen's Own Rifles, p.87 (196P-10), p.101 (196P-56), p.142 (196P-33)

Canada, Army, Queen's Own rifles, No. 9 Company, p.59 (196P-35)

Canada, Army, R.C.A.M.C., p.59 (7P-702)

Canada, Army, Regiment of Canadian Guards, p.119 (7P-1485)

Canada, Army, Royal Canadian Corps of Signals, p.123 (7P-1975), p.133 (7P-1669)

Canada, Army, Royal Canadian Regiment, p.2 (7P-11)

Canada, Army, Scout Company of the 63rd Regiment, p.117 (1P-73)

Canada, Army, World War II, p.30 (7P-320)

Canada, Army, 1st Battalion, Royal Canadian Regiment, p.26 (7P-1962)

Canada, Army, 1914-1918, p.53 (7P-614)

Canada, Army, 3rd Field Company, p.37 (7P-399)

Canada, Army, 3rd (Prince of Wales) Canadian Dragoons, p.90 (7P-1173)

Canada, Army, 34th Regiment, p.15 (7P-173)

Canada, Army, 57th Regiment, p.112 (7P-1406)

Canada, Army, 7th Canadian Machine Gun Company, p.86 (7P-1102)

Canada, Army, 8th Canadian Mounted Rifles, p.96 (7P-1192)

Canada, Atlantic Tidal Power Programming Board, p.21 (7P-1921)

Canada, Bureau du Conseil Privé, p.21 (7P-1922)

Canada, Bureau du Premier Ministre, p.22 (7P-1960)

Canada, Centennial Commission, p.22 (7P-1898)

Canada, Central Mortgage and Housing Corporation, p.22 (7P-1899)

Canada, Chambre du Sénat, p.22 (7P-1896)

Canada, Chambre du Sénat, Comité sénatorial sur la pauvreté, p.22 (7P-1897)

Canada, Comité de guerre, p.21 (7P-1922)

Canada, Commission de la capitale nationale, p.22 (7P-1951)

Canada, Commission royale d'enquête sur le statut de la femme, p.12 (7P-136), p.22 (7P-1968)

Canada, Confederation Centennial, p.22 (7P-1898)

Canada, Conseil national de recherches du Canada, p.22 (7P-1957)

Canada, Défense nationale, officier de liaison avec l'Université d'Ottawa, p.22 (303P-9)

Canada, Department of Agriculture, p.22 (7P-1901), p.56 (7P-672), p.82 (7P-1014)

Canada, Department of Energy, Mines and Resources, p.22 (7P-1903)

Canada, Department of Finance, p.22 (7P-1905)

Canada, Department of Immigration and Colonization, p.22 (7P-1906)

Canada, Department of Indian Affairs and Northern Development, p.22 (7P-1904)

Canada, Department of Justice, p.22 (7P-1927)

Canada, Department of Labour, p.23 (7P-1928)

Canada, Department of Militia and Defence, p.23 (7P-1933)

Canada, Department of Munitions and Supply, p.23 (7P-1934)

Canada, Department of National Defence, p.23 (7P-1928), p.23 (7P-1976), p.33 (7P-352)

Canada, Department of National Health and Welfare, p.33 (7P-352)

Canada, Department of Naval Service, Ottawa, Ont., p.23 (7P-1974)

Canada, Department of the Environment, p.23 (7P-1917)

Canada, Department of the Interior, p.23 (7P-1926), p.152 (7P-1882)

Canada, Department of the Solicitor-General, Penitentiary Branch, p.23 (7P-1937)

Canada, Department of the Solicitor-General, Royal Canadian Mounted Police, p.23 (7P-1938)

Canada, Department of Transport, p.23 (7P-1911)

Canada, Department of Transport, Coast Guard, Aids and Waterways, Ottawa, Ont., p.23 (1P-30)

Canada, Department of Militia and Defence, Records Office, 1918, p.130 (7P-1628)

Canada, Dominion-Provincial Conference on Reconstruction, p.23 (7P-1941)

Canada, Eastern Rockies Forest Conservation Board, p.23 (7P-1942)

Canada, Energie, Mines et Ressources, Commission geologique du Canada, p.24 (7P-1916)

Canada, Federal Government, p.21 (7P-256)

Canada, Food Price Review Board, p.24 (7P-1943)

Canada, House of Commons, p.24 (7P-1945)

Canada, International Boundary Commission, p.24 (7P-1913)

Canada, Labour Relations Board, p.150 (7P-1852)

Canada, Legislative Assembly, p.24 (18P-31)

Canada, Library of Parliament, p.24 (7P-1947)

Canada, Members of Parliament, p.128 (7P-1601)

Canada, Militia, p.23 (7P-1976), p.90 (7P-1173), p.105 (304P-1), p.109 (7P-1365), p.116 (7P-1458), p.134 (7P-1321)

Canada, Militia, Governor General's Body Guard, p.42 (7P-468), p.83 (7P-1025)

Canada, Militia, Grand Trunk Brigade, p.43 (7P-487)

Canada, Militia, Halifax Field Battery, p.69 (134P-2)

Canada, Militia, Halifax Provisional Battalion, p.139 (7P-1751)

Canada, Militia, Halton Rifles, 20th Regiment, p.42 (7P-463)

Canada, Militia, Lord Strathcona Horse, C Squadron, p.40 (7P-439)

Canada, Militia, Midland Battalion, p.150 (7P-1850)

Canada, Militia, Northwest Field Force, p.38 (7P-419)

Canada, Militia, Princess Louise Dragoon Guards, p.133 (7P-1679)

Canada, Militia, Quebec Battery of Artillery, p.82 (134P-3)

Canada, Militia, Quebec Voluntary Field Battery, p.82 (134P-3)

Canada, Militia, Queen's Own Rifles, p.42 (7P-468), p.66 (7P-787), p.100 (7P-1263), p.152 (7P-1872)

Canada, Militia, Royal Canadian Artillery, p.69 (134P-2), p.102 (7P-1283)

Canada, Militia, Royal Canadian Artillery, "B" Battery, p.75 (7P-918)

Canada, Militia, Royal 22nd Regiment, p.4 (134P-1)

Canada, Militia, Seaforth Highlanders of Canada, 1st Battalion, p.72 (7P-881)

Canada, Militia, Tenth Brant Dragoons, p.7 (7P-66)

Canada, Militia, Victoria Rifles, p.82 (7P-1005)

Canada, Militia, 10th Royal Grenadiers, p.42 (7P-468)

Canada, Militia, 3rd (Prince of Wales) Canadian Dragoons, p.90 (7P-1173)

Canada, Militia, 42nd Brockville Infantry Battalion, p.95 (7P-1122)

Canada, Militia, 43rd Battalion, p.59 (7P-709)

Canada, Militia, 44th Regiment, p.66 (7P-797)

Canada, Militia, 96th Battalion, p.152 (7P-1872)

Canada, Ministère de la Marine et des Pêcheries, p.24 (7P-1930)

Canada, Ministère de la santé nationale et du bien-être social, p.24 (7P-1931)

Canada, Ministère de l'Emploi et de l'Immigration, p.24 (7P-1929)

Canada, Ministère de l'Industrie et du Commerce, p.24 (7P-1907)

Canada, Ministère des Affaires des anciens combattants, p.24 (7P-1940)

Canada, Ministère des Affaires extérieures, p.24 (7P-1918)

Canada, Ministère des Postes, p.25 (7P-1961)

Canada, Ministère des Travaux publics, p.25 (7P-1935)

Canada, Ministère du Révenu national (Douanes et Accise), p.25 (7P-1932)

Canada, Musée canadien de la guerre, p.25 (7P-1908)

Canada, Mutual Air Board, p.25 (7P-1949)

Canada, National Battlefields Commission, p.25 (7P-1950)

Canada, National Defence, photo., p.32 (7P-347)

Canada, National Harbours Board, p.25 (7P-1953)

Canada, National Library, p.25 (7P-1952)

Canada, National Museums, National Gallery of Canada, p.9 (7P-86), p.25 (7P-1954)

Canada, National Museums, National Gallery of Canada Collection, Ottawa, Ont., p.25 (123P-1)

Canada, National Museums, National Museum of Natural Sciences, p.26 (7P-1955)

Canada, National Museums, National Museum of Science and Technology, p.25 (7P-1948)

Canada, National Parks, Commissioner, p.35 (1P-6)

Canada, Office of the Secretary to the Governor General, p.25 (7P-1970)

Canada, Parliament, p.113 (7P-1418)

Canada, Resources for Tomorrow Conference, p.26 (7P-1902)

Canada, Royal Commission into the Non-Medical Use of Drugs (Le Dain Commission), p.26 (7P-1966)

Canada, Royal Commission Investigating Halifax Disorders, p.26 (7P-1964)

Canada, Royal Commission on Bilingualism and Biculturalism, p.26 (7P-1962)

Canada, Royal Commission on Farm Machinery, p.26 (7P-1963)

Canada, Royal Commission on Newfoundland Finances, p.26 (7P-1965)

Canada, Royal Commission on Pilotage, p.26 (7P-1967)

Canada, St. Lawrence River Joint Board of Engineers, p.26 (7P-1969)

Canada, Secrétariat d'Etat, p.26 (7P-1971)

Canada, Treasury Board, p.26 (7P-1285)

Canada, Wartime Prices and Trade Board, p.26 (7P-1972)

Canada (Western) - general views, p.40 (7P-443)

Canada, 13th Royal Regiment of Hamilton, p.121 (7P-1517)

Canada Air Board, p.26 (7P-1919)

Canada Atlantic Railway Old Boys' Association, Ottawa, Ont., p.26 (7P-263)

Canada Book Week, p.33 (7P-353)

Canada Foundation, Ottawa, Ont., p.26 (7P-264)

Canada House, London, England, p.26 (7P-265), p.88 (7P-1148)

Canada, Les musées nationaux, p.24 (7P-1909)

Canada (Northern) - general views, p.42 (7P-459), p.43 (7P-486), p.44 (7P-497), p.106 (7P-1328)

Canada (SS), p.114 (7P-1424)

Canada Steamship Lines, Montreal, Que., p.26 (7P-266), p.63 (7P-756)

Canada (Western) - general views, p.22 (7P-1906), p.42 (7P-470), p.54 (7P-635), p.57 (9P-21), p.60 (9P-25), p.61 (9P-26), p.61 (9P-27), p.72 (9P-33), p.97 (7P-1215), p.97 (7P-1220), p.111 (92P-19), p.118 (7P-1484), p.148 (9P-73)

Canada's Aviation Hall of Fame, Edmonton, Alta., p.26 (7P-269)

Canada's Book of Remembrance, p.104 (7P-1314)

Canadian Air Board, p.60 (7P-720), p.99 (7P-1241), p.99 (7P-1244), p.133 (7P-1674)

Canadian Air Board
 see also
 Flying Boats - Canadian Air Board

Canadian Airways Ltd., p.66 (7P-799), p.71 (7P-865), p.80 (7P-989), p.137 (7P-1734), p.144 (7P-1773)

Canadian Arctic Expedition, p.23 (7P-1974)

Canadian Arctic Expedition, 1913-1918, p.3 (7P-23), p.31 (7P-341)

Canadian Army Photo Collection, p.27 (9P-8)

Canadian Association of Amateur Oarsmen, Ottawa, Ont., p.27 (7P-267)

Canadian Authors' Association, Ottawa, Ont., p.27 (7P-268), p.33 (7P-353)

Canadian Authors Association Conferences, p.112 (12P-3)

Canadian Baptist Archives, Hamilton, Ont., p.27 (7P-270)

Canadian Bar Association, Quebec, Que., p.135 (7P-1706)

Canadian Broadcasting Corporation, p.2 (7P-9), p.37 (1P-66), p.97 (8P-13), p.98 (7P-1228), p.102 (7P-1281)

Canadian Christian Council for the Resettlement of Refugees, p.27 (7P-271)

Canadian Citizenship Council, Ottawa, Ont., p.27 (7P-272)

Canadian Commission for UNESCO, Ottawa, Ont., p.27 (7P-273)

Canadian Conference of the Arts, Toronto, Ont., p.27 (7P-274)

Canadian Consul in Los Angeles, p.44 (7P-491)

Canadian Dental Association, Montreal, Que., p.27 (7P-275)

Canadian Eclipse Expedition, p.27 (45P-4)

Canadian Embassy, Mexico City, Mexico, p.69 (7P-845)

Canadian Expeditionary Force, p.23 (7P-1976), p.25 (7P-1908), p.38 (7P-410), p.79 (7P-970), p.96 (7P-1207), p.115 (7P-1435), p.121 (7P-1517)

Canadian Expeditionary Force, B. Squadron, Remounted Depot, p.55 (7P-641)

Canadian Expeditionary Force, Bands, p.95 (7P-1141)

Canadian Expeditionary Force, Camp Hughes, Man., p.21 (7P-1910)

Canadian Expeditionary Force, Canadian Field Artillery, p.133 (7P-1678), p.148 (7P-1819)

Canadian Expeditionary Force, Canadian Field Artillery, 65th Battery, p.69 (7P-846)

Canadian Expeditionary Force, Canadian Field Artillery, 66th Battery, p.37 (7P-403)

Canadian Expeditionary Force, Canadian Field Artillery, 67th Battery, p.153 (196P-1)

Canadian Expeditionary Force, Canadian Field Artillery, 7th Battery, p.67 (7P-802)

Canadian Expeditionary Force, Canadian Forestry Corps, p.31 (7P-333)

Canadian Expeditionary Force, Canadian Medical Corps, p.13 (31P-39)

Canadian Expeditionary Force, Kootenay Battalion, p.34 (7P-368)

Canadian Expeditionary Force, No. 7 Canadian General Hospital, p.75 (7P-912)

Canadian Expeditionary Force, Princess Patricia's Canadian Light Infantry, p.94 (7P-1108), p.116 (7P-1457)

Canadian Expeditionary Force, Royal Canadian Corps of Signals, p.123 (7P-1540)

Canadian Expeditionary Force, School of Instruction, p.116 (7P-1455)

Canadian Expeditionary Force, Siberia, p.15 (7P-179)

Canadian Expeditionary Force, (Siberia), Vladivostock, Russia, p.108 (7P-1341), p.110 (7P-1369), p.123 (7P-1541)

Canadian Expeditionary Force, 1st Battalion, p.110 (7P-1376)

Canadian Expeditionary Force, 1st Canadian Division, p.111 (7P-1386)

Canadian Expeditionary Force, 101st Battalion, p.128 (7P-1607)

Canadian Expeditionary Force, 109th (Cyclists) Battalion, p.56 (7P-670)

Canadian Expeditionary Force, 128th Battalion, p.2 (7P-11)

Canadian Expeditionary Force, 2nd Canadian Siege Battery, p.128 (7P-1607)

Canadian Expeditionary Force, 2nd Division, Engineers and Signal Company, p.93 (7P-1065)

Canadian Expeditionary Force, 20th Ottawa-Carleton Battalion, p.116 (7P-1459)

Canadian Expeditionary Force, 3rd Divisional Signals Company, p.95 (7P-1139)

Canadian Expeditionary Force, 35th Battalion, p.11 (7P-115)

Canadian Expeditionary Force, 38th Battalion, p.67 (7P-812), p.145 (7P-1785)

Canadian Expeditionary Force, 49th Battalion, p.128 (7P-1607)

Canadian Expeditionary Force, 5th (Royal Highalnders of Canada) Regiment, p.23 (7P-1933)

Canadian Expeditionary Force, 51st Battalion, p.128 (7P-1607)

Canadian Expeditionary Force, 53rd Regiment, p.31 (7P-330)

Canadian Expeditionary Force, 58th Battalion, p.24 (7P-1940)

Canadian Expeditionary Force, 6th Infantry Battalion, p.95 (7P-1121)

Canadian Expeditionary Force, 77th Battalion, p.150 (7P-1842)

Canadian Expeditionary Force, 8th Overseas Draft, p.74 (7P-903)

Canadian Expeditionary Force, 80th Battalion, p.90 (7P-1173)

Canadian Federation of Agriculture, Ottawa, Ont., p.27 (7P-276)

Canadian Federation of Business & Professional Women's Clubs, p.27 (7P-288)

Canadian Federation of Catholic Convent Alumni, p.1 (200P-17), p.27 (200P-16)

Canadian Federation of Music Teachers' Associations, p.27 (7P-277)

Canadian Federation of University Women, p.27 (7P-278)

Canadian Figure Skating Association, Ottawa, Ont., p.27 (7P-279)

Canadian Film Institute, Ottawa, Ont., p.27 (7P-280)

Canadian Forestry Association, Ottawa, Ont., p.27 (7P-281)

Canadian Government Exhibition Commission, p.27 (7P-1944)

Canadian Government Motion Picture Bureau, photo., p.40 (7P-432), p.56 (7P-672)

Canadian Government Travel Bureau, p.44 (7P-491)

Canadian Grand Prix Races, Mosport, Ont., p.131 (7P-1648)

Canadian Hadassah-Wizo, Montreal, Que., p.28 (7P-282)

Canadian Institute on Public Affairs, Toronto, Ont., p.28 (7P-283)

Canadian Intercollegiate Athletic Union, Vanier, Ont., p.28 (7P-284)

Canadian Interfaith Conference, Ottawa, Ont., p.28 (7P-285)

Canadian International Development Agency, p.21 (7P-256)

Canadian Jewish Congress, p.71 (305P-1)

Canadian Labour Congress, p.69 (7P-843)

Canadian Labour Congress, Ottawa, Ont., p.28 (7P-289), p.29 (7P-303)

Canadian Labour Union, p.28 (7P-289)

Canadian Ladies' Golf Association, Vanier, Ont., p.28 (7P-286)

Canadian Ladies' Golf Union, Winnipeg, Man., p.28 (7P-286)

Canadian Legion, p.30 (31P-37)

Canadian Legion Conventions -Nova Scotia, p.137 (1P-75)

Canadian Marconi Company, Montreal, Que., p.28 (7P-287)

Canadian Memorial - Vimy, France, p.85 (31P-51)

Canadian Mothercraft Society, Toronto, Ont., p.28 (7P-290)

Canadian National Exhibition, Toronto, Ont., p.2 (7P-8), p.28 (7P-291), p.32 (140P-1), p.43 (7P-488), p.70 (140P-15), p.128 (7P-1595)

Canadian National Exhibition National Air Show, p.153 (7P-1885)

Canadian National Railways
 see also
 Railroads - Canadian National Railways

Canadian National Railways, Cowichan Lake, B.C., p.110 (7P-1374)

Canadian National Railways, Montreal, Que., p.28 (7P-292)

Canadian National Recreation System Baseball Team, Moncton, N.B., p.95 (7P-1140)

Canadian Officers' Training Corps, p.22 (303P-9), p.87 (196P-10), p.142 (196P-33)

Canadian Overseas Telecommunication Corporation, Montreal, Que., p.28 (7P-293)

Canadian Pacific Airlines, p.18 (7P-216), p.28 (7P-294), p.76 (7P-929), p.92 (7P-1042), p.118 (7P-1480), p.137 (7P-1734)

Canadian Pacific Airlines
 see also
 Aircraft - Canadian Pacific Airlines

Canadian Pacific Railway
 see also
 Railroads - Canadian Pacific Railway

Canadian Pacific Railway, Montreal, Que., p.28 (7P-295)

Canadian Pacific Railway Camp, Bull River, B.C., p.47 (333P-39)

Canadian Pacific Railway Mill, Canal Flats, B.C., p.74 (333P-38)

Canadian Pacific Railway Surveys, p.22 (7P-1903)

Canadian Pacific Steamships Line, p.69 (7P-836)

Canadian Philatelic Society, p.56 (7P-670)

Canadian Photo Co., photo., p.74 (7P-905)

Canadian Photographers, p.28 (327P-4)

Canadian Polar Expedition, 1932-1933, p.41 (7P-450)

Canadian Press, photo., p.96 (7P-1193), p.145 (7P-1783)

Canadian Press, Toronto, Ont., p.28 (7P-296)

Canadian Rockies
 see
 Rocky Mountains - general views

Canadian Ski Museum, Ottawa, Ont., p.28 (7P-297)

Canadian Soccer Association, Vanier, Ont., p.28 (7P-298)

Canadian Society of Cinematographers, Toronto, Ont., p.60 (7P-718)

Canadian Society of Microbiologists, p.28 (7P-299)

Canadian Teachers' Federation, p.29 (7P-300)
Canadian Theatre Centre, Toronto, Ont., p.29 (7P-302)
Canadian Transcontinental Airways, p.144 (7P-1773)
Canadian Transportation Commission, p.144 (7P-1773)
Canadian Tribune, Toronto, Ont., p.29 (7P-303)
Canadian Vickers Ltd., Montreal, Que., p.29 (7P-304), p.63 (7P-756)
Canadian Victoria Cross, Toronto, Ont., p.4 (7P-26)
Canadian War Records Office, photo., p.79 (7P-970)
Canadian Water Ski Association, Vanier, Ont., p.29 (7P-305)
Canadian Wheelmen's Association, p.56 (7P-670)
Canadian Women's Press Club, p.29 (9P-9), p.96 (7P-1193)
Canadian Women's Senior Golf Association, Montreal, Que., p.28 (7P-286)
Canadian Writers Foundation Inc., Ottawa, Ont., p.29 (7P-306)
Canadiens-français au Canada (ouest), p.131 (222P-1)
Canadiens-français au Manitoba, p.131 (222P-1)
Canal Carillon (Québec) - vues, p.25 (7P-1935)
Canal de Chambly (Québec) - vues, p.25 (7P-1935)
Canal de Lachine (Québec) - vues, p.25 (7P-1935)
Canal Grenville (Québec) - vues, p.25 (7P-1935)
Canard, N.S. - general views, p.88 (1P-47)
Cancalais (SS), p.107 (7P-1338)
Canmore, Alta. - general views, p.58 (166P-29), p.92 (7P-1047), p.105 (123P-5)
Cannes, France - vues, p.141 (303P-12)
Cannington Manor, Sask., p.132 (7P-1664)
Cannon, T., p.29 (7P-307)
Cantell, Elsie, p.146 (7P-1797)
Cantin, Louise, p.29 (7P-308)
Cantwell, photo., p.153 (161P-1)
Canusa (Schooner), p.66 (31P-40)
Caouette, David-Réal, p.29 (7P-309)
Cap-à-l'Aigle, Que. - general views, p.59 (7P-704)
Cap-Rouge, Que. - general views, p.44 (7P-497)
Cape Blomidon (Tern Schooner), p.12 (31P-104)
Cape Bonnie (steel trawler), p.14 (1P-59)
Cape Breton, N.S. - general views, p.9 (104P-1), p.35 (1P-6), p.63 (7P-752), p.93 (12P-26), p.111 (7P-1383)
Cape Breton Giant, p.95 (7P-1119)
Cape Dorset, N.W.T. - general views, p.126 (7P-1570)
Cape Split, N.S. - general views, p.35 (1P-6), p.88 (1P-47)
Cape Wolstenholme, N.W.T. - general views, p.91 (7P-1187)
Capital Press, photo., p.21 (7P-256), p.26 (7P-264), p.31 (7P-338), p.32 (7P-347), p.53 (7P-623), p.103 (7P-1296), p.152 (7P-1883)
Caple, N., & Co., photo., p.40 (7P-440)
Capreol, Ont. - general views, p.131 (7P-1648)
Caraquet, New Brunswick - scenes, p.37 (46P-5)
Carcross, Yukon - general views, p.42 (7P-459)
Card, R.C., p.29 (7P-310)
Cardston, Alta. - general views, p.56 (7P-672), p.62 (18P-65)
Cariboo, B.C. - general views, p.114 (228P-5)
Cariboo District, B.C. - general views, p.40 (18P-8), p.78 (7P-955)
Cariboo Rd. (C.-B) - vues, p.17 (7P-201)
Cariboo Road, B.C. - general views, p.38 (7P-413), p.95 (7P-1117)
Cariboo Stopping Houses - Wagon Road, Cariboo, B.C., p.29 (228P-4)
Carless, Roy, p.5 (7P-46)

Carleton Place, Ont. - general views, p.18 (7P-222), p.20 (7P-252), p.47 (7P-540), p.101 (7P-1267)
Carling, J. Innes, and family, p.29 (7P-311)
Carling, John, Sir, p.29 (7P-311)
Carlisle, Sask. - general views, p.90 (7P-1180)
Carmack, George Washington, p.69 (7P-841)
Carman, Bliss, p.63 (7P-749), p.100 (31P-101)
Caron, R.E., Hon., p.71 (7P-862), p.71 (7P-862)
Carp, Ont. - general views, p.83 (7P-1026)
Carpenter & Co., photo., p.139 (7P-1739)
Carpenter, Rév. et famille, p.149 (7P-1835)
Carr, Emily, p.61 (8P-1)
Carribean - general views, p.7 (16P-2)
Carrick, Wellington M., Dr., p.108 (7P-1341)
Carriere, W.H.C., photo., p.114 (7P-1425)
Carroll, E. Garry, p.29 (7P-312)
Carroll (Mount), B.C. - general views, p.131 (7P-1645)
Carson, Percy A., p.29 (7P-313)
Carss family, Ont., p.122 (7P-1518)
Carter, John, and family, p.29 (149P-4)
Carter, Joseph C., p.29 (337P-2)
Carter, R.A., photo., p.153 (161P-1)
Cartes-de-visite, p.6 (7P-49), p.10 (7P-112), p.31 (185P-17), p.45 (7P-506), p.45 (7P-507), p.48 (31P-83), p.48 (7P-560), p.56 (7P-658), p.58 (7P-696), p.60 (31P-84), p.62 (7P-739), p.64 (45P-5), p.65 (7P-786), p.72 (7P-874), p.92 (31P-89), p.94 (228P-3), p.99 (7P-1243), p.103 (31P-90), p.105 (31P-91), p.107 (31P-92), p.111 (31P-68), p.119 (31P-93), p.125 (7P-1562), p.126 (31P-94), p.128 (7P-1598), p.129 (7P-1623), p.135 (7P-1710), p.137 (1P-2), p.153 (7P-1887)
Cartier, George Etienne, Hon. Sir, p.29 (7P-314), p.80 (7P-985), p.85 (7P-1064), p.109 (7P-1368)
Cartier, Georges Etienne, Hon. Sir, p.93 (7P-1081)
Cartier, Joseph-Louis, et famille, p.30 (7P-315)
Cartier (C.G.S.), p.23 (7P-1917)
Cartoonists
 see
 individual names
Cartwright, John Robert, p.30 (7P-316)
Cartwright family, B.C., p.112 (7P-1395)
Carty, A.C., p.30 (7P-317)
Carty, Olive E., p.30 (7P-317)
Casca (SS), p.2 (7P-13), p.9 (7P-94), p.16 (7P-192), p.147 (7P-1809)
Cascapedia River, Que. - general views, p.37 (7P-394)
Case and Draper, photo., p.30 (7P-319), p.153 (161P-1)
Casgrain, H.R., Abbé, p.96 (7P-1201), p.101 (7P-1276)
Casgrain, Marie Thérèse (Forget), p.30 (7P-318), p.34 (7P-358)
Cashman, Caroline, p.30 (31P-37)
Cass, John, p.30 (12P-11)
Cass, Samuel, Rabbi, p.30 (7P-320)
Casselman (Ont.) - scènes, p.34 (185P-12)
Castle, Vernon, Capt., p.54 (7P-635)
Castonguay, A.J., photo., p.135 (7P-1703)
Castonguay, Jules Alexander, photo., p.30 (7P-321), p.53 (7P-623), p.78 (7P-960)
Castor, Alta. - general views, p.114 (7P-1422)
Casummit Lake (Ont.) - vues, p.17 (7P-200)
Cathedrals - England - Peterborough, p.100 (31P-101)
Cathedrals - Northwest Territories - Aklavik (All Saints Protestant-Cathedral), p.44 (7P-482)
Cathedrals - Nova Scotia - Halifax (All Saint's Cathedral), p.139 (1P-17)
Cathedrals - Ontario - Ottawa (Christ Church Cathedral), p.39 (7P-447), p.137 (7P-1724)
Cathedrals - Quebec - Montreal (Christ Church Cathedral), p.90 (7P-1184)

Cathedrals (Roman Catholic) -Manitoba - Saint Boniface, p.62 (7P-741)
Catherwood, Frederick J., p.30 (7P-322)
Cauchon, Noulan, p.30 (7P-323)
Caughnawauga, Que. - general views, p.113 (7P-1419)
Cautley, R.W., p.35 (1P-6)
Cavouk, photo., p.25 (7P-1970), p.26 (7P-1971), p.30 (7P-324), p.69 (7P-1946), p.97 (7P-1212)
Cavoukian (Cavouk), Artin, photo., p.30 (7P-324)
Cayuga, Ont. - general views, p.40 (7P-435)
CCF in Alberta, p.122 (7P-1524)
Central Canada Exhibition, Lansdowne Park, Ottawa, Ont., p.121 (7P-1511)
Central Canada Veterinary Association, p.30 (7P-325)
Central Library, Toronto, Ont., p.139 (18P-88)
Central Northern Airways Ltd., Cold Lake (Man.), p.18 (7P-216)
Centrales hydro-électriques -Ontario - Sly Rapids, p.14 (7P-171)
Centre Emilie Gamelin, Montréal (Québec), p.30 (326P-1)
Century Village Museum, Lang, Ont., p.30 (7P-326)
Ceylon - general views, p.95 (7P-1125)
CHAK, broadcasting station, Aklavik, N.W.T., p.123 (7P-1975)
Chaleurs (des), Baie (Québec) - vues, p.11 (131P-2)
Challies, John Bow, p.30 (7P-327)
Chambers, Robert W., p.5 (7P-46)
Champagne
 voir aussi
 Beaugrand dit Champagne
Champagne, Claude, et famille, p.30 (149P-5)
Champagne, Harvey Joseph Moise, p.30 (7P-328)
Champlain, Que. - general views, p.82 (7P-1012)
Champlain Studio, photo., p.30 (7P-329)
Chandler, Albert, p.31 (7P-330)
Channel, Nfld. - general views, p.70 (7P-857)
Chantiers maritimes - Québec - Lauzon, p.80 (131P-4)
Chapais, Jean-Charles, p.8 (185P-20)
Chapais, Thomas, Sir, (famille), p.8 (185P-20)
Chapelles
 voir aussi
 Chapels
Chapelles - (Ont.) - Brantford (Mohawks), p.16 (7P-193)
Chapels
 see also
 Chapelles
Chapels - Guernsey - St. Peter Port (Brock Chapel), p.151 (314P-1)
Chapels - Nova Scotia - Yarmouth (Yarmouth cemetery chapel), p.46 (1P-34)
Chapels - Ontario - Brantford (H.M. Chapel of the Mohawks), p.75 (7P-910)
Chapels - Quebec - Caughnawauga (Chapelle de Saint-Jean-Baptiste), p.129 (7P-1615)
Chapman, George Arthur Emerson, Maj., p.31 (7P-331)
Chapman, M., Mrs., p.31 (7P-332)
Chapman, William, p.31 (185P-17)
Chapple, F.G., Mrs., p.31 (7P-333)
Charbonneau, Blondine, p.31 (185P-8)
Chard, C.S., and family, p.31 (7P-334)
Charlebois, Robert, p.135 (7P-1708)
Charles, Thos., photo., p.102 (200P-13)
Charles Mair Memorial, p.88 (7P-1150)
Charlesbourg (Québec) clercs de Saint Viateur
 voir aussi
 institut des sourds
Charlie, Tagish, p.69 (7P-841)
Charlotte (Paddleboat), p.121 (228P-1)
Charlottetown, P.E.I. - general views, p.3 (7P-22), p.29 (7P-312), p.45 (7P-510), p.50 (7P-582), p.53 (7P-615), p.60 (7P-717), p.77 (7P-940),

p.131 (5P-4)

Charlottetown Camera Club, Charlottetown, P.E.I., p.31 (5P-5), p.31 (5P-6)

Charlottetown Conference, p.31 (7P-335), p.77 (7P-940)

Charlottetown (I.-P.-E.) - vues, p.14 (7P-164)

Charlton, John Andrew, p.31 (7P-336)

Charron, B., photo., p.72 (7P-880)

Chase, William, photo., p.39 (1P-68), p.49 (1P-36), p.65 (7P-786), p.85 (7P-1085), p.137 (1P-55)

Chasse - Terre-Neuve (phoques), p.8 (7P-72)

Chateau Lake Louise, Alta., p.50 (166P-11)

Château-Richer (Québec) - vues, p.4 (134P-1)

Chatham, Ont. - general views, p.65 (7P-776), p.70 (7P-856), p.101 (7P-1267), p.149 (7P-1836), p.151 (7P-1863)

Chats, Lac des, Ont. - general views, p.94 (7P-1109)

Chats Falls, Ont. - general views, p.93 (7P-1069)

Chaudière (chutes), rivière des Outaouais - vues, p.16 (7P-183)

Chaudière Falls, Ottawa River - general views, p.50 (7P-573), p.103 (7P-1300), p.110 (7P-1374)

Chaudière River, Que. - general views, p.104 (8P-7)

Chauveau, P.J.O., Hon., p.71 (7P-862), p.71 (7P-862)

Cheesman, Al, p.106 (7P-1329)

Chelsea, Que. - general views, p.55 (7P-643), p.147 (7P-1811)

Chelsea (Québec) - vues, p.18 (7P-251)

Chemin de fer - Ontario, p.18 (7P-215)

Chemins de fer - Accidents, p.63 (7P-760)

Chemins de fer - Canada, p.14 (7P-164), p.146 (7P-1793)

Chemins de fer - Canadian Northern, p.63 (7P-760)

Chemins de fer - Canadien National, p.15 (7P-172)

Chemins de fer - Canadien Pacifique, p.16 (7P-188), p.18 (7P-217), p.63 (7P-760)

Chemins de fer - Colombie-Britannique, p.35 (7P-148)

Chemins de fer - Grand Tronc, p.24 (7P-1929), p.63 (7P-760)

Chemins de fer - Grand Tronc du Pacifique, p.152 (7P-1879)

Chemins de fer - Grande Bretagne, p.17 (7P-210)

Chemins de fer - Great Pacific Eastern, p.63 (7P-760)

Chemins de fer - Ligne transcontinentale, p.16 (7P-188), p.18 (7P-215), p.63 (7P-760)

Chemins de fer - Midland Railway, p.63 (7P-760)

Chemins de fer - New York Central Railway, p.15 (7P-172)

Chemins de fer - Northern Railway, p.63 (7P-760)

Chemins de fer - Ontario and Rainy River, p.150 (7P-1855)

Chemins de fer - South Eastern, p.63 (7P-760)

Chemins de fer - Temiskaming and Northern Ontario, p.63 (7P-760)

Chemins de fer - wagons, p.19 (7P-233)

Chemistry - generalities, p.36 (332P-1)

Chergwin, W.L., p.31 (1P-62)

Chesapeake (U.S.S.), p.117 (7P-1465)

Chester, N.S. - scenes, p.61 (8P-1)

Chesterfield, A.A., photo., p.31 (75P-5)

Chesterfield Inlet, N.W.T. - general views, p.119 (7P-1489)

Chesterton, Lillian, p.31 (7P-337)

Chevalier, Maurice, p.83 (7P-1027)

Chevrier, Lionel, Hon., M.P., p.31 (7P-338)

Chicago, Ill. - general views, p.64 (18P-4) p.68 (333P-5), p.74 (7P-904), p.120 (123P-8)

Chicora (SS), p.66 (7P-787) p.133 (8P-10)

Chicoutimi, Que. - general views, p.30 (7P-323)

Chicoutimi (Québec) - vues, p.80 (335P-1)

Chiel, Arthur A., rabbi, p.31 (7P-339)

Chien d'or, le, Quebec, Que., p.31 (7P-340)

Chilcotin (Paddleboat), p.121 (228P-1)

Children - care and hygiene -Ontario - Toronto, p.32 (140P-4), p.74 (7P-901), p.138 (140P-17)

Chilkoot Pass, B.C. - general views, p.2 (7P-13), p.74 (7P-898), p.112 (7P-1399)

Chimie - generalités, p.36 (332P-1)

China - general views, p.13 (16P-4), p.48 (7P-554), p.91 (16P-13), p.95 (196P-39), p.148 (7P-1817), p.149 (16P-20)

Chinese in Canada, p.16 (8P-6)

Chipman, Kenneth Gordon, p.31 (7P-341)

Chipman, Kenneth Gordon, photo., p.3 (7P-23)

Chisamore, Lloyd, p.31 (7P-342)

Chisholm, C., photo., p.23 (7P-1917)

Chisolm, George Brock, Dr., p.31 (7P-343)

Chisolm, O., photo., p.41 (31P-82)

Christensen, J., p.31 (7P-344)

Christian, J.H. Mrs., p.32 (1P-31)

Christie, Duncan H., p.32 (7P-345)

Christie, M., and family, p.32 (334P-36)

Chronicle-Herald, (The), Halifax, N.S., p.136 (1P-40)

Chuchla, Walter F., p.32 (7P-346)

Church, Thomas Langton, p.32 (18P-43)

Church family, p.32 (12P-6)

Church (Methodist) - Nova Scotia, p.89 (24P-1)

Church (Methodist) - Ontario, p.72 (7P-880)

Church Point, N.S. - general views, p.43 (1P-19)

Church (Presbyterian) - Canada, p.53 (7P-617), p.55 (317P-2), p.116 (317P-1)

Church (Presbyterian) - Nova Scotia, p.89 (24P-1)

Church (Presbyterian) - Ontario, p.72 (7P-880)

Church (Roman Catholic) - Canada, p.42 (7P-470)

Church (Ukrainian Greek Catholic) - Saskatchewan - Stornoway, p.135 (7P-1711)

Church (United) - Ontario, p.83 (7P-1026)

Churches - Alberta, p.1 (13P-10), p.112 (13P-9)

Churches - British Columbia -New Westminster, p.35 (334P-28), p.38 (334P-3), p.97 (334P-25), p.100 (334P-19), p.116 (334P-9)

Churches - England - Frant (Saint Alban), p.72 (7P-882)

Churches - Manitoba, p.3 (13P-11), p.37 (9P-12)

Churches - Manitoba - Winnipeg, p.124 (9P-65)

Churches - New Brunswick - Saint John, p.103 (2P-1)

Churches - Nova Scotia, p.63 (1P-26), p.105 (1P-77)

Churches - Nova Scotia - Halifax, p.60 (1P-78)

Churches - Ontario - Bedford, p.45 (7P-509)

Churches - Ontario - Kingston (St. Andrews Church), p.87 (7P-1134)

Churches - Ontario - Kirk Hill (St. Columba), p.147 (7P-1806)

Churches - Ontario - Middleville, p.151 (7P-1854)

Churches - Ontario - Oakville, p.106 (47P-6)

Churches - Ontario - Sault Ste. Marie, p.126 (121P-1)

Churches - Ontario - Toronto, p.43 (18P-27)

Churches - Ottawa River Valley, p.122 (7P-1518)

Churches - Prince Edward Island - park corner (Geddie Memorial Church), p.62 (31P-29)

Churches - Quebec - Montreal (Marie Reine du Monde), p.110 (7P-1370)

Churches - Quebec - Quebec (the Basilica), p.63 (8P-5)

Churches - Quebec - St. Cyriac, p.29 (7P-308)

Churches - Quebec (Notre-Dame Cathedral), p.145 (8P-9)

Churches - Quebec (St. Paul Cathedral), p.145 (8P-9)

Churches - Saskatchewan, p.112 (13P-9)

Churches (Anglican) - Manitoba, p.124 (9P-66)

Churches (Anglican) - Ontario - Diocese of Ottawa, p.4 (301P-1)

Churches (Anglican) - Ontario - Ottawa (Saint Bartholomew), p.91 (7P-1187)

Churches (Anglican) - Ontario - Toronto (St. Stephen's-in-the-Fields Anglican Church), p.125 (18P-91)

Churches (Baptist) - Nova Scotia - Liverpool, p.130 (1P-54)

Churches (Baptist) - Nova Scotia - Springfield, p.101 (1P-49)

Churches (Baptist) - Ontario - Osnabruck, p.147 (7P-1806)

Churches (Methodist) - Nova Scotia - Springfield, p.101 (1P-49)

Churches (Methodist) - Ontario - Carp (Saint Paul's Methodist Church), p.83 (7P-1026)

Churches (Methodist) - Ontario - Merrickville, p.98 (7P-1225)

Churches (Methodist) - Ontario - Spencerville, p.107 (7P-1330)

Churches (Presbyterian) - British Columbia - Lake Bennett, p.2 (7P-13)

Churches (Presbyterian) - Canada, p.116 (317P-1)

Churches (Presbyterian) - Ontario - Carp (Saint Andrew's Presbyterian Church), p.83 (7P-1026)

Churches (Presbyterian) - Ontario - Pakenham, p.104 (7P-1309)

Churches (Presbyterian) - Ontario - Peterborough (Saint Andrew's), p.124 (7P-1553)

Churches (Presbyterian) - Ontario - Roebuck, p.107 (7P-1330)

Churches (Presbyterian-Ukrainian) - Ontario - Toronto, p.50 (7P-581)

Churches (Roman Catholic) - Alberta - Edmonton (Holy Rosary Polish R.C. Church), p.88 (7P-1153)

Churches (Roman Catholic) - New Brunswick - Newcastle (Saint Mary's R.C. Church), p.84 (7P-1032)

Churches (Roman Catholic) - Ontario - Barry's Bay, p.88 (7P-1153)

Churches (Roman Catholic) - Ontario - South Gloucester (Our Lady of the Visitation), p.107 (7P-1332)

Churches (Roman Catholic) - Quebec - St. Andrew East, p.90 (7P-1171)

Churches (Roman Catholic) - Yukon - Dawson, p.147 (7P-1809)

Churches (United) - Newfoundland - Greens Harbour, p.108 (38P-8)

Churches (United) - Nova Scotia, p.89 (24P-1)

Churches (United) - Nova Scotia - (Italy Cross United Church), p.76 (31P-77)

Churches (United) - Ontario -Ottawa (Britannia United Church), p.86 (7P-1112)

Churchill, Gordon M., Hon., M.P., p.32 (7P-347)

Churchill, Man. - general views, p.80 (7P-983), p.80 (7P-987), p.119 (7P-1489), p.130 (7P-1636)

Churchill, Winston Leonard Spencer, Sir, p.9 (7P-95), p.34 (7P-366), p.43 (7P-489), p.53 (7P-613), p.66 (7P-790), p.96 (7P-1191), p.107 (7P-1295), p.150 (7P-1847)

Churchill Falls, Nfld. - aerial views, p.68 (7P-826)

Churchill Falls (T.N.-O.), p.21 (7P-1910)

Churchill (Man.) - vues, p.17 (7P-200)

Churchill No 1 (Dragueur), p.24 (7P-1930)

Chutes
 voir
 le nom de la chute

Citadelle de Québec - feu - 1887, p.4 (134P-1)

City of Selkirk (SS), p.91 (7P-1187)

City of Toronto
 see also
 Toronto, Ont.

City of Toronto (SS), p.133 (8P-10)

Civil Rights, p.108 (7P-1348)

CKAC, Radio Station, Montreal, Que., p.133 (7P-1668)

Clancy, Frank (King), p.93 (7P-1071)
Clare, F.A., p.33 (9P-10)
Claremont, Ont. - general views, p.26 (7P-1920), p.41 (7P-448)
Clark, p.56 (7P-666)
Clark, Cecil, p.33 (12P-9)
Clark, Charles, photo., p.33 (1P-8)
Clark, Joe, p.21 (7P-256)
Clark, Lily, p.33 (7P-348)
Clarke, Allan, p.27 (7P-272)
Clarke, Borden, p.33 (7P-349)
Clarke, J.H., photo., p.22 (7P-1903)
Clarke, Katharine, p.33 (7P-350)
Clarke, Roger F., p.33 (7P-351)
Clark's Harbour, N.S. - individuals, p.152 (7P-1884)
Claxton, Brooke, Hon., M.P., p.33 (7P-352)
Clay, Charles, p.33 (7P-353)
Clay, Rush, p.33 (7P-354)
Clearihue, J.B., and family, p.33 (12P-27)
Clearihue, Joyce, p.33 (7P-355)
Cleeve (ship), p.145 (334P-27)
Clementsport, N.S. - general views, p.69 (1P-18)
Clementt, Amelia, p.33 (7P-356)
Clercs de Saint-Viateur, Joliette, Québec, p.4 (221P-1)
Clercs de Saint-Viateur, Montréal (Québec), p.33 (208P-1)
Clercs de Saint-Viateur de Montréal (Québec), p.34 (7P-357)
Clergy
 see
 name of religion under subdivision
 Church
Clerihue, p.34 (334P-37)
Cléroux, Alexina, p.34 (185P-12)
Cleven, Endre J., photo., p.22 (7P-1903)
Cleverdon, Catherine L., Dr., p.34 (7P-358)
Clifden, Irlande - vues, p.152 (7P-1875)
Cliff, G.B. photo., p.114 (7P-1422)
Clifford, Theodore A., Mrs., p.34 (31P-21)
Clifton-Sclater, Comdr., p.50 (7P-574)
Climo, p.49 (1P-36)
Climo, J.S., photo., p.92 (7P-1039)
Climo, photo., p.47 (1P-35), p.89 (24P-1), p.98 (1P-48), p.110 (1P-51)
Clinton, B.C. - general views, p.29 (228P-4), p.54 (7P-629)
Clinton (C.-B.) - vues, p.35 (7P-371)
Clougher, Nugent M., and family, p.34 (7P-359)
Club de Hockey Canadien de Montreal, Que., p.91 (7P-1189)
Clyde River, Ont. - general views, p.151 (7P-1854)
Co-operative Commonwealth Federation, p.36 (7P-391)
Co-operative Commonwealth Federation Meeting, Calgary, Alta, p.122 (7P-1524)
Coaker, William Ford, Sir, p.20 (38P-1)
Coal Mining - Alberta, p.18 (13P-1), p.53 (7P-624), p.88 (7P-1152), p.92 (7P-1047)
Coal mining - British Columbia, p.1 (31P-3)
Coal mining - Nova Scotia, p.1 (31P-3), p.9 (104P-1), p.34 (1P-64), p.86 (1P-23)
Coates, David Mervin, G.M., R.C.A.F., p.34 (7P-360)
Coates, E.E., p.34 (1P-64)
Coatsworth, Emerson, p.34 (18P-59)
Cobalt, Ont. - general views, p.39 (7P-420), p.41 (7P-452), p.47 (7P-543), p.54 (7P-635), p.67 (7P-813), p.110 (7P-1374), p.119 (7P-1492)
Coburn, C.C., Mrs., p.34 (7P-361)
Cochin, Louis, Rév., p.12 (7P-130), p.36 (7P-384)
Cochran, photo., p.19 (200P-11)
Cochrane, Alta. - general views, p.125 (166P-2), p.148 (7P-1825)
Cochrane, Harry, photo., p.60 (1P-41), p.98 (1P-48)
Cochrane (Ont.) - vues, p.10 (185P-6), p.18 (7P-215)

Cockburn, photo., p.2 (7P-14)
Cockburn, W.H., p.34 (9P-77)
Coderre, Joan E., p.34 (7P-362)
Coderre, John, and family, p.34 (7P-362)
Cody, H.J., Mrs., p.34 (7P-363)
Cody, Henry J., p.34 (196P-8), p.143 (196P-59)
Cogswell, A.R., photo., p.34 (7P-364), p.43 (1P-33), p.49 (1P-36), p.49 (1P-9)
Cohen, Horace, p.34 (7P-365)
Cohen, Leonard, p.135 (7P-1708)
Cohen, Lyon, p.34 (7P-365)
Col. By (SS), p.147 (7P-1813)
Colchester Historical Society, p.34 (31P-106)
Colcleugh family, Man., p.54 (9P-20)
Cold Lake, Man. - general views, p.130 (7P-1636)
Coldwell, Major James William, Hon., p.34 (7P-366), p.36 (7P-391)
Cole, Jean, p.34 (7P-367)
Cole, Ron, photo., p.69 (7P-833)
Colebrook, F.H., Mrs., p.34 (7P-368)
Collège classique
 voir aussi
 la subdivision au nom de l'endroit
College St. Anne productions, Church Point, N.S., p.148 (31P-59)
Colleges - England - Goring-on-Thames, p.111 (7P-1384)
Collèges - Nouveau-Brunswick - Bathurst (Collège de Bathurst), p.69 (15P-6)
Collèges - Nouveau-Brunswick - Church Point (Sainte-Anne de Church Point), p.69 (15P-6)
Collèges - Nouveau-Brunswick - Moncton (Notre-Dame D'Acadie), p.69 (15P-6)
Colleges - Nova Scotia - Halifax (Dalhousie College), p.87 (31P-9)
Colleges - Nova Scotia - Halifax (R.C.N. College), p.63 (7P-751)
Colleges - Nova Scotia - Oxford (Queen's College), p.112 (7P-1399)
Colleges - Nova Scotia - Windsor (Kings College), p.120 (7P-1509)
Collèges - Nova Scotia - Wolfville (Acadia College), p.137 (1P-75)
Colleges - Ontario - Guelph (Ontario Agricultural College), p.108 (7P-1347)
Colleges - Ontario - Kingston (Royal Military College), p.18 (7P-225), p.145 (7P-1785)
Colleges - Ontario - London (Brough's Bridge), p.82 (7P-1015)
Colleges - Ontario - London (Fanshawe College), p.49 (7P-572)
Colleges - Ontario - London (Hellmuth Ladies College), p.82 (7P-1015)
Colleges - Ontario - Ottawa (Ashbury), p.39 (7P-424), p.152 (7P-1877)
Collèges - Ontario - Ottawa (Collège Bruyère), p.141 (303P-8)
Colleges - Ontario - Ottawa (Ottawa Ladies College), p.55 (7P-655)
Collèges - Ontario - Ottawa (Ottawa Teacher's College), p.109 (303P-16)
Colleges - Ontario - Toronto (Emmanuel College), p.83 (196P-55)
Colleges - Ontario - Toronto (Erindale College), p.142 (196P-23)
Colleges - Ontario - Toronto (Frontier College), p.53 (7P-625)
Colleges - Ontario - Toronto (Knox College), p.76 (317P-3), p.76 (317P-4), p.83 (196P-55), p.116 (317P-5)
Colleges - Ontario - Toronto (Loretto College), p.142 (196P-57)
Colleges - Ontario - Toronto (Ontario Veterinary College), p.83 (196P-55)
Colleges - Ontario - Toronto (St. Joseph's College), p.124 (200P-10)
Colleges - Ontario - Toronto (St. Michael's College), p.88 (200P-3), p.88 (200P-4), p.124 (200P-10)

Colleges - Ontario - Toronto (Trinity College), p.83 (196P-55)
Colleges - Ontario - Toronto (University College), p.143 (196P-27)
Colleges - Ontario - Toronto (University of Trinity College), p.143 (196P-30)
Colleges - Ontario - Toronto (University of Victoria College), p.144 (196P-45)
Colleges - Ontario - Toronto (Upper Canada College), p.111 (7P-1384), p.127 (7P-1593), p.144 (196P-19)
Colleges - Ontario - Toronto (Victoria College), p.9 (196P-49), p.35 (7P-381), p.83 (196P-55)
Colleges - Ontario - Toronto (Wycliffe College), p.83 (196P-55)
Colleges - Ontario (Loretto College), p.124 (200P-10)
Colleges - Quebec - Montreal (Loyola College), p.75 (7P-913)
Colleges - Quebec - Montreal (presbyterian college), p.3 (7P-24), p.116 (317P-5)
Colleges - Royal College of Dental Surgeons, p.27 (7P-275)
Colleges (Tufts College), p.83 (7P-1021)
Collenette, B., photo., p.151 (314P-1)
Collier, F.C., p.34 (7P-369)
Collingwood, Ont. - general views, p.91 (7P-1183), p.97 (7P-1208)
Collins, John, p.5 (7P-46)
Collins, photo., p.75 (131P-6)
Collona, Jerry, p.101 (7P-1272)
Colloquium '67, Montreal, Que, p.29 (7P-302)
Colombie Britannique - scènes, p.15 (7P-178), p.35 (7P-1894), p.123 (7P-1542)
Colombie-Britannique, Archives provinciales, Victoria (C.-B.), p.35 (7P-371)
Colombie Britannique, Yukon, Alaska - autoroute, p.35 (7P-370)
Colombo, Plan (de), p.24 (7P-1918)
Colonial Conference, London England, p.126 (7P-1575)
Colorado, United States - scenes, p.49 (7P-572)
Columbia, S.C. - general views, p.120 (123P-8)
Columbia River Valley, B.C. -general views, p.35 (7P-372)
Columbia Valley, B.C. - general views, p.56 (166P-47)
Columbian (newspaper), Coquitlam, B.C., p.35 (334P-28)
Columbian (SS), p.135 (7P-1695)
Colwell, Wayne, p.35 (7P-373)
Combe, Robert G., Lt., p.33 (7P-356)
Comer, George, p.35 (7P-374).
Cominco Ltd., Trail, B.C., p.4 (7P-33)
Cominco Ltd., Vancouver, B.C., p.35 (7P-375)
Comité de la Grande Fête de Hull, Hull, Que., p.35 (7P-376)
Commerce - Ontario, p.106 (47P-7)
Commercial and Press Photographers Association of Canada, Toronto, Ont., p.35 (7P-377)
Commercial Photo Service, photo., p.5 (1P-27)
Commission
 see
 name of country, province or state
Commission Canadienne du Transport, p.35 (7P-1894)
Commission des chemins de fer, p.35 (7P-148)
Commonwealth Labour Parties Conference, p.36 (7P-391)
Commonwealth Parliamentary Association Conference, p.25 (7P-1952)
Commonwealth War Graves Commission, Ottawa Ont., p.35 (7P-378)
Communauté canadienne - allemande, Montreal (Quebec), p.145 (7P-203)
Communication - Quebec - Montreal, p.132 (7P-1656)
Communications
 see also
 name of country, province or state

Communications - Canada, p.28 (7P-287)
Communications - Canada-Ireland, p.53 (7P-618)
Communications - Canada-New Zealand, p.52
 (7P-599)
Communications - Nova Scotia, p.106 (1P-89)
Comox, B.C. - general views, p.95 (7P-1117)
Compagnie Aérienne Française - photo., p.23
 (7P-1926)
Compagnie d'assurance-vie métropolitaine,
 Ottawa, Ont., p.35 (7P-379)
Compagnie de la Baie d'Hudson, p.17 (7P-200)
Company of Young Canadians, p.35 (7P-1900)
Compton family, p.73 (12P-10)
Condon, Eddie, p.28 (7P-297)
Condor (H.M.S.), p.50 (7P-574)
Confederation - Canada, p.125 (7P-1566), p.135
 (113P-7), p.147 (7P-1805)
Confederation - Newfoundland, p.123 (7P-1538)
Confederation Centennial Ceremonies,
 Charlottetown, P.E.I., p.101 (7P-1268)
Confederation Chamber, Provincial Building,
 Charlottetown, P.E.I., p.50 (7P-582)
Conférence «Atome et Paix», p.104 (7P-1322)
Conférence de Bruxelles de 1920, Bruxelle,
 Belgique, p.35 (7P-380)
Conférence de Québec, p.26 (7P-1971)
Conférence de Québec
 voir aussi
 Quebec Conference
Conférence du Commonwealth sur la
 radiodiffusion, 1945, p.20 (7P-246)
Conférence Impériale, p.24 (7P-1918)
Congrégation des Filles de la Charité du
 Sacré-Coeur de Jésus, Sherbrooke, Québec,
 p.35 (329P-1)
Congrégation des Saints Noms de Jésus et de
 Marie, Outremont (Québec), p.35 (325P-1)
Congrès canadien des juifs, p.9 (7P-96)
Congrès des missionnaires laïcs, Toronto (Ont.),
 p.152 (7P-1874)
Congrès eucharistique, Québec, 1923-1938, p.80
 (131P-4)
Congrès inter-américain de radiologie, p.69
 (7P-1946)
Congrès international des juifs, p.9 (7P-96)
Congrès marial, Québec, 1929, p.80 (131P-4)
Conklin, Maurice, p.35 (7P-381)
Conlon, C.A., photo., p.49 (1P-36)
Connally, A.P., Col., p.152 (7P-1872)
Connaught, Louise Margaret Alexandra Victoria
· Agnes, Duchess of, p.68 (7P-827)
Connaught and Strathearn, Arthur William Patrick
 Albert, Duke of, p.56 (7P-658), p.68 (7P-827),
 p.69 (7P-834), p.130 (7P-1629), p.139
 (7P-1751)
Connaught et Strathearn, Arthur William Patrick
 Albert, duc de, p.11 (131P-2), p.13 (7P-142),
 p.149 (7P-1839)
Connolly, Earl, Mrs., p.36 (1P-65)
Connon, John, photo., p.39 (7P-427)
Connon, Thomas, photo., p.39 (7P-427)
Connor, Harry, p.36 (7P-382)
Connor, James Henry, and family, p.36 (7P-383)
Connor, W.H., photo., p.148 (7P-1823)
Connor, W.M., p.36 (7P-383)
Connor Washing Machine Co., p.36 (7P-383)
Connors, Thomas, p.36 (1P-32)
Conrad, Yukon - general views, p.42 (7P-459)
Conseil intermunicipal des loisirs du Témiscouata,
 Notre-Dame-du-Lac (Québec), p.36 (343P-1)
Conseil national de recherches, Divisions du
 CNRC, Ottawa (Ont.), p.36 (332P-1)
Consolidated Mine, Yellowknife, N.W.T., p.80
 (7P-983)
Consolidated Mining & Smelting Ltd.
 see also
 Aircraft - Consolidated Mining &
 Smelting Ltd.

Consolidated Mining & Smelting Ltd., p.51
 (7P-586)
Consolidated Paper Co. Ltd., Pembroke, Ont., p.83
 (7P-1022), p.101 (7P-1267)
Constantine, Charles Francis, p.36 (7P-384)
Constantine, Henrietta, photo., p.36 (7P-385)
Construction - Alberta, p.47 (13P-8)
Contant, Alexis, p.36 (149P-6)
Convent Jesus-Marie, Woonsocket, R.I., p.50
 (7P-580)
Convents - Ontario - Ottawa (Notre Dame du
 Sacre Coeur), p.105 (7P-1324)
Convents - Quebec - Rigaud (Juvenists Convent
 School), p.51 (7P-593)
Cook, Geo. H., p.56 (7P-666)
Cook, George Douglas, Lt. Comdr., p.36 (7P-386)
Cook, J.B., photo., p.72 (7P-874)
Cook, R.S., photo., p.88 (7P-1146)
Cook, Sidney Jabez, p.36 (7P-387)
Cook, Terry, p.36 (7P-388)
Cook House, N.W.T. - general views, p.130
 (7P-1625)
Cooke, J.F., photo., p.20 (7P-239), p.77 (7P-947)
Cooking Lake, Alta. - general views, p.80
 (7P-983), p.94 (7P-1113)
Cookshire, Que. - general views, p.145 (7P-1786)
Cooksley, William T., photo., p.36 (334P-7)
Cookstown, Ont. - general views, p.75 (7P-910)
Coolidge, Calvin, p.16 (75P-2)
Coombs, Douglas, p.36 (7P-389)
Cooper, Frank, photo., p.15 (7P-168), p.53
 (7P-619)
Cooper, Richard J.G., p.36 (7P-390)
Cooper, W.A., photo., p.126 (7P-1571)
Copernicus, Nicholas, p.32 (7P-346)
Copernicus Committee, p.32 (7P-346)
Copland, A.D., p.36 (7P-392)
Copland, Aaron, p.7 (31P-99)
Copper Cliff, Ont. - general views, p.27 (7P-270)
Copper Cliff, (Ont.) - vues, p.10 (7P-103)
Coppermine, N.W.T. - general views, p.62
 (7P-746)
Coppermine Eskimos, p.148 (7P-1820)
Coppermine (T.N.-O.) - vues, p.11 (7P-119)
Coral Leaf (Tern Schooner), p.12 (31P-104)
Corbeau's Island, Georgian Bay, Ont. - Basilian
 Fathers, p.148 (200P-15)
Corberrie, N.S. - general views, p.43 (1P-19)
Corless, C.V., Dr., p.36 (7P-393)
Cornell, Margaret, p.37 (196P-43)
Cornell University Expedition to Greenland, 1896,
 p.75 (7P-914)
Cornell Unviersity Archives, Ithaca, N.Y., p.37
 (7P-394)
Cornwall (Ont.) - clercs de Saint Viateur
 voir aussi
 Collège Classique
Cornwall, Ont. - general views, p.95 (7P-1118)
Cornwall and York, Duchess of, p.2 (7P-14), p.79
 (7P-971), p.115 (7P-1437), p.115 (7P-1447),
 p.123 (7P-1545)
Cornwall and York, Duke of, p.2 (7P-14), p.79
 (7P-971), p.115 (7P-1437), p.115 (7P-1447),
 p.123 (7P-1545)
Cornwall et de York, duc de, p.10 (7P-102)
 p.146 (7P-1790)
Cornwall et de York, duchesse de, p.10 (7P-102),
 p.146 (7P-1790)
Cornwallis (H.M.C.S.), p.10 (7P-107)
Corps Expéditionaire Canadien, Camp Hughes
 (Man.), p.21 (7P-1910)
Corps Expeditionnaire Canadien pour la Sibérie,
 Vladivostok, Sibérie, U.R.S.S., p.15 (7P-179)
Corps of Royal Engineers, photo., p.123 (7P-1542)
Correctional Institutions - Alberta (Lethbridge
 Provincial Gaol), p.132 (7P-1658)
Correctional Institutions - Alberta (Spy Hill
 Provincial Gaol), p.132 (7P-1658)

Correctional Institutions - British Columbia, p.23
 (7P-1937)
Correctional institutions - Manitoba - Riding
 Mountain, p.70 (7P-857)
Correctional Institutions - New Brunswick -
 Dorchester, p.23 (7P-1937)
Correctional Institutions - Ontario - Kingston
 (Women's prison), p.55 (7P-644)
Correctional Institutions - Quebec - Cowansville,
 p.55 (7P-644)
Correctional Institutions - Quebec - Laval
 (Leclerc), p.55 (7P-644)
Correctional Institutions - Quebec -
 Saint-Vincent-de-Paul, p.23 (7P-1937)
Correctional Institutions - Quebec -
 Sainte-Anne-Des-Plaines (Archambault), p.55
 (7P-644)
Correctional Institutions - Saskatchewan, p.23
 (7P-1937)
Corrigan family, Ont., p.49 (7P-563)
Corston, James, Dr., p.37 (31P-23)
Côté, Ernest A., Mme., p.37 (7P-395)
Côté, J.G., p.37 (7P-396)
Côté, photo., p.125 (7P-1562)
Côte de Beaupré (Québec) -vues, p.108 (113P-12)
Côte Saint-Antoine, Que., p.145 (7P-1780)
Coteau-du-Lac, Que. - general views, p.34
 (7P-362)
Coteau-Landing, Que. - general views, p.34
 (7P-362)
Cottingham, William McOuat, Hon., p.37 (7P-397)
Cotton, E., p.37 (334P-38)
Cotton, F.S., Mrs., p.51 (7P-584)
Cotton, William Henry, p.37 (7P-398)
Couchiching, Lake, Ont. - general views, p.39
 (7P-420), p.54 (7P-635)
Couchiching, Ont. - scenes, p.49 (8P-8)
Couchiching Conference, Geneva Park, Ont., p.28
 (7P-283)
Couchiching Lake, Ont. - general views, p.110
 (7P-1374)
Couchman, Arthur, p.37 (7P-399)
Coughlin, Mary, p.37 (7P-400)
Couillard-Desprès, Azarie, p.89 (7P-1165)
Coulombe, Danielle, p.37 (185P-11)
Council of the Engineering Institute of Canada,
 p.30 (7P-327)
Countess of Dufferin (SS), p.49 (8P-8)
Coupal, J.L., Mrs., p.70 (7P-851)
Cour supérieure, Montréal (Québec), p.121
 (7P-1515)
Cournoyer, Jean, Hon., p.46 (7P-520)
Courtois, Joseph, Rev., p.37 (46P-5)
Coutlee, Charles R., p.37 (7P-401)
Couvent des Soeurs de l'Assomption, Haileybury,
 Ont., p.19 (200P-2)
Coventry, Alan Freeth, p.53 (196P-12)
Covert, Earl, p.37 (7P-402)
Cowan, E.M., Mrs., p.37 (7P-403)
Cowan, George Hoyle, p.37 (196P-4)
Cowan, James A., p.37 (7P-404)
Coward, Elizabeth Ruggles, photo., p.37 (1P-11)
Cowell, John, p.37 (9P-11)
Cowichan Lake, B.C. - general views, p.56
 (7P-660), p.110 (7P-1374)
Cowichan River, B.C. - general views, p.56
 (7P-660)
Cowley, F.P.W., p.37 (9P-12)
Cox, Dorothy Gordon, p.37 (1P-66)
Cox, Dudley, p.37 (38P-2)
Cox, J.R., photo., p.3 (7P-23)
Coxsippi River, Nfld. - general views, p.22
 (7P-1927)
Craib, Peter, p.38 (7P-405)
Craick, W.A., p.38 (1P-67)
Craig, James, p.95 (7P-1118)
Craig, William, photo., p.50 (200P-12), p.142
 (200P-8)
Crain, Harold F., p.38 (7P-406)

Cranberry Portage, Man. - general views, p.80
(7P-983)
Cranbrook, B.C. - general views, p.21 (333P-42),
p.39 (333P-6), p.47 (333P-8), p.58 (333P-33),
p.64 (7P-762), p.73 (333P-14), p.75 (333P-7),
p.77 (333P-41), p.84 (333P-30), p.112
(7P-1395), p.122 (333P-9), p.148 (333P-12)
Craswell, O.C., photo., p.38 (5P-7)
Craven Foundation Museum and Restoration
Centre, Toronto, Ont., p.38 (7P-407)
Crawford, Isabella Valancy, p.38 (7P-408)
Crawford, photo., p.3 (81P-7)
Crawley Film Ltd., Ottawa, Ont., p.38 (7P-409)
Crealman, James S., p.44 (31P-72)
Crediton, Ont. - general views, p.124 (7P-1549)
Cree Indians, p.33 (7P-349), p.75 (1P-71), p.129
(7P-1619)
Creelman, Marion, p.126 (7P-1571)
Creelmen, Isabel, p.126 (7P-1571)
Creighton, Thomas Colton, and family, p.38
(31P-11)
Creighton Mines (Ont.) - vues, p.10 (7P-103)
Crerar, Henry Duncan Graham, Gen., p.38
(7P-410), p.87 (7P-1130)
Creston, B.C. - general views, p.112 (7P-1395)
Creston Valley Archives, Creston, B.C., p.38
(7P-411)
Croak, John B., p.41 (7P-458)
Crocker, Ernest, photo., p.38 (9P-13)
Croft family, Ont., p.151 (7P-1854)
Crofton Hall (bateau), p.152 (7P-1872)
Croft's Lumber and Shingle Mill, Middleville, Ont.,
p.151 (7P-1854)
Croix-Rouge du Canada, p.35 (7P-379)
Crooked River, Sask. - general views, p.31
(7P-334)
Crooks, Richard, p.119 (31P-100)
Cropp, Marjorie E., p.38 (7P-412)
Crosby, Malcolm, photo., p.147 (7P-1805)
Crosby, R.T., Mrs., p.38 (7P-413)
Cross family, Ont., p.72 (7P-880)
Cross Lake, Ont. - general views, p.119 (7P-1492)
Crossley, H.N., p.38 (7P-414)
Croton Studio, photo., p.38 (334P-3)
Crowe's Beach, Toronto, Ont., p.51 (18P-85)
Crowfoot Glacier, Alta. - general views, p.23
(7P-1926)
Crownest Mountain, Alta. - general views, p.148
(7P-1825)
Crowsnest, B.C. - general views, p.15 (333P-40)
Crowsnest Landing, Waldo, B.C. - general views,
p.122 (333P-9)
Crowsnest Pass, Alta. - general views, p.118
(11P-5)
Cruickshank, Gwen, p.38 (7P-416)
Cruickshank, Julia, p.92 (7P-1050)
Cruickshank, R.E., V.C., p.38 (7P-416)
Cruikshank, Ernest Alexander, p.38 (7P-415), p.66
(7P-797), p.92 (7P-1050)
Cruiser (SS), p.110 (7P-1374)
Cryderman, Raymond L., p.38 (7P-417)
Crysler, Norah, p.96 (7P-1205)
Cucuel, Jean-Pierre, p.134 (7P-1567)
Cumberland County Council, N.S., p.38 (31P-44)
Cumbria, England - general views, p.15 (123P-9)
Cunard Line, p.69 (7P-836)
Cunard White Star Line, p.69 (7P-836)
Cunningham, Walter, p.38 (7P-418)
Curiosity Shop, Winnipeg, Man., p.38 (7P-419)
Curran, John Edward Gardiner, p.39 (7P-420)
Curran family, B.C., p.146 (7P-1797)
Currie, Arthur William, Lt. Gen., Sir, p.39
(7P-421), p.39 (7P-422), p.87 (7P-1130)
Currie, Garner O., p.39 (7P-422)
Currie, Thomas R., p.39 (7P-423)
Currier, Cyril, p.39 (7P-424)
Curtis, G.S., Mrs., p.39 (7P-425)
Curtis, photo., p.153 (161P-1)

Curtis, Wilfrid Austin, p.39 (7P-426)
Curtis Bros. Brickyard, Peterborough, Ont., p.110
(7P-1374)
Curtiss, Glenn, p.67 (7P-806)
Curtiss Aviation School, p.99 (7P-1241)
Curylo, Frederick A., p.39 (7P-427)
Curzon, George Nathanel, 1st Marquis, p.39
(7P-428)
Curzon of Kedleston, Earl, p.39 (7P-428)
Customs Houses - British Columbia, p.80 (7P-987)
Cut Knife Creek, N.W.T. - general views, p.100
(7P-1263)
Cuthbertson, Eileen (Odevaine), p.39 (1P-68)
Cuthbertson, George Adrian, p.39 (7P-429)
Cutts, Anson Bailey, p.39 (7P-430)
Cutts, Gertrude Spurr, p.61 (8P-1)
Cyriax, Richard Julius, p.39 (7P-431)
Cyril T (Schooner), p.39 (31P-107)

D'Arcy McGee, Thomas, Hon.
see
McGee, Thomas D'Arcy, Hon.
D.M.B. (tugboat), p.41 (334P-39)
Dagenais, J.A., photo., p.151 (7P-1866)
Daguerréotypes, p.4 (131P-9), p.4 (8P-16), p.15
(7P-170), p.20 (7P-239), p.21 (7P-1910), p.28
(327P-4), p.29 (337P-2), p.33 (208P-1), p.39
(131P-8), p.65 (7P-784), p.72 (7P-881), p.76
(7P-928), p.77 (7P-946), p.82 (7P-1008), p.88
(7P-1146), p.104 (7P-1310), p.107 (47P-17),
p.110 (7P-1377), p.111 (7P-1380), p.127
(324P-1)
Dahl, E.H., p.39 (7P-447)
Daigneault, Robert, p.5 (7P-46)
Dailey, H.C., p.39 (333P-6)
Daily News (the), photo., p.117 (38P-9)
Dainty, Ernest, p.39 (149P-9)
Dale, F.N., p.39 (7P-446)
Dale, Jack, p.39 (7P-445)
Dalgleish, J.B., photo., p.40 (7P-444)
Dalglish, Alex, p.40 (7P-443)
Dalglish, George, p.40 (7P-443)
Dalhousie, New Brunswick - general views, p.79
(46P-4)
Dalhousie University
see also
Universities - Nova Scotia - Halifax
(Dalhousie)
Dalhousie University, Halifax, N.S., p.40 (31P-1)
Dallinger, Henry, p.40 (7P-442)
Dally, F., photo., p.47 (12P-21)
Dally, Frederick, photo., p.40 (18P-8), p.78
(7P-955)
Dallyn, Gordon Mealey, p.40 (7P-441)
Dalton, Lucy, p.54 (7P-635)
D'Altroy, R., p.40 (7P-440)
Daly, George J., and family, p.40 (9P-14)
Daly, Harold M., p.40 (7P-439)
Dalziel, W.J., Lt., p.40 (7P-438), p.121 (7P-1513)
Dandurand, Raoul, Hon., p.13 (7P-146), p.14
(7P-163), p.40 (7P-437)
D'Angelo family, Ont., p.40 (7P-436)
Daniels, G., p.40 (7P-435)
Dansereau, Hector, p.109 (7P-1368)
D'Aoust, P.J., photo., p.137 (7P-1727)
Darling, Gordon J., photo., p.40 (7P-434)
Darragh, Harold, p.40 (7P-433)
Dartmouth, N.S. - general views, p.40 (31P-45),
p.112 (7P-1399), p.122 (1P-74)
Dartmouth ferry terminal, Dartmouth, N.S., p.40
(31P-45)
Daughters of Italy, p.43 (7P-484)

Daviault, Georges A., p.40 (7P-432)
Daviault, Pierre, p.60 (7P-716)
Davidson, George, and family, p.40 (9P-15)
Davidson, George, photo., p.40 (9P-15)
Davidson, T.G.M., p.41 (1P-69)
Davidson Bros., photo., p.22 (7P-1903)
Davies, Blodwen, p.41 (7P-448)
Davies, Frank Thomas, p.41 (7P-450)
Davies, Louis Henry, Rt. Hon. Sir, p.43 (7P-483),
p.66 (7P-796), p.133 (7P-1676)
Davies, Raymond Arthur, p.41 (7P-451)
Davies family, B.C., p.136 (7P-1714)
Davis, E.J., Hon., p.101 (7P-1276)
Davis, H.P., p.41 (7P-452)
Davis, J.S., p.41 (7P-454)
Davis, Jake, p.41 (7P-453)
Davis, V.E., and family, p.41 (47P-3)
Davis Book Co. Ltd., Montreal, Que., p.41
(7P-449)
Davison, A.W., p.41 (7P-455)
Davison, Edward S., photo., p.41 (31P-82)
Davison, Marjorie, photo., p.36 (7P-391)
Davison Lumber Co. Camp, N.S., p.76 (31P-77)
Dawe, Harold, p.41 (334P-14)
Dawe, Mary, p.41 (334P-39)
Dawson, G.M., photo., p.20 (7P-241)
Dawson, George M., p.41 (7P-456)
Dawson, Robert MacGregor, and family, p.41
(31P-25)
Dawson, Yukon - general views, p.2 (7P-13), p.2
(81P-5), p.39 (7P-420), p.70 (7P-848), p.74
(7P-898), p.81 (7P-1003), p.123 (7P-1975),
p.128 (7P-1599), p.131 (7P-1639), p.140
(16P-18), p.147 (7P-1809), p.153 (161P-1)
Dawson (Yukon) - vues, p.21 (7P-1973),
p.35 (7P-370)
Day, Bernhard, p.41 (7P-457)
Day, Frank Parker, p.41 (31P-32)
Day, Mabel Killam, p.41 (31P-32)
Day, Vivian, p.41 (7P-458)
Dayspring (ship), p.62 (31P-29)
Daze, John, p.80 (7P-981)
De Cruz, Hugh Emil, p.41 (7P-460)
De Gaulle, Charles, p.135 (7P-1707)
De Havilland Aircraft of Canada, Downsview,
Ont., p.41 (7P-462)
De La Roche, Mazo, p.42 (16P-7)
De La Roche, William Richmond, and family, p.42
(16P-7)
De Lesseps, Jacques, Count, p.29 (7P-307)
De Lorme, Louis Alfred, p.42 (7P-465)
De Mille, James, p.20 (31P-15), p.42 (31P-4)
De Montigny, Louvigny, p.60 (7P-716)
De Roquebrune, Robert, p.60 (7P-716)
De Tonnancourt, Jean, p.135 (7P-1708)
De Verchères, Madeleine, et famille, p.56 (7P-667)
Deane, Burton, Capt., p.12 (7P-130), p.36
(7P-384)
Dearing, W.E., p.42 (9P-16)
Dease Lake, B.C. - general views, p.118 (12P-23)
DeCelles, A.D., p.68 (7P-824)
Deckson, W.A., p.42 (7P-459)
D'Egville, Geoffrey, p.42 (7P-461)
Deja, Ron, p.42 (7P-463)
Del rio Le Bell isle, Detroit, Mich. - genreral views,
p.120 (123P-8)
Delawana II (yacht), p.89 (7P-1159)
Delisle, Georges, p.42 (7P-464)
Demers, M.C., p.42 (7P-466)
Dempsey, Lotta, p.96 (7P-1193)
Dempsey, W., p.42 (333P-3)
Denholm Angling Club, Gatineau, Que., p.42
(7P-467)
Denison, George Taylor II, and family, p.42
(18P-68)
Denison, George Taylor III, p.42 (7P-468)
Denison, M., p.42 (7P-469)
Denley, Norman, p.42 (7P-470)
Denman, Harold, p.42 (7P-471)

Denne, T.H.G., p.42 (158P-1)
Dennison, P.E., p.25 (7P-1932)
Denny, William, photo., p.42 (7P-472), p.114 (7P-1432)
Denroche, W.S., photo., p.58 (7P-696)
Densmore, Mattie, p.42 (1P-70)
Dent, John Charles, and family, p.42 (18P-61)
Dent family, Ont., p.42 (18P-61)
Denver, Colo. - general views, p.64 (18P-4)
Dependants Allowance Board, p.43 (7P-473)
Derengoski, W.A. Mrs., p.43 (1P-33)
Derick, Carrie M., p.34 (7P-358)
Derry, Douglas M., photo., p.43 (18P-27)
Desbiens, Raymond, p.43 (7P-474)
Deseronto, Ont. - general views, p.97 (7P-1208)
Desjardins Canal (Ont.) - vues, p.25 (7P-1935)
Desmarais, photo., p.46 (7P-522), p.125 (7P-1562)
Desmond, L.A., p.43 (7P-475)
Desperation Lake, N.W.T. - general views, p.80 (7P-983)
Dessaulles, George-Casimir, hon., p.10 (7P-101)
Dessaulles, Georges-Casimir, Hon., p.15 (7P-174)
D'estee, Mimi, p.43 (7P-480)
Désy, Jean, p.43 (7P-476)
Det Kongelige Bibliotek, Kobenhavn K, Danemark, p.43 (7P-477)
Detroit Marine Historical Society, Detroit, Mich., p.43 (7P-478)
Dettloff, Claude P., p.43 (7P-479)
Deverereux Wagon Works, Seaforth, Ont, p.113 (7P-1413)
Devon, England - general views, p.121 (18P-11)
Devonshire, Duc (de), p.21 (7P-1910)
Devonshire, Duchesse (de), p.21 (7P-1910)
Deyglun, Henri, p.43 (7P-480)
Dezell-Stanley, Gloria, p.49 (7P-572)
Di Giulio, Donald, p.43 (7P-484)
Diable (chutes), Péribonka (Québec), (7P-7)
Diamond City, Alta. - general views, p.36 (7P-390), p.146 (11P-10)
Diamond Jubilee, London, England, p.112 (7P-1399)
Diamond Jubilee Regatta, p.117 (1P-73)
Diapositives de projection, p.3 (7P-18)
Diapositives de projection
 voir aussi
 Lantern Slides
Dibdin, Hanry G., p.43 (7P-488)
D'Iberville, Pierre Lemoyne -commémoration, p.24 (7P-1918)
Dibney, Dora, p.43 (7P-487)
Dickens, "Punch", p.94 (7P-1113)
Dickey, John H., p.100 (340P-1)
Dickie, Alfred, p.43 (31P-73)
Dickie family, p.43 (31P-73)
Dickins, Clennell Haggerston, p.43 (7P-486), p.68 (7P-830)
Dickson, J.R., p.43 (7P-485)
Diefenbaker, Edna Mae, p.43 (7P-489)
Diefenbaker, John George, Rt. Hon., p.43 (7P-489), p.70 (7P-856), p.101 (7P-1272), p.113 (7P-1411), p.116 (7P-1462)
Diehl, Bracy, photo., p.50 (200P-12), p.102 (200P-13)
Dieppe, France - scènes, p.25 (7P-1908)
Digby, N.S. - general views, p.115 (7P-1446), p.127 (7P-1582)
Dill, John, Sir, p.17 (7P-207)
Dillon, M., p.43 (7P-483)
Dimock family, N.S., p.43 (31P-27)
Diocese of Athabasca, Alta., p.3 (13P-12)
Diocese of Edmonton, p.3 (13P-11)
Diocese of Ottawa (Anglican), Ontario, p.4 (301P-1)
Diocese of Rupert's Land, N.W.T., p.3 (13P-11)
Diocese of the Arctic, Toronto, Ont., p.44 (7P-482)
Dionne Quintuplets, p.13 (196P-5), p.54 (7P-629), p.55 (7P-653)
Distributor (SS), p.37 (7P-402)

Diver, Ont. - general views, p.120 (7P-1504)
Dixon, Alonzo, p.119 (7P-1493)
Dixon, Frederick A., photo., p.44 (7P-481)
Dixon, John, photo., p.44 (7P-481)
Dixon, photo., p.102 (200P-13)
Dixon, S.J., photo., p.50 (200P-12), p.72 (7P-874)
Doane, T.C., photo., p.48 (7P-548), p.65 (7P-786)
Dockyard (H.M.C.S.), p.10 (7P-107)
Dodd, Francis, p.100 (31P-101)
Dodge, George Blanchard, p.44 (12P-8)
Dodge, H.O., photo., p.99 (7P-1249)
Dodge, Jack, photo., p.41 (31P-82), p.49 (1P-36), p.98 (1P-48)
Dodge family, Ont., p.44 (7P-490)
Dogrib Indians, p.73 (7P-894)
Doide & Co., photo., p.50 (200P-12)
Dolan, D. Leo, p.44 (7P-491)
Dominion Arsenals, Cartridge Factory, Quebec, Que., p.99 (7P-1246)
Dominion Astrophysical Observatory, Victoria, B.C., p.9 (7P-85)
Dominion Bank, p.138 (320P-1)
Dominion Bridge Company of Canada, Montreal, Que., p.44 (7P-492)
Dominion Chair Co., Bass River, N.S., p.44 (31P-72)
Dominion Coal Board, Ottawa, Ont., p.92 (7P-1047)
Dominion Coal Co., Sydney, N.S., p.46 (1P-34)
Dominion Conference, Agriculture Service, Toronto, Ont., p.22 (7P-1901)
Dominion Drama Festival, p.44 (31P-58), p.44 (7P-494)
Dominion Drama Festival, Antigonish, N.S., p.106 (31P-61)
Dominion Drama Festival, Brockville, Ont., p.133 (7P-1667)
Dominion Drama Festival, N.S., p.148 (31P-59)
Dominion Experimental Farm, Beverlodge, Alta., p.130 (7P-1634)
Dominion Iron & Steel Co., Sydney (N.-E.), p.35 (7P-379)
Dominion Observatory, Ottawa, Ont., p.9 (7P-85), p.137 (7P-1725)
Dominion of Canada Football Association, Winnipeg, Man., p.28 (7P-298)
Dominion of Canada Rifle Association, Ottawa, Ont., p.44 (7P-493)
Dominion Panoramic Co., photo., p.59 (7P-714)
Dominion Police, Ottawa, Ont., p.128 (7P-1600)
Dominion Police Force, p.23 (7P-1938)
Dominion-Provincial Conference, p.22 (7P-1898), p.22 (7P-1905), p.99 (7P-1249)
Dominion-Provincial Conference on Reconstruction, p.23 (7P-1941)
Dominion-Provincial Youth Training Plan, p.23 (7P-1928)
Dominion Public Building, Hamilton, Ont., p.63 (8P-5)
Dominion (SS), p.82 (7P-1010)
Dominion Wabana Ore Limited, Bell Island, Nfld., p.44 (38P-3)
Dominion-Wide, photo., p.22 (7P-1898), p.22 (7P-1968), p.30 (7P-316), p.44 (7P-495), p.53 (7P-623)
Donald, E.F., p.44 (7P-496)
Donalda, Pauline (Lightstone), p.44 (149P-7)
Donato, Andy, p.5 (7P-46)
Donlon, James, Rev., p.124 (200P-6)
Donnachie, Dave, p.44 (7P-497)
Donnell, Robert, p.44 (7P-498)
Donney, W. & D., photo., p.34 (7P-363)
Donovan, Duncan, photo., p.44 (8P-14)
Donovan, Oscar Glennie, Dr., p.44 (31P-31)
Doody, J., photo., p.153 (161P-1)
Doolittle, G.A., p.44 (7P-499)
Doran, Harold J., p.44 (113P-6)
Dorchester, N.S. - general views, p.64 (7P-766)
Dore, William G., p.45 (7P-500)

Dorion, Best A., p.45 (7P-501)
Dorion & Delorme, photo., p.57 (7P-686)
Dorion, L.N., photo., p.72 (7P-880)
Dornan, Harold Alexander, p.45 (7P-502)
Dornbush, Ann, p.45 (7P-503)
Dornbush, Trevor, p.45 (7P-503)
Doucet, H.E.T., p.45 (7P-504)
Doucette, Wilfred, photo., p.152 (7P-1883)
Doughty, Arthur George, Sir, p.21 (7P-1910), p.45 (7P-508), p.114 (7P-1427), p.122 (7P-1522)
Douglas, George Mellis, p.45 (7P-505)
Douglas, H.T., p.45 (7P-506)
Douglas, Howard, and family, p.45 (166P-35)
Douglas, Percy, p.28 (7P-297)
Douglas, Robert, p.45 (7P-507)
Douglas, Thomas Clement, p.105 (7P-1325)
Douglas Lyon, G.R.D., p.97 (7P-1216)
Doukhobors in Canada, p.91 (16P-13)
Doukhobors in Manitoba, p.97 (7P-1208)
Doukhobors in Saskatchewan, p.23 (7P-1926)
Dowson, William C.H. and family, p.45 (7P-509)
Doyle, Charles Hastings, p.45 (7P-510)
Dragan, George E., Dr. and family, p.45 (7P-511)
Drapeau, Jean, p.9 (7P-91)
Draper, photo., p.153 (161P-1)
Drayton, W.A., p.45 (333P-31)
Drennan, Hannah Oliver, p.94 (7P-1114)
Dresden, Germany - general views, p.56 (7P-659)
Dresden, Ont. - general views, p.70 (7P-856)
Drew, George Alexander, Hon., p.45 (7P-512), p.116 (7P-1462)
Drewitt, Lillian, p.45 (7P-513)
Droit, Le, Ottawa, Ont., p.134 (7P-1687)
Drottningholm (ship), p.49 (7P-570)
Drought, Percy, p.96 (7P-1204)
Drumheller, Alta. - general views, p.88 (7P-1152)
Drummond, William Henry, p.78 (7P-951), p.92 (7P-1048)
Drury, E.C., p.57 (7P-686)
Dryden, J.W., p.45 (7P-514)
Du Plessis, L., Maj., p.3 (7P-20)
Dubé, Raymond, p.45 (7P-515)
Duberger, p.45 (7P-516)
Ducharme, p.46 (7P-517)
Duchess of Richmond (SS), p.2 (7P-9)
Duchess of York (SS), p.129 (7P-1619)
Duck Lake, N.W.T. - general views, p.83 (7P-1025), p.112 (7P-1407)
Duckworth, H.E., Dr, p.123 (7P-1543)
Duclos, photo., p.24 (7P-1909)
Dudeney, Gertrude, p.46 (7P-518)
Dudlessis, Maurice, Hon., p.48 (7P-550)
Duff, Lyman Poore, Sir, p.46 (7P-519)
Dufferin, Harriet Georgiana, Lady, p.46 (7P-528), p.54 (7P-635), p.85 (7P-1089), p.133 (7P-1676)
Dufferin and Ava, Frederick Temple Blackwood, Marquess of, p.46 (7P-528), p.85 (7P-1089), p.115 (7P-1447), p.133 (7P-1676)
Dufferin and Sappers' Bridges, Ottawa, Ont., p.46 (7P-529)
Dugas, Marcel, p.60 (7P-716)
Duhamel, Joseph Thomas, Mgr., p.46 (7P-522)
Dumaresq, J. Philip, p.46 (1P-34)
Dumas, Albert, photo., p.81 (7P-996)
Dumas, J.A., photo., p.137 (7P-1727)
Dumont, Gabriel, p.73 (7P-889)
Dumouchel, Jean, p.46 (7P-520)
Dumoulin, J.L., p.46 (185P-3)
Dunbrack, Charlotte S., p.46 (31P-46)
Dundas, Ont. - general views, p.138 (7P-83)
Dunlap, Clarence Rupert, p.46 (7P-527)
Dunlop, Edward Arunah, Maj., p.46 (7P-530)
Dunlop, R.G., p.46 (7P-531)
Dunn, G., p.46 (7P-532)
Dunn, Oscar, p.46 (7P-521)
Dunsmore, Fulton, photo., p.110 (166P-8)

Dunsterforce - Caucassus, p.147 (7P-1804)
Duplessis, Edgar, p.46 (7P-522)
Duplessis, Maurice, Hon., p.78 (7P-953)
Dupras & Colas, photo., p.29 (7P-306)
Dupuis, Frank J., p.46 (7P-523)
Durand, Paul, p.46 (7P-524)
Durbin, Diana, p.54 (7P-635)
Durnford, Hugh, p.46 (7P-525)
Durocher, Lyman, p.46 (7P-526)
Dutch Creek, B.C. - general views, p.112 (7P-1395)
Duxburry (schooner), p.23 (7P-1974)
Dwarfs - Hupman, Mr., p.2 (7P-16)
Dwyer, Peter, p.27 (7P-274)
Dynes, J. photo., p.6 (7P-48)
Dyonnet, Edmond, p.46 (113P-2)

E.M. Bronson (ship), p.52 (7P-609)
Eager, Auville, photo., p.52 (92P-11)
Earl Grey (SS), p.102 (7P-1288)
Easson, A., p.46 (7P-533)
Easson, J.G., p.47 (7P-534)
East Kildonan, Man. - general views, p.76 (9P-80)
East Kootenay, B.C.
 see
 Kootenay, B.C. - general view
East Kootenay Area - Fort Steele Historic Park,
 p.47 (333P-8)
Eastcott, J.C., lieutenant surgeon, p.47 (12P-21)
Eastman Kodak Ltd., Rochester, N.Y., p.138
 (7P-1735)
Eaton, Arthur Wentworth Hamilton, and family,
 p.47 (1P-35)
Eaton, John Craig - residence, p.53 (18P-36)
Eaton, T., Co., Toronto, Ont., p.136 (7P-1717)
Eaton Auditorium, p.103 (16P-14)
Eaton family, Ont., p.70 (140P-15)
Eckert, K., p.47 (7P-535)
Eckhardt-Gramatte, Sonia Carmen, p.47 (149P-8)
Eckman, C.M., p.47 (7P-536)
Eckstein, Simon Layble, Rabbi, p.47 (7P-537)
Eclipses, solar - 1905, p.27 (45P-4)
Eclipses de soleil - 1927, p.6 (7P-57)
Ecoles
 voir aussi
 Schools
Ecoles - Colombie-Britannique - Cache-Creek
 (pensionnat de Cache-Creek), p.9 (7P-89)
Ecoles - Manitoba - Brandon (Ruthenian Training
 School), p.12 (7P-133)
Ecoles - Nouveau-Brunswick, p.69 (15P-6)
Ecoles - Ontario - Uxbridge école secondaire, p.11
 (7P-117)
Ecoles - Québec - Montréal (Beaux-Arts), p.11
 (7P-127)
Economic Council of Canada, National
 Productivity Council, p.23 (7P-1956)
Eddy, E.B., Hull, Que., p.130 (7P-1633)
Eddy, E.B., Hull (Québec), p.9 (7P-87)
Edelsten, E.R.F., p.47 (7P-538)
Eden, p.47 (333P-28)
Edenbridge, Sask. - general views, p.122 (7P-1524)
Edgar, Mary Suzanne, and family, p.47 (75P-6)
Edgell, Mimi, p.109 (7P-1362)
Edinburgh, Scotland - general views, p.97
 (7P-1220)
Edith (Mount), Alta. - general views, p.23
 (7P-1926)
Editorial Associates, photo., p.69 (7P-839)
Edmonds, Frederick Conway, p.47 (7P-539)
Edmonds, Mabel, p.47 (7P-539)
Edmonds, Sarah, p.47 (7P-539)
Edmonton, Alta. - aerial views, p.68 (7P-826)

Edmonton, Alta. - general views, p.13 (13P-3),
 p.18 (13P-1), p.40 (7P-440), p.47 (13P-8),
 p.54 (7P-629), p.62 (7P-744), p.90 (7P-1180),
 p.92 (11P-13), p.95 (7P-1125), p.128
 (7P-1613), p.130 (7P-1634)
Edmonton (Alberta) - vues, p.19 (7P-228), p.24
 (7P-1940)
Edmonton Eskimos Football Club, Edmonton,
 Alta., p.81 (7P-1004)
Edmonton Journal (The), Edmonton, Alta., p.47
 (13P-8)
Edmonton Mission House, Edmonton, Alta., p.3
 (13P-11)
Edmunston, N.B. - general views, p.65 (7P-782)
Edward, William B., photo., p.47 (7P-542)
Edward VII, King, p.26 (7P-1285)
Edward VII, Roi, p.26 (7P-1971)
Edward VIII, Prince, p.125 (10P-6),
 p.146 (7P-1797)
Edwards & Harrison, photo., p.72 (7P-880)
Edwards, Howard, p.47 (7P-540)
Edwards', J.H., General Store, Carleton Place, Ont.,
 p.47 (7P-540)
Edwards, R.G., p.47 (7P-541)
Edwards, Ron, p.47 (333P-39)
Edwards, W.B., photo., p.25 (7P-1950)
Edwards, W.H., photo., p.49 (1P-36)
Edwards, W.S., p.47 (7P-543)
Edwards, William B., photo., p.4 (131P-9), p.29
 (7P-314)
Edy, J.N. and Co., photo., p.16 (7P-196)
Edy Brothers, photo., p.47 (7P-544)
Egan, James, photo., p.66 (7P-787)
Egan, James Yates, p.66 (7P-800)
Egerton, Frank, Mrs., p.47 (7P-546)
Eglinton, Ont. - general views, p.98 (7P-1225)
Eglise catholique du Canada, archidiocèse
 d'Ottawa, Ottawa (Ont.), p.48 (306P-1)
Eglises - Maritimes, p.81 (15P-4)
Eglises - Québec, p.97 (7P-1209), p.125 (7P-1562)
Eglises - Québec - Québec (Hôtel-Dieu), p.6
 (171P-2), p.67 (171P-1)
Eglises - Québec - Saint-Joachim, p.91 (131P-3)
Eglises, (catholiques romaines) - Québec -
 Montréal (Notre Dame), p.125 (7P-1563)
Eglises (Anglicanes) - Seaforth (Ont.), p.14
 (7P-162)
Eglises (catholiques romaines) - diocèse d'Ottawa,
 p.48 (306P-1)
Eglises (méthodistes) - Québec - Montréal (Saint
 Jacques), p.125 (7P-1563)
Eglises (presbytériennes) - Ontario - Lanark (Saint
 André), p.150 (7P-1856)
Eglises (ukrainiennes) - Québec - Montréal, p.14
 (7P-150)
Egypt, Ont. - general views, p.109 (7P-1351)
Egypte - vues, p.4 (113P-09), p.11 (7P-114), p.90
 (7P-1176)
Eielsen Search Mission, 1929, p.106 (7P-1329)
Einarsson, John, p.43 (7P-489)
Eldorado Mining & Refining Ltd., Port Radium,
 N.W.T., p.48 (7P-545)
Eldorado Mining and Refining Ltd., Port Radium,
 N.W.T., p.5 (7P-41), p.37 (7P-404), p.41
 (7P-457)
Eldred, Doris E., p.48 (7P-547)
Electrical Engineering - generalities, p.36 (332P-1)
Elena (SS), p.11 (7P-118)
Elgin, Lady, p.48 (7P-548)
Elgin, Ont. - general views, p.79 (7P-982)
Elgin, Victor Alexander Bruce, Earl of, p.48
 (7P-548)
Elgin and Kincardine, James Bruce, Earl of, p.48
 (7P-548)
Elijah Concert, Ottawa, Ont., p.12 (7P-135)
Eliot, Charles W., p.48 (7P-549)
Eliza (Brig), p.51 (7P-593)

Elizabeth, Queen, p.25 (7P-1954), p.42 (1P-70),
 p.55 (7P-647), p.67 (7P-808), p.85 (31P-51),
 p.90 (7P-1171), p.117 (7P-1467), p.139
 (1P-17), p.145 (7P-1786)
Elizabeth, reine mère, p.6 (7P-61), p.9 (7P-88)
Elizabeth II, Queen, p.25 (7P-1952), p.53
 (7P-612), p.53 (7P-617), p.70 (7P-856), p.77
 (7P-941), p.97 (7P-1212), p.99 (7P-1240),
 p.132 (7P-1661)
Elizabeth II, reine, p.24 (7P-1907), p.26
 (7P-1971), p.69 (7P-1946)
Elk City, Ont. - general views, p.41 (7P-452)
Elk Lake, Ont. - general views, p.67 (7P-813)
Ellefsen, Marc, p.48 (7P-550)
Ellefsen, Marc, photo., p.69 (7P-1946)
Ellesmere Island, N.W.T. - general views, p.58
 (7P-701)
Ellice (Man.) - vues, p.20 (7P-241)
Ellingsen, E.O., photo., p.153 (161P-1)
Elliot and The Roy Studio, photo., p.75 (7P-911)
Elliot, A.H., p.25 (7P-1932)
Elliott, Adelaide, p.29 (337P-2)
Elliott, Anne Bell
 see
 Truro, Anne Bell Elliott
Elliott & Fry, photo., p.58 (7P-693)
Elliott, Harriet, p.29 (337P-2)
Elliott, J. Davis, p.48 (7P-551)
Elliott, John, p.29 (337P-2)
Elliott, Ruby, Lady, p.130 (7P-1629)
Elliott, W.E., p.48 (7P-552)
Elliott and Fry, photo., p.5 (7P-37)
Ellis, W., p.48 (7P-553)
Ellisson & Co., photo., p.59 (7P-704), p.65
 (7P-786), p.92 (7P-1039)
Ellisson, photo., p.84 (7P-1057), p.133 (7P-1675)
Ells, R.W., Dr., p.48 (7P-554)
Ells, Sidney Clarke and family, p.48 (7P-554)
Elmer, V., p.48 (7P-555)
Elmsdale, N.S. - general views, p.58 (7P-694)
Elmsley, J.H., Maj. Gen., p.134 (7P-1694)
Elmsley, Mr., p.5 (7P-40)
Elmsley, Mrs., p.129 (319P-1)
Elora, Ont. - general views, p.39 (7P-427)
Elswick, Angleterre - vues, p.14 (7P-160)
Emerald Isle, N.S. - general views, p.120 (1P-93)
Emerald Summit Lake, Ont. - general views, p.127
 (7P-1582)
Emeric, Que. - general views, p.10 (7P-99)
Emerson, P.H., photo., p.25 (123P-1)
Emond Family, Que., p.29 (7P-308)
Empress of Australia (SS), p.82 (7P-1012)
Empress of Canada (SS), p.24 (7P-1929)
Empress (SS), p.2 (7P-9), p.110 (7P-1374)
Empringham, George, and family, p.48 (18P-55)
Empry, Gino, p.48 (7P-556)
England - general views, p.9 (7P-95), p.51
 (1P-37), p.60 (1P-25), p.87 (7P-1133), p.93
 (12P-26), p.96 (7P-1191)
England, L., Mrs., p.48 (7P-557)
English, C.E., Lt. Col., p.3 (7P-20)
Enniskillen, Ont. - general views, p.103 (7P-1304)
Eno, John C., p.48 (7P-558)
Enterprise (Paddleboat), p.121 (228P-1)
Entomological Society of Canada, p.48 (7P-559)
Epp, Jacob, p.39 (7P-447)
Epstein, David, p.48 (7P-560)
Era (Whaling schooner), p.35 (7P-374)
Erables (produits d') - Ontario, p.149 (7P-1836)
Erb, Isaac & Son, photo., p.21 (7P-257), p.92
 (7P-1039)
Erebus (Baie), T.N.-O. - vues, p.14 (7P-159)
Erhard, Ludwig, p.30 (7P-324)
Erickson, B.C. - general views, p.112 (7P-1395)
Erieau, Ont. - general views, p.70 (7P-856), p.149
 (7P-1836)
Erindale, Ont. - general views, p.29 (7P-307)
Erkan, Ismet, p.48 (7P-561)

Ernest Lapointe (C.G.S.), p.77 (7P-940)
Ernsberger, p.48 (31P-83)
Eskimos, p.148 (7P-1820)
Eskimos
 see also
 Inuit
Eskimos in Canada, p.132 (7P-1657)
Eskimos in Northwest Territories, p.119 (7P-1489),
 p.135 (7P-1696)
Espagne - guerre civile, 1936-1939 - participation
 canadienne, p.8 (7P-79)
Esquimalt, B.C. - general views, p.17 (7P-205),
 p.40 (18P-8), p.47 (12P-21), p.95 (7P-1117),
 p.139 (7P-1739)
Esquimalt (C.B.) - vues, p.17 (7P-201)
Esquimaux
 voir aussi
 Inuit
Esquimaux - Art, p.149 (7P-1839)
Esquimaux - Territoires du Nord-Ouest, p.117
 (7P-1472)
Esson, James, photo., p.49 (7P-562), p.49 (8P-8),
 p.59 (7P-704), p.72 (7P-874)
Esterhazy, Paul O.D', Count, p.125 (7P-1566)
Estevan, Sask. - general views, p.56 (7P-664), p.90
 (7P-1180)
Esturion (SS), p.110 (7P-1374)
Etats-Unis - immigration, p.125 (7P-1563)
Etats-Unis - vues, p.16 (7P-183), p.35 (329P-1),
 p.90 (7P-1176)
Ethnic Groups
 see
 original nationality by name
Etobicoke, Ont. - general views, p.125 (18P-12)
Eucharistic Congress, p.127 (7P-1581)
Europe - general views, p.93 (12P-26)
Europe - scenes, p.48 (7P-554), p.65 (7P-775),
 p.90 (7P-1176)
European War, 1914 - 1918 - Belgium-Namur,
 p.38 (7P-410)
European War, 1914-1915 - Belgium, Mons, p.133
 (7P-1678)
European War, 1914-1918, p.1 (13P-10), p.5
 (334P-23), p.23 (7P-1976), p.25 (7P-1908),
 p.77 (7P-944), p.87 (7P-1133), p.98
 (7P-1231), p.102 (7P-1279), p.103 (2P-1)
European War, 1914-1918
 see also
 Guerre, 1914-1918 (Mondiale 1e)
European War, 1914-1918 - aerial operations, p.67
 (7P-801)
European War, 1914-1918 - Battle-fields, France,
 p.99 (7P-1251)
European War, 1914-1918 - Battlefields, French,
 p.120 (7P-1500), p.128 (7P-1607), p.129
 (18P-21)
European War, 1914-1918 - battlefields, Germany,
 p.128 (7P-1607)
European War, 1914-1918 - Campaigns - France,
 p.123 (7P-1540)
European war, 1914-1918 - campaigns - France -
 Vimy Ridge, p.30 (31P-37), p.53 (7P-620),
 p.99 (7P-1251)
European War, 1914-1918 - campaigns - Turkey
 and the Near East - Meospotamia, p.122
 (31P-24)
European War, 1914-1918 - campaigns - Western -
 Ypres, p.53 (7P-620)
European War, 1914-1918 - decorations, p.49
 (304P-2), p.108 (7P-1342), p.128 (7P-1607)
European War, 1914-1918 - journalism, p.83
 (31P-10)
European War, 1914-1918 - literature and the war,
 p.118 (31P-18)
European War, 1914-1918 - medical and sanitary
 affairs, p.7 (31P-12), p.26 (7P-265), p.44
 (31P-31), p.59 (7P-702), p.74 (7P-907), p.75
 (7P-912), p.104 (7P-1309), p.110 (92P-18),
 p.120 (7P-1500), p.131 (7P-1644), p.150

(7P-1855)
European War, 1914-1918 - prisons and prisoners,
 Canada, p.3 (31P-42)
European War, 1914-1918 - prisons and prisoners,
 Germany, p.82 (7P-1014), p.96 (7P-1072)
European War, 1914-1918 - prisons and prisoners,
 Canadian, p.136 (7P-1713)
European War, 1914-1918 - return of troops,
 Canadian, p.41 (1P-69), p.91 (1P-46)
European War, 1914-1918 - troops, Canadian, p.23
 (7P-1933), p.40 (7P-438), p.53 (7P-620), p.67
 (7P-802), p.69 (7P-846), p.70 (140P-15), p.79
 (7P-970), p.94 (7P-1108), p.96 (7P-1204),
 p.98 (7P-1234), p.111 (7P-1386), p.128
 (7P-1607), p.131 (7P-1641), p.133 (7P-1678),
 p.137 (1P-75), p.140 (5P-3), p.148 (7P-1819)
European War, 1914-1918 - troops, German, p.67
 (7P-802)
European War, 1914-1918 - troops, Newfoundland,
 p.37 (38P-2)
European War, 1914-1918 - University of Toronto
 Recruits, p.143 (196P-15)
Evans, Frederick, photo., p.25 (123P-1)
Evans, Walker, photo., p.25 (123P-1)
Evelyn Island, Parry Sound, Ont. - Basilian
 Fathers, p.148 (200P-15)
Evening Telegram (newspaper) St. John's, Nfld.,
 p.49 (38P-4)
Ewan, John Alexander, p.61 (8P-1)
Ewanchuk, Michael, p.49 (9P-81)
Ewers, W.G., Mrs., p.49 (7P-563)
Ewing, R.D., photo., p.5 (7P-37), p.15 (7P-168)
Exeter, England - general views, p.121 (18P-11)
Exploitation forestière - Ontario, p.15 (7P-172)
Expo 67
 see
 Universal Exhibition, Montreal, Que.
 voir
 Exposition universelle, Montréal (Québec)
Exposition universelle, Montréal (Québec), p.13
 (7P-145), p.24 (7P-1907)
Exposition universelle, New York (N.Y.) 1939, p.6
 (7P-61)
Exposition universelle de Bruxelles, Bruxelles,
 Belgique, p.49 (7P-565)
Eykyn, D.A.D., p.49 (7P-564)

Fabien, Henri Zotique, p.49 (185P-19)
Fabien, J. Henri, p.49 (7P-566)
Fabre, Hector, p.102 (7P-1284)
Fackenheim, Emil L., Rabbi, p.49 (7P-567)
Fader family, N.S., p.49 (1P-36)
Faed, James, p.143 (196P-5)
Fahlman, Andreas A., and family, p.49 (7P-568)
Fahlman, M., p.49 (7P-568)
Fainstein, Clara, p.49 (9P-17)
Fairbairn family, p.72 (7P-880)
Fairbanks family, N.S., p.49 (1P-9)
Fairclough, Ellen, p.149 (7P-1837)
Fairfield, W.H., p.22 (7P-1901)
Fairmile Q 60 (H.M.C.S.), p.41 (7P-454)
Fairmont, B.C. - general views, p.148 (333P-12)
Fairmont (barque), p.43 (31P-27)
Falaise, France - vues, p.10 (7P-108)
Falardeau, Antoine - Sébastien (Le Chevalier),
 p.49 (7P-569)
Falconar-Stewart, Nita, p.49 (7P-570)
Falconer, Robert, p.56 (7P-670)
Falher, Alta. - general views, p.130 (7P-1634)
Famee Furlane Association, Toronto, Ont., p.49
 (7P-571)
Fanshawe College, London, Ont., p.49 (7P-572)
Farm and Country Records, p.49 (75P-7)
Farm Young People's Week, p.142 (92P-9)
Farman, Violet, p.50 (7P-573)
Farmer, Irene, Rev. Sister, p.100 (340P-1)
Farmer, W., photo., p.102 (200P-13)

Farmer Bros., photo., p.19 (200P-11), p.72
 (7P-874), p.142 (200P-8)
Farquhar, George, p.50 (31P-121)
Farraline-Fraser family, p.60 (1P-25)
Faucher, Olivier, p.11 (7P-114)
Faulkner, Charles, p.50 (18P-66)
Faulkner, Dora, p.50 (31P-30)
Faulkner, Jenifer, p.50 (7P-574)
Faure, Félix, p.102 (7P-1284)
Fauteux, Aegidius, p.50 (103P-11), p.89 (7P-1165)
Faversham, William, p.110 (7P-1373)
Fayle, L.U., p.50 (7P-575)
Feagan, Isabelle Anne, p.50 (7P-576)
Fédération des femmes libérales du Canada, p.50
 (7P-1865)
Federation of Canadian Archers, Toronto, Ont.,
 p.50 (7P-577)
Fee, Norman, p.50 (7P-578)
Fell, S.B., photo., p.72 (7P-880)
Fenelon Falls, Ont. - general views, p.82
 (7P-1010), p.110 (7P-1374)
Fenelon Falls (Ont.) - vues, p.13 (7P-149)
Fenelon (Ont.) - vues, p.16 (7P-183)
Fenwick, Ella, p.6 (333P-23)
Fenwick, M.J., p.141 (7P-1767)
Ferber, Edna, p.7 (31P-99)
Fergus, Ont. - general views, p.39 (7P-427)
Ferguson, D.C., photo., p.72 (7P-880)
Ferguson, Michael Joseph, p.50 (200P-12), p.142
 (200P-18)
Ferland, A., p.50 (7P-579)
Ferland, Albert (famille), p.50 (185P-14)
Ferland, Fr., p.50 (7P-579)
Ferland, J., p.50 (7P-579)
Ferme expérimentale, Ottawa (Ont.), p.115
 (7P-1441)
Fernet-Martel, Florence, and family, p.50 (7P-580)
Fernie, B.C. - fire, 1908, p.54 (7P-640)
Fernie, B.C. - general views, p.47 (333P-8)
Fernie (C.-B.) - vues, p.35 (7P-148)
Ferrier, R. Douglas, p.50 (92P-10)
Ferries - British Columbia, p.70 (334P-30)
Ferries - Saskatchewan, p.125 (10P-2), p.125
 (10P-5)
Ferrotypes, p.3 (7P-18), p.18 (7P-223), p.20
 (7P-239), p.21 (7P-1910), p.33 (208P-1), p.69
 (134P-2), p.118 (7P-1477), p.127 (324P-1),
 p.135 (7P-1710)
Ferrotypes
 voir aussi
 Tintypes
Ferryland, Nfld. - general views, p.68 (7P-823)
Fesenko, Michael, p.50 (7P-581)
Fessenden, Reginald A., p.25 (7P-1948)
Feuz, Edward Jr., photo., p.3 (166P-43), p.50
 (166P-11)
Field, B.C. - general views, p.75 (7P-910), p.114
 (7P-1424), p.139 (7P-1739)
Field, Ont. - general views, p.56 (7P-656)
Field, Ont. - tornado, 1970, p.56 (7P-656)
Fielding, P.S., p.50 (7P-582)
Fife, R.A., Dr., p.38 (7P-412)
Fifth Pacific Science Congress, Victoria-Vancouver,
 B.C., p.36 (7P-387)
Filey, Michael, p.50 (7P-583)
Fillmore, Roscoe Alfred, p.51 (31P-118)
Fillmore, W.E., p.51 (7P-584)
Filteau, F.X., photo., p.72 (7P-880)
Findlay, A.A.W., Mrs., p.51 (7P-585)
Fingal-Smith, Adelaide Bailey, p.133 (333P-22)
Fink, photo., p.108 (7P-1341)
Finland - general views, p.115 (7P-1438)
Finland, George Harold, p.51 (7P-586)
Finlay River (C.-B.) - vues, p.35 (7P-370)
Finley, G.W., photo., p.55 (131P-1)
Finley, photo., p.10 (7P-102)
Finner, Francis, p.51 (7P-587)
Finnie, R.S., photo., p.153 (161P-1)
Finnie, Richard, p.56 (7P-662)

187

Finnish Canadian Rest Home Association, Vancouver, B.C., p.51 (7P-588)
Finnish Community - Ontario -Northwest, p.104 (146P-1)
Finnish in Canada, p.22 (7P-1906)
Finnish Organization of Canada, Montreal, Que., p.73 (7P-887)
Finnish Organization of Canada, Sudbury, Ont., p.51 (7P-589)
Finns in Canada, p.51 (7P-588), p.51 (7P-589)
Finns in Toronto, p.112 (7P-1400)
First Slovak Radio Club in Canada, St. Catharines, Ont., p.51 (7P-590)
Firth, Edith G., p.51 (7P-591)
Fischer, Sarah, p.51 (7P-592)
Fish, E., photo., p.55 (7P-654)
Fish Creek, N.W.T. - general views, p.83 (7P-1025), p.112 (7P-1407)
Fisher, Geoffrey Francis, Archbishop of Canterbury, p.3 (13P-11)
Fisher, Sydney Arthur, Hon., p.61 (8P-1)
Fisher family, Ont., p.111 (7P-1384)
Fishing - New Brunswick, p.37 (46P-5)
Fisken, John, and Co., p.51 (18P-75)
Fitch, Stephen, p.51 (18P-85)
Fitzgerald, T.F., p.25 (7P-1932)
Fitzpatrick, A. and family, p.53 (7P-625)
Fitzpatrick, Charles and family, p.51 (7P-593)
Fitzsimmons, Ernie, p.51 (7P-594)
Fitzsimmons, Robert C., and family, p.51 (13P-13)
Fitzwilliam, Daisy, p.85 (7P-1089)
Five Finger Rapid, Yukon - general views, p.42 (7P-459)
Five Finger Rapid (Yukon) - vues, p.35 (7P-370)
Flagstaff, Ariz. - general views, p.120 (123P-8)
Flaherty, Robert, photo., p.96 (7P-1195)
Flahiff, Margaret, Sister, p.51 (1P-37)
Flat Islands, Nfld. - general views, p.70 (7P-857)
Flathead Indians, p.72 (7P-870)
Flavelle, Joseph Wesley, p.51 (7P-595)
Flax industry - Quebec, p.30 (7P-328)
Fleet, Max, photo., p.51 (7P-596)
Fleming, Allan, p.25 (7P-1954)
Fleming, D., p.16 (7P-188)
Fleming, R.B., & Co., Ltd., London, England, p.51 (7P-597)
Fleming, Robert John, p.51 (18P-71)
Fleming, Roy F., p.52 (7P-598)
Fleming, Sandford and family, p.52 (7P-599)
Fletcher, W.A., p.52 (7P-600)
Fletcher family, Ont., p.52 (18P-49)
Flewin, W.R., p.52 (12P-5)
Flin Flon, Man. - general views, p.80 (7P-983), p.112 (7P-1402), p.117 (7P-1469), p.130 (7P-1636)
Flin Flon (Man.) - vues, p.16 (7P-188)
Floral Show 1974, p.52 (7P-601)
Florence, Italie - vues, p.11 (7P-114)
Flowerdew, G.M., Lt., p.137 (7P-1730)
Flowers, J.F. and family, p.52 (7P-602)
Flying Boats - Canadian Air Board, p.99 (7P-1244)
Flying Boats - Canadian Air Board
see also
Canadian Air Board
Flying Boats - Quebec, p.100 (7P-1254)
Fogo, Nfld. - aerial views, p.68 (7P-826)
Fokes, Roy, p.52 (7P-603)
Folkins, J.C., p.129 (7P-1618)
Fontaine, Jean, p.52 (354P-1)
Foote, Benjamin, photo., p.52 (9P-19)
Footner, Hulbert, photo., p.52 (92P-11)
Forbes, C., Mrs., p.52 (7P-604)
Forbes, Ken, p.56 (7P-661)
Ford, Glenn, p.54 (7P-635)
Ford, Henry, p.67 (7P-806)
Ford Motor Co. of Canada, p.56 (7P-672)
Fordyce, Patrick C., p.52 (7P-605)
Forebay Canal, Ontario, p.131 (196P-41)

Forest City Coins, London, Ont., p.52 (7P-606)
Forester, Norman Gladstone, p.52 (7P-607)
Forestry - Canada, p.23 (7P-1917)
Forestry Conservation Youth Training Camps, Sandilands Forest Reserve, Man., p.88 (9P-45)
Forget, Rodolphe, Sir, and family, p.30 (7P-318)
Forget, Rodolphe, Sir et famille, p.117 (113P-4)
Forrester, Maureen, p.30 (7P-324)
Forsey, Eugene, p.52 (7P-608), p.52 (7P-608)
Fort Anne, N.S. - general views, p.69 (1P-18)
Fort Chimo, Que. - general views, p.126 (7P-1570)
Fort Chipewyan, Alta. - general views, p.3 (13P-12), p.98 (7P-1229), p.116 (7P-1451)
Fort Churchill, Man. - general views, p.42 (7P-471), p.93 (7P-1059), p.145 (7P-1787)
Fort Conger, N.W.T. - general views, p.58 (7P-701)
Fort-Coulonge, Que. - general views, p.46 (7P-532), p.101 (7P-1267)
Fort Cumberland, N.S. - general views, p.118 (31P-18)
Fort Dearborn, Mich. - capture, 1812, p.52 (7P-598)
Fort Dufferin, N.B. - general views, p.103 (2P-1)
Fort Edmonton, Alta. - general views, p.1 (13P-10), p.77 (7P-935)
Fort Edward, N.S. - general views, p.75 (7P-918)
Fort Erie, Ont. - general views, p.92 (7P-1050)
Fort Fitzgerald, Alta. - general views, p.50 (92P-10)
Fort Frances, Ont. - general views, p.91 (7P-1185)
Fort Garry, Man. - general views, p.9 (7P-82), p.29 (7P-312), p.54 (7P-629), p.68 (333P-5), p.133 (7P-1670)
Fort George, B.C. - general views, p.92 (92P-15)
Fort George, Ont. - general views, p.137 (7P-1724)
Fort George, Que. - general views, p.97 (7P-1212)
Fort George (C.-B.) - vues, p.25 (7P-1935)
Fort Good Hope, N.W.T. - general views, p.98 (7P-1229)
Fort Guysborough, N.S. - general views, p.152 (1P-4)
Fort Howe, N.B. - general views, p.103 (2P-1)
Fort La Have, N.S. - general views, p.152 (1P-4)
Fort McLeod (Alberta) - vues, p.135 (7P-1699)
Fort McMurray, Alta. - general views, p.48 (7P-554), p.50 (92P-10), p.51 (13P-13), p.91 (7P-1188)
Fort McPherson, N.W.T. - general views, p.23 (7P-1934)
Fort Nelson (C.-B.) - vues, p.17 (7P-200)
Fort Norman, N.W.T. - general views, p.3 (13P-12), p.98 (7P-1229)
Fort Point, California, U.S.A., p.52 (31P-47)
Fort Prince of Wales (T.N.-O.), p.21 (7P-1910)
Fort Providence, N.W.T. - general views, p.73 (7P-894), p.77 (7P-939), p.125 (7P-1564), p.130 (7P-1634), p.135 (7P-1696)
Fort Qu'Appelle, Sask. - general views, p.101 (10P-9)
Fort Rae, N.W.T. - general views, p.73 (7P-894), p.98 (7P-1229)
Fort Resolution, N.W.T. - general views, p.98 (7P-1229), p.116 (7P-1451)
Fort Saskatchewan, N.W.T. - general views, p.56 (7P-666)
Fort Simpson, N.W.T. - general views, p.3 (13P-12), p.37 (7P-402), p.98 (7P-1229), p.118 (7P-1484)
Fort Smith, N.W.T. - general views, p.80 (7P-983), p.130 (7P-1625), p.130 (7P-1634), p.135 (7P-1696)
Fort Steele, B.C. - general views, p.6 (333P-23), p.8 (333P-17), p.39 (333P-6), p.45 (333P-31), p.47 (333P-28), p.47 (333P-8), p.68 (333P-5), p.73 (333P-14), p.75 (333P-7), p.85 (333P-1), p.88 (7P-1150), p.99 (333P-19), p.124 (333P-26), p.135 (333P-20), p.152 (333P-27)

Fort Vermillion, Alta. - general views, p.50 (92P-10), p.91 (7P-1188)
Fort Walsh, Sask. - general views, p.47 (333P-8), p.125 (7P-1566)
Fort William, Ont. - general views, p.46 (7P-528), p.47 (7P-546), p.79 (7P-971), p.85 (7P-1088), p.85 (7P-1089)
Fort William, Que. - general views, p.86 (7P-1100), p.97 (7P-1218)
Fort Wrigley, N.W.T. - general views, p.50 (92P-10), p.73 (7P-894)
Fort York, Toronto, Ont., p.136 (18P-28)
Fort York restoration (1932-1934), Toronto, Ont., p.32 (140P-5)
Fortin, Edouard, p.42 (7P-465)
Fortune, Nfld. - general views, p.131 (7P-1642)
Forward, Dorothy, p.52 (7P-609)
Fosbery, K.G., Lt., p.52 (7P-610)
Foster, George, Sir, p.31 (7P-332)
Foster, George Eulas, and family, p.52 (7P-611)
Foster, Margaret C., p.53 (7P-612)
Foster, Ralph E., p.53 (7P-613)
Foster, Walter E., p.26 (7P-1971)
Fotheringham, John Taylor, p.53 (7P-614)
Fouchu, N.S. - general views, p.89 (7P-1159)
Foundries - British Columbia - Cranbrook, p.86 (333P-35)
Fowler, P.D., p.25 (7P-1932)
Fowler, Walter Warren, p.53 (7P-615)
Fowler family, Ont., p.34 (7P-362)
Fox-Movietone, New York, N.Y., p.53 (7P-616)
Fox River (C.-B.) - vues, p.35 (7P-370)
Framed portraits, p.53 (7P-617)
Français au Canada (ouest), p.131 (222P-1)
Français au Manitoba, p.131 (222P-1)
France - general views, p.31 (7P-331), p.39 (7P-421), p.60 (1P-25), p.72 (7P-879), p.87 (7P-1133), p.121 (1P-53)
France - vues, p.35 (329P-1), p.124 (185P-13)
France - war memorials, p.35 (7P-378)
France, l'armée de l'air, p.8 (7P-80)
Frances Lake (Ont.) - vues, p.20 (7P-241)
Francis, Anne, pseud.
voir
Bird, Florence Bayard
Frank, Alta. - general views, p.148 (7P-1825)
Frank, Leonard, photo., p.145 (300P-1)
Frank, Robert, p.120 (123P-8)
Franklin, Ed, p.5 (7P-46)
Franklin, John, Sir, p.39 (7P-431)
Franklin Expedition, 1845, p.36 (7P-392), p.39 (7P-431)
Frasch, photo., p.128 (7P-1607)
Fraser, Allen, photo., p.60 (1P-41)
Fraser, Charles Frederick, Jr., photo., p.60 (1P-25)
Fraser, Charles Frederick, Sir, and family, p.60 (1P-25)
Fraser, Geoffrey, p.53 (7P-621)
Fraser, H. Douglas, Mrs., p.53 (7P-618)
Fraser, Helen G., and family, p.53 (7P-619)
Fraser, James, Rev., and family, p.77 (7P-947)
Fraser, Ronald, p.53 (7P-620)
Fraser & Sons, photo., p.50 (200P-12)
Fraser and Webb, photo., p.6 (7P-48)
Fraser Canyon, B.C. - general views, p.105 (123P-5)
Fraser River, B.C. - general views, p.53 (334P-31), p.92 (7P-1039), p.92 (92P-15), p.95 (7P-1117), p.104 (8P-7)
Fraser's Photographic Gallery, p.6 (7P-48)
Frechette, Louis-Honoré, p.53 (7P-622)
Frederickhouse (Ont.) - vues, p.18 (7P-215)
Fredericton, N.B. - general views, p.1 (1P-3), p.29 (7P-312), p.33 (7P-353), p.45 (7P-510), p.65 (7P-782), p.107 (7P-1336), p.136 (7P-1713)
Fredericton, N.B. - scenes, p.61 (8P-1), p.116 (46P-1)
Fredericton (N.-B.) - vues, p.111 (7P-1385)

Freeborn, Frank W., p.3 (166P-4)
Freeland, William Thomson, photo., p.53 (18P-36), p.126 (200P-7)
Freeman family, p.120 (31P-54)
Freighters - Newfoundland, p.91 (7P-1186)
Freiman, Lawrence, and family, p.53 (7P-623)
French-Canadians in Manitoba, p.81 (9P-41)
French River, Ont. - general views, p.131 (7P-1648)
Frish, Neil A., p.53 (1P-38)
Frith's Saltworks, p.153 (31P-69)
Frolick, Stanley William, p.53 (7P-624)
Frontenac Co., Ont. - general views, p.63 (75P-11)
Frontier College, Toronto, Ont., p.53 (7P-625)
Frontier College, Toronto, Ont.
 see also
 Colleges - Ontario - Toronto
 (Frontier College)
Frost, Ernest Ralph Clyde, p.53 (7P-626)
Frost, Patricia, p.53 (7P-626)
Fry, Frederick Ernest Joseph, p.53 (196P-12)
Fryer, Bryant W., p.54 (7P-627), p.54 (7P-628)
Fryer, Enid, p.54 (7P-627)
Fryer-Keighley Collection, p.54 (7P-628)
Fuller, Howard, p.54 (7P-629)
Fuller, J.F.C., Maj. Gen., p.7 (7P-62)
Fullerton, Elmer Garfield, p.54 (7P-630)
Fullerton, N.W.T. - general views, p.23 (7P-1938)
Fulton, E. Davie, p.54 (7P-631)
Fulton, E. Margaret, Dr., p.100 (340P-1)
Fulton, George, p.44 (31P-72)
Fulton, O., p.16 (7P-188)
Fundy (Bay of) - aerial views, p.21 (7P-1921)
Fur Trade, p.1 (13P-10), p.21 (7P-262), p.50 (92P-10), p.53 (7P-614), p.122 (92P-21), p.146 (16P-19), p.148 (7P-1820)
Fur Trade
 see also
 Trading Post
Fur trade - Ontario, p.4 (8P-16)
Furnishings - Nova Scotia, p.105 (1P-83)
Furniture - Nova Scotia, p.105 (1P-81)
Furniture - Nova Scotia - early years, p.111 (1P-52)
Furniture, Canadian, p.44 (31P-72), p.151 (31P-78)
Fushimi, Prince of Japan, p.54 (7P-632)
Futvoye, E.M., Mrs., p.54 (7P-633)
Futvoye, George, Maj., p.54 (7P-633)

G.B. Greene (SS), p.133 (8P-10)
Gabarus, N.S. - general views, p.89 (7P-1159)
GAF Corporation, New York, N.Y., p.54 (7P-634)
Gagen & Fraser, photo., p.72 (7P-874)
Gagnon, Charles E., p.37 (7P-396)
Gagnon, Phileas, et famille, p.108 (113P-12)
Gagnon (Québec) - vues, p.14 (007P-161)
Galbraith, p.54 (312P-2)
Galbraith's Ferry, B.C. - general views, p.18 (333P-10)
Gall, C. & Co., photo., p.72 (7P-874)
Gall, Chas., photo., p.50 (200P-12)
Gallaway, William E., p.54 (7P-635)
Galles, Prince (de), p.8 (7P-69), p.8 (7P-76), p.13 (7P-142), p.24 (7P-1918), p.91 (131P-3)
Galles, Princes de
 voir aussi
 Wales, Prince of
Galt, Alexander Tilloch, Hon. Sir, p.54 (7P-636), p.74 (7P-899)
Galt family, Ont., p.87 (7P-1145)

Gamble, Alvan, p.54 (7P-637)
Gamble, Millie, p.54 (5P-2)
Gammon, Arthur, Mrs., p.54 (7P-638)
Gananoque, Ont. - scenes, p.49 (8P-8)
Gananoque (H.M.C.S.), p.87 (7P-1136)
Gananoque (Ont.) - vues, p.10 (7P-102)
Gano, John Henry, photo., p.54 (11P-8)
Garbutt, Dorothy, p.54 (9P-20)
Garden Island, Ont. - general views, p.97 (7P-1208)
Gardner, Alexander, photo., p.25 (123P-1)
Gardner Creek, N.B. - general views, p.43 (7P-475)
Gariepy, Edgar, photo., p.54 (7P-639)
Garland, Edward Joseph, p.132 (7P-1654)
Garneau, F.X., p.6 (7P-49)
Garnier, Joshua, photo., p.82 (7P-1015)
Garrand, Mr., p.50 (7P-579)
Garratt, Phil., p.41 (7P-462)
Garrett, Roland S., p.54 (7P-640)
Gaskell, I., p.55 (7P-641)
Gaspe Bay, Que. - general views, p.7 (1P-28)
Gaspereau Valley, N.S. - general views, p.88 (1P-47)
Gaspésie (Québec) - vues, p.16 (7P-189), p.80 (131P-4)
Gates, H.L., p.55 (7P-642)
"Gateside" - Hendrie family, p.64 (45P-5)
Gatineau Historical Society, Wakefield, Que., p.55 (7P-643)
Gatineau Park, Que. - general views, p.15 (123P-9)
Gatineau River, Que. - general views, p.55 (7P-650)
Gaudard, Pierre, photo., p.55 (7P-644)
Gaudaur, J.G., p.39 (7P-420)
Gaudet, Placide, p.17 (7P-194)
Gaudette, Alice, p.55 (7P-645)
Gaulle, Charles de, Mme, p.97 (7P-1212)
Gault, E.F., p.55 (7P-646)
Gault, W. Lea, p.55 (7P-647)
Gauthier, Clarence, p.55 (7P-648)
Gauthier, Juliette, p.55 (7P-649), p.109 (7P-1368)
Gautier, photo., p.75 (131P-6)
Gauvin & Gentzel, photo., p.136 (302P-1)
Gauvin and Gentzel, photo., p.72 (7P-1404), p.115 (7P-1448)
Gauvin and Gentzell, photo., p.38 (1P-67), p.43 (1P-33), p.49 (1P-36), p.49 (1P-9), p.66 (7P-789), p.69 (1P-18), p.89 (24P-1), p.98 (1P-48), p.110 (1P-51), p.122 (1P-74), p.137 (1P-55)
Gauvreau, Robert, p.55 (131P-1)
Gazette (The), photo., p.136 (7P-1248)
Gazon, Henri, p.102 (7P-1290)
Geddie, John, Rev., and family, p.62 (31P-29)
Geggie, N.S., p.55 (7P-650)
Geiger-Torel, Herman, p.55 (149P-10)
Gélinas, Gratien, p.135 (7P-1708)
Gelling family, N.S., p.55 (1P-13)
Gely, Gabriel, p.55 (7P-651)
Gemmill, W.R., Mrs., p.55 (7P-652)
Gemmill family, Ont., p.55 (7P-652)
Gendarmerie Royale du Canada, p.6 (7P-59), p.24 (7P-1930)
Gendarmerie Royale du Canada
 voir aussi
 Royal Canadian Mounted Police
General Assembly of the Presbyterian Church in Canada, p.55 (317P-2)
General Chapters of the Basilian Fathers - St. Michaels College, p.142 (200P-14)
General Mining Association Ltd., p.25 (7P-1948), p.31 (1P-62)
General Motors of Canada Co. Ltd., Oshawa, Ont., p.55 (7P-653), p.62 (7P-740)
Genie Electrique - generalités, p.36 (332P-1)
Genie Mecanique - generalités, p.36 (332P-1)
Genoa Bay, B.C. - general views, p.30 (12P-11)

Gentile, Charles, photo., p.12 (7P-134)
Geodetic Survey of Canada, p.57 (7P-687), p.137 (7P-1725)
Geoffrion, Louis-Philippe, p.89 (7P-1165)
Georgevich, Alex S., p.55 (7P-654)
Geological Survey of Canada, p.130 (7P-1638), p.140 (16P-18), p.140 (16P-18)
George, Dan, p.113 (7P-1411)
George, Prince, p.24 (7P-1918)
George Bothwell (SS), p.15 (7P-166)
George Latta, Gén., et famille, p.95 (7P-1128)
George Lilley, photo., p.23 (7P-1937)
George V, King, p.2 (81P-3), p.39 (7P-422), p.56 (7P-659), p.109 (7P-1357), p.117 (7P-1467)
George V, roi, p.16 (7P-183)
George VI, King, p.25 (7P-1954), p.42 (1P-70), p.53 (7P-612), p.55 (7P-647), p.63 (7P-753), p.67 (7P-808), p.85 (31P-51), p.90 (7P-1171), p.90 (7P-1173), p.114 (7P-1425), p.135 (7P-1707), p.139 (1P-17), p.145 (7P-1786)
George VI, Roi, p.6 (7P-61), p.11 (7P-120), p.24 (7P-1907)
George's Square, Oakville, Ont., p.106 (47P-14)
Georgian Bay, Ontario - general views, p.136 (196P-11)
Georgian Bay (SS), p.127 (8P-3)
Geraldine S (Trawler), p.66 (31P-40)
Germans in Canada, p.22 (7P-1906)
Germans in Montreal, p.145 (7P-199), p.145 (7P-203)
Germans in Toronto, p.59 (7P-712)
Germany - general views, p.60 (1P-25)
Germany - historic sites, p.126 (196P-15)
Germany, Navy, submarines, p.55 (7P-648)
Gernie, B.C. - general views, p.79 (7P-971)
Gertsman, S. Lillian, p.55 (7P-655)
Gervais, H.G., p.56 (7P-656)
Ghandi, Indira, p.96 (7P-1191)
Giants - Van Buren Bates, Martin, Mr. & Mrs., p.2 (7P-16)
Gibbon, Murray, p.56 (7P-657)
Gibbons, Alan O., Mrs., p.56 (7P-658)
Gibbs, S., p.56 (7P-659)
Gibson, Helen (Beny), Mrs., p.56 (92P-13)
Gibson, photo., p.19 (7P-229)
Gibson, William Hewison, photo., p.56 (7P-660)
Gilbert, Albert, photo., p.56 (7P-661)
Gilbert, Béatrice Hart, p.126 (351P-1)
Gilbert, Effie, p.150 (7P-1856)
Gilbert, Walter Edwin, p.7 (7P-63), p.56 (7P-662)
Gilchrist, Varge, p.56 (7P-663)
Gilchrist, W.A., Mrs., p.56 (7P-664)
Gilead, Ont. - general views, p.147 (7P-1816)
Gilels, Emil, p.83 (7P-1027)
Gill, Charles, p.77 (7P-934)
Gill, Goerge, p.113 (7P-1414)
Gillespie, A., p.56 (7P-665)
Gillies, Ont. - general views, p.101 (7P-1267)
Gillies family, Ont., p.20 (7P-252)
Gillies Lumber Mills, Braeside, Ont., p.101 (7P-1267)
Gillies Mills, Ont. - general views, p.89 (7P-1160)
Gillies Sawmill, Carleton Place, Ont., p.101 (7P-1267)
Gilmour, Thomas Chalmers, p.56 (7P-666)
Girard, Jean-Pierre, p.5 (7P-46)
Girl Scouts - Manitoba, p.66 (9P-30)
Giroux, Albert, p.56 (7P-667)
Giroux, Sylvio, p.56 (7P-668)
Gittel, Arch A., p.56 (7P-669)
Glacier Cascade Mountain, Alta. - general views, p.23 (7P-1926)
Gladish, William M., p.56 (7P-670)
Gladstone, Man. - general views, p.90 (7P-1180)
Gladstone, William E., Rt. Hon., p.43 (7P-483), p.52 (7P-604), p.66 (7P-796)
Gladys (SS), p.84 (334P-44)
Glasgow, Ecosse - vues, p.14 (7P-160)
Glass stereographs, p.94 (18P-22)

Gleason, Arthur A., photo., p.56 (7P-671)
Gleason, Herbert W., photo., p.56 (166P-47)
Gleichen, Alta. - general views, p.75 (7P-910),
 p.134 (11P-6), p.136 (7P-1714)
Glenbow Foundation, Glenbow-Alberta Institute,
 Calgary, Alta., p.56 (7P-672)
Glengarry Point, Ont. - vues, p.85 (7P-1092)
Glenora, British Columbia - general views, p.33
 (7P-355)
Glidden, M., p.8 (7P-71)
Glide (SS), p.122 (7P-1531)
Globe and Mail, p.57 (312P-1)
Globe and Mail, photo., p.30 (7P-316), p.57
 (7P-673)
Gloster Aircraft Ltd., p.153 (7P-1892)
Glover, Donald A., p.57 (7P-675)
Glynn, Hugh, p.57 (7P-676)
Go-Home Bay, Ontario - general views, p.136
 (196P-11)
Goat Island, N.S. - general views, p.69 (1P-18)
Godard, George, p.57 (1P-12)
Goderich, Ont. - aerial views, p.68 (7P-826)
Goderich, Ont. - general views, p.48 (7P-552),
 p.125 (7P-1561)
Godin, Aime, p.57 (7P-677)
Godin, Lorenzo, p.57 (7P-677)
Godin, Paulette, p.49 (7P-572)
Godin, Raoul, p.57 (7P-677)
Goetzman, photo., p.153 (161P-1)
Gojoa Heaven, N.-W.T. - general views, p.3
 (7P-19)
Gold Mining - Alaska, p.82 (11P-1)
Gold Mining - British Columbia, p.140 (16P-18)
Gold Mining - Manitoba, p.140 (16P-18)
Gold Mining - Manitoba - Penniac, p.65 (9P-28)
Gold Mining - Newfoundland, p.140 (16P-18)
Gold Mining - Nova Scotia, p.118 (31P-18)
Gold Mining - Ontario, p.86 (1P-23), p.137
 (7P-1728), p.140 (16P-18)
Goldbloom, Richard, Mrs., p.100 (340P-1)
Golden, B.C. - general views, p.68 (333P-5)
Golden City, Ont. - general views, p.47 (7P-543)
Golden City, Ont. - scenes, p.113 (8P-15)
Goldfulls (Sask.) - vues, p.17 (7P-200)
Goldpines (Ont.) - vues, p.17 (7P-200)
Gondin, Edward, p.41 (7P-448)
Good Lake, Ont. - general views, p.107 (7P-1334)
Goodeve, H.T., Mrs., p.57 (7P-678)
Goodfellow, J.C., Rev., p.77 (7P-945)
Goodman, Gisli, p.57 (9P-21)
Goose Bay, Labrador - general views, p.121
 (7P-1514)
Gordon, Donald, p.128 (7P-1608)
Gordon, Jacob, Rabbi, p.57 (7P-679)
Gordon, Norman G., p.57 (7P-680)
Gordon, Peter, p.56 (7P-661)
Gordon, Victor, Capt., p.57 (38P-5)
Gordon, Wesley, Hon., p.41 (7P-448)
Gore Bay, Ont. - general views, p.60 (7P-719)
Gorge (C.-B.) - vues, p.17 (7P-201)
Goring-on-Thames, England - general views, p.36
 (7P-388)
Gorman, Joseph, p.57 (7P-681)
Gorman, Maria Rosaria, Rev. Sister, p.100
 (340P-1)
Gorman, Thomas Patrick, p.57 (7P-682)
Gosling, Laura M.E. (Nash), p.57 (38P-6)
Gosling Memorial Library, St. John's, Nfld., p.123
 (38P-10)
Goss, Arthur S., photo., p.29 (7P-306), p.32
 (140P-11), p.32 (140P-12), p.32 (140P-13),
 p.32 (140P-5), p.33 (140P-14), p.33 (140P-6)
Gosselin, Mgr., p.11 (131P-2)
Goudreault, J.N., photo., p.31 (7P-338)
Goulden, Robert A., and family, p.57 (7P-683)
Goulden, W. Taylor, p.57 (7P-684)
Goulding, William S., p.57 (196P-46)
Government House, Ottawa, Ont., p.51 (7P-591)

Government House annual garden party, St.
 John's, Nfld., p.117 (38P-9)
Governors General - Canada, p.67 (18P-33), p.140
 (75P-4), p.150 (7P-1847)
Grace, W.J., p.57 (7P-685)
Gracefield (Québec) - vues, p.18 (7P-251)
Graetz, photo., p.69 (7P-839)
Graham, Alex W., p.137 (7P-1729)
Graham, C.W., photo., p.82 (7P-1005)
Graham, Dorothea, p.57 (7P-686)
Graham, Eleanor, p.57 (7P-687)
Graham, H.P., p.58 (333P-25)
Graham, photo., p.122 (1P-74), p.136 (302P-1)
Graham, Stuart, p.58 (7P-688)
Grampian (ship), p.49 (7P-570)
Granby (Québec) - vues, p.77 (344P-1)
Grand Bank, Nfld. - general views, p.131
 (7P-1642)
Grand Falls, N.B. - general views, p.110 (7P-1374)
Grand Hotel, Dartmouth, N.S., p.112 (7P-1399)
Grand Lac de l'Ours (T.N.-O.) - vues, p.17
 (7P-204)
Grand Lake, Ont. - general views, p.41 (7P-448)
Grand Manan Island, N.B. - general views, p.33
 (7P-353)
Grand Pré, Man. - general views, p.113 (7P-1415)
Grand Pre, N.S. - general views, p.88 (1P-47)
Grand Rapids, Alta. - general views, p.116
 (7P-1451)
Grand Trunk Railway Co.
 see also
 Railroads - Grand Trunk Railway Co.
Grand Trunk Railway Co., Toronto, Ont., p.58
 (7P-689)
Grande Bretagne - vues, p.16 (7P-183)
Grande Prairie, Alta. - general views, p.3 (13P-12),
 p.130 (7P-1634)
Grand'mere, Que. - general views, p.108 (7P-1342)
Grant, Charity, p.58 (7P-690)
Grant, Charles, p.89 (7P-1159)
Grant, Cuthbert, p.87 (9P-44), p.146 (16P-19)
Grant, Frank, photo., p.22 (7P-1898)
Grant, George, p.58 (7P-690)
Grant, James, p.78 (7P-956)
Grant, James A., Sir, p.88 (7P-1146)
Grant, M., p.58 (333P-33)
Grant, Maude, p.58 (7P-691)
Grant, Ted, photo., p.22 (7P-1898)
Grant, Thomas J., p.58 (7P-692)
Grant, William Lawson, p.58 (7P-690), p.58
 (7P-691), p.58 (7P-693)
Grant (famille), Ont., p.111 (7P-1385)
Grant family, Ont., p.58 (7P-690), p.58 (7P-691),
 p.58 (7P-693)
Grantmyre, Barbara, p.58 (7P-694)
Granville Ferry, N.S. - general views, p.69 (1P-18)
Graphic Antiquity, Arlington Heights, Ill., p.58
 (7P-695)
Grassi, Lawrence, p.58 (166P-29)
Grave family, Ont., p.96 (7P-1204)
Graver, Nicholas M., p.58 (7P-696)
Graves, Wesley G., p.58 (1P-39)
Gray, Charles F., p.58 (7P-698)
Gray, Charles F., and family, p.146 (7P-1797)
Gray, Henry, Sir, p.5 (7P-36)
Gray, Jack, p.58 (7P-697)
Gray, John, Mrs., p.58 (7P-699)
Gray, Robert Hampton, Lt., p.102 (7P-1279)
Gray, Robert Hampton, Lt., and family, p.58
 (7P-699)
Gray, Robin, photo., p.128 (7P-1597)
Greary, B.H., Maj., p.102 (7P-1279)
Great Bear Lake, N.W.T. - general views, p.21
 (92P-8), p.41 (7P-457)
Great Britain - general views, p.31 (7P-331), p.72
 (7P-879), p.121 (1P-53), p.128 (75P-16)
Great Britain - historic sites, p.126 (196P-15)
Great Britain, Army, p.58 (7P-692)

Great Britain, Army, Dunsterforce, p.147
 (7P-1804)
Great Britain, Army, Rifle Brigade, p.58 (18P-37)
Great Britain, Army, Royal Flying Corps, p.40
 (7P-438), p.79 (7P-968)
Great Britain, Army, Royal Flying Corps, No. 4
 School of Military Aeronautics, p.67 (7P-814)
Great Britain, Army, 1st Battalion, Prince Consort's
 Own Rifle Brigade, p.70 (7P-854)
Great Britain, Army, 61st (South Gloucestershire)
 Regiment, p.57 (7P-674)
Great Britain, Army (Troops in Canada), p.53
 (7P-617)
Great Britain, Royal Air Force, No. 158 Squadron,
 p.57 (7P-680)
Great Britain, Royal Air Force, No. 211 Squadron,
 p.147 (7P-1815)
Great Britain, Royal Air Force, No. 56 Squadron,
 p.56 (7P-662)
Great Britain, Royal Air Force, No. 625 Squadron,
 p.113 (7P-1412)
Great Britain, Royal Air Force, School of Aerial
 Gunnery, Beamsville, Ont., p.60 (7P-720)
Great Britain, Royal Flying Corps, Texas, p.60
 (7P-720)
Great Lakes - general views, p.58 (7P-700)
Great Lakes Historical Society, p.58 (7P-700)
Greece - general views, p.73 (200P-19)
Greeks in Ontario, p.96 (7P-1200)
Greely, Adolphus Washington, Lt., p.58 (7P-701)
Greely Arctic Expedition, 1881-1884, p.58
 (7P-701)
Green, Bill, p.10 (7P-109)
Green, Hubert Unsworth, photo., p.59 (166P-26)
Green, John, p.59 (9P-22)
Green, T.B., Mrs., p.59 (7P-702)
Greenaway, Keith Rogers, p.59 (7P-703)
Greene, Lorne, p.102 (7P-1281)
Greene, Nancy, p.65 (7P-774)
Greenhill, Ralph Ackland, photo., p.59 (7P-704)
Greenland - expeditions, p.75 (7P-914)
Greenland - general views, p.98 (7P-1233)
Greenlees, Stephen, Mrs., p.59 (7P-705)
Greenly (Island), Que. - general views, p.97
 (7P-1208)
Greer, George S., p.59 (7P-706)
Greer family, Ont., p.147 (7P-1816)
Gregg, Milton Fowler, p.59 (7P-707)
Grégoire, Félix, and family, p.59 (9P-23)
Greig family, Ont., p.59 (18P-81)
Grenfell, Sask. - general views, p.116 (7P-1454),
 p.117 (7P-1466)
Grenfell (SS), p.29 (7P-307)
Grenville (C.G.S.), p.24 (7P-1930)
Grey, Lord, S.E., p.91 (131P-3)
Grey Owl, p.79 (7P-975), p.118 (31P-18)
Grice, Arthur D., photo., p.59 (7P-708)
Grier, Crawford G.M., Col., p.59 (196P-35)
Grier, Helen, p.82 (166P-46)
Griffin, M.T., p.96 (7P-1204)
Griffin, Peter, p.59 (7P-709)
Griffis, C.H.R., p.59 (7P-710)
Griffis, Edith, p.59 (9P-24)
Griffiths, J.H., photo., p.15 (7P-168), p.129
 (7P-1623)
Griffon (Ship), p.84 (7P-1031)
Grignon, Claude Henri, p.102 (7P-1290)
Grimsby, Ont. - general views, p.70 (7P-854),
 p.138 (7P-83)
Grimsby Beach, Ont. - general views, p.43
 (7P-484)
Grittani, Giuseppe, p.59 (7P-711)
Groh, Phillip, p.59 (7P-712)
Grohovaz, Giovani Angelo, p.59 (7P-713)
Groome, R.J., p.96 (7P-1206)
Grosse Isle, Que. - general views, p.25 (7P-1952)
Grossman, John, p.59 (12P-24)
Grosvenor, Len, p.59 (7P-714)
Groulx, Henri, p.2 (7P-10)

Groulx, Lionel, Abbé, p.89 (7P-1165)
Groundhog River (Ont.) - vues, p.18 (7P-215)
Group of Seven, p.62 (7P-748)
Groupe des Sept, Ottawa, Ont., p.60 (7P-716)
Groupes ethniques
 voir
 la nationalité d'origine
Groves, R. James, p.60 (7P-715)
Gruppe, Charles, p.150 (7P-1855)
Gubelman, photo., p.50 (200P-12)
Guelph, Ont. - general views, p.56 (7P-672)
Guelph, Ont. - individuals, p.153 (7P-1887)
Guerre, 1914-1918 (mondiale le)
 voir aussi
 European War, 1914-1918
Guerre, 1914-1918 (mondiale le) - Mauritanie,
 p.150 (7P-1842)
Guerre, 1914-1918 (mondiale le) - services
 médicaux et sanitaires, p.150 (7P-1846)
Guerre, 1914-1918 (mondiale le), p.14
 (7P-160)
Guerre, 1914-1918 (mondiale le), p.150 (7P-1855)
Guerre, 1914-1918 (mondiale le) - participation
 canadienne, p.120 (7P-1501)
Guerre, 1914-1918 (mondiale le), p.20
 (7P-239)
Guerre, 1939-1945 - Hollande, occupation
 allemande, p.135 (7P-1699)
Guerre mondiale, 1939-1945, p.90 (7P-1174)
Guerre sud-africaine, 1899-1902, p.14 (7P-158),
 p.24 (7P-1940), p.150 (7P-1842)
Guerre sud-africaine, 1899-1902
 voir aussi
 South African War, 1899-1902
Guerre, 1914-1918 (mondiale le), p.12
 (7P-139)
Guest, Jack, p.132 (7P-1659)
Guillet, Edwin Clarence, p.60 (18P-44), p.60
 (7P-719)
Guindon (Lac)(Québec) - vues, p.14 (007P-161)
Gunn, Ann, p.60 (334P-40)
Gunn, George H., p.60 (9P-25)
Gunn, Norman A., p.60 (7P-718)
Gunterman, Mattie, photo., p.145 (300P-1)
Gustafson, David, p.60 (7P-717)

H.H. Silver (schooner), p.92 (31P-88)
Hackett, Margaret, p.61 (7P-724)
Haggarty, Mary Albertus, Rev. Sister, p.100
 (340P-1)
Hahn, Emmanuel, p.127 (7P-1583)
Haida Indians, p.22 (7P-1901), p.30 (7P-328)
Haileybury, Ont. - general views, p.47 (7P-543),
 p.67 (7P-813)
Haines, Durwards M., p.60 (7P-720)
Halcro, W.A., p.60 (7P-721)
Hale, Reginald B., p.60 (7P-722)
Haliburton, Ont. - scenes, p.16 (8P-6)
Haliburton, Thomas Chandler, p.60 (7P-723)
Haliburton (Ont.) - vues, p.13 (7P-149)
Halifax, N.S., - places, p.60 (1P-78)
Halifax, N.S. - aerial views, p.65 (7P-785)
Halifax, N.S. - explosion, 1917, p.23 (7P-1917),
 p.60 (1P-42), p.60 (31P-48), p.70 (140P-15)
Halifax, N.S. - explosion, 1945, p.60 (31P-48)
Halifax, N.S. - general views, p.1 (1P-3), p.14
 (1P-29), p.36 (1P-32), p.36 (1P-65), p.39
 (1P-68), p.41 (31P-25), p.45 (7P-510), p.46
 (1P-34), p.58 (7P-692), p.58 (7P-693), p.58
 (7P-695), p.60 (1P-25), p.60 (1P-63), p.60
 (1P-78), p.60 (31P-48), p.65 (7P-786), p.69
 (1P-18), p.72 (7P-878), p.78 (1P-45), p.84

(7P-1054), p.86 (1P-23), p.89 (24P-1), p.98
 (1P-48), p.104 (8P-7), p.105 (1P-76), p.113
 (7P-1420), p.121 (1P-14), p.122 (1P-74),
 p.137 (1P-2), p.137 (1P-55), p.139 (1P-17),
 p.145 (7P-1775), p.145 (7P-1777)
Halifax, N.S. - individuals, p.69 (1P-18), p.152
 (7P-1884)
Halifax, N.S. - scenes, p.49 (1P-36), p.61 (8P-1),
 p.117 (1P-73)
Halifax, N.S. - VE Day Riots, 1945, p.26
 (7P-1964), p.153 (31P-97)
Halifax Academy, Halifax, N.S., p.13 (1P-58),
 p.122 (1P-74)
Halifax Citadel, Halifax, N.S., p.60 (1P-15)
Halifax Conservatory of Music, Halifax, N.S., p.91
 (1P-46)
Halifax County Academy, Halifax, N.S., p.91
 (1P-46)
Halifax Herald Ltd. (The), Halifax, N.S., p.136
 (1P-40)
Halifax Local Council of Women, Halifax, N.S.,
 p.60 (1P-41)
Halifax (N.-E.) - vues, p.8 (7P-78), p.25
 (7P-1935)
Halifax Photo Service, photo., p.60 (1P-41)
Halifax Photographic Co., p.43 (1P-33), p.60
 (31P-84)
Halifax Provisional Battalion - Medicine Hat, Alta.,
 p.75 (1P-71)
Halifax Relief Commission, Halifax, N.S., p.60
 (1P-42)
Halifax School for the Blind, Halifax, N.S., p.60
 (1P-25)
Halifax theatre history, p.11 (31P-62)
Halifax Volunteer Fire Department, p.36 (1P-65)
Hall, André, p.61 (7P-727)
Hall, Emmett Matthew, p.61 (7P-725)
Hall, Frank, p.61 (9P-26)
Hall, Janet, p.61 (7P-726)
Hall, R.S., Sergent, R.C.A., p.4 (134P-1)
Hallamore family, N.S., p.53 (1P-38)
Halliday, D., p.61 (7P-728)
Halliday, Milton S., p.61 (7P-729)
Halliday, W.E. Durrant, p.61 (7P-730)
Hamacher, E.J., photo., p.153 (161P-1)
Hambleton, Ronald, p.42 (16P-7)
Hambourg, Boris, p.61 (7P-731)
Hambourt Clement, p.61 (7P-731)
Hamel, Sgt, p.82 (134P-3)
Hamel, Théophile, p.25 (7P-1954)
Hamilton, Ont. - aerial views, p.68 (7P-826)
Hamilton, Ont. - general views, p.40 (7P-435),
 p.58 (7P-695), p.59 (7P-704), p.60 (7P-722),
 p.61 (45P-1), p.70 (7P-854), p.77 (7P-941),
 p.92 (7P-1039), p.101 (7P-1267), p.104
 (8P-7), p.152 (45P-3)
Hamilton, Ont. - individuals, p.10 (45P-2)
Hamilton, Ont. - scenes, p.49 (8P-8), p.61 (8P-1)
Hamilton, S. Ross, p.61 (7P-732)
Hamilton, W. Raymond, p.61 (7P-733)
Hamilton, Zachary M., p.61 (7P-734), p.61
 (9P-27)
Hamilton family, p.94 (228P-3)
Hamilton Inlet, Labrador (T.-N.), p.75 (131P-6)
Hamilton River, Nfld. - general views, p.83
 (7P-1020)
Hamilton Spectator, photo., p.31 (7P-338)
Hamiota, Man. - general views, p.98 (7P-1224)
Hamly, E.T., photo., p.41 (7P-449)
Hammacher, E.J., p.42 (7P-459)
Hammett, N.D., photo., p.41 (31P-82)
Hammond & Butler, photo., p.2 (7P-14)
Hammond, H.E., photo., p.2 (7P-14)
Hammond, John, p.61 (8P-1)
Hammond, Melvin Ormond, and family, p.61 (8P-1)
Hammond, Melvin Ormond, photo., p.61 (196P-8),
 p.61 (8P-1), p.126 (196P-16)
Hampton, Ont. - general views, p.103 (7P-1304)
Hamwood family, Ont., p.61 (18P-86)

Hand, Kenneth H., photo., p.61 (7P-735)
Hand, Stella, p.61 (7P-736)
Handford, Arthur L., photo., p.61 (7P-737)
Handicrafts - Nova Scotia, p.105 (1P-82)
Hands Studio, photo., p.53 (7P-623)
Handy, Clifford, p.61 (31P-108)
Hanington, A.E., p.55 (7P-642)
Hanington, Chanoine, Rev., p.20 (7P-240)
Hanlan, Edward, p.124 (7P-1549)
Hannam, H.H., p.27 (7P-276)
Hanson, Richard Burpee, Hon., p.62 (7P-738)
Hanson Family, N.B., p.83 (7P-1028)
Harbours - British Columbia -Vancouver, p.25
 (7P-1953)
Harbours - New Brunswick - Restigouche, p.118
 (7P-1475)
Harbours - New Brunswick - Saint John, p.103
 (2P-1)
Harbours - Newfoundland - St. John's, p.23
 (7P-1917)
Harbours - Nova Scotia, p.60 (1P-78), p.60
 (1P-78), p.60 (31P-48), p.69 (1P-18), p.78
 (1P-45), p.105 (1P-76), p.105 (1P-77), p.105
 (1P-79), p.117 (1P-73), p.139 (1P-17)
Harbours - Nova Scotia - Halifax, p.72 (7P-1404)
Harbours - Nova Scotia - Weymouth, p.40
 (7P-432)
Harbours - Ontario - Bronte, p.106 (47P-10), p.106
 (47P-9)
Harbours - Ontario - Oakville, p.106 (47P-10),
 p.106 (47P-9)
Harbours - Ontario - Rondeau, p.3 (7P-22)
Harbours - Ontario - Toronto, p.121 (18P-39),
 p.138 (322P-1), p.138 (322P-2), p.138
 (322P-3), p.138 (7P-1738), p.150 (18P-52)
Harbours - Quebec - Quebec (Queen's Wharf),
 p.115 (7P-1436)
Harder, John, p.39 (7P-447)
Harding, A.D., photo., p.19 (200P-11)
Harding, Alice, p.62 (166P-27)
Harding, C., photo., p.149 (7P-1828), p.152
 (7P-1884)
Hardy, Una M., p.62 (7P-739)
Hare, Mary P., p.62 (7P-740)
Hare, W.S., photo., p.153 (161P-1)
Harkness, R.G., photo., p.2 (7P-14)
Harlaw (SS), p.4 (7P-30)
Harley, Mr., p.62 (7P-741)
Harlow, Frederica, Gallery Inc. New York, N.Y.,
 p.62 (7P-742)
Harman family, Ont., p.62 (18P-65)
Harmer, William Morell, photo., p.62 (7P-743)
Harmon, Byron, photo., p.62 (166P-3)
Harmon, Donald, photo., p.62 (166P-20)
Harmon, Lloyd, photo., p.62 (166P-7)
Harms, William L., p.62 (7P-744)
Harries, James Leslie, Comm., p.62 (7P-745)
Harrigan Cove, N.S. - general views, p.63 (1P-26)
Harrington, Charlotte Geddie, p.62 (31P-29)
Harrington, R., photo., p.153 (161P-1)
Harrington, Richard Walter, photo., p.62 (7P-746)
Harris, A.W., D.V.S., p.30 (7P-325)
Harris, Gladys M., p.62 (7P-747)
Harris, Lawren Stewart, p.62 (7P-748)
Harris, Robert E., p.62 (1P-43)
Harrison, William Joseph, p.62 (7P-750)
Harriss, Charles Albert Edwin, p.63 (149P-11)
Hart, Juliette, p.126 (351P-1)
Hart House String Quartet, Toronto, Ont., p.61
 (7P-731)
Hart House Theatre, Toronto, Ont., p.88 (7P-1154)
Hartill Art Associates, photo., p.63 (313P-1)
Hartling, Philip, p.63 (1P-26)
Hartney, Man. - general views, p.113 (7P-1415)
Harvey, Ont. - School Section No. 1, p.70 (7P-847)
Hat Creek, B.C. - general views, p.29 (228P-4)
Hathaway, Ernest J., Mrs., p.63 (7P-749)
Hathaway, R.H., p.63 (7P-749)
Hatheway, Frank, p.34 (7P-358)

Hatheway, Leslie G., Mrs., p.63 (7P-751)
Haultain, H.E.T., p.63 (196P-42)
Havre-Saint-Pierre (Québec), p.75 (131P-6)
Hawaii - general views, p.93 (12P-26)
Hawker, Harry, p.88 (7P-1156)
Hawkins, T. Hartley, and family, p.63 (7P-753)
Hay River, N.W.T. - general views, p.3 (13P-12), p.91 (7P-1187)
Hay River (T.N.-O.) - vues, p.117 (7P-1472)
Haydon, Ont. - general views, p.103 (7P-1304)
Haynes, William, photo., p.63 (7P-752)
Hays, Charles Melville, p.63 (7P-754)
Hayter, Harry, p.95 (7P-1125)
Hayter, Henry Winston, p.63 (7P-755)
Hayward, J.C.M., photo., p.122 (1P-74)
Hayward, Lawrence, p.63 (8P-5)
Hayward Studio, photo., p.29 (7P-304), p.63 (7P-756)
Hazelgrove, A. Ronald, p.63 (7P-757)
Hazelgrove, Ronald, p.63 (75P-11)
Hazelton, B.C. - general views, p.52 (12P-5), p.142 (7P-1769)
Hearst (Ont.) - vues, p.37 (185P-11), p.107 (185P-1)
Heaslip, Robert Thomas, p.63 (7P-758)
Heath, David, p.40 (123P-7)
Heather, J.A., Maj., p.152 (7P-1875)
Hebert, Dr., p.50 (7P-579)
Hébert, Phillipe, p.63 (8P-5)
Hebrew Sick Benefit Association, Winnipeg, Man., p.63 (7P-759)
Hector Centre, Pictou, N.S., p.63 (31P-110)
Hector Pass, B.C. - general views, p.3 (166P-43)
Hedrick, Tony, p.5 (7P-46)
Heels, C.H., p.63 (7P-760)
Heenan, Gordon, photo., p.22 (7P-1898)
Heeney, Arnold Danforth Patrick, and family, p.64 (7P-761)
Hegg, E.A., photo., p.24 (7P-1909), p.57 (7P-675), p.153 (161P-1)
Hehner, Eric O.W., p.64 (7P-763)
Heikkila, Vihtor, p.64 (7P-764)
Hein, Lester C., p.64 (7P-762)
Helbecque, Raymond G., p.64 (7P-765)
Helen Mine (Ont.) - vues, p.24 (7P-1916)
Helga (Ship), p.63 (31P-110)
Hellenic Community Centre, Ottawa, Ont., p.96 (7P-1200)
Hellman, Fee, p.64 (333P-21)
Hellyer, Paul, p.21 (7P-256)
Henderson, Alexander, p.92 (7P-1039)
Henderson, Alexander, photo., p.25 (123P-1), p.58 (7P-692), p.64 (113P-5), p.64 (123P-4), p.64 (18P-24), p.64 (18P-4), p.64 (327P-2), p.64 (7P-766), p.65 (7P-778), p.70 (7P-855), p.105 (18P-3)
Henderson, James, p.61 (8P-1)
Henderson, L.J., Mrs., p.64 (7P-767)
Henderson, Robert, p.152 (7P-1872)
Henderson, Toky, p.147 (7P-1809)
Hendrie, William Senior, and family, p.64 (45P-7)
Hendrie family, Ont., p.64 (45P-5)
Hendry, Janet, p.64 (7P-768)
Hendry, Thomas Best, p.64 (7P-769)
Heney, J. Bower L., p.64 (7P-771)
Heney, J.G., photo., p.64 (7P-771)
Henry, D., Miss, p.64 (7P-770)
Henry, David, p.64 (7P-770)
Henry, Eugene M., p.64 (7P-772)
Henry Hudson (C.G.S.), p.23 (7P-1917)
Herbert, Albertina, Lady, p.64 (7P-773)
Herbert, Henri, p.127 (7P-1583)
Herbert, Ivor John Caradoc, p.64 (7P-773)
Herbert, W.B., p.26 (7P-264)
Herchmer, L.W., Comm., p.83 (7P-1025)
Herman (SS), p.112 (7P-1396)
Hermion (SS), p.26 (7P-1967)
Hermon, E.B., p.65 (12P-4)
Herodier, Gaston, p.122 (92P-21)

Héroux, George, photo., p.65 (315P-1)
Héroux, photo., p.81 (353P-1)
Herridge, Herbert Wilfred, p.65 (7P-774)
Herring Cove, N.S. - general views, p.34 (7P-364)
Herron - Gillies Mill, Lanark, Ont., p.101 (7P-1267)
Herron Mills, Ont. - general views, p.89 (7P-1160)
Herschel Island, N.W.T. - general views, p.135 (7P-1696)
Hertel family, Ont., p.91 (7P-1187)
Hess, A.L., photo., p.38 (7P-415)
Hetherington, C., photo., p.48 (7P-550)
Hetherington, George A., p.65 (7P-775)
Hicklin, Ralph, p.65 (18P-69)
Hicklin, Ross, p.65 (7P-776)
Hicks, A.R., p.65 (7P-777)
Hicks, James Henry, and family, p.65 (9P-28)
Higginson, T.B., p.65 (7P-778)
Higginson, Thom, Lt. Col., p.91 (7P-1187)
Higginson, Thomas, p.91 (7P-1187)
Higginson, William, Col., p.91 (7P-1187)
Higgonson's Plaster and Marble Dust Works, Newburg, New York, p.65 (31P-85)
Higgs, David C., p.65 (7P-779)
High River, Alta. - general views, p.152 (7P-1883)
Hileman, T.J., photo., p.65 (11P-7)
Hilger, Jone, p.65 (7P-780)
Hill, A. Edward, p.65 (7P-781)
Hill, C.W., photo., p.72 (7P-874)
Hill, David Octavius, photo., p.25 (123P-1)
Hill, Hammett P., p.45 (7P-506)
Hill, Isabel Louise, p.65 (7P-782)
Hill, "Red", p.101 (7P-1272)
Hill, Shuldham H., p.65 (7P-786)
Hill, T.S., photo., p.72 (7P-874)
Hill family, B.C., p.65 (334P-24)
Hillcoat, H.P., Millcoat, M.P., p.122 (7P-1529)
Hillcrest, Alta. - general views, p.53 (7P-624)
Hillcrest Lumber Co., Mesachie Lake (C.-B.), p.16 (7P-188)
Hillman, Aleck B., p.65 (7P-785)
Hills, Albert, p.65 (7P-783)
Hills, Arthur J., and family, p.65 (7P-784)
Hillyard, Len, photo., p.65 (339P-2), p.102 (7P-1293)
Hime, Humphrey Lloyd, photo., p.4 (8P-16), p.62 (7P-741), p.65 (9P-29), p.66 (18P-9)
Hime, Maurice W., p.66 (7P-787)
Himmelman, George, Captain, p.66 (31P-40)
Hinchley, Harry, p.66 (7P-788)
Hine, Lewis, photo., p.25 (123P-1)
Hines, Sherman, photo., p.66 (7P-789)
Hinman, Caroline B., photo., p.66 (166P-5)
Hirsch, Sask. - general views, p.102 (7P-1282)
Hirsch, Sask. - scenes, p.135 (7P-1701)
Hirschfeld, A.C., photo., p.153 (161P-1)
Hirtle, Lewis A, photo., p.100 (7P-1261)
Hiscocks, Bettie, p.66 (7P-790)
Historic Monument
 see
 name of monument
Historic Site
 see
 name of site
Historical Society of Ottawa, Ottawa, Ont., p.66 (7P-791)
Hitchman, Lionel, p.34 (7P-361)
Hitler, Adolph, p.14 (7P-158)
Hoag, Robert, p.66 (7P-793)
Hoare, Robert, photo., p.66 (13P-4)
Hoboken, N.J. - general views, p.120 (123P-8)
Hobson, F.J., Sgt., p.115 (7P-1442)
Hockey, p.116 (7P-1464)
Hockey Hall of Fame, Toronto, Ont., p.66 (7P-792)
Hodge, J., photo., p.142 (200P-8)
Hodgson, Man. - general views, p.49 (9P-17)
Hodgson, T.C., photo., p.33 (7P-353)
Hodson, K.L.B. Air Comm., p.112 (7P-1393)
Hoferichter, Norbert R., photo., p.66 (7P-794)

Hoffer, Clara, p.66 (7P-795)
Hoffer, Israel, and family, p.66 (7P-795)
Hoffer, Sask. - general views, p.31 (7P-339), p.49 (9P-17), p.66 (7P-795)
Hoffer family, Man., p.49 (9P-17)
Hogan, Lyla, p.66 (7P-796)
Holden, Alan T., p.66 (7P-797)
Holder, Richard B., photo., p.66 (7P-798)
Holland, p.66 (334P-41)
Holland, L.J., Mrs., p.66 (9P-30)
Hollande - vues, p.135 (7P-1699)
Hollick-Kenyon, Herbert, p.66 (7P-799)
Hollinger, Ben, p.41 (7P-452)
Hollister, H., photo., p.70 (7P-855)
Holloway, photo., p.87 (7P-1145)
Holloway Studios, photo., p.117 (4P-1)
Hollywood, Calif. - general views, p.120 (123P-8)
Holmes, Alice S., p.66 (7P-800)
Holmes, E., p.11 (7P-126)
Holmes, T.K., Dr., p.65 (7P-776)
"Holmstead" - Hendrie family, p.64 (45P-7)
Holroyde, H., p.67 (7P-801)
Holt, Bernard N., p.67 (7P-802)
Holyrood, Ont. - general views, p.41 (47P-3)
Home Bank of Canada (The), Toronto, Ont., p.67 (7P-803)
Honey, F.I., p.67 (7P-804)
Honey, S.L., Lt., p.67 (7P-804)
Honeywell Farm, Britannia, Ont., p.109 (7P-1364)
Hong Kong, China - general views, p.135 (7P-1708)
Honiton, England - general views, p.121 (18P-11)
Hood, A.S., photo., p.67 (31P-86), p.152 (7P-1884)
Hood, Hugh, p.135 (7P-1708)
Hoodspith, Randolph B., p.67 (7P-805)
Hoover, Frederick A., p.67 (7P-806)
Hope, B.C. - general views, p.29 (7P-312), p.117 (7P-1467)
Hope, Lois, p.67 (7P-807)
Hopetown, Ont. - general views, p.151 (7P-1854)
Hopetown (Ont.) - vues, p.14 (7P-171)
Hopewell Hill, (N.-B.) - vues, p.119 (7P-1275)
Hopewell Hill, N.B. - general views, p.119 (7P-1486)
Hôpital
 voir aussi
 Hôpitaux
Hôpital de l'Hôtel-Dieu de Québec (Québec), p.67 (171P-1)
Hôpitaux
 voir aussi
 Hôpital
Hôpitaux - Québec - Québec (Hôtel-Dieu), p.67 (171P-1)
Hoppé, E.O., p.152 (7P-1877)
Hopper, Wilfred, p.67 (7P-808)
Horetzky, Charles George, photo., p.9 (7P-82), p.22 (7P-1903), p.67 (7P-809)
Horetzsky, Roderick, p.123 (7P-1547)
Horetzsky, Sophia, p.123 (7P-1547)
Horn, John, p.67 (18P-33)
Hornby, John, photo., p.136 (7P-1716)
Hornell, David E., p.36 (7P-389)
Hornings Mill (Ont.) - vues, p.146 (7P-1796)
Horsdal, Paul, photo., p.67 (7P-810), p.78 (7P-960)
Horse Child, Cree Indian, p.36 (7P-384)
Horse Child, Cri, p.12 (7P-130)
Horse-racing - British Columbia - Fort Steele, p.140 (333P-24)
Horsethief Glacier, B.C. - general views, p.112 (7P-1395)
Horsey, E.M., p.67 (7P-812)
Horsey, H.I., Capt. the Rev., p.67 (7P-812)
Horsfield, Richard E., p.67 (7P-811)
Hosmer, B.C. - general views, p.18 (7P-221)
Hospitals - Alberta, p.1 (92P-2)

Hospitals - Alberta - Edmonton (military), p.110 (92P-18)
Hospitals - Alberta - Edmonton (University of Alberta), p.110 (92P-18), p.113 (92P-20)
Hospitals - British Columbia - New Denver (Slocan Community Hospital), p.140 (7P-1759)
Hospitals - England - Shorncliffe (Queen's Canadian Military Hospital), p.26 (7P-265), p.115 (7P-1435)
Hospitals - Nova Scotia, p.87 (1P-22), p.105 (1P-77)
Hospitals - Nova Scotia - Halifax, p.60 (1P-78)
Hospitals - Nova Scotia - Sydney, p.23 (1P-30)
Hospitals - Ontario - Ottawa (County of Carleton General Protestant Hospital), p.77 (7P-938)
Hospitals - Ontario - Toronto, p.32 (140P-1)
Hospitals - Quebec - Quebec (Hotel-Dieu), p.25 (7P-1950)
Hospitals - Saskatchewan - Moose Jaw (St. John The Divine), p.124 (7P-1554)
Hôtel de Ville de Montréal, Montréal (Québec), p.21 (7P-1910)
Hotels - Alberta - Banff (Banff Spring Hotel), p.117 (166P-48)
Hotels - Alberta - Banff (Banff Springs Hotel), p.110 (166P-13)
Hotels - British Columbia - Fort Steele (Commercial), p.47 (333P-39)
Hotels - British Columbia - New Westminster (Fraser Hotel), p.111 (334P-13)
Hotels - British Columbia - Rodger's Pass (Glacier House), p.62 (166P-27)
Hotels - Nova Scotia, p.105 (1P-77)
Hotels - Nova Scotia - Halifax (Queen), p.32 (1P-31)
Hotels - Ontario - Oakville, p.106 (47P-11)
Hotels - Ontario - Ottawa (Russell), p.20 (7P-242)
Hotels - Ontario - Toronto, p.48 (18P-55)
Hotels - Ontario - Toronto (Queen's), p.117 (18P-19)
Hotels - Québec - Sainte-Anne (Hotel de Tempérance), p.4 (134P-1)
Hotels - Saskatchewan - Radisson (Zimmerman Hotel), p.125 (7P-1566)
Hotels - Saskatchewan - Saskatoon (Bessborough), p.65 (339P-2)
Hotels - Saskatchewan - Saskatoon (Windsor Hotel), p.125 (7P-1566)
Hottah Lake Mines Ltd., N.W.T., p.130 (7P-1625)
Houde, Camilien, p.4 (7P-32), p.9 (7P-91), p.102 (7P-1290)
House, Philip, p.104 (7P-1315)
House of Memories Museum, Latchford, Ont., p.67 (7P-813)
Houses
 see also
 subdivision general views under name of cities
Houses - Ontario - Oakville, p.106 (47P-12)
Houses - Ontario - Toronto, p.32 (140P-3)
Houses - Saskatchewan, p.31 (7P-342)
Howard, Arthur L., Maj., p.19 (7P-232)
Howard, John, p.67 (7P-814)
Howard, John, and family, p.67 (10P-8)
Howard, John, photo., p.67 (10P-8)
Howe, Clarence Decatur, Hon., p.7 (7P-63), p.68 (7P-822), p.107 (7P-1295)
Howe, Joseph, Hon., p.71 (7P-862), p.71 (7P-862)
Howe Sound, B.C. - general views, p.67 (7P-803)
Howell, Alfred, p.63 (8P-5)
Howell, photo., p.75 (131P-6)
Howse, Albert Elgin and family, p.67 (12P-20)
Hubbard family, Ont., p.139 (7P-1743)
Huber, Emil, photo., p.3 (166P-43), p.14 (7P-160)
Hudon, Normand, p.43 (7P-480)
Hudson, H. Paul, p.68 (7P-815)

Hudson Bay - general views, p.20 (7P-253), p.31 (75P-5), p.142 (7P-1768)
Hudson Bay - settlement, p.120 (9P-64)
Hudson Strait Expedition, 1922-1928, p.23 (7P-1911)
Hudson's Bay Company, p.122 (92P-21)
Hudson's Bay Company, Cameron Bay, N.W.T., p.148 (7P-1820)
Hudson's Bay Company, p.17 (7P-200), p.21 (7P-262), p.34 (7P-367), p.92 (92P-15)
Hudson's Bay Fort, Edmonton, Alta., p.18 (13P-1)
Hudson's Bay Oil and Gas Company, N.W.T., p.5 (7P-41)
Huff, D.R., p.68 (7P-816)
Hughes, Nelson, p.68 (7P-817)
Hughes, Richard, p.68 (7P-818)
Hughes, Sam, Gen. Sir, p.95 (7P-1128)
Hughson, Gertrude E., p.68 (7P-819)
Hughson, Hugh M., Mrs., p.68 (7P-820)
Hughson and Company, p.68 (7P-819)
Hugill, John W., p.68 (1P-44)
Huguet-Latour, Maj., p.17 (7P-194)
Hull, Que. - fire, 1900, p.50 (7P-573), p.148 (7P-1823)
Hull, Que. - general views, p.35 (7P-376), p.57 (7P-677), p.72 (7P-880), p.78 (7P-961), p.79 (7P-969), p.114 (7P-1425), p.150 (7P-1859)
Humber River, Ont. - general views, p.71 (18P-78)
Humboldt, Sask. - general views, p.42 (7P-468)
Hume, John Alex, p.68 (7P-822)
Hume, John F., p.68 (12P-15)
Hume, John J., p.68 (7P-823)
Humphrys, Elizabeth, p.68 (7P-824)
Hungarians in Canada, p.145 (7P-1788)
Hungarians in Canada (Western), p.108 (7P-1342)
Hunt, George, p.68 (7P-825)
Hunter, A.W., p.68 (333P-5)
Hunter & Co., photo., p.68 (7P-829), p.72 (7P-874)
Hunter, George, photo., p.68 (7P-826)
Hunter, James Blake, p.68 (7P-827)
Hunter, Malcolm, p.28 (7P-297)
Hunter, Raoul, p.5 (7P-46)
Hunter, T., photo., p.58 (7P-696)
Huntingdon, Que. - general views, p.127 (7P-1586)
Huntington (C.-B.) - vues, p.25 (7P-1935)
Huntsville Lakes (SS), p.127 (8P-3)
Hupman, Mr., p.2 (7P-16)
Huron Expositor, Seaforth, Ont., p.68 (7P-828)
Hutterites au Manitoba, p.135 (7P-1699)
Hutterites in Alberta, p.132 (7P-1658)
Hutton, E.T.H., Maj. Gen., p.115 (7P-1447)
Hyack Festival - British Columbia - New Westminster, p.1 (334P-34)
Hydro-Electric Power Commission of Ontario, Ontario, p.131 (196P-41)
Hydro Quebec, Montreal, Que., p.134 (7P-1688)
Hydroelectric power generation - Canada, p.28 (7P-295), p.148 (7P-1825)
Hydroelectric power generation - Ontario, p.108 (316P-1)
Hyndman, R., Mrs., p.68 (7P-829)
Hynek, Barbara, p.68 (334P-17)
Hynes, P., photo., p.50 (200P-12)
Hynes, P.W., photo., p.142 (200P-8)

Icarus, Order of, p.68 (7P-830)
Icelanders in Manitoba, p.103 (9P-58)
Idaho (SS) U.C., p.150 (7P-1842)
Ide, V.R., p.68 (7P-831)
Igloolik, N.W.T. - general views, p.62 (7P-746)
Il Giornale Di Toronto (newspaper), p.59 (7P-713)

Ile-à-deux-Têtes (Québec) - vues, p.77 (131P-5)
Ile-aux-Coudres, Que. - general views, p.135 (7P-1697)
Ile-aux-Grues, Que. - general views, p.109 (7P-1366)
Ile-aux-Oies (Québec) - ferme des Augustines, p.6 (171P-2)
Ile d'Orléans, Que. - scenes, p.61 (8P-1)
Imlah, W.E., Capt., p.124 (7P-1550)
Imlah, W.E., Lt. Col., R.C.A., p.69 (134P-2)
Imperial Conference, London, England, p.78 (7P-960)
Imperial Economic Conference, Ottawa, Ont., p.79 (7P-975)
Imperial Japanese Navy, p.123 (7P-1534)
Imperial Life Assurance Co. of Canada, Vancouver, B.C., p.58 (7P-698)
Imperial Oil Ltd., Toronto, Ont., p.69 (7P-833)
Imperial Oil Ltd., Toronto, Ont.
 see also
 Aircraft - Imperial Oil Ltd.
Imperial War Cabinet, Londres, Angleterre, p.14 (7P-160)
Indes - vues, p.11 (7P-114)
Indians in Saskatchewan, p.54 (7P-635)
Indians, p.120 (9P-79)
Indians
 see also
 name of tribe
Indians - British Columbia, p.89 (7P-1167)
Indians - Canada - Six Nations Chiefs, p.16 (7P-196)
Indians - Sundance, p.152 (7P-1873)
Indians in Alberta, p.1 (13P-10), p.13 (13P-3), p.18 (13P-1), p.24 (7P-1940), p.68 (333P-5), p.84 (11P-2), p.108 (11P-3), p.114 (13P-2), p.134 (11P-6), p.139 (7P-1739), p.148 (166P-28), p.151 (166P-16)
Indians in British Columbia, p.22 (7P-1901), p.40 (18P-8), p.42 (333P-3), p.47 (12P-21), p.47 (333P-8), p.56 (7P-660), p.68 (333P-5), p.70 (334P-33), p.93 (12P-26), p.94 (16P-9), p.95 (7P-1117), p.114 (7P-1431), p.116 (334P-9), p.142 (7P-1769), p.145 (334P-27)
Indians in Canada, p.16 (8P-6), p.22 (7P-1904), p.28 (327P-4), p.49 (8P-8), p.98 (7P-1229), p.105 (327P-1), p.132 (7P-1657), p.148 (7P-1825)
Indians in Canada (Northern), p.45 (7P-507)
Indians in Manitoba, p.54 (7P-629)
Indians in Northwest Territories, p.2 (7P-13)
Indians in Nova Scotia, p.9 (104P-1), p.43 (1P-19), p.105 (1P-86)
Indians in Ontario, p.4 (8P-16), p.75 (7P-910), p.84 (7P-1032), p.103 (7P-1303), p.127 (7P-1582), p.140 (16P-18), p.148 (7P-1818)
Indians in Quebec, p.48 (7P-550), p.61 (7P-727), p.64 (327P-2)
Indians in Saskatchewan, p.56 (7P-664), p.59 (7P-710), p.125 (10P-2), p.152 (7P-1873)
Indians in the Yukon, p.153 (161P-1)
Indians in western Canada, p.100 (9P-57), p.108 (333P-4)
Indiens
 voir aussi
 le nom de la tribu
Indiens - Art, p.149 (7P-1839)
Indiens - danse du soleil, p.14 (7P-156), p.152 (7P-1873)
Indiens en Saskatchewan, p.152 (7P-1873)
Indiens en Alberta, p.24 (7P-1940)
Indo-China - general views, p.46 (7P-531)
Industrial Shipping Co., Mahone Bay, N.S., p.122 (1P-74)
Industry - Alberta, p.81 (7P-994), p.82 (7P-1006)
Industry - British Columbia, p.5 (334P-23), p.35 (334P-28), p.70 (334P-30), p.105 (334P-4), p.145 (334P-27)
Industry - Canada, p.28 (327P-4), p.105 (327P-1)

Industry - Canada (Western), p.61 (9P-26)
Industry - Manitoba, p.89 (9P-50)
Industry - New Brunswick, p.103 (2P-1)
Industry - Newfoundland, p.6 (7P-54)
Industry - Nova Scotia, p.7 (1P-28), p.63 (1P-26), p.105 (1P-88), p.106 (1P-50)
Industry - Ontario, p.106 (47P-7)
Industry - Prince Edward Island, p.84 (5P-1)
Industry - Québec, p.2 (7P-7), p.29 (7P-304)
Industry - Saskatchewan, p.99 (163P-1), p.125 (10P-7)
Information Canada, p.69 (7P-1946)
Ingall, Gertrude L., p.69 (7P-834)
Inglis, James, photo., p.27 (7P-268), p.53 (7P-617), p.59 (7P-704), p.69 (7P-835), p.70 (7P-855), p.92 (7P-1039), p.116 (7P-1460)
Ingonish, N.S. - general views, p.4 (7P-30)
Ingramport, N.S. - general views, p.49 (1P-36)
Innes, Tom W., p.5 (7P-46)
Innes family, N.S., p.117 (1P-73)
Innes-Taylor, Allan, p.69 (7P-837)
Inness, Ronald, p.69 (7P-836)
Innis, Harold Adams, p.69 (7P-838)
Innisfail, Alta. - general views, p.66 (13P-4)
Institut des sourd-muets
 voir aussi
 la subdivision au nom de l'endroit
Institut pour aveugles
 voir aussi
 la subdivision au nom de l'endroit
Institute of Child Study, Toronto, Ont., p.13 (196P-5)
Institutes - Manitoba - Brandon (Brandon Collegiate Institute), p.126 (7P-1579)
Institutes - Ontario - Ottawa (Lady Stanley Institute for Trained Nurses), p.77 (7P-938)
Institutions d'enseignement francophones du Nouveau-Brunswick, p.69 (15P-6)
Interior Decoration - Nova Scotia, p.105 (1P-84)
Interlake area, Man. - general views, p.129 (9P-83)
International Association of Machinists, Ottawa, Ont., p.69 (7P-842)
International Bitumen Co., p.51 (13P-13)
International Boundary Commission, p.37 (7P-396)
International Civil Aviation Organization, p.58 (7P-688)
International Civil Aviation Organization, photo., p.69 (7P-839)
International Congress of Archives, Extraordinary Congress, Washington, D.C., United States, p.77 (7P-945)
International Federation of Library Associations, Toronto, Ont., p.69 (196P-9)
International Federation of University Women, p.27 (7P-278)
International Fisheries Exhibition, p.23 (7P-1917)
International Geological Congress, p.103 (7P-1306)
International Grenfell Association, Ottawa, Ont., p.69 (7P-840)
International Harvester Co. of Canada, Hamilton, Ont., p.56 (7P-672), p.69 (7P-841)
International Joint Commission, p.87 (7P-1145)
International Labour Congress, Geneve, 1938, p.10 (7P-109)
International Labour Organization, p.23 (7P-1928)
International Labour Organization, Geneva, Switzerland, p.69 (7P-843)
International Labour Organization Week, Montreal, Que., 1967, p.69 (7P-843)
International Marine Signal Co., Ottawa, Ont., p.121 (7P-1510)
International Nickel Company, p.10 (7P-103)
International Nickel Company, N.W.T., p.5 (7P-41)
International Stereoscopic View Co., photo., p.112 (7P-1399)
Interprovincial Conference, Ottawa, Ont., p.114 (7P-1427)
Inuit, p.7 (16P-2), p.18 (13P-1), p.96 (7P-1195)

Inuit - Arctic, p.7 (16P-2), p.140 (16P-18)
Inuit à la Baie D'Hudson, p.11 (7P-118)
Inuit au Groenland, p.16 (7P-190)
Inuit in Alaska, p.82 (11P-1)
Inuit in Canada, p.13 (12P-22), p.22 (7P-1904), p.28 (327P-4), p.98 (7P-1229)
Inuit in Canada (Northern), p.23 (7P-1938), p.45 (7P-507)
Inuit in Labrador, p.102 (7P-1289)
Inuit in Northwest Territories, p.55 (7P-651), p.62 (7P-746), p.83 (7P-1020), p.91 (7P-1187), p.114 (327P-3)
Invermere, B.C. - general views, p.68 (333P-5), p.77 (333P-41)
Irish, King and family, p.69 (7P-844)
Iron industry and trade - British Columbia, p.124 (334P-21)
Iron industry and trade - Nova Scotia, p.152 (31P-96)
Iron Mining - Newfoundland - Bell Island, p.44 (38P-3)
Iroquois, Ont. - general views, p.68 (7P-816), p.124 (7P-1549), p.128 (7P-1597)
Iroquois (Ont.) - vues, p.10 (7P-97)
Irvin, Dick, p.93 (7P-1071)
Irvine, A.G., Capt., p.77 (7P-935)
Irvine, Del, p.111 (7P-1382)
Irvine, John A., photo., p.69 (1P-18)
Irvine, L., photo., p.153 (161P-1)
Irvine, W. Robert, p.69 (7P-845)
Irvine, William, p.109 (7P-1352)
Irvine, John George, Lt. Col., p.93 (7P-1081)
Irving, George Frederick, p.69 (7P-846)
Irving House Historic Centre, New Westminster, B.C., p.70 (334P-30)
Irwin, A., Mrs., p.70 (7P-847)
Isaac, Michael V., p.70 (1P-21)
Isaacs, A.C. photo., p.54 (7P-635)
Isabelle, Laurent, p.70 (303P-13)
Isle of Skye, Scotland - general views, p.15 (123P-9)
Isom, E.W., Mrs., p.70 (7P-848)
Isom, E.W., photo., p.70 (7P-848)
Israel-Wizo, Israel, p.28 (7P-282)
Italians in British Columbia, p.137 (7P-1733)
Italians in Canada, p.102 (7P-1292)
Italians in Ontario, p.40 (7P-436)
Italians in Toronto, p.59 (7P-711), p.59 (7P-713), p.83 (7P-1019), p.111 (7P-1387), p.114 (7P-1421)
Italic - vues, p.124 (185P-13)
Italiens en Ontario, p.98 (7P-1230)
Italy - general views, p.31 (7P-331), p.129 (7P-1622)
Itey, Pierre, photo., p.4 (131P-9)
Itomlenski, Alexander, p.70 (7P-849)
Ives, Burl, p.113 (7P-1411)
Iveson, Frank, p.70 (7P-850)

J.A. McKee (C.G.S.), p.119 (7P-1490)
Jack, p.70 (334P-33)
Jackfish, Ont. - general views, p.129 (7P-1619)
Jackson, A.Y., p.7 (16P-2), p.62 (7P-748)
Jackson, J.F., photo., p.57 (7P-686)
Jackson, J.R., Mrs., p.70 (7P-852)
Jackson, John R., p.70 (7P-851)
Jackson, R.E., p.70 (7P-853)
Jackson Point, Ont. - general views, p.124 (7P-1549)
Jacobs, Capt., p.70 (7P-854)
Jacobson, Leon, p.70 (7P-855)
Jamaica - general views, p.18 (45P-6)

James, George R., photo., p.4 (8P-16)
James, George W., photo., p.27 (7P-288), p.70 (7P-856)
James, Reginald Heber, Maj., p.70 (7P-857)
James & Son, photo., p.123 (7P-1539)
James, W.J., photo., p.70 (10P-10)
James, William, p.70 (140P-15)
James Swift (SS), p.98 (7P-1225), p.147 (7P-1813)
Jameson, James, photo., p.4 (8P-16)
Jamieson, E.L., p.71 (7P-858)
Jamieson, Elmer, p.71 (166P-38)
Jandrew, Cyrus B., Mrs., p.71 (7P-859)
Janes, Simeon Heman, p.71 (18P-63)
Japan - general views, p.47 (75P-6), p.91 (16P-13), p.95 (196P-39), p.102 (7P-1279)
Japanese in Alberta, p.104 (7P-1312)
Japanese in British Columbia, p.53 (7P-612), p.91 (7P-1181), p.98 (7P-1235), p.98 (7P-1236), p.118 (7P-1484), p.139 (7P-1748)
Japanese in Manitoba, p.23 (7P-1928)
Japanese in Ontario, p.53 (7P-612)
Japanese Students Christian Association of North America, Vancouver Chapter, p.98 (7P-1236)
Japanese Vegetable Farmers' Cooperative, Lethbridge, Alta., p.104 (7P-1312)
Japon - vues, p.11 (7P-114)
Japonnais en Colombie-Britiannique, p.17 (7P-208)
Jarché, A.L., photo., p.58 (7P-693)
Jarraud, Frenchie, p.43 (7P-480)
Jarvis, A.H., Bookstore, Ottawa, Ont., p.71 (7P-861), p.71 (7P-861)
Jarvis, Alan, p.27 (7P-274)
Jarvis, Ann Frances, p.71 (7P-860)
Jarvis, Catherine G., p.71 (7P-861), p.71 (7P-861)
Jarvis, Edward Aemilius, p.71 (7P-862), p.71 (7P-862)
Jarvis, J.J., photo., p.12 (7P-135), p.15 (7P-168)
Jarvis, Julia, p.71 (7P-863), p.71 (7P-863)
Jarvis, Ont. - general views, p.40 (7P-435)
Jarvis, Samuel J., photo., p.17 (7P-202), p.20 (7P-248), p.22 (7P-1896), p.57 (7P-686), p.61 (7P-724), p.64 (7P-771), p.71 (7P-864), p.72 (7P-880), p.114 (7P-1428), p.127 (7P-1581), p.151 (7P-1866)
Jarvis, Stephen, Col., p.96 (7P-1204)
Jarvis Collegiate Cadet Corps, p.87 (196P-10)
Jarvis River, Yukon - general views, p.42 (7P-459)
Jarvis Studio, photo., p.74 (7P-899)
Jasper, Alta. - general views, p.13 (13P-3)
Jasper National Park, Alta. -general views, p.45 (166P-35), p.62 (166P-7)
Jaworski, Joachim (Jack), p.71 (7P-865)
Jean, J.A. Albert, Cie. Ltee, Montreal, Que., p.71 (7P-866)
Jefferson, Harry, photo., p.71 (18P-78)
Jenkins, famille, Ont., p.92 (7P-1049)
Jenkins, Frank Tristram, p.71 (7P-867)
Jenness, Diamond, photo., p.3 (7P-23)
Jennings, p.71 (334P-42)
Jennings, Maggie, p.126 (7P-1571)
Jennings, William, p.71 (7P-868)
Jessop, Cyril, photo., p.71 (9P-31), p.90 (7P-1180), p.114 (7P-1422)
Jewell family, B.C., p.71 (333P-2)
Jewell Lumber Mill, Fort Steele, B.C., p.71 (333P-2)
Jewett, B.L., Dr., p.71 (7P-872)
Jewish Community, Montreal, Que., p.34 (7P-365)
Jewish Historical Society of Western Canada Inc., Winnipeg, Man., p.71 (305P-1), p.71 (9P-32)
Jewish Labour Committee, p.73 (7P-888)
Jewish Labour Committee of Canada, p.108 (7P-1348)
Jewish National Fund of Canada, p.72 (7P-869)
Jewish Public Library, Montreal, Que., p.72 (7P-870)
Jewish War Veterans of Canada, Montreal, Que., p.72 (7P-871)

Jewitt, William Gladstone, p.72 (7P-873)
Jews in Canada (Western), p.71 (305P-1), p.71 (9P-32), p.122 (7P-1524)
Jews in Europe (Eastern), p.71 (305P-1)
Jews in Manitoba, p.122 (7P-1524)
Jews in Ontario, p.22 (7P-1906), p.45 (7P-509), p.109 (7P-1359)
Jews in Saskatchewan, p.31 (7P-339), p.102 (7P-1282), p.122 (7P-1524), p.135 (7P-1701)
Jim, Skookum, p.69 (7P-841)
Joan Perkal Rouks, Sherman Oaks, Calif., p.72 (7P-1404)
Joannidi, S.N.C., p.72 (9P-33)
Jobin, Dennis T., p.72 (7P-874)
Jobin, Louis, p.61 (8P-1)
Jockey Club, Toronto, Ont., p.70 (140P-15)
Joel, Miss, p.72 (7P-875)
Johanneson, Herman "Jack Rabbit", p.28 (7P-297)
Johansen, Fritz, photo., p.3 (7P-23)
Johnson, Albert, p.104 (7P-1318)
Johnson, Daniel, Hon., p.13 (7P-145)
Johnson, David, p.72 (7P-876)
Johnson, Duncan, p.75 (31P-50)
Johnson, E.L., photo., p.48 (7P-552)
Johnson, Eric Arthur, p.72 (7P-877)
Johnson, Henry A., p.72 (7P-878)
Johnson, Herbert Stanley, p.72 (9P-34)
Johnson, John, and family, p.61 (7P-724)
Johnson, Lyndon Baines, p.45 (7P-502)
Johnson, Pauline, p.10 (7P-110), p.46 (7P-525), p.132 (7P-1649)
Johnson, William Main, p.72 (18P-90)
Johnston, Clifford M., photo., p.72 (7P-879)
Johnston, G., photo., p.153 (161P-1)
Johnston, Margot, p.72 (7P-881)
Johnston family, Ont., p.72 (7P-880)
Johnstone, Barbara, p.72 (9P-35)
Joliffe, Fred, p.130 (7P-1625)
Joly de Lotbinière, Henri Gustave, Sir et famille, p.8 (7P-70)
Jones, A.G.E., p.72 (7P-882)
Jones, Art, p.7 (7P-63)
Jones, Arthur Stanley, p.72 (18P-97)
Jones, Colin, photo., p.73 (7P-883)
Jones, Francis, p.72 (7P-884)
Jones, H.W., Mrs., p.73 (12P-13)
Jones, J.G., p.73 (9P-36)
Jones, J.L., photo., p.51 (7P-593), p.72 (7P-884), p.78 (7P-956), p.80 (7P-990), p.82 (134P-3)
Jones, Jacobin, p.63 (8P-5)
Jones, W.D., p.33 (7P-353)
Jones, Yardley, p.5 (7P-46)
Jones family, p.73 (196P-6)
Jones family, Ont., p.72 (7P-884)
Jong, Klaas de, and family, p.76 (9P-80)
Jonquiere (H.M.C.S.), p.149 (7P-1833)
Jordan, Henri Kew, p.73 (149P-12)
Jordan, John, p.43 (7P-475)
Jordan River Lumber Co., Victoria, B.C., p.126 (12P-14)
Jordon, Mabel, p.73 (333P-11)
Joss, Robert A., p.73 (7P-885)
Journée nationale du film parlant français, Montreal, Que., p.79 (7P-964)
Juan De Fuca Strait, B.C. - general views, p.95 (7P-1117)
Judd, William Wallace, p.73 (18P-93)
Juliana, Reine Des Pays - Bas, p.107 (7P-1295)
Julianeshaab, Groenland - vues, p.16 (7P-190)
Juneau, Alaska - general views, p.74 (7P-898)
Jupp, Ursula, p.73 (12P-10)
Jutra, Claude, p.135 (7P-1708)

Kaeble, Joseph, Cpl., p.82 (7P-1013)
Kaellgren, Peter, p.73 (7P-886)
Kahrs, W.H., photo., p.72 (7P-874)
Kahshe (SS), p.127 (8P-3)
Kakabeka Falls, Ont. - general views, p.27 (7P-280)
Kalen, Henry, photo., p.22 (7P-1898)
Kaministiquia Power Co., Kakabeka Falls, Ont., p.57 (7P-687)
Kamloops, B.C. - general views, p.73 (91P-1), p.104 (8P-7)
Kamloops (C.-B.) - vues, p.12 (7P-134)
Kamloops Museum Association Collection, Kamloops, B.C., p.73 (91P-1)
Kamouraska, Que. - general views, p.64 (123P-4)
Kananaskis Valley, Alta. - general views, p.71 (166P-38)
Kangas, Victor, and family, p.73 (7P-887)
Kaplansky, Kalmen, p.73 (7P-888)
Kapuskasing, Ont. - general views, p.145 (7P-1786)
Kapustiansky, Myron, Gen., p.127 (7P-1587)
Karachun, Doris, p.73 (7P-889)
Karluk (H.M.C.S.), p.23 (7P-1974)
Karsh, Yousuf, photo., p.11 (7P-122), p.22 (7P-1905), p.26 (7P-264), p.36 (7P-391), p.43 (7P-476), p.53 (7P-623), p.55 (7P-642), p.55 (7P-655), p.69 (7P-1946), p.73 (7P-890), p.74 (7P-909), p.80 (7P-979), p.80 (95P-1), p.109 (7P-1359), p.109 (7P-1362), p.114 (7P-1425), p.126 (196P-16), p.126 (7P-1577), p.132 (7P-1662)
Karsh et Gaby, photo., p.1 (7P-4)
Katholy, Karl, p.73 (200P-19)
Katnich, Steven, p.73 (7P-891)
Kaufmanis, Rusins, p.5 (7P-46)
Kaufmann, Hans, p.73 (166P-39)
Kavanagh, photo., p.75 (131P-6)
Kawartha (Ont.) - vues, p.13 (7P-149)
Kawartha (SS), p.127 (8P-3)
Kay, Dave, p.73 (333P-14)
Kaye (Kysilewsky), Vladimir Julian, Dr., p.73 (7P-892)
Kearney, James, p.20 (7P-243)
Kearney, John D., p.73 (7P-893)
Kearney Lake, N.S. - general views, p.98 (1P-48)
Keefer, Allen, p.55 (7P-642), p.85 (7P-1068)
Keefer, C.H., and family, p.85 (7P-1068)
Keefer, Charles A., photo., p.73 (7P-894)
Keefer, George, p.104 (7P-1310)
Keefer, Samuel, p.74 (7P-895), p.74 (7P-896)
Keefer family, Ont., p.85 (7P-1068)
Keen, George, p.74 (7P-897)
Keene, Ont. - general views, p.30 (7P-326), p.75 (7P-911), p.86 (7P-1097), p.112 (7P-1406)
Keene Lumber Mill, Lang, Ont., p.46 (7P-533)
Keewatin (SS), p.35 (7P-381)
Keighley, Geoffrey, p.54 (7P-628)
Keir, Ernest F., photo., p.74 (7P-898)
Keith, Gerald, p.74 (7P-899)
Keller, Helen, p.78 (7P-951)
Kelley, Viola, p.74 (7P-900)
Kelley and Co., photo., p.43 (1P-33), p.49 (1P-36), p.58 (1P-39)
Kelly, W.P., photo., p.81 (7P-1003)
Kelly and Co., photo., p.69 (1P-18)
Kelowna, B.C. - general views, p.132 (7P-1665)
Kelso, John Joseph, p.74 (7P-901)
Kelso, Ont. - general views, p.2 (7P-14)
Keltic Lodge, Ingonish, N.S., p.106 (1P-94)
Kemerobo, U.S.S.R., p.51 (31P-118)
Kemp, A.T., Mrs., p.74 (7P-902)
Kemp, E., Sir, p.24 (7P-1918)
Kempton, Gilbert, p.74 (31P-87)
Kemptville, Ont. - general views, p.94 (7P-1099)
Kendrick, H.J., p.74 (7P-903)
Kennebecasis River, N.B. - general views, p.145 (7P-1775)

Kennedy, Jacqueline, p.14 (7P-163)
Kennedy, John, p.7 (7P-67)
Kennedy, John Fitzgerald, p.14 (7P-163)
Kennedy, Leo, and family, p.74 (7P-904)
Kennedy, M., p.74 (333P-38)
Kennedy, Margaret, photo., p.74 (9P-37)
Kennedy, photo., p.79 (7P-971)
Kennedy, Roderick, p.33 (7P-353)
Kennedy, William Nassau, Lt. Col., p.89 (7P-1158)
Kennelly, Hazel Loreen M., p.74 (196P-7)
Kenney, Charles W., Mrs., p.74 (7P-905)
Kenney, James Francis, p.74 (7P-906)
Kenny, Brendan J., p.74 (38P-7)
Kenny, Randall Y., p.74 (7P-907)
Keno (SS), p.9 (7P-94)
Kenosee Lake, Sask. - general views, p.50 (7P-579)
Kentville, N.S. - general views, p.5 (1P-27)
Kerr, John, and family, p.74 (9P-38)
Kerr, John Andrew, p.74 (7P-908)
Kerr, Mark, Lord, p.48 (7P-548)
Kerr, Muriel, p.74 (7P-909)
Kershaw family, B.C., p.75 (333P-7)
Ketchum, Henry, G.C., photo., p.65 (7P-782)
Keystone View Co., photo., p.4 (131P-9)
Kiborn, Frank G., photo., p.112 (7P-1401)
Kidd, J.P., p.94 (7P-1114)
Kidd, Kenneth Earl, p.75 (7P-910)
Kidd, Martha Ann, p.75 (7P-911)
Kidd, W.L., p.75 (7P-912)
Kierans, Eric William, p.75 (7P-913)
Kierzkowski family, Que., p.122 (7P-1520)
Kilburn, B.W., photo., p.64 (7P-762), p.110 (7P-1374), p.112 (7P-1399)
Killam, Thomas, p.75 (31P-50)
Kindle, Edward Martin, p.75 (7P-914)
King, Andrew, p.75 (1P-71)
King, Donna, p.75 (7P-915)
King, Ont. - general views, p.75 (7P-919)
King, S., photo., p.2 (7P-14)
King, W.F., p.75 (131P-6)
King, W.M. and family, p.75 (47P-4)
King, William Lyon Mackenzie, Rt. Hon., p.22 (7P-1905), p.30 (7P-329), p.45 (7P-501), p.53 (7P-613), p.66 (7P-790), p.68 (7P-822), p.75 (7P-916), p.78 (7P-953), p.78 (7P-960), p.79 (7P-972), p.81 (7P-1002), p.96 (7P-1191), p.97 (8P-13), p.100 (7P-1264), p.104 (7P-1314), p.135 (7P-1707), p.140 (7P-1756)
King, William Lyon Mackenzie, Très Hon., p.3 (7P-18), p.14 (7P-160), p.18 (7P-220), p.107 (7P-1295), p.109 (7P-1360), p.151 (7P-1861)
King Edward (Bâteau à vapeur), p.75 (131P-6)
King William Island, N.W.T. -Franklin Expedition, p.36 (7P-392)
Kingfisher (H.M.S.), p.110 (7P-1374)
Kings College, Windsor, N.S., p.75 (31P-49)
Kings College Dramatic Club, Halifax, N.S., p.148 (31P-59)
Kings College School and Students, Windsor, N.S., p.110 (1P-51)
Kingsford, William, p.75 (7P-917), p.78 (7P-951)
Kingsmere, Que. - general views, p.28 (7P-297)
Kingston, Ont. - general views, p.29 (7P-307), p.37 (7P-398), p.38 (7P-414), p.40 (7P-435), p.45 (7P-508), p.63 (7P-753), p.70 (7P-854), p.75 (75P-12), p.87 (7P-1134), p.92 (7P-1039), p.94 (7P-1099), p.101 (7P-1267), p.104 (8P-7), p.115 (75P-14), p.132 (7P-1652)
Kingston, Ont. - individuals, p.75 (75P-12)
Kingston Co., Ont. - general views, p.63 (75P-11)
Kingston (Ont.) - vues, p.24 (7P-1916)
Kingston (SS), p.40 (7P-435)
Kinnear, A. Muriel, p.75 (7P-918)
Kinnear, James G., p.75 (7P-919)
Kinnears Mills, Que. - general views, p.75 (7P-919)
Kinney, J.E., Captain, p.111 (31P-68)
Kino (SS), p.147 (7P-1809)
Kinred, Sheila, p.75 (31P-50)

Kinsey and Kinsey, photo., p.81 (7P-1003), p.153
(161P-1)
Kipp, Yvonne, p.75 (7P-920)
Kirby, Ont. - general views, p.103 (7P-1304)
Kirk, Elsie, p.76 (334P-26)
Kirk, H.T., and family, p.76 (334P-26)
Kirkland Lake, Ont. - general views, p.54
(7P-635), p.118 (7P-1473), p.119 (7P-1492),
p.140 (16P-18)
Kirks Ferry, Que. - general views, p.61 (7P-730)
Kirks Ferry (Québec) - vues, p.18 (7P-251)
Kirkwood, Alex, p.101 (7P-1276)
Kirkwood, Kenneth Porter, p.76 (7P-921)
Kirst, Cora, p.150 (7P-1856)
Kirwan, John, p.76 (7P-922)
Kitchen, Ruth, p.76 (7P-923)
Kitsilano Beach, B.C. - general views, p.91
(7P-1183)
Kitwanga, B.C. - general views, p.52 (12P-5)
Klein, Abraham Moses, p.76 (7P-924)
Klengenberg family, p.135 (7P-1696)
Klondike, Yukon - general views, p.2 (7P-13), p.28
(327P-4), p.69 (7P-837), p.140 (16P-18)
Klondike, Yukon - Gold Rush, p.18 (13P-1), p.21
(7P-262), p.33 (7P-349), p.38 (7P-406), p.38
(7P-409), p.57 (7P-675), p.69 (7P-841), p.71
(7P-872), p.74 (7P-898), p.81 (7P-1003),
p.147 (7P-1809), p.153 (161P-1)
Klondike, Yukon - scènes, p.24 (7P-1909)
Klondike Days Parade, p.47 (13P-8)
Klondike (SS), p.2 (7P-13), p.9 (7P-94), p.16
(7P-192), p.147 (7P-1809)
Klotz, Oskar, Dr., p.76 (7P-925)
Kluane Lake, Yukon - general views, p.42
(7P-459)
Knapp, Martha de Jong, p.76 (9P-80)
Knickle, Wilfred, and family, p.84 (31P-76)
Knicle, J.E., photo., p.122 (1P-74)
Knight, Col., and family, p.133 (7P-1675)
Knight, Stanley Neil, p.56 (7P-662), p.76 (7P-926)
Knights of Pythias - British Columbia - New
Westminster, p.36 (334P-7)
Knowles, Robert, p.150 (7P-1848)
Knowles, Stanley Howard, p.76 (7P-927)
Knox, Wilbert George Melvin, p.76 (7P-929)
Knox College, Toronto, Ont., p.76 (317P-3), p.76
(317P-4)
Knox College, Toronto, Ont.
see also
Colleges - Ontario - Toronto
(Knox college)
Knox Presbyterian Church
see also
Churches
Knox Presbyterian Church, Manotick, Ont., p.76
(7P-928)
Kobau (Mount), B.C. - general views, p.140
(7P-1752)
Kohashigawa, K., p.76 (7P-930)
Komagata Maru (SS), p.25 (7P-1970)
Kootenay, B.C. - general views, p.18 (333P-10),
p.68 (333P-5), p.101 (333P-18), p.120
(333P-13)
Kootenay District, B.C. - scenes, p.68 (12P-15)
Kootenay Indians, p.42 (333P-3), p.47 (333P-8),
p.68 (333P-5), p.152 (333P-27)
Kootenay National Park, B.C. - general views,
p.125 (166P-2)
Kootenay River, B.C. - general views, p.47
(333P-8)
Korea - general views, p.91 (16P-13)
Korean Conflict, p.23 (7P-1976)
Kouri, P.J., p.76 (7P-931)
Krasnopera, Charles, photo., p.140 (7P-1761)
Kresz, Geza de, p.61 (7P-731)
Krieber, Hans Johann, photo., p.76 (7P-932)
Krieghoff, Cornelius, p.75 (7P-918), p.86
(7P-1110)

Kuehner, Martha, p.49 (7P-572)
Kysilewska, Olena, p.73 (7P-892), p.76 (7P-933)

La Have Outfitting Co., La Have, N.S., p.76
(31P-77)
La Malbaie (H.M.C.S.), p.41 (7P-454)
La Marco, A.J., p.76 (7P-942)
La Pocatière (Québec) - individus, p.134 (348P-1),
p.134 (349P-1)
La Pocatière (Québec) - vues, p.134 (349P-1)
La Presse Canadienne, photo., p.96 (7P-1193)
La Rocque, Alfred Chevalier de, p.76 (7P-965)
La Rocque, Antoine-B., and family, p.76 (7P-965)
La Ronde, Cape, N.S. - general views, p.84
(7P-1035)
La Société historique du comté de Shefford,
Granby (Québec), p.77 (344P-1)
La Vigilance (flying boat), p.79 (7P-975)
Laberge, Albert, p.77 (185P-16), p.77 (7P-934)
Laberge (Lake), Yukon - general views, p.135
(7P-1695)
Laboratories - Alberta (Provincial), p.110 (92P-18)
Labour-Progressive Party of Canada, p.29 (7P-303)
Labour Unions, p.73 (7P-888), p.108 (7P-1348),
p.141 (7P-1766), p.141 (7P-1767)
Labour Unions - Nova Scotia, p.106 (31P-116),
p.107 (31P-115), p.114 (31P-117)
Labrador - scenes, p.25 (7P-1952), p.41 (31P-82),
p.69 (7P-840), p.87 (7P-1145), p.126
(7P-1579)
Labrador - settlement, p.129 (7P-1620)
Lac
voir
le nom du lac
Lac de Saint-Maurice, Sask. -general views, p.50
(7P-579)
Lac-des-Isles, Que. - general views, p.64 (123P-4)
Lac du Petit Poisson Blanc (Qué) - vues, p.141
(303P-3)
Lac Edouard, Que. - general views, p.117 (!8P-6)
Lac-Saint-Jean (Québec) - vues, p.80 (131P-4)
Lacasse (famille), p.77 (185P-2)
Lachance, Vernon, Const., p.77 (7P-935)
Lachance-Mercier, E., p.4 (134P-1)
Lachine, Que.; - general views, p.2 (7P-10)
Lachine, Que. - scenes, p.61 (8P-1)
Lachine Canal, Que. - general views, p.128
(7P-1605)
Lachine (Québec) - vues, p.25 (7P-1935)
Lachine Rowing Club, Lachine Que., p.27
(7P-267)
Lachute, Que. - general views, p.37 (7P-397)
Lackner, M., p.77 (7P-936)
Lacombe, Alta. - general views, p.21 (11P-9)
Ladder Lake, Sask. - general views, p.137
(7P-1726)
Lady Drummond, p.100 (123P-3)
Lady Grey (icebreaker), p.44 (7P-497)
Lady Grey (SS), p.135 (7P-1710)
Lady Head (ship), p.103 (7P-1303)
Lady of the Lake (SS), p.49 (8P-8)
Lady Rodney (SS), p.148 (7P-1822)
Lady Stanley Institute Nurses' Alumni, Ottawa,
Ont., p.77 (7P-938)
Ladysmith, B.C. - general views, p.132 (7P-1661)
Ladysmith, Ont. - general views, p.39 (7P-420)
Ladysmith, Que. - general views, p.71 (7P-859)
Lafayette, photo., p.14 (7P-160), p.112 (7P-1398)
Lafferty, Victor, p.77 (7P-939)
Laflamme, Joseph Clovis Kemner, Mgr, p.77
(131P-5)
Laforce, Marcel, p.77 (7P-940)

L'Africain, Eugène, p.105 (123P-5)
Laing, Arthur, Hon., p.6 (7P-52)
Laing, H.M., photo., p.3 (7P-23)
Laird David, Hon., and family, p.29 (7P-312)
Lajeunesse, photo., p.75 (131P-6)
Lake
see also
name of lake
Lake Buntzen Power Plant, Burrard Inlet, B.C.,
p.65 (12P-4)
Lake family, B.C., p.77 (333P-41)
Lake Harbour, N.W.T. - general views, p.126
(7P-1570)
Lake Magnetawan (SS), p.127 (8P-3)
Lake Memphremagog, Que. - general views, p.64
(7P-766), p.104 (8P-7)
Lake Nipissing (SS), p.127 (8P-3)
Lake of Bays (SS), p.127 (8P-3)
Lake of the Woods - general views, p.81 (7P-994)
Lake of the Woods, Ont. - general views, p.23
(7P-1938)
Lake of 1,000 Islands, Que. -general views, p.64
(123P-4)
Lake Simcoe (SS), p.127 (8P-3)
Lake Superior, Ont. - general views, p.105
(123P-5)
Lake Temiscamingue (SS), p.127 (8P-3)
Lake Timagami (SS), p.127 (8P-3)
Lakefield, Ont. - general views, p.75 (7P-911),
p.110 (7P-1374), p.140 (7P-1758)
Lakeside Park, Oakville, Ont., p.106 (47P-14)
Laliberté, Alfred, p.61 (8P-1), p.63 (8P-5), p.109
(7P-1368), p.127 (7P-1583)
L'Alliance canadienne, Toronto, Ont., p.77
(7P-941)
Lalonde & Son, photo., p.149 (7P-1828)
Lamarre-Lacourse, Germaine, p.77 (185P-5)
Lamarsh, Judy, Hon., p.27 (7P-272)
Lamb, Eileen, photo., p.77 (7P-943)
Lamb, Henry John, p.77 (7P-944)
Lamb, William Kaye, Dr., p.77 (7P-945)
Lambart, Evelyn, p.77 (7P-946)
Lambart, F.H.J., and family, p.77 (7P-946)
Lambart, H., p.77 (7P-947)
Lambert, Augustin Emanuel, p.78 (7P-948)
Lamberti, Carlo, p.78 (7P-949)
Lambi, John, p.64 (333P-21)
Lambton, Alice, Lady, p.48 (7P-548)
Lamont, Alta. - general views, p.7 (13P-5)
Lamoureux, Wilfred L., p.78 (7P-950)
Lampman, Archibald, p.33 (7P-350), p.78
(7P-951), p.145 (7P-1787)
Lanark, Ont. - general views, p.71 (7P-858), p.93
(7P-1063), p.94 (7P-1090), p.150 (7P-1856),
p.151 (7P-1854)
Lanark County Museum, Lanark, Ont., p.78
(7P-952)
Lanark (Ont.) - vues, p.14 (7P-171) ·
Lancaster, Ont. - scenes, p.8 (8P-11)
Lance, Beatrice (Longstaff), photo., p.78 (166P-37)
Lancefield, G.B., photo., p.110 (7P-1370), p.121
(7P-1511)
Lancefield, G.R., photo., p.52 (7P-599), p.70
(7P-853)
Lancefield Abell Ltd., photo., p.152 (7P-1884)
Lanctôt, Gustave, p.78 (303P-11)
Lanctôt, Gustave, Maj., p.60 (7P-716), p.78
(7P-953)
Landry, Armour, photo., p.30 (326P-1)
Lane, photo., p.115 (7P-1439)
Lang, Ont. - general views, p.46 (7P-533)
L'Ange-Gardien (Québec) - vues, p.11 (131P-2)
Langevin, Edouard-Joseph, and family, p.78
(7P-954)
Langevin, Hector Louis, Sir, p.78 (7P-954), p.78
(7P-955)
Langton, H.H., p.144 (196P-13)
Languedoc, Adele De Guerry, p.78 (7P-956)
Lansdale, Robert, p.78 (196P-47)

Lansdown House (Ont.) - vues, p.17 (7P-200)
Lansdowne, Henry Charles Keith,
 Petty-Fitzmaurice, Marquess of, p.115
 (7P-1447)
Lansdowne, Henry Charles Keith
 Petty-Fitzmaurice, Marquess of, p.78 (7P-957)
Lantern slides, p.4 (32P-1), p.54 (7P-635), p.85
 (7P-1091), p.86 (16P-10), p.149 (16P-20)
Lantern Slides
 see also
 Diapositives de projection
Lanthier, Joseph Antonio, p.78 (7P-958)
Lapalme, Béatrice, p.109 (7P-1368)
LaPalme, Robert, p.5 (7P-46)
Lapierre, André, p.78 (185P-10)
Lapierre, Dorothy, p.78 (1P-45)
Laplante, Oswald, p.78 (7P-959)
Lapointe, Ernest, Hon., p.68 (7P-822), p.78
 (7P-960)
Lapointe, Pierre-Louis, p.78 (7P-961)
Laport, Edmund Abner, p.78 (7P-962)
Laprairie, Que. - general views, p.34 (7P-362)
Larden, A.W.J., p.79 (7P-963)
Larente, Arthur, p.79 (7P-964)
Larkin, photo., p.153 (161P-1)
Larose (Chutes)
 voir
 Saint Féréol (Québec) -vues
Larsen, Henry Asbjorn, p.79 (7P-966)
Larsen, Ole, photo., p.79 (46P-4)
Larson, E.G., p.79 (7P-967)
Larss, photo., p.24 (7P-1909)
Larss and Duclos, photo., p.153 (161P-1)
Larue, Juge, p.96 (7P-1201)
Lascelles, Jessie L., p.79 (7P-968)
Laskin, Bora, Hon., p.56 (7P-661)
Latchford, Francis Robert, p.79 (7P-969)
Latchford, Ont. - general views, p.67 (7P-813)
Laterrière, Marie, photo., p.4 (131P-9)
Lathe, photo., p.53 (7P-623)
Laubach, Grace, p.79 (7P-970)
Lauder, Man. - general views, p.113 (7P-1415)
Laughlin, J.R., photo., p.55 (131P-1)
Laurentide Air Services Ltd., p.144 (7P-1773)
Laurentide Inn, Grand'Mere, Que., p.110
 (7P-1374)
Laurie, John Wimburne, p.118 (7P-1477)
Laurier, Henri, p.79 (7P-971)
Laurier, Henri Wilfrid, p.79 (7P-973)
Laurier, Robert, p.79 (7P-973)
Laurier, Wilfrid, Sir, p.7 (31P-99), p.26 (7P-1971),
 p.43 (7P-483), p.43 (7P-485), p.45 (7P-508),
 p.54 (7P-635), p.56 (7P-668), p.57 (7P-685),
 p.61 (8P-1), p.64 (7P-763), p.66 (7P-796),
 p.67 (7P-813), p.79 (7P-971), p.79 (7P-972),
 p.79 (7P-974), p.81 (7P-1002), p.98
 (7P-1227), p.102 (7P-1284), p.110 (7P-1374),
 p.112 (7P-1394), p.114 (7P-1428), p.115
 (7P-1439), p.121 (7P-1511), p.126 (7P-1575),
 p.127 (7P-1581), p.133 (7P-1676), p.134
 (7P-1692)
Laurier, Zoe Lafontaine, Lady, p.56 (7P-668), p.57
 (7P-685), p.64 (7P-763), p.79 (7P-971), p.98
 (7P-1227), p.126 (7P-1575), p.134 (7P-1692)
Laurier House, Ottawa, Ont., p.77 (7P-936), p.79
 (7P-972), p.140 (7P-1763)
Laurin, François, p.79 (185P-4)
Lautrec, Donald, p.150 (7P-1858)
Lavoie, Yvon, p.79 (7P-975)
Law, June Catherine Nurse, p.106 (7P-1327)
Lawler, Gertrude, p.129 (319P-1)
Lawrie Wagon and Carriage Co. Ltd., Winnipeg,
 Man., p.79 (9P-39)
Lawson, K., Dr., p.79 (7P-976)
Lawson family, Ont., p.58 (7P-691)
"Lawton Park" - Fisken family, p.51 (18P-75)
Layton, Irving, p.135 (7P-1708)
Lazier, Florence Gwendolyn, p.16 (75P-2)
Lazier, Florence Gwendolyn

see also
 Florence Gwendolyn (Lazier)
Lazier family, Ont., p.16 (75P-2)
Le Clair, Eleanor, p.79 (7P-982)
Le Moine, Harriet, Lady, p.69 (7P-834)
Le Moine, James, Sir, p.69 (7P-834)
Le Moyne (SS), p.43 (7P-478)
Le Soleil , Quebec, Que., p.79 (7P-992)
Leach, Frederic, Bro., p.79 (9P-40)
Leach, Wilson George, p.80 (7P-977)
Leacock, Beatrix, p.80 (7P-980)
Leacock, Stephen Butler, and family, p.54
 (7P-635), p.80 (7P-979), p.80 (7P-980), p.80
 (95P-1)
Leacock, Stephen Butler, Associates, p.80 (7P-978)
Leacock, Stephen Butler, Memorial Home, p.80
 (7P-979)
Leacock, W.P., p.109 (7P-1351)
League of Nations Society of Canada, Ottawa,
 Ont., p.33 (7P-353)
Leake, Hiram, p.20 (7P-245)
Leamy Lake, Que. - general views, p.57 (7P-677)
Learmouth, O.M., Capt., p.111 (7P-1388)
Leash, H.E., p.80 (334P-43)
Leaside, Ont. - general views, p.64 (7P-765)
Lecavalier, D.E., Dr., p.102 (7P-1284)
Leclair, Denise, p.80 (7P-981)
Leduc, Alta. - general views, p.7 (13P-5)
Lee, Brian, p.49 (7P-572)
Leech, Alice, p.80 (7P-983)
Lees, Elizabeth, p.147 (1P-57)
Leeson, B.W., photo., p.72 (7P-870)
Lefebvre, J.B., Mme, p.80 (7P-984)
Lefebvre, Rosario, p.80 (131P-4)
Lefevre, Pierre, p.148 (31P-59)
Légaré et Ked, photo., p.4 (131P-9)
Leger, Gaby Carmel, p.80 (7P-985)
Léger, Paul-Emile, Cardinal, p.102 (7P-1290)
Leger, Rod, photo., p.74 (7P-905)
Legere, Norman D., p.80 (7P-986)
Legg, Herbert K., p.80 (7P-987)
Leggo, W.A., p.59 (7P-704)
Lehman, Reginald J., p.80 (7P-988)
Leigh, Zebulon Lewis, p.80 (7P-989)
Leighton, T., p.80 (333P-43)
Leith, Ont. - general views, p.41 (7P-448)
Lemaitre, C., photo., p.4 (8P-16)
Lemaitre, J.H., photo., p.19 (200P-11), p.50
 (200P-12), p.142 (200P-8)
Lemay, Hugolin-Marie, Rev., p.89 (7P-1165)
Lemay, J.-E., p.80 (335P-1)
Lemieux, Lucien and family, p.80 (7P-990)
Lemieux, Rodolphe, p.81 (185P-9), p.81 (7P-991)
Lemire, Roland, photo., p.81 (353P-1)
Lemon Creek, Ont. - general views, p.48 (7P-551)
Lemoyne (SS), p.26 (7P-266)
Lennox and Addington, Ont. - general views, p.81
 (22P-1)
Lennox and Addington Historical Society,
 Napanee, Ont., p.81 (22P-1)
Lennoxville, Que. - general views, p.91 (7P-1185)
Leslie, Charles, Lt. Col., p.16 (7P-183)
Leslie, Kenneth, p.4 (31P-33)
Lesser Slave Lake, Alta. - general views, p.36
 (7P-385)
Lester - Garland, George Henry, photo., p.81
 (7P-993)
Lester - Garland, George Henry and family, p.81
 (7P-993)
Lethbridge, Alta. - general views, p.62 (18P-65),
 p.76 (7P-930), p.87 (7P-1145), p.92
 (7P-1047), p.118 (11P-5)
Lethbridge, Community Services Department, Sir
 Alexander Galt Museum, p.81 (7P-994)
Létourneau, Henri, p.81 (9P-41)
Letourneau, J., Mrs, p.81 (7P-995)
Letson, E. Marguerite, photo., p.81 (1P-1)
Leurs, Hubert, p.81 (7P-996)
Levasseur, Nazaire, p.81 (7P-997)

Levendel, photo., p.109 (7P-1359)
Levesque, Joseph and family, p.42 (7P-465)
Levesque, Raymond, p.43 (7P-480)
Levi, S. Gershon, Rabbi, p.81 (7P-998)
Lévis (Québec) - camp militaire, p.82 (134P-3)
Lewes River (Yukon) - vues, p.20 (7P-241)
Lewis, Collis, p.81 (7P-999)
Lewis, David, p.36 (7P-391), p.81 (7P-1000)
Lewis, J. Bower, p.21 (7P-1910)
Lewis, John T., and family, p.91 (7P-1187)
Lewrey, Norman, p.81 (7P-1001)
Liard River, B.C. - general views, p.118 (12P-23)
Liberace, p.83 (7P-1027)
Liberal Party of Canada, Ottawa, Ont., p.81
 (7P-1002)
Liberal Party of Quebec, p.126 (7P-1569)
Liddell Hart, B.H., Capt., p.7 (7P-62)
Lidstone, F.C., p.81 (7P-1003)
Lieberman, Samuel S., p.81 (7P-1004)
Lieutenant Governors - Ontario, p.19 (75P-3)
Lieux et édifices - Maritimes, p.81 (15P-4)
Lièvre, du (Rivière) (Québec) - vues, p.15
 (7P-166)
Lightfoot, Frederick S., p.82 (7P-1005)
Lighthouses - Canada, p.23 (7P-1911)
Lighthouses - Nova Scotia, p.23 (1P-30)
Lila B. Boutilier (Schooner), p.66 (31P-40)
Lillooet District, B.C. - general views, p.40 (18P-8)
Lincoln Ellsworth Expedition, p.66 (7P-799)
Lind, Jenny, p.94 (7P-1104)
Lindbergh, Charles, Capt., p.45 (7P-501), p.51
 (7P-585)
Lindsay, Crawford, p.82 (134P-3)
Lindsay, James, Maj. Gen., p.121 (7P-1893)
Lindsay, Robert, photo., p.82 (9P-42)
Lineham, D.K., Mrs., p.82 (7P-1006)
Link, Henry David, p.82 (7P-1007)
Lion's Head, Ont. - general views, p.50 (7P-578)
Lipton, Sask. - general views, p.101 (10P-9), p.122
 (7P-1524)
Lisgar, John Young, Bart., Baron, Sir, p.115
 (7P-1447)
Lisle, Robert, p.82 (7P-1008)
Lismer, Arthur, p.61 (8P-1), p.62 (7P-748)
Literary landmarks - Canada, p.80 (95P-1), p.121
 (75P-15)
Lithuania - Individuals, p.118 (7P-1473)
Littell, Walter J., p.82 (7P-1011)
Little, Margaret E., p.82 (7P-1009)
Little, T.V., photo., p.26 (7P-264), p.53 (7P-623)
Little Red River, Alta. - general views, p.50
 (92P-10)
Little Sand Creek, B.C., p.5 (7P-40)
Littleton, Harry, p.82 (7P-1010)
Livernois, Jules Ernest, photo., p.4 (131P-9), p.4
 (134P-1), p.6 (7P-48), p.19 (200P-11), p.22
 (7P-1903), p.26 (7P-1971), p.37 (7P-395),
 p.43 (7P-474), p.48 (7P-550), p.51 (7P-593),
 p.65 (7P-786), p.72 (7P-884), p.78 (7P-954),
 p.80 (131P-4), p.80 (7P-990), p.82 (134P-3),
 p.82 (7P-1012), p.91 (131P-3), p.101
 (7P-1276), p.109 (7P-1367), p.125 (7P-1562),
 p.133 (7P-1675)
Liverpool, Angleterre - vues, p.14 (7P-160)
Liverpool, N.S. - general views, p.41 (31P-82),
 p.74 (31P-87)
Liverpool (N.-E.) - vues, p.24 (7P-1916)
Livres et auteurs canadiens/québécois, p.82
 (185P-15)
Lizotte, M.L.V., p.82 (7P-1013)
Lloydminster, Alta. - general views, p.136
 (7P-1714)
Lobbate, E., Lt., p.82 (134P-3)
Local History Department, Saskatoon, Sask., p.82
 (339P-1)
Locke, Ralphine, p.82 (166P-46)
Lockhead, Allan Grant, Dr., p.82 (7P-1014)
Lockwood, Alvira, photo., p.72 (7P-880), p.72
 (7P-884), p.101 (7P-1270)

Locomotives
 see
 Railroads
Logan, John Daniel, p.82 (31P-98)
Logan, William Edmond, Sir, p.82 (18P-35)
Lomen Brothers, photo., p.82 (11P-1)
Lomond, Loch, Lake, N.B. - general views, p.43 (7P-475)
London - Victoria Air Race, p.133 (7P-1680)
London, England - general views, p.97 (7P-1220), p.135 (7P-1708)
London, Ont. - aerial views, p.68 (7P-826)
London, Ont. - general views, p.26 (7P-1963), p.47 (7P-544), p.56 (7P-671), p.113 (7P-1410)
London and Middlesex Historical Society, p.82 (7P-1015)
London Conference, 1886, p.51 (7P-597)
London Green Stripes Team, London, Ont., p.59 (7P-714)
London Philharmonic Orchestra, London, England, p.129 (7P-1622)
London Public Library and Art Museum, Toronto, Ont., p.83 (196P-55)
London Stereoscopic and Photographic co., photo., p.23 (7P-1917)
Londres, Angleterre - vues, p.14 (7P-160)
Long Beach, Calif. - general views, p.120 (123P-8)
Long Branch, Ont. - general views, p.108 (7P-1342)
Long Lake, Ont. - general views, p.148 (7P-1818)
Long Sault, Ont. - general views, p.20 (7P-252)
Longley, C.F., p.83 (31P-10)
Longueuil, Que. - general views, p.88 (7P-1151), p.122 (7P-1520)
Longueuil, Que. - individuals, p.137 (7P-1727)
Loranger, Francoise, p.135 (7P-1708)
Lordly family, N.S., p.83 (1P-7)
Lorenz, J.A., photo., p.48 (7P-549)
Loretta (SS), p.147 (7P-1813)
Lorette (chutes) (Québec) - vues, p.104 (7P-1323)
Lorette Falls, Que. - general views, p.145 (8P-9)
Loring, Frances, p.127 (7P-1583)
Lorne, John Douglas Sutherland Campbell, Marquess of, Sir, p.66 (7P-787), p.83 (7P-1016), p.115 (7P-1447), p.135 (7P-1705)
Lorne Pierce Collection, p.83 (75P-13)
Lorne Pierce Collection
 see also
 Pierce, Lorne, and family
Los Angeles, Calif. - general views, p.120 (123P-8)
Lost Creek, B.C., p.101 (7P-1272)
Lothian, Georges Bayliss, p.83 (7P-1017)
Lougheed, James, p.22 (7P-1903)
Louisbourg, N.S. - general views, p.88 (1P-47), p.118 (31P-18)
Louise (lac) (Alberta) - vues, p.107 (7P-1335)
Louise Caroline Alberta, H.R.H. Princess, p.83 (7P-1018)
Louise (Lake), Alta. - general views, p.5 (166P-30), p.150 (7P-1847)
Lounsbury, W.R. photo., p.10 (7P-112)
Love, J.W., photo., p.59 (7P-704)
Lovello, Vincent, photo., p.83 (7P-1019)
Low, Albert Peter, photo., p.14 (7P-159), p.24 (7P-1916), p.83 (7P-1020)
Low, Estelle, p.83 (7P-1020)
Low Expedition, 1903, p.142 (7P-1768)
Lowe, Freeman Henry Hetherington, p.83 (9P-43)
Lowell, Arthur Reginald Marsden, Dr., and family, p.83 (75P-8)
Lower, Arthur Reginald Marsden, Dr. and family, p.83 (7P-1021)
Lowes Studio, photo., p.83 (7P-1022)
Lowrey, Thomas Gordon, p.83 (7P-1024)
Lowry, D Hallie, p.83 (7P-1023)
Lucas, Arthur, p.83 (7P-1025)
Lucas, Glenn, p.83 (7P-1026)
Lucas, Leslie, p.83 (7P-1027)
Luce, Charles T., p.35 (7P-374)

Lugrin, A.L., photo., p.83 (7P-1028)
Lugrin, C.T., p.83 (7P-1028)
Lugrin Studio, photo., p.83 (7P-1028)
Luke, L. William, p.84 (7P-1029)
Lumber industry and trade - Alberta, p.7 (13P-5), p.8 (166P-15), p.27 (7P-270)
Lumber industry and trade - British Columbia, p.27 (7P-270), p.30 (7P-328), p.35 (334P-28), p.47 (333P-39), p.68 (333P-5), p.70 (334P-30), p.77 (333P-41), p.100 (333P-34), p.105 (334P-4), p.120 (333P-36), p.122 (333P-9), p.124 (334P-21)
Lumber industry and trade - Canada, p.27 (7P-281), p.28 (7P-295), p.34 (7P-359), p.40 (7P-441), p.105 (327P-1), p.134 (7P-1685)
Lumber industry and trade - Manitoba, p.27 (7P-270), p.82 (9P-42)
Lumber industry and trade - Michigan, p.62 (7P-743)
Lumber industry and trade - New Brunswick, p.37 (46P-5), p.103 (2P-1), p.116 (46P-1)
Lumber industry and trade - Nova Scotia, p.20 (1P-60), p.43 (31P-73)
Lumber industry and trade - Ontario, p.1 (7P-3), p.20 (7P-252), p.31 (7P-336), p.93 (7P-1063), p.94 (7P-1109), p.101 (7P-1267), p.120 (7P-1504), p.151 (7P-1854)
Lumber industry and trade - Ottawa River Valley, p.62 (7P-743), p.69 (7P-834), p.83 (7P-1023), p.93 (7P-1069), p.114 (7P-1426)
Lumber industry and trade - Ottawa River Valley, Ont., p.144 (7P-1771)
Lumber industry and trade - Quebec, p.71 (7P-859), p.101 (7P-1267)
Lummis, Floyd Bert, G.H., p.84 (7P-1030)
Lumsden, Elliott, photo., p.84 (5P-1)
Lunenburg, N.S. - general views, p.7 (1P-28), p.35 (1P-6), p.100 (7P-1261), p.110 (1P-51)
Lunenburg Harbour, N.S. - general views, p.122 (1P-74)
Lunenburg Marine Railway, N.S., p.76 (31P-77)
Lunenburg Outfitting Co., Lunenburg, N.S., p.84 (31P-76)
Lupson, Arnold, photo., p.84 (11P-2)
Lyall, Laura Muntz, p.100 (123P-3)
Lyle, B., p.84 (334P-44)
Lyle, James Miller, p.137 (7P-1729)
Lyman, Dot (White), p.84 (166P-41)
Lyman, photo., p.75 (131P-6)
Lynch, Francis, Christopher Chisholm, p.84 (7P-1031)
Lynch, Francis Joseph, p.84 (7P-1032)
Lyonde, Frederick William & Fils, photo., p.14 (7P-163)
Lyonde, Frederick William, photo., p.19 (200P-11), p.84 (7P-1033), p.126 (200P-7)
Lyonde, Louis Laurier, photo., p.84 (7P-1033)
Lytton, B.C. - general views, p.104 (8P-7)
Lytton (C.-B.) - vues, p.25 (7P-1935), p.35 (7P-371)

Macaskill, Wallace R., photo., p.5 (1P-27), p.62 (1P-43), p.68 (7P-823), p.84 (7P-1035)
MacBeth, Madge, p.84 (7P-1036)
MacCormack, J. Gordon, p.84 (7P-1044)
MacDonald, Alexander E., Dr., p.84 (7P-1052)
MacDonald, C.D., Mrs., p.92 (7P-1053)
MacDonald, D., p.84 (333P-30)
MacDonald, Ena, p.84 (7P-1054)
MacDonald, Flora, p.21 (7P-256)
Macdonald, Hugh John, Sir, p.84 (7P-1055), p.85 (7P-1060), p.128 (7P-1600)

Macdonald, Isabelle Clark, p.84 (7P-1055), p.84 (7P-1057)
Macdonald, James Edward Hervey, Memorial Exhibition, 1933, p.5 (140P-16)
Macdonald, J.F., Maj., p.3 (7P-20)
Macdonald, James A., p.15 (7P-176)
Macdonald, James Edward Hervey, p.25 (7P-1954), p.62 (7P-748), p.84 (7P-1056)
Macdonald, John Alexander, Sir, p.2 (7P-14), p.13 (7P-147), p.14 (7P-160), p.15 (7P-176), p.22 (7P-1903), p.29 (7P-311), p.38 (7P-414), p.40 (7P-439), p.45 (7P-508), p.60 (7P-719), p.84 (7P-1055), p.84 (7P-1057), p.85 (7P-1051), p.85 (7P-1060), p.87 (7P-1134), p.87 (7P-1135), p.93 (7P-1081), p.109 (7P-1368), p.110 (7P-1370), p.147 (7P-1808), p.151 (200P-9)
Macdonald, Mr., p.37 (334P-38)
MacDonald, Robert James, p.85 (7P-1061)
MacDonald, Ross, Hon., p.13 (7P-143), p.97 (7P-1212)
MacDonald, Vincent C., p.85 (31P-14)
Macdonald Brier Curling Championship, p.147 (7P-1800)
MacDonald Funeral, p.85 (7P-1051)
Macdonald of Earnscliffe, Susan Agnes, Baroness, p.85 (7P-1060), p.132 (7P-1655)
Macdonell, Alexander, Rev., p.109 (7P-1353)
Macdonell, Archibald Cameron, Maj. Gen. Sir, p.85 (7P-1062)
MacDonell, John, Col., p.85 (7P-1092)
Macdonell, "Red George", p.42 (7P-468)
Macdonell (famille), Ont., p.111 (7P-1385)
MacDonnell family, Ont., p.58 (7P-690), p.58 (7P-693)
MacDougall, A., p.108 (7P-1343)
MacDougall, E., p.85 (31P-26)
MacDougall, F.A., p.85 (7P-1067)
MacDougall, Miss, p.85 (7P-1064)
MacDougall, Peter, p.85 (7P-1068)
MacDougall, R.J., p.85 (333P-1)
MacEachern, George, p.85 (31P-113)
Macenko, Paulo, p.12 (7P-133)
MacGillivray, Dougald, Dr., p.85 (31P-51)
Machar, Rev., p.87 (7P-1134)
MacInnis, George A., p.85 (7P-1085)
MacInnis, Gerald Lester, p.85 (7P-1086)
MacInnis, Grace, p.85 (7P-1087)
MacIntyre, Duncan Eberts, p.85 (7P-1088)
MacIntyre, John, p.85 (7P-1089), p.85 (7P-1089)
MacIntyre, John and family, p.85 (7P-1088)
Mackay, p.85 (7P-1091)
Mackay, B.R., p.85 (7P-1092)
Mackay, Dan, p.85 (7P-1093)
Mackay, Donald, and family, p.86 (7P-1094)
MacKay, Donald Cameron, p.86 (31P-28)
MacKay, George Walker, p.86 (1P-23)
Mackay, R.A., Dr., p.77 (7P-945)
Mackay, W.B.F., Dr., p.86 (7P-1096)
MacKay, William, p.120 (7P-1504)
MacKean, F.D., photo., p.41 (31P-82)
MacKelvie, John, p.86 (7P-1097)
Mackenzie - Papineau Battalion, p.8 (7P-79)
Mackenzie, Alexander, Hon., p.12 (7P-132), p.57 (7P-685)
Mackenzie, Hugh, Lt., p.86 (7P-1102)
MacKenzie, Ian A., Hon., p.86 (7P-1101)
MacKenzie, Mary, p.86 (7P-1100)
Mackenzie, R., p.86 (7P-1102)
Mackenzie, R. Tait, Dr., p.49 (7P-566)
MacKenzie, Simon, p.86 (31P-13)
Mackenzie, T., p.24 (7P-1918)
Mackenzie, William Roy, p.86 (31P-35)
Mackenzie-Grieve, Kenneth, p.88 (7P-1156)
Mackenzie King, William Lyon
 see
 King, William Lyon Mackenzie

Mackenzie River, N.W.T. - general views, p.21
 (7P-262), p.98 (7P-1229), p.122 (92P-21),
 p.142 (7P-1769)
MacKeracher, Barry, p.86 (7P-1103)
Mackie, Irwin Cameron, p.86 (31P-120)
MacKinnon, Archie, p.86 (333P-35)
MacKinnon, E., p.86 (333P-35)
MacKinnon, James Angus, Hon., et famille, p.86
 (7P-1105)
MacLachlan, Lorne E., p.86 (16P-10)
MacLaren family, Que., p.74 (7P-905)
MacLaren Mill, Buckingham, Que., p.78 (7P-961)
MacLaren's Mill, Wakefield, Que., p.55 (7P-650)
MacLaughlin, J.B., p.86 (7P-1110)
MacLaurin, Cameron Roy, Const., p.86 (7P-1112)
MacLaurin, Donald, p.86 (7P-1112)
MacLean, John, Rev., p.86 (7P-1120)
MacLean, Ross, p.90 (7P-1178)
MacLennan, Charles, p.86 (31P-111)
MacLeod, Alta. - general views, p.148 (7P-1825)
MacLeod, Anna E., p.86 (31P-2)
Macleod, Hector, p.86 (31P-19)
MacLeod, James O., p.86 (31P-2)
MacLeod, Margaret Arnett, p.87 (9P-44)
MacMechan, Archibald McKellar, p.87 (31P-9)
MacMillan, Bertha, p.87 (7P-1123)
MacMillan, George Boyd, p.87 (7P-1124)
MacMillan, Rose, p.109 (7P-1368)
MacNamara, Charles, p.87 (8P-2)
MacNaught, J. Watson, Hon., p.92 (7P-1047)
MacNaughton, Alan A., Hon., p.87 (7P-1129)
MacNeil, Alison, F., Mme, p.87 (7P-1130)
MacNeil, John Alexander, p.87 (16P-11)
Macoun, Clara, p.149 (7P-1826)
Macoun, Ellen, p.149 (7P-1826)
Macoun, John, p.149 (7P-1826)
Macoun, Minnie, p.149 (7P-1826)
Macoun, Sask. - general views, p.29 (7P-312)
Macphail, Agnes Campbell, p.74 (7P-909), p.87
 (7P-1132), p.118 (7P-1483), p.149 (7P-1837)
MacPhail, Andrew, Sir, p.87 (7P-1133)
MacPherson, Alexander F., p.87 (7P-1134)
MacPherson, Allan, p.87 (7P-1134)
MacPherson, Hugh, p.87 (7P-1135)
MacPherson, Kenneth R., p.87 (7P-1136)
MacPherson, Robert George, and family, p.87
 (7P-1137)
MacPherson, William Molson, p.87 (7P-1138)
Macpherson family, Ont., p.72 (7P-884)
Macredie, John Robert Clarke, p.87 (7P-1143)
MacRitchie, John James, p.87 (1P-22)
MacTavish, Newton McFaul, p.87 (18P-77)
Madill, Henry Harrison, p.87 (196P-10)
Maernling, Jean, p.87 (7P-1144)
Magrath, Charles Alexander, p.87 (7P-1145)
Magri, Baron, p.115 (7P-1448)
Magri, Countess, p.115 (7P-1448)
Magro, Joseph, Mrs., p.88 (7P-1146)
Maheux, J.T. Arthur, Abbe, p.88 (7P-1147)
Mahone (H.M.C.S.), p.78 (7P-959)
Maidstone, Sask. - general views, p.59 (7P-710)
Mail-Star (The), Halifax, N.S., p.136 (1P-40)
Mailhot, Charles-Edouard, Abbe, p.88 (7P-213)
Maillard, F.J., p.88 (7P-1148)
Maine Historical Society, p.88 (1P-47)
Mainguy, E. Rollo, p.88 (7P-1149)
Mair, Charles, p.42 (7P-468), p.85 (333P-1), p.88
 (7P-1150)
Maison Saint-Jean, Montréal (Québec), p.90
 (113P-8)
Maison St. Mars, Longueuil, Que., p.88 (7P-1151)
Maitland, G.F., photo., p.153 (7P-1887)
Maitland, Ont. - general views, p.48 (7P-551)
Maizerets (Québec) - vues, p.11 (131P-2), p.77
 (131P-5)
Majestic Theatre, Halifax, p.88 (31P-65)
Makishi, Anno, p.88 (7P-1152)
Makowski, William B., p.88 (7P-1153)

Malaher, G.W., p.88 (9P-45)
Malak, photo., p.22 (7P-1898), p.53 (7P-623)
Malette and Gordon, photo., p.127 (7P-1581)
Maligne (Isle), Lac St. Jean (Québec), p.2 (7P-7)
Mallett, Frederick John, p.88 (7P-1154)
Mallett, Jane, p.88 (7P-1154)
Mallon, Hugh Vincent, p.88 (200P-3), p.88
 (200P-4), p.142 (200P-18)
Malott, Richard Kenneth, photo., p.88 (7P-1156)
Maltese Canadian Society of Toronto, Toronto,
 Ont., p.88 (7P-1157)
Maltese in Ontario, p.88 (7P-1157)
Manifestations - Ontario, p.114 (7P-1423)
Manion, R.J., Dr., p.94 (7P-1084)
Manita (SS), p.82 (7P-1010)
Manitoba - Architectural Survey, p.88 (9P-47)
Manitoba - communities, p.88 (9P-48)
Manitoba - Department of Immigration and
 Colonisation, p.89 (9P-51)
Manitoba - Francophones, p.81 (9P-41)
Manitoba - general views, p.14 (9P-82)
Manitoba - highways, p.89 (9P-49)
Manitoba - individuals, p.88 (9P-48)
Manitoba - Interlake Region, p.129 (9P-67)
Manitoba - military activities, p.27 (9P-8)
Manitoba - personalities, p.88 (9P-18)
Manitoba - scenes, p.1 (31P-3), p.21 (9P-7), p.33
 (7P-351), p.34 (7P-359), p.52 (7P-599), p.54
 (7P-629), p.72 (9P-34), p.72 (9P-35), p.74
 (9P-37), p.88 (9P-45), p.88 (9P-48), p.89
 (9P-49), p.89 (9P-50), p.92 (7P-1040), p.97
 (7P-1213), p.108 (7P-1342), p.111 (9P-61),
 p.118 (9P-63), p.127 (7P-1580), p.132
 (9P-68), p.136 (9P-69), p.151 (9P-75)
Manitoba - settlement, p.88 (9P-18), p.89 (9P-51),
 p.99 (7P-1252), p.129 (9P-67)
Manitoba, Department of Agriculture and
 Immigration, p.71 (9P-31)
Manitoba Museum of Man, Winnipeg, Man., p.89
 (7P-1158)
Manitoba Photo Library Collection, p.89 (9P-50)
Manitoba Telephone System, p.89 (9P-54)
Manitoba Theatre Centre, Winnipeg, Man., p.64
 (7P-769)
Manitoba Water Surveys, p.89 (9P-53)
Manitou Falls, Ont. - general views, p.64 (123P-4)
Manitoulin Island, Ont. - general views, p.84
 (7P-1031)
Manitowaning, Ont. - general views, p.52 (7P-598)
Maniwaki, Que. - general views, p.123 (7P-1537)
Mann, Stella C., p.89 (7P-1159)
Manning, Ralph V., p.89 (7P-1160)
Manning family, Ont., p.89 (18P-47)
Manoir de l'Ile-aux-grues (Québec), p.109 (7P-1366)
Manoir Papineau, Montebello (Québec), p.110
 (7P-1377)
Manoir Richelieu, La Malbaie (Québec), p.89
 (7P-1161)
Manson family, p.94 (228P-3)
Maple Leaf Club, p.34 (7P-363)
Maple Leaf Gardens, Toronto (Ont.), p.89
 (7P-1162)
Maple Leaf (SS), p.82 (7P-1010)
Maple Leafs de Toronto, Ont., p.93 (7P-1071)
Maple sugar processing - Ontario, p.79 (7P-982),
 p.151 (7P-1854)
Maple sugar processing - Quebec, p.71 (7P-859)
Marchand, Felix Gabriel, and family, p.40
 (7P-437)
Marchand, Gabriel, p.14 (7P-163)
Marchand, Jean, p.115 (7P-1449)
Marcil, C., Studio, photo., p.109 (7P-1362)
Marconi, Guglielmo, p.89 (7P-1163)
Marconi Wireless Stations, Cape Race, Nfld., p.28
 (7P-287)
Mariano, Luis, p.43 (7P-480)
Marie-Victorin, Frère, p.89 (7P-1165)
Marion, Lucette, p.89 (7P-1164)

Marion, Séraphin, p.17 (7P-194), p.60 (7P-716),
 p.89 (303P-10), p.89 (7P-1165)
Maritime Conference of the United Church,
 Halifax, N.S., p.89 (24P-1)
Maritime Telegraph and Telephone Co. Ltd.,
 Halifax, N.S., p.89 (1P-72)
Maritimes - general views, p.64 (327P-2), p.77
 (7P-943), p.93 (7P-1078)
Maritimes - personnalités, p.112 (15P-3)
Maritimes - sites historiques, p.81 (15P-4), p.131
 (341P-1)
Maritimes - vues, p.14 (7P-164), p.24 (7P-1916),
 p.35 (7P-1894), p.81 (15P-4), p.131 (341P-1)
Marjoribanks family, p.51 (7P-591)
Markowitz, Jacob, Dr., p.89 (196P-12)
Markwick, William A.G., p.89 (7P-1166)
Marlatt, R.H., Mrs., p.89 (7P-1167)
Marquet, Maurice C., p.90 (7P-1168)
Marquis (SS), p.76 (7P-931)
Marrison, photo., p.18 (7P-225)
Marsan, F.E., photo., p.142 (7P-1768)
Marseille, France - vues, p.80 (131P-4)
Marshall, G.L., p.90 (7P-1169)
Marshall, W., photo., p.58 (7P-696), p.153
 (7P-1887)
Marsters, J.H., p.90 (7P-1170)
Martin, A.A., photo., p.5 (7P-38)
Martin, Bawden and family, p.90 (7P-1171)
Martin, Fred, p.5 (7P-46)
Martin, Grace, p.90 (7P-1171)
Martin, James, p.112 (7P-1394)
Martin, John, p.104 (7P-1318)
Martin, Maureen R., p.90 (7P-1171)
Martin, Paul-Joseph-James, Hon., p.90 (7P-1172)
Martin, Paul-Joseph-John, p.24 (7P-1918)
Martin, Phil, p.49 (7P-572)
Martin, Sandy, p.18 (7P-215)
Martin, Thomas, p.120 (7P-1503)
Martin, Tom, photo., p.98 (1P-48)
Martin, Vernon, p.90 (7P-1171)
Martin, W.H.B., and family, p.90 (7P-1171)
Martin, Wentworth, p.90 (7P-1171)
Martintown, Ont. - scenes, p.8 (8P-11)
Mary, Queen, p.2 (81P-3), p.56 (7P-659)
Mary, Reine, p.24 (7P-1918)
Mary F. Anderson (Tern Schooner), p.86 (31P-111)
Maskinonge River, Que. - general views, p.64
 (123P-4)
Mason, Herbert G., p.90 (7P-1173)
Masons - Ontario, p.101 (7P-1266)
Massachussetts, United States - scenes, p.60
 (1P-25)
Massenet, Bruno, photo., p.90 (113P-8)
Masset, B.C. - general views, p.22 (7P-1901)
Massey, Charles Vincent, H.E., p.27 (7P-274), p.30
 (7P-324), p.90 (7P-1178)
Massey, Chester D., p.90 (7P-1174)
Massey, Hart (famille), p.90 (7P-1176)
Massey, Lionel, p.90 (7P-1174)
Massey, Ont. - general views, p.90 (7P-1177)
Massey, Vincent, S.E, p.90 (7P-1174)
Massey and Flanders Architects, Ottawa, Ont., p.90
 (7P-1175)
Massey (famille), Ont., p.90 (7P-1174), p.90
 (7P-1176), p.111 (7P-1385)
Massey family, p.90 (7P-1176)
Massey family, Ont., p.58 (7P-690), p.58 (7P-693),
 p.111 (7P-1384)
Massey Museum, Massey, Ont., p.90 (7P-1177)
Massicotte, Edmond-Joseph, p.90 (7P-1179)
Massicotte, Edouard Zotique, p.90 (113P-1)
Masson, Que. - general views, p.124 (7P-1552)
Mather, James, p.18 (7P-224)
Mather, Leslie, and family, p.90 (166P-49)
Mather, Leslie, photo., p.90 (166P-49)
Mather family, B.C., p.90 (333P-16)
Mathers - Rice - Jessop, photo., p.90 (7P-1180)

Mathers, Charles W., photo., p.18 (13P-1), p.18 (7P-217), p.90 (7P-1180), p.90 (9P-55), p.98 (7P-1229)
Matheson, Ont. - fire, 1916, p.45 (7P-509)
Matheson, Ont. - general views, p.45 (7P-509)
Mathewson, F. Stanton, p.90 (7P-1184)
Mathieu, Olivier Elzéor, Mgr., p.6 (7P-48), p.91 (131P-3)
Matsumoto, Isamu, p.91 (7P-1181)
Mattagami (Ont.) - vues, p.18 (7P-215)
Matthes, Tinchen, p.91 (7P-1182)
Matthews, James Skitt, Maj., p.91 (7P-1183)
Matthews, Steve, p.49 (7P-572)
Matthews family, B.C., p.91 (334P-45)
Mattingly, A., p.91 (7P-1185)
Maud (SS), p.112 (7P-1396)
Maude (SS), p.93 (7P-1069)
Maugham, W. Somerset, p.7 (31P-99)
Maunder, John, p.91 (7P-1186)
Maunder, photo., p.75 (131P-6)
Maurer, Fred, photo., p.3 (7P-23)
Mavor, James, p.91 (16P-13)
Maxwell, Cliff, photo., p.98 (1P-48)
May, Barbara, p.91 (7P-1187)
May, Wilfred Reid, "Wop", p.91 (7P-1188)
Mayer, Charles, p.91 (7P-1189)
Maynard, Robert, photo., p.70 (7P-855), p.83 (7P-1018)
Mayors - British Columbia - New Westminster, p.70 (334P-30), p.103 (334P-5)
Mayors - Ontario - Fort William, p.6 (7P-58)
Mayors - Ontario - Ottawa, p.71 (7P-864)
Mayors - Ontario - Toronto, p.32 (140P-10)
McAloney, Elsie (Campbell), p.91 (1P-46)
McArthur, D.C., p.91 (7P-1034)
McArthur, Peter, p.78 (7P-951)
McAskill, Angus, p.95 (7P-1119)
McBratney, Helen L, p.91 (7P-1037)
McBride, Berta A., p.91 (7P-1038)
McBridge, H.W., p.92 (92P-15)
McCallum, John, p.98 (7P-1225)
McCann, Edward, p.92 (7P-1039)
McCarthy, Francis D'Assissi, Rev. Sister, p.100 (340P-1)
McCartney, Gordon, p.92 (7P-1040)
McCaul, John, p.78 (196P-47)
McClearn Co. Ltd., Liverpool, N.S., p.92 (31P-88)
McClellanville, S.C. - general views, p.120 (123P-8)
McClennan, Charles A., p.92 (31P-89)
McClintock, Leopold, Sir, p.39 (7P-431)
McClung, Mark, p.92 (7P-1041)
McClung, Nellie L., p.92 (7P-1041), p.96 (7P-1193)
McClure, J., & Co., photo., p.92 (7P-1039)
McClure, James, photo., p.59 (7P-704)
McConachie, George William Grant, p.28 (7P-294), p.92 (7P-1042)
McConkey, G., photo., p.129 (7P-1623)
McCormick, Dan, p.92 (7P-1043)
McCowan family, B.C., p.112 (7P-1395)
McCracken, Budd, p.92 (7P-1046)
McCracken, George W., p.92 (7P-1047)
McCrae, John, Maj., p.76 (7P-925), p.92 (7P-1045)
McCrea, J.M., p.116 (7P-1459)
McCready, Earl, p.132 (7P-1659)
McCullough, C.R., p.92 (7P-1048)
McCully, Richard T., photo., p.92 (32P-3), p.152 (1P-4)
McCurdy, Avis Marshall, p.92 (31P-38)
McCurdy, J.A.D., p.26 (7P-269), p.74 (7P-900)
McCurry, Dorothy L., p.92 (7P-1049)
McCurry, Harry Orr, p.92 (7P-1049)
McCurry family, Ont., p.92 (149P-13)
McDermid, photo., p.96 (7P-1193)
McDermid Studios, photo., p.92 (11P-13), p.92 (92P-16), p.114 (7P-1422)
McDermott, Louis, p.92 (7P-1050)

McDonald, A.L., p.115 (7P-1449)
McDonald, Archibald, Chief Factor, p.34 (7P-367)
McDonald, J.E., and family, p.93 (12P-26)
McDonald, Marion, Sr., p.93 (7P-1058)
McDonald, Mary, p.93 (7P-1058)
McDonald, Percy, p.93 (7P-1059)
McDonald, Percy E., photo., p.74 (7P-903)
McDonald Studio, photo., p.50 (7P-578)
McDonalds Corners (Ont.) - vues, p.14 (7P-171)
McDonell, Antoinette, Sr., p.129 (319P-1)
McDougall, p.93 (7P-1063)
McDougall, A.H., p.93 (7P-1065)
McDougall, C., p.93 (7P-1066)
McElhinney, M.G., Dr., p.93 (7P-1069)
McElwain Studio, photo., p.95 (7P-1140)
McEwen, C.M., Mme, p.93 (7P-1070)
McFadden, Ray, photo., p.138 (322P-1)
McFarlane, Brian, p.93 (7P-1071)
McFaul family, Ont., p.147 (7P-1816)
McGee, Frank, p.93 (7P-1073)
McGee, J.J., p.101 (7P-1276)
McGee, Thomas d'Arcy, Hon., p.27 (7P-268), p.59 (7P-704), p.93 (7P-1074), p.101 (7P-1274), p.151 (7P-1870)
McGiffin, J.S., Mrs., p.93 (7P-1075)
McGill, Elizabeth, p.93 (7P-1077)
McGill, Frank S., p.93 (7P-1076)
McGill, Herbert F., p.93 (7P-1077)
McGill, Peter, Hon., p.93 (7P-1077)
McGill University Archives, Montreal, Que., p.93 (7P-1078)
McGillivray, Charles A., p.93 (7P-1079)
McGlashan, Clarke, p.93 (7P-1080)
McGlashan, Leonard Lee, p.93 (7P-1080)
McGreevy, Brian I., p.93 (7P-1081)
McGregor, Gordon Roy, p.1 (7P-4), p.93 (7P-1082)
McGuire, F.R., Capt., p.94 (7P-1083)
McGuire, Sadie, p.38 (7P-418)
McIlraith, George J., Hon., p.94 (7P-1084)
McIlwraith, Thomas Forsyth, photo., p.94 (16P-9)
McInnis, Angus, p.34 (7P-366)
McIntyre, D.E., p.95 (7P-1118)
McIntyre, Jack, p.41 (7P-452)
McIntyre, Stanley, p.94 (7P-1090)
McKague, Donald, photo., p.25 (7P-1952)
Mckay, Robert Alexander, p.94 (7P-1095)
McKay, Thomas, Hon., p.33 (7P-348)
McKean, f. photo, p.11 (7P-118)
McKee Trophy, p.85 (7P-1086)
McKendry, B.R., p.94 (7P-1098)
McKendry, Jean, p.94 (7P-1099)
McKenzie, Donald, Rev., p.76 (7P-928)
McKenzie, John, p.95 (7P-1118)
McKenzie, R. Tait, p.63 (8P-5)
McKinlay, William, photo., p.3 (7P-23)
McKinlay family, p.94 (228P-3)
McKinley, John, p.94 (7P-1104)
McKnight, Wes, p.94 (7P-1106)
McLaren, F.E., p.94 (7P-1107)
McLaren, J.W., p.94 (7P-1108)
McLaren, John W., p.61 (8P-1)
McLaren, Norman, p.135 (7P-1708)
McLauchlin Lumber Yards Co., Arnprior, Ont., p.87 (8P-2)
McLaughlan, James, photo., p.39 (1P-68)
McLaughlin, D., p.94 (7P-1109)
McLaughlin, J., photo., p.49 (1P-36), p.98 (1P-48)
McLaughlin, Sam, Col., p.45 (7P-509)
McLaughlin, Samuel, photo., p.25 (7P-1952), p.94 (7P-1111), p.107 (7P-1331), p.122 (7P-1527), p.128 (7P-1605), p.151 (7P-1870)
McLaughlin Carriage Works, p.62 (7P-740)
McLaughlin Estate, Oshawa, Ont., p.63 (8P-5)
McLaughlin family, Ont., p.62 (7P-740)
McLean, A., photo., p.108 (7P-1340)
McLean, Alexander Daniel, p.94 (7P-1113)
McLean, Arthur, p.95 (7P-1118)
McLean, Bruce, Mrs., p.94 (7P-1114)

McLean, E.H., p.94 (18P-22)
McLean, Howard V., p.94 (7P-1115)
McLean, J.R., photo., p.94 (7P-1116)
McLean, John, p.150 (7P-1856)
McLean family, Ont., p.94 (18P-73)
McLennan, Alex, p.95 (7P-1118)
McLennan, Barbara, p.143 (196P-63)
McLennan, Duncan, p.95 (7P-1118)
McLennan, F.D., p.95 (7P-1118)
McLennan, Francis, p.95 (7P-1117)
McLennan, Roderick, p.95 (18P-45)
McLeod, Albert M., p.95 (7P-1119)
McLeod, Malcolm, p.94 (228P-3)
McMaster University, Hamilton, Ont., p.95 (7P-1121)
McMeckan family, Ont., p.95 (18P-25)
McMillan, Alexander, p.95 (7P-1122)
McMillan, Michael A., p.43 (7P-489)
McMillan, Neil Lamont, p.95 (18P-72)
McMillan, photo., p.142 (200P-8)
McMillan, Stanley Ransom, p.68 (7P-830), p.95 (7P-1125)
McMullen, A.M., p.68 (7P-830)
McMullen, Archie, p.95 (7P-1126)
McMurray, Edward James, Hon., p.146 (7P-1798)
McMurray, N.W.T. - general views, p.130 (7P-1625)
McMurray (Alberta) - vues, p.11 (7P-119)
McNab Island, N.S. - general views, p.60 (1P-78)
McNabb, Grace, p.95 (7P-1127)
McNaughton, Andrew, p.95 (7P-1128)
McNaughton, Andrew, Gen., p.101 (7P-1272)
McNaughton, Andrew George Latta, Gen., p.93 (7P-1066)
McNeely, Verna, p.95 (196P-39)
McNeill, John, Rev., p.95 (7P-1131)
McNeill, William Everett, p.95 (75P-9)
McQuarrie, Joseph P., p.95 (7P-1139)
McQueen, William, p.95 (196P-38)
McQuinn, I.M. (Ted), p.95 (7P-1140)
McWilliams, James L., p.95 (7P-1141)
Meach Lake, Que. - general views, p.55 (7P-643)
Mead, Bert W., p.95 (7P-1190)
Meadowvale, Ont. - general views, p.29 (7P-307)
Meadowvale, Ont. - scenes, p.61 (8P-1)
Measures, W. Howard, p.96 (7P-1191)
Mechanical Engineering - generalities, p.36 (332P-1)
Medcalf, J.V., Lt., p.30 (7P-317)
Medd, S.T., p.96 (7P-1192)
Medhurst, Jack, p.148 (31P-59)
Media Club of Canada, p.96 (7P-1193)
Medical Council of Canada, Ottawa, Ont., p.96 , (7P-1194)
Medicine Hat, Alta., p.75 (1P-71)
Medicine Hat, Alta. - general views, p.38 (7P-419), p.68 (333P-5), p.139 (7P-1751), p.148 (7P-1825)
Medland, Margaret, p.96 (7P-1195)
Medley, John, Rev., p.29 (7P-312)
Meech, Asa, p.96 (7P-1196)
Meech, L.M., p.96 (7P-1197)
Meedren, R.J., p.96 (7P-1072)
Meehan, Mary Louise, Rev. Mother, p.100 (340P-1)
Meek, John F., p.96 (7P-1198)
Meek, R.J., p.96 (7P-1199)
Mefsut, Paul, p.96 (7P-1200)
Megantic (Lac) (Québec) - vues, p.16 (7P-189)
Meighen, Arthur, Hon., p.22 (7P-1903), p.94 (7P-1084)
Meleron, Andrew, p.18 (7P-215)
Melgund, Man. - general views, p.113 (7P-1415)
Melville, de (Baie), Groenland - vues, p.16 (7P-190)
Memorial Tower, Halifax, N.S., p.49 (1P-36)
Memorial University of Newfoundland Folklore and Language Archives, St. John's, Nfld., p.96 (39P-1)

Memphis, Tenn. - general views, p.120 (123P-8)
Ménard, Jean, p.96 (7P-1201)
Mendelsohn, A., Brig. Gen, p.96 (7P-1202)
Menier, Georges, Mme, p.96 (7P-1203)
Menier, Henri, p.4 (7P-28), p.96 (7P-1203)
Mennonites in the Caucasus, U.S.S.R., p.91 (7P-1182)
Mercer, A., p.96 (334P-22)
Merchant's Bank of Canada, Souris, Man., p.114 (7P-1422)
Mercier, Honore, p.48 (7P-550)
Meredith, Colborne Powell, p.96 (7P-1204)
Meredith family, Ont., p.94 (18P-73), p.96 (7P-1204)
Merkley, Helen Flagg, p.96 (7P-1205)
Merkley, Henry G., p.96 (7P-1205)
Merkley family, Ont., p.96 (7P-1205)
Merrickville, Ont. - general views, p.97 (7P-1221), p.98 (7P-1225), p.149 (7P-1834)
Merrickville (Ont.) - vues, p.16 (7P-187)
Merrifield, Nelson, p.96 (7P-1206)
Merrilees, A. Andrew, p.96 (7P-1207)
Mersereau, Jacob Y., photo., p.96 (46P-3)
Mesopotamia - general views, p.93 (12P-26)
Metabachowan (rivière) (Québec) - vues, p.151 (7P-1862)
Metcalfe, Ont. - general views, p.70 (7P-850)
Metcalfe, Willis, p.97 (7P-1208)
Métis au Canada (ouest), p.131 (222P-1)
Métis au Manitoba, p.131 (222P-1)
Metis in Manitoba, p.81 (9P-41)
Metropolitan Toronto Library, Toronto, Ont., p.139 (18P-88)
Mexico - general views, p.1 (31P-3), p.101 (7P-1272)
Micay, Harry, p.146 (7P-1798)
Michaud, Joseph W., photo., p.97 (7P-1209)
Michel, B.C. - general views, p.151 (333P-29)
Michel, photo., p.4 (131P-9)
Michell, William, p.97 (7P-1210)
Michener, Daniel Roland, H.E., p.25 (7P-1970), p.27 (7P-274), p.30 (7P-316), p.30 (7P-324)
Michener, Daniel Roland, S.E., p.97 (7P-1211), p.97 (7P-1212)
Michener, Norah Willis, p.30 (7P-324), p.97 (7P-1212)
Michigan, Department of State, History Division, p.97 (7P-1213)
Michiganpuget Sound Lumber Co., Victoria, B.C., p.126 (12P-14)
Michipicoten (Ont.) - vues, p.24 (7P-1916)
Micklethwaite, Frank W., photo., p.97 (7P-1214), p.138 (7P-1736)
Micklethwaite, John, p.97 (7P-1214)
Micmac Indians, p.9 (104P-1), p.43 (1P-19), p.58 (7P-694)
Middleville (Ont.) - vues, p.14 (7P-171)
Midland, Ont. - shrines (Fort Ste-Marie), p.2 (7P-7)
Midnapore, Alta. - general views, p.82 (7P-1006)
Midnapore Woolen Mills, Midnapore, Alta., p.82 (7P-1006)
Mihaychuk, Andrew, p.97 (9P-56)
Milan, Italie - vues, p.11 (7P-114)
Milanou, Zinka, p.119 (31P-100)
Miles Canyon, Yukon - general views, p.42 (7P-459)
Military bases - Nova Scotia - Halifax, p.105 (1P-76)
Militia - Nova Scotia, p.34 (31P-21), p.105 (1P-76)
Militia - Ontario, p.78 (7P-952)
Milk River, Alta. - general views, p.118 (11P-5)
Millar, David, p.97 (7P-1215)
Millard, photo., p.50 (200P-12)
Miller, Archie, p.97 (334P-25)
Miller, David, Mrs, p.97 (7P-1216)
Miller, Evelyn, p.97 (7P-1217)

Miller, Florence, p.97 (7P-1218)
Miller, Mabel, p.97 (7P-1219)
Miller, William, Hon., p.93 (7P-1070)
Millikan, J.J., photo., p.94 (7P-1099)
Millman, Thomas, Dr., p.97 (7P-1220)
Mills, Belle, p.97 (7P-1221)
Mills, David, Hon., p.57 (7P-685)
Mills, J.E., Capt., p.3 (7P-20)
Mills, John M., p.97 (7P-1222)
Mills family, Ont., p.53 (7P-619)
Milne, David Brown and family, p.97 (7P-1223)
Milne, Eleonor, p.63 (8P-5)
Milne, Gilbert, photo., p.69 (7P-833), p.96 (7P-1193)
Milne, Gilbert A., photo., p.97 (8P-13)
Milne, J.M., p.98 (7P-1224)
Milne, James, p.98 (7P-1225)
Milne, May, p.97 (7P-1223)
Milne, Robert, photo., p.98 (7P-1226), p.102 (200P-13), p.142 (200P-8)
Milton, Lord, p.85 (7P-1089)
Milton, Ont. - general views, p.29 (7P-307)
Minaki, N.B. - general views, p.110 (7P-1374)
Mineau, Jacqueline, p.98 (7P-1227)
Mines - Alberta, p.8 (166P-15)
Mines - British Columbia, p.4 (7P-33), p.95 (7P-1117)
Mines - British Columbia - Rossland, p.123 (7P-1532), p.139 (7P-1739)
Mines - Canada, p.23 (7P-1926)
Mines - Manitoba, p.148 (9P-71)
Mines - New Brunswick, p.35 (7P-375)
Mines - Newfoundland, p.35 (7P-375), p.62 (1P-43)
Mines - Nova Scotia, p.105 (1P-88), p.113 (7P-1420)
Mines - Ontario, p.35 (7P-375), p.39 (7P-420), p.40 (7P-435), p.41 (7P-452), p.47 (7P-543), p.54 (7P-635), p.119 (7P-1492)
Mines - Quebec, p.35 (7P-375), p.54 (7P-635), p.126 (7P-1570)
Mines - United States - Alaska, p.75 (7P-914)
Mines - Yukon, p.13 (7P-142), p.99 (7P-1246)
Minifie, James M., p.98 (7P-1228)
Ministère des Communications du Québec, Division de la documentation photographique, p.98 (342P-1)
Mink (ship), p.103 (7P-1303)
Minnesota Historical Society, St. Paul Minn., p.98 (7P-1229)
Minnewanka (Lake), Alta. - general views, p.130 (166P-33)
Minto, Gilbert John Elliot, Earl of, p.50 (7P-573), p.115 (7P-1447), p.130 (7P-1629)
Minto, Mary Caroline Grey, p.50 (7P-573), p.130 (7P-1629)
Miramichi, New Brunswick - scenes, p.79 (46P-4), p.116 (46P-1)
Missionaries - Alberta, p.3 (13P-12), p.112 (13P-9)
Missionaries - England - Anglican, p.3 (13P-11)
Missionaries - Saskatchewan, p.112 (13P-9)
Missions - Afrique - Congrégation des Saints Noms de Jésus et de Marie, p.35 (325P-1)
Missions - Afrique du Sud - Oblats de Marie-Immaculée, p.107 (193P-1)
Missions - Athabaska River - Church of England, p.116 (7P-1451)
Missions - Basutoland - Lesotho - Oblats de Marie-Immaculée, p.107 (193P-1)
Missions - Bolivie - Oblats de Marie-Immaculée, p.107 (193P-1)
Missions - Brazil - Sisters Servants of Mary Immaculate, p.130 (338P-1)
Missions - Brésil - Congrégation des Saints Noms de Jésus et Marie, p.35 (325P-1)
Missions - Canada - Grand Nord - Oblats de Marie-Immaculée, p.107 (193P-1)
Missions - Canada - Indiens -Oblats de Marie-Immaculée, p.107 (193P-1)

Missions - Canada - Presbyterian, p.133 (7P-1677)
Missions - Ceylan - Sri Lanka - Oblats de Marie-Immaculée, p.107 (193P-1)
Missions - Chilie - Oblats de Marie-Immaculée, p.107 (193P-1)
Missions - China, p.148 (7P-1817)
Missions - China - Anglican Church, p.149 (16P-20)
Missions - Chine - Pères franciscains, p.112 (328P-1)
Missions - Corée - Pères franciscains, p.112 (328P-1)
Missions - Etat-Unis - Congrégation des Saints Noms de Jésus et de Marie, p.35 (325P-1)
Missions - France - Sisters Servants of Mary Immaculate, p.130 (338P-1)
Missions - Japon - Congrégation des Saints Noms de Jésus et de Marie, p.35 (325P-1)
Missions - Japon - Pères franciscains, p.112 (328P-1)
Missions - New Hebrides - Aneityum, p.62 (31P-29)
Missions - Pérou - Pères franciscains, p.112 (328P-1)
Missions - Québec - Bonne Espérance, p.149 (7P-1835)
Missions - Québec - Rivière Saint-Paul, p.149 (7P-1835)
Missions - Québec - Salmon Bay, p.149 (7P-1835)
Missions - Rupert's Land - Anglican church, p.124 (9P-66)
Missions - Terre-Sainte - Pères franciscains, p.112 (328P-1)
Missions - Territoires du Nord-Ouest - Anglican, p.117 (7P-1472)
Missions - Ukraine - Sisters Servants of Mary Immaculate, p.130 (338P-1)
Missions - United States - Sisters Servants of Mary Immaculate, p.130 (338P-1)
Missions - Yugoslavia - Sisters Servants of Mary Immaculate, p.130 (338P-1)
Missori, Marco, p.98 (7P-1230)
Mitchell, C.H., p.63 (196P-42)
Mitchell, Charles Hamilton, p.98 (7P-1231)
Mitchell, Coulson Norman, Capt., p.98 (7P-1232)
Mitchell, Thomas, photo., p.98 (7P-1233)
Mitchell-Turner Air Photos, photo., p.98 (7P-1234)
Miyagama, George Sutekichi, and family, p.98 (7P-1235)
Miyazaki, Masajiro, Dr., p.98 (7P-1236)
Mizony, I.T., photo., p.153 (161P-1)
Moar, Jack, p.98 (7P-1237)
Moberly, Frank, p.108 (7P-1346)
Moberly, Walter, p.108 (7P-1346)
Modoc (U.S.C.G.C.), p.147 (1P-57)
Moffat, Leo, p.98 (7P-1238)
Moffat family, B.C., p.98 (333P-37)
Mohawks, Indiens, p.16 (7P-193), p.18 (7P-218)
Moir, J., photo., p.100 (7P-1259)
Moir, L.H., p.98 (7P-1239)
Moirs Ltd., Halifax, N. S., p.98 (1P-48)
Mole, Dennis A., p.99 (7P-1240)
Molson, Kenneth M., p.99 (7P-1241)
Monarch (SS), p.28 (7P-293)
Monastères
 voir aussi
 le nom de la communauté
Monastères - Québec - Québec (Augustines), p.6 (171P-2)
Monasteries (Augustinian) - Nova Scotia - Tracadie, p.75 (7P-918)
Monasteries (Trappist) - Quebec - Oka, p.127 (7P-1581)
Monasteries
 see also
 name of community
Moncton, N.B. - general views, p.53 (7P-615), p.84 (7P-1052), p.111 (337P-1)

Moncton Museum Inc., sports photo collection, p.99 (337P-4)
Monora, Lake, Ont. - general views, p.54 (7P-635)
Mons, Belgique - scènes, p.25 (7P-1908)
Mont Laurier, Que. - general views, p.67 (7P-813)
Mont-Royal, Que. - general views, p.147 (7P-1806)
Montagnais Indians, p.61 (7P-727)
Montague, Percival John, p.99 (196P-48)
Montcalm (icebreaker), p.44 (7P-497)
Montebello, Que. - general views, p.91 (7P-1187)
Montgomery, Donald, p.108 (7P-1348)
Montgomery, H. Tully, Rev. Canon, and family, p.99 (166P-24)
Montiminy, Marc Alfred, photo., p.79 (7P-971)
Montizambert, Frederick, Dr., p.99 (7P-1242)
Montmagny, Que. - general views, p.42 (7P-465)
Montminy, J.V., p.99 (7P-1243)
Montminy, Marc Alfred, photo., p.3 (7P-20), p.4 (131P-9), p.80 (131P-4)
Montmorency, Que. - general views, p.42 (7P-463), p.43 (7P-485), p.64 (123P-4), p.82 (7P-1012)
Montmorency (chutes) (Québec) - vues, p.4 (134P-1), p.75 (131P-6), p.104 (7P-1323)
Montmorency Falls, Que., p.114 (7P-1432)
Montmorency Falls, Que. - general views, p.62 (7P-742), p.64 (18P-4), p.87 (7P-1144)
Montmorency (Rapides) (Québec) - vues, p.12 (7P-134)
Montréal - Conservatoire, p.30 (149P-5)
Montréal - Conservatoire (Ecole Vincent d'Indy), p.30 (149P-5)
Montreal, Que., p.99 (7P-1244)
Montreal, Que. - aerial views, p.68 (7P-826)
Montreal, Que. - general views, p.1 (1P-3), p.5 (123P-2), p.17 (7P-205), p.24 (7P-1947), p.25 (7P-1948), p.29 (7P-310), p.31 (7P-332), p.40 (7P-434), p.41 (7P-455), p.42 (7P-463), p.43 (7P-488), p.46 (7P-518), p.46 (7P-524), p.46 (7P-528), p.52 (7P-609), p.54 (7P-639), p.58 (7P-692), p.58 (7P-695), p.58 (7P-696), p.59 (7P-704), p.61 (7P-728), p.63 (7P-756), p.64 (123P-4), p.64 (18P-24), p.64 (18P-4), p.64 (327P-2), p.64 (7P-762), p.64 (7P-766), p.65 (7P-778), p.69 (7P-835), p.70 (7P-854), p.70 (7P-855), p.78 (7P-953), p.81 (7P-996), p.82 (7P-1008), p.90 (7P-1184), p.92 (7P-1039), p.95 (7P-1117), p.99 (7P-1245), p.103 (7P-1299), p.104 (8P-7), p.105 (18P-3), p.110 (7P-1374), p.113 (7P-1419), p.113 (7P-1420), p.116 (7P-1458), p.119 (7P-1492), p.119 (7P-1499), p.127 (7P-1589), p.128 (7P-1597), p.131 (7P-1643), p.135 (7P-1708), p.136 (7P-1248), p.144 (7P-1770), p.145 (7P-1777), p.149 (7P-1828)
Montreal, Que. - individuals, p.104 (7P-1309), p.137 (7P-1727), p.151 (7P-1866)
Montreal, Que. - scenes, p.61 (8P-1)
Montreal, Que. - settlement, p.76 (7P-932)
Montréal (Québec) - clercs de Saint Viateur
 voir aussi
 institut des sourds-muets
Montreal Album, p.99 (7P-1245)
Montreal Amateur Athletic Association skating rink, Montreal, Que., p.97 (7P-1217)
Montreal Book Auctions, Montreal, Que., p.99 (7P-1246)
Montréal (Québec) - sites historiques, p.4 (113P-09), p.99 (113P-3)
Montréal (Québec) - vues, p.4 (113P-09), p.11 (7P-127), p.19 (7P-236), p.20 (7P-241), p.64 (113P-5), p.99 (113P-3), p.104 (7P-1323), p.125 (7P-1563)
Montréal (Québec) -vues, p.6 (7P-60)
Montreal Riders Bicycle Club, Montreal, Que., p.55 (7P-647)
Montreal River (SS), p.127 (8P-3)
Montreal (SS), p.133 (8P-10)

Montreal Star , Montréal (Québec), p.99 (7P-1249)
Montrealer Nachrichtear, p.145 (7P-203)
Monuments - Ottawa, p.100 (7P-1260)
Monuments - Vimy, France, p.24 (7P-1940)
Moodie, G., photo., p.6 (7P-59)
Moodie, J.D., maj., p.11 (7P-118)
Moodie, J.D., photo., p.23 (7P-1938)
Moodie, Susanna, p.140 (7P-1758)
Moodie family, Ont., p.139 (7P-1743)
Moody Park, New Westminster, B.C., p.66 (334P-5)
Moon, Charlie, p.87 (7P-1137)
Moonlight (schooner), p.89 (7P-1159)
Moore, Delbert C., p.99 (7P-1247)
Moore, E.I., p.99 (333P-19)
Moore, Philip, photo., p.99 (166P-19)
Moore, Philip A., and family, p.99 (166P-19)
Moore, Tom, p.99 (7P-1250)
Moorhead, W.G., p.99 (7P-1251)
Moose Factory, Ont. - general views, p.75 (7P-910)
Moose Jaw, Sask. - general views, p.67 (7P-803), p.69 (7P-842), p.90 (7P-1180), p.99 (163P-1), p.115 (7P-1440), p.140 (7P-1753)
Moose Jaw Public Library, Moose Jaw, Sask., p.99 (163P-1)
Moose Mountain, Sask. - general views, p.50 (7P-579)
Moose River, N.S. - mine disaster, p.10 (7P-99), p.32 (1P-31)
Moosonee, Ont. - general views, p.103 (7P-1303)
Moran, Mary Evaristus, Rev. Mother, p.100 (340P-1)
Morant, Nicholas, p.99 (7P-1252)
Morden, N.S. - general views, p.33 (1P-8)
Moreash, Ken, photo., p.98 (1P-48), p.136 (302P-1)
Morgan, Harry, p.100 (7P-1253)
Morgan, Ian C., p.100 (7P-1254)
Morgan & Mann, photo., p.2 (7P-14)
Morin, J.A., Lt. Col., p.3 (7P-20)
Morin, Victor, p.89 (7P-1165)
Morisset, Jean-Paul, p.100 (7P-1257)
Morisset, P., p.100 (7P-1256)
Morley, Alta. - general views, p.148 (166P-28)
Morning, Isaac, photo., p.100 (7P-1258)
Morris, Edmond, p.100 (7P-1255)
Morris, Edmund Montague, p.100 (9P-57)
Morris, Rita, p.100 (334P-19)
Morris, William, Hon., p.100 (7P-1259)
Morrisburg, Ont. - general views, p.68 (7P-816), p.147 (7P-1806), p.147 (7P-1811)
Morrisburg (Ont.) - vues, p.10 (7P-97)
Morrison, Ezekiel, photo., p.94 (7P-1099), p.151 (7P-1866)
Morrison, Frederick, photo., p.152 (1P-4)
Morrison, Harold R.W., p.100 (7P-1260)
Morrison, J., p.100 (333P-34)
Morrisset, Gerard, p.79 (7P-992)
Morrow, James, p.100 (7P-1261)
Morrow, Laura, p.2 (16P-1)
Morse, Charles, p.100 (7P-1262)
Morse, William Inglis, p.100 (31P-101)
Mortimer-Lamb, Harold, photo., p.100 (123P-3)
Morton, L.C.P., p.100 (7P-1263)
Moser River, N.S. - general views, p.63 (1P-26)
Mosher, Murray, photo., p.30 (7P-316)
Mosport, Ont. - general views, p.131 (7P-1648)
Moss, E.A. photo., p.110 (1P-51)
Moss, Harry J., photo., p.5 (1P-27), p.49 (1P-36), p.62 (1P-43), p.122 (1P-74)
Moss Studio, photo., p.98 (1P-48)
Motherwell, William Richard, Hon., p.100 (7P-1264)
Motion picture industry, p.13 (196P-5), p.75 (7P-915), p.77 (7P-941), p.145 (7P-1781), p.149 (166P-10), p.149 (7P-1830)
Motzfeldy, Peter, p.16 (7P-190)
Mount, Marie, p.100 (7P-1265)

Mount Allison University, Sackville, N.B., p.100 (32P-4)
Mount Allison University, Sackville, N.B.
 see also
 Universities - New Brunswick
Mount Robson, B.C. - general views, p.146 (7P-1792)
Mount St. Vincent University, Halifax, N.S., p.100 (340P-1)
Mount Saint Vincent University, Halifax, N.S.
 see also
 Universities - Nova Scotia - Halifax
 (Mount Saint Vincent University)
Mount Stephen - general views, p.105 (123P-5)
Mount Zion Masonic Lodge (No. 28), Mount Zion, Ont., p.101 (7P-1266)
Moylan, William Michael, p.101 (200P-5), p.142 (200P-18)
Muirhead, Arnold Gillies, p.101 (7P-1267)
Muirhead, photo., p.153 (161P-1)
Mulcahy, Stan, p.101 (7P-1268)
Mulherin, Herbert W., p.101 (7P-1269)
Mullock, Vernon, P., p.101 (1P-49)
Mulock, Lady, p.101 (18P-18)
Mulock, William, Sir, p.101 (18P-18), p.101 (196P-56)
Mulroney, Brian, p.21 (7P-256)
Mundare, Alta. - general views, p.130 (7P-1634)
Munro, Alice, p.135 (7P-1708)
Munro, D.G., Mrs, p.101 (7P-1270)
Munro, Douglas John, photo., p.101 (10P-9)
Munro, Edward T., p.101 (7P-1270)
Munro, George Reid, p.101 (7P-1271)
Munro, John, p.101 (7P-1270)
Munro, R.A., photo., p.110 (7P-1371)
Munro, Raymond Alan, p.101 (7P-1272)
Munro, William Bennett, p.101 (7P-1273)
Munto., A.B., photo., p.10 (7P-102)
Murchie, A., p.101 (334P-12)
Murdoch, R., p.101 (333P-18)
Murdoch Bros., photo., p.142 (200P-8)
Murphy, Charles, Hon., p.101 (7P-1274)
Murphy, Emily, p.96 (7P-1193)
Murphy, Joseph J., p.101 (7P-1276)
Murray, Alexa, p.101 (7P-1277)
Murray, Alexander, p.68 (7P-818)
Murray, Edmund Francis, Rev., p.101 (200P-5), p.102 (200P-13), p.142 (200P-18)
Murray, Ella W., p.28 (7P-286)
Murray, G.B. & Son, photo., p.102 (7P-1278)
Murray, L.F., p.102 (7P-1279)
Murray, Leonard Warren, Rear Adm., p.102 (7P-1280)
Murray & Son, photo., p.94 (7P-1099)
Murray, William Ewart Gladstone, p.102 (7P-1281)
Murray Bay, Que. - general views, p.59 (7P-704)
Murray Harbour, P.E.I. - general views, p.84 (5P-1)
Murray River, P.E.I. - general views, p.84 (5P-1)
Muscowitch, Alex S. and family, p.102 (7P-1282)
Musée de l'Artillerie royale canadienne, Shilo (Man.), p.102 (7P-1283)
Musée Laurier, Arthabaska, Que., p.102 (7P-1284)
Mushaboom, N.S. - general views, p.63 (1P-26)
Musicians - British Columbia, p.16 (334P-35)
Musicians - Canada, p.118 (7P-1481)
Musicians - Manitoba, p.151 (9P-76)
Muskego (Ont.) - vues, p.18 (7P-215)
Muskoka, Ont. - general views, p.19 (200P-1), p.62 (7P-740), p.70 (140P-15), p.97 (7P-1214), p.110 (7P-1374)
Muskoka, Ont. - scenes, p.16 (8P-6), p.49 (8P-8)
Muskoka (SS), p.127 (8P-3)
Mutual Benefit Society of St. Joseph, Kitchener, Ont., p.102 (7P-1286)
Mynarski, Andrew, Mrs., p.102 (7P-1287)
Mynarski, Andrew V.C., p.102 (7P-1287)
Mystic, Que. - general views, p.147 (7P-1806)

N.E. Thing Co., Ltd., Downsview, Ont., p.102 (7P-1297)
Naden (H.M.C.S.), p.41 (7P-454)
Naftel, William, p.102 (7P-1288)
Nahant, Mass. - general views, p.15 (123P-9)
Nahlin (C.-B.) - vues, p.35 (7P-370)
Naismith, James, Dr., p.83 (7P-1023)
Nakamura, Richard Yoshio, p.102 (7P-1289)
Nakashian (Nakash), A. George, photo., p.102 (7P-1290)
Nakusp, B.C. - general views, p.148 (7P-1825)
Nanaimo, B.C. - general views, p.30 (12P-11), p.59 (7P-710), p.83 (7P-1018)
Nanaimo (C.-B.) - vues, p.35 (7P-371)
Nandor, Bob, p.120 (7P-1506)
Napinka, Man. - general views, p.113 (7P-1415)
Narcisse, Man. - general views, p.122 (7P-1524)
Nares Expedition, 1875, p.98 (7P-1233)
Naress Expedition to Arctic Regions, 1875, p.43 (7P-477)
Nash, Albert E., capt., p.18 (7P-215)
Nasutlin (SS) p.147 (7P-1809)
National Advisory Council on Fitness and Amateur Sport, p.91 (7P-1189)
National Arts Centre, Ottawa, Ont., p.27 (7P-274), p.133 (7P-1680)
National Ballet Guild of Canada, p.102 (7P-1291)
National Coal Board of Great Britain, International Conference, 1956, p.18 (16P-6)
National Congress of Italian-Canadians, Ottawa, Ont., p.102 (7P-1292)
National Council of Women of Canada, Ottawa, Ont., p.60 (1P-41), p.102 (7P-1293), p.109 (7P-1363)
National Council of Women of Canada, Triennial Conference, Istanbul, Turkey, p.102 (7P-1293)
National Farm Radio Forum, Canada, p.102 (7P-1294)
National Film Board, Still Photo Division, p.117 (7P-1470)
National Film Board of Canada, p.107 (7P-1295)
National Film Board of Canada, photo., p.26 (7P-264), p.36 (7P-391), p.60 (7P-721), p.69 (7P-839), p.71 (7P-868), p.94 (7P-1095)
National Hockey League, p.112 (7P-1397)
National Liberal Federation, Ottawa, Ont., p.103 (7P-1296)
National Park
 see
 name of park
National Parks Surveys, p.22 (7P-1903)
National Research Council - Public Information Branch (PIB), Research Divisions, Ottawa, Ont., p.36 (332P-1)
National Rifle Associations Empire Meet, Bisley, England, p.44 (7P-493)
National Sport and Recreation Centre, Vanier, Ont., p.57 (7P-676)
Naughton, Ont. - general views, p.131 (7P-1648)
Naval Vessels
 see
 subdivision Warships under name of country
Navires - Colombie-Britannique, p.24 (7P-1930)
Navy - Nova Scotia, p.105 (1P-79)
Neaman family, Man., p.49 (9P-17)
Near, photo., p.75 (131P-6)
Nechaco River, B.C. - general views, p.92 (92P-15)
Nechako (Paddleboat), p.121 (228P-1)
Nedza, Michal, p.103 (7P-1298)
Nègre, Charles, photo., p.25 (123P-1)
Nehru, Jawaharlal, p.96 (7P-1191)
Neikrub Galleries, New York, N.Y., p.103 (7P-1299)
Neiser, Doris, p.49 (7P-572)

Nelson, A.V.H., Mrs., p.103 (7P-1300)
Nelson, B.C. - general views, p.64 (7P-762)
Nelson, Nels, p.54 (7P-640)
Nelson, Wolfred, Dr., p.78 (7P-953), p.80 (7P-984)
Nelson River, Man. - general views, p.61 (7P-726)
Neptune (C.G.S.), p.83 (7P-1020)
Neptune (SS), p.11 (7P-118), p.14 (7P-159)
Neptune Theatre, Halifax, N.S., p.58 (7P-697)
Neptune Theatre Foundation, Halifax, N.S., p.103 (31P-57)
Nesbitt, Rankin, p.103 (196P-54)
New Brunswick - aerial views, p.21 (7P-1921)
New Brunswick - scenes, p.35 (1P-6), p.65 (7P-782), p.92 (32P-3), p.92 (7P-1040), p.103 (2P-1), p.119 (337P-3), p.127 (7P-1580)
New Brunswick, Fredericton - scenes, p.135 (46P-2)
New Brunswick, Miramichi - general views, p.96 (46P-3)
New Brunswick Museum, Saint John, N.B., p.103 (2P-1), p.103 (7P-1301)
New Glasgow, N.S. - industries, p.132 (31P-79)
New Iceland - settlement, p.103 (9P-58)
New Iceland Collection, p.103 (9P-58)
New Liskeard, Ont. - general views, p.107 (7P-1337)
New Mexico, United States - scenes, p.49 (7P-572)
New Orleans, La. - general views, p.120 (123P-8)
New Play Society, Toronto, Ont., p.103 (16P-14)
New Richmond (Québec) - vues, p.20 (7P-248)
New Westminster, B.C. - general views, p.1 (334P-34), p.20 (334P-20), p.35 (334P-28), p.37 (334P-38), p.38 (334P-3), p.41 (334P-39), p.68 (333P-5), p.68 (334P-17), p.70 (334P-30), p.83 (7P-1018), p.91 (334P-45), p.95 (7P-1117), p.97 (334P-25), p.100 (334P-19), p.104 (7P-1311), p.105 (334P-4), p.116 (334P-9), p.134 (334P-2), p.145 (334P-29), p.146 (334P-1)
New Westminster, B.C. - Politics and Government, p.103 (334P-5)
New Westminster (C.-B.) - vues, p.12 (7P-134), p.17 (7P-201), p.35 (7P-371)
New Westminster City Hall, New Westminster, B.C., p.103 (334P-5)
New Westminster City Police, New Westminster, B.C., p.103 (334P-18)
New Westminster Fire Department, New Westminster, B.C., p.17 (334P-6), p.80 (334P-43)
New Westminster Public Library, New Westminster, B.C., p.71 (334P-42)
New York, N.Y. - general views, p.31 (7P-331), p.39 (7P-427), p.60 (7P-722), p.120 (123P-8)
New York American Hockey Club, p.36 (7P-382)
New York (N.Y.) - vues, p.4 (113P-09), p.118 (7P-1477)
New York Rangers Hockey Club, New York, N.Y., p.103 (7P-1305)
New Zealand - general views, p.85 (333P-1)
Newcastle Island, B.C. - general views, p.30 (12P-11)
Newcombe & Baird, photo., p.103 (31P-90)
Newcombe, photo., p.43 (1P-33)
Newfoundland - scenes, p.26 (7P-1965)
Newfoundland - Confederation, p.123 (7P-1538)
Newfoundland - fishing, sealing, and whaling, p.117 (4P-1)
Newfoundland - general views, p.68 (7P-823)
Newfoundland - industries, p.117 (4P-1)
Newfoundland - political and social events, p.117 (4P-1)
Newfoundland - public buildings, p.117 (4P-1)
Newfoundland - scenes, p.20 (38P-1), p.25 (7P-1952), p.52 (7P-608), p.69 (7P-840), p.71 (7P-867), p.77 (7P-943), p.87 (7P-1145), p.96 (39P-1), p.103 (38P-11), p.117 (4P-1), p.126 (7P-1579), p.130 (7P-1635)

Newfoundland - shipbuilding and shipping, p.117 (4P-1)
Newfoundland - tidal wave, 1929, p.145 (7P-1786)
Newfoundland - transportation, p.117 (4P-1)
Newfoundland (SS), p.32 (1P-31)
Newhouse, chef Mohawk, p.18 (7P-218)
Newman, Archibald Hamilton, p.103 (7P-1302)
Newman, Margaret Creswick, p.103 (7P-1302)
Newmarket, Ont. - general views, p.66 (7P-798)
Newnham, Jervois Arthur, p.103 (7P-1303)
Newnham, Jervois Arthur, Mrs., p.103 (7P-1303)
Newspapers
 see
 name of newspaper
Newton, Bill & Jean, photo., p.26 (7P-264), p.124 (7P-1556)
Newton, J.W., p.103 (9P-59)
Newton, Neil, photo., p.51 (7P-596), p.53 (7P-623), p.103 (7P-1304)
Newton, photo., p.55 (7P-655)
Niagara, Ont. - general views, p.70 (140P-15), p.96 (7P-1207), p.109 (7P-1365), p.115 (7P-1435), p.128 (7P-1604)
Niagara (chutes) (Ont.) - vues, p.8 (7P-74), p.13 (7P-143), p.16 (7P-183)
Niagara Falls, N.Y. - general views, p.136 (7P-1718)
Niagara Falls, Ont. - general views, p.17 (7P-205), p.39 (7P-427), p.40 (7P-435), p.46 (7P-528), p.49 (7P-563), p.54 (7P-635), p.58 (7P-692), p.58 (7P-695), p.59 (7P-704), p.70 (7P-855), p.77 (7P-941), p.87 (7P-1144), p.92 (7P-1039), p.94 (18P-22), p.95 (7P-1117), p.103 (7P-1299), p.104 (8P-7), p.105 (18P-3), p.110 (7P-1374), p.120 (7P-1508), p.145 (7P-1777)
Niagara Falls, Ont. - individuals, p.108 (7P-1349)
Niagara Falls, Ont. - scenes, p.61 (8P-1)
Niagara Generating Station, Ontario, p.131 (196P-41)
Niagara-on-the-Lake, Ont. - scenes, p.61 (8P-1)
Niagara River, Ont. - general views, p.124 (7P-1558)
Nicholas, Tressilian C., p.103 (7P-1306)
Nicholls and Parkin Popular Photograph Parlor, photo., p.103 (7P-1308)
Nicholson, Leonard Hanson, p.104 (7P-1307)
Nicol, Jane, p.58 (7P-690)
Nicol, Pegi, p.58 (7P-690)
Nicola Valley, B.C. - general views, p.67 (12P-20)
Nicoll, Marion, p.104 (7P-1309)
Nicolson, G.B., p.104 (7P-1310)
Nield, A., p.104 (7P-1311)
Ninette, Man. - general views, p.83 (9P-43)
Nipissing District, Ont. - general views, p.104 (7P-1313)
Nipissing (SS), p.49 (8P-8)
Nishima, C., p.104 (7P-1312)
Niven, Alexander, p.104 (7P-1313)
Noble, George, photo., p.104 (166P-1)
Noble, John E., p.104 (7P-1314)
Nome, Alaska - general views, p.82 (11P-1)
Nordegg, Alta. - general views, p.104 (7P-1315)
Nordegg, Martin, p.104 (7P-1315)
Norfolk, Duc (de), p.91 (131P-3)
Norfolk County Historical Society, p.104 (7P-1316)
Norman Wells, N.W.T. - general views, p.64 (7P-770)
Normand, Jacques, p.43 (7P-480)
Noronic (SS) p.58 (7P-700), p.70 (140P-15)
Norquay, Mount, Alta. - general views, p.17 (166P-14), p.62 (166P-7)
Norris, Leonard M., p.5 (7P-46)
Norrish, Wilbert Henry, p.57 (7P-687), p.104 (7P-1317)
North, Dick, p.104 (7P-1318)
North American Boundary Commission, p.23 (7P-1938)

North American Boundary Commission, 1872-1875, p.9 (7P-82), p.41 (7P-456), p.97 (7P-1220), p.104 (9P-4)
North American Conference on Conservation of Natural Resources, p.104 (7P-1319)
North Battleford, Sask. - general views, p.59 (7P-710), p.72 (18P-97)
North Bay, Ont. - general views, p.30 (7P-323)
North Bay, Ont. - individuals, p.104 (7P-1309)
North Pacific Lumber Co., Barnet, B.C., p.74 (7P-905)
North Platte, Neb. - general views, p.120 (123P-8)
North Saskatchewan River, N.W.T. - general views, p.67 (7P-809)
North Star Mine, B.C. - general views, p.8 (333P-17), p.120 (333P-36)
North Sydney, N.S. - general views, p.119 (7P-1490)
North West Company Trading Post, Rainy Lake, Ont., p.71 (7P-863)
North West Mounted Police
 see
 Royal Canadian Mounted Police
North West Rebellion, 1885
 see
 Riel Rebellion, 1885
North York, Ont. - general views, p.125 (18P-12), p.131 (18P-87)
Northern Crown Bank, p.136 (323P-1)
Northern Ontario Pipe Line Crown Corporation, p.25 (7P-1958)
Northumberland, Straits of, P.E.I. - general views, p.29 (7P-312)
Northwest Ontario community, p.104 (146P-1)
Northwest Territories - general views, p.22 (7P-1904)
Northwest Territories - scenes, p.34 (7P-359), p.39 (7P-431), p.76 (7P-926), p.112 (13P-9), p.113 (7P-1417), p.114 (327P-3), p.133 (7P-1676), p.136 (7P-1716)
Northwest Territories and Yukon Radio System, p.133 (7P-1669)
Norwalk, Conn. - general views, p.74 (7P-904)
Norway House, Man. - general views, p.29 (7P-312), p.59 (9P-24)
Norwood, Ont. - general views, p.75 (7P-911)
Noseworthy, Joseph William, p.104 (7P-1320)
Notman & Fils, photo., p.14 (7P-163)
Notman & Fraser, photo., p.15 (7P-168), p.19 (200P-11), p.25 (7P-1952), p.50 (200P-12), p.105 (18P-3), p.153 (7P-1887)
Notman, Jacques, photo., p.80 (95P-1)
Notman, James Geoffrey, p.104 (7P-1322)
Notman, James Geoffrey, Mme, p.104 (7P-1322)
Notman & Sandham, photo., p.51 (7P-593), p.117 (7P-1471)
Notman & Son, photo., p.131 (7P-1645)
Notman, W.J., photo., p.118 (7P-1477)
Notman, Willia,Whitby, Ont. - general views, p.110 (7P-1374)
Notman, William, photo., p.1 (1P-3), p.2 (16P-1), p.6 (7P-60), p.17 (7P-194), p.24 (7P-1918), p.25 (123P-1), p.38 (1P-67), p.39 (1P-68), p.43 (1P-33), p.47 (1P-35), p.49 (1P-9), p.53 (7P-623), p.55 (131P-1), p.58 (7P-692), p.58 (7P-695), p.59 (7P-704), p.70 (7P-855), p.71 (7P-862), p.71 (7P-862), p.75 (7P-917), p.78 (1P-45), p.78 (7P-954), p.82 (18P-35), p.83 (7P-1018), p.101 (7P-1274), p.104 (7P-1323), p.104 (8P-7), p.105 (123P-5), p.105 (18P-3), p.105 (31P-91), p.105 (327P-1), p.105 (334P-4), p.110 (1P-51), p.116 (7P-1460), p.119 (7P-1499), p.121 (7P-1893), p.122 (1P-74), p.122 (7P-1518), p.123 (7P-1544), p.124 (7P-1548), p.137 (1P-55)
Notman and Fraser, photo., p.126 (200P-7)
Notman and Moffett Studios, photo., p.56 (7P-672)
Notman Gallery, photo., p.102 (200P-13)
Notman Studio
 see also
 Studio Notman
Notman Studio of Halifax, p.134 (7P-1321)
Notman Studio of Halifax, photo., p.84 (7P-1054), p.89 (24P-1), p.105 (1P-76), p.105 (304P-1)
Notman Studio of Montreal, photo., p.93 (7P-1074)
Notre-Dame-de-la-Salette, Que. - landslides, p.124 (7P-1552)
Notre-Dame-du-Portage (Québec) - vues, p.80 (131P-4)
Notre-Dame-du-Sacré-Coeur Convent, Ottawa, Ont., p.105 (7P-1324)
Nouveau-Brunswick - scènes, p.14 (7P-158)
Nouveau parti démocratique, p.105 (7P-1325)
Nova Scotia - aerial views, p.21 (7P-1921), p.94 (7P-1113)
Nova Scotia - Agriculture, p.105 (1P-87)
Nova Scotia - Army, p.105 (1P-80)
Nova Scotia - Commission on Federal Statutes, p.137 (1P-75)
Nova Scotia - Furnishings, p.105 (1P-83)
Nova Scotia - Furniture, p.105 (1P-81)
Nova Scotia - Group Photographs, p.105 (1P-92)
Nova Scotia - Handicrafts, p.105 (1P-82)
Nova Scotia - Indians, p.105 (1P-86)
Nova Scotia - individuals, p.43 (1P-33), p.105 (1P-91), p.128 (7P-1598)
Nova Scotia - Industries, p.105 (1P-88)
Nova Scotia - Interior Decoration, p.105 (1P-84)
Nova Scotia - Legislative Assembly, p.137 (1P-75)
Nova Scotia - Navy, p.105 (1P-79)
Nova Scotia - Office buildings, p.106 (1P-94)
Nova Scotia - Places, p.105 (1P-77)
Nova Scotia - Public buildings, p.106 (1P-94)
Nova Scotia - scenes, p.5 (1P-27), p.14 (1P-29), p.60 (1P-25), p.63 (1P-26), p.63 (7P-752), p.86 (1P-23), p.89 (1P-72), p.91 (1P-46), p.92 (32P-3), p.105 (1P-76), p.105 (1P-77), p.106 (1P-50), p.130 (7P-1635)
Nova Scotia - Ships and shipping, p.105 (1P-85)
Nova Scotia - Sports, p.106 (1P-90)
Nova Scotia - Transportation and Communications, p.106 (1P-89)
Nova Scotia, Department of Public Works, p.106 (1P-94)
Nova Scotia, Dept. of Health, p.87 (1P-22)
Nova Scotia, Militia, 4th Regiment, 2nd Co. (Sydney Mines Volunteer Rifles), p.31 (1P-62)
Nova Scotia Communications and Information Centre, p.106 (1P-50)
Nova Scotia communities, p.14 (1P-29)
Nova Scotia Drama League (N.S.D.L.), Halifax, N.S., p.106 (31P-61)
Nova Scotia Federation of Labour (N.S.F.L.), p.106 (31P-116)
Nova Scotia Light and Power Co. Ltd., Halifax, N.S., p.106 (1P-24)
Nova Scotia Provincial Council of Women, p.60 (1P-41), p.60 (1P-41)
Nova Scotia Region, Antigonish, N.S., p.44 (31P-58)
Nova Scotian (The)
 see
 Halifax Herald (The)
Novadoc (SS), p.24 (7P-1930)
Noverre, J.H., photo., p.58 (7P-696), p.129 (7P-1623)
Noyes, Alfred, p.126 (196P-16)
Nulty, Joseph H., p.106 (7P-1326)
Nureyev, Rudolph, p.59 (7P-713)
Nurse, W.H., p.106 (7P-1327)
Nurseries - Ontario - Toronto, p.138 (18P-48)
Nursery School (Garrison Lane), Birmingham, Eng., p.13 (196P-5)
Nutt, David C., p.106 (7P-1328)
Nye, Archibald, Sir, p.117 (38P-9)
Oakes, T.F., p.48 (7P-558)
Oaks, H.A., p.106 (7P-1329)
Oaks, H.A., Mrs., p.106 (7P-1329)
Oakville, Ont. - general views, p.70 (140P-15), p.107 (47P-18), p.146 (47P-1)
Oakville Bridges, p.106 (47P-5)
Oakville Churches, p.106 (47P-6)
Oakville commerce and industry, p.106 (47P-7)
Oakville Fair, Oakville, Ont., p.75 (47P-4)
Oakville Groups, p.106 (47P-8)
Oakville Harbour after 1900, p.106 (47P-10)
Oakville Harbour before 1900, p.106 (47P-9)
Oakville Hotels (Inns), p.106 (47P-11)
Oakville Houses, p.106 (47P-12)
Oakville Individuals, p.106 (47P-13)
Oakville Parks, p.106 (47P-14)
Oakville Public Buildings, p.106 (47P-15)
Oakville Schools, p.107 (47P-16)
Oakville Shipping, p.107 (47P-17)
Oakville Shops, Stores, Banks, Offices, p.107 (47P-18)
Oakville streets, p.107 (47P-20)
Oakville Transportation, p.107 (47P-21)
Oakwell, Sydney, Rev., p.107 (7P-1330)
Oblates Missionnaires de Marie-Immaculée, Trois-Rivières (Québec)., p.81 (331P-1)
Oblats de Marie-Immaculée
 voir aussi
 Missions
Oblats de Marie-Immaculée, Ottawa, Ont., p.107 (193P-1)
O'Brien, H.A., p.107 (7P-1331)
O'Brien, Osmond, p.107 (31P-81)
O'Brien, Walter J., p.107 (7P-1332)
O'Connell, P.J., p.101 (200P-5)
O'Connor, W., photo., p.142 (200P-8)
O'Connor, William, p.101 (200P-5)
Odiham (Angl.) - vues, p.8 (7P-78)
O'Donnell & McLaughlin, photo., p.152 (7P-1884)
O'Donnell, W.D., photo., p.39 (1P-68), p.43 (1P-33), p.49 (1P-36), p.69 (1P-18), p.107 (31P-92), p.137 (1P-55), p.152 (7P-1884)
Oelschlager, Louise, p.126 (7P-1573)
Oelschlager, Martha, p.126 (7P-1573)
Office de télécommunication éducative de l'Ontario, p.107 (185P-1)
Office national du Film, (l'), p.107 (7P-1295)
Ogallala, Neb. - general views, p.120 (123P-8)
Ogden family, p.94 (228P-3)
Ogilvie, William, p.107 (18P-38)
Ogilvie, William, photo., p.107 (7P-1335)
Ogilvy, Charles, Ltd., Ottawa, Ont., p.107 (7P-1333)
Ogilvy, R.W., p.107 (7P-1334)
Ogilvy, Stewart M., p.107 (7P-1334)
O'Grady, Gerald F. de Courcy, p.107 (7P-1336)
O'Hanley, John Lawrence Power, p.107 (7P-1337)
O'Hea, Timothy, p.8 (7P-68)
O'Henly, Michael, p.49 (7P-572)
Oil Chemical and Atomic Workers International Union -Local 9-825, Halifax, N.S., p.107 (31P-115)
Ojibwa Indians, p.148 (7P-1818)
Oka (Québec) - vues, p.22 (7P-1951)
Old Arts Building, Kingston, Ont., p.63 (7P-757)
Old Crow, Yukon - general views, p.2 (7P-13)
Oldford, Henry R., p.107 (7P-1338)
Oldham (N.-E.) - vues, p.24 (7P-1916)
Olds, Alta. - general views, p.66 (13P-4)
O'Leary, P.E.I. - general views, p.140 (5P-3)
O'Leary, Peter Michael, Lt. Col., p.108 (7P-1339)
Oliver, Howard, p.108 (38P-8)
Oliver, James, p.94 (7P-1114)
Oliver, Mrs., p.134 (7P-1692)
Oliver, William J., photo., p.81 (7P-1004), p.108 (11P-3)
Olivier, Daniel, p.108 (113P-12)
Olson, Rick, p.108 (333P-4)
O'Meara, J.E., p.108 (7P-1340)

O'Meara, photo., p.77 (7P-947)

"On to Ottawa" trek, p.63 (7P-753)

O'Neil, James G., p.108 (7P-1341)

O'Neill, J.J., photo., p.3 (7P-23)

Onions, Bill, photo., p.68 (7P-830)

Ontario - Economy, p.21 (7P-259)

Ontario - general views, p.4 (8P-16), p.15 (123P-9)

Ontario - Lieutenant Governors, p.19 (75P-3)

Ontario - Politics and government, p.4 (8P-16)

Ontario - scenes, p.15 (7P-186), p.34 (7P-359), p.41 (7P-452), p.47 (7P-536), p.52 (7P-608), p.57 (7P-687), p.70 (140P-15), p.70 (7P-856), p.71 (7P-867), p.76 (7P-926), p.92 (7P-1040), p.96 (7P-1204), p.104 (146P-1), p.105 (18P-3), p.108 (18P-23), p.127 (7P-1580), p.147 (7P-1806), p.150 (18P-52)

Ontario - vues, p.24 (7P-1916)

Ontario, Archives of Ontario, Toronto, Ont., p.108 (7P-1342)

Ontario, Department of Crown Lands, p.108 (18P-23)

Ontario, Department of Lands and Forests, p.85 (7P-1067)

Ontario, Lake - general views, p.41 (47P-3)

Ontario, Legislature, p.25 (7P-1952), p.96 (7P-1207), p.108 (18P-57), p.111 (7P-1379), p.153 (7P-1891)

Ontario, Ministère des Terres et Forêts, p.108 (7P-1343)

Ontario, Ministère du Tourisme et de l'Information, p.108 (7P-1345)

Ontario Agricultural College, Guelph, Ont., p.108 (7P-1347)

Ontario Children's Aid Society, Toronto, Ont., p.74 (7P-901), p.127 (7P-1581)

Ontario Federation of Labour, p.108 (7P-1348)

Ontario Hydro, Toronto, Ont., p.108 (316P-1), p.108 (7P-1346)

Ontario Labour Committee for Human Rights, Toronto, Ont., p.108 (7P-1348)

Ontario (Lake), Ont. - Yachting, p.41 (7P-454)

Ontario Motion Picture Bureau, Bronte, Ont., p.6 (7P-57), p.75 (7P-915), p.111 (7P-1389)

Ontario Motor League, Toronto Club, Toronto, Ont., p.108 (18P-54)

Ontario Provincial Air Service, p.76 (7P-926), p.99 (7P-1241), p.106 (7P-1329), p.108 (7P-1343), p.137 (7P-1734)

Ontario Provincial Air Service
see also
Aircraft - Ontario Provincial
Air Service

Ontario Silver Co., Niagara Falls, Ont., p.93 (7P-1080)

Ontario (SS), p.133 (8P-10)

Opal (H.M.S.), p.17 (7P-201)

Oppen, Jean, Mrs., p.108 (7P-1349)

Orange Day Parade - Ontario -Toronto, p.32 (140P-12)

Orchard, C.D., p.108 (12P-2)

Orde family, Ont., p.112 (7P-1406)

Order of Icarus, first investiture, p.101 (7P-1272)

Ordre de Jacques-Cartier, p.109 (7P-1350)

Orillia, Ont. - general views, p.39 (7P-420), p.80 (7P-978), p.80 (7P-979), p.80 (7P-980), p.80 (95P-1), p.101 (7P-1267)

Orillia Orchestra, Orillia, Ont., p.39 (7P-420)

Orillia Public Library, Orillia, Ont., p.109 (7P-1351)

Orléans, d'(Ile) (Québec) -vues, p.82 (134P-3)

Orleans Island, Que. - general views, p.31 (75P-5), p.129 (7P-1622)

Orr Family, p.109 (12P-17)

Osberg, Edith, p.109 (7P-1352)

Osborne, F.E., p.25 (7P-1932)

Oshawa, Ont. - general views, p.62 (7P-740), p.64 (7P-772)

Oshawa (H.M.C.S.), p.149 (7P-1833)

Osler, Edmund Boyd, Sir, p.56 (7P-658)

Osnabruck, Ont. - general views, p.147 (7P-1806)

Osnaburg House (Ont.) - vues, p.17 (7P-200)

Ostrom, Ethel, p.109 (7P-1353)

O'Sullivan, T.H., photo., p.25 (123P-1)

Ottawa, Ont. - aerial views, p.26 (7P-1919), p.141 (303P-7)

Ottawa, Ont. - citizens, p.67 (7P-810)

Ottawa, Ont. - fire, 1900, p.50 (7P-573), p.148 (7P-1823)

Ottawa, Ont. - general views, p.3 (7P-22), p.5 (123P-2), p.17 (7P-205), p.22 (7P-1905), p.23 (7P-1926), p.24 (7P-1947), p.28 (7P-297), p.30 (7P-323), p.36 (7P-390), p.37 (7P-400), p.38 (7P-414), p.39 (7P-424), p.41 (7P-455), p.44 (7P-495), p.45 (7P-500), p.46 (7P-528), p.47 (7P-538), p.49 (7P-562), p.50 (7P-573), p.52 (7P-605), p.53 (7P-616), p.55 (7P-655), p.58 (7P-692), p.58 (7P-695), p.59 (7P-704), p.59 (7P-705), p.60 (7P-722), p.61 (7P-728), p.61 (7P-730), p.61 (7P-736), p.62 (7P-743), p.63 (7P-753), p.64 (7P-771), p.67 (7P-807), p.69 (7P-834), p.70 (140P-15), p.70 (7P-854), p.70 (7P-855), p.71 (7P-864), p.72 (7P-879), p.72 (7P-880), p.75 (7P-910), p.76 (7P-922), p.77 (7P-941), p.77 (7P-946), p.78 (7P-953), p.78 (7P-957), p.86 (1P-23), p.86 (7P-1103), p.87 (7P-1144), p.90 (7P-1175), p.91 (7P-1037), p.94 (7P-1099), p.98 (7P-1225), p.103 (7P-1300), p.105 (18P-3), p.107 (7P-1336), p.109 (7P-1356), p.109 (7P-1365), p.110 (7P-1374), p.114 (7P-1428), p.116 (7P-1458), p.118 (7P-1473), p.120 (7P-1508), p.122 (7P-1518), p.123 (7P-1536), p.127 (7P-1589), p.128 (7P-1600), p.129 (7P-1622), p.132 (7P-1653), p.138 (18P-5), p.138 (7P-83), p.140 (16P-18), p.140 (7P-1754), p.144 (7P-1771), p.145 (7P-1777), p.146 (7P-1795), p.147 (7P-1811), p.149 (7P-1828), p.150 (7P-1859)

Ottawa, Ont. - individuals, p.104 (7P-1309), p.151 (7P-1866), p.152 (7P-1884)

Ottawa, Ont. - scenes, p.49 (8P-8), p.61 (8P-1)

Ottawa, Ont. - vues, p.99 (7P-1243)

Ottawa Amateur Orchestral Society, Ottawa, Ont., p.127 (7P-1581)

Ottawa and District Labour Council, p.109 (7P-1361)

Ottawa Board of Education, Ottawa, Ont., p.109 (7P-1354)

Ottawa Camera Club, Ottawa, Ont., p.109 (7P-1355)

Ottawa Carbide Co., Lac Meach, Qué., p.121 (7P-1510)

Ottawa Chess Club, Ottawa, Ont., p.52 (7P-600)

Ottawa Citizen (the), Ottawa, Ont., p.109 (7P-1356)

Ottawa Gas Works, Ottawa, Ont., p.134 (7P-1691)

Ottawa Government Printing Bureau, p.128 (7P-1605)

Ottawa Grand Opera Company, Ottawa, Ont., p.37 (7P-399)

Ottawa Harrier Club, Ottawa, Ont., p.45 (7P-506)

Ottawa Historical Society, Ottawa, Ont., p.109 (7P-1357)

Ottawa Horticultural Society, Ottawa, Ont., p.109 (7P-1358)

Ottawa Jewish Historical Society, Ottawa, Ont., p.109 (7P-1359)

Ottawa Journal (the), Ottawa, Ont., p.109 (7P-1360)

Ottawa Lawn Tennis Club, Ottawa, Ont., p.127 (7P-1581)

Ottawa Little Theatre, Ottawa, Ont., p.109 (7P-1362)

Ottawa Local Council of Women, Ottawa, Ont., p.109 (7P-1363)

Ottawa (Ont.) - vues, p.6 (7P-61), p.16 (7P-189), p.17 (7P-194), p.22 (7P-1951), p.24 (7P-1918), p.123 (7P-1535), p.150 (7P-1842), p.152 (7P-1876)

Ottawa Public Library, Ottawa, Ont., p.109 (7P-1364)

Ottawa River - general views, p.52 (7P-609), p.69 (7P-834), p.105 (18P-3), p.112 (7P-1407), p.114 (7P-1426)

Ottawa River, Ont. - general views, p.64 (123P-4)

Ottawa River Navigation Co., p.128 (7P-1596)

Ottawa Rowing Club, Ottawa, Ont., p.62 (7P-750)

Ottawa Teacher's College, p.109 (303P-16)

Ottawa Transportation Company, Ottawa, Ont., p.55 (7P-642)

Ottawa Valley Hunt Club, Connaught Park, Aylmer, Que., p.91 (7P-1187)

Otter, William Dillon, Gen. Sir, p.100 (7P-1263)

Otter, William Dillon, Gen. Sir and family, p.109 (7P-1365)

Otterburne (Man.) - clercs de Saint Viateur
voir
Makinak-Otterburne, Man.-clercs de
Saint Viateur

Ouellet, Jacques, p.109 (7P-1366)

Ouellette, Fernand, p.17 (7P-194)

Ouimet, Ernest, p.79 (7P-964)

Ouimet, Gédéon, Hon., p.109 (7P-1367), p.109 (7P-1368)

Ouimet, Paul G., p.109 (7P-1368)

Ouimet, Raphaël, p.110 (113P-11)

Outaouais (rivière des) - vues, p.152 (7P-1872)

Outlook, Sask. - genral views, p.29 (7P-312)

Outram, Alan A., p.110 (7P-1369)

Overseas Military Council of Canada, London, England, p.128 (7P-1603)

Owen, Cambridge, p.110 (7P-1370)

Owen, Elizabeth G. and family, p.110 (1P-51)

Owen, John, photo., p.153 (7P-1887)

Owen Sound, Ont. - general views, p.40 (7P-435), p.101 (7P-1267)

Owens Art Gallery, Mount Allison University, Sackville, N.B., p.110 (32P-5)

Ower, John James, Dr., p.110 (92P-18)

Oxford, Angleterre - vues, p.111 (7P-1385)

Oxford, England - general views, p.95 (75P-9)

Pablo-Allard Buffalo Roundup, 1907, p.45 (166P-35)

Pacific Press Ltd., Vancouver, B.C., p.110 (7P-1371)

Pacific Western Airlines, Vancouver, B.C., p.110 (7P-1372)

Packard, Frank Lucius, p.110 (7P-1373)

Packinawatick, Indian chief, p.123 (7P-1537)

Paddleboats
see also
subdivision under individual names

Paddleboats - British Columbia - Fort Steele, p.47 (333P-8)

Paddleboats - Montana - Jennings, p.47 (333P-8)

Padlei, N.W.T. - general views, p.62 (7P-746)

Paestum, Italy - Greek ruins, p.85 (31P-51)

Page, P.K., p.135 (7P-1708)

Page family, Ont., p.139 (7P-1743)

Paigne, H.E., photo., p.10 (7P-102)

Painter, Walter S., and family, p.110 (166P-13)

Painter Family Collection, p.110 (166P-13)

Pakenham, Ont. - general views, p.83 (7P-1023)

Palestine - vues, p.11 (7P-114)

Palliser, John, Capt., p.56 (7P-657)

Palmerston, Ont. - general views, p.34 (7P-362)

Paltridge, photo., p.19 (200P-11)
Pammett, Howard T., p.110 (7P-1374)
Pan American Exhibition, p.41 (7P-455)
Panet, A.H., Maj., p.3 (7P-20)
Panet, Antoine de Lotbinière, Maj., p.3 (7P-20),
 p.110 (7P-1375)
Panet, E. de B., p.110 (7P-1375)
Panoramic Camera Co., photo., p.22 (7P-1901),
 p.96 (7P-1207), p.110 (7P-1376)
Paper Mill Lake, N.S. - general views, p.98
 (1P-48)
Papineau, Louis Joseph, Hon., p.71 (7P-862), p.71
 (7P-862), p.110 (7P-1377)
Papineau, Talbot Mercer, p.110 (7P-1378)
Paradise, Nfld. - general views, p.70 (7P-857)
Parcs - Québec - Montréal, p.11 (7P-127)
Paré, Judith, p.55 (131P-1)
Parent, Etienne, p.6 (7P-49)
Parent, S.N., Hon., p.117 (7P-1468)
Paris, Cyril, photo., p.110 (166P-8)
Paris, France - general views, p.97 (7P-1220),
 p.135 (7P-1708)
Paris, France - vues, p.4 (113P-09), p.8 (7P-80),
 p.14 (7P-160), p.80 (131P-4), p.89 (303P-10)
Paris, George, photo., p.110 (166P-9)
Paris, Ont. - general views, p.2 (7P-8)
Parish and Co., photo., p.1 (1P-3), p.39 (1P-68)
Park & Co., photo., p.111 (7P-1379)
Park, Edward P., p.111 (7P-1379)
Park, Matt, photo., p.38 (7P-415)
Park, P.E., photo., p.19 (200P-11)
Park, Seth, photo., p.111 (7P-1380)
Park and Co., photo., p.108 (18P-57)
Park Brothers, photo., p.72 (7P-874)
Parker, C.W., photo., p.72 (7P-880)
Parker, David W, p.111 (7P-1381)
Parker, Elizabeth, p.3 (166P-22)
Parker, G. Albert, photo., p.111 (337P-1)
Parker, G.F., photo., p.41 (31P-82)
Parker, Gilbert, p.78 (7P-951)
Parker, John E., p.111 (7P-1382)
Parker, John Primrose, p.111 (7P-1383)
Parker Eakins Co. Ltd., Yarmouth, N.S., p.111
 (31P-68)
Parkin, Annie Conwell, Lady, p.111 (7P-1385)
Parkin, F.W., photo., p.149 (7P-1828)
Parkin, George Robert, Sir, p.58 (7P-690), p.111
 (7P-1384), p.111 (7P-1385)
Parkin, Raleigh, p.111 (7P-1385)
Parkin family, Ont., p.58 (7P-690), p.58 (7P-693)
Parks
 see also
 name of Park
Parks - Wyoming (Yellowstone National Park),
 p.23 (7P-1926)
Parks - British Columbia - New Westminster, p.35
 (334P-28), p.38 (334P-3), p.70 (334P-30),
 p.91 (334P-45), p.116 (334P-9), p.145
 (334P-27), p.145 (334P-29)
Parks - Manitoba, p.89 (9P-50)
Parks - Nova Scotia, p.49 (1P-36), p.60 (1P-78),
 p.69 (1P-18), p.78 (1P-45), p.105 (1P-76),
 p.106 (1P-50), p.139 (1P-17)
Parks - Ontario - Algonquin, p.1 (7P-2), p.101
 (7P-1267)
Parks - Ontario - Oakville, p.106 (47P-14)
Parks - Ontario - Toronto, p.32 (140P-5), p.50
 (18P-66), p.138 (18P-29)
Parks - Quebec - Lachine, p.2 (7P-10)
Parks, J.G., photo., p.6 (7P-60), p.58 (7P-696),
 p.59 (7P-704), p.70 (7P-855), p.92 (7P-1039),
 p.119 (7P-1499)
Parlement (édifices), Ottawa, (Ont.)
 voir aussi
 Parliament Buildings, Ottawa, Ont.
Parlement (édifices) Winnipeg (Man.), p.101
 (7P-1274)
Parlement (édifices), bibliothèque, Ottawa (Ont.),
 p.21 (7P-1910), p.24 (7P-1918),

p.151 (7P-1870)
Parlement (édifices), Ottawa (Ont.), p.11
 (7P-113), p.12 (7P-134), p.13 (7P-147), p.15
 (7P-186), p.25 (7P-1935), p.69 (7P-1946),
 p.93 (7P-1070), p.101 (7P-1274), p.115
 (7P-1441), p.149 (7P-1837), p.151 (7P-1870)
Parliament Buildings, Library, Ottawa, Ont., p.101
 (7P-1270), p.128 (7P-1600)
Parliament Buildings, Ottawa, Ont., p.13 (7P-146),
 p.21 (7P-258), p.24 (7P-1947), p.25
 (7P-1952), p.41 (7P-455), p.48 (7P-560), p.50
 (7P-573), p.52 (7P-608), p.68 (7P-827), p.70
 (7P-853), p.76 (7P-922), p.85 (7P-1051), p.94
 (7P-1111), p.101 (196P-56), p.107 (7P-1331),
 p.114 (7P-1428), p.122 (7P-1527), p.127
 (7P-1585), p.132 (7P-1653), p.132 (7P-1663),
 p.132 (7P-1666), p.133 (7P-1676), p.134
 (7P-1692), p.146 (7P-1795), p.147 (7P-1810),
 p.147 (7P-1811)
Parliament Buildings, Ottawa, Ont.
 see also
 Parlement (édifices), Ottawa (Ont.) ()
Parliament Buildings, Peace Tower, Ottawa, Ont.,
 p.44 (7P-498)
Parliament Hill, Lover's Walk, Ottawa, Ont., p.91
 (7P-1034)
Paroisses - diocèse d'Ottawa, p.48 (306P-1)
Parry (C.G.S.), p.23 (7P-1917)
Parry Sound, Ont. - scenes, p.16 (8P-6), p.136
 (8P-4)
Parson, S.M., photo., p.52 (7P-608)
Parsons, Johnson Lindsay Rowlett, p.111
 (7P-1386)
Parsons, R.M. Capt., p.104 (7P-1311)
Parsons, S.H., photo., p.68 (7P-818), p.70
 (7P-855), p.111 (7P-1912), p.117 (4P-1),
 p.126 (7P-1574)
Pasonault, photo., p.126 (7P-1579)
Paspebiac (Québec) - vues, p.15 (7P-177)
Paterson, R.W., p.111 (9P-61)
Pathescope Ltd., p.128 (7P-1604)
Patias, Fortunato, p.111 (7P-1387)
Patricia Airways and Exploration, p.106 (7P-1329),
 p.137 (7P-1734)
Patricia Bay, (C.-B.) - vues, p.150 (7P-1845)
Patricia Bay (C.-B.) - vues, p.6 (7P-61)
Patrick, A., p.9 (7P-90)
Patrick, George, p.111 (7P-1388)
Patterson, Dickson, p.61 (8P-1)
Patterson, Mr. and Mrs., p.113 (7P-1415)
Patterson R.M., photo., p.71 (166P-38)
Patterson (SS), p.112 (7P-1396)
Patton, George E., p.111 (7P-1389)
Paul, Henri, photo., p.11 (7P-127), p.26 (7P-264),
 p.136 (7P-1712)
Paulet, F., Lord, p.121 (7P-1893)
Paulson family, B.C., p.111 (334P-13)
Payne, photo., p.52 (7P-604)
Payne, Thomas, p.130 (7P-1623)
Payne, Tom, and family, p.80 (7P-983)
Payzant, Florence (Belcher), p.111 (1P-52)
Peace River - field trips, p.141 (92P-12)
Peace River, Alta. - general views, p.3 (13P-12),
 p.9 (7P-82), p.36 (7P-385)
Peace River (Alberta) - vues, p.25 (7P-1935)
Peace River District, Alta. -general views, p.52
 (92P-11)
Peacock, Edward, Sir, p.111 (7P-1385)
Peagam, F.R., p.111 (7P-1390)
Peake & Whittingham, photo., p.111 (7P-1391)
Pearce, A. Douglas, p.111 (7P-1392)
Pearce, William, p.111 (92P-19)
Pearl (SS), p.40 (7P-443)
Pearse, Charles, p.112 (7P-1393)
Pearson, J., Sgt., p.96 (7P-1197)
Pearson, John, p.21 (7P-258)

Pearson, Lester Bowles, Rt. Hon., p.24 (7P-1947),
 p.30 (7P-316), p.30 (7P-324), p.45 (7P-502),
 p.70 (7P-856), p.81 (7P-1002), p.103
 (7P-1296)
Pearson, Lester Bowles, Très Hon., p.22 (7P-1960),
 p.112 (7P-1394)
Pearson, Lester Bowles, Très Hon., et famille, p.26
 (7P-1971)
Peck, E.J., Dr., p.91 (7P-1187)
Peck, Mary and family, p.112 (7P-1395)
Pederson, C.T., p.112 (7P-1396)
Pederson, Carl, p.93 (7P-1071), p.112 (7P-1397)
Peggy's Cove, N.S. - general views, p.7 (1P-28),
 p.131 (7P-1648)
Peigan Indians, p.84 (11P-2)
Pele, p.48 (7P-561)
Pellatt, Henry, Sir, p.70 (140P-15)
Pelletier, Louis Philippe, Hon., p.112 (7P-1398)
Pelletier, Winnifred, p.112 (7P-1399)
Pembina River, Alta. - general views, p.3 (13P-11)
Pembroke, Ont. - individuals, p.104 (7P-1309),
 p.152 (7P-1884)
Pen and Pencil Club of Montreal, Montréal
 (Québec), p.46 (113P-2)
Pende Harbour (C.-B.) - vues, p.25 (7P-1935)
Penetang (H.M.C.S.), p.78 (7P-959)
Penetanguishene, Ont. - general views, p.34
 (7P-362), p.75 (7P-910), p.121 (18P-15)
Penfield, Wilder, Dr., p.3 (7P-24)
Pengough, Percy R., p.109 (7P-1361)
Péninsule gaspésienne (Québec) - vues, p.151
 (7P-1862)
Penrose, J., photo., p.129 (7P-1623)
Pensive Lake, N.W.T. - general views, p.80
 (7P-983)
Penticton, B.C. - general views, p.9 (7P-85)
Penttinen, Lauri, p.112 (7P-1400)
People - Nova Scotia, p.105 (1P-92)
Percé, Que. - general views, p.24 (7P-1947), p.40
 (7P-434)
Perch, David G., p.112 (7P-1401)
Perepeluk, Wasyl John, p.112 (7P-1402)
Pères Franciscains, Montréal (Québec), p.112
 (328P-1)
Pères Oblats de Marie Immaculée des Territoires
 du Nord-Ouest, p.112 (13P-9)
Performing Arts Collection, p.112 (7P-1403)
Péribonca (Québec) - vues, p.11 (7P-127)
Perkins, Simeon, house of, Liverpool, N.S., p.129
 (31P-56)
Perkins, Thomas E., photo., p.72 (7P-874), p.94
 (7P-1099), p.94 (7P-1114), p.149 (7P-1828)
Perley, George, Sir, p.24 (7P-1918)
Perry, Levi Hoyt, Dr., p.38 (7P-412)
Perry, M. Eugenie, p.112 (12P-3)
Perry, R.G., p.112 (7P-1405)
Perry Creek, B.C. - general views, p.47 (333P-8),
 p.73 (333P-11)
Personnalités acadiennes - Maritimes, p.112
 (15P-3)
Perth, Ont. - general views, p.101 (7P-1267), p.119
 (7P-1492)
Perth, Ont. - individuals, p.104 (7P-1309), p.151
 (7P-1866)
Perth (Ont.) - vues, p.14 (7P-171)
Petawawa, Ont. - general views, p.90 (7P-1173),
 p.96 (7P-1204), p.109 (7P-1365)
Petawawa (Ont.) - vues, p.8 (7P-78)
Peterborough, Ont. - general views, p.42 (158P-1),
 p.75 (7P-911), p.82 (7P-1009), p.91
 (7P-1038), p.93 (7P-1075), p.110 (7P-1374),
 p.112 (7P-1406)
Peterborough, Ont. - scenes, p.112 (158P-2)
Peterborough Centennial Museum and Archives
 Collection, p.112 (158P-2), p.112 (7P-1406)
Peterkin, Ruby G., p.150 (7P-1846)
Peters, Frederick Hatheway, p.112 (7P-1407)
Peters, H., photo., p.113 (8P-15)
Peters, James, Col., p.112 (7P-1407)

Peterson, Harold L., p.113 (7P-1408)

Peterson, Roy, p.5 (7P-46)

Peterson, T.A., Mrs, p.113 (92P-20)

Petit-Cap, Saint-Joachim (Québec) - vues, p.11 (131P-2), p.77 (131P-5), p.80 (131P-4)

Petit Metis, Que. - general views, p.145 (7P-1780)

Petit Séminaire de Québec, p.11 (131P-2), p.77 (131P-5), p.80 (131P-4)

Petrie, Alfred E.H., p.113 (7P-1409)

Petrie, H. Leslie, Col., p.113 (7P-1410)

Petrigo, Walter, photo., p.22 (7P-1898), p.113 (7P-1411)

Petroglyphs - British Columbia, p.77 (333P-41)

Petroglyphs - British Columbia - Cranbrook, p.73 (333P-14)

Pétrole - Industrie et commerce - Territoires du Nord-Ouest - Bear Island, p.146 (7P-1789)

Petroleum industry and trade - Alberta, p.32 (7P-345), p.54 (11P-8), p.114 (13P-2)

Petroleum industry and trade - Canada, p.69 (7P-833)

Petroleum industry and trade - Northwest Territories - Norman Wells, p.64 (7P-770)

Petroleum industry and trade - Southern Alberta, p.12 (11P-4), p.108 (11P-3)

Petty Harbour, Nfld. - general views, p.68 (7P-823)

Peyto, E.W. (Bill), p.113 (166P-21)

Peyto Glacier, Alta. - general views, p.23 (7P-1926)

Phelps, Edward, p.113 (196P-40)

Philip, Prince, p.25 (7P-1952), p.26 (7P-1971), p.69 (7P-1946)

Philippe, Comte de Paris, p.109 (7P-1367)

Philippe, Lac (à), (Québec) - vues, p.77 (131P-5)

Phillies, George, p.108 (7P-1343)

Phillips, Allan S., p.113 (7P-1412)

Phillips, Frank, p.113 (7P-1413)

Phillips, George Hector Reid, p.113 (7P-1414)

Phillips, Gordon George, p.113 (7P-1415)

Phillips, Lazarus, p.113 (7P-1416)

Phipps, Welland Wilfred, p.113 (7P-1417), p.139 (7P-1747)

Photo Illustration of Canada, photo., p.36 (7P-391)

Photo Moderne, photo., p.78 (7P-960), p.79 (7P-992), p.135 (7P-1706)

Photo-Montreal project, photo., p.113 (7P-1419)

Photographe
 voir
 le nom du photographe

Photographer
 see
 name of photographer

Photographic Stores Ltd., Ottawa, Ont., p.113 (7P-1418)

Photography, p.40 (123P-7)

Photography - history, p.25 (123P-1)

Photography - Ontario, p.4 (8P-16)

Photography, Canadian, p.116 (7P-1461)

Photography Studio
 see
 name of studio

Photos Duplain, Enr., p.113 (345P-1)

Physics - generalities, p.36 (332P-1)

Physique - generalités, p.36 (332P-1)

Pickerel River (SS), p.127 (8P-3)

Pickering Township, Ont. - general views, p.108 (7P-1342)

Pickersgill, Peter, p.5 (7P-46)

Pickford, Mary, p.54 (7P-635), p.111 (7P-1389)

Pickford and Black Ltd., Halifax, N.S., p.113 (31P-71)

Pickings, Harry B., and family, p.113 (7P-1420)

Pickle Lake (Ont.) - vues, p.17 (7P-200)

Pickthall, Marjorie Lowry Christie, p.114 (18P-34)

Picton, Ont. - general views, p.97 (7P-1208)

Pictou, N.S. - shipyards, p.47 (7P-541)

Pictou County Trades and Labour Council, N.S., p.114 (31P-117)

Pier One Theatre, Halifax, N.S., p.114 (31P-63)

Pierce, Lorne
 see also
 Lorne Pierce Collection

Pierce, Lorne, and family, p.83 (75P-13)

Pietropaulo, Vincenzo, photo., p.114 (7P-1421)

Pike, Frederick R., p.114 (7P-1422)

Pikulin, Michael Alan, p.114 (7P-1423)

Pilcher, Samuel, p.114 (7P-1424)

Pilgrim (Schooner), p.66 (31P-40)

Pilot, Dorothy, p.114 (7P-1425)

Pilsworth, Graham, p.5 (7P-46)

Pinard, Arthur A, p.114 (7P-1426)

Pinchbeck family, B.C., p.114 (228P-5)

Pincher Creek (Alberta) - vues, p.135 (7P-1699)

Pinkham, Lydia E., p.86 (7P-1100)

Pisces V (Submersible vessel), p.28 (7P-293)

Pitseolak, Peter, and family, p.114 (327P-3)

Pitstau Nipi, Nfld. - general views, p.22 (7P-1927)

Pittaway, Alfred George, p.121 (7P-1512)

Pittaway, Alfred George, photo., p.14 (7P-157), p.14 (7P-160), p.45 (7P-506), p.52 (7P-605), p.61 (7P-724), p.114 (7P-1427), p.114 (7P-1428), p.115 (7P-1447), p.120 (7P-1507), p.130 (7P-1626), p.130 (7P-1629), p.149 (7P-1828), p.151 (7P-1866), p.152 (7P-1877)

Pittaway & Jarvis, photo., p.55 (7P-655), p.57 (7P-686), p.72 (7P-880), p.79 (7P-974), p.84 (7P-1057), p.94 (7P-1099), p.114 (7P-1428), p.121 (7P-1512), p.122 (7P-1518), p.152 (7P-1884)

Pittaway Studio, photo., p.38 (7P-411)

Pittman, Harold Herbert, p.114 (10P-14)

Plains Indians, p.42 (333P-3), p.100 (9P-57), p.108 (333P-4)

Plamondon, Antoine, p.25 (7P-1954)

Plamondon, Joseph Edward, et famille, p.55 (131P-1)

Plaskett, photo., p.75 (131P-6)

Platinum Photo Co., photo., p.49 (1P-36)

Plaut, W. Gunther, Rabbi, p.114 (7P-1429)

Players Club, Victoria College, B.C., p.33 (12P-27)

Plessisville (Québec), p.52 (354P-1)

Ploughboy (SS), p.91 (7P-1183)

Plumptre, Beryl, p.24 (7P-1943)

Po-ti-nak, Blood Indian, p.24 (7P-1940)

Pocahontas, Alta. - general views, p.3 (13P-11)

Point du Bois, Man. - general views, p.146 (7P-1797)

Point Pelee, Ont. - general views, p.70 (7P-856)

Point Traverse, Ont. - general views, p.97 (7P-1208)

Pointe aux Esquimaux (Québec), p.75 (131P-6)

Pointe Gatineau, Que. - general views, p.61 (7P-730)

Poirier, Fr., p.50 (7P-579)

Poland - general views, p.129 (7P-1622)

Poland, Army, Canada, p.87 (196P-10)

Poldhu Station, Cornwall, England, p.89 (7P-1163)

Poles
 see also
 Polonais

Poles in Alberta, p.32 (7P-346)

Poles in Canada, p.103 (7P-1298), p.114 (7P-1430)

Poles in Manitoba, p.114 (9P-62)

Polish Alliance Friendly Society of Canada, Toronto, Ont., p.114 (7P-1430)

Polish Alliance of Canada, Toronto, Ont., p.103 (7P-1298)

Polish Canadian Pioneer Survey, Winnipeg, Man., p.114 (9P-62)

Pollard, Arthur V., p.114 (7P-1431)

Pollard, Harry, photo., p.69 (7P-833), p.114 (13P-2)

Pollock, Mr. & Mrs., p.85 (7P-1061)

Polonais
 voir aussi
 Poles

Polson, Kathleen, p.114 (7P-1432)

Poltimore, Que. - general views, p.42 (7P-467)

Polymer Corporation, N.W.T., p.5 (7P-41)

Pond, photo., p.153 (161P-1)

Pontiac, Que. - general views, p.46 (7P-526)

Pontiac Historical Society, Shawville, Que., p.115 (7P-1433)

Ponting, A.H., p.115 (7P-1434)

Ponting, H.G., photo., p.135 (16P-17)

Ponton, William Nisbet and family, p.115 (7P-1435)

Ponts
 voir aussi
 Bridges

Ponts - Maritimes, p.81 (15P-4)

Ponts - Ontario - Niagara (Pont de la Paix), p.24 (7P-1918)

Ponts - Ontario - Ottawa (rue Sussex), p.13 (7P-142)

Ponts - Québec, p.16 (7P-189)

Poole, E., photo., p.72 (7P-874)

Poole, F.N., photo., p.115 (18P-40)

Poole, H.E., photo., p.137 (7P-1727)

Pope, Beatrice, p.115 (7P-1436)

Pope, J.C., Hon., p.133 (7P-1676)

Pope, Joseph, p.115 (7P-1437)

Porcupine, Ont. - general views, p.41 (7P-452), p.47 (7P-543), p.67 (7P-813)

Porcupine, Ont. - scenes, p.113 (8P-15)

Porcupine (Ont.) - vues, p.34 (185P-12)

Porsild, Alf Erling, Dr., photo., p.42 (7P-461), p.115 (7P-1438)

Port Alfred, Qué. - general views, p.2 (7P-7)

Port Arthur, Ont. - explosion, 1945, p.37 (7P-396)

Port Arthur, Ont. - explosion, 1952, p.37 (7P-396)

Port Arthur, Ont. - general views, p.28 (7P-292), p.58 (7P-700), p.63 (7P-753), p.73 (7P-886), p.77 (7P-947), p.115 (7P-1439)

Port Arthur, Ont. - vues, p.152 (7P-1872)

Port Arthur Album, p.115 (7P-1439)

Port-au-Prince, Haiti - general views, p.57 (1P-12)

Port Burwell, N.W.T. - general views, p.126 (7P-1570)

Port Colborne, Ont. - general views, p.39 (7P-429)

Port Dalhousie, Ont. - general views, p.39 (7P-429)

Port Dufferin West, N.S. - general views, p.63 (1P-26)

Port Essington, B.C. - general views, p.52 (12P-5)

Port Hastings, N.S. - general views, p.111 (7P-1383)

Port Hope, Ont. - general views, p.48 (7P-545), p.59 (7P-704), p.70 (7P-855), p.71 (18P-63)

Port Latour, N.S. - general views, p.152 (1P-4)

Port Medway, N.S. - general views, p.81 (1P-1)

Port Milford, Ont. - general views, p.97 (7P-1208)

Port Morien, N.S. - general views, p.111 (7P-1383)

Port Nelson, Man. - general views, p.61 (7P-726), p.72 (7P-875)

Port Radium, N.W.T. - general views, p.48 (7P-545), p.80 (7P-983)

Port Radium (T.N.-O.) - vues, p.19 (7P-228)

Port Royal, N.S. - general views, p.152 (1P-4)

Port Royal Habitation, Annapolis Royal, N.S., p.85 (7P-1060)

Port-Royal (N.-E.) - vues, p.78 (303P-11)

Port Said, Egypt - vues, p.11 (7P-114)

Port Simpson, B.C. - general views, p.52 (12P-5)

Port Stanley, Ont. - general views, p.115 (18P-26)

Port Sudan, Sudan - general views, p.104 (7P-1315)

Portage La Prairie, Man. - general views, p.37 (9P-11), p.97 (7P-1208)

Porter, N.J., photo., p.69 (7P-842)

Porter N.J., photo., p.115 (7P-1440)

Porter's Lake, N.S. - general views, p.117 (1P-73)

Porteus family, Que., p.129 (7P-1622)

Portland, Or., - general views, p.111 (7P-1382)

Portneuf, Que. - general views, p.82 (7P-1012)

Portneuf (Cté) (Québec) - vues, p.113 (345P-1)

Ports - Ontario - Kingston (Ile-du-Pont), p.4 (134P-1)
Ports - Ontario - Toronto, p.10 (7P-104)
Portuguese in Toronto, p.65 (7P-779)
Post, Georgiana, p.102 (7P-1279)
Potter, Jean, p.115 (7P-1441)
Potter, Ray A., p.115 (7P-1442)
Potts, Ont. - general views, p.47 (7P-543)
Potvin, Jacques, photo., p.53 (7P-623)
Pouliot, Jean-François and family, p.115 (7P-1443)
Pounden, Charles Edward, p.115 (7P-1444)
Poundmaker, chef Cri, p.12 (7P-130)
Poundmaker, Cree Chief, p.36 (7P-384)
Poussette, Henry Rivington and family, p.115 (7P-1445)
Powell, Alan, p.115 (7P-1446)
Powell, C. Berkeley, p.115 (7P-1447)
Powell, J.W., photo., p.94 (7P-1099), p.115 (75P-14)
Powell, L.J., p.96 (7P-1204)
Powell, Walter, p.115 (7P-1448)
Powell family, Ont., p.96 (7P-1204)
Power, Charles Gavan, Hon., p.115 (7P-1449), p.116 (7P-1450)
Power, William Pendleton, p.116 (7P-1450)
Powis, John, photo., p.25 (7P-1970)
Powley, Gordon W., photo., p.116 (8P-12)
Prairie Creek (Alberta) - vues, p.20 (7P-241)
Pratt, Capt., p.52 (7P-603)
Preble, Norman A., p.116 (7P-1451)
Preeceville, Sask. - general views, p.146 (7P-1797)
Presbyterian Church in Canada, p.116 (317P-1)
Presbyterian Church in Canada - Colleges, p.116 (317P-5)
Presbyterian Union Theological College, Pyeng Young, p.116 (317P-5)
Prescott, Ont. - general views, p.43 (7P-488)
Prescott, Ont. - individuals, p.127 (7P-1581)
Press Library (the), Vancouver, B.C., p.116 (7P-1452)
Preston, G. Violet, p.116 (7P-1453)
Pretoria, South Africa - general views, p.149 (7P-1831)
Price, Agnes, p.116 (7P-1454)
Price, Andrew, photo., p.50 (200P-12)
Price, Basil, p.116 (7P-1455)
Price, E.H., photo., p.19 (200P-11)
Price, Harry Edward, Cpl., p.116 (7P-1456)
Price, Henry Edward, photo., p.116 (7P-1456)
Price, Leontyne, p.83 (7P-1027)
Price, R.C., Capt., p.70 (7P-855)
Priceville, Ont. - general views, p.145 (7P-1775)
Pridham, R.S., photo., p.49 (1P-36)
Pridham family, p.149 (7P-1828)
Prime Minister - Canada, p.21 (7P-256)
Prince, J.C., photo., p.56 (7P-666)
Prince Albert, Sask. - general views, p.125 (7P-1566)
Prince Consort's Own Rifle Brigade, p.70 (7P-854)
Prince Daird (SS), p.28 (7P-292)
Prince Edward Island - general views, p.38 (5P-7)
Prince Edward Island - history, p.31 (5P-6)
Prince Edward Island - scenes, p.31 (5P-5), p.87 (7P-1124)
Prince Rupert, B.C. - general views, p.52 (12P-5), p.70 (7P-848), p.62 (7P-744), p.142 (7P-1769)
Prince Rupert (C.-B.) - vues, p.152 (7P-1879)
Princes Lodge, N.S. - general views, p.5 (1P-27)
Princess Royal Island, B.C. -general views, p.52 (12P-5)
Princess (SS), p.91 (7P-1187)
Pringle et Booth, photo., p.12 (7P-140)
Prior-Wandesforde, Maureen E., p.116 (7P-1458)
Pritchard, James, p.116 (7P-1459)
Pritzker, Lee, p.116 (7P-1460)
Professional Photographers of Canada Inc., p.116 (7P-1461)

Progressiste - conservateur, p.10 (7P-105)
Progressive Conservative Party of Canada, Ottawa, Ont., p.116 (7P-1462)
Propp, Daniel, photo., p.116 (7P-1463)
Protector (H.M.C.S.), p.55 (7P-648)
Proulx, David, photo., p.22 (7P-1898)
Proulx, Roger, p.116 (7P-1464)
Provincial Archives of British Columbia, Victoria, B.C., p.116 (334P-9)
Provincial Archives of New Brunswick, Fredericton, N.B., p.116 (46P-1)
Provincial Reference Library, St. John's, Nfld., p.117 (38P-9)
Prud'homme, Mgr., p.50 (7P-579)
Public Archives of Canada, Ottawa, Ont., p.45 (7P-508)
Public Works - Alberta, p.47 (13P-8)
Puccini, Abramo, p.117 (18P-92)
Pullen, E.F., p.18 (7P-215)
Pullen, Hugh Francis, p.117 (7P-1465)
Pullen, Thomas C., p.117 (7P-1466)
Pulsifer Bros., photo., p.98 (1P-48)
Punch, Terrence, p.117 (1P-73)
Purcell, Jack, p.132 (7P-1659)
Purcell Mountains, B.C. - general views, p.56 (166P-47)
Purdy, J.E., photo., p.92 (7P-1048)
Purvis, F., p.117 (334P-10)
Putnam, G.G., photo., p.117 (7P-1467)

Quaker Oats Bicycle Tour, p.113 (7P-1408)
Qu'Appelle, Sask. - general views, p.101 (10P-9)
Québec - auteurs, p.77 (185P-16), p.82 (185P-15)
Quebec - general views, p.23 (7P-1911)
Québec - individus, p.90 (113P-1)
Quebec - Legislature, p.89 (7P-1164)
Quebec - scenes, p.1 (31P-3), p.34 (7P-359), p.35 (7P-1894), p.37 (7P-397), p.52 (7P-599), p.54 (7P-635), p.57 (7P-687), p.60 (1P-25), p.61 (7P-727), p.64 (113P-5), p.64 (18P-24), p.64 (327P-2), p.71 (7P-865), p.71 (7P-867), p.76 (7P-932), p.80 (131P-4), p.92 (7P-1040), p.97 (7P-1209), p.97 (7P-1213), p.105 (18P-3), p.127 (7P-1580), p.138 (18P-5)
Québec - vues, p.24 (7P-1916), p.65 (315P-1), p.98 (342P-1)
Québec, Commission pour la codification des lois du Bas-Canada, p.43 (7P-474)
Quebec & Lake St. John Railway Company, Quebec, Que., p.117 (18P-6)
Quebec, Que. - aerial views, p.68 (7P-826)
Quebec, Que. - Citadel, p.80 (7P-984), p.114 (7P-1432), p.145 (8P-9), p.150 (7P-1847)
Quebec, Que. - fire, 1908, p.101 (7P-1271)
Quebec, Que. - general views, p.1 (1P-3), p.4 (7P-30), p.28 (7P-297), p.41 (31P-82), p.42 (7P-463), p.42 (7P-472), p.45 (7P-508), p.45 (7P-510), p.46 (7P-27), p.46 (7P-518), p.46 (7P-528), p.47 (7P-542), p.48 (7P-547), p.48 (7P-550), p.58 (7P-692), p.58 (7P-695), p.59 (7P-704), p.61 (7P-728), p.64 (18P-4), p.65 (7P-786), p.68 (7P-827), p.70 (7P-854), p.70 (7P-855), p.74 (7P-895), p.75 (7P-918), p.77 (7P-940), p.77 (7P-941), p.78 (7P-953), p.80 (7P-990), p.82 (7P-1012), p.92 (7P-1039), p.94 (7P-1111), p.98 (7P-1239), p.104 (8P-7), p.105 (18P-3), p.110 (7P-1374), p.116 (7P-1458), p.119 (7P-1499), p.120 (7P-1508), p.130 (7P-1632), p.131 (7P-1643), p.144 (7P-1770), p.144 (7P-1774), p.145

(7P-1777), p.145 (8P-9)
Quebec, Que. - individuals, p.104 (7P-1309)
Quebec, Que. - scenes, p.61 (8P-1), p.133 (8P-10)
Quebec, Que. - settlement, p.76 (7P-932)
Quebec, Que. - Tercentenary, p.35 (7P-373), p.91 (7P-1034), p.110 (7P-1375)
Quebec, Qué. - tricentenaire, p.99 (7P-1249)
Québec, (Québec) - vues, p.75 (131P-6)
Quebec Air Ltd., p.144 (7P-1773)
Quebec and Lake St. John Railway
see also
Railroads - Quebec and Lake St. John Railway
Quebec Bank, p.136 (323P-1)
Quebec Battlefields Association, Ottawa, Ont., p.117 (7P-1468)
Quebec Conference
see also
Conférence de Québec
Quebec Conference, Quebec, Que., p.71 (7P-868), p.101 (7P-1272), p.114 (7P-1428)
Québec (Québec) - Citadelle, p.104 (7P-1323)
Québec (Québec) - vues., p.4 (131P-9), p.4 (134P-1), p.14 (7P-164), p.16 (7P-183), p.16 (7P-189), p.19 (7P-236), p.24 (7P-1918), p.46 (185P-3), p.67 (171P-1), p.80 (131P-4), p.125 (7P-1563)
Quebec (SS), p.133 (8P-10), p.147 (7P-1813)
Queen Charlotte, B.C. - general views, p.47 (7P-534)
Queen Charlotte Island, B.C. - general views, p.52 (12P-5)
Queen Studio, photo., p.43 (1P-33)
Queen Victoria (C.G.S.), p.77 (7P-940)
Queen's University, Kingston, Ont.
see also
Universities - Ontario - Kingston (Queen's University)
Queens Co., N.S. - general views, p.119 (31P-52)
Queen's Hotel, Toronto, Ont., p.117 (18P-19)
Queen's Own Rifles, p.100 (7P-1263)
Queen's Own Rifles of Canada Trust Fund (The), Toronto, Ont., p.117 (82P-1)
Queen's Park, Toronto, Ont., p.59 (18P-81)
Queen's University, Kingston, Ont., p.117 (7P-1469), p.117 (75P-10)
Queenston, Ont. - general views, p.128 (7P-1604), p.151 (314P-1)
Queenston, Ont. - scenes, p.133 (8P-10)
Queenston Power House, Queenston, Ont., p.96 (7P-1191)
Quemont Mine, Noranda (Québec), p.24 (7P-1916)
Query, Frères, photo., p.117 (113P-4)
Quesnel (C.-B.) - vues, p.25 (7P-1935), p.35 (7P-371)
Quesnel (H.M.C.S.), p.41 (7P-454)
Quick, C.J., p.117 (7P-1470)
Quick, Norman Charles, photo., p.117 (7P-1470)
Quinte Queen (SS), p.147 (7P-1813)
Quinze (Rapides des), (Québec) - vues, p.9 (7P-87)
Quipp, C.H., Mrs., p.117 (7P-1471)
Quirt, Bessie, p.117 (7P-1472)
Quoddy, N.S. - general views, p.63 (1P-26)
Quoddy Head, Me. - general views, p.15 (123P-9)

R.C.A. Victor Ltd., Montreal, Que., p.78 (7P-962)
R-Theta Navigation Computer System, p.152 (7P-1880)
Rabin, Joseph and family, p.118 (7P-1473)

Racicot, Vincent, p.118 (7P-1474)
Racine, Marie-Paule, p.118 (7P-1475)
Rackham, William, p.118 (9P-63)
Raddall, Thomas Head, and family, p.118 (31P-18)
Radio stations - Montreal, Que., p.133 (7P-1668)
Radio stations - Northwest Territories and Yukon, p.133 (7P-1669)
Radisson, Sask. - general views, p.78 (7P-948)
Radium, B.C. - general views, p.147 (333P-15)
Radium Mining - Northwest Territories, p.41 (7P-457), p.48 (7P-545)
Radium mining - Ontario, p.48 (7P-545)
Rae, John, Dr., p.39 (7P-431), p.94 (228P-3), p.118 (7P-1476)
Rafa, Jean, p.43 (7P-480)
Rafton-Canning, A., photo., p.118 (11P-5)
Ragsdale, Robert C. photo., p.127 (7P-1592)
Rail Bridges
 see
 Railroads
Railroads
 see also
 Chemins de fer
 see also
 Individual name of locomotive
Railroads - Alberta, p.1 (13P-10), p.18 (13P-1), p.51 (13P-13)
Railroads - Bay of Quinte Railway, p.97 (7P-1208)
Railroads - British Columbia, p.33 (7P-355), p.47 (333P-28), p.68 (334P-17), p.87 (7P-1137), p.105 (334P-4), p.116 (334P-9), p.151 (333P-29)
Railroads - British Columbia - Electric Railway, p.1 (334P-34)
Railroads - British Columbia - Fraser River Rail Bridge, p.70 (334P-30)
Railroads - Canada, p.28 (327P-4), p.34 (7P-359), p.48 (7P-547), p.105 (327P-1), p.137 (7P-1732), p.148 (7P-1825)
Railroads - Canada Atlantic Railway, p.26 (7P-263)
Railroads - Canada Government, p.63 (7P-753)
Railroads - Canadian National Railway, p.5 (7P-45), p.12 (11P-12), p.28 (7P-292), p.42 (7P-461), p.72 (7P-876), p.80 (7P-986), p.147 (7P-1802)
Railroads - Canadian National Railway
 see also
 Canadian National Railway
Railroads - Canadian Northern Railway, p.28 (7P-292), p.87 (7P-1143), p.100 (7P-1253), p.119 (7P-1492), p.148 (9P-73)
Railroads - Canadian Pacific Railway, p.18 (7P-217), p.28 (7P-295), p.33 (7P-349), p.42 (7P-461), p.42 (7P-463), p.42 (7P-470), p.47 (7P-540), p.49 (7P-563), p.52 (12P-5), p.52 (7P-599), p.52 (7P-602), p.54 (7P-635), p.64 (7P-762), p.68 (7P-817), p.75 (7P-920), p.77 (333P-41), p.87 (7P-1138), p.87 (7P-1143), p.89 (7P-1167), p.91 (7P-1185), p.95 (18P-45), p.97 (7P-1220), p.99 (7P-1252), p.123 (7P-1534), p.131 (7P-1645), p.147 (333P-15)
Railroads - Canadian Pacific Railway - bridges, p.15 (333P-40)
Railroads - Canadian Pacific Railway
 see also
 Canadian Pacific Railway
Railroads - Carillon and Grenville Railway, p.119 (7P-1490)
Railroads - Columbia Western Railway, p.57 (7P-678)
Railroads - construction, p.8 (9P-2)
Railroads - Crownsnest Railway, p.47 (333P-8)
Railroads - disasters, p.99 (7P-1244)
Railroads - Edmonton, Dunvegan & British Columbia Railway, p.130 (7P-1634)
Railroads - Grand Trunk Pacific Railway, p.28

(7P-292), p.62 (7P-744), p.63 (7P-754), p.79 (7P-971), p.92 (92P-15), p.98 (7P-1224), p.148 (7P-1822)
Railroads - Grand Trunk Railway Bridge, p.75 (47P-4)
Railroads - Grand Trunk Railway Co., p.43 (7P-485), p.58 (7P-689), p.60 (7P-722), p.98 (7P-1224), p.104 (7P-1317), p.147 (7P-1802)
Railroads - Grand Trunk Railway Co.
 see also
 Grand Trunk Railway Co.
Railroads - Great Britain, p.17 (7P-210)
Railroads - Hudson Bay Railway, p.80 (7P-983), p.101 (7P-1271), p.116 (7P-1452)
Railroads - Hudson Bay Railway terminal, Fort Churchill, N.W.T., p.23 (7P-1911)
Railroads - Intercolonial railway, p.52 (7P-599), p.84 (7P-1032)
Railroads - Kootenay Central Railway, p.47 (333P-8)
Railroads - London and Port Stanley Railway, p.28 (7P-292)
Railroads - Manitoba, p.40 (9P-14), p.148 (9P-71)
Railroads - McMillan-Bloedel Ltd., Chemainus, B.C., p.132 (7P-1661)
Railroads - National Transcontinental Railway, p.107 (7P-1334)
Railroads - New Brunswick, p.103 (2P-1)
Railroads - Nova Scotia - Chignecto Marine Railway, p.41 (31P-82)
Railroads - Nova Scotia - Western Counties Railroad, p.67 (31P-86)
Railroads - Ontario, p.4 (8P-16), p.40 (7P-435), p.55 (7P-645)
Railroads - Ontario - Oakville (Railway Stations), p.107 (47P-21)
Railroads - Parry Sound Colonization Railroad, p.84 (7P-1032)
Railroads - Prince Rupert Railway, p.148 (7P-1822)
Railroads - Quebec, p.48 (7P-550)
Railroads - Quebec - Montreal, p.40 (7P-434), p.64 (327P-2)
Railroads - Quebec and Lake St. John Railway, p.82 (7P-1012), p.117 (18P-6)
Railroads - Quebec and Lake St. John Railway
 see also
 Quebec and Lake St. John Railway
Railroads - Saskatchewan, p.69 (7P-842)
Railroads - Témiscouata Railway, p.131 (7P-1647)
Railroads - Temiskaming and Northern Ontario Railway, p.79 (7P-969)
Railroads - United States, p.52 (7P-599)
Rainville, Ernest, photo., p.4 (131P-9)
Rainy Lake, Ont. - general views, p.71 (7P-863)
Rainy River, Ont. - general views, p.119 (7P-1492)
Ralston, C.G., p.115 (7P-1449)
Ralston, James Layton, Hon., p.107 (7P-1295), p.118 (7P-1479)
Ramon Cortada & Co., p.153 (31P-69)
Ramsay, J. Hale et famille, p.8 (7P-76)
Ramsey, H. Lauder, and family, p.73 (12P-10)
Ranches - Alberta, p.8 (166P-15), p.12 (11P-12), p.150 (7P-1843)
Ranches - Alberta - Crawling Valley, p.136 (7P-1714)
Randall, Robert Cheetham, p.118 (7P-1478)
Rankin, Niall, photo., p.118 (166P-42)
Rasminsky, Louis, p.118 (7P-1479)
Rassemblements Acadiens - Maritimes, p.118 (15P-5)
Rat Portage, Ont. - general views, p.84 (7P-1032)
Rawdon (Québec) - vues, p.25 (7P-1935)
Rawson, Bernard Anderson, Capt., p.118 (7P-1480)
Ray, Marcel, photo., p.118 (7P-1481)
Rayfield, Victor C., p.118 (7P-1482)
Rayfield, W.L., Capt., p.118 (7P-1482)
Raynham, Fred, p.88 (7P-1156)
Rea, Hermanos, Cigar Factory, Toronto, Ont.,

p.118 (18P-50)
Reade, Herbert T., Serg., p.57 (7P-674)
Reany, Meredith, p.118 (7P-1483)
Rébellion de Riel, 1885, p.12 (7P-130), p.18 (7P-217), p.146 (7P-1791)
Rébellion de Riel, 1885
 voir aussi
 Riel Rebellion, 1885
Rébellion du Nord-Ouest, 1885
 voir
 Rébellion de Riel, 1885
Red Cap Snowshoe Club, p.7 (31P-12)
Red Deep Valley, Alta. - general views, p.141 (92P-12)
Red River, Man. - settlement, p.65 (9P-29), p.87 (9P-44), p.88 (9P-18), p.120 (9P-64)
Redonda Bay, B.C. - general views, p.118 (12P-19)
Reed, T.F. Harper, p.118 (12P-23)
Reed, Thomas Arthur, p.118 (18P-2)
"Reflections on a Capital" - exhibition, p.54 (7P-635)
Reford, Robert, p.118 (7P-1484)
Regiment of Canadian Guards, CFB Petawawa, Ont., p.119 (7P-1485)
Regina, Sask. - City Council, p.34 (7P-366)
Regina, Sask. - cyclone, 1912, p.128 (7P-1610)
Regina, Sask. - general views, p.2 (81P-4), p.54 (7P-629), p.122 (7P-1524), p.125 (7P-1566)
Regina, Sask. - individuals, p.104 (7P-1309)
Régina (Sask.) - vues, p.80 (131P-4)
Regional Dominion Drama Festival productions, N.S., p.148 (31P-59)
Reid, C., Rev. and family, p.71 (7P-859)
Reid, D. Smith, photo., p.119 (7P-1486)
Reid, D.M., photo., p.2 (7P-14)
Reid, Harold B., photo., p.119 (337P-3)
Reid, R., p.43 (7P-483), p.119 (7P-1489)
Reid, Robert Sutor, p.119 (7P-1487)
Reid, Thomas Mayne (Pat), p.106 (7P-1329), p.119 (7P-1489)
Reid, W. Harold, Rev., p.119 (7P-1490)
Reid Studio, photo., p.119 (7P-1275)
Reilly, John Hardisty, p.119 (7P-1491)
Reinhardt, Carl, p.150 (7P-1855)
Reinhardt, Carl and family, p.119 (7P-1492)
Reiser, Stella Maria, Rev. Mother, p.100 (340P-1)
Rempel, John I., p.119 (18P-13)
Renaud, M., p.119 (7P-1493)
Renaud, Osias, photo., p.119 (7P-1494)
Renfrew, Ont. - general views, p.21 (7P-261), p.51 (7P-587), p.61 (7P-737), p.63 (7P-753), p.66 (7P-788)
Rennie, George, p.119 (7P-1495)
Rennie, John, p.119 (7P-1495)
Reno, Ginette, p.150 (7P-1858)
Reservoir Parks, Oakville, Ont., p.106 (47P-14)
Resource Rangers Leadership Training Camp, Albion Hills, Ont., p.119 (18P-74)
Restigouche, N.B. - general views, p.118 (7P-1475)
Restigouche River, Que. - general views, p.64 (123P-4)
Reuter, P.A., photo., p.31 (7P-338)
Reversing Falls, N.B. - general views, p.37 (7P-401)
Rexford (Mont.) - vues, p.35 (7P-148)
Rhodes, E.M., Hon., p.119 (7P-1496)
Rhodes, Edgar N., p.119 (7P-1496)
Rhodes, Harold L., p.119 (7P-1498)
Rhodes, Henry G., p.119 (7P-1497)
Rice, E. Lane, photo., p.140 (7P-1753)
Rice, Ernest, photo., p.72 (7P-884), p.80 (7P-990)
Rice, Lewis, photo., p.119 (31P-93), p.136 (302P-1)
Rice, Margaret, p.119 (31P-52)
Rice and Bennett, photo., p.72 (7P-884)
Rice Studios, photo., p.90 (7P-1180)
Richards, S.Y., photo., p.19 (200P-11)
Richardson, A.H., photo., p.94 (16P-9)
Richardson, Arthur John Hampson, p.119 (7P-1499)

Richardson, Bruce Harder, p.120 (7P-1500)
Richardson, Evelyn (Fox), and family, p.120 (1P-93)
Richardson, H.E., p.120 (333P-13)
Richardson, James A., Sr., p.26 (7P-269)
Richardson, James Cleland, p.101 (7P-1277)
Richardson, W.L., photo., p.94 (7P-1099)
Richelieu (manoir) - Québec, p.13 (7P-145)
Riddiford, Walter G., p.120 (7P-1501)
Rideau Canal, Ont. - general views, p.97 (7P-1216), p.114 (7P-1425)
Rideau Falls, Ont. - general views, p.50 (7P-573)
Rideau Hall, Ottawa, Ont., p.46 (7P-528), p.52 (7P-608), p.83 (7P-1018), p.122 (7P-1527), p.130 (7P-1629)
Rideau Hall, Ottawa (Ont.), p.24 (7P-1918)
Rideau King (SS), p.97 (7P-1222), p.147 (7P-1813)
Rideau King (SS), p.55 (7P-642)
Rideau Lake Navigation Co., p.110 (7P-1374)
Rideau Queen (SS), p.97 (7P-1222), p.110 (7P-1374), p.147 (7P-1813)
Rideau Queen (SS), p.55 (7P-642)
Rideau Waterways, Ottawa, Ont., p.147 (7P-1813)
Rider-Rider, William, photo., p.42 (7P-464), p.120 (7P-1502)
Ridgetown, Ont. - general views, p.55 (7P-654)
Riding Mountain, Man. - general views, p.70 (7P-857)
Riding Mountain National Park, Man. - general views, p.59 (166P-26)
Riel, Louis, p.40 (7P-439), p.54 (7P-635), p.70 (7P-855), p.73 (7P-891), p.81 (7P-995), p.135 (7P-1704)
Riel Rebellion, 1885, p.18 (13P-1), p.18 (7P-217), p.36 (7P-384), p.42 (7P-468), p.54 (7P-638), p.75 (1P-71), p.83 (7P-1025), p.100 (7P-1263), p.101 (1P-49), p.112 (7P-1407), p.114 (13P-2), p.120 (9P-60), p.124 (7P-1554), p.146 (7P-1791)
Riel Rebellion, 1885
 see also
 Rébellion de Riel, 1885
Righton, C., p.120 (333P-36)
Riley, Barbara, p.120 (7P-1503)
Riley, John, p.120 (7P-1504)
Riley, Marjorie, p.120 (7P-1505)
Rimouski (Québec) - individus, p.4 (7P-34)
Rimouski (Québec) - vues, p.4 (7P-34)
Rindisbacher, Peter, p.120 (9P-64)
Rinehart, F.A., photo., p.120 (9P-79)
Rinfret, Bertha, p.120 (7P-1506)
Ritchie's Sport Club, Ottawa (Ont.), p.120 (7P-1507)
Ritley family, p.120 (31P-53)
River Valley (Ont.) - vues, p.107 (185P-1)
Rivière-du-Loup, Que. - general views, p.79 (7P-975), p.99 (7P-1241), p.104 (8P-7), p.131 (7P-1647)
Rivière Gatineau (Québec) -vues, p.24 (7P-1916)
Rivière-Rouge, Que. - general views, p.34 (7P-362)
Roach, P.A., Mrs., p.120 (31P-54)
Roach family, p.120 (31P-54)
Roads - Saskatchewan, p.125 (10P-4), p.125 (10P-5)
Roamer Bicycle Club, Ottawa, Ont., p.55 (7P-647), p.56 (7P-670)
Robarts, John, p.144 (196P-13)
Robb, W.D., p.148 (7P-1822)
Robb, W.D., Mrs., p.148 (7P-1822)
Robb Engineering Co. Ltd., Amherst, N.S., p.120 (31P-67)
Robb family, Amherst, N.S., p.120 (31P-67)
Robbins, J.E., Dr., p.27 (7P-272)
Robert, Yvon, p.120 (7P-1506)
Roberts, A.B., p.120 (7P-1508)
Roberts, Charles George Douglas, Sir, p.10 (7P-110), p.29 (7P-306), p.64 (7P-767), p.65 (7P-783), p.103 (7P-1302), p.126 (196P-16)

Roberts, Charles George Douglas, Sir and family, p.121 (75P-15)
Roberts, Joan, p.120 (7P-1509)
Roberts, John A., Dr., p.121 (228P-1)
Roberts, Marian, p.121 (7P-1510)
Roberts, Theodore G., p.64 (7P-767), p.120 (7P-1509)
Roberts, Vaughan Maurice, p.121 (18P-39)
Robertson, Anne S., p.121 (7P-1511)
Robertson, Beverly, p.12 (7P-130), p.36 (7P-384)
Robertson, Hugh B., p.121 (1P-53)
Robertson, Hugh Shaw, p.121 (196P-50)
Robertson, James Carayon, p.101 (200P-5)
Robertson, James Peter, p.92 (7P-1053)
Robertson, John Ross, p.121 (18P-1), p.121 (18P-11), p.121 (18P-15), p.121 (18P-7), p.121 (18P-79)
Robertson, Lois, p.121 (7P-1512)
Robertson, Melvin Norman Williams, p.121 (7P-1513)
Robertson, Peter David Williams, p.121 (7P-1514)
Robertson, William and Son, Ltd., Halifax, N.S., p.121 (31P-70)
Robertson family, Ont., p.91 (7P-1187), p.147 (7P-1806)
Roberval, Que. - general views, p.94 (7P-1111)
Robinson, Benjamin, juge, p.121 (7P-1515)
Robinson, Clifford Hanks, p.22 (7P-1901)
Robinson, H.P., photo., p.25 (123P-1)
Robson, Charles, p.121 (7P-1516)
Robson, H.H., p.49 (7P-564)
Robson, James, p.121 (7P-1516)
Robson, photo., p.152 (7P-1884)
Robson Lang Leathers, Ltd., Kitchener, Ont., p.121 (7P-1516)
Robson Lang Leathers Ltd., Oshawa, Ont., p.121 (7P-1516)
Roche Miette Creek, Alta. - general views, p.3 (13P-11)
Rocher Percé (Québec) - vues, p.13 (7P-143)
Roches Point, Ont. - general views, p.131 (18P-60)
Rocheuses (montagnes)-vues
 voir aussi
 Rocky Mountains - general views
Rocheuses (montagnes) - vues, p.13 (7P-143)
Rockcliffe, Ont. - general views, p.85 (7P-1068), p.132 (7P-1666)
Rocketon, Man. - general views, p.112 (7P-1402)
Rockland (Ont.) - vues, p.107 (185P-1)
Rockport, Ont. - general views, p.5 (123P-2)
Rocky Mountain House, Alta. -general views, p.104 (7P-1315)
Rocky Mountains - general views, p.2 (166P-18), p.3 (166P-22), p.3 (166P-4), p.9 (7P-82), p.17 (166P-14), p.29 (7P-313), p.48 (7P-547), p.50 (166P-11), p.52 (7P-602), p.58 (166P-29), p.62 (166P-20), p.62 (166P-3), p.66 (166P-5), p.73 (166P-39), p.78 (166P-37), p.82 (166P-46), p.84 (7P-1036), p.97 (7P-1213), p.99 (166P-19), p.104 (166P-1), p.112 (12P-3), p.112 (7P-1407), p.113 (166P-21), p.129 (166P-6), p.131 (166P-32), p.133 (166P-36), p.144 (166P-25), p.145 (7P-1782), p.148 (166P-28), p.149 (166P-23)
Rocky Mountains - general views
 see also
 Rocheuses (montagnes)-vues
Rocky Mountains - International Boundary, p.104 (9P-4)
Rodgers, W., photo., p.18 (7P-224)
Roe, George, p.55 (7P-647)
Roebuck, H.A., p.121 (7P-1517)
Roebuck, John Arthur, p.121 (7P-1893)
Rogart, Sutherlandshire, Scotland - general views, p.147 (7P-1808)
Rogers, A., photo., p.113 (7P-1408)
Rogers, Christopher Chapman, p.122 (7P-1518)

Rogers, Joseph S., photo., p.39 (1P-68), p.121 (1P-14)
Rogers, Lizzie, p.52 (7P-606)
Rogers, Marion G., p.122 (7P-1518)
Rogers, Robert, p.22 (7P-1903)
Roger's Pass, B.C. - scenes, p.133 (8P-10)
Rogersville (N.-B.) - individus, p.131 (341P-1)
Rohland, Terry, p.122 (7P-1519)
Rolfson, O., D.L.S., p.33 (7P-351)
Rolland, Roch, p.122 (7P-1520)
Romanet, Louis Auguste, photo., p.122 (92P-21)
Romanet, Louis Auguste and family, p.122 (92P-21)
Rome, Italie - vues, p.11 (7P-114), p.80 (131P-4)
Romkey, G.E. & Co., West Dublin, N.S., p.122 (31P-80)
Rood, James Lindsay, p.122 (7P-1521)
Rooke family, B.C., p.146 (7P-1797)
Roome, Richard Edward Graham, Brig., p.122 (31P-24)
Roosevelt, Eleanor, p.7 (31P-99)
Roosevelt, Franklin Delano, p.7 (31P-99), p.9 (7P-95), p.26 (7P-1971), p.101 (7P-1272), p.107 (7P-1295), p.150 (7P-1847)
Roosevelt, Theodore, p.85 (31P-51), p.122 (7P-1522)
Roper, M. Carol, p.122 (1P-74)
Roschov, Victor, p.5 (7P-46)
Roscoe, Peter (famille), p.122 (7P-1523)
Rose Prairie, B.C. - general views, p.59 (12P-24)
Rosecastle (SS), p.24 (7P-1930)
Rosenbaum, E.M, p.122 (7P-1529)
Rosenberg, Louis, p.15 (7P-165)
Rosenberg, Louis and family, p.122 (7P-1524)
Rosenberg, Stuart E., Rabbi, p.122 (7P-1525)
Rosenblatt, Joe, p.122 (7P-1526)
Rosetta (Ont.) - vues, p.14 (7P-171)
Rosewarne, Robert Victor, p.122 (7P-1527)
Ross, Alexander, p.122 (31P-22)
Ross, David, Lt. Col., p.133 (7P-1675)
Ross, Douglas, H., p.122 (333P-9)
Ross, Eli M., p.122 (7P-1529)
Ross, Graham, p.122 (7P-1530)
Ross, W. Lawlor, p.122 (7P-1531)
Ross Rifle Factory, Quebec, Que., p.46 (7P-523)
Ross River, Yukon - general views, p.104 (7P-1318)
Rossland, B.C. - general views, p.122 (110P-1), p.139 (7P-1739)
Rossland, B.C. - Mines, p.122 (110P-1), p.123 (7P-1532)
Rotary (Club), Congrès annuel, Tacoma (Wash.), p.14 (7P-159)
Rotary Clubs, p.115 (7P-1441)
Roth, Michael M., p.123 (7P-1533)
Rotterdam, Netherlands - general views, p.147 (7P-1806), p.147 (7P-1807)
Roumanians in Canada, p.22 (7P-1906)
Roumanians in Canada (Western), p.108 (7P-1342)
Round, R.S., p.18 (7P-215)
Rourke, James Ernest, p.123 (7P-1534)
Roux, Jean-Louis, p.135 (7P-1708)
Rouyn, Que. - general views, p.54 (7P-635), p.99 (7P-1241)
Rove, William, p.123 (31P-5)
Rowe, J.Y., p.123 (7P-1535)
Rowe, Maurice, and family, p.49 (7P-563)
Rowe, William Earl, Hon., p.97 (7P-1212)
Rowe, William Earl, Mrs., p.97 (7P-1212)
Rowe family, Ont., p.49 (7P-563)
Rowell, N.W., Hon., p.72 (18P-90)
Roxborough, Myrtle, p.123 (7P-1536)
Roy, Anastase, photo., p.123 (7P-1537)
Roy, Arthur, photo., p.41 (7P-460)
Roy, Camille, Mgr, p.89 (7P-1165)
Roy, Carmen, p.17 (7P-194)
Roy, Guy, photo., p.134 (7P-1688)
Roy, Philippe, Hon., p.22 (7P-1896)

Roy Arthur, photo., p.123 (7P-1538)
Royal Agricultural Winter Fair, Toronto, Ont., p.22 (7P-1901)
Royal Air Force, p.96 (7P-1207), p.153 (7P-1892)
Royal Alexandra Theatre, Toronto, Ont., p.73 (7P-886), p.103 (16P-14)
Royal Artillery Park, p.39 (1P-68)
Royal Bank of Canada, Montreal, Que., p.136 (323P-1)
Royal Canadian Academy of Arts, Ottawa, Ont., p.61 (196P-8)
Royal Canadian Academy of Arts, Toronto, Ont., p.123 (7P-1539)
Royal Canadian Air Force, p.13 (12P-16), p.23 (7P-1976), p.39 (7P-426), p.40 (7P-444), p.42 (7P-466), p.46 (7P-527), p.59 (7P-703), p.63 (7P-758), p.71 (7P-865), p.80 (7P-977), p.80 (7P-988), p.80 (7P-989), p.90 (7P-1171), p.94 (7P-1113), p.114 (13P-2), p.121 (7P-1514), p.137 (7P-1726), p.140 (7P-1755), p.152 (7P-1883)
Royal Canadian Air Force
 see also
 Aircraft - Royal Canadian Air Force
Royal Canadian Air Force, Bombing and Gunnery School, p.54 (7P-637)
Royal Canadian Air Force, No. 1 Central Navigation School, p.86 (7P-1096)
Royal Canadian Air Force, No. 1 Pilot Weapons School, p.56 (7P-669)
Royal Canadian Air Force, No. 10 (BR) Squadron, p.134 (7P-1690)
Royal Canadian Air Force, No. 11 (BR) Squadron, p.39 (7P-423), p.56 (7P-663), p.134 (7P-1690)
Royal Canadian Air Force, No. 11(BR) Squadron, p.45 (7P-514)
Royal Canadian Air Force, No. 110 (AC) Squadron, p.8 (7P-78)
Royal Canadian Air Force, No. 111 (CAC) Squadron, p.47 (7P-535), p.67 (7P-808)
Royal Canadian Air Force, No. 111 (F) Squadron, p.48 (7P-553)
Royal Canadian Air Force, No. 118 Squadron, p.67 (7P-811)
Royal Canadian Air Force, No. 122 Squadron, p.150 (7P-1845)
Royal Canadian Air Force, No. 160 (BR) Squadron, p.56 (7P-663)
Royal Canadian Air Force, No. 161 (BR) Squadron, p.45 (7P-514)
Royal Canadian Air Force, No. 168 (HT) Squadron, p.38 (7P-417), p.72 (7P-877)
Royal Canadian Air Force, No. 2 (AC) Squadron, p.8 (7P-78)
Royal Canadian Air Force, No. 2 Technical Training School, p.135 (7P-1709)
Royal Canadian Air Force, No. 3 Initial Training School, p.121 (7P-1513)
Royal Canadian Air Force, No. 3 Operational Training Unit, p.86 (7P-1096)
Royal Canadian Air Force, No. 3 Wireless School, p.61 (7P-735)
Royal Canadian Air Force, No. 39 Reconaissance Wing, p.90 (7P-1170)
Royal Canadian Air Force, No. 4 Squadron, p.3 (7P-21), p.12 (7P-128)
Royal Canadian Air Force, No. 412 (Falcon) Squadron, p.68 (7P-815)
Royal Canadian Air Force, No. 413 Squadron, p.65 (7P-785)
Royal Canadian Air Force, No. 414 (Sarnia Imperials) Squadron, p.79 (7P-976)
Royal Canadian Air Force, No. 419 Squadron, p.48 (7P-555)
Royal Canadian Air Force, No. 5 Operational Training Unit, p.38 (7P-417), p.68 (7P-815)
Royal Canadian Air Force, No. 6 Bomber Group, p.55 (7P-646), p.116 (7P-1456)

Royal Canadian Air Force, No. 6 (BR) Squadron, p.55 (7P-646), p.67 (7P-808)
Royal Canadian Air Force, No. 6 Squadron, p.3 (7P-21), p.12 (7P-128)
Royal Canadian Air Force, No. 6 (TB) Squadron, p.67 (7P-805)
Royal Canadian Air Force, No. 7 (BR) Squadron, p.44 (7P-499)
Royal Canadian Air Force, No. 7 Operational Training Unit, p.86 (7P-1096)
Royal Canadian Air Force, No. 8 Air Observers School, p.9 (7P-95)
Royal Canadian Air Force, No. 8 (BR) Squadron, p.48 (7P-553)
Royal Canadian Air Force, Northwest Air Command, p.38 (7P-417)
Royal Canadian Air Force, photo., p.76 (7P-922)
Royal Canadian Air Force, Stations, p.47 (7P-534)
Royal Canadian Air Force Air Council, p.115 (7P-1449)
Royal Canadian Corps of Signals, p.133 (7P-1669)
Royal Canadian Corps of Signals Museum, Kingston, Ont., p.123 (7P-1540), p.123 (7P-1975)
Royal Canadian Legion, p.65 (7P-774)
Royal Canadian Mounted Police, p.1 (13P-10), p.1 (81P-1), p.3 (81P-6), p.18 (13P-1), p.23 (7P-1938), p.36 (7P-384), p.36 (7P-392), p.54 (7P-635), p.55 (7P-645), p.67 (7P-811), p.69 (7P-833), p.73 (9P-36), p.77 (7P-935), p.79 (7P-966), p.83 (7P-1025), p.108 (11P-3), p.115 (7P-1444), p.147 (7P-1809), p.153 (161P-1)
Royal Canadian Mounted Police
 see also
 Gendarmerie Royale du Canada
Royal Canadian Mounted Police Museum, Regina, Sask., p.123 (7P-1541)
Royal Canadian Naval College, Halifax, N.S., p.63 (7P-751)
Royal Canadian Naval Volunteer Reserve, p.78 (7P-950)
Royal Canadian Navy, p.23 (7P-1976), p.41 (7P-454), p.88 (7P-1149), p.114 (13P-2)
Royal Canadian Navy - Nova Scotia, p.105 (1P-79)
Royal City Planing Mills, New Westminster, B.C., p.105 (334P-4)
Royal City Saw Mills, New Westminster, B.C., p.105 (334P-4)
Royal Engineers, Institution of The, Chatham, Angleterre, p.123 (7P-1542)
Royal Hudson (locomotive), p.68 (334P-17)
Royal Italian Air Force, p.129 (7P-1618)
Royal Naval Air Service, p.39 (7P-426)
Royal Navy, p.41 (7P-454)
Royal North West Mounted Police
 see
 Royal Canadian Mounted Police
Royal Ontario Museum Theatre, p.103 (16P-14)
Royal Photo Service, photo., p.123 (38P-10)
Royal Society of Canada, p.143 (196P-63)
Royal Society of Canada, Ottawa, Ont., p.123 (7P-1543)
Royal Society of Canada, Quebec, Que., p.40 (7P-437), p.79 (7P-992)
Royal Studios, Hamilton, Ont., p.2 (7P-14)
Royal Tour of 1860, p.123 (7P-1544)
Royal Tour of 1901, p.123 (7P-1545)
Royal Tour of 1919, p.123 (7P-1546)
Royal visits, p.108 (11P-3)
Royalmount (H.M.C.S.), p.41 (7P-454)
Royick, Alexander, p.123 (7P-1547)
Rozmus, Karol, p.123 (7P-1528)
Ruaux, Ile aux, Que. - general views, p.101 (7P-1267)
Rubinstein, Arthur, p.7 (31P-99)
Rudisill, Richard, p.124 (7P-1548)
Rue, A.B., photo., p.55 (131P-1)

Rundle Mountain, Alta. - general views, p.23 (7P-1926)
Runions, N., photo., p.72 (7P-880)
Rupert, Que. - general views, p.55 (7P-643)
Rupert's Land Collection, p.124 (9P-66)
Rushton, Ernest, p.124 (334P-21)
Rushworth, Richard, photo., p.58 (166P-29)
Russel, J.H.G., p.124 (9P-65)
Russell, Man. - general views, p.22 (7P-1906)
Russell, Robert, p.124 (7P-1549)
Russell District, Man. - general views, p.7 (9P-1)
Russell Studio, photo., p.124 (334P-8)
Russia - general views, p.6 (7P-52), p.115 (7P-1438), p.124 (7P-1557)
Russians in Canada, p.22 (7P-1906)
Russians in Saskatchewan, p.49 (7P-568)
Rutherford, Robert William, Capt., p.124 (7P-1550)
Ruttan, H., p.124 (333P-26)
Ryan, James, photo., p.22 (7P-1898), p.124 (7P-1551)
Ryan, Matthew, Capt., p.111 (7P-1383)
Ryan, Patrick, p.124 (7P-1552)
Ryerson, G.S., Lt. Col., p.101 (7P-1276)
Ryerson Institute of Technology
 see
 Ryerson Polytechnical Institute
Ryerson Polytechnical Institute, Toronto, Ont., p.65 (18P-69), p.124 (307P-1)
Rykerts, B.C. - general views, p.80 (7P-987)

Sable Island, N.S. - general views, p.23 (1P-30), p.118 (31P-18)
Sables (lac aux) Que. - general views, p.45 (7P-507)
Sackville (N.-B.) - vues, p.25 (7P-1935)
Sadler-Brown, Nowell, p.124 (7P-1559)
Sadler-Leake, Charlotte, p.45 (7P-513)
Saguenay (Québec) - vues, p.80 (131P-4)
Saguenay River, Que. - general views, p.64 (123P-4), p.104 (8P-7), p.117 (18P-6)
Saguenay River, Que. - scenes, p.133 (8P-10)
Sailing vessels - Canada, p.77 (7P-945)
St. Andrews, Man. - general views, p.91 (7P-1185)
St. Andrews, Ont. - scenes, p.8 (8P-11)
Saint Andrews East, Que. - general views, p.34 (7P-367), p.91 (7P-1187)
St. Andrew's United Church, Peterborough, Ont., p.124 (7P-1553)
Saint-Antoine-sur-Richelieu, Que. - general views, p.29 (7P-314)
Saint-Antoine-sur-Richelieu (Québec) - vues, p.30 (7P-315)
St. Basil's Novitiate, Toronto, Ont., p.126 (200P-7)
St. Boniface (Man.) - vues, p.89 (303P-10)
St. Catharines, Ont. - general views, p.54 (7P-629)
Saint-Charles - lac - vues, p.4 (134P-1)
Saint-Charles, Joseph, p.61 (8P-1), p.79 (185P-4), p.124 (185P-13)
Saint Charles (Point), Que. -general views, p.5 (7P-35)
Saint-Charles-sur-Richelieu (Québec) - vues, p.30 (7P-315)
Saint-Denis, Que. - scenes, p.61 (8P-1)
Saint-Denis (Québec) - vues, p.30 (7P-315)
Saint-Domingue - vues, p.80 (131P-4)
Saint-Eugène Mission, B.C. - general views, p.47 (333P-28), p.47 (333P-8)
Saint-Féréol (Québec) - vues, p.11 (131P-2), p.77 (131P-5)
Saint-George (SS), p.145 (7P-1775)

Saint-Germain, Lake, Que. - general views, p.42 (7P-467)

St. Helena, S.C. - general views, p.120 (123P-8)

Saint-Hermas, Que. - general views, p.41 (7P-460)

Saint-Hilaire, Madeleine Fohy, p.77 (7P-941)

Saint-Hyacinthe (Québec) - vues, p.30 (7P-315)

Saint-Irénée-les-Bains (Québec) - vues, p.117 (113P-4)

Saint James, Man. - Brownies, p.66 (9P-30)

Saint-Jean, Idola, p.34 (7P-358)

Saint-Jean-Baptiste - défilés., p.90 (113P-1)

St. Jean Baptiste, Man. - general views, p.59 (9P-23)

St. Jean Baptiste Day Parade - Quebec - Montreal, p.29 (7P-310)

Saint-Jean-Baptiste Society of Montreal, Montreal, Que., p.40 (7P-432)

Saint-Joachim, Que. - general views, p.117 (7P-1468)

Saint John, N.B. - fire, 1877, p.103 (2P-1)

Saint John, N.B. - general views, p.21 (7P-257), p.42 (7P-463), p.59 (7P-704), p.75 (7P-910), p.76 (7P-923), p.92 (7P-1039), p.103 (2P-1), p.103 (7P-1301), p.104 (8P-7), p.116 (7P-1452), p.145 (7P-1777)

Saint John, N.B. - scenes, p.61 (8P-1), p.133 (8P-10)

Saint John (N.-B.) - vues, p.19 (7P-227), p.151 (7P-1868)

Saint John Regional Library, Saint John, N.B., p.124 (7P-1555)

St. John's, Nfld. - aerial views, p.68 (7P-826)

St. John's, Nfld. - fire, 1892, p.21 (7P-258), p.127 (7P-1581)

St. John's, Nfld. - general views, p.26 (7P-1967), p.57 (38P-6), p.64 (7P-762), p.68 (7P-823), p.70 (7P-855), p.74 (38P-7), p.89 (7P-1163), p.91 (7P-1186), p.126 (7P-1574), p.128 (7P-1600)

St. John's, Nfld. - scenes, p.23 (7P-1917)

St. John's Convent, Willowdale, Ont., p.124 (7P-1554)

St. John's Harbour, St. John's, Nfld., p.111 (7P-1912)

St. Joseph, Ont. - general views, p.134 (7P-1683)

Saint-Joseph, Oratory, Montreal, Que., p.81 (7P-996), p.142 (7P-1768)

Saint-Jovite (Québec) - vues, p.14 (007P-161)

Saint-Lambert (Québec) - vues, p.25 (7P-1935)

St. Laurent, Louis Stephen, Rt. Hon., p.81 (7P-1002), p.103 (7P-1296)

St. Laurent, Louis Stephen, Rt. Hon., and family, p.124 (7P-1556)

St. Laurent, Louis Stephen, Très Hon., p.69 (7P-1946), p.102 (7P-1290)

Saint Laurent, Lower, Que. - general views, p.44 (7P-497)

St. Laurent, S., p.115 (7P-1449)

Saint-Laurent, voie maritime - vues, p.95 (7P-1127)

St. Laurent, William, p.124 (7P-1557)

Saint-Laurent (Québec) - vues, p.25 (7P-1935)

St. Lawrence, Gulf, Que. - general views, p.61 (7P-727)

St. Lawrence, Que. - scenes, p.133 (8P-10)

St. Lawrence River -general views, p.64 (123P-4)

St. Lawrence River, locks near Cardinal, Ont., p.129 (7P-1621)

St. Lawrence River, Que. - general views, p.72 (7P-879), p.105 (18P-3)

St. Lawrence Seaway - general views, p.26 (7P-1969), p.124 (7P-1558), p.147 (7P-1811)

St. Lawrence Seaway Authority, Montreal, Que., p.124 (7P-1558)

Saint-Louis (famille), p.77 (185P-5)

Saint Louis (SS), p.147 (7P-1813)

Saint-Marc (Québec) - vues, p.30 (7P-315)

St. Margaret's Bay, N.S. - general views, p.7 (1P-28)

St. Martin, Alexis, et famille, p.18 (7P-214)

St. Mary River, Alta. - general views, p.18 (7P-221)

St. Maurice River, Que. - general views, p.64 (123P-4)

St. Maurice River, Que. - scenes, p.133 (8P-10)

Saint-Maxime
 voir
 Longueuil (Québec)

St. Michael's College, Toronto, Ont., p.124 (200P-10), p.124 (200P-6)

St. Michael's Hospital Archives, Toronto, Ont., p.125 (318P-1)

Saint-Ours, Que., p.122 (7P-1520)

Saint-Ours (Québec) - vues, p.30 (7P-315)

Saint-Pascal (Québec) - vues, p.11 (131P-2), p.134 (350P-1)

Saint-Patrick's Band, Halifax, N.S., p.125 (31P-55)

St. Peters, N.S. - general views, p.111 (7P-1383), p.152 (1P-4)

St. Peter's Canal, Richmond Co., N.S., p.21 (1P-61)

St. Peter's Mission, Mont. -general views, p.139 (7P-1745)

Saint-Pierre, Denyse, p.43 (7P-480)

Saint-Pierre, Maurice, Collection, p.125 (347P-1)

St. Thomas, Ont. - individuals, p.153 (7P-1887)

Saint-Thomas de Montmagny (Québec) - camp militaire, p.82 (134P-3)

Saint-Tite-des-Caps (Québec) - vues, p.80 (131P-4)

Saint-Yvon, Que. - general views, p.42 (7P-465)

Saint-Zotique, Que. - general views, p.34 (7P-362)

Sainte-Agathe, Que. - general views, p.119 (7P-1494)

Sainte-Agathe (Man.) - vues, p.135 (7P-1699)

Sainte-Anne, N.S. - general views, p.152 (1P-4)

Sainte-Anne, Que. - general views, p.104 (8P-7)

Sainte-Anne-de-Beaupré, (chutes), (Québec) - vues, p.91 (131P-3)

Sainte-Anne-de-Beaupré (chutes), (Québec) - vues, p.11 (131P-2)

Sainte-Anne-de-Beaupré (chutes) (Québec) - vues, p.77 (131P-5)

Sainte-Anne-de-la-Pérade (Québec) - vues, p.136 (352P-1)

Sainte-Foy (Québec) - vues, p.4 (134P-1)

Sainte-Pétronille (Québec) - vues, p.11 (131P-2)

Sair, Samuel, p.125 (7P-1560)

Salaberry, de, family, Que., p.122 (7P-1520)

Salk Institute, San Diego, Calif., p.18 (16P-6)

Sallows, Reuben R., photo., p.22 (7P-1903), p.48 (7P-552), p.102 (200P-13)

Sallows, Rev. Ben R., p.125 (7P-1561)

Salmon, B.B., photo., p.26 (7P-264)

Salmon, James Victor, p.32 (140P-11)

Salmon, James Victor, photo., p.125 (18P-12)

Salmon Arm, B.C. - general views, p.124 (7P-1549)

Salonique, Grèce - vues, p.150 (7P-1846)

Salt Lake City, Utah - general views, p.64 (18P-4), p.120 (123P-8)

Salt mining - Nova Scotia, p.86 (1P-23)

Salter, J.K., photo., p.84 (7P-1032)

Salton, George F., p.125 (7P-1562)

Salverson, Sandra Scott, p.2 (7P-9)

Salzmann, Auguste, photo., p.25 (123P-1)

Samson (Locomotive), p.25 (7P-1948)

San Francisco, Calif. - general views, p.64 (18P-4), p.120 (123P-8)

San Juan Islands (C.-B.) - vues, p.35 (7P-371)

San Marino, Calif. - general views, p.68 (333P-5)

Sanagan River, B.C. - general views, p.22 (7P-1901)

Sand Point, Ont. - general views, p.114 (7P-1426)

Sandler, Martin W., p.125 (7P-1563)

Sangster, Charles, p.108 (7P-1345)

Sanson, Norman B., p.125 (166P-2)

Santa Fé, N.M. - general views, p.120 (123P-8)

Sarcee Camp, Alta. - general views, p.38 (7P-415)

Sarcee Indians, p.68 (333P-5), p.84 (11P-2), p.108 (11P-3)

Sarcee Indians
 see also
 Sarsi, indiens

Sardinian (Ship), p.125 (31P-112)

Sarrault, Henri, p.125 (7P-1564)

Sarsi, indiens, p.14 (7P-156)

Sarsi, indiens
 voir aussi
 Sarcee Indians

Sasaki, Steve, p.125 (7P-1565)

Sash and Door Lumber Co., Kitchener, B.C., p.84 (333P-30)

Saskatchewan - general views, p.125 (10P-2), p.125 (10P-5)

Saskatchewan - history, p.82 (339P-1)

Saskatchewan - Politics and Government, p.125 (10P-2), p.148 (10P-11)

Saskatchewan - scenes, p.9 (7P-82), p.9 (7P-84), p.10 (9P-3), p.16 (9P-5), p.34 (7P-359), p.47 (7P-536), p.61 (18P-86), p.67 (10P-8), p.70 (10P-10), p.92 (7P-1040), p.93 (7P-1066), p.108 (7P-1342), p.125 (10P-4), p.125 (10P-7), p.127 (7P-1580), p.148 (10P-11)

Saskatchewan - Settlement, p.8 (7P-832), p.133 (7P-1670)

Saskatchewan, Department of Agriculture, p.125 (10P-2)

Saskatchewan, Department of Agriculture, Livestock Branch, p.125 (10P-3)

Saskatchewan, Department of Education, p.125 (10P-6)

Saskatchewan, Department of Highways, p.125 (10P-4)

Saskatchewan, Department of Highways, Ferry Branch, p.125 (10P-5)

Saskatchewan, Photographic Art Services, p.125 (10P-7)

Saskatchewan Archives, Regina, Sask., p.125 (7P-1566)

Saskatchewan River, Sask. - general views, p.40 (7P-440), p.76 (7P-931)

Saskatchewan (SS), p.76 (7P-931)

Saskatchewan Wheat Pool, Regina, Sask., p.126 (10P-12)

Saskatoon, Sask. - general views, p.39 (7P-425), p.56 (7P-664), p.65 (339P-2), p.82 (339P-1), p.116 (7P-1452), p.130 (7P-1634)

Saskatoon, Sask. - scenes, p.136 (10P-13)

Saskatoon (Sask.) - vues, p.14 (7P-164), p.24 (7P-1940)

Sault-au-cochon (Québec)
 voir
 Beaupré (Québec)

Sault Canal, Ont. - general views, p.39 (7P-429)

Sault Ste. Marie, Ont. - general views, p.126 (121P-1)

Sault Ste. Marie, Ont. - scenes, p.49 (8P-8), p.133 (8P-10)

Sault Ste. Marie and 49th Field Regiment R.C.A. Historical Society, Sault Ste. Marie, Ont., p.126 (121P-1)

Sault Ste. Marie (Ont.) - vues, p.107 (185P-1)

Sault Ste. Marie, Ont. - general views, p.127 (7P-1582), p.130 (7P-1624)

Sault Ste. Marie Canal, Ont. - general views, p.124 (7P-1558)

Saunders, Charles E., Dr., p.125 (10P-6), p.126 (7P-1568)

Saunders, Sylvia, p.126 (196P-37)

Saunders, William, p.22 (7P-1901)

Saunders (William) Building, Dominion Experimental Farm, Ottawa, Ont., p.100 (7P-1264)

Sauvageau, Alain, p.126 (351P-1)

Sauvé, Maurice, p.126 (7P-1569)

Savage, John A., Mrs., p.126 (7P-1570)

Savage, Marion Creelman, p.126 (7P-1571)
Savanah, photo., p.79 (7P-971)
Sawback Range, Alta. - general views, p.23
 (7P-1926)
Scadding, Henry, p.126 (196P-15)
Scarborough, England - general views, p.13
 (18P-10)
Scarth, Jessie, p.126 (7P-1572)
Scarth, Marion, p.126 (7P-1572)
Scarth, W.B., Mrs., p.126 (7P-1572)
Schaffer, Mary, photo., p.99 (166P-19)
Schellinger, A.K., photo., p.153 (7P-1890)
Schleyer, George W., photo., p.126 (31P-94)
Schmalz, William Henry Eugene, p.126 (7P-1573)
Schmidt, Gisele, p.43 (7P-480)
Schnieder, Stuart, p.126 (7P-1574)
School - B.C. - Victoria (Victoria Boys Central
 School), p.33 (12P-27)
School - Ontario - Georgetown (Canadian Jewish
 Farm School), p.22 (7P-1906)
Schools
 see also
 Ecoles
Schools - Alberta, p.112 (13P-9)
Schools - Alberta - Banff (Fine Arts), p.1
 (149P-1), p.142 (92P-9)
Schools - British Columbia - Crowsnest Pioneer
 School, p.68 (333P-5)
Schools - British Columbia - Fort Steele, p.16
 (333P-32)
Schools - British Columbia - Masset, p.22
 (7P-1901)
Schools - British Columbia - New Westminster, p.1
 (334P-34), p.35 (334P-28), p.116 (334P-9)
Schools - British Columbia - New Westminster
 (High School), p.134 (334P-2)
Schools - British Columbia - New Westminster
 (Queensborough), p.96 (334P-22)
Schools - British Columbia - New Westminster
 (West End School), p.117 (334P-10)
Schools - Canada, p.27 (7P-270)
Schools - Manitoba - Winnipeg (Fort Rouge
 school), p.111 (7P-1382)
Schools - Nova Scotia, p.105 (1P-77), p.106
 (1P-94)
Schools - Nova Scotia - Halifax, p.60 (1P-78),
 p.137 (1P-55)
Schools - Nova Scotia - Halifax (Pine Hill), p.89
 (24P-1)
Schools - Nova Scotia - Halifax (School for the
 Blind), p.60 (1P-25)
Schools - Ontario - Ashburn (Ashburnham Public
 School), p.110 (7P-1374)
Schools - Ontario - Bullock, p.151 (7P-1854)
Schools - Ontario - Caledonia, p.40 (7P-435)
Schools - Ontario - Ethel (Ethel Public School),
 p.121 (7P-1513)
Schools - Ontario - Hawkesbury (Hawkesbury
 Public School), p.87 (7P-1123)
Schools - Ontario - Hopetown, p.151 (7P-1854)
Schools - Ontario - Lanark (secondary school),
 p.98 (7P-1225)
Schools - Ontario - London (Service School of
 International Harvester Co.), p.26 (7P-1963)
Schools - Ontario - Merrickville, p.98 (7P-1225)
Schools - Ontario - Middleville, p.151 (7P-1854)
Schools - Ontario - Oakville, p.107 (47P-16)
Schools - Ontario - Orangeville (high school), p.35
 (7P-381)
Schools - Ontario - Ottawa (Normal School), p.38
 (7P-411)
Schools - Ontario - Ottawa (Ottawa Board of
 Education), p.109 (7P-1354)
Schools - Ontario - Port Hope, p.41 (7P-449)
Schools - Ontario - Renfrew (public school), p.68
 (7P-817)
Schools - Ontario - Sault Ste. Marie, p.126
 (121P-1)

Schools - Ontario - Toronto (Curtiss Aviation
 School), p.99 (7P-1241)
Schools - Ontario - Toronto (High Park Forest),
 p.138 (140P-17)
Schools - Ontario - Toronto (Jesse Ketchum
 School), p.45 (7P-509), p.50 (7P-583)
Schools - Ontario - Toronto (Ontario School of
 Practical Science), p.143 (196P-53)
Schools - Ontario - Toronto Province (Brothers of
 the Christian Schools), p.18 (310P-1)
Schools - Ontario - Toronto (School of Military
 Aeronautics), p.67 (7P-814)
Schools - Ontario - Toronto (School of Practical
 Science), p.142 (196P-58)
Schools - Ontario - Toronto (Sisters Servants of
 Mary Immaculate), p.130 (338P-1)
Schools - Ontario - Toronto (Toronto School of
 Medicine), p.37 (196P-4)
Schools - Ontario - Toronto (Trinity Medical
 School), p.139 (196P-2)
Schools - Quebec - Montreal (Marconi Wireless
 Co.), p.28 (7P-287)
Schools - Quebec - Quebec (Royal School of
 Artillery), p.3 (7P-20)
Schools - Saskatchewan, p.112 (13P-9), p.125
 (10P-2), p.125 (10P-6)
Schools - United States - North Dakota - Ralla
 (Public School), p.126 (7P-1579)
Schools (Jewish) - Manitoba, p.71 (305P-1)
Schooners - Newfoundland, p.6 (7P-54)
Schooners - Nouveau-Brunswick, p.24 (7P-1930)
Schooners - Ontario, p.97 (7P-1208)
Schooners - United States, p.82 (11P-1)
Schreiber, Charlotte M.B., p.57 (196P-46)
Schreier, Michael, p.97 (123P-6)
Schubert Choir, Brantford, Ont., p.73 (149P-12)
Schull, Joseph, p.126 (7P-1575)
Schuster, Nigel, p.126 (7P-1576)
Schwarzkopf, Elizabeth, p.83 (7P-1027)
Schweitzer, Albert, p.43 (7P-476)
Sciences - field works, p.3 (7P-23)
Sciences biologiques - généralités, p.36 (332P-1)
Scollard, Robert Joseph, p.126 (200P-7), p.142
 (200P-18)
Scotland - general views, p.60 (1P-25), p.87
 (7P-1124), p.87 (7P-1135)
Scott, Armstrong, p.104 (7P-1317)
Scott, Barbara Ann, p.57 (7P-682)
Scott, D.C., p.25 (7P-1952)
Scott, Desire Elise, p.126 (7P-1577)
Scott, Duncan Campbell, Dr., p.29 (7P-306), p.61
 (8P-1), p.126 (196P-16), p.126 (7P-1577)
Scott, E.B., p.126 (12P-14)
Scott, George D., p.5 (7P-46)
Scott, George T., p.126 (7P-1578)
Scott, Gordon T., Lt., p.14 (7P-152)
Scott, Henri-Arthur, Chanoine, p.89 (7P-1165)
Scott, J.T., p.34 (334P-37)
Scott, Lloyd E.W., and family, p.126 (7P-1579)
Scott, Richard, Sir, p.22 (7P-1896)
Scott, W.L. and family, p.127 (7P-1581)
Scott, William D., p.127 (7P-1580)
Scott family, Man., p.54 (9P-20)
Scott Paper Co., Sheet Harbour, N.S., p.127
 (31P-74)
Scottsville, Ont. - general views, p.47 (7P-543)
Scouts (Boys) - Saskatchewan, p.125 (10P-6)
Scribner's Sons, Charles, New York, N.Y., p.127
 (7P-1582)
Sculptors - Canada, p.127 (7P-1583)
Sculptors Society of Canada, Toronto, Ont., p.127
 (7P-1583)
Seaforth, Ont. - general views, p.68 (7P-828)
Seagrim, Herbert Walter, p.127 (7P-1584)
Sealing - Alaska, p.30 (7P-328)
Sealing - British Columbia, p.30 (7P-328)
Sealing - Labrador, p.129 (7P-1620)
Sealing - Newfoundland, p.6 (7P-54), p.8 (7P-72),
 p.28 (7P-287), p.91 (7P-1186), p.117 (4P-1)

Sealing - United States - Alaska, p.75 (7P-914)
Seaman, Amos, and family - gravestones -
 Minudie, N.S., p.34 (1P-64)
Seaner, N.B., p.127 (7P-1585)
Seaton, photo., p.153 (161P-1)
Sechelt (C.-B.) - vues, p.25 (7P-1935)
See, Joseph I, photo., p.102 (200P-13)
Seele & Co., photo., p.12 (7P-133)
Segwun Steamship Museum, Gravenhurst, Ont.,
 p.127 (8P-3)
Seigneurie de la Petite Nation, p.55 (7P-649)
Seigniory Club, Montebello, Que., p.91 (7P-1187)
Selassie, Haile, Emporer of Ethiopia, p.137
 (7P-1721)
Seldon, R., p.43 (7P-483)
Seleshko, Matthew, photo., p.127 (7P-1587)
Selkirk, Man. - general views, p.54 (9P-20)
Selkirk, Man. - settlement, p.59 (9P-22)
Selkirk Mountains, B.C. - general views, p.2
 (166P-18), p.3 (166P-4), p.3 (166P-43), p.50
 (166P-11), p.62 (166P-3), p.73 (166P-39),
 p.82 (166P-46), p.89 (7P-1167)
Selkirk Mountains, B.C. - scenes, p.133 (8P-10)
Sellar, Robert Watson, p.127 (7P-1586)
Selwyn, A.R.C., p.24 (7P-1916)
Semak, Michael, photo., p.127 (7P-1588)
Séminaire de Nicolet, Nicolet (Québec), p.127
 (324P-1)
Séminaire de Québec, p.4 (131P-9), p.6 (7P-49),
 p.11 (131P-2), p.77 (131P-5)
Séminaires - diocèse d'Ottawa, p.48 (306P-1)
Seminaries - Quebec - Sherbrooke (St. Charles
 Seminary), p.124 (7P-1556)
Senhora da Monte , Madeira Park, Toronto, Ont.,
 p.65 (7P-779)
Sept Chutes (les) (Québec) -chutes, p.11 (131P-2)
Sept Chutes (Québec) - chûtes, p.77 (131P-5)
Sewell, Dr, p.78 (7P-956)
Sexsmith, Alta. - general views, p.130 (7P-1634)
Seymour, Frederic B.C., p.12 (7P-134)
Seymour, Horace L., p.127 (7P-1589)
Seymour, Murton Adams, p.127 (7P-1590)
Shackleton, Edward, Expedition, 1907-1908, p.97
 (7P-1210)
Shag Harbour, N.S. - general views, p.120 (1P-93)
Shakespearian Festival, Stratford, Ont., p.128
 (7P-1608)
Shamrock (SS), p.24 (7P-1930)
Shanghai, China - general views, p.135 (7P-1708)
Shannon (Ship), p.117 (7P-1465)
Sharky, F.H., photo., p.2 (7P-14)
Sharp, Mitchell William, Hon., p.30 (7P-324)
Sharpe, H.F., Mrs., p.5 (7P-38)
Sharpe, H.F., photo., p.5 (7P-38)
Sharples, John, Hon., p.67 (171P-1)
Sharpshooters Monument, Ottawa, Ont., p.100
 (7P-1260)
Shaver, Margaret Ann Sissons, p.129 (7P-1623)
Shaver, Peter, p.129 (7P-1623)
Shaver, Peter, Mrs., p.129 (7P-1623)
Shaw, Edith, p.127 (7P-1591)
Shaw, Nell, p.127 (7P-1593)
Shaw, Nellie, p.127 (7P-1594)
Shaw, W.G.A., Master, p.127 (7P-1593)
Shaw Festival, 1963-1965, p.2 (7P-9)
Shaw Festival Theatre, Niagara-on-the-Lake, Ont.,
 p.60 (7P-717), p.127 (7P-1592)
Shaw (H.M.S.), p.17 (7P-201)
Shawville, Que. - general views, p.115 (7P-1433)
Shedden, photo., p.32 (7P-347)
Shediac, N.B. - general views, p.129 (7P-1618)
Sheep Creek, Yukon - general views, p.42 (7P-459)
Sheet Harbour flood, 1956, p.127 (31P-74)
Sheet Harbour Passage, N.S. -general views, p.63
 (1P-26)
Shefford (Co.) (Québec) - vues, p.77 (344P-1)
Shelburne (N.-E.) - vues, p.16 (7P-189)
Sheldon & Davis, photo., p.58 (7P-693), p.94
 (7P-1099)

Sheldon, H.K., photo., p.77 (7P-947)
Shelton, A.C., photo., p.68 (7P-823)
Shelton, Percioal, H., p.13 (7P-141)
Shenston, Thomas Strachan, p.127 (18P-42)
Shenstone, Beverley Strahan, p.128 (7P-1595)
Shepherd, R.W., p.128 (7P-1596)
Shepherd, R.W., Mrs., p.128 (7P-1597)
Shera, J.W., p.25 (7P-1932)
Sherbrooke, Que. - general views, p.46 (7P-528)
Sherbrooke, Que. - scenes, p.61 (8P-1)
Sheriffs, A.J., p.128 (7P-1598)
Sherry, Agnes B., p.128 (7P-1599)
Sherwood, Arthur Percy, p.128 (7P-1600)
Sherwood, H. Crossley, p.128 (7P-1601)
Sherwood, Helen, p.128 (7P-1602)
Sherwood, Livius P., p.128 (7P-1603)
Shiels, Michael Joseph, p.128 (7P-1604)
Shih, Hsieh-Yen, Dr., p.30 (7P-324)
Shingle Point Mission (T.N.-O.) - vues, p.117 (7P-1472)
Shipbuilding - British Columbia - New Westminster, p.116 (334P-9)
Shipbuilding - Newfoundland, p.131 (7P-1642)
Shipbuilding - Nova Scotia, p.122 (1P-74)
Shipbuilding - British Columbia - New Westminster, p.41 (334P-14)
Shipbuilding - Nova Scotia, p.12 (31P-104), p.47 (7P-541), p.61 (31P-108), p.64 (7P-766), p.76 (31P-77), p.100 (31P-1261), p.123 (31P-5)
Shipka, Ont. - general views, p.124 (7P-1549)
Shipman, J.C., and family, p.128 (7P-1605)
Shipman, N.C., p.128 (7P-1605)
Shipman family, Ont., p.132 (7P-1651)
Shippegan (N.-B.) - individus, p.131 (341P-1)
Ships - British Columbia, p.116 (334P-9)
Ships - Royal Canadian Navy, p.105 (1P-79)
Ships - Yukon, p.153 (161P-1)
Ships and shipping, p.136 (31P-41)
Ships and shipping - British Columbia, p.114 (7P-1431)
Ships and shipping - Canada, p.28 (7P-292), p.69 (7P-836), p.77 (7P-945), p.150 (7P-1855)
Ships and shipping - Halifax, N.S., p.121 (1P-53)
Ships and shipping - Newfoundland, p.91 (7P-1186)
Ships and shipping - Newfoundland - St-John's, p.6 (7P-54)
Ships and shipping - Nova Scotia, p.23 (1P-30), p.34 (31P-106), p.43 (31P-73), p.85 (31P-26), p.87 (31P-9), p.105 (1P-85), p.107 (31P-81)
Ships and shipping - Ontario, p.3 (7P-22)
Ships and shipping - Ontario - Oakville, p.107 (47P-17)
Ships and shipping - Ontario - Trenton, p.106 (7P-1326)
Ships and shipping - Quebec -Montreal, p.77 (7P-943)
Ships and shipping - Toronto, Ont., p.150 (18P-52)
Ships and shipping - United States, p.28 (7P-292)
Ships and shipping - wrecks, p.23 (7P-1911)
Short, Alice, p.8 (7P-75)
Short, C.J., Major, R.C.A., p.4 (134P-1)
Short, Samuel, et famille, p.8 (7P-75)
Shortill, R.M., p.128 (7P-1606)
Shortreed, Robert, p.128 (7P-1607)
Shortt, Adam, p.114 (7P-1427)
Shortt-Haydon Collection, p.128 (75P-16)
Showalter, H.A., Dr., p.128 (7P-1608)
Showler, John Gavin, p.128 (7P-1609)
Shriner's Club, p.102 (7P-1282)
Shuswap Indians, p.42 (333P-3), p.108 (333P-4)
Shute, Elizabeth, p.128 (7P-1610)
Shutt, Frank Thomas, p.22 (7P-1901)
Shuttleworth, E.B., p.128 (7P-1611)
Shuttleworth, Gertrude, p.128 (7P-1611)
Siberia, U.S.S.R. - general views, p.115 (7P-1438)
Sicamous (SS), p.132 (7P-1665)
Sidney Island, B.C. - general views, p.150 (12P-12)
Sidney Island, B.C. - scenes, p.150 (12P-12)

Siegfried, André, p.43 (7P-476)
Siemens, Abe, p.128 (7P-1612)
Sifton, Arthur Lewis, Rt. Hon. and family, p.128 (7P-1613)
Sifton, Clifford, Sir, p.129 (18P-21)
Sifton, E.W., p.129 (7P-1614)
Sifton, Man. - general views, p.112 (7P-1402)
Sifton, Nellie, p.129 (7P-1614)
Sigouin, Leon, Rev., p.129 (7P-1615)
Silcox, David, p.27 (7P-274)
Sillery, Que. - general views, p.145 (7P-1775)
Silver Cliff, Ont. - general views, p.119 (7P-1492)
Silver Heights, Alta. - general views, p.105 (123P-5)
Silver Islet, Ont. - scenes, p.49 (8P-8)
Silver Sands Fishing Lodge, B.C., p.16 (12P-25)
Silverthorn, Mary, p.129 (196P-44)
Silverthorne, F.G., p.129 (7P-1616)
Simcoe, John Graves, p.121 (18P-11), p.139 (18P-71)
Simcoe, Lake, Ont. - general views, p.126 (7P-1579)
Simcoe, Ont. - scenes, p.133 (8P-10)
Simm, Donald, p.129 (7P-1617)
Simmons, Donald B., p.129 (7P-1618)
Simon Fraser Monument - dedication, p.60 (334P-40)
Simonite, Charles Edward, p.129 (9P-78)
Simpson, Beatrix, p.129 (7P-1619)
Simpson, George, and family, p.91 (7P-1187)
Simpson, George, Sir, p.85 (7P-1089)
Simpson, H.E., photo., p.5 (7P-37), p.58 (7P-693), p.72 (7P-874)
Simpson, James, p.129 (18P-51)
Simpson, James, Sr., p.129 (166P-6)
Simpson Bros., photo., p.149 (7P-1828)
Sims, Arthur George, p.129 (7P-1620)
Sims, Rear Admiral, p.85 (31P-51)
Simzer, Earl D., p.129 (7P-1621)
Sinclair Family, N.B., p.83 (7P-1028)
Singh, Gurdit, p.77 (7P-945)
Sioux Indians, p.42 (7P-468), p.65 (7P-780), p.101 (1P-49)
Sioux Lookout (Ont.) - vues, p.17 (7P-200)
Sir Alexander Galt Museum, Lethbridge, Alta., p.81 (7P-994)
Sirius (Ship), p.92 (7P-1043)
Sise, Hazen and family, p.129 (7P-1622)
Siskind, Aaron, photo., p.25 (123P-1)
Sisler, William James, p.129 (9P-67), p.129 (9P-83)
Sissons, Charles Bruce, p.129 (7P-1623)
Sissons, Jonathan, p.129 (7P-1623)
Sisters of St. Joseph, Willowdale, Ont. - convents and buildings, p.129 (319P-1)
Sisters of St. Joseph of the Diocese of Toronto of Upper Canada, Willowdale, Ont., p.129 (319P-1)
Sisters Servants of Mary Immaculate, Eparchy of Christ the King, p.130 (338P-1)
Sisters Servants of Mary Immaculate, Eparchy of Edmonton, p.130 (338P-1)
Sisters Servants of Mary Immaculate, Eparchy of Saskatoon, p.130 (338P-1)
Sisters Servants of Mary Immaculate, Eparchy of Toronto, p.130 (338P-1)
Sisters Servants of Mary Immaculate, Eparchy of Winnipeg, p.130 (338P-1)
Sisters Servants of Mary Immaculate, Toronto, Ont., p.130 (338P-1)
Site Historique
voir
le nom du site ou du pays
Sixteen Mile Creek, Ont. - general views, p.41 (47P-3), p.106 (47P-5), p.130 (47P-19)
Sixth Commonwealth Mining and Metallurgical Congress, 1957, p.63 (7P-753)
Sjostedt, Jessie, p.130 (7P-1624)

Skagway, Alaska - general views, p.30 (7P-319), p.74 (7P-898)
Skeena River, B.C. - general views, p.52 (12P-5)
Skeena (rivière) (C.-B.) - vues, p.12 (7P-138)
Skelton, O.D., Dr, p.24 (7P-1907), p.104 (7P-1314)
Skinner, L.B., p.130 (7P-1625)
Skirrow, George "Lucky", p.130 (166P-33)
Skis and skiing - Alberta, p.62 (166P-7), p.110 (166P-8)
Skoki Area, Alta. - general views, p.118 (166P-42)
Skuce, G.O., Mrs., p.130 (7P-1626)
Skuce, Lester, p.130 (7P-1627)
Slack, W., p.130 (7P-1628)
Sladen, Arthur F., p.130 (7P-1629)
Slater, James D. and family, p.39 (7P-424)
Slater, T.A., photo., p.39 (1P-68)
Slattery, Beatrice C., p.130 (7P-1630)
Slave River, N.W.T. - general views, p.98 (7P-1229)
Sloan, John Charles, p.130 (7P-1631)
Slocan City, B.C. - general views, p.91 (7P-1181), p.139 (7P-1748)
Slocomb family, N.S., p.130 (1P-54)
Slovaks in Canada, p.54 (7P-640)
Sly Rapids (Ont.) - vues, p.14 (7P-171)
Smeaton, Charles, photo., p.65 (7P-786), p.130 (7P-1632)
Smith, Adelaide Bailey Fingal
see
Fingal-Smith, Adelaide Bailey
Smith, Albert James, Hon. Sir, p.74 (7P-899)
Smith, Alta. - general views, p.130 (7P-1634)
Smith, Arthur Y., p.130 (7P-1633)
Smith, B.J., photo., p.142 (200P-8)
Smith, C.E. Stanfield, p.130 (7P-1634)
Smith, Charles Lyman, p.130 (7P-1635)
Smith, Deane C., p.130 (7P-1636)
Smith, E.J.G., photo., p.149 (7P-1828)
Smith, Edith M., p.130 (7P-1637)
Smith, Elizabeth, p.130 (7P-1638)
Smith, H.D., p.131 (7P-1639)
Smith, H.H., p.61 (7P-734)
Smith, Harlan Ingersoll, photo., p.94 (16P-9)
Smith, Henry, p.131 (5P-4)
Smith, Herbert "Soapy", p.131 (166P-32)
Smith, Hugh, p.131 (7P-1639)
Smith, Jefferson "Soapy", p.23 (7P-1938)
Smith, Larratt William, and family, p.131 (18P-60), p.131 (18P-64)
Smith, Lois, p.30 (7P-324)
Smith, Maurice, p.131 (7P-1640)
Smith, Minnie C., p.131 (7P-1641)
Smith, Phillip E.L., p.131 (7P-1642)
Smith, Roger, p.40 (7P-433)
Smith, Sidney, p.131 (196P-41)
Smith, Strathy, p.131 (7P-1643)
Smith, Thomas Benton, p.131 (7P-1644)
Smith family, B.C., p.131 (334P-15)
Smithers, B.C. - general views, p.136 (7P-1714)
Smith's Cove, N.S. - general views, p.69 (1P-18)
Smiths Falls, Ont. - individuals, p.104 (7P-1309)
Smiths Falls, Ont. - vues, p.14 (7P-171)
Smiths Falls (Ont.) - vues, p.16 (7P-187)
Smithsonian Institution, Washington, D.C., p.131 (7P-1645)
Smuts, Maréchal, p.95 (7P-1128)
Smyth, S.A., photo., p.131 (166P-45)
Smythe, Conn, p.93 (7P-1071)
Snake Creek, Ont. - general views, p.72 (7P-880)
Sneddon, Wilfred, p.131 (7P-1646)
Snell, H.W., Rev., p.75 (7P-910)
Sneyd, Douglas, p.5 (7P-46)
Snider, G.A., photo., p.57 (7P-686), p.72 (7P-880), p.72 (7P-884), p.151 (7P-1866)
Snider, H.P., photo., p.98 (1P-48)
Snider, John C., and family, p.131 (18P-87)
Snider, K.W., photo., p.94 (7P-1099)
Snider family, Ont., p.131 (18P-87)

Sober Island, N.S. - general views, p.63 (1P-26)
Soccer, p.48 (7P-561)
Société d'archéologie de Rivière-du-Loup, Rivière-
du-Loup, Que., p.131 (7P-1647)
Société historique de Saint-Boniface, Saint-
Boniface (Man.), p.131 (222P-1)
Société historique Nicholas-Denys (S.H.N.D)
Bertrand (N.-B.), p.131 (341P-1)
Société Radio-Canada, p.20 (7P-246)
Société Radio-Canada, Montreal, Qué., p.134
(7P-1688)
Société Radio-Canada, Ottawa, Ont., p.131
(311P-1)
Société royale du Canada, p.20 (7P-241), p.89
(7P-1165)
Soest, West Germany - general views, p.26
(7P-1962)
Somers, Harry, p.30 (7P-324)
Sommerer, Karl, photo., p.131 (7P-1648)
Sommerfeld, Man. - general views, p.122
(7P-1524)
Soper, J.D., photo., p.42 (7P-461)
Sorel, Que. - general views, p.37 (7P-397)
Sorel (Québec) - vues, p.24 (470P-1930)
Souder, S.I., photo., p.102 (200P-13)
Soulanges Canal, Que. - general views, p.51
(7P-591)
Soulanges (Québec) - vues, p.25 (7P-1935)
South Africa
 see also
 Afrique du sud
South Africa - general views, p.115 (7P-1445),
p.131 (1P-10)
South Africa Constabulary, p.149 (7P-1831)
South African War, 1899-1902, p.23 (7P-1976),
p.31 (7P-331), p.39 (1P-68), p.65 (7P-783),
p.102 (7P-1279), p.103 (2P-1), p.105 (1P-76),
p.110 (7P-1370), p.132 (7P-1652)
South African War, 1899-1902
 see also
 Guerre sud-africaine, 1899-1902
South African War, 1899-1902-1902, p.1 (7P-3)
South African War Monument, Ottawa, Ont.,
p.100 (7P-1260)
South African War 1899-1902, p.137 (1P-75)
South Peigan Indians, p.65 (11P-7)
Southam Sisters, p.100 (123P-3)
Southampton, Ont. - general views, p.115 (18P-40)
"Southern Exposure '74" Expedition, p.49
(7P-572)
Spain - civil war, 1936-1939, p.129 (7P-1622)
Spalding, J. Frederick, photo., p.132 (7P-1649)
Sparks, (famille), (Ont.), p.151 (7P-1864)
Spartan Air Services and Aerophysics Ltd., N.W.T.,
p.5 (7P-41)
Spear, Bertha, p.132 (7P-1651)
Spence, Charles, p.132 (7P-1652)
Spence Bay, N.W.T. - general views, p.62 (7P-746)
Spencer, E., photo., p.41 (7P-455), p.45 (7P-506)
Spencer, Elihu, photo., p.72 (7P-880), p.132
(7P-1653)
Spencer, Henry, p.132 (7P-1654)
Spencer, L.B., p.132 (7P-1655)
Spencer, Leonard, p.132 (7P-1656)
Spier, Jack, p.132 (7P-1657)
Spiteri, Ed, photo., p.132 (7P-1658)
Sponagle, photo., p.110 (1P-51), p.122 (1P-74)
Sport (SS), p.147 (7P-1813)
Sports - Alberta, p.28 (7P-297), p.62 (166P-7),
p.81 (7P-1004), p.99 (7P-1244), p.149
(166P-34)
Sports - British Columbia, p.5 (334P-23), p.35
(334P-28), p.41 (7P-453), p.70 (334P-30),
p.116 (334P-9), p.122 (110P-1), p.124
(334P-8), p.145 (334P-27)
Sports - Canada, p.3 (7P-17), p.19 (7P-238), p.23
(7P-1926), p.28 (7P-295), p.29 (7P-305), p.34
(7P-359), p.50 (7P-577), p.51 (7P-594), p.54
(7P-635), p.54 (7P-640), p.57 (7P-682), p.58

(7P-692), p.66 (7P-792), p.91 (7P-1189),
p.105 (327P-1), p.116 (7P-1464), p.135
(7P-1700), p.145 (7P-1776), p.147 (7P-1800),
p.147 (7P-1801)
Sports - Canada (Northern), p.44 (7P-497)
Sports - Colombie Britannique, p.152 (7P-1872)
Sports - England, p.57 (7P-681)
Sports - Manitoba, p.20 (9P-6), p.111 (7P-1382),
p.152 (7P-1872)
Sports - Mexico, p.57 (7P-682)
Sports - New Brunswick, p.99 (337P-4), p.116
(7P-1460)
Sports - Nova Scotia, p.36 (1P-32), p.106 (1P-50),
p.106 (1P-90), p.117 (1P-73)
Sports - Ontario, p.2 (7P-8), p.3 (7P-18), p.4
(7P-29), p.5 (7P-42), p.6 (7P-61), p.10
(7P-102), p.17 (7P-202), p.18 (7P-222), p.20
(7P-250), p.28 (7P-297), p.29 (7P-307), p.34
(7P-363), p.35 (7P-381), p.39 (7P-420), p.40
(7P-433), p.47 (7P-543), p.56 (7P-670), p.59
(7P-714), p.62 (7P-750), p.65 (7P-784), p.76
(317P-4), p.83 (7P-1024), p.88 (200P-3), p.92
(7P-1049), p.93 (7P-1071), p.97 (7P-1219),
p.112 (7P-1400), p.116 (7P-1453), p.120
(7P-1507), p.127 (7P-1585), p.130 (7P-1626),
p.132 (7P-1666), p.138 (143P-1), p.138
(7P-1737), p.139 (160P-1), p.141 (303P-15),
p.149 (7P-1836)
Sports - Prince Edward Island, p.9 (5P-9)
Sports - Quebec, p.14 (007P-161), p.28 (7P-297),
p.62 (7P-739), p.65 (7P-784), p.85 (7P-1068),
p.89 (7P-1161), p.93 (7P-1078), p.97
(7P-1217), p.116 (7P-1460), p.117 (7P-1471),
p.136 (7P-1248)
Sports - Saskatchewan, p.50 (7P-579), p.67
(10P-8), p.70 (10P-10), p.99 (163P-1), p.116
(7P-1454), p.125 (7P-1566), p.148 (10P-11)
Sports - Toronto, p.89 (7P-1162)
Sports - United States, p.34 (7P-361), p.57
(7P-682)
Sports - United States - Oregon, p.111 (7P-1382)
Sports - University of Toronto, p.144 (196P-14)
Sports Hall of Fame, Toronto, Ont., p.132
(7P-1659)
Spratt, Mr., p.97 (7P-1216)
Spreadbury, Alfred, and family, p.132 (7P-1650)
Spremo, Boris, photo., p.132 (7P-1660)
Spring Thaw Productions, p.48 (7P-556)
Sproat Lake, B.C. - general views, p.56 (7P-660)
Sproule, H., photo., p.72 (7P-880)
Sproule, J.P., photo., p.59 (7P-704)
Spruce Grove (Alberta) - vues, p.19 (7P-228)
Spurr, Norman, photo., p.132 (7P-1661)
Spurrill, Dan, p.132 (9P-68)
St. Michael's College, Toronto, Ont.
 see also
 Colleges - Ontario - Toronto (St.
 Michael's College)
St. Roch (vessel), p.79 (7P-966)
Stackhouse, A.G., photo., p.74 (7P-905)
Stadacona (H.M.C.S.), p.10 (7P-107)
Standard Clay Products Ltd., New Glasgow, N.S.,
p.132 (31P-79)
Standing Buffalo, Sioux Chief, p.65 (7P-780)
Stanfield, Robert Lorne, p.132 (7P-1662)
Stanhope, Lady, p.132 (7P-1663)
Stanier, S. Edward P., p.132 (7P-1664)
Staniforth, Alan and family, p.132 (7P-1665)
Staniforth, Harry, photo., p.132 (7P-1665)
Stanley, Ruby, p.132 (7P-1666)
Stanley of Preston, Frederick Arthur Stanley,
Baron, p.119 (7P-1487)
Stanley Park Photographers, photo., p.74 (7P-905)
Stanstead, Que. - scenes, p.133 (8P-10)
Stanton, Eldridge, photo., p.60 (7P-719)
Stanton, Elridge, photo., p.2 (7P-14), p.142
(200P-8)
Staples, Lucy, p.152 (7P-1874)
Staples, Owen P., p.132 (18P-76)

Star-Phoenix, Saskatoon, Sask. (newspaper), p.136
(10P-13)
Starke, Sarah G.E., p.133 (7P-1667)
Steacy, George W. et famille, p.8 (7P-76)
Steam engines - Manitoba, p.42 (9P-16)
Steam tractors - Manitoba, p.42 (9P-16)
Steamships - British Columbia, p.58 (333P-25),
p.70 (334P-30), p.101 (334P-12)
Steamships - Canada, p.48 (7P-547), p.77
(7P-945), p.128 (7P-1596), p.129 (7P-1621),
p.148 (7P-1825)
Steamships - Ontario, p.97 (7P-1208)
Steamships - United States, p.82 (11P-1)
Steamships - Yukon, p.147 (7P-1809)
Steel, William Arthur, Lt. Col., p.133 (7P-1669)
Steel Company of Canada, Hamilton (Ont.), p.13
(7P-144)
Steel industry and trade - Nova Scotia, p.9
(104P-1), p.105 (1P-88)
Steele, A.M., p.133 (333P-22)
Steele, S.B., Col., p.149 (7P-1831)
Steele, Sam, p.47 (333P-8)
Steele and Co., photo., p.133 (7P-1670)
Steep Rock Mine, Steep Rock Lake (Ont.) - vues,
p.24 (7P-1916)
Steichen, Edward, photo., p.25 (123P-1)
Steiglitz, Alfred, photo., p.25 (123P-1)
Stein, C.E., p.133 (7P-1671)
Steinberg, Nathan, p.135 (7P-1702)
Steinberg's Ltd., Montreal, Que., p.63 (7P-756)
Stephens, Dorothy, p.61 (8P-1)
Stéréogrammes, p.4 (131P-9), p.6 (171P-2), p.19
(7P-227), p.67 (171P-1), p.127 (324P-1)
Stéréogrammes
 voir aussi
 Stereographs
Stereograms
 see
 Stereographs
Stereographs, p.4 (8P-16), p.28 (327P-4), p.46
(7P-27), p.46 (7P-518), p.49 (7P-562), p.58
(7P-696), p.59 (7P-704), p.64 (7P-762), p.65
(7P-783), p.82 (7P-1015), p.87 (7P-1144),
p.91 (7P-1034), p.112 (7P-1399), p.133
(8P-10), p.138 (18P-32), p.140 (7P-1764)
Stereographs
 see also
 Stéréogrammes
Stettler, Alta. - general views, p.90 (7P-1180)
Stevens, Henry Herbert, Hon., p.15 (7P-180), p.133
(7P-1672)
Stevens, photo., p.136 (302P-1)
Stevens, Ruth (Bovey), and family, photo., p.133
(166P-34)
Stevens, William H., p.133 (7P-1673)
Stevenson, Leigh Forbes, p.133 (7P-1674)
Stewart, A.D., p.12 (7P-130), p.36 (7P-384)
Stewart, Campbell, p.152 (7P-1877)
Stewart, Charles, p.22 (7P-1903)
Stewart, Dorothy, p.133 (7P-1675)
Stewart, Herbert Leslie, p.133 (31P-6)
Stewart, Hugh R., p.133 (7P-1676)
Stewart, I., and family, p.151 (7P-1854)
Stewart, James S., Rev., p.133 (7P-1677)
Stewart, John Capt., p.133 (7P-1679)
Stewart, John James, p.133 (31P-16)
Stewart, John Smith, p.133 (7P-1678)
Stewart, Louis B., p.63 (196P-42)
Stewart, Mrs., p.110 (7P-1374)
Stewart, Muriel, p.150 (7P-1856)
Stewart, Sheila, p.133 (7P-1679)
Stewart, Walter P., p.133 (7P-1680)
Stewart J. Cort (SS), p.133 (7P-1671)
Stewart River (Yukon) - vues, p.19 (7P-237)
Stiff, photo., p.15 (7P-168), p.45 (7P-506)
Stiff Bros., photo., p.72 (7P-880), p.99 (7P-1243)
Stikine, B.C. - general views, p.118 (12P-23)
Stitt, Donald Monroe, p.133 (7P-1681)

Stobies' Egg Emporium, Seaforth, Ont., p.113 (7P-1413)
Stocken, Harry Gibbon, Canon, p.134 (11P-6)
Stone, Edgard J., p.134 (7P-1682)
Stone, Joe, & Son, photo., p.33 (7P-353)
Stone, Winthrop Ellsworth, p.2 (166P-18)
Stoney Lake (SS), p.110 (7P-1374)
Stony Indians, p.84 (11P-2), p.108 (11P-3), p.151 (166P-16)
Storthoaks, Sask. - general views, p.50 (7P-579)
Story, Norah, p.134 (7P-1683)
Strain, Mary P., p.68 (7P-819)
Strange, F., p.3 (7P-20)
Stratas, Teresa, p.83 (7P-1027)
Stratford, Ont. - general views, p.134 (7P-1684)
Stratford, Ont. - individuals, p.134 (7P-1684), p.153 (7P-1887)
Stratford and Perth Co. Archives, Stratford, Ont., p.134 (7P-1684)
Strathcona, Lord, p.14 (7P-160), p.37 (7P-396), p.41 (334P-39), p.45 (7P-507)
Strathcona Horse (Monument, Carré Dominion, Montréal (Québec), p.125 (7P-1563)
Strathcona (SS), p.149 (7P-1835)
Strawberry Island, Lake Simcoe, Ont. - Basilian Fathers, p.148 (200P-15)
Streatfield, Eric, Capt., p.115 (7P-1447)
Strickland, D.A.E., p.23 (7P-1938)
Strickland, S., Col., and family, p.110 (7P-1374)
Strickland, Sam, and family, p.140 (7P-1758)
Strickland, Samuel, p.75 (7P-911)
Strickland family, Ont., p.139 (7P-1743)
Stride Studios, photo., p.134 (334P-2)
Stringer, Isaac, Rev., p.70 (7P-848)
Stringer, Issac, Rév., p.149 (7P-1839)
Strong, Elmer T., p.134 (7P-1685)
Stuart, Ronald Neil, Comm., p.134 (7P-1686)
Stuart famille (Ont.), p.6 (7P-49)
Student Christian Methodist conference, Jasper, Alta., p.76 (7P-927)
Studio Boutet, p.134 (349P-1)
Studio de photographie
 voir
 le nom du studio
Studio Gendreau, p.134 (348P-1)
Studio Impact, photo., p.134 (7P-1687)
Studio Jac-Guy, photo., p.134 (7P-1688)
Studio Jean-Paul, p.134 (350P-1)
Studio Max Sauer, photo., p.134 (7P-1567)
Studio Notman
 voir aussi
 Notman Studio
Studio Notman d'Halifax, photo., p.134 (7P-1321)
Studio Rembrandt, photo., p.11 (7P-115)
Studio Theater Productions, Edmonton, Alta., p.9 (92P-6)
Sturgeon Chute, Que. - general views, p.93 (7P-1069)
Sturgeon Falls (Ont.) - vues, p.34 (185P-12)
Sturgeon Lake Lumber Co., Prince Albert, Sask., p.110 (7P-1374)
Stursberg, Peter, p.134 (7P-1689)
Suarez, Andrew L., p.134 (7P-1690)
Submarines - German, p.55 (7P-648)
Sudbury, Ont. - general views, p.27 (7P-270), p.29 (7P-307), p.41 (7P-452), p.131 (7P-1648)
Sudbury Junction, Ont. - general views, p.28 (7P-292)
Sudbury (Ont.) - vues, p.24 (7P-1916)
Sullivan, B.C. - mines, p.68 (333P-5)
Summerhays & Walford, photo., p.149 (7P-1828)
Sunbeam (SS), p.82 (7P-1010)
Sundance, p.14 (7P-156)
Sunshine, Alta. - general views, p.17 (166P-14), p.62 (166P-7), p.144 (166P-25)
Superior, Lake, Ont. - general views, p.48 (7P-547), p.77 (7P-947)
Supreme Court of Canada, Ottawa, Ont., p.61 (7P-725), p.71 (7P-864), p.114 (7P-1428)

Suresnes, France - general views, p.23 (7P-1926)
Surrey (ferryboat), p.134 (334P-2)
Sutherland, George, p.79 (7P-967)
Sutherland, Joan, p.83 (7P-1027)
Sutherland, John, p.134 (7P-1691)
Sutherland, Robert Franklin, Hon., p.134 (7P-1692)
Sutlej (H.M.S.), p.95 (7P-1117)
Svartehuk, p.16 (7P-190)
Swain, L.G., photo., p.5 (1P-27), p.134 (31P-95), p.152 (7P-1884)
Swanhilda (Barque), p.63 (31P-110)
Swannell, F., p.134 (7P-1693)
Swansea, Ont. - general views, p.1 (18P-56), p.71 (18P-78)
Swettenham, John Alexander, p.134 (7P-1694)
Swindell, Dorothy M.E., p.135 (7P-1695)
Sydney, N.S. - general views, p.23 (1P-30)
Sydney, N.S. - general views, p.31 (1P-62), p.58 (7P-693), p.111 (7P-1383)
Sydney, Susie, photo., p.135 (7P-1696)
Sydney (H.M.A.S.), p.94 (7P-1083)
Sydney Mines, N.S. - general views, p.31 (1P-62)
Sydney Mines Volunteer Rifles, 2nd Co., 4th Regiment, p.31 (1P-62)
Sylviculture - Canada, p.27 (7P-281)
Synagogues - Manitoba, p.71 (305P-1)
Szilasi, Gabor, photo., p.135 (7P-1697)

T.N.-O. - vues, p.24 (7P-1916)
Tabaret, Joseph Henri, Rév. Frère, p.135 (7P-1698)
Taché, Louis-Hippolyte, p.135 (113P-7)
Taconis, Kryn, photo., p.135 (7P-1699)
Tadoussac, Que. - general views, p.25 (7P-1952), p.64 (7P-766), p.70 (7P-854), p.94 (7P-1111), p.117 (18P-6), p.119 (7P-1499), p.145 (7P-1775), p.145 (8P-9)
Tadoussac, Que. - scenes, p.133 (8P-10)
Taggart, C.B., photo., p.72 (7P-880), p.151 (7P-1866)
Tahiti - vues, p.35 (329P-1)
Takayesu, Mr., p.76 (7P-930)
Take, A.O., Lt. Comdr., p.52 (7P-610)
Takhini Lake, Yukon - general views, p.42 (7P-459)
Tanguay, Rodolphe, Dr., p.109 (7P-1350)
Tanner, Douglas, p.135 (7P-1700)
Tannhauser family, B.C., p.135 (333P-20)
Tantallon, Sask. - general views, p.67 (7P-803)
Tapper, Lawrence F., p.135 (7P-1701)
Tapper, Murray Harvey, p.135 (7P-1702)
Tar Sands
 see also
 name of individual companies
Tar Sands - Alberta - Athabaska, p.13 (92P-7), p.141 (92P-17)
Tara, Ont. - general views, p.115 (18P-40)
Tardif, Thérèse, p.135 (7P-1703)
Tardivel, Louis, p.135 (7P-1704)
Tarte, Joseph, p.135 (7P-1705)
Taschereau, Andre, p.135 (7P-1706)
Tash, Roy, photo., p.135 (7P-1707)
Tashme, B.C. - general views, p.125 (7P-1565)
Tata, Sam, photo., p.135 (7P-1708)
TaTa Creek, B.C. - general views, p.64 (333P-21)
Taylor, Albert C., p.135 (7P-1709)
Taylor, George Thomas, photo., p.135 (46P-2)
Taylor, Nat. W., photo., p.55 (131P-1)
Taylor, Thomas Griffith, p.135 (16P-17)

Telegram, Toronto, Ont. (newspaper), p.121 (18P-79), p.139 (160P-1)
Telegraph Creek, B.C. - general views, p.97 (7P-1221), p.118 (12P-23)
Telegraph Creek (C.-B.) - vues, p.35 (7P-370)
Telfer, John W., p.135 (7P-1710)
Telfordville, Alta. - general views, p.70 (7P-852)
Temiscaming, Que. - general views, p.20 (7P-252)
Templeman, William, Hon., p.61 (8P-1), p.79 (7P-971)
Templeton, Que. - general views, p.74 (7P-905)
Tennant, Veronica, p.59 (7P-713)
Terre-Neuve - scènes, p.22 (7P-1897)
Territoires du Nord-Ouest - scènes, p.6 (7P-59), p.15 (7P-178)
Tesiorowski, Carol, p.49 (7P-572)
Tesla, Iwan, p.135 (7P-1711)
Teslin, B.C. - general views, p.118 (12P-23)
Tessier, Roger, p.136 (352P-1)
The Gazette , Montreal, Que., p.136 (7P-1248)
The Madawaska Club Ltd., p.136 (196P-11)
The Pas, Man. - general views, p.80 (7P-983), p.130 (7P-1636)
Theater, p.133 (7P-1667)
Theater - Nova Scotia, p.11 (31P-62), p.17 (31P-64), p.44 (31P-58), p.88 (31P-65), p.103 (31P-57), p.106 (31P-61), p.114 (31P-63), p.136 (31P-60), p.148 (31P-59)
Theatre Arts Guild, p.136 (31P-60)
Théâtre du Nouveau Monde, Montréal, (Quebec), p.136 (7P-1712)
Theatre Guild of St. Louis, Mo., p.70 (7P-851)
Theodore, Sask. - general views, p.135 (7P-1711)
Therrien, Armand, p.136 (31P-41)
Thibault, photo., p.55 (7P-655)
Thierbach, Otto, p.136 (7P-1713)
Thomas, A. Vernon, p.136 (9P-69)
Thomas, David L., p.136 (8P-4)
Thomas, Gladys, p.136 (7P-1714)
Thomas, Gordon Evan, photo., p.136 (7P-1715)
Thomas, Sandra, p.136 (7P-1716)
Thomas family, B.C., p.136 (7P-1714)
Thompson, A.H., Mrs., p.136 (7P-1717)
Thompson, Elizabeth J., p.136 (18P-28)
Thompson, F.K., p.136 (7P-1718)
Thompson, Fred W., p.137 (31P-119)
Thompson, John S.D., p.22 (7P-1903)
Thompson, John Sir, p.128 (7P-1600)
Thompson, Marjorie J., p.137 (7P-1719)
Thompson, Phillip W., p.137 (7P-1720)
Thompson, R.T., p.137 (7P-1723)
Thompson, Richard Rowland, p.137 (7P-1722)
Thompson, Richard Rowland, Mrs., p.137 (7P-1722)
Thompson, Robert, p.29 (7P-309)
Thompson, Robert Norman, p.137 (7P-1721)
Thompson, Roy, p.135 (7P-1707)
Thompson, S.J., photo., p.139 (7P-1739)
Thompson, Samuel, and family, p.137 (7P-1723)
Thompson & Son, photo., p.2 (7P-14)
Thompson, T. Phillips, p.137 (7P-1720)
Thompson, Tom, p.25 (7P-1954)
Thompson, William, and family, p.137 (7P-1720)
Thoms, Elise, p.137 (7P-1724)
Thomson, J.J., p.143 (196P-63)
Thomson, John, and family, p.41 (7P-448)
Thomson, Malcolm M., p.137 (7P-1725)
Thomson, Tom, p.41 (7P-448), p.62 (7P-748)
Thomson, Virgil, p.7 (31P-99)
Thorington, J. Monroe, Dr., p.137 (166P-44)
Thorington Mountaineering Expeditions, p.137 (166P-44)
Thorne Center, Que. - general views, p.71 (7P-859)
Thornton, Henry, Sir, p.127 (7P-1591), p.148 (7P-1822)
Thorpe, Victor N., p.137 (1P-75)
Thorson, J.T., Hon., p.26 (7P-264)
Thousand Islands, Ont. - general views, p.11 (75P-1), p.49 (7P-562)

Thousand Islands, Ont. - scenes, p.49 (8P-8)

Threlfall, Frederick W., p.137 (7P-1726)

Thumb, Tom, Capt., p.95 (7P-1119)

Thunder Bay, Ont. - general views, p.104 (146P-1)

Thunder Cape, Ont. - scenes, p.49 (8P-8)

Thurber, Robert, photo., p.137 (7P-1727)

Tibet - general views, p.46 (7P-531)

Tidd, photo., p.153 (161P-1)

Tigert, Thomas, p.137 (7P-1728)

Tilbury, Ont. - general views, p.70 (7P-856)

Tilley, Mary, p.137 (1P-55)

Tilley, Samuel Leonard, p.137 (7P-1729)

Tilley, Samuel Leonard, Hon. Sir, p.74 (7P-899)

Tillott, Lorna, p.137 (7P-1730)

Tilly, Leonard, Sir, p.93 (7P-1073)

Timagami, Ont. - general views, p.67 (7P-813), p.101 (7P-1267)

Timiskaming (lake), Ont. - general views, p.144 (7P-1771)

Timmins, Ont. - general views, p.2 (7P-8), p.27 (7P-270)

Timmins, Ont. - scenes, p.113 (8P-15)

Timmins (Ont.) - vues, p.107 (185P-1)

Timmis, Reginald Symonds, Col., and family, p.137 (7P-1731)

Timms & Howard, photo., p.137 (7P-1732)

Timms, Philip, photo., p.145 (300P-1)

Tincall, Thos. H., photo., p.19 (200P-11)

Tingley, Merle R., p.5 (7P-46)

Tintypes, p.4 (8P-16), p.19 (200P-11), p.28 (327P-4), p.29 (337P-2), p.46 (31P-46), p.52 (7P-606), p.55 (1P-13), p.55 (1P-652), p.58 (1P-39), p.68 (7P-819), p.72 (7P-874), p.73 (12P-10), p.77 (7P-946), p.80 (7P-985), p.83 (1P-7), p.95 (7P-1122), p.100 (7P-1258), p.102 (200P-13), p.128 (7P-1598), p.130 (1P-54), p.137 (1P-2), p.142 (200P-18), p.146 (1P-56), p.146 (16P-19)

Tintypes
 voir aussi
 ferrotypes

Titanic (SS), p.118 (31P-18), p.147 (1P-57)

Tobacco manufacture and trade - Ontario, p.118 (18P-50)

Tobacco Plains Indians, p.42 (333P-3), p.47 (333P-8)

Tobermary, Ont. - general views, p.33 (7P-353)

Todd family, p.73 (12P-10)

Tognotti, Allan, p.137 (7P-1733)

Tokyo, Japan - general views, p.135 (7P-1708)

Tombs, J.H., Corp., p.127 (7P-1594)

Tomlinson, Samuel Anthony, p.68 (7P-830), p.106 (7P-1329), p.119 (7P-1489), p.137 (7P-1734)

Topley, Emma, p.128 (7P-1605)

Topley, H.N., photo., p.22 (7P-1903)

Topley, William James, photo., p.5 (7P-37), p.12 (7P-132), p.13 (7P-143), p.14 (7P-160), p.15 (7P-168), p.20 (7P-241), p.20 (7P-250), p.22 (7P-1901), p.25 (7P-1952), p.45 (7P-504), p.47 (1P-35), p.51 (7P-593), p.52 (7P-599), p.59 (7P-704), p.59 (7P-705), p.61 (7P-724), p.68 (7P-824), p.74 (7P-896), p.78 (7P-954), p.78 (7P-957), p.83 (7P-1018), p.94 (7P-1099), p.107 (7P-1337), p.115 (7P-1447), p.120 (7P-1508), p.123 (7P-1535), p.127 (7P-1581), p.130 (7P-1629), p.132 (7P-1655), p.135 (7P-1698), p.138 (18P-5), p.138 (7P-83), p.149 (7P-1828), p.152 (7P-1884)

Toronto, Ont.
 see also
 City of Toronto

Toronto, Ont. - aerial views, p.68 (7P-826)

Toronto, Ont. - Architecture, Domestic, p.51 (18P-71), p.51 (18P-75), p.71 (18P-63), p.121 (18P-79), p.132 (18P-76)

Toronto, Ont. - Fire, 1904, p.70 (140P-15), p.138 (7P-1736)

Toronto, Ont. - Fire 1904, p.60 (18P-44), p.138 (18P-80)

Toronto, Ont. - general views, p.1 (1P-3), p.2 (18P-96), p.2 (7P-8), p.7 (1P-28), p.13 (18P-10), p.17 (7P-205), p.24 (7P-1947), p.29 (7P-307), p.32 (140P-1), p.32 (140P-11), p.32 (140P-2), p.32 (140P-5), p.32 (140P-7), p.32 (140P-9), p.33 (140P-6), p.38 (7P-414), p.40 (7P-436), p.43 (7P-488), p.45 (7P-509), p.48 (7P-556), p.50 (18P-66), p.50 (7P-583), p.51 (7P-596), p.54 (312P-2), p.59 (7P-704), p.60 (7P-722), p.61 (18P-86), p.61 (7P-728), p.68 (7P-829), p.70 (140P-15), p.71 (18P-78), p.74 (7P-901), p.75 (7P-910), p.78 (7P-949), p.92 (7P-1039), p.94 (7P-1099), p.96 (7P-1207), p.97 (7P-1214), p.98 (7P-1225), p.104 (8P-7), p.105 (18P-3), p.109 (7P-1365), p.110 (7P-1374), p.111 (7P-1391), p.115 (7P-1435), p.118 (18P-2), p.121 (18P-1), p.121 (18P-15), p.123 (7P-1539), p.125 (18P-12), p.126 (196P-15), p.128 (7P-1604), p.130 (7P-1630), p.131 (7P-1643), p.132 (7P-1660), p.137 (7P-1727), p.138 (18P-29), p.138 (18P-32), p.138 (18P-89), p.138 (320P-1), p.138 (7P-1737), p.139 (18P-17), p.139 (7P-1741), p.144 (7P-1770), p.145 (7P-1777), p.148 (200P-15), p.149 (7P-1828)

Toronto, Ont. - individuals, p.84 (7P-1033), p.139 (160P-1), p.153 (7P-1887)

Toronto, Ont. - Politics and government, p.32 (140P-10), p.32 (18P-43), p.34 (18P-59), p.138 (7P-1737)

Toronto, Ont. - Public buildings, p.33 (140P-6)

Toronto, Ont. - scenes, p.2 (18P-96), p.5 (18P-53), p.16 (8P-6), p.49 (8P-8), p.51 (18P-85), p.61 (8P-1), p.73 (18P-93), p.97 (8P-13), p.116 (8P-12), p.133 (8P-10), p.139 (18P-94)

Toronto, Ont. - Social conditions, p.138 (7P-1737)

Toronto, Ont., East End Day Nursery, p.138 (18P-48)

Toronto, Ont., fire, 1904, p.5 (7P-38)

Toronto, Ont., High Park Sanitarium, p.138 (18P-70)

Toronto, Ont., Monuments, p.138 (18P-20)

Toronto, Stereographs, p.138 (18P-32)

Toronto, Stereographs
 see also
 Stereographs

Toronto Board of Education, Toronto, Ont., p.138 (140P-17), p.138 (143P-1)

Toronto Camera Club, Toronto, Ont., p.138 (7P-1735)

Toronto Children's Theatre, Toronto (Ont.), p.150 (7P-1858)

Toronto (City) Architects Department, Toronto, Ont., p.32 (140P-1)

Toronto (City) Assessment Department, Real Estate Branch, Toronto, Ont., p.32 (140P-7)

Toronto (City) Assessment Department, Toronto, Ont., p.32 (140P-2)

Toronto (City) Buildings Department, Housing Section, Toronto, Ont., p.32 (140P-3)

Toronto (City) Department of Public Health, Toronto, Ont., p.32 (140P-4)

Toronto (City) Department of Public Works, miscellaneous photographs, Toronto, Ont., p.32 (140P-12)

Toronto (City) Department of Public Works, portraits, Toronto, Ont., p.32 (140P-13)

Toronto (City) Department of Public Works, Toronto, Ont., p.32 (140P-11)

Toronto City Engineer's Department, p.32 (140P-9)

Toronto City Engineer's Office, photo., p.138 (7P-1736)

Toronto City Hall, Toronto, Ont., p.138 (7P-1736)

Toronto (City) Mayors, p.32 (140P-10)

Toronto (City) Parks Department, Toronto, Ont., p.32 (140P-5)

Toronto (City) Planning Board, Toronto, Ont., p.33 (140P-18)

Toronto (City) Property Department, Toronto, Ont., p.33 (140P-6)

Toronto (City) Street Cleaning Department, Toronto, Ont., p.33 (140P-8)

Toronto (City) Water Works, Toronto, Ont., p.33 (140P-14)

Toronto Cricket, Skating and Curling Club, Toronto, Ont., p.138 (18P-67), p.138 (18P-83), p.138 (18P-95)

Toronto Daily Star, photo., p.138 (7P-1737)

Toronto Daily Star, Toronto, Ont., p.138 (7P-1737)

Toronto-Dominion Bank, Toronto, Ont., p.138 (320P-1)

Toronto Harbour Commission, Toronto, Ont., p.138 (322P-3)

Toronto Harbour Commissioners, Toronto, Ont., p.138 (322P-1), p.138 (322P-2), p.138 (7P-1738)

Toronto Island, Ont. - general views, p.32 (140P-11), p.32 (140P-5)

Toronto Islands, Ont. - general views, p.32 (140P-9)

Toronto Jewish Folk Choir, Toronto, Ont., p.139 (149P-14)

Toronto Manresa Pickering Italian Choir, p.49 (7P-571)

Toronto (Ont.) - vues, p.10 (7P-104), p.14 (7P-164), p.90 (7P-1176), p.151 (7P-1868)

Toronto Public Library, Beaches Branch, p.139 (18P-14)

Toronto Public Library, Toronto, Ont., p.139 (18P-88), p.139 (7P-1739)

Toronto Public Library, Toronto Ont., p.139 (18P-17)

Toronto Reform Association, Toronto, Ont., p.79 (7P-971)

Toronto Skating Club Carnival, 1956, p.138 (18P-67)

Toronto Star , photo., p.66 (7P-790)

Toronto Star , Toronto, Ont., p.101 (7P-1272)

Toronto Teacher's College, Toronto, Ont., p.139 (7P-1740)

Toronto Telegram, photo., p.139 (7P-1741)

Toronto Telegram, Toronto, Ont., p.139 (160P-1), p.139 (7P-1741)

Toronto Transit Commission, Toronto, Ont., p.130 (7P-1630), p.139 (7P-1742)

Torpey, Cpl., p.3 (81P-7)

Torpley, Mrs., p.3 (81P-7)

Tory, H.M., Dr., p.36 (7P-387)

Totems, p.12 (7P-138)

Tourouvre en Perche, France -vues, p.108 (113P-12)

Townend, photo., p.122 (7P-1518)

Townsend, J.W., photo., p.72 (7P-874)

Traders Bank of Canada, p.136 (323P-1)

Trades and Labour Congress of Canada, p.10 (7P-109), p.23 (7P-1928), p.28 (7P-289), p.73 (7P-888), p.99 (7P-1250)

Trading Posts
 see also
 Fur Trade

Trading Posts - Alberta, p.114 (13P-2)

Trading Posts - Northwest Territories, p.98 (7P-1229)

Trading Posts - Ontario, p.103 (7P-1303)

Trading posts - Yukon, p.104 (7P-1318)

Trail, B.C. - general views, p.148 (7P-1825)

Trail (C.-B.) - vues, p.25 (7P-1935)

Traill, Catharine Parr, p.75 (7P-911)

Traill family, Ont., p.124 (7P-1549), p.139 (7P-1743)

Train, C.W., Sgt., p.139 (7P-1744)

Train, J.W., p.139 (7P-1744)

Trains
 see
 Railroads

Trans-Atlantic Telephone Cable, p.28 (7P-293)
Trans-Canada Air Lines, p.1 (7P-4), p.80
 (7P-989), p.83 (7P-1017), p.118 (7P-1480),
 p.144 (7P-1773)
Trans-Canada Air Lines
 see also
 Aircraft - Trans-Canada Air Lines
Trans-Canada Pipeline, p.25 (7P-1958)
Transcona, Man. - general views, p.30 (7P-328)
Transport - New Brunswick, p.116 (46P-1)
Transportation
 see also
 Automobiles
Transportation - Alberta, p.1 (13P-7), p.3
 (13P-12), p.18 (13P-1), p.66 (13P-4), p.122
 (92P-21)
Transportation - British Columbia, p.17 (334P-16),
 p.29 (228P-4), p.32 (334P-36), p.53
 (334P-31), p.58 (333P-33), p.131 (334P-15),
 p.134 (334P-2), p.152 (334P-32)
Transportation - Canada, p.23 (7P-1926), p.27
 (7P-270), p.28 (327P-4), p.54 (7P-635), p.85
 (7P-1091), p.91 (7P-1187), p.105 (327P-1)
Transportation - Canada (Western), p.139 (9P-52)
Transportation - Manitoba, p.54 (7P-629), p.79
 (9P-39), p.139 (9P-52)
Transportation - New Brunswick, p.103 (2P-1)
Transportation - Northwest Territories, p.122
 (92P-21)
Transportation - Nova Scotia, p.9 (104P-1), p.63
 (1P-26), p.106 (1P-24), p.106 (1P-89)
Transportation - Ontario, p.47 (7P-543), p.62
 (7P-740)
Transportation - Ontario - Kingston, p.75 (75P-12)
Transportation - Ontario - Oakville, p.107 (47P-21)
Transportation - Ontario - Toronto, p.125 (18P-12)
Transportation - Saskatchewan, p.125 (10P-2)
Tremblay, Michel, p.135 (7P-1708)
Tremblay Concerts, Ottawa, Ont., p.83 (7P-1027)
Trenchard, Lord, p.9 (7P-95)
Trenet, Charles, p.43 (7P-480)
Trent (Vallée) (Ont.) - vues, p.16 (7P-184)
Trent Valley, Ont. - general views, p.110
 (7P-1374)
Trent Valley Navigation Co. Ltd., p.110 (7P-1374)
Trenton, Ont. - general views, p.106 (7P-1326)
Trevan, Henry, Dr., p.62 (7P-747)
Trevena, John E., p.139 (7P-1745)
Trickey, N.M., photo., p.151 (7P-1866)
Trinity, Nfld. - general views, p.70 (7P-857), p.81
 (7P-993)
Tripp, Leonard John, p.139 (7P-1746)
Triquet, Paul, Maj., p.113 (7P-1410)
Trois Pistoles, Que. - general views, p.49 (7P-563)
Trois-Rivières (Québec) - vues, p.65 (315P-1)
Trois-Rivières , (H.M.C.S.), p.48 (7P-557)
Trois-Rivières, Que. - general views, p.78 (7P-953)
Trois-Rivières, Que. - scenes, p.61 (8P-1)
Trudeau, Pierre Elliott, Rt. Hon., p.21 (7P-256),
 p.48 (7P-561), p.81 (7P-1002)
Trudeau, Pierre Elliott, Très Hon., p.22 (7P-1960),
 p.69 (7P-1946), p.134 (7P-1567), p.139
 (7P-1747)
Trudel, Geraldine, p.139 (7P-1747)
Trudel, Marcel, p.17 (7P-194)
Trueman, R.H. and Company, photo., p.117
 (166P-48)
Truman & Caple, photo., p.139 (7P-1739)
Truro, Anne Bell Elliott, p.29 (337P-2)
Truro, N.S. - general views, p.64 (123P-4)
Truro Community Theatre, Truro, N.S., p.148
 (31P-59)
Trussler, Eric, p.35 (7P-377)
Tryon, P.E.I. - general views, p.54 (5P-2)
Tucker, family, N.S., p.139 (1P-17)
Tucker, M. Grace, p.139 (7P-1748)
Tudhope, John Henry, p.139 (7P-1749)
Tully, T.B., Capt., p.30 (7P-317)

Tupper, Charles, Rt. Hon. Sir, p.15 (7P-176), p.22
 (7P-1903), p.34 (7P-369), p.139 (7P-1750)
Tupper, Charles, Très Hon. Sir, p.20 (7P-241)
Tupper, Henrietta, p.151 (314P-1)
Tupper, William Johnston, p.139 (7P-1751)
Turcotte & Gousse, photo., p.78 (7P-960)
Turin, Italy - general views, p.28 (7P-284)
Turk, Sidney, p.140 (7P-1753)
Turnball, A.D., p.140 (12P-7)
Turnball, Grandma, p.98 (7P-1238)
Turnball, Walter, p.98 (7P-1238)
Turnbull, Duncan R., p.140 (7P-1752)
Turner, p.140 (333P-24)
Turner, B.H. (Jack), p.140 (5P-3)
Turner, F. Leonard, p.140 (7P-1754)
Turner, John Napier, Hon., p.6 (7P-52), p.72
 (7P-883)
Turner, Mr., p.45 (7P-506)
Turner, Percival Stanley, p.140 (7P-1755)
Turner, photo., p.129 (7P-1623)
Turner, Thomas H., photo., p.140 (7P-1756)
Tutshi (SS), p.2 (7P-13)
Tweed, Thomas William, and family, p.140
 (7P-1757)
Tweedsmuir, John Buchan, Baron, p.6 (7P-61),
 p.17 (7P-204), p.26 (7P-1971), p.37 (7P-404),
 p.70 (7P-856)
Tweedsmuir, John Buchan, Baron, and family,
 p.140 (75P-4)
Tweedsmuir, Susan, Lady, p.79 (7P-972)
Twist, John L., p.140 (7P-1758)
Tyner, Adam Clarke, p.140 (18P-41)
Tyner, Christopher, p.140 (18P-41)
Tyner, Richard James, p.140 (18P-41)
Tyner family, Ont., p.140 (18P-41)
Tyrone, Ont. - general views, p.103 (7P-1304)
Tyrrell, Joseph Burr, p.140 (16P-18)

U.S.S.R. - general views, p.115 (7P-1438)
U-190 (submarine), p.55 (7P-648)
Uchida, Matasaburo, p.140 (7P-1759)
Ukrainian Canadian Committee, p.140 (7P-1760)
Ukrainian Canadian Relief Fund, West Germany,
 p.140 (7P-1760)
Ukrainian Canadian Servicemen's Association,
 England, p.140 (7P-1760)
Ukrainian Free Academy of Science, Winnipeg,
 Man., p.140 (7P-1761)
Ukrainian National Federation Camp, Acton, Ont.,
 p.127 (7P-1587)
Ukrainian National Home Choir, Winnipeg
 (Man.), p.12 (7P-133)
Ukrainian National Youth Federation of Canada,
 p.140 (7P-1762)
Ukrainians in Alberta, p.73 (7P-892), p.130
 (7P-1634)
Ukrainians in Canada, p.45 (7P-511), p.49
 (9P-81), p.50 (7P-581), p.76 (7P-933), p.127
 (7P-1587)
Ukrainians in Manitoba, p.73 (7P-892), p.112
 (7P-1402)
Ukrainians in Saskatchewan, p.73 (7P-892)
Ukrainians in Toronto, p.127 (7P-1587)
Unad (submarine), p.50 (7P-578)
Underhill, Frank Hawkins, and family, p.140
 (7P-1763)
UNESCO Headquarters Building, Paris, France,
 p.129 (7P-1622)
Ungava District, Que. - general views, p.20
 (7P-253)
Uniacke family, N.S., p.38 (1P-67), p.39 (1P-68)

Uniacke Mount, N.S. - general views, p.38 (1P-67),
 p.39 (1P-68)
Union Bank of Canada, p.136 (323P-1)
Union Bank of Halifax, p.136 (323P-1)
Union Bay, B.C. - general views, p.124 (7P-1549)
Union catholique des cultivateurs, p.78 (7P-961)
Union Furniture and Merchandise Co., p.44
 (31P-72)
United Auto Workers, Ottawa (Ont.), p.119
 (7P-1497)
United Church of Canada Central Archives,
 Toronto, Ont., p.140 (7P-1764)
United Electrical, Radio and Machine Workers of
 America, Don Mills, Ont., p.141 (7P-1765)
United Farmers' Convention, December 1944, p.49
 (75P-7)
United Packinghouse Workers, Toronto, Ont.,
 p.141 (7P-1766)
United Photo Studios, photo., p.19 (200P-11)
United States - general views, p.13 (13P-3), p.46
 (7P-518), p.46 (7P-528), p.48 (7P-554), p.65
 (7P-775), p.93 (7P-1078), p.95 (7P-1117),
 p.132 (7P-1660)
United States, Army, 104th Infantry Division,
 p.114 (7P-1429)
United States Army Signal Corps, photo., p.150
 (7P-1847)
United States of America Air Force, p.80 (7P-988)
United Steelworkers of America, p.141 (7P-1767)
Unity, Sask. - general views, p.33 (7P-354)
Universal Exhibition, Montreal, Que., p.20
 (7P-254), p.69 (7P-843)
Université de Moncton, Moncton (N.-B.), p.141
 (15P-1)
Université de Saint-Joseph, Moncton, N.B.
 voir aussi
 Universités - Nouveau-Brunswick -
 Moncton
Université d'Ottawa, College Bruyère, p.141
 (303P-8)
Université d'Ottawa, Département de diététique et
 sciences domestiques, p.141 (303P-6)
Université d'Ottawa, Ecole de bibliothécaires,
 p.141 (303P-2)
Université d'Ottawa, Ecole des sciences de l'activité
 physique et du loisir, p.141 (303P-3)
Université d'Ottawa, Ecole des Sciences infirmières,
 p.141 (303P-5)
Université d'Ottawa, Enseignement et recherche,
 vice-recteur, p.141 (303P-12)
Université d'Ottawa, Faculté de Droit coutumier,
 p.141 (303P-17)
Université d'Ottawa, Faculté de médecine, p.141
 (303P-14)
Université d'Ottawa, Faculté d'éducation (Ecole
 normale), p.141 (303P-4)
Université d'Ottawa, Relations extérieures, p.141
 (303P-1)
Université d'Ottawa, Ressources financières, p.141
 (303P-7)
Université d'Ottawa, Services des sports, p.141
 (303P-15)
Université Saint-Joseph, Moncton (N.-B.), p.141
 (15P-2)
Universités
 voir aussi
 nom de l'université
Universités - Israel - Tel-Aviv (Université Bor iian),
 p.135 (7P-1702)
Universités - Nouveau-Brunswick - Moncton
 (Saint-Joseph), p.141 (15P-2)
Universités - Nouveau-Brunswick - Moncton
 (Université de Moncton), p.141 (15P-1)
Universités - Ontario - London (Université
 Western Ontario), p.10 (7P-104)

Universités - Ontario - Ottawa (Université d'Ottawa), p.22 (303P-9), p.48 (306P-1), p.141 (303P-1), p.141 (303P-12), p.141 (303P-14), p.141 (303P-15), p.141 (303P-17), p.141 (303P-2), p.141 (303P-3), p.141 (303P-4), p.141 (303P-5), p.141 (303P-6), p.141 (303P-7), p.141 (303P-8)

Universités - Ontario - Toronto (Université de Toronto), p.10 (7P-104)

Universités - Québec - Montréal (McGill), p.16 (7P-191), p.19 (7P-236)

Universités - Québec - Montréal (Université de Montréal), p.11 (7P-127)

Universités - Québec - Québec (Laval), p.77 (131P-5)

Universities
 see also
 name of university

Universities - Alberta - Edmonton (University of Alberta), p.3 (92P-3), p.7 (92P-4), p.7 (92P-5), p.21 (92P-8), p.56 (92P-13), p.92 (92P-16), p.141 (92P-17), p.142 (92P-1), p.142 (92P-23), p.142 (92P-9)

Universities - British Columbia - Vancouver (University of British Columbia), p.98 (7P-1236)

Universities - England (Oxford University), p.78 (7P-953)

Universities - Manitoba - Winnipeg (University of Manitoba), p.33 (9P-10), p.83 (7P-1021), p.146 (7P-1798)

Universities - New Brunswick - Sackville (Mount Allison), p.100 (32P-4)

Universities - Nova Scotia - Halifax, (Dalhousie), p.13 (1P-58), p.122 (1P-74)

Universities - Nova Scotia - Halifax (Dalhousie), p.40 (31P-1), p.43 (1P-33), p.50 (31P-121), p.51 (1P-37), p.85 (31P-51), p.86 (31P-120), p.86 (31P-2), p.86 (31P-35), p.92 (31P-38), p.105 (31P-91), p.107 (31P-92), p.137 (1P-55)

Universities - Nova Scotia - Halifax (King's College), p.136 (302P-1)

Universities - Nova Scotia - Halifax (Mount St. Vincent University), p.100 (340P-1)

Universities - Nova Scotia - Windsor (King's College), p.136 (302P-1)

Universities - Ontario - Kingston (Queen's University), p.57 (7P-687), p.63 (7P-757), p.92 (7P-1040), p.95 (75P-9), p.117 (75P-10)

Universities - Ontario - Toronto (McMaster University), p.143 (196P-62)

Universities - Ontario - Toronto (University of Ottawa), p.143 (196P-61)

Universities - Ontario - Toronto (University of Toronto), p.9 (196P-49), p.34 (196P-8), p.37 (196P-43), p.49 (7P-567), p.53 (7P-614), p.70 (140P-15), p.73 (196P-6), p.74 (196P-7), p.78 (196P-47), p.83 (196P-55), p.83 (7P-1021), p.95 (196P-38), p.97 (8P-13), p.99 (196P-48), p.103 (196P-54), p.121 (196P-50), p.126 (196P-37), p.129 (196P-44), p.131 (7P-1641), p.131 (196P-41), p. 136 (196P-11), p.140 (7P-1763), p.141 (321P-1), p.142 (196P-33), p.142 (196P-34), p.142 (196P-57), p.142 (196P-58), p.142 (196P-64), p.143 (196P-15), p.143 (196P-16), p.143 (196P-21), p.143 (196P-22), p.143 (196P-24), p.143 (196P-25), p.143 (196P-29), p.143 (196P-32), p.143 (196P-36), p.143 (196P-52), p.143 (196P-53), p.143 (196P-60), p.143 (196P-62), p.143 (196P-63), p.143 (196P-65), p.143 (196P-66), p.144 (196P-13), p.144 (196P-14), p.144 (196P-17), p.144 (196P-18), p.144 (196P-20), p.144 (196P-26), p.144 (196P-28), p.144 (196P-31), p.146 (196P-3), p.146 (196P-51), p.153 (196P-1)

Universities - Ontario - Toronto (York University Glendon Hall), p.152 (196P-5)

Universities - Quebec - Montreal (McGill University), p.40 (7P-440), p.82 (7P-1014), p.93 (7P-1078), p.116 (7P-1459)

Universities - Saskatchewan -Regina (University of Saskatchewan), p.125 (10P-2), p.125 (10P-6), p.140 (7P-1763)

Universities - United States - Connecticut - New Haven (Yale), p.75 (7P-914)

Universities - United States - Massachussettes - Cambridge (Harvard University), p.83 (7P-1021)

Universities and Colleges - Canada (Agricultural Courses), p.49 (75P-7)

University
 see also
 Universities

University - Alberta - Edmonton (University of Alberta), p.142 (92P-14)

University College Archives, Toronto, Ont., p.141 (321P-1)

University of Alberta, Department of Geology, p.141 (92P-12)

University of Alberta, Department of Mineral Engineering, p.141 (92P-17)

University of Alberta, Faculty of Agriculture, p.142 (92P-1)

University of Alberta, Faculty of Extension, p.142 (92P-9)

University of Alberta, Publications Office, Edmonton, Alta., p.142 (92P-23)

University of Alberta Library, Edmonton, Alta., p.142 (92P-14)

University of Alberta Mixed Chorus, Edmonton, Alta., p.142 (92P-22)

University of King's College Library, Halifax, N.S., p.136 (302P-1)

University of Ottawa Library, Ottawa, Ont., p.142 (7P-1768)

University of St. Michael's College, Toronto, Ont., p.142 (200P-14)

University of St. Michael's College Archives, Toronto, Ont., p.142 (200P-18), p.142 (200P-8)

University of Saskatchewan Institute for Northern Studies, Saskatoon, Sask., p.142 (7P-1769)

University of St. Michael's College,
 see also
 St. Michael's College

University of Toronto, Delta Upsilon Fraternity, p.113 (196P-40)

University of Toronto, Department of Alumni Affairs, p.142 (196P-57)

University of Toronto, Department of Electrical Engineering, p.142 (196P-64)

University of Toronto, Department of Information, p.142 (196P-34)

University of Toronto, Engineering Alumni Association, p.142 (196P-58)

University of Toronto, Erindale College, p.142 (196P-23)

University of Toronto, Faculty of Applied Science, 1911 Graduating class, p.144 (196P-17)

University of Toronto, Faculty of Education, p.144 (196P-20)

University of Toronto, Faculty of Food Sciences, p.143 (196P-16)

University of Toronto, Faculty of Forestry, p.143 (196P-36)

University of Toronto, Faculty of Music, p.143 (196P-29)

University of Toronto, Faculty of Nursing, p.144 (196P-28)

University of Toronto, Hart House, p.143 (196P-65)

University of Toronto, Hart House Chess Club, p.143 (196P-22)

University of Toronto, Hart House Theatre, p.143 (196P-32)

University of Toronto, Information Services, p.143 (196P-21)

University of Toronto, Library, Photocopy Unit, p.143 (196P-60)

University of Toronto, McLennan Physical Laboratories, p.143 (196P-63)

University of Toronto, Office of the Registrar, p.143 (196P-15)

University of Toronto, Office of the Vice-President and Provost, p.143 (196P-59)

University of Toronto, Ontario School of Practical Science, p.143 (196P-53)

University of Toronto, Physical Plant Department, p.144 (196P-18)

University of Toronto, School of Hygiene, p.143 (196P-66)

University of Toronto, School of Medicine, p.57 (196P-46)

University of Toronto, Sigmund Samuel Library, p.143 (196P-62)

University of Toronto, Student Administrative Council, Varsity, p.143 (196P-24)

University of Toronto, Students Administrative Council, p.143 (196P-25)

University of Toronto, Trinity College Athletics Association, p.113 (196P-40)

University of Toronto, Trinity College Board of Stewards, p.113 (196P-40)

University of Toronto, Trinity College Literary Institute, p.113 (196P-40)

University of Toronto, Trinity College Literary Institute Council, p.113 (196P-40)

University of Toronto, University College, p.143 (196P-27)

University of Toronto, University College Literary and Scientific Society, p.143 (196P-52)

University of Toronto, University of Toronto Union, p.143 (196P-61)

University of Toronto, University of Trinity College, p.143 (196P-30)

University of Toronto, University of Victoria College Library, p.144 (196P-45)

University of Toronto Athletic Association, p.144 (196P-14)

University of Toronto Collection, Toronto, Ont., p.144 (196P-26)

University of Toronto Library, Exhibitions Unit, p.144 (196P-13)

University of Toronto Library, Toronto, Ont., p.144 (196P-31)

University of Utah, Salt Lake City, Utah, p.144 (7P-1770)

University Women's Club of Winnipeg, Winnipeg, Man., p.144 (9P-70)

Uno, Man. - general views, p.99 (7P-1244)

Upper Canada College, p.144 (196P-19)

Upper Canada Village, Ont. - general views, p.33 (7P-353)

Upper Fort Garry, Man. - general views, p.99 (7P-1252)

Upper Musquodoboit, N.S. - general views, p.63 (1P-26)

Upper Ottawa Improvement Co., Ottawa, Ont., p.144 (7P-1771)

Uppington, Shropshire, England - general views, p.132 (7P-1664)

Upton, photo., p.75 (131P-6)

Upton, William Ross, p.144 (7P-1772)

Upton, William Ross, Mrs., p.144 (7P-1772)

Uranium Mines - Northwest Territories, p.130 (7P-1625)

Uranium Mining - Northwest Territories, p.48 (7P-545)

Uranium Mining - Ontario, p.48 (7P-545)

Utah - general views, p.15 (123P-9)

Utah, United States - scenes, p.49 (7P-572)

V-E Day - Ontario - Alexandria, p.147 (7P-1807)
V-E Day - Ontario - Toronto, p.2 (7P-8)
V-J Day - Ontario - Toronto, p.2 (7P-8)
Vachon, Joseph Pierre Roméo, p.144 (7P-1773)
Vaillancourt, photo., p.55 (131P-1)
Val d'Or, Que. - general views, p.27 (7P-270), p.54 (7P-635)
Val d'Or (Québec) - vues, p.10 (7P-104)
Val Gagné (Ont.) - vues, p.107 (185P-1)
Valcartier, Que. - general views, p.115 (7P-1435), p.149 (7P-1829)
Valiquette, p.44 (7P-497)
Vallée, Louis-Prudent, photo., p.4 (131P-9), p.6 (171P-2), p.41 (31P-82), p.58 (7P-695), p.59 (7P-704), p.67 (171P-1), p.70 (7P-855), p.92 (7P-1039), p.119 (7P-1499),p.144 (7P-1774), p.145 (8P-9)
Valley, Charley, p.47 (7P-534)
Valleyfield (Québec) - vues, p.112 (7P-1394)
Van Buren, Henry, p.145 (7P-1775)
Van Buren Bates, Martin, Mr. & Mrs., p.2 (7P-16)
Van Cliburn, p.83 (7P-1027)
Van Der Smissen, W.H., p.144 (196P-13)
Van Horne, William, p.111 (7P-1385)
Van Loo, photo., p.55 (131P-1)
Van Zeggeren, Frederick, p.145 (7P-1780)
Vancouver, B.C. - aerial views, p.68 (7P-826)
Vancouver, B.C. - general views, p.4 (7P-31), p.41 (7P-453), p.54 (7P-629), p.59 (7P-708), p.59 (7P-710), p.63 (7P-753), p.64 (7P-762), p.67 (7P-808), p.89 (7P-1167), p.95 (7P-1117), p.112 (12P-3), p.116 (7P-1463), p.132 (7P-1665), p.139 (7P-1739), p.140 (7P-1764), p.145 (7P-1777)
Vancouver, B.C. - scenes, p.133 (8P-10), p.145 (300P-1)
Vancouver (C.-B.) - vues, p.20 (7P-244), p.35 (7P-371)
Vancouver City Archives, Vancouver, B.C., p.145 (7P-1776)
Vancouver Harbour Commission, Vancouver, B.C., p.25 (7P-1953)
Vancouver Island, B.C. - general views, p.2 (7P-9), p.30 (12P-11), p.40 (18P-8), p.114 (18P-34), p.114 (7P-1431)
Vancouver Public Library, Vancouver, B.C., p.145 (334P-29), p.145 (7P-1777)
Vancouver Public Library Collection, Vancouver, B.C., p.145 (300P-1)
Vandry, J.W., p.3 (131P-7)
Vandry, photo., p.80 (131P-4)
Vanier, George Philias, H.E., p.61 (7P-725), p.65 (7P-785)
Vanier, Georges-Philias, H.E., p.30 (7P-324)
Vanier, Georges Philias, H.E. and family, p.145 (7P-1778)
Vanier, Pauline, p.30 (7P-324), p.97 (7P-1212)
Vanier Institute of the Family, Ottawa, Ont., p.145 (7P-1779)
Vankleek Hill (Ont.) - scènes, p.31 (185P-8)
Van's Studio, photo., p.53 (7P-623)
Vansittart, Henry, Jr., p.38 (7P-412)
Varley, Fred, p.62 (7P-748)
Varsity Stadium, Toronto, Ont., p.48 (7P-561)
Vaughan, Wilfrid Eldred, p.145 (7P-1781)
Vaux, George, p.145 (7P-1782)
Vegreville, Alta. - general views, p.90 (7P-1180), p.114 (7P-1422)
Venables, Percy, p.145 (334P-27)
Venables, Richard, p.145 (334P-27)
Venables family, B.C., p.145 (334P-27)
Venerable (H.M.S.), p.41 (7P-454)
Venise, Italie - vues, p.80 (131P-4)
Veno (SS), p.16 (7P-192)
Venture (H.M.C.S.), p.41 (7P-454)
Verchères (Québec) - vues, p.30 (7P-315)
Verdun, Que. - general views, p.74 (7P-904)
Vernon (C.-B.) - vues, p.17 (7P-207)

Vey, James, photo., p.50 (7P-578), p.103 (38P-11), p.117 (4P-1)
Vickers, Isabel Joséphine et famille, p.14 (7P-158)
Victoria, B.C. - aerial views, p.68 (7P-826)
Victoria, B.C. - general views, p.13 (12P-16), p.17 (7P-205), p.33 (12P-9), p.40 (18P-8), p.41 (7P-453), p.46 (7P-528), p.59 (7P-704), p.62 (18P-65), p.68 (333P-5), p.70 (7P-855), p.73 (12P-10), p.78 (7P-955), p.83 (7P-1018), p.89 (7P-1167), p.95 (7P-1117), p.112 (12P-3), p.124 (7P-1551), p.140 (7P-1764), p.145 (7P-1777), p.145 (7P-1783), p.148 (7P-1825)
Victoria, B.C. - scenes, p.33 (12P-27)
Victoria, Queen, p.147 (7P-1814)
Victoria, Reine, p.18 (7P-215)
Victoria (C.-B.) - vues, p.6 (7P-61), p.14 (7P-164), p.17 (7P-201), p.24 (7P-1918), p.35 (7P-371), p.80 (131P-4), p.89 (303P-10)
Victoria Island, N.W.T. - general views, p.135 (7P-1696)
Victoria Memorial Museum, Ottawa, Ont., p.13 (7P-146), p.74 (7P-906), p.93 (7P-1070)
Victoria Museum, Ottawa, Ont., p.24 (7P-1947), p.146 (7P-1795)
Victoria (Paddleboat), p.121 (228P-1)
Victoria Press Ltd., Victoria, B.C., p.145 (7P-1783)
Victorian Order of Nurses, Ottawa, Ont., p.145 (7P-1784)
Vietnam - International Commission of Control and Supervision, p.88 (7P-1156)
Vietnam (South) - general views, p.132 (7P-1660)
Viets, Robert B. and family, p.145 (7P-1785)
Vigneault, Gilles, p.135 (7P-1708)
Viking (SS), p.145 (7P-1786)
Villa-Lobos, Hector, p.7 (31P-99)
Villeneuve, Cardinal, p.124 (200P-6), p.142 (200P-18)
Villers-Au-Bois, France - Kootenay Battalion - graves, p.34 (7P-368)
Vincent, Carl Roy, p.145 (7P-1786)
Virginia City, Mont. - general views, p.68 (333P-5)
Vita, Man. - general views, p.97 (9P-56)
Vladivostock, Russia - general views, p.123 (7P-1541)
Vladivostok, Sibérie, U.R.S.S. - vues, p.15 (7P-179)
Vogee, A., photo., p.153 (161P-1)
Vogt, A.S., p.128 (7P-1611)
Von Brentani, Mario, p.145 (7P-199), p.145 (7P-203)
Von Newmayer, George, p.3 (7P-19)
Voorhis, Ernest, Dr., p.145 (7P-1787)
Vorkony, Lazslo, photo., p.145 (7P-1788)

Wabana, Nfld. - general views, p.62 (1P-43)
Waddell, William J., p.146 (7P-1789)
Waddell family, p.146 (196P-51)
Wadds Bros., photo., p.146 (334P-1)
Wade, Constance E., and family, p.146 (1P-56)
Wade, Maxwell C., p.146 (7P-1790)
Wade, Ralph, and family, p.110 (7P-1374)
Wade, Robert, and family, p.110 (7P-1374)
Wadmore, Robinson Lyndhurst, p.146 (7P-1791)
Wagner, Claude, p.21 (7P-256)
Wah-Wash-Kesh, Lake - Ont., p.2 (7P-9)
Wainwright, Alta. - general views, p.32 (7P-345), p.54 (11P-8)
Wainwright National Park, p.54 (11P-8), p.108 (11P-3)
Waite-Amulet-Dufault Mine, Noranda (Québec), p.24 (7P-1916)
Wakefield, Que. - general views, p.55 (7P-643), p.55 (7P-650)

Wakeham Expedition, 1897, p.142 (7P-1768)
Walcott, C.D., photo., p.146 (7P-1792)
Waldo, B.C. - general views, p.122 (333P-9)
Wales - general views, p.46 (7P-518)
Wales, Prince of
see also
subdivision Prince of Wales under individual name
Wales, Prince (of), p.2 (7P-11), p.17 (7P-209), p.70 (7P-849), p.91 (7P-1187), p.110 (7P-1375), p.117 (7P-1468), p.123 (7P-1544), p.123 (7P-1546), p.130 (7P-1629), p.146 (7P-1797), p.147 (7P-1814)
Wales, Prince of
see also
Galles, Princes (de)
Wales, Princess (of), p.147 (7P-1814)
Walker, C.C., p.146 (7P-1794)
Walker, David, p.146 (7P-1793)
Walker, J.C., & Co., photo., p.149 (7P-1828)
Walker, J.C., photo., p.2 (7P-14), p.16 (7P-193), p.72 (7P-874)
Walker, Kay, p.146 (7P-1794)
Wall, Florence I., p.100 (340P-1)
Wall, Ray, photo., p.146 (11P-10)
Wallace, Catherine, Rev. Sister, p.100 (340P-1)
Wallace, George, p.146 (7P-1796)
Wallace, H.C., photo., p.102 (200P-13)
Wallace, Joseph W., p.146 (7P-1795)
Wallace, Mary Elizabeth, p.146 (196P-3)
Wallace, W.S., p.144 (196P-13)
Wallace, William Stewart, p.146 (16P-19)
Wallaceburg, Ont. - general views, p.70 (7P-856), p.107 (7P-1336)
Walleck, Sergent, R.C.A., p.4 (134P-1)
Wallis, J.D., photo., p.29 (7P-311), p.57 (7P-686), p.72 (7P-880), p.93 (7P-1065), p.151 (7P-1866)
Walsh, Harry, p.146 (7P-1798)
Walter, Arnold, Dr., and family, p.146 (149P-15)
Walter Moorhouse Collection, p.106 (47P-12)
Walter Moorhouse Collection, Oakville, Ont., p.146 (47P-1)
Walters, Angus, p.146 (31P-20)
Walton, Avis, p.146 (7P-1797)
Wamboldt - Waterfield, photo., p.98 (1P-48)
Wamboldt, Lee, photo., p.98 (1P-48)
Wanikiwan (SS), p.147 (7P-1813)
War Comox (ship), p.145 (334P-27)
War Memorial, Regina, Sask., p.1 (81P-1)
War of 1812-1814, p.66 (7P-797)
Ward, A.M., p.146 (7P-1799)
Ward, Amos P., and family, p.146 (31P-17)
Ward, Howard, p.147 (7P-1800)
Ward, Howard H., p.147 (7P-1801)
Ward, James, p.147 (7P-1802)
Ward, M.W., p.68 (7P-830)
Ward, Maxwell William, p.147 (7P-1803)
Ward, Richard, p.119 (31P-100)
Ward family, B.C., p.147 (333P-15)
Warden, John Weightman, p.147 (7P-1804)
Warden's Conference, p.23 (7P-1937)
Wardner, B.C. - general views, p.39 (333P-6), p.101 (333P-18), p.147 (333P-15)
Warner, D.K., Mrs., p.147 (7P-1806)
Warner, Dorothy J., p.147 (7P-1805)
Warner, Hilton J., p.147 (7P-1807)
Warner, Howard Willard, p.147 (7P-1808)
Warner, Iris, p.147 (7P-1809)
Warner family, Ont., p.147 (7P-1806)
Warrander, photo., p.53 (7P-623)
Warren, Emily, R.B.A., p.86 (16P-10)
Warren, Stewart Wesley, and family, p.147 (7P-1810)
Warships - Canada, p.136 (31P-41)
Warships - Great Britain, p.40 (18P-8), p.86 (31P-13), p.136 (31P-41)

Warships - Newfoundland, p.91 (7P-1186)
Warships - United States, p.86 (31P-13), p.136
 (31P-41)
Wartime Industries Control Board, p.64 (7P-763)
Washington, D.C. - general views, p.16 (75P-2),
 p.34 (7P-367), p.120 (123P-8)
Washington, Etats-Unis - scènes, p.123 (7P-1542)
Washington, United States - scenes, p.40 (18P-8)
Wasson, Everett L., p.56 (7P-665)
Waterloo Row (N.-B.) - vues, p.111 (7P-1385)
Waterton Lakes, Alta. - general views, p.133
 (166P-36)
Waterton National Park, Alta. - general views,
 p.125 (166P-2)
Waterways, Alta. - general views, p.3 (13P-12)
Watkins, E.J., p.147 (7P-1811)
Watson, Arnold, p.147 (1P-57)
Watson, Donald Netterville (Don), p.147
 (7P-1812)
Watson, H., p.147 (7P-1813)
Watson, J.E., p.50 (200P-12)
Watson, J.E., photo., p.19 (200P-11), p.102
 (200P-13)
Watson, James, p.147 (7P-1814)
Watson, Robert, and family, p.91 (7P-1187)
Watson, William Gerald, p.147 (7P-1815)
Watsons Corners (Ont.) - vues, p.14 (7P-171)
Watt, Robert D., p.147 (7P-1816)
Watt, Roy MacGregor, Mrs., p.109 (7P-1362)
Watts, Ruth Jenkins, photo., p.148 (7P-1817)
Waupoos, Ont. - general views, p.97 (7P-1208)
Waugh, R.F., p.148 (7P-1818)
Way, Amuel, Sir, p.111 (7P-1385)
Weatherhead, Fred, p.27 (7P-267)
Weaver, Wilfred E., p.148 (7P-1819)
Webb, W., photo., p.65 (7P-786)
Weber, H.W., photo., p.55 (131P-1)
Weber, Harvey L., p.148 (9P-71)
Weber, M.A., p.148 (7P-1820)
Webistan Nipi, Nfld. - general views, p.22
 (7P-1927)
Webster, J.C., Dr., p.148 (7P-1821)
Webster, K.G.T., p.148 (31P-8)
Weese, D.A., & Co., photo., p.94 (7P-1099)
Weir, Ernest Austin, p.148 (7P-1822)
Weir, Que. - general views, p.40 (7P-434)
Weir, T.N., p.148 (333P-12)
Welland Canal, Ont. - general views, p.2 (7P-8),
 p.16 (8P-6), p.39 (7P-429), p.40 (7P-435),
 p.67 (7P-802), p.124 (7P-1558), p.139
 (7P-1740)
Welland Canal, Ont. - scenes, p.133 (8P-10)
Welland (Ont.) - vues, p.107 (185P-1)
Wellman, Frank and family, p.148 (166P-28)
Welty, Emil Jerome, p.148 (200P-15)
Wembley Exhibition, London, England, p.148
 (7P-1822)
Werely, Mrs., p.148 (7P-1823)
Wesleyan Conference, Hamilton, Ont., p.98
 (7P-1226)
West, Roland Burgess, p.148 (7P-1824)
West and Peachey and Sons, Simcoe, Ont., p.104
 (7P-1316)
West Coast Indians, p.89 (7P-1167)
West Dove, N.S. - general views, p.131 (7P-1648)
West Indies - Gralston & Co., p.153 (31P-69)
West port, Ont. - vues, p.28 (7P-292)
Westcott, Mary Eleanor, p.110 (7P-1377)
Western Canada Airways, p.54 (7P-640)
Western Canada Airways Ltd., p.51 (7P-586), p.66
 (7P-799), p.76 (7P-926), p.106 (7P-1329),
 p.137 (7P-1734)
Western Canada Airways Ltd.
 see also
 Aircraft - Western Canada Airways Ltd.
Western Canada Aviation Museum Collection,
 p.148 (9P-72)
Westinghouse Power Co., Point du Bois, Man.,
 p.58 (7P-698), p.146 (7P-1797)

Westmoreland, P.E.I. - general views, p.54 (5P-2)
Westmount, Que. clercs de Saint Viateur
 voir aussi
 Institut pour aveugles ()
Weston, Edward, photo., p.25 (123P-1)
Weston, George, p.148 (18P-62)
Weston, J. Lambert and Son, photo., p.26
 (7P-265)
Weston, Joseph, p.148 (18P-62)
Weston, Ont. - first aeroplane flights, 1910, p.70
 (140P-15)
Weston, Ont. - general views, p.2 (7P-8), p.140
 (16P-18)
Weston, T.C., photo., p.24 (7P-1916)
Weston family, Ont., p.148 (18P-62)
Westport (SS), p.147 (7P-1813)
West's Studio Ltd, photo., p.148 (10P-11)
Wetaskiwin, Alta. - general views, p.114 (7P-1422)
Wethey, H.D.W., p.148 (7P-1825)
Wetmore, Donald, p.148 (31P-59)
Wetton, Thomas Charles, p.148 (9P-73)
Weymouth, N.S. - general views, p.40 (7P-432),
 p.43 (1P-19)
Whaling - Northwest Territories, p.114 (327P-3)
Wheatley, Frank M., p.148 (166P-40)
Wheeler, A.O., p.149 (7P-1826)
Wheeler, C., p.149 (7P-1826)
Wheeler, E.O., p.149 (7P-1826)
Wheeler, Emmaline S., p.149 (7P-1826)
Wheeler, J.A., photo., p.149 (7P-1827)
Wheeler, Lucile, p.28 (7P-297)
Wheelhouse Maritime Museum, Ottawa, Ont.,
 p.149 (7P-1828)
Whitby, Ont. - general views, p.110 (7P-1374)
White, David, p.149 (7P-1829)
White, David M. Sr., p.149 (166P-34)
White, Harold, p.149 (7P-1830)
White, Jeanne I., p.149 (7P-1831)
White, Lewis E., and family, p.149 (1P-20)
White, Robert Allan (Bud), p.149 (7P-1832)
White, Tex, p.40 (7P-433)
White, Thomas M., p.149 (7P-1832)
White, William Charles, p.149 (16P-20)
White Cap, Sioux Chief, p.42 (7P-468)
White Mountains, N.H. - general views, p.15
 (123P-9)
Whitehead, Alfred, Dr., p.149 (149P-16)
Whitehorse, W., Mrs., p.149 (7P-1833)
Whitehorse, Yukon - general views, p.2 (7P-13),
 p.42 (7P-459), p.46 (7P-519), p.118
 (7P-1474), p.133 (7P-1680), p.147 (7P-1809)
Whitehorse Rapids, Yukon - general views, p.112
 (7P-1399)
Whitehorse (SS), p.9 (7P-94)
Whitehorse (Yukon) - vues, p.17 (7P-200), p.35
 (7P-370)
Whitelaw, W.M., photo., p.149 (7P-1834)
Whiteley, A., p.149 (7P-1835)
Whiteside, Don, p.149 (7P-1836)
Whitewood, Sask. - general views, p.40 (7P-440),
 p.67 (10P-8)
Whitmore, photo., p.142 (200P-8)
Whitton, Charlotte Elizabeth, p.103 (7P-1302),
 p.149 (7P-1837)
Whycocomagh, N.S. - general views, p.4 (7P-30)
Whymper, E.D., photo., p.127 (7P-1582)
Whyte, Catharine (Robb), p.149 (166P-10)
Whyte, Harold, photo., p.22 (7P-1898)
Whyte, Peter, and family, p.149 (166P-23)
Wiarton, Ont., p.50 (7P-578)
Wicks, Ben, p.5 (7P-46)
Wilcox, Sask. - general views, p.50 (7P-579)
Wild Horse River, B.C. - general views, p.112
 (7P-1395)
Wildhorse, B.C. - general views, p.18 (333P-10),
 p.47 (333P-8)
Wildhorse Creek, B.C. - general views, p.39
 (333P-6), p.68 (333P-5), p.120 (333P-36)
Wilgress, Dana and family, p.41 (7P-451)

Wilgress, Dana L., p.149 (7P-1838)
Wilkins, G.H., photo., p.3 (7P-23)
Wilkinson, Heber, p.149 (7P-1839)
Willan, Healey, Dr., p.86 (7P-1094), p.150
 (7P-1840)
Willan, Healey, Dr., p.150 (7P-1841)
Willan, James Healey, and family, p.150 (149P-17)
Willan, Mary, p.150 (7P-1841)
Willan family, Ont., p.150 (149P-17)
Willard, C.F., p.29 (7P-307)
Willette, fireman, p.52 (7P-603)
Williams, Charles A., p.150 (18P-52)
Williams, Eileen, p.150 (7P-1842)
Williams, Fred A., p.150 (7P-1843)
Williams, Thomas Frederic, p.68 (7P-830),
 p.150 (7P-1844)
Williamson, G.F., p.150 (7P-1845)
Williamson, M.F., p.150 (7P-1846)
Williamstown, Ont. - general views, p.95
 (7P-1118)
Williamstown, Ont. - scenes, p.8 (8P-11)
Willingdon, Freeman Freeman-Thomas, Comte de,
 p.26 (7P-1971)
Willingdon, Freeman Freeman-Thomas, Earl of,
 p.25 (7P-1970), p.27 (7P-280), p.91 (7P-1187)
Willingdon, Marie Adelaide, Hon. Lady, p.25
 (7P-1970), p.27 (7P-280)
Willis, Sara Ann, p.122 (7P-1518)
Willis-O'Connor, Henry and family, p.150
 (7P-1847)
Willows, Mabel M., p.150 (7P-1848)
Wilson, A.W., p.150 (7P-1850)
Wilson, Andrew, photo., p.120 (7P-1503)
Wilson, Arthur Haliburton, p.150 (7P-1849)
Wilson, Barbara M., p.150 (7P-1851)
Wilson, Bernard, p.150 (7P-1852)
Wilson, Cairine, p.149 (7P-1837)
Wilson, D.S., p.150 (7P-1855)
Wilson, Etta Kirst, p.150 (7P-1856)
Wilson, F.J., & Co., Buckingham (Québec), p.150
 (7P-1851)
Wilson, Hilda, p.150 (7P-1856)
Wilson, Irene, p.131 (7P-1639)
Wilson, J., p.47 (7P-543)
Wilson, James, p.150 (7P-1856)
Wilson, John Armistead, p.150 (7P-1857)
Wilson, M.J., & Son's, Ottawa, Ont., p.91
 (7P-1037)
Wilson, Marian, p.150 (7P-1858)
Wilson, Norman D., p.150 (7P-1859)
Wilson, Ross, p.150 (12P-12)
Wilson, T.S., p.151 (333P-29)
Wilson, Thomas Woodrow, p.85 (31P-51)
Wilson, Tom, p.151 (166P-16)
Wilson, W.A., p.150 (7P-1850)
Wilson-Croft, p.151 (7P-1854)
Wilson family, B.C., p.112 (7P-1395)
Wilson family, Ont., p.4 (47P-2)
Wilson family, Que., p.121 (7P-1510)
Wimperis family, Ont., p.58 (7P-693)
Winchester, Ont. - individuals, p.151 (7P-1866)
Windeat, W., photo., p.58 (7P-696)
Windermere, B.C. - general views, p.112
 (7P-1395), p.120 (333P-13)
Windermere Valley, B.C. - general views, p.56
 (166P-47)
Windflower (H.M.C.S.), p.87 (7P-1136)
Windham, Charles, Sir, p.85 (7P-1089)
Windsor, N.S. - fire, 1897, p.68 (1P-44)
Windsor, N.S. - general views, p.60 (7P-723), p.75
 (7P-918)
Windsor, N.S. - individuals, p.152 (7P-1884)
Windsor, Ont. - executions, p.112 (7P-1401)
Windsor, Ont. - family portraits, p.151 (200P-9)
Windsor, Ont. - general views, p.44 (7P-497),
 p.151 (7P-1860)
Windsor, Ont. - scenes, p.133 (8P-10)

Windsor Furniture Co., Windsor, N.S., p.151
(31P-78)
Windsor Star , p.40 (7P-444)
Windsor Star (the), Windsor, Ont., p.151
(7P-1860)
Wing, E., photo., p.50 (200P-12)
Wings Ltd, Lac du Bonnet (Man.), p.18 (7P-216)
Winkler, Howard Waldemar, p.151 (7P-1861)
Winnipeg, Man. - general views, p.20 (9P-6), p.23
(7P-1926), p.38 (9P-13), p.46 (7P-528), p.52
(9P-19), p.54 (7P-629), p.56 (7P-672), p.66
(7P-787), p.72 (9P-33), p.74 (9P-38), p.89
(7P-1167), p.103 (9P-59), p.105 (123P-5),
p.124 (9P-65), p.129 (9P-83), p.130
(7P-1634), p.145 (7P-1777), p.146 (7P-1797),
p.148 (7P-1825), p.149 (7P-1828), p.151
(9P-74), p.151 (9P-75)
Winnipeg, Man. - Politics and government, p.146
(7P-1797)
Winnipeg, Man. - scenes, p.34 (9P-77), p.129
(9P-78)
Winnipeg, Man. - strike, 1919, p.97 (7P-1215)
Winnipeg Free Press, Winnipeg, Man.
(newspaper), p.151 (9P-75)
Winnipeg general strike, p.54 (7P-629)
Winnipeg (Lake), Man. - general views, p.91
(7P-1187)
Winnipeg (Lake), Man. - settlement, p.79 (9P-40)
Winnipeg (Man.) - vues, p.24 (7P-1940)
Winter and Pond, photo., p.153 (161P-1)
Wiseman, Beverley, p.151 (7P-1862)
Wodehouse, R.E., p.55 (7P-642)
Wolf (H.M.C.S.), p.41 (7P-454)
Wolfe, (famille), (Ont.), p.151 (7P-1864)
Wolfe, George, p.151 (7P-1863)
Wolfe, James, Gén., p.12 (7P-131)
Wolfe, photo., p.153 (161P-1)
Wolford, England - general views, p.121 (18P-11)
Wolford, Ont. - general views, p.139 (18P-17)
Wolfville, N.S. - scenes, p.61 (8P-1)
Wolki family, p.135 (7P-1696)
Women's Canadian Club, Ottawa, Ont., p.85
(7P-1091)
Womens' International Zionist Organization, p.28
(7P-282)
Women's Musical Club, Winnipeg, Man., p.151
(9P-76)
Women's Royal Canadian Naval Service, p.78
(7P-950)
Wood, Alice, p.151 (7P-1866)
Wood, Eliz. Wynn, p.127 (7P-1583)
Wood, James Taylor, Capt., p.39 (1P-68)
Wood, S.T., p.151 (7P-1867)
Wood, William Charles Henry, p.151 (7P-1868)
Wood Buffalo National Park, Alta., p.32 (7P-345)
Wood family, N.B., p.151 (32P-6)
Woodbury, J.R., photo., p.92 (7P-1039)
Woodham, Sidney J., p.151 (7P-1869)
Wooding, H., p.151 (7P-1870)
Woodruff, Bernard J., p.151 (7P-1871)
Woodruff, John, photo., p.22 (7P-1903), p.23
(7P-1926), p.76 (7P-922), p.151 (7P-1871)
Woods, Frank, p.152 (45P-3)
Woods, J.R., p.95 (7P-1118)
Woods, Jean (famille), p.152 (185P-7)
Woods, Lake of the, Ont. - International Boundary,
p.104 (9P-4)
Woodside, H.J., photo., p.153 (161P-1)
Woodside, Henry Joseph et famille, p.152
(7P-1872)
Woodside Family, Ont., p.63 (7P-753)
Woodstock, Ont. - general views, p.116 (7P-1460)
Woodstock, Ont. - scenes, p.133 (8P-10)
Woodsworth, James Shaver, p.129 (7P-1623)
Woodsworth, James Shaver and family, p.85
(7P-1087)

Woodsworth, James Shaver et famille, p.152
(7P-1874)
Woodsworth, Mr., p.152 (7P-1873)
Woodward, J.C., p.22 (7P-1901)
Woolford, Lily, p.152 (7P-1876)
Wooll, G.R., p.152 (7P-1875)
Woollcombe, George P., Mme, p.152 (7P-1877)
Woollcombe, George P., Rév., p.152 (7P-1877)
Woonsocket, R.I. - general views, p.50 (7P-580)
Worden, O.O., p.152 (7P-1878)
Workmen's Circle, Toronto, Ont., p.73 (7P-888)
World Congress of Scientists, Toronto, Ont., p.43
(7P-484)
World Federation of Ukrainian Women's
Organizations, p.73 (7P-892)
World Health Organization, Geneva, Switzerland,
p.31 (7P-343)
World Poultry Congress, Calgary, Alta., p.100
(7P-1264)
World School Children's Art Exhibition, 1964, p.27
(7P-273)
World University Games, Turin, Italy, p.28
(7P-284)
World War, 1914-1918
 see
 European War, 1914-1918
World War, 1939-1945, p.23 (7P-1976), p.25
(7P-1908), p.28 (7P-295), p.30 (7P-320), p.54
(7P-635), p.60 (7P-721), p.61 (7P-733), p.90
(7P-1174), p.94 (7P-1095), p.103 (2P-1),
p.136 (302P-1), p.140 (7P-1755)
World War, 1939-1945 - aerial operations, p.68
(7P-825), p.153 (7P-1892)
World War, 1939-1945 - Canadian Troops -
France, p.10 (7P-108)
World War, 1939-1945 - Canadian Troops - North
Western Europe, p.10 (7P-104)
World War, 1939-1945 - Chaplains, p.81 (7P-998)
World War, 1939-1945 - communications, p.26
(7P-264)
World War, 1939-1945 - munitions, p.23
(7P-1934)
World War, 1939-1945 - naval operations, p.133
(7P-1673)
World War, 1939-1945 - Prisons and prisoners,
German, p.123 (7P-1533)
World War, 1939-1945 - Troops, Canadian, p.38
(7P-410), p.153 (7P-1888)
World War, 1939-1945 - troops, German, p.54
(7P-635)
World War, 1939-1945, Halifax, N.S., p.60
(1P-42)
Wrathall, Jack R., p.152 (7P-1879)
Wright, p.152 (333P-27)
Wright, Charles H., photo., p.152 (1P-4)
Wright, Jerauld George, p.152 (7P-1880)
Wright, Tiberius, Mme, p.21 (7P-1910)
Wurtele, Jonathan, p.152 (7P-1881)
Wurtele, Rhoda, p.28 (7P-297)
Wurtele, Rhona, p.28 (7P-297)
Wurtele, W.F., p.152 (7P-1881)
Wuschak, Edward D., p.5 (7P-46)
Wycliffe, B.C. - general views, p.80 (333P-43)
Wyle, Florence, p.63 (8P-5), p.127 (7P-1583)

Yarmouth, N.S. - individuals, p.152 (7P-1884)
Yarmouth, N.S. - scenes, p.61 (8P-1), p.133
(8P-10)
Yarmouth Academy, Yarmouth, N.S., p.5 (1P-27)
Yarmouth Iron Foundery Agency, Yarmouth, N.S.,
p.152 (31P-96)
Yasnaya Polyana, Russia - general views, p.91
(16P-13)
Yates, K., p.152 (334P-32)
Yellowknife, N.W.T. - general views, p.2 (7P-13),
p.3 (13P-12), p.73 (7P-894), p.80 (7P-983)
Yellowknife (T.N.-O.) - vues, p.17 (7P-200)
Yellowstone Mine, B.C. - general views, p.63
(196P-42)
Yesterday Antiques, Ottawa, Ont., p.152 (7P-1882)
Yorath, Dennis Kestell, p.152 (7P-1883)
York, Ont. - general views, p.125 (18P-12)
York Factory, Man. - general views, p.59 (9P-24)
York Redoubt, p.39 (1P-68)
York University, Gaby Collection, Glendon Hall,
p.152 (196P-5)
Yorkton, Sask. - general views, p.23 (7P-1926)
Yould, James, p.124 (7P-1559)
Young, Ann M., p.152 (7P-1884)
Young, Franklin Inglee, p.153 (7P-1885)
Young, G.P., p.78 (196P-47)
Young, J., Mrs., p.153 (7P-1886)
Young, J.F., p.153 (7P-1886)
Young, James, p.121 (7P-1513)
Young, Leda, p.153 (7P-1887)
Young Men's Christian Association, Halifax, N.S.,
p.137 (1P-55)
Young Men's Christian Association, Toronto, Ont.,
p.153 (7P-1888)
Young Men's Christian Association Maritimes
Boys' Camp, p.69 (1P-18)
Young Men's Hebrew Association Board of
Directors, Winnipeg, Man., p.146 (7P-1798)
Young Women's Christian Association of Canada,
Toronto, Ont., p.153 (7P-1889)
Young's Point, Ont. - general views, p.112
(7P-1406)
Ypres, Belgique - vues, p.15 (7P-182)
Ypres, Belgium - general views, p.51 (7P-587)
Yritys Athletic Club, Toronto, Ont., p.64 (7P-764)
Yukon - aerial views, p.94 (7P-1113)
Yukon - general views, p.118 (12P-23), p.153
(161P-1)
Yukon - individuals, p.153 (161P-1)
Yukon - scenes, p.2 (81P-5), p.21 (7P-262), p.42
(7P-459), p.74 (7P-898), p.75 (7P-914), p.107
(18P-38), p.107 (7P-1335), p.126 (7P-1576),
p.129 (7P-1617), p.133 (8P-10), p.147
(7P-1809), p.151 (7P-1867), p.153 (7P-1890)
Yukon, Department of the Interior Forest Service,
p.41 (31P-82)
Yukon Archives Photograph Collection, p.153
(161P-1)
Yukon Consolidated Gold Corporation, p.153
(7P-1890)
Yukon Field Force, 1898, p.145 (7P-1784)
Yukon (rivière) (Yukon) - vues, p.107 (7P-1335)
Yukon Southern Air Transport, p.92 (7P-1042)
Yukoner (SS), p.2 (7P-13)

Yale, B.C. - general views, p.70 (7P-855), p.83
(7P-1018), p.89 (7P-1167)
Yale (C.-B.) - vues, p.12 (7P-134), p.17 (7P-201),
p.35 (7P-371)
Yarmouth, N.S. - general views, p.5 (1P-27), p.35
(1P-6), p.59 (7P-704), p.85 (7P-1085), p.93
(7P-1073)

Zellers Ltd., Halifax, N.S., p.153 (31P-97)
Zimmerman, Adam Hartley, p.153 (7P-1891)
Zinck, Hilda, p.153 (1P-16)
Zoos - Ontario - Scarborough, p.140 (16P-18)
Zouaves (Pontifical), p.76 (7P-965)
Zurakowski, Janusz, p.153 (7P-1892)

Zwicker & Co. Ltd., Lunenberg, N.S., p.153
 (31P-69)
70 Mile House, B.C. - general views, p.38 (7P-413)
153 Mile House Store, Caribou, B.C., p.153
 (228P-2)

CAPTION LIST

LISTE DES LÉGENDES

Caption list

1 Market Day at Halifax, N.S., Corner of Bedford Row and Cheapside, 1886. Photo by Notman. Public Archives of Nova Scotia, 1P.

2 Lunenburg Harbour, Lunenburg, N.S., 1898. Anonymous. Public Archives of Nova Scotia, 1P.

3 Fishing at George Ives Mill, Tryon, P.E.I., ca. 1912. Photographer and collection: Mrs. Millie Gamble, accession no. 2667, item 18. Public Archives of Prince Edward Island, 5P-2.

4 Murray Harbour, P.E.I., ca. 1915. Photographer and collection: Elliott Lumsden, accession no. 2689, item 122. Public Archives of Prince Edward Island, 5P-1.

5 Beaver Hall Hill, Craig Street in Foreground, Montreal, Que., ca. 1852. Daguerreotype. Anonymous. Robert Lisle Collection. Public Archives of Canada, 7P-1008. Negative no. C 47354.

6 Mrs. Wickstad (Lady Young), 1869. Photographer and collection: William James Topley. Public Archives of Canada, 7P-83. Negative no. D 2075.

7 John G. Diefenbaker and Lester B. Pearson at Government House for a State Dinner the Evening before Opening of Parliament, Ottawa, Ont., 14 January 1959. Photographer and collection: Duncan Cameron. Public Archives of Canada, 7P-256. Negative no. 7904.

8 V-E Day Celebrations on Parliament Hill, Ottawa, Ont., 8 May 1945. Anonymous. Department of National Defence Collection. Public Archives of Canada, 7P-1976. Negative no. Z-3849-17.

9 Leaving Jeffery's Hotel, Rockingham, Ont. Photographer and collection: Charles Macnamara, accession no. 2271 S.5051. Archives of Ontario, 8P-2.

10 Sarnia Waterfront in Winter, Sarnia, Ont. Photographer and collection: John Boyd, accession no. 9912-5-10. Archives of Ontario, 8P-6.

11 Presentation of Petition by the Political Equality League for Enfranchisement of Women, 23 December 1915. (Bottom row, left to right: Dr. Mary Crawford and Mrs. Amelia Burrit; top row, left to right: Mrs. A.V. Thomas and F.J. Dixon.) Photo by Foote and James. Events Collection no. 173/3. Provincial Archives of Manitoba, 9P.

12 Joe Wacha and His Wife Plastering House, Six Miles North of Vita, Man., 1916. Photographer and collection: W.J. Sisler, no. 118. Provincial Archives of Manitoba, 9P-67.

13 Skiing, St. Luke District. Poles Are Made from Poplar Trees, ca. 1910. Photographer and collec-

Liste des légendes

1 Le jour du marché à Halifax (N.-É.), au coin de Bedford Row et Cheapside, 1886. Photo prise par Notman. Public Archives of Nova Scotia, 1P.

2 Le havre de Lunenburg, Lunenburg (N.-É.), 1898. Anonyme. Public Archives of Nova Scotia, 1P.

3 Scène de pêche à George Ives Mill, Tryon (Î.-P.É.), vers 1912. Photographe et collection: Mme Millie Gamble. Acquisition no 2667, article no 18. Public Archives of Prince Edward Island, 5P-2.

4 Murray harbour (Î.-P.-É), vers 1915. Photographe et collection: Elliott Lumsden. Acquisition no 2689, article no 122. Public Archives of Prince Edward Island, 5P-1.

5 Côte du Beaver Hall, rue Craig, au premier plan, Montréal (Qué.), vers 1852. Daguerréotype. Anonyme. Collection Robert Lisle. Archives publiques du Canada, 7P-1008. (Négatif no C 47354)

6 Mme Wickstad (Lady Young), 1869. Photographe et collection: William James Topley. Archives publiques du Canada, 7P-83. (Négatif no D 2075)

7 John G. Diefenbaker et Lester B. Pearson, à la résidence du gouverneur général, lors d'un dîner d'État la veille de l'ouverture du Parlement, Ottawa (Ont.), le 14 janvier 1959. Photographe et collection: Duncan Cameron. Archives publiques du Canada, 7P-256. (Négatif no 7904)

8 Les célébrations du jour de la victoire sur la colline du Parlement, Ottawa (Ont.), le 8 mai 1945. Anonyme. Collection du ministère de la Défense nationale. Archives publiques du Canada, 7P-1976. (Négatif no Z-3849-17)

9 Des clients quittent le Jeffery's Hotel, Rockingham (Ont.). Photographe et collection: Charles Macnamara. Acquisition no 2271 S.5051. Archives of Ontario, 8P-2.

10 La rive de Sarnia en hiver, Sarnia (Ont.). Photographe et collection: John Boyd. Acquisition no 9912-5-10. Archives of Ontario, 8P-6.

11 Présentation d'une pétition par la Political Equality League for Enfranchisement of Women, le 23 décembre 1915. Première rangée, de gauche à droite: Mme Mary Crawford et Mme Amelia Burrit; seconde rangée, de gauche à droite: Mmes A.V. Thomas et F.J. Dixon. Photo prise par Foote and James. Collection Events no 173/3. Provincial Archives of Manitoba, 9P.

12 Joe Wacha et son épouse plâtrant leur maison, six milles au nord de Vita (Man.), 1916. Photographe et collection: W.J. Sisler. No 118. Provincial Archives of Manitoba, 9P-67.

13 Une promenade à ski, district de St. Luke, au nord de Whitewood (Sask.), vers 1910. Les bâtons sont

tion: John Howard, photo no. A 6188. Saskatchewan Archives Board, 10P-8.

14 Barr Colonists upon Setting Out for Their Homesteads, Saskatoon, Sask., April 1903. Photo by Steele, photo no. B 970. Saskatchewan Archives Board, 10P.

15 Drifter Getting onto Train, June 1931. Photographer and collection: McDermid Studios Ltd., file no. 12955(b). Glenbow-Alberta Institute, 11P-13.

16 Anglican Mission School, Blackfoot Reserve, Southern Alberta, ca. 1900. Photographer and collection: Canon H.W. Gibbon Stocken, file no. NC-5-61. Glenbow-Alberta Institute, 11P-6.

17 Homesteading near Lloydminster, Alta. E. Brown Collection, item B.661. Provincial Archives of Alberta, 13P-1.

18 Imperial Oil. Leduc No. 1 Well. Leduc Oil Fields, 13 February 1947 (this was the day that the Leduc no. 1 blew in). Harry Pollard Collection, item P.2721. Provincial Archives of Alberta, 13P-2.

19 University of Toronto Gates, College St., West Side of Yonge St., Toronto, Ont., ca. 1875. Anonymous, accession E 3-2a. Metropolitan Toronto Library, 18P.

20 Yonge St., Queen to College Sts., West Side between Queen and Albert Sts., 1872. Shows row of shops known as Cameron Block and later as Page's Block. Photo by R.W. Anderson. Accession B 12-16b. Metropolitan Toronto Library, 18P.

21 Three Children Seated, Austria, ca. 1905. Gum bichromate print. Photographer and collection: Heinrich Kühn. The National Gallery of Canada, 123P-1.

22 Paving Spadina Avenue, South of College Street Looking North, Toronto, Ont., 10 June 1902. Anonymous. City Engineer's Collection, Vol. 3, p. 67. City of Toronto Archives, 140P-9.

23 [Decorative Cushion Cover], ca. 1890. Cyanotype on cloth. Anonymous. The National Gallery of Canada, 123P-1.

24 Arthur Lismer Teaching a Drawing Class at the Art Gallery of Toronto, Toronto, Ont., 10 May 1934. Photo by Arthur S. Goss. Department of Public Works Collection, Art Gallery Series no. 34. City of Toronto Archives, 140P-11.

25 Interior of the Northern Restaurant, Dawson City, Y.T., ca. 1900. Photo by Cantwell. Adams and Larkin Collection. Temporary print no. 52. Yukon Archives, 161P-1.

26 Sternwheeler *Whitehorse* and Workmen after Completing Its Construction Just 43 Days after the

en branches de peuplier. Photographe et collection: John Howard. Photo n° A 6188. Saskatchewan Archives Board, 10P-8.

14 Les colons Barr sur le point de partir vers leurs terres, Saskatoon (Sask.), avril 1903. Photo prise par Steele, photo n° B 970. Saskatchewan Archives Board, 10P.

15 Vagabond montant dans un train, juin 1931. Photographe et collection: McDermid Studios Ltd. Dossier n° 12955(b). Glenbow-Alberta Institute, 11P-13.

16 École de la mission anglicane, Blackfoot Reserve (Sud de l'Alb.), vers 1900. Photographe et collection: H.W. Gibbon Stocken. Dossier n° NC-5-61. Glenbow-Alberta Institute, 11P-6.

17 La récolte près de Lloydminster (Alb.). Collection Ernest Brown, article n° B.661. Provincial Archives of Alberta, 13P-1.

18 Imperial Oil. Puits Leduc n° 1. Champs pétrolifères Leduc (Alb.), le 13 février 1947 (le jour où le puits n° 1 explosa). Collection Harry Pollard, article n° P.2721. Provincial Archives of Alberta, 13P-2.

19 Grilles de l'université de Toronto, rue College du côté ouest de la rue Yonge, Toronto (Ont.), vers 1875. Anonyme, acquisition n° E 3-2a. Metropolitan Toronto Library, 18P.

20 Vue de la rue Yonge, des rues Queen à College, prise du côté ouest entre les rues Queen et Albert, Toronto (Ont.), 1872. On y voit une série de boutiques appelées Cameron Block et plus tard Page's Block. Photo prise par R.W. Anderson, acquisition n° B 12-16b. Metropolitan Toronto Library, 18P.

21 Trois enfants assis, Autriche, vers 1905. Gomme bichromatée. Photographe et collection Heinrich Kühn. Galerie nationale du Canada, 123P-1.

22 Pavage de l'avenue Spadina, vue vers le nord prise de la rue College sud, Toronto (Ont.), le 10 juin 1902. Anonyme. Collection City Engineer, vol. 3, p. 67. City of Toronto Archives, 140P-9.

23 [Taie de coussin décorative], vers 1890. Cyanotype sur tissu. Anonyme. Galerie nationale du Canada, 123P-1.

24 Arthur Lismer donnant une leçon de dessin à l'Art Gallery of Toronto, Toronto (Ont.), le 10 mai 1934. Photo prise par Arthur S. Goss. Collection du ministère des Travaux publics, Art Gallery Series, n° 34. City of Toronto Archives, 140P-11.

25 Vue intérieure du Northern Restaurant, Dawson City (Yukon), vers 1900. Photo prise par Cantwell. Collection Adams & Larkin. Numéro temporaire de l'épreuve: 52. Yukon Archives, 161P-1.

26 Le vapeur à aubes *Whitehorse* et les ouvriers à la fin des travaux de construction, quarante-trois jours

Keels Were Laid in Time for the Opening of Navigation on the Yukon River, Whitehorse Shipyard, Whitehorse, Y.T., May 1901. Photographer and collection: H.C. Barley, print no. 5550. Yukon Archives, 161P-1.

27 Panoramic View Looking North on Main Street from 7th Avenue, Vancouver, B.C., 1889. Photographer and collection: Bailey Brothers. Bailey Brothers Collection, item 36. Vancouver Public Library, 300P-1.

28 Panoramic View Looking North on Granville from Georgia, Tally-Ho Wagon, Vancouver, B.C., 1905. Photographer and collection: Philip Timms. Philip Timms Collection, item 5204. Vancouver Public Library, 300P-1.

après la mise en chantier, à temps pour l'ouverture de la navigation sur la rivière Yukon, chantier naval Whitehorse, Whitehorse (Yukon). Photographe et collection: H.C. Barley. Photo n⁰ 5550. Yukon Archives, 161P-1.

27 Vue de la rue Main vers le nord, prise de la 7ᵉ avenue, Vancouver (C.-B.), 1889. Photographe et collection: Bailey Brothers. Article n⁰ 36. Vancouver Public Library, 300P-1.

28 Vue de la rue Granville vers le nord, prise de la rue Georgia, calèche Tally-Ho, Vancouver (C.-B.), 1905. Photographe et collection: Philip Timms. Article n⁰ 5204. Vancouver Public Library, 300P-1.

ERRATA

ERRATA

In the next volume of this guide the following institutions will be identified by the numbers used in the *Union List of Manuscripts:*

Dans le volume 2 du présent guide les institutions suivantes seront identifiées par les numéros adoptés dans le *Catalogue collectif des manuscrits* soit:

34P– Army Museum, Halifax, N.S.
49P– Saskatchewan Archives Board, Saskatoon, Sask.
86P– Vancouver Public Library, Vancouver, B.C.
94P– Women's Canadian Historical Society, Toronto, Ont.
124P– New Westminster Public Library, New Westminster, B.C.
229P– Fort Steele Historic Park, Fort Steele, B.C.
239P– Archives nationales du Québec, Centre régional de la Mauricie Bois-Francs, Trois-Rivières (Québec)
240P– Archives des Franciscains, Montréal (Québec)

KEY TO LOCATION OF PHOTOGRAPHS

LISTE NUMÉRIQUE DES DÉPÔTS

KEY TO LOCATION OF PHOTOGRAPHS/LISTE NUMÉRIQUE DES DÉPÔTS

1P– Public Archives of Nova Scotia, Halifax, N.S.
2P– New Brunswick Museum, Saint John, N.B.
4P– Provincial Archives of Newfoundland, St. John's, Nfld.
5P– Public Archives of Prince Edward Island, Charlottetown, P.E.I.
7P– Public Archives of Canada/Archives publiques du Canada, Ottawa (Ont.)
8P– Archives of Ontario, Toronto, Ont.
9P– Provincial Archives of Manitoba, Winnipeg, Man.
10P Saskatchewan Archives Board, Regina, Sask.
11P Glenbow–Alberta Institute, Calgary, Alta.
12P Provincial Archives of British Columbia, Victoria, B.C.
13P Provincial Archives of Alberta, Edmonton, Alta.
15P Centre d'études acadiennes, Moncton (N.-B.)
16P Thomas Fisher Rare Book Library, Toronto, Ont.
18P Metropolitan Toronto Central Library, Toronto, Ont.
22P Lennox and Addington Historical Society, Napanee, Ont.
24P United Church of Canada, Maritime Conference Archives, Halifax, N.S.
31P Dalhousie University Archives, Halifax, N.S.
32P Mount Allison University Archives, Sackville, N.B.
38P Provincial Reference Library, Newfoundland Public Library Services, St. John's, Nfld.
39P Memorial University of Newfoundland, Folklore and Language Archives (MUNFLA), St. John's, Nfld.
45P Hamilton Public Library, Hamilton, Ont.
46P Provincial Archives of New Brunswick/Archives provinciales du Nouveau-Brunswick, Fredericton
47P Oakville Museum, Oakville, Ont.
75P Queen's University Archives, Kingston, Ont.
81P Royal Canadian Mounted Police Museum, Regina, Sask.
82P Queen's Own Rifles, Regimental Museum, Toronto, Ont.
91P Kamloops Museum, Kamloops, B.C.
92P University of Alberta Archives, Edmonton, Alta.
95P Stephen Leacock Memorial Home, Orillia, Ont.
104P Beaton Institute of Cape Breton Studies, College of Cape Breton, Sydney, N.S.
110P Rossland Historical Museum, Rossland, B.C.
113P Bibliothèque municipale de la ville de Montréal, Montréal (Québec)
121P Sault Ste. Marie Historical Society Museum, Sault Ste. Marie, Ont.
123P National Gallery of Canada/Galerie nationale du Canada, Ottawa (Ont.)
131P Archives du séminaire de Québec, Québec (Québec)
134P Musée du Royal 22e régiment, La Citadelle, Québec (Québec)
140P City of Toronto Archives, Toronto, Ont.
143P Archives of the Toronto Board of Education, Toronto, Ont.
146P Lakehead University Library, Thunder Bay, Ont.
149P National Library of Canada/Bibliothèque nationale du Canada, Ottawa (Ont.)
158P Peterborough Centennial Museum and Archives, Peterborough, Ont.
160P York University Archives, Downsview, Ont.
161P Yukon Archives, Whitehorse, Yukon
163P Moose Jaw Public Library, Moose Jaw, Sask.
166P Archives of the Canadian Rockies, Banff, Alta.
171P Archives du monastère de l'Hôtel-Dieu de Québec, Québec (Québec)
185P Centre de recherche en civilisation canadienne-francaise, Ottawa (Ont.)
193P Archives Deschâtelets (Oblats de Marie-Immaculée), Ottawa (Ont.)
196P University of Toronto Archives, Toronto, Ont.
200P University of St. Michael's College Library, Toronto, Ont.
208P Archives des clercs de Saint-Viateur, Montréal (Québec)
221P Archives provinciales des Clercs de Saint-Viateur de Joliette, Joliette (Québec)
222P Archives de la Société historique de Saint-Boniface, Saint-Boniface, (Man.)
228P Cariboo-Chilcotin Archives, Williams Lake, B.C.
300P Vancouver Public Library, Vancouver, B.C.
301P Ottawa Diocesan Archives, Ottawa, Ont.
302P University of King's College Library, Halifax, N.S.
303P Centre de documentation de **La Presse**, Montréal (Québec)
304P Army Museum, Halifax, N.S.
305P Jewish Historical Society of Western Canada Inc., Winnipeg, Man.
306P Archives de l'Archidiocèse d'Ottawa, Ottawa (Ont.)
307P Ryerson Institute Archives, Toronto, Ont.
308P Art Gallery of Ontario, Toronto, Ont.
309P Bank of Nova Scotia Archives, Toronto, Ont.
310P Archives of the Brothers of the Christian School of Ontario, Don Mills, Ont.

311P Canadian Broadcasting Corporation Archives/Archives de la Société Radio-Canada, Ottawa (Ont.)
312P The Globe and Mail Library, Toronto, Ont.
313P Hartill Art Associates, London, Ont.
314P Women's Canadian Historical Society, Toronto, Ont.
315P Archives nationales du Québec, Centre régional de la Mauricie Bois-Francs, Trois-Rivières (Québec)
316P Ontario Hydro Photo Library, Toronto, Ont.
317P Archives of the Presbyterian Church in Canada, Toronto, Ont.
318P St. Michael's Hospital Archives, Toronto, Ont.
319P Sisters of St. Joseph Archives, Willowdale, Ont.
320P Toronto Dominion Bank Archives, Toronto, Ont.
321P University College Archives, University of Toronto, Toronto, Ont.
322P Toronto Harbour Commissioners, Toronto, Ont.
323P Banque royale (archives historiques), Montréal (Québec)
324P Archives du séminaire de Nicolet (Grand séminaire de Nicolet), Nicolet (Québec)
325P Service central des archives de la congrégation des Soeurs des Saints Noms de Jésus, Outremont (Québec)
326P Centre Emilie Gamelin, Montréal (Québec)
327P Notman Photographic Archives (McCord Museum), Montreal, Que.
328P Archives des Franciscains, Montréal (Québec)
329P Service des archives, Maison provinciale des Filles de la Charité du Sacré-Coeur de Jésus, Sherbrooke (Québec)
330P Bell Canada (collection historique) Montréal, (Québec)
331P Archives générales des Oblates Missionnaires de Marie-Immaculée, Trois-Rivières (Québec)
332P National Research Council of Canada/Conseil national de recherches du Canada, Ottawa (Ont.)
333P Fort Steele Historic Park, Fort Steele, B.C.
334P New Westminster Public Library, New Westminster, B.C.
335P Archives nationales du Québec, Centre régional du Saguenay - Lac Saint-Jean, Chicoutimi (Québec)
337P Moncton Museum Inc., Moncton, N.B.
338P Sisters Servants of Mary Immaculate Community Archives, Toronto, Ont.
339P Saskatoon Public Library, Saskatoon, Sask.
340P Mount St. Vincent University Archives, Halifax, N.S.
341P Centre de documentation de la Société historique Nicolas-Denys, Bertrand (N.-B.)
342P Ministère des Communications du Québec, Division de la documentation photographique, Québec (Québec)
343P Conseil intermunicipal des loisirs du Témiscouata, Notre-Dame-du-Lac (Québec)
344P La Société historique du comté de Shefford, Granby (Québec)
345P Photos Duplain, Enr., Saint-Raymond, Cté de Portneuf (Québec)
346P Bishop's College School, Lennoxville (Québec)
347P Maurice Saint-Pierre, Bromptonville (Québec)
348P Studio Gendreau, La Pocatière, Cté de Kamouraska (Québec)
349P Studio Boutet, La Pocatière, Cté de Kamouraska (Québec)
350P Studio Jean-Paul, Saint-Pascal, Cté de Kamouraska (Québec)
351P Alain Sauvageau, Cap-de-la-Madeleine (Québec)
352P C.E.G.E.P. de Shawinigan, Shawinigan (Québec)
353P Jean Fontaine, Plessisville (Québec)
354P Roland Lemire, Trois-Rivières (Québec)